Author Class

JACOBSTHAL 709.
Vol.1. 715.
 212
 JAC

City of Coventry College of Art and Design Library

EARLY
CELTIC ART

VOLUME I
TEXT

EARLY CELTIC ART

By

PAUL JACOBSTHAL

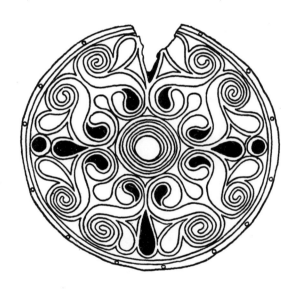

OXFORD

AT THE CLARENDON PRESS

Oxford University Press, Ely House, London W. 1

GLASGOW NEW YORK TORONTO MELBOURNE WELLINGTON
CAPE TOWN SALISBURY IBADAN NAIROBI LUSAKA ADDIS ABABA
BOMBAY CALCUTTA MADRAS KARACHI LAHORE DACCA
KUALA LUMPUR SINGAPORE HONG KONG TOKYO

FIRST PUBLISHED 1944
REPRINTED LITHOGRAPHICALLY IN GREAT BRITAIN
FROM CORRECTED SHEETS OF THE FIRST EDITION
AT THE UNIVERSITY PRESS, OXFORD
BY VIVIAN RIDLER
PRINTER TO THE UNIVERSITY
1969

PREFACE

DÉCHELETTE's masterly *Manuel d'archéologie préhistorique celtique et gallo-romaine* is still the only comprehensive study of Celtic archaeology. The scope of my book is narrower: it is confined to the early phase, which covers roughly the fourth and third centuries B.C., and part of the fifth and second, and its subject is not the civilization of the Gauls, but their art. I have tried to link Early Celtic art with the arts of Europe and Asia which nourished it.

The selection of objects, the manner of illustration and description are intended to serve this purpose: the book is not a *corpus* of all specimens preserved—which would comprise thousands of items and require many hundred plates—but a selection of works chosen for their style or technique. In spite, or because, of the one-sidedness of my approach the book, I trust, will answer or help to answer questions which are the primary concern of prehistory, questions of the chronology and the connexions of Celtic civilization in its early age. The book may also help to lay the foundations of future work on later Celtic art.

There are gaps in the material: I have intentionally omitted glass, which is of little value for my special purposes; and I have purposely excluded Celtic art in Spain: I have not visited the country, and Spanish art, not only of this period, has so strong a note of its own and modifies its models so deeply and peculiarly that the student of Celtic art as a general European phenomenon might well leave Spain on one side.

Other gaps are due to difficulties which I could not overcome. The Bohemian material, preserved for its greater part in Prague, is inadequately represented, and the eighteen clay vases, nos. 402–19 of my Catalogue, are far from giving an idea of Celtic pottery: war has prevented me from studying this important subject in French and Hungarian museums. The omission of Early Celtic works in this country is also due to the war: I hope to fill this gap in a book on *Celtic Art in the British Isles*, which I have in preparation.

The description of the objects contained in the Catalogue (pp. 165–205), with a few exceptions, is based on study of the originals; the photographs, apart from a few, were taken by the friend mentioned below or by myself. They are illustrated in *pls. 1–215*, each with its Catalogue number affixed, and, as far as possible, in the order of the Catalogue. For technical reasons and for the sake of clearness the scale of reproduction varies: the measurements of the pieces are given in the Catalogue.

Pls. 216–60 show objects illustrating chapters 1–6: they can be identified by consulting Index 2.

Pls. 261–79 contain linear drawings which illustrate Chapter 3, the Grammar of Celtic Ornament. The scale of reproduction is arbitrary. A key to these patterns is given on pp. 60–7.

The material of the objects, if not otherwise stated, is bronze. Patina, being due to external influences, is only described in exceptional cases and for special reasons.

The classification of the objects in the Catalogue according to the kind of implement and the material led to resolution of tomb-units, which some readers will criticize as inconvenient: they are asked to avail themselves of the lists of graves on pp. 135–6 and of Index 4.

A preface is not and should not be a pretext for autobiography, but in my case, it would, I feel, be almost insincere not to speak of myself and the times, and I have to apologize for many imperfections for which I am not responsible.

First, I should like to satisfy the curiosity of readers asking how and why I, a classical archaeologist, came to poach on the hunting-grounds of prehistory. *Chaque chose appartient à qui sait en jouir*: one day in the cold and hungry winter of 1921 when I was studying Greek vases in Stuttgart, I was attracted by the painted Attic cup from the Klein Aspergle chieftain-grave (*pl. 26*), not because of its beauty or its importance for the history of Greek vase-painting—it was a third-rate piece and had not yet been attributed by Beazley to the Amymone painter: what struck me was the fact that a Greek cup had been found in this Hyperborean country, and the gold plaques of a strange style mounted on it; there were similar gold ornaments and Italic bronzes, all from the same tomb. Here were two problems: trade between the Mediterranean and the North, and this odd gold which seemed to reflect, in a peculiar way, Greek forms. I first tried to become clear about the Southern imports in the North: the results were published in Jacobsthal and Langsdorff, *Die Bronzeschnabel-kannen* (1929), and in Jacobsthal and Neuffer, *Gallia Graeca, Recherches sur l'hellénisation de la Provence* (*Préhistoire* 1933). The other problem, Celtic art, was more difficult: I soon realized that most of the finds, though known for fifty years, had never been examined and illustrated with the care they deserve. For years I travelled to many European museums, handled and photographed objects, much helped by a friend whose name, but for hateful reasons, would appear on the title of the book. Down to 1935 my studies and journeys were furthered by the German Archaeological Institute, and by the Notgemeinschaft der deutschen Wissenschaft, and the book was to be published by the German Archaeological Institute whose then presidents took a personal interest in it.

In 1935 the Hitler government dismissed me from the chair of Archaeology in the University of Marburg and deprived me of the use of my Seminar, well equipped for my studies: the University of Oxford made me a Reader in Celtic Archaeology, Christ Church a Lecturer, and various bodies in the University and the British Academy took a most active interest in my work and helped me to carry on: my warmest thanks are due to them. The book, drafted since 1933 in German, had to be rewritten in English, not only rewritten but re-thought: it was a hard lesson, much to the advantage of the book and to my own, for writing English (and Latin) is the test whether you have your object in focus.

I am deeply grateful to friends, to none more than to Professor J. D. Beazley, who taught me to write English, who read my manuscript and proofs more than once, not confining his interest to what is Greek or Etruscan in this book. C. E. Stevens was my teacher and expert in technical terminology. I owe much to discussions with the late Professor Collingwood, with C. F. C. Hawkes, E. T. Leeds, J. M. de Navarro, Kenneth Sisam. I had expert advice on the archaeology of the Near and Far East from Professor Ellis H. Minns, Dr. Sidney Smith, and Professor W. Perceval Yetts, who very kindly contributed the drawings reproduced in *pl. 221, g, h*. I owe a great debt of gratitude to Dr. Jacob Hirsch who for twenty years furthered my studies in many ways. I would also express my thanks to Mr. J. von Fleissig and Mr. E. von Kund of Budapest who provided me with photographs of

objects in their collections, with manifold information and books on Hungarian archaeology. I gratefully remember the hospitality, kindness, and patience of Keepers and Staffs of the museums in which the objects published are preserved. My thanks to my German friends and pupils who are unforgotten must go anonymous. . . . I offer my sincere thanks to the Delegates of the Clarendon Press for considering and carrying through the publication under very adverse conditions, and to their Staff for their pains and never-failing patience in producing the plates.

P. J.

OXFORD,
January, 1943

VIRO BONO

LABORUM ET ITINERUM

SOCIO FIDELI

CONTENTS

CHAPTER 1. THE IMAGE OF MAN

CHAPTER 2. ANIMALS

CONTENTS

CHAPTER 3. GRAMMAR OF CELTIC ORNAMENT

CHAPTER 4. A SURVEY OF IMPLEMENTS AND SOME REMARKS ON THEIR TECHNIQUE

CHAPTER 5. CHRONOLOGY

CHAPTER 6. CELTIC CRAFTS, THEIR ORIGIN AND CONNEXIONS

EPILOGUE

ABBREVIATIONS

AA — *Archaeologischer Anzeiger.*

Åberg — Åberg, *Bronzezeitliche und früheisenzeitliche Chronologie.*

AJA — *American Journal of Archaeology.*

AM — *Athenische Mitteilungen.*

Annuario — *Annuario della Reale Scuola archeologica di Atene.*

Arch. Ert. — *Archaeologiai Értesitö.*

ASA — *Anzeiger für Schweizerische Altertumskunde.*

AuhV — *Altertümer unserer heidnischen Vorzeit.*

Aurigemma — Aurigemma, *Il R. Museo di Spina.*

AZ — *Archaeologische Zeitung.*

BA — *Bulletin archéologique.*

BAF — *Bulletin de la Société des Antiquaires de France.*

BARV — J. D. Beazley, *Attic Red-figured Vase-Painters.*

BCH — *Bulletin de correspondance hellénique.*

Behn — Behn, *Kataloge Mainz No. 8, Italische Altertümer vorhellenistischer Zeit.*

Behrens — Behrens, *Bodenurkunden aus Rheinhessen.*

Besig — Besig, *Gorgo und Gorgoneion in der archaischen griechischen Kunst* (Diss. Berlin, 1937).

Bieńkowski — Bieńkowski, *Die Darstellungen der Gallier in der hellenistischen Kunst.*

Bittel — Bittel, *Die Kelten in Württemberg.*

BJ — *Bonner Jahrbücher.*

Blanchet — Blanchet, *Traité des monnaies gauloises.*

Blinkenberg — Blinkenberg, *Fibules grecques et orientales.*

BM — British Museum.

BMC — British Museum, *Catalogue.*

BM EIA — British Museum, *Guide to Early Iron Age Antiquities.*

Bonstetten — de Bonstetten, *Recueil d'antiquités suisses.*

Borovka — Borovka, *Scythian Art.*

Bossert — Bossert, *Geschichte des Kunstgewerbes.*

BPI — *Bullettino di Paletnologia Italiana.*

BSA — *The Annual of the British School at Athens.*

BSPF — *Bulletin de la Société préhistorique de France.*

BSR — *Papers of the British School at Rome.*

BWP — *Berliner Winckelmannsprogramm.*

CdM — Cabinet des Médailles.

Cl. Rh. — *Clara Rhodos.*

CIA — *Congrès internationaux d'anthropologie et d'archéologie préhistoriques.*

CPF — *Congrès préhistorique de France.*

CVA — *Corpus Vasorum Antiquorum.*

Dall' Osso — Dall' Osso, *Guida illustrata del Museo Nazionale di Ancona.*

Dalton — Dalton, *The Treasure of the Oxus².*

Déchelette — Déchelette, *Manuel d'archéologie préhistorique celtique et gallo-romaine* (I quote the first edition).

Dolgozatok — Dolgozatok 9/10 1933/4 (Travaux de l'Institut archéologique de l'Université François-Joseph à Szeged (Hongrie)), Márton, *Das Fundinventar der Frühlatènegräber.*

Ducati — Ducati, *Storia dell' arte etrusca.*

Duhn — Duhn, *Italische Gräberkunde.*

Ebert — Ebert, *Reallexikon der Vorgeschichte.*

Eph. arch. — ʽΕφημερὶς ʼΑρχαιολογική.

Espérandieu — Espérandieu, *Recueil des bas-reliefs de la Gaule.*

ESA — *Eurasia Septentrionalis Antiqua.*

Filow — Filow, *Die archaische Nekropole von Trebenischte.*

Fourdrignier — Fourdrignier, *La double sépulture de la Gorge-Meillet.*

Furtwängler — Furtwängler, *Die antiken Gemmen.*

FR — Furtwängler und Reichhold, *Griechische Vasenmalerei.*

Gérin — de Gérin-Ricard, *Le sanctuaire préromain de Roquepertuse.*

GGA — *Göttingische gelehrte Anzeigen.*

Giglioli — Giglioli, *L'arte etrusca.*

Ginters — Ginters, *Das Schwert der Skythen und Sarmaten.*

Godard — Godard, *Les bronzes du Louristan.*

Gössler — Gössler, *Der Silberring von Trichtingen.*

Hampe — Hampe, *Frühe griechische Sagenbilder in Boeotien.*

Hanfmann — *Altetruskische Plastik,* I.

Haspels — Haspels, *Attic black-figured Lekythoi.*

Jacobsthal, Ornamente — Jacobsthal, *Ornamente griechischer Vasen.*

JdI — *Jahrbuch des Archäologischen Instituts des deutschen Reiches.*

JHS — *Journal of Hellenic Studies.*

JL — Jacobsthal and Langsdorff, *Bronzeschnabelkannen.*

IPEK — *Jahrbuch für prähistorische Kunst.*

JRAI — *Journal of the Royal Anthropological Institute.*

JRS — *Journal of Roman Studies.*

KiB — *Kunstgeschichte in Bildern.*

Kühn — Kühn, *Vorgeschichtliche Kunst Deutschlands.*

Kunkel — Kunkel, *Oberhessens vorgeschichtliche Altertümer.*

Kunze — Kunze, *Kretische Metallreliefs.*

Lindenschmit — Lindenschmit, *Das Römisch-Germanische Zentralmuseum in bildlichen Darstellungen aus seinen Sammlungen.*

Lipperheide — Lipperheide, *Antike Helme.*

Lippold — Lippold, *Gemmen und Kameen.*

Luschey — Luschey, *Die Phiale* (Dissertation, München, 1939).

MAAR — *Memoirs of the American Academy in Rome.*

MAF — *Mémoires de la Société des Antiquaires de France.*

Márton — Márton, *Die Frühlatènezeit in Ungarn, Archaeologia Hungarica,* II.

Minns — Minns, *Scythians and Greeks.*

MJ — *Münchener Jahrbuch der bildenden Kunst.*

Mon. Ant. — *Monumenti antichi.*

Mon. Piot — *Monuments et Mémoires. Fondation Eugène Piot.*

Montelius — Montelius, *La civilisation primitive en Italie.*

Morel — Morel, *La Champagne souterraine.*

Morin-Jean — Morin-Jean, *Le dessin des animaux.*

Mühlestein — Mühlestein, *Die Kunst der Etrusker.*

Not. Sc. — *Notizie degli Scavi.*

OeJ	*Jahreshefte des Oesterreichischen Archäologischen Institutes.*	Salmony, Loo	Salmony, *Sino-Siberian Art in the Collection of C. T. Loo.*
Orthia	Dawkins, *The Sanctuary of Artemis Orthia at Sparta.*	Sarre	Sarre, *Die Kunst des alten Persien.*
Paret	Paret, *Das Fürstengrab der Hallstattzeit von Bad Cannstatt.*	Schaeffer	Schaeffer, *Les tertres funéraires dans la forêt d'Haguenau, 2.*
Payne, NC	Payne, *Necrocorinthia.*	Schefold	Schefold, *Der skythische Tierstil in Südrussland, Eurasia Septentrionalis Antiqua 12.*
Payne, PV	Payne, *Protokorinthische Vasenmalerei.*		
Perachora	Payne and others, *Perachora*, 1.	Schránil	Schránil, *Vorgeschichte Böhmens und Mährens.*
Pfuhl	Pfuhl, *Die Malerei und Zeichnung der Griechen.*	Sprater	Sprater, *Die Urgeschichte der Pfalz.*
		Stocky	Stocky, *La Bohème à l'âge du fer.*
Pope	Pope, *A Survey of Persian Art.*	Treasures	Mahr and others, *Prehistoric Grave Material from Carniola (Treasures of Carniola)*, Sale Catalogue, New York, 1934.
PZ	*Prähistorische Zeitschrift.*		
RA	*Revue archéologique.*		
RE	*Paulys Realencyclopädie der classischen Altertumswissenschaft.* Neue Bearbeitung.	Troyes	Musée de Troyes, *Catalogue des bronzes* (Troyes, 1898).
Reinecke	Reinecke, *Zur Kenntnis der La-Tène-Denkmäler der Zone nördlich der Alpen, Mainzer Festschrift*, 1902, 53 ff.	Ulrich	Ulrich, *Die Gräberfelder in der Umgebung von Bellinzona.*
		Uvarov	Uvarov, *Materiali po Arkheologii Kavkasa*, 8.
Riegl	Riegl, *Stilfragen.*	Viollier	Viollier, *Les sépultures du second âge du fer sur le plateau Suisse.*
RGK	*Römisch-germanische Kommission des Deutschen Archaeologischen Instituts.*		
Roscher	Roscher, *Lexikon der Mythologie.*	Vouga	Vouga, *La Tène.*
RM	*Römische Mitteilungen.*	Wagner	Wagner, *Funde und Fundstätten in Baden, 2.*
Rostovtzeff AS	Rostovtzeff, *Animal Style in South Russia and China.*	Ward	Ward, *The Seal Cylinders of Western Asia.*
		Weber	Weber, *Altorientalische Siegelbilder.*
Rostovtzeff IG	Rostovtzeff, *Iranians and Greeks in South Russia.*	Wiedmer-Stern	Wiedmer-Stern, *Das gallische Gräberfeld bei Münsingen.*
Rostovtzeff SB	Rostovtzeff, *Skythien und der Bosporus.*	WPZ	*Wiener Prähistorische Zeitschrift.*
Sacken	Sacken, *Das Grabfeld von Hallstatt in Oberösterreich und dessen Altertümer.*	WV	*Wiener Vorlegeblätter.*
		Zannoni	Zannoni, *Gli Scavi della Certosa di Bologna.*
Salmony, Jade	Salmony, *Carved Jade in Ancient China.*	Zwicker	Zwicker, *Fontes historiae religionis Celticae.*

P, PP Pattern(s), i.e. the drawings of ornaments (nos. 1–476) illustrated in *pls. 261–79.*

CHAPTER 1
THE IMAGE OF MAN

EVEN a rapid glance at the plates cannot fail to convey the impression of a striking contrast between the refinement of the metalwork with its beautiful and ingenious ornamentation and the clumsy idols figured in *pls. 1–15*. And how narrow is the repertory of Early Celtic imagery! It is confined to huge menhir-like statues in stone, to a few busts or miniature doll-like men, and to a multitude of heads, either primitive or strongly stylized, adorning metal objects.

Only where foreign influence works on the Gauls is it otherwise. The sword from Hallstatt, no. 96, is the best and the most interesting of these hybrid works. Celtic are its general shape, the plastic frame of the chape,[1] and some geometric and floral motives.[2] But to decorate a sword-sheath with figures and to depict riders, foot-soldiers, wrestlers, and wheel-turners is un-Celtic. This is a reflection of the arts of Este, of those situlae and other figured bronzes made from about 500 B.C. down to the fourth century B.C. by the Veneti and copied with varying success over a wide area of North-east Italy and the adjacent Alpine regions.[3] The Veneti wrote in North Etruscan characters[4] and their figure style also reflects Etruscan models. The interest of the buckets does not lie in the animal friezes and other things which one can see in a more perfect form on their Etruscan prototypes, but in what they teach us about customs, dress, and implements of the natives, in the pictures of battle, symposion, sacrifice, games, and love-making. The wheel-turners and wrestlers of the sword have no parallel on the situlae. Foot-soldiers and riders occur frequently: in *pl. 216, c*, I illustrate a detail of the situla in Providence,[5] in *pl. 216, a*, the top frieze of that from the Certosa di Bologna, grave 68,[6] which was found together with an Attic lekythos (Zannoni pl. 35, 4, p. 101; Bologna, Pellegrini 94), dated by Miss Haspels about 490 B.C. I also refer to the bronze girdle from Watsch, Ebert 3 pl. 121, g; 14, 256; Déchelette fig. 591, p. 769.

The pictures on the Hallstatt sword are engraved in sharp hair-fine lines. The longest panel shows three foot-soldiers and four riders; the second rider strikes with his spear at an enemy, who, with the feet in the air, lies on the ground under the horse of the first rider and tries to keep the blow off—not quite a vivid picture of a fight. On each side follows a framed scene of two wheel-turners, and the triangular field at the chape is filled with a group of three wrestlers. The contours of the men—except certain naked parts—and of the horses are doubled. The heads of the men are roundish and heavy; eyes, ears, and the long hair, where not hidden by a helmet, are neatly engraved. The riders wear helmets with low flattish crowns, a brim with a simple ornament, and chin-straps. They and the wheel-turners wear patterned trousers, recalling those of Amazons, Scythians, or Persians, borrowed from the East.[7] The wheel-men have tail-coats, girded round the waist.[8] The shoes are of tsarouchia-type; the leather is stippled, tongues and straps are carefully drawn. The

[1] p. 43.
[2] *PP 105, 218, 251, 395*, pp. 31, 45.
[3] Ebert 12, 183 (von Duhn).
[4] G. Herbig in Ebert 11 pl. 6; 14, 118. For the inscription on the Providence situla see Whatmough in the publication quoted in footnote 5.

[5] Bull. of the Museum of Art, Rhode Island School of Design 28, no. 1, 1940 (Hanfmann).
[6] Zannoni pl. 35; Montelius pl. 105; Ducati pl. 152, and elsewhere.
[7] p. 156.
[8] M. Rosenberg, Geschichte der Goldschmiedekunst, Einführung 17.

riders are seen from the back: they wear chequered corslets and, underneath, a short chiton with stylized folds. The horses are drawn in a very Celtic manner.[1] Their bridles are leather straps adorned with metal phalerae.[2] The foot-soldiers are bare-headed and have no trousers, only shoes; their bodies are hidden behind the ellipsoid shields which often occur in Este monuments;[3] the three-leaf pattern at the ends of the midrib and beside it looks Celtic; two of the shields have maeander-hooks on the rim, like the shield of the warrior from Fondo Baratela at Este, Not. Sc. 1888 pl. 9; the same motive is used to decorate the rim of the wheel.

There are other pictures of games on Venetian and related works:[4] that wheel-turning here is an action connected with war has been plausibly suggested by Drexel, JdI 30 1915, 27:[5] on the silver cauldron from Gundestrup (JdI l.c. plate facing p.1, bottom), an East Celtic work of the first century B.C., a warrior with a horn-helmet turns a wheel; warrior and wheel pertain to the god at his side.

The picture of the wrestlers, clearer in Hoernes's slightly reconstructed drawing, which I have substituted for the vulgate, than in the original, shows a group of three; the defeated man lying on the ground, the victor sitting astride of him, fetching him a blow with the fist on the forehead: the victim grasps his left wrist and right forearm; a third party, in a half-squatting position, the feet firmly planted on the ground, pulls—if Hoernes is right—the left leg of the conqueror. From his buttocks grow tendrils of Celtic style:[6] this 'tail' is either—and I prefer this alternative—an amusing improvisation without symbolic meaning, just a clever filling of the corner, like snakes and tendrils in classical pediments—or the man is a demon, a member of the family of vegetation gods, originating in Asia Minor.[7] One might also think of that funny creature, half man, half ornament, on a razor from Borgdorf, Holstein.[8]

The sword is a blend of Venetian and Celtic elements, either the result of collaboration between a Celtic armourer and an Este engraver already familiar with Celtic forms, or done by one man commanding both styles. It was made in a transalpine workshop.

Another proof of the close connexion of Celts and Veneti[9] (Polybius 2, 17, 5) is given by works in hybrid style from Gallia cisalpina. The situla from Moritzing, no. 399, has figure friezes of the worst provincial Este style, and near the upper rim a row of Celtic leaves, *P317*.[10] The dagger from Este,[11] *pl. 216, b*, shows warriors which go with bronzes from Fondo Baratela at Este and with the above-mentioned bronze girdle from Watsch in Carniola. Of the ornament above the warriors, the lower frieze, *P 318*, is definitely Celtic[12] and the top row, with a guilloche and zigzag lines, can be compared with the sword from Sanzeno, no. 104.

A dagger of this type is carved on the rocks in the Val Camonica, the valley of the Oglio,

[1] pp. 31, 45. [2] pp. 122; 156.

[3] Déchelette 1168, 2.

[4] Merhart, Mannus, 24, 61; JRS 28 1938, 66.

[5] Drexel has suggested—and I wrongly followed him (JRS 28 1938, 66)—that on the dagger from Peschiera on the lake of Garda (BJ 85 1888 pl. 1, p. 1; Montelius pl. 64, 13; Hoernes, Urgeschichte der bildenden Kunst 662 fig. 199) the same ritual game is represented in an abbreviated, obscured form: this seems to be based on the corrupt drawing in Montelius, but is not supported by the reproduction in the first publication, BJ l.c.

[6] *P 105*.

[7] L. Curtius, RM 49 1934, 225 ff.

[8] Ebert 3 pl. 121, d, p. 320; Mitteilungen des Anthrop. Vereins Schleswig-Holstein 1896, 4 fig. 4; WPZ 2, 10 fig. 9, where Hoernes wrongly connects the piece with Cretan seals from Knossos.

[9] p. 160. [10] p. 83.

[11] BPI 37 1912 pl. 4, p. 90; Montelius pl. 59, 13; JRS 28 1938 pl. 11, 2, p. 66; Duhn 2 pl. 9, a. A second piece from Este is published in Not. Sc. 1932, 39 fig. 9.

[12] p. 83.

in the territory of the Raetian tribe Camuni (Altheim, Die Welt als Geschichte 3 1937 fig. 5; JRS 28 1938 pl. 11, 4), together with other pictures which well illustrate the Veneto-Celtic civilization of this Raetian backwater in the fourth century B.C. I content myself with showing three specimens, and refer to the discussion in the papers quoted.[1] *Pl. 217, a*, the Celtic Stag-god Cernunnus, differs from all other representations of the god in that he is not squatting in a Buddha-like attitude[2] but standing upright and clad in a long garment. His arms are raised, his right hand seems to hold a small indistinct object; a torc hangs round the right elbow,[3] and possibly another round the left; but this part is badly damaged and it must remain uncertain whether what is to be seen under the left arm is, as Altheim suggested, a snake, or a bungled bird. Beside Cernunnus stands an 'orans'—phallic: this is a regional or tribal feature, because on the whole the Celts are 'decent'.[4] The orans and other figures carved on the rock have excellent analogies among bronze figurines found between the rivers Inn and Lech, products of Raetian local workshops, and distant reflections of Este models.[5] *Pl. 217, d* shows a horse which well compares with one painted on an urn from the Marne, *pl. 217, b*: both have the same calligraphic curvy outline, and no bones.[6] The whirligig *pl. 217, c*[7] should be compared with *PP 281–3* and my remarks on p. 77.

Celtic stone sculptures are scarce, and inferior to the figure decoration of metalwork: it is unlikely that Celtic sculpture in stone or wood had an appreciable influence on the plastic arts in the Roman Provinces.[8]

There are two regions in which stone sculptures have survived, Provence and Germany: that they do not appear in other productive Celtic lands must be accidental.[9] The works from Germany (nos. 10–15) are far more original, since they are untouched by direct foreign influences: the sculptures in Provence speak audibly of the neighbourhood of Massilia.

The most important of these come from the sanctuary of Roquepertuse near Aix-en-Provence. General reasons suggest a fourth-century date.[10] The frieze of horses, no. 1, is bad and timeless: I feel unable to see any likeness to the Iberian stele from Xiprana with which Lantier (AA 4419 29, 287) compares it. The very fragmentarily preserved bird, no. 2, gives the impression of a kind of goose.[11] The energetic movement, the turn of the head, the modelling, and the flow of lines betray strong classical influence: I could imagine it to be by the sculptor of the squatting men, no. 4.

The double head, no. 3, decorated the architrave of a portico, of which two, probably four, pillars remain; these are lavishly adorned with particoloured pictures of birds, fishes, horses, plants, and ornaments and with inserted skulls of slain foes, a splendid illustration to

[1] Professor Altheim's retort to my paper in JRS l.c. in RM 54 1939, 1 is neither convincing nor fair. See also Howald and E. Meyer, Die römische Schweiz 364.

[2] Lantier in Mon. Piot 34 1934, 1 ff.

[3] On torcs worn round the arm see Goessler, Trichtingen 28.

[4] An exception perhaps on the fibula from Niederschönhausen no. 308; see p. 194.

[5] Merhart in Mannus 24, 56 ff. On 'orantes' see Gössler, Préhistoire 1, 266.

[6] p. 7. See also no. 156 *d*; p. 11.

[7] The little man on the left of the pattern has nothing to do with it; Altheim's interpretation as 'Herakles and the Hydra' and his fantastic thesis of Corinthian influence on this fourth-century Raetian backwater have been refuted—for good, I hope —in JRS l.c. 67.

[8] Schober, Oe J 26 1930, 9 ff.

[9] On a double statue from the Aisne, mentioned in a text of the sixth century A.D., see p. 10.

[10] The pottery from the site covers the period from about 600 B.C. down to about the second century B.C. (Préhistoire 2, 27), but it is unknown which of the sherds were found in the sanctuary and which elsewhere on the plateau, and even if it were known, it would not give us a date for the sculptures. A scientific publication of the finds from Roquepertuse is one of the most urgent tasks of archaeology in France.

[11] Lantier, 20. Bericht RGK 1931, 117 speaks of webs between the toes which, he says, resembles those of a bird of prey. That the eyes have a 'missgünstigen' look (ib.) seems to be a wrong translation of 'œil émerillonné' (Gérin-Ricard l.c. 19).

Posidonius (Jacoby, FGrHist ii, p. 258; Zwicker 15; see also Jacoby, p. 304, Zwicker 17):
τὰς κεφαλὰς τῶν πολεμίων . . . προσπατταλεύειν τοῖς προπυλαίοις.[1]

The heads, a little under life-size, differ slightly in measurements, details, and expression. Seen from the front they are long: A is contoured by unbroken curves, the outline of B curves in slightly between cheeks and chin, but is far from the typical exaggerated stylization of this part in Celtic sculpture;[2] there is also a break between forehead and skull. The chin of both heads ends with a hard straight horizontal. The heads are actually façade: plastic conception ends at the cheek-bones, and the cheeks beyond are dead planes: even ears are missing—quite logically, for the heads were meant to be looked at by people entering or leaving the sanctuary which the portico enclosed. Thus the profile is but the by-product of the modelled front view: it runs in a hard stepped line. The forehead passes without break into the nose, which has the triangular shape common in Celtic heads.[3] The nose of A has more plastic detail, the alae are more marked, and the outline is perceptibly concave. Neither A nor B has nostrils. The eyelids are fillets of even breadth all round the slightly convex eye, the upper does not overlap the lower at the outer corner. The distance between eyes and brow-line is larger in B, the furrows between nose and corners of mouth are deeper in A. The mouth is the most expressive and personal feature of these heads: it is long and uneven, the upper lip narrow. The mouth of A is farther from the nose and runs in an arc, open above; the mouth of B has a fuller under-lip; its opening runs in a curve, slowly rising from the corners towards the middle. The Celticity of the heads is proved beyond doubt by comparison with the double heads from Heidelberg (no. 14) and Holzgerlingen (no. 13), where also *one* leaf-crown stands between the two heads, belonging to each of them when looked at from front or back: it must be the same god or demon, though we are unable to give him a name. The leaf-crown, the distinctive wear of Celtic deities,[4] definitely refutes the assumption that the heads are *têtes de décapités* (Lantier, AA l.c. 286). And their expression was certainly very lively before the black painted pupils had faded. There are also some stylistic Celtic features: but otherwise this work is radically different from all other Celtic heads: those achieve the effect of superhuman power by stylization—which is Oriental. Compared with them—if it is not too paradoxical to say so—the heads from Roquepertuse bear the mark of Greek humanity, shining through primitiveness and weirdness. They are the work of a Gaulish sculptor taught at Massilia: this is most clearly betrayed by the eyes, but in other parts of the faces as well there is more plastic feeling than in Celtic sculptures from Germany. Only a Greek training could enable the native master to shape these profoundly un-Greek mouths. It is more difficult to define the stratum of Greek art which worked here on the Celts. The heads have been called archaic: indeed, seen from the side, more than from the front, they vaguely resemble classical archaic works of bad quality, such as the kouros from Thera, the worst kouroi from Boeotia, or the women from the Tumulo della Pietrera.[5] But this is delusive: there is always a certain superficial likeness between backward, provincial works of many periods and real archaic works. Apart from general considerations on the possible date of Celtic sculptures in Provence, and apart from the analysis of the other sculptures from the sanctuary, the eyes point not to archaic Greek art but to a model not earlier than the early classical style. And quite possibly later: Iberian

[1] The earliest witness for the immolation of prisoners of war to the gods by the Gauls is the comic poet Sopatros of the early third century B.C.: Kaibel, Com. Graec. Fragm. frg. 6; Zwicker 6. A Gaulish warrior with a trophy head in his hand is represented on a silver coin of Dubnoreix, de la Tour, Atlas pl. 15 no. 5044; Blanchet fig. 13.

[2] p. 13.

[3] p. 13.

[4] pp. 15 ff.

[5] Hanfmann 38.

sculpture shows how fourth-century classical art, frozen and hardened under the hands of barbarian artists, can assume a deceptive archaic look.[1]

The statues of the squatting men, no. 4, are one and a half life-size. They are seated on a plaque wrought in one with them: that of no. B and C has acroteria at the corners; A and C give the plaque a different level for buttocks and shanks: in C a 'cushion', semicircular in section, runs across under the buttocks (Espérandieu, text to no. 6703, seems to take this device for a real cushion). The plaques were probably the tops of square bases, but this cannot be established without technical examination of the bottom surface. The heads are lost. The men sit with legs crossed, the right in front. Legs and arms are bare. The right arm of no. A comes down vertically, and the hand, as the break shows, was near the knee. The left arm is bent, the hand was resting on the breast: dimensions and shape of the break suggest that the hand held an object of considerable size. This is confirmed by a fragment of no. B which Gérin-Ricard 29 describes as follows: 'La main droite qui était vraisemblable- ment appliquée à la poitrine . . . tenait un objet en fer ou en pierre scellé par un tenon de plus de 6 centimètres dont il reste l'emplacement fortement teinte de rouille et aussi un morceau de métal.' The men wear a short sleeveless chiton, covering belly, hiding genitals, and coming down to the upper legs. A study of the garments must be based on the most completely preserved statue no. A: in the years which have passed since its discovery much of the painted detail has faded, and for the *recensio* we have to recur to the old drawing and descriptions. The chiton below the waist shows neatly engraved vertical folds, some of them converging upwards, equally well executed all round: the statues were meant to be looked at from all sides. Along the lower edge of the chiton were fringes. Round the waist, two engraved lines mark a girdle. Above it, on the front, a net of engraved lozenges. For the patterns below the girdle one has to rely on Gérin-Ricard's statement on p. 26: the fields between the folds are filled with the motives illustrated in Gérin-Ricard 26 top and *P185*, the former to be seen on statue no. A, the latter on no. B. The second garment, worn over the chiton and covering the upper part of the breast, shoulders, and back, is difficult to interpret. The front of it has a stepped contour; the top row, just covering the shoulders, has six squares, the middle four, and the bottom row, damaged by the break round the left hand, two: these squares, as shown by the old drawing, are filled with crosses and maeanders. The back part is one large square, bearing the ornament reproduced in *P257*. Gérin-Ricard and Lantier (Mon. Piot 34 1934, 12) take the garment for a stole. The latter gives the following description: 'elle ⟨la tunique⟩ est recouverte d'une sorte de chasuble, ornée de grecques et de quadrillages qui, dans le dos, forme un large rectangle. Un bracelet la relie au bras gauche contre lequel elle s'applique dans toute sa longueur. Le même bracelet devait exister sur l'autre bras.' This interpretation is weakened by the following observations: (1) The back part, as can be seen in my profile photograph, is twice as thick as the front part. (2) It stands up on the back like a piece of felt; above and at the sides it projects beyond the more pliable part which joins it above the shoulders. (3) It is an odd way to fix the cloak with a bangle round the arm, giving hold only to its back part. This bangle has its counterpart in one round the right arm of the other statue, no. B, where the movement of the arms is in- verted; Gérin-Ricard p. 30, describes this fragment no. 7 found recently. I feel not at all

[1] I suspect the conventional dates (Rhys Carpenter, The Greeks in Spain 37 ff.· Bosch-Gimpera in Antike Plastik, W. Amelung zum 60. Geburtstag 31 ff.; the same in 25 Jahre Römisch-Germanische Kommission 86). See also my remarks in Journal of R. Society of Antiquaries of Ireland 68 1938, 52.

sure that these two members are parts of one and the same cloak: the square on the back might well be a separate garment, tied by strings which were in paint. But I confess my inability to understand its construction without examining the originals.

The men are of slim build. Their posture is erect, but lacks vigour and tension. The bodies have curvy contours, but the artist was apparently more interested to show patterned garments than anatomy. The arms are roundish and languid, the modelling of the legs is livelier, they are the most classical part of the statues.

The clearest proof of Greek influence is given by the acroteria:[1] whether they are merely a motive of decoration or show the bases to have been altars cannot be decided.

Here again the Celtic origin of the statues has to be established. The arguments are: (1) To sit with crossed legs is a typical posture of Celtic gods, Cernunnus and others: see the list given by Lantier in Mon. Piot 34 1934, 22 ff. (2) The patterns of the garments are characteristically Celtic, and so is the stepped contour of the stole. (3) Gérin-Ricard 29, no. 6 describes a fragment, completing no. B: 'Partie de devant ou extrémités du torque ou collier: ce fragment adhère parfaitement à la statue.' And it is likely that the object held in the left hand of no. A was a torc as well. The examples of torcs in the hands of Celtic gods have been collected by Lantier l.c.

These three statues of identical type were votive offerings and represent either the god—better to refrain from giving him a name—or priests, adopting the divine posture and attributes.[2]

The classical component is here more in the foreground than in the double head, and stronger: the modelling of the legs and the mastery of the third dimension throughout is clear proof of intensive Greek training in the sculptor. Though judgement would be easier if the heads were preserved, I have the impression that the three statues are of higher quality then the double head, nearer to Greek models, but roughly of the same date.[3]

I append a few notes on other pre-Roman[4] Celtic sculptures in Southern France. The frieze from Nages, Espérandieu no. 515 (and vol. 9, p. 146); Déchelette fig. 709, as proved by the style of the horses, and the heads from Die, Espérandieu no. 6777, are obviously later than the sculptures from Roquepertuse. The head from Orgon, Espérandieu 6701, seems to be a work of an Iberianizing school.[5] The pillar from Entremont, no. 5, is probably contemporary with the other pillar from the site, Déchelette fig. 707 which, as Déchelette 1536 rightly states, can be dated about the second century B.C. by the form of the swords represented. In the heads, however, there is still something of earlier tradition: I figure one of these. The warrior from Grézan with the Iberian girdle-clasp[6] and Iberian corslet,

[1] This has been observed by Lantier, AA 44 1929, 286.

[2] I should not care to follow Möbius (AM 50 1925, 47) who explains the squatting posture of Celtic gods by what Posidonius apud Diod. 5, 28, 4 Jacoby, FGrHist. ii A p. 304, reports on the table habits of the Gauls: Δειπνοῦσι δὲ καθήμενοι πάντες οὐκ ἐπὶ θρόνων, ἀλλ' ἐπὶ γῆς, ὑποστρώμασι χρώμενοι λύκων καὶ κυνῶν δέρμασι. Strabo 4, 4, 3: χαμευνοῦσι δὲ καὶ μέχρι νῦν οἱ πολλοὶ καὶ καθεζόμενοι δειπνοῦσι ἐν στιβάσι.

[3] See above, p. 4. Lantier, Mon. Piot l. c. '5th–2nd centuries B.C.'

[4] The statuette from Euffigneix (Haute-Marne) in the Chaumont Museum (Blanchet, Mon. Piot 31 1931 pl. 3, p. 19, and in Mélanges Cumont pl. 2; Lantier, 20. Bericht RGK 1931 pl. 15, p. 145), with a boar on the breast, an eye below the left, an ear below the right shoulder, has been taken for pre-Roman

by Blanchet and Lantier, but the stylization of the eyes and the 'Kerbschnitt' technique of the torc, wrongly compared by Blanchet with the gold torc from Fenouillet, favour a Roman date. Blanchet (Mélanges Cumont l.c.) ingeniously suggests that it represents the god Baco.

[5] With it goes a badly damaged head form the oppidum Mont-Menu near Eyguières (Bouches-du Rhône) in a private collection at Avignon; photograph of Archaeologisches Seminar Marburg no. 2108; on the site see Jacobsthal and Neuffer, Préhistoire 2, 62.

[6] Déchelette, fig. 706, gives a drawing of the clasp. On the chronology of Iberian girdle-clasps see Déchelette 1243, fig. 529; idem, Opuscula archaeologica Montelio dicata 233; Ebert 10 pls. 143 and 147 (Bosch-Gimpera), and 4, 578 (del Castillo). Espérandieu, Mon. Piot 30 1929, 70, states that at

Espérandieu 427; Déchelette figs. 705–6; Gérin-Ricard pl. 7, 1, 2, and the barbaric busts of warriors from Castelnau-le-Lez (Substantion), Espérandieu 6859; Gérin-Ricard pl. 7, 3 and Espérandieu 6863, are most certainly also pre-Roman, but I see no means of giving them an exact date.

The warrior bust from St. Chaptes, no. 6, is of earlier style and goes more closely with Roquepertuse. The engraved animals are indistinct, but the horses seem to have the typical curvy lines of Celtic horses.[1] The triangular pendants of the necklace are a local sub-Hallstatt survival.[2]

The relief from Montsalier, no. 7, also gives the impression of being rather early. There is no reason to suspect the antiquity of the enigmatic Greek inscription, though I cannot count it contemporary with the sculpture: the letters below the group on the left have serifs: how a Celtic inscription of pre-Roman date in Greek characters looks is shown by the base from Montagnac which I have figured in AA 45 1930, 237–8, figs. 23 and 24 and dated about 200 B.C. The Montsalier 'Orpheus relief' is among the worst creations of European sculpture: the woman looks like a peasant copy of a Hellenistic draped figure.[3] The head is a herm, in relief, like the warriors from Les Chaptes and Castelnau-le-Lez. These represent one type of herm, the other sets the heads on higher pillars: the herm from Beaucaire, no. 8, is 77 cm. high, and that of a man with an olive-wreath from Les Baux, AA 45 1930, 233/4 figs. 18, 19, an Augustan descendant of the type, measures 54 cm. The herm from Beaucaire, of uncertain date, is of special interest because of the cone standing beside the heads: undoubtedly the aniconic equivalent of what the heads express in the language of an advanced civilization.

The double head no. 9 was supported by a pillar of unknown height. Its alleged provenance from Southern France sounds trustworthy; it carries on local tradition in Antonine times. The men look like butchers or professional athletes: one is taller than the other and is also distinguished by the little Gaulish pigtail.[4] But there is a difference in principle: they are a double portrait, the likeness of two persons, brothers like Dermys and Kittylos, or united by other ties: the early Celtic double heads are the image of one and the same person, and dicephaly is the expression of superhuman power and dignity: I shall return to this presently.

This short survey of Celtic sculpture in Provence has been hampered by my insufficient knowledge of the originals, but it may perhaps lead to a more careful study of these monuments. I now turn to Germany.

Ensérune an iron Iberian girdle-clasp was found with Greek vases of the 'VI–Vth centuries': this is vague in itself and of no value, for it is generally known that the excavator of this important site, M. Mouret, has failed to observe with due care the association of objects in the single graves. Iberian girdle-clasps from this region were published by Héléna, Les origines de Narbonne: fig. 83 (from Fleury d'Aude), fig. 167 (from Oppidum du Cayla). The Iberian girdle-clasp from Olympia, Olympia, Bronzen, no. 1151, pl. 66, has commonly been taken for a dedication by a Greek from Emporion: but was Zeus really interested in Iberian archaeology? Another explanation would be: in the fourth century B.C. Iberian mercenaries fought in the Peloponnese, Diodorus 15, 70 (G. T. Griffith, The Mercenaries of the Hellenistic World 195): a Greek may have killed one and dedicated the spoils to Olympia. A cuirass of this type has been found at Calaceite, Anuari del Institut d'Estudis Catalans 1913/4, 825

fig. 48. These cuirasses are somehow connected with the sub-Hallstatt group dealt with by Déonna, Préhistoire 3, 93 ff. For the 'sun' on breast and back of the Grézan corslet compare the piece from Saint-Germain-du-Plain, l.c. 120 fig. 28.

[1] p. 3.

[2] Triangular clackets often hang from brooches of Late Hallstatt or La Tène date: Santa Lucia, Déchelette fig. 372, 2; Carniola, Treasures passim; Este, Randall MacIver, Iron Age in Italy pl. 7 and passim; Uffing, Upper Bavaria, Ebert 3 pl. 104, e; Hungary, Márton pls. 2, 3, 5. I do not happen to know of a torc with triangular pendants, but one from Bussy-le-Château in Saint-Germain, no. 22164, P 53, with square pendants, is identical in principle and is a translation of better models such as no. 243, PP 47–52, into peasant style.

[3] An analogy for the drapery patterns is given by a barbaric relief of the second or third century A.D. from Zsámbék, Pannonia, Oe J 26 1930, 27 fig. 17. [4] BJ 118 1909, 64 (Salis).

The Rhenish double head no. 10 is of a style too rustic to be dated.[1]

The pillar no. 11 probably once stood on a grave of a chieftain, before pious Christians gave the strange heathen monument its place beside the village church of Pfalzfeld in the Hunsrück, in the land of the Treveri: the neighbourhood is full of Celtic mounds.[2] The original height can be reckoned at over 2 metres: it was surmounted by a human head: in 1739 old villagers had still a faint knowledge of the fact, but by 1608/9, when the drawing repeated in *pl. 12* was made, the head had already disappeared. It must have been a stately piece, attractive and uncanny when the colours were still there: there are no traces of them now, but the Celts, fond of polychrome decoration, can hardly have failed to paint this monument, which is the most ornate of all those preserved. One could go round and look at it from all four sides: from each side one saw a head with the huge, impressive leaf-crown amidst ornament: the similarity of the design to the attachment-plaque of the Salzburg flagon, no. 382 (*PP 99, 339*),[3] is instructive: there was no tradition in elaborate decoration of stone sculpture and the mason had to copy bronze work or to draw from a pattern-book used by metalworkers.

The elaborate architectural shape distinguishes the pillar from certain coarse monoliths and menhirs of this period which can be compared in principle.[4] The pillar proper, tapering upwards and supported by a low trapezoid base, stands on a column of unknown height: in the present condition, two convex bands are still visible round the column-head, the lower narrower and less projecting, and, as the drawings show, there was a third below where the shaft begins. This odd combination of obelisk and column is a product of Celtic fancy, but the Southern origin of single elements can be proved. Rope-patterns along the edges of cippi occur in Etruria.[5] The column-head is derived from Tuscan columns.[6] Columns like *pl. 218, a*, from Este,[7] are among the possible models of another feature: here the technique of the upper surface—central mortise, and circular guide-line almost reaching the circumference—suggests that it was surmounted by another stone member.

These proofs of Italic origin of single elements, weak in themselves, can be brought to certainty by study of another Rhenish monument. The phalloid stone no. 12 now stands by a church at Irlich in the basin of Neuwied: like the pillar from Pfalzfeld, it owes its preservation to piety and superstition.[8] This region also is a centre of Celtic civilization[9] and full of Celtic graves. Phalloid tombstones are to be found in various parts of the world, but no other is known from Germany,[10] of any period. Beside this *argumentum e silentio*, there is positive proof that the stone is Celtic and descended from Etruscan models. In *pl. 218, b*

[1] Schober, Oe J 26 1930, 35 has wrongly compared it with the Montsalier bust: the other herms from Austria and Croatia published there might be works of any age, but not Celtic.

[2] BJ 18 1852, 27 (von Cohausen).

[3] p. 85.

[4] Behrens, Germania 16 1932, 35; Dehn, Germania 20 1936, 53, note 3.

[5] Chiusi: Martha, L'art étrusque figs. 235–7; Barracco and Helbig, Collection Barracco pl. 76; Doro Levi, II Museo Civico di Chiusi fig. 17 a, b, and cippus 2269 in the same museum, Alinari 37500–1; cippus from Settimello in Florence, *pl. 233, a*. See also Studi etruschi 12 pls. 13 ff. On rope patterns generally see p. 71.

[6] Oelmann, Germania 17 1933, 179 in his important study of the ground-plan of Celtic temples says: 'Was dagegen sehr wohl dem nachbarlichen Einfluss der Etrusker verdankt werden könnte, das ist die Stilisierung der Säule. Die auffällige Erscheinung, dass die Säulen der galloromischen Tempel fast ausnahmslos der toskanischen Ordnung angehören, würde sich dann so erklären, dass die in Oberitalien sesshaft gewordenen Kelten dort die toskanische Säule — natürlich in Holz, wie sie die Etrusker selber noch verwandten — übernahmen und sie den in Gallien zurückgebliebenen Verwandten übermittelten.'

[7] Not. Sc. 1888 pl. 1 fig. 3.

[8] For the rites mentioned in my description of the stone on p. 166, Hepding refers to Hoops, Reallexikon 3, 414 and Niederdeutsche Zeitschrift für Volkskunde 2 1925, 94, 95.

[9] Rheinische Vorzeit in Wort und Bild 2 1939, 98 (Neuffer).

[10] Information from Hepding.

I give a selection of pieces from Orvieto, Praeneste, and Asia Minor.[1] Sepulchral customs are not goods 'imported' like vases or bronzes, and I take it for granted that the Etruscans in Italy followed a rite which they had already practised in their former abodes—another evidence for the origin of the Etruscans in Asia Minor. The Celts became acquainted with these tomb-phalloi in Etruscanized North Italy.

The Janus statue from Holzgerlingen (Württemberg), no. 13, is about one and a half life-size, a parallelepiped with no depth, not to be looked at from left and right, two façades, identical, one better preserved than the other. Each side has one arm only: it is bent, and the forearm rests on the stomach with hand open and fingers of equal length. Below the arm is a girdle in flat relief. Other details of the garment were certainly painted. On the heads, as in those from Heidelberg, no. 14, and from Roquepertuse, no. 3, stands a single leaf-crown, rising from the shoulders. The loose piece on top is misplaced: the correct position is given in the drawing reproduced in *pl. 13*. The face, as may be seen on the better preserved side, is made by simple means, the mouth is a long, straight notch, the nose a triangle, the eyebrows one flat moulded arch, recessed below. The pupils were certainly painted. The face is almost a circle, and differs from the typical outline of Celtic heads. There are no ears. This 'menhir' is rustic indeed, but it has the charm of touching sincerity, it is work of a local Swabian sculptor.

The pillar from another place in this province, Waldenbuch, no. 15, is of higher quality and in closer touch with central Celtic workshops. It is broader than it is deep, and executed with equal care on all four sides. The only human feature that remains is a left forearm, bent over the 'stomach'—I shall presently explain the inverted commas—the thumb on top, the tips of the other four fingers, with a break between, going round the edge of the pillar: the outline of arm and hand are not without vigour; the knuckle is modelled on the under side. The left upper arm must have come down parallel with the edge of the pillar. There is no room for a right arm: the man was one-armed like the statue from Holzgerlingen— apparently a regional feature. But it differs in this respect that it is not a double statue and the missing head was in all probability not a Janus-head. The four sides are covered all over with ornament, geometric and floral: the latter (*PP 454–6*) is of 'Waldalgesheim' style, and dates the work to the late fourth century B.C.[2] The arrangement of the ornament, with slight variants, is the same on all four sides: the framed rectangular panel at the bottom is filled with upright tendrils, the top field with step patterns and tendrils above on three sides—to judge from (c)—and with a large tendril only on (d), here partly covered by the arm. Between these panels is a broad band with engraved vertical lines. It is perfectly possible that the sculptor was here thinking of folds, and that the other patterns are also intended to render the decoration of a garment which reached the ground. But 'garment', like 'stomach', is already too realistic a word: this pillar with a head, *one* arm, and no feet is a menhir, or to say it in Greek, a herm—half-way between aniconic and iconic shape.

The Janus-head from Heidelberg, no. 14, which, when complete, was about 40 cm. high, is from a statue of about the same size as the Holzgerlingen Janus. The two heads, as the profile view shows, are flat convex disks. Again, one crown serves for both heads, but its

[1] Nos. 1–3 from my drawings of the unpublished pieces; no. 4 from Perrot and Chipiez, Art in Phrygia, Lydia, Caria 49 fig. 18 (Sipylos); no. 5=Berlin no. 1151 (Smyrna). For Sardis see von Olfers, Abh. Berliner Akademie der Wissenschaften 1858 pl. 3: Herodotus 1, 93, Strabo 13, 4, 7. Pergamon: AM 33 1908, 426. Phrygia: JHS 9 1888, 352; AM 24 1899 pl. 1, 1, p. 7. Caria: JHS 20 1900, 68. The problem has been dealt with by Pfuhl, JdI 20 1905, 90 and L. Curtius, Phallus-grabmal in Smyrna, in Die Wissenschaft am Scheidewege, Festschrift für Ludwig Klages, 1932. [2] p. 94.

two halves, with a sort of cushion between them, are slightly inclined forwards.[1] Front and back face are differently stylized. The front face has circular eyes with an engraved pupil, pushed towards the root of the clumsy triangular nose. The 'shamrock' on the forehead has its like among other Celtic masks.[2] The reverse is farther away from nature: one recognizes the eyes, large almonds, reaching the temples: the rest is an ornamental variation on the theme 'face'. There are two upright arcs, back to back, and a third, below, horizontal and flatter, which corresponds to a mouth and sets off the circular upper part of the face from the chin, the greater part of which is missing. The workmanship is coarse, but the head is the work of a man who knew what he was doing.

These four works, the pillar from Pfalzfeld, the statues from Holzgerlingen and Waldenbuch, and the Heidelberg head, are the only Early Celtic stone sculptures from Germany.[3]

To the stone sculptures still preserved[4] I should add a work of which we have literary evidence. In the life of Saint Medardus, bishop of Noyon and Tournay (about A.D. 465–545), we read: 'Erat autem illud rus cui Croviacus vocabulum est (i.e. Crouy, department Aisne) ex antiquo profano idolorum cultui mancipatum. Nam et usque hoc Danorum (i.e. Normannorum) tempora bifrons lapideus magnae altitudinis (Acta Sanct. 8 Jun. ii p. 84 B; Zwicker 242: latitudinis) ante fores aedis in eodem loco perstitit.' Thus we learn that in the region of the Aisne in the fifth or sixth century A.D. a Celtic Janus statue, over life-size, stood in front of a church: the only such sculpture known to us outside Germany and Provence, and a third instance of a heathen image being removed by the Christians to a safer place.[5]

Representations of man in bronze are confined to miniature figures: certain pendants for which I refer to Gössler, Préhistoire 1, 260, are of timeless primitiveness and lack particularly Celtic features. The Δεσπότης θηρῶν in the girdle-hook from Hölzelsau, no. 360, will be discussed on pp. 53, 57. There remains the manikin on the fibula no. 308: the body, tiny and in flat relief, gives the impression of an appendage to the huge, well-modelled head; he is possibly phallic like the pendants just mentioned.

The figures studied hitherto were full-figures or parts of such. I turn to busts, first to those in the bronze reliefs from Waldalgesheim, no. 156 d, which decorated an unknown implement. Both pieces are fragmentary, but together they give a complete picture, save that the left hand is missing in both. All contours are hatched, except those of the hands. The nipples, large and too near each other, were inlaid in coral. The head is too large in proportion, the neck short. The bust rises from a ledge and has a highly stylized concave outline. The arms are bent and raised, the upper arm following the contour of the trunk

[1] Compare the girdle-hook from Hermeskeil, no. 354.

[2] p. 14.

[3] The material collected by Schober, Oe J 26 1930, 38 ff. to which I had already referred, is of very doubtful nature. The figure from Reibreitenbach, l.c. fig. 29, has been taken for Celtic by Schober and Lehner (Germania 5 1921, 9), for Slav by Anthes (Germania 4 1920, 37), which comes nearer the truth. No less various are the views expressed on the over life-size statue of a bearded, clothed man from Wildberg (Württemberg), Schumacher, Germanendarstellungen 73, Germania 6 1922, 4 fig. 1; Oe J l.c. fig. 30; Baum, Die Malerei und Plastik des Mittelalters 2 (Handbuch der Kunstwissenschaft, herausg. von Burger und Brinckmann) 10 fig. 8: it is really medieval; Dr. Veeck, Keeper of the Stuttgart Museum, kindly informed me that the piece is only one of a set.

[4] Timaios (apud Diod. 4, 56, 4) FHG 1, p. 194a frg. 6, Zwicker, p. 5, ἀποδείξεις δὲ τούτων φέρουσι (scil. that the Argonauts reached the Ocean) δεικνύντες τοὺς παρὰ τὸν Ὠκεανὸν κατοικοῦντας Κέλτας σεβομένους μάλιστα τῶν θεῶν τοὺς Διοσκούρους: should not 'Dioscouroi' be the interpretatio Graeca of Celtic double statues? An example of interpretatio Romana of a Celtic god is Suetonius, Tiberius 14, 3 (Zwicker, p. 63): 'et mox, cum Illyricum petens iuxta Patavium adisset Geryonis oraculum, sorte tracta, qua monebatur, ut de consultationibus in Aponi fontem talos aureos iaceret, evenit, ut summum numerum iacti ab eo ostenderent; hodieque sub aqua visuntur hi tali.' 'Geryones' was probably a tricephalic Celtic god.

[5] p. 8.

and the forearm that of the vertical edge. The hand is very long and has the shape of a spear-head: four fingers, marked by engraved strokes, stick together, the S-shaped thumb stands apart. This man has no bones, he looks like a 'rubber man' performing tricks at the circus.

The most famous example of Celtic busts with upraised arms are the gods on the silver cauldron from Gundestrup; full-figure 'orantes' occur among the rock-carvings in the Val Camonica, *pl. 217.*

Trunk and upper arms are covered with tendrils of the same style as in other objects from the grave. The man wears a cloak with short sleeves. This is the fourth patterned garment we have come across. The first were the striped trousers of the men on the Hallstatt sword no. 96, the second the clothes of the squatters from Roquepertuse, no. 4, the third those of the 'menhir' from Waldenbuch, no. 15.

And here a word on Celtic textiles. None of the remains are well enough preserved to show more than the texture.[1] The piece from Hallstatt, Sacken pl. 26 no. 21 (p. 126), has a well-preserved chequer pattern, but the context of the find and its date are unknown to me.

There are five valuable passages in ancient writers, telling us about the patterned garments of the Gauls: I copy them.

(1) Posidonius (apud Diodorum 5, 30, 1) FGrHist ii A, p. 304 ἐσθῆσι δὲ χρῶνται καταπληκτικαῖς, χιτῶσι μὲν βαπτοῖς χρώμασι παντοδαποῖς διηνθισμένοις, καὶ ἀναξυρίσιν, ἃς ἐκεῖνοι βράκας προσαγορεύουσιν. ἐπιπορποῦνται δὲ σάγους ῥαβδωτούς, ἐν μὲν τοῖς χειμῶσι δασεῖς, κατὰ δὲ τὸ θέρος ψιλούς, πλινθίοις πολυανθέσι καὶ πυκνοῖς διειλημμένους.

(2) Virgil, Aeneid 8, 659

> aurea caesaries ollis atque aurea vestis,
> virgatis lucent sagulis, tum lactea colla
> auro innectuntur.

(3) Silius Italicus 4, 155 auro virgatae vestes . . .

(4) Pliny, Nat. Hist. 8, 196 scutulis dividere Gallia vestes (instituit).

(5) Strabo 4, 4, 5 τὰς ἐσθῆτας βαπτὰς φοροῦσι καὶ χρυσοπάστους οἱ ἐν ἀξιώματι.

Posidonius (no. 1) describes three parts of the dazzling dress of the Gauls: the chiton of many colours; the trousers; the buckled sagum thick in winter, thin in summer, striped, and picked out with thick-sown parti-coloured squares.[2] Posidonius is probably also the direct or indirect source of nos. 2, 4, 5.[3] The intermediate source of Virgil and Pliny may have been Varro; Pliny's statement that the Gauls *invented* clothes with lozenges is probably out of his own head.[4] Silius in his imaginary portrait of Crixus, the pseudo-historical leader of the Boi in the second Punic war, copies the learned Virgilian description of the gallomachy on the shield of Aeneas.

The Hungarian clay fragment, no. 416, in its present shape might be mistaken for a bust, but actually, when complete, it was the top of a handle, either of an amphora or of a one-

[1] The largest piece which has come down to us is that from Mercey, RA 43 1882, 69. Smaller fragments of textiles in the graves at La Gorge-Meillet, Fourdrignier pl. 8, p. 4, 5; Hatten, JL p. 34; Dürkheim, AuhV 2, 2, text to pl. 2; Weisskirchen, BJ 43 1867, 125. Impression of a textile in the earth of the tomb at Klein Aspergle, AuhV 3, 12, text to pl. 6. Impressions of textiles in iron or iron rust on bronze implements of all sorts are very frequent: sword from Marson, no. 93; chariot-horn from La Bouvandeau, no. 168; Wiedmer-Stern pl. 6, 26, 27, 29; Vouga, passim. See also Flouest, Les tumulus des Mousselots 46. The same has been observed in finds from other civilizations and times: impression of linen sheath of a Proto-geometric iron dagger from the Kerameikos, AA 49 1934, 233. For Hallstatt see Déchelette 832.

[2] διειλημμένος is common in descriptions of patterned textiles: [Arist.] de miris auscult. 96, 838a; Demokritos of Ephesos apud Athen. xii 525 c (JHS 58 1938, 208, note 19).

[3] Strabo's immediate source in this chapter (see FGrHist ii A, p. 258, frg. 55), as F. Jacoby points out to me, is Timagenes of Alexandria: the passage introduced by φησὶ γοῦν Ποσειδώνιος was either inserted by him or, more likely, also taken from Timagenes who quoted Posidonius.

[4] Compare ῥόμβοις ὑφαντά, Demokritos of Ephesos l.c.; von Lorentz, RM 52 1937, 208.

handled urn;[1] these handles are in the shape of a figure bending back, with arms raised, and are copied from Italian bronze vessels (JL pls. 11, 12). Another and coarser reflection of such an Italian model is the jug from Kosd, no. 415.

The handle of the bronze mirror from Hochheim, no. 373, is the janiform protome of a youth whose raised hands support the mirror-disk: below, this protome was fastened into a wooden or bone rod—the handle proper. The plastic circlets round the wrists and the neck are either bangles and torc or signify the hems of clothing. The curves of body and arms remind one of the Waldalgesheim busts. The heads differ slightly from each other, for instance in the eyes; they are both earless. They bear no relation to the common type of the early period and rather recall works of the second and first century B.C., such as the heads on the silver phalerae no. 84, which have their like on silver coins of the Boi, *pl. 218 e*, the bronze from Křivoklát (Pič, Le Hradischt de Stradonitz 67 fig. 9), and less closely, the heads on the Dejbjerg chariot.

What was the model of this mirror-figure ? Greek mirrors often have stands in the form of human figures, male and female,[2] and Greek or Etruscan paterae have handles of the same form.[3] It is quite possible that one of the models of the Hochheim mirror was an Italiote mirror with a youth as handle, like the examples quoted; these are full figures, and here we have a bust: this points towards another civilization, archaic Italy. Hanfmann 78 gives a list of Etruscan seventh- and sixth-century bronze protomai, ending below in a peg which was fitted into the lid of a vessel, and with raised arms supporting its handle. There is an interval of centuries between these potential models and the Hochheim mirror, but this is not an isolated case.[4]

Here and there in my description of statuary on the foregoing pages I have already mentioned some peculiarities of Celtic heads. I will now survey these heads in detail and systematically.

Not all of them have all the characteristics of the genus, but there is hardly ever a doubt whether a head is Celtic or not. At least in the early phase of Celtic art; for as time goes on, the physiognomy changes: I have just mentioned the Hochheim mirror, and other heads: these look much less characteristic and more disillusioned: there is still, however, a strong 'old Celtic' note in the attachment-heads of the Aylesford bucket.[5]

Apart from the sculptures in Provence, which are more or less under classical influence, the heads, whether in stone, bronze, or gold, are conceived strictly for the front view, like Greek gorgoneia: the profile is no more than the by-product of the façade and is often rather shapeless.[6] A few of the heads are modelled in the round, such as the mask at the foot of the Parsberg brooch, no. 316, or that of the victim of the handle-beast in the Salzburg flagon, no. 382. The typical outline resembles that of a hanging pear: good examples are given by the Pfalzfeld pillar, no. 11, and the girdle-hook from Schwabsburg, no. 351. Moon-faces are rare: gold ornaments from Schwarzenbach, no. 18, Weisskirchen brooch, no. 290 (on the flanks); less pronounced, the heads on the gold plaque from the same place, no. 20.

[1] Marton, Dolgozatok 159 erroneously speaks of hydria-handles.

[2] Jantzen, Bronzewerkstätten pls. 4, 22, 31; Praschniker, Oe J 15 1912, 238 ff.; Studniczka, AA 34 1919, 1; idem, Festgabe zur Winckelmannsfeier Leipzig 1918.

[3] Payne, NC pl. 46, 5, 6; Sieveking, Antike Metallgeräte pl. 4; Karlsruhe 488, 489; Die Antike 16, 27 fig. 21; CdM, Babelon-Blanchet 1428; JL pl. 17, a.

[4] pp. 155, 160.

[5] Archaeologia 52 1890, 361, 363; BM EIA fig. 135; Ebert 1 pl. 26, a.

[6] For this reason I doubt whether the little bronze head from the Dürrnberg (Salzburg), Germania 18 1934, 258/9 figs. 1–3; Die bildende Kunst in Oesterreich (ed. Ginhart) fig. 85, is really Early Celtic: the modelling of mouth and chin also differs from Early Celtic style.

Sometimes the lower part is set off from the upper by the horizontal of the mouth, which reaches the outline: girdle-hook from Langenlonsheim, no. 353, brooches 311, 312, 313, 316, and others, probably also the reverse of the Janus from Heidelberg, no. 14. Or the contour of the cheeks passes into the moustache: gold bracelet from Rodenbach, no. 59, and finger-ring from the same grave, no. 72. So also the heads of the beak-flagon from Klein Aspergle, no. 385, but here the curve, which elsewhere was formed by the moustache, is part of the contour of the cheeks.

Most of the heads are earless. The ears are often ornamentalized and take the form of Celtic spirals or leaves. In *pl. 218, c* I show some sketches.[1] This was the same in Greek archaic art.[2] The following masks have animal ears: fibula no. 316 (at the head part), flagons nos. 385 and 383, gold bracelets from Dürkheim, no. 57, Schwarzenbach, no. 58. The ears are sometimes misplaced, and it is not always certain that they are meant for ears.

The nose is clumsy, triangular, or, more correctly speaking, it corresponds to two sides of a three-sided pyramid. The eyebrows and the side of the nose are often drawn in one. Detail is rarely shown: the attachment-heads of the Lorraine flagons, no. 381, of that from Waldalgesheim, no. 387, the head at the foot of the Parsberg brooch and the masks on the ring no. 175b have the alae marked; there is also some modelling at this spot in the gold heads from Schwarzenbach, no. 34. The head of the fibula no. 310 has wrinkles across the nose, and so have those of the gold finger-ring from Rodenbach, no. 72: here, however, the wrinkles belong at the same time to the stem of the flower decorating the forehead. The warts on the nose-tip of the heads on the bronzes no. 175 are a unique feature.

There is great variety in the shape of the mouth. It either remains in the 'background' or forms part of the line mentioned above—that which divides the upper part of the face from the lower: if there are beads, they may signify teeth, moustache, or nothing. Such a well-modelled mouth, with full lips, as that of the Schwabsburg girdle-hook, no. 351, is rare: the lips of the Marson 'negroes', no. 93, also have character.

For the variation in the eyes a glance at the plates says more than description or lists. The eyes are often narrow—whether horizontal or aslant—and have lids which may be beaded or not. At other times the eyes are huge, circular, and popping, like those of the attachment-heads in the Lorraine jugs; here and in the fibula from Monsheim, *pl. 218, d*, the whole eye is inlaid in coral. In some cases the eyes take up almost the whole of the cheeks, as in the girdle-hooks from Weisskirchen, no. 350, and Langenlonsheim, no. 353: in the latter the eye-sockets are hatched.

The eyebrows are of fundamental importance for the architecture of these faces. Sometimes they are drawn quite naturally. Occasionally they are contracted into a flat concave arc, open towards the eye, as in the statue from Holzgerlingen, the girdle-hook from Hermeskeil, no. 354, the linch-pin from Grabenstetten, no. 160, or two of the gold heads from Schwarzenbach, no. 34. Usually they rise from the root of the nose in an S-curve, swinging upwards with spiral scrolls at the temples: in extreme cases they look like horns, as in the mask at the head part of the Ostheim brooch, no. 315, in the girdle-hook from Langenlonsheim, no. 353, in the Salzburg fibula, no. 307, or in the handle-beast of the Salzburg flagon, no. 382.

[1] (1), (2) no. 382; (3) no. 34; (4) no. 316; (5) no. 387; (6) no. 84; (7) Armorican coin, Blanchet fig. 217 (Déchelette fig. 729, 2): one of many such ears on Gaulish coins.

[2] Déonna, Les Apollons archaïques pl. 6; Payne, NC 82 ff. See also Chalcidian eye-cups, Rumpf, Chalkidische Vasen pls. 43, 177 ff. passim.

The hair is unimportant for the build and character of the heads. There is little space left for it: just below it are the strongly accentuated eyebrows, and above it, with a few exceptions, stands the leaf-crown. Occasionally the hair is not represented at all. In the following objects it is done in vertical strokes, covering the skull as far down as the line marking the upper contour of the forehead: in the girdle-hooks from Schwabsburg, no. 351, and Langenlonsheim, no. 353, the gold bracelet from Schwarzenbach, no. 58, the attachment-head of the Salzburg flagon, no. 382, four of the gold heads from Schwarzenbach, no. 34: the latter have also scalloped fringes of hair coming almost to the eyebrows. In the girdle-hook from Weisskirchen, no. 350, the Parsberg brooch, no. 316, the nail from Dürkheim, no. 165, the torc from Trebur, no. 224, the engraved hair-lines cover the whole of the forehead down to the eyebrows. The back hair is shown only when the heads are intended to be looked at all round from all sides, as in the Parsberg fibula (foot part), no. 316, and the gold bracelets from Dürkheim, no. 57, and Schwarzenbach, no. 58: in the last piece the hair hangs far down and forms a kind of triangle with vertical hatchings and a knob or circle at the lower point. If the same triangle stands above heads which are not modelled in the round, as in the Salzburg flagon, no. 382 (attachment), or the heads over the coil of the fibulae from Parsberg, no. 316, and Salzburg, no. 307, it is a trick of primitive perspective to make the invisible visible. The victim in the Salzburg flagon, in consequence of its four-sided conception, has the hair combed down from the temples round the ears, and the same idea underlies the odd stylization of the hair in the masks on the fair-lead no. 175b.

Bearded heads are in the minority, but whether the unbearded are female is an open question.[1] Some heads, like most of the Gauls portrayed by classical artists,[2] have moustaches only: so in the Lorraine flagons, the gold bracelet from Rodenbach, no. 59, the finger-ring from Rodenbach, no. 72, the gold ornament from Ferschweiler, no. 30. Sometimes the beards are long and pointed,[3] as in the beak-flagon from Borscher Au, no. 383, or the attachment of the Waldalgesheim flagon, no. 387, where the beard looks like a pod. Others are of medium length, as in the girdle-hook from Langenlonsheim, no. 353, and the nail from Dürkheim, no. 165; or square and compact, as in the fibula no. 312, where the moustache, with ends scrolling downwards, forms the counterpart to the eyebrow-scrolls. For the palmette-beard of the Klein Aspergle attachment-head, no. 385, see p. 89.

The forehead is often ornamented. To accentuate the middle of it with a circle is a typical feature of masks through the ages: I refer to the fibula from Monsheim, *pl. 218, d*, or to the attachment-head of the Salzburg flagon, no. 382. The foreheads of the Hausbergen fibula, no. 296, and of that from Kyšicky, Déchelette fig. 533, 3, have hooks, repeating the rhythm of the eyebrows, and decreasing in size towards the top: possibly to be interpreted as wrinkles. The reverse-head of the Heidelberg Janus has a huge trefoil, the heads on the Pfalzfeld pillar a leaf pattern,[4] the roundel from Königsheim, no. 201, a rising leaf of coral, two of the Schwarzenbach gold masks, no. 34, stress the middle with an 'hour-glass', flanked by an horizontal leaf on each side, a motive which, with slight alteration, is used for

[1] Gössler, Festschrift für Seeger 208, seems to believe that there are more bearded than unbearded heads and takes the latter for female.

[2] Bieńkowski, Die Darstellung der Gallier in der hellenistischen Kunst, and idem, Les Celtes dans les arts mineurs gréco-romains.

[3] There are still heads with a beard of this shape on South Gaulish sigillata, see *pl. 219, c* and pp. 17–18.

[4] A similar leaf pattern decorates the forehead of the head in the anthropoid sword from Ballyshannon, Co. Donegal, Journ. R. Society of Antiquaries Ireland 55 1925, 137, and 68 1938, 52.

the leaf-crowns of the other four heads from the same find. The head over the pin-catch of the Parsberg fibula, no. 316, uses spirals instead. The motives on the forehead of the Hermeskeil mask, no. 354, express the same in a coarser manner by more geometric means. The treatment of this part in the gold finger-ring from Rodenbach, no. 72, is unique: the two masks join foreheads in the centre of the ring and grow together: in the middle a flower with a long stem rises from the noses, and to right and left of this there are horizontal S-spirals combining together to form 'lyres'.[1]

I return to those triangles which could be understood as back-hair in a peculiar projection. Their hatching points to hair, and in the Parsberg fibula the transverse lines are either fillets or the whole is a kind of 'layer-coiffure'. These triangles rise above the forehead. But they are related to configurations of which the fibula no. 304 gives the clearest example: here a figure of similar outline comes down on to the eyebrows, swallowing the forehead. In the fibula no. 312 it has a beaded vertical midrib and more resembles a long pointed cap: the organic union with the bow of the brooch is masterly. The heads at the ends of the Weisskirchen fibula, no. 292, wear the same 'cap', here decorated with a geometric pattern. That above the handle-mask of the Lorraine jugs, no. 381, which is broad and lacks depth, is beautifully floralized.

One of the chief characteristics of Celtic heads is the two-leaved crown, to be seen in stone heads from Roquepertuse, Holzgerlingen, Heidelberg, Pfalzfeld, and in little bronze and gold heads, too numerous to specify. The leaves, pointing downwards, cling to the outline of the skull; the edge, by plastic or by graphic means, is frequently set off from the 'flesh' of the leaf, a feature following classical models. The gap above between the two leaves may be filled with little motives of various kinds: e.g. in four of the Schwarzenbach gold heads, no. 34, or on the disks from Hořovic, *pl. 218, g.* Variations: the leaves of the Waldalgesheim busts, no. 156 *d*, do not end with the points, but swing up again in smaller leaves, repeating the rhythm of the major ones in the opposite direction, a motive which has analogies in this particular style.[2] The shape of the crown in the Weisskirchen gold ornament, no. 20, results from the double role it plays in the decoration of the plaque.[3] In the flagon no. 385 the leaves of the attachment, like other parts of this fantastic mask, defy interpretation. A very individual variant of a normal leaf-crown is to be seen in the Weisskirchen girdle-hook, no. 350, a pair of massive S-spirals coming down on to the back of the neighbouring griffins and bridging them with the central mask. No less anomalous is the shape of the leaves in the linch-pin from Leval-Trahegnies, no. 162; those over the attachment-mask of the Salzburg flagon, no. 382, have a spiral foot.[4] In some cases it is difficult to decide whether crown-leaves or ears are intended: girdle-hook from Schwabsburg, no. 351, gold from Ferschweiler, no. 30, and others.

As a rule, the crown-leaves stick to the skull and reach the ears, but those of the heads on the phalerae from Hořovic, *pl. 218, g*, touch each other with their points below the chin. A good many heads have a lateral frame: some have hatched strands with bottom scrolls, clearly copying the 'Hathor coiffure'. Examples are the attachment-heads of the Lorraine and Klein Aspergle jugs, nos. 381 and 385, the gold bracelet from Rodenbach, no. 59, and the gold ornament from Ferschweiler, no. 30; the motive came to the Celts from Egypt via Phoenicia–Etruria. In Etruria Hathor-heads first appear in the seventh century B.C. and the

[1] p. 125.
[2] Bronze from Comacchio, no. 401 *d*.

[3] *PP 388, 389*, p. 92.
[4] *P 315*; p. 83.

Celts' models may have been Etruscan jewellery of the mid-fifth century, such as the gold necklace of the same find to which the gold finger-ring *pl. 252, b* belongs (AJA 44 1940, 435, fig. 7).[1]

On the gold finger-ring from Rodenbach, no. 72, leaves with spiral foot (*PP 315–26*) cling to the cheeks, in the Ferschweiler gold, no. 30, to the Hathor-strands. The motives in the fibula from Kyšicky—to judge from the poor drawings published (Déchelette fig. 533, 3)—seem to be of much the same kind. The tendency to surround the heads with ornament goes even farther: the Klein Aspergle attachment-mask continues below in a Celtic palmette, the heads in the gold openwork from Dürkheim, no. 28, have a trio of circles[2] under the chin, the gold ornament from Ferschweiler, no. 30, fills the gap between the bottom curls of the Hathor coiffure with a leaf, the attachment-heads of the Lorraine flagons have a large coral here; on the gold finger-ring from Rodenbach, no. 72, the hatched leaf with a trio of circles forms part of the mask, but also acts as bridge to the hoop of the ring. The Pfalzfeld heads attach a three-leaved palmette to the chin.

The heads—setting aside those of statues or busts where they are an end in themselves—serve the following purposes. They are terminals of handles, brooches, girdle-hooks, torcs, are side acroteria (linch-pins from the Erms no. 159, Mezek no. 164), or stress a centre (bow of fibula no. 290, girdle-hook from Weisskirchen, no. 350).

Double heads are to be seen in two forms, either as real Janus-heads, back to back (gold bracelet from Rodenbach, torc from Glauberg, no. 246, mirror no. 373, 'silenus' no. 369), or in flat projection, forehead to forehead or chin to chin—not always touching each other actually: fibulae nos. 304, 308, 309, gold bracelets from Dürkheim, no. 57, and Schwarzenbach, no. 58, bronze rings from Hermeskeil, no. 248, Schwieberdingen (Germania 19 1935, 292, fig. 2, 2) Méry-sur-Seine (Troyes, pl. 33, no. 344). In the Rodenbach gold finger-ring the two masks share one forehead.

There is no example in Early Celtic art of real tricephaly, but three single heads are set on the Glauberg torc, one of them, that of the victim, forming part of a 'story'. The three single heads on the torc from Rouillerot in Troyes, *pl. 218, f* are the anthropomorphic interpretation of the three-ball motive. The triad of negroes on the plaque of the sword from Marson, no. 93, is unique. A frieze of heads appears on the phalera from Hořovic, *pl. 218*, and the silver phalerae from Manerbio, no. 84, both of them following foreign models.

All these crowns and other floral forms were detachable additions to the heads: the heads always had priority and could well exist without the decoration. In the attachment of the Salzburg jug and in the Pfalzfeld pillar the spirals serve to frame the heads; they keep at a distance and do not grow together with them. It is otherwise with a class of forms which I now have to describe in detail because of their high importance for the nature of Celtic art and possibly for its chronology: motives in which the human and floral elements fuse.

The Etrusco-Celtic helmet, no. 144, fills the upper tier of the lyre with a head which is not of very characteristic appearance, but may have a torc round the neck, and if so, is a Gaul. The insertion of a face into floral ornament reflects Etruscan models, which for their part copy South Italian ornament of the fourth century B.C.[3] In *pl. 219, a* I show an example, the frieze on the neck of the Apulian volute krater with the Persians in Naples, made in the late fourth century B.C.

[1] On the Hathor-heads see Petazzoni, Ausonia 4, 181; V. Müller, AM 50 1925, 61.

[2] p. 67.
[3] Behn, Die Ficoronische Cista 18.

The problem is less simple in works of pure Celtic style and can only be solved by careful interpretation of the single objects. In the gold bracelets from Waldalgesheim, no. 55, the triangular space between the plastic cross-ribbons and the cushions terminating this part of the ring is filled with a head: the eyebrow-scrolls are the same stuff as the scrolls of the neighbouring tendrils, but the head stands by itself and does not coalesce with the ornament round it. Similar—and different—is the decoration of the bronze torc no. 241, which either copies a gold model or is made from a pattern-book which served goldsmiths as well.[1] Similar, inasmuch as here also the heads fill the axils of the plastic ribbons; different because the union of heads and ornament goes much further. On the top of the heads stands a lyre— possibly a synonym of the leaf-crown in its normal shape—ending above in a typically asymmetrical[2] spiral. The lyre runs downwards along the cheeks and the chin of the mask, and is actually the continuation of the plastic ribbon-contour: at a hasty glance, however, one may see the eyes of the mask as the foot-spirals of the lyre. In the torc from Trebur, no. 224, the mask does not really blend with the ornament, but stands in a circular frame, which projects strongly and is continued at each side by a wave tendril. On the linch-pin no. 163 the broad face is the centre of a double lyre formed by the scrolling eyebrows and a pair of spirals starting with little scrolls below the chin and swinging sidewards in a movement which repeats that of the eyebrows in the opposite direction. In two other works there is a blend of mask and lyre. In the torc no. 245, *P 350*, the masks are the anthropomorphic interpretation of the foot-scrolls of the opposed lyres. Torc no. 208 is of coarse workmanship, but its pattern is cleverly adapted to the requirements of a round tapering hoop. The buffers, once also decorated with plastic spirals, are supported by a mask which has an impressively sad look. The eyebrows scroll sideways; a lyre grows downwards from the cheeks and its head-scrolls are swallowed by the chin of another mask, slightly smaller than the former and facing it: a substitute for the missing involutions is the pair of horizontal S-spirals beside the chin of the lower mask. The lyre is filled with a motive half-way between a kind of spiral ornament and a face, human or animal: see, for instance, the ram in the bracelet no. 249. The eyebrows of the bottom mask swing upwards, or if you like downwards, and form a lyre corresponding to the other.

In the Swabian linch-pin no. 159 the lateral masks grow from thin tendrils which run towards the crockets in the middle. With this goes the linch-pin from Thrace, no. 164, where the tendrils growing from chin and forehead of the 'side acroteria' end in scrolls slung round four knobs in the middle of the plaque. These motives recall Celtic coins and sigillata of much later date. The Armorican coin, *pl. 219, b*, shows on the obverse a head with a boar on top, round it beaded tendrils ending in miniature human heads: here there are three, on other coins one, two, three, or four.[3] Reverse, a galloping 'centaur', on the ground a boar and an eagle, in the field tendrils with heads symmetrically arranged. The type of the obverse has been much misused: it has been taken for a representation of Ogmios and connected with the fantastic painting described by Lucian, Hercules (Zwicker 78); it has been interpreted as a symbol of a federation of Celtic tribes; others spoke of 'têtes de décapités'.[4] In the South Gaulish sherd, *pl. 219, c*, the alternation of heads and floral ornament is certainly Roman, but the way the thin tendrils grow from the ears

[1] p. 153.
[2] p. 90.
[3] See Blanchet figs. 9, 189 (de la Tour pl. 23, 6879), 190, 192 (de la Tour pl. 21, 6728), 199, 208; Roscher 3, 682 (from the apocryphal drawing in Hucher, L'art gaulois 2 pl. 1). Sometimes there are no heads, tendrils only, beaded or not: Blanchet figs. 207, 211, 213, 214, 219, 222.
[4] For criticism see Blanchet pp. 153, 308.

of the conservative Celtic mask is a reminiscence of the motives seen in the Early Celtic linch-pins.

The works described belong partly to the Waldalgesheim phase, partly to the third—only on the date of the torc from Trebur, no. 224, I must reserve judgement. Thus it is chronologically possible that the blend of human faces and ornament in Celtic art was inspired by classical models, in the first instance Italic ones; but there are two objects from South Russia[1] which have a remarkable affinity to the Celtic motives. One of them is the gold phiale from the Kul-Oba,[2] *pl. 219, d*, which is of mid-fourth-century date, Greek, but of an exuberance suitable to the taste of the barbarians. The union of the gorgoneia and the tier-lyres is not so close as in Celtic objects. The other is the gold horse-nasal from Volkovtsy,[3] *pl. 219, e*, a hybrid work of the first half of the fourth century B.C. The stylization of the mask[4] and the way it joins the ornament are too like Celtic motives to be due to mere coincidence or contemporaneity.

I shall presently[5] discuss the peculiar, delusive character of these influences from abroad on the Celts. It is unlikely that the idea of blending human faces and ornament occurred to the Celts themselves, but it cannot be ruled out.

I have still to describe some masks of special interest. A good many of the masks studied hitherto were indeed strongly stylized, although real ornamentalization was confined to the eyebrows which, when the masks were blended with ornament, became the starting-point of lyres or tendrils. Otherwise the faces themselves were, so to speak, natural. An exception was the reverse face of the Heidelberg Janus, no. 14. The masks which we shall now study are *constructions* throughout.

The head on the upper surface of the linch-pin no. 161 lacks forehead and mouth. The eyes are the involutions of a half-circle contouring cheeks and chin, a kind of pelta. The eyebrows swing sideways and end near the edge of the plaque in a sort of crocket. The head on the front of the linch-pin is more complete and has a high forehead and a mouth; the eye-spirals, here running in the opposite direction, continue in the nose. Above the head lies an arched fluted tendril with side-scrolls; the deep niche in which the head stands[6] is outlined below by a smaller tendril which runs round the chin and joins the other tendril in little scrolls.

Similar in principle are the faces on the ring from Thrace, no. 176, b, and on the girdle-hook from Hungary, *pl. 219, f*.

Round the terret no. 175 *a* (development in *P 475*) runs a spiral ribbon, with large involutions in which masks stand, the middle one the right way up, the others upside down owing to the movement of the ribbon. The ribbon arrives from top left, contours the right cheek of the mask, then loses its swell and circumscribes the other cheek and forehead: the left eye is an offshoot-spiral, the other eye the final involution of the main spiral and, at the same time, the start of the next turn of the ribbon: the ribbon starts thin, runs round the forehead, swells, and at the following mask the same game starts again, this time the other way round.

[1] From lack of photographs I reproduce drawings.
[2] Minns fig. 99; Luschey 96, no. 11; p. 112.
[3] Minns fig. 78 (drawing); Ebert 13 pl. 39 E (photograph reproduced here); PZ 18 1927, 18; WPZ 23 1936, 24, pl. 2, 7 (Pink, with incorrect interpretation).
[4] Rostovtzeff SB 455 'wie ein geometrisches Ornament gebildeter Medusenkopf (?)'—the question mark is his: actually the mask has nothing of a gorgoneion: there are Greek horse-nasals with a gorgoneion exactly at the same place (Karlsruhe 782, Schumacher pl. 16, 19; pl. 22; Wagner, Bronzen pl. 27), but the model was apparently of the type with the head of a warrior wearing a Corinthian helmet (Karlsruhe 780, pl. 16, 18; Wagner, Bronzen pl. 26; Naples, JdI 24 1909, 143 fig. 17). On horse-nasals see Pernice, 56. BWP 28.
[5] pp. 157 ff.
[6] Compare the torc from Trebur, no. 224.

The masks have no mouth, the nose, with a wart on the tip, comes right down to the bottom point of the circle. The eyeballs stand on little flats formed by the spirals, and aslant, looking outwards.

The pendant, from the same find, no. 175 b (development P 476) is in higher relief and more elaborate: the masks stand on platforms which are the involutions of the ribbon. But they are less purely abstract than in the other piece. They are oddly asymmetrical: the right half of the face is neglected, the right eye is much smaller than the left, which is of exaggerated size and very well modelled, the axes of the eyes differ. The left cheek is decorated with a wart—the artist is very fond of them. The nose is pushed towards the right side of the face and appears in profile, only the visible ala being fully modelled. From the outer corner of the left eye a tuft of hair hangs down; another long striated tuft, growing above the right eye, and combed back and upwards, recalls the coiffure of the man under the jaws of the lion on the Salzburg flagon, no. 382. The hair fills the gap between the platform and the ribbon. Again no indication of a mouth.

Finally I should mention the torc from Les Jogasses, no. 211 (pls. 127, 219, h): there are two opposed part-masks—eyes and nose. The right eyebrow of one face is connected with the left eyebrow of the other by a diagonal line, and the field is closed at the sides by a curve rising from the other eye and swinging towards the diagonal. Similar faces decorate the torc from Vitry-les-Reims, no. 208 B.

In this particular mask-style the line dividing human form and ornament is blurred. One can often hesitate whether a face is intended or not: take the pattern of the nape part of the torc no. 228, a spiral ribbon with a double pelta in the involutions,[1] add a few strokes and it becomes the spiral ribbon with faces of torc no. 230. The ornament of torc no. 230 is a coarse version of the elaborate ornament of the terrets no. 175 a, b, the masks now looking in the direction of the run of the ribbon. Again how little would be required for making a face of the ornament on bump-rings such as no. 270.

Most of the objects decorated with those faces, though not all, belong to the third phase, and build with the material of the Plastic Style, but it is worth noticing that fibula no. 280, with its cleverly constructed masks, the linch-pin no. 162, with a partial face, and the torcs from Vitry-les-Reims, no. 208 A, B, with partial faces in the 'intermittent wave tendril', contemporary with the torcs from Courtisols, no. 208, and from Avon-Fontenay, no. 241, are definitely works of the Early Style.

There is something fleeting and evanescent about these masks, which often are not even complete faces, only bits of a face. It is the mechanism of dreams, where things have floating contours and pass into other things. If it were not too frivolous, one might call this the Cheshire Style: the cat appears in the tree, and often just the grin of the cat.

In the blend of masks and ornament two processes are at work, moving in opposite directions, one, so to speak, upward, the other downward: the obverse of the Heidelberg Janus, no. 14, is a face stylized down to abstract arcs, whereas in the torc no. 245 the starting-point is the lyre and the face is 'seen into it'. These are clear examples; in other cases it is not so easy to ascertain start and direction: what matters is that the two elements, faces and ornament, are brought under one denominator—otherwise they could not marry.

It would be too far-reaching a task to set these Celtic forms against a world-wide ethnographical background, but it is instructive to compare related phenomena in archaic Greek

[1] PP 101–4; p. 70.

art. The Greeks ornamentalize lions and birds, man withstands such attempts: the sole exception is the gorgoneion, the only Greek bogy which had a career and gained a shape. It offers analogies for certain features of the Celtic spectre faces: it is façade; some gorgoneia have spiral eyebrows, 'horns', wrinkled noses, flowers on the forehead.[1] The gorgoneion set on the body of the πότνια θηρῶν on the Rhodian plate in the British Museum (JHS 1889 pl. 59; Buschor, Griechische Vasenmalerei fig. 60; Radet, Cybèbe fig. 59; Besig 51 and 96 no. 191; M. Robertson, JHS 40 1940, 10) is almost as strongly ornamentalized as the back face of the Heidelberg Janus. Related are the partial gorgoneia on Rhodian vases like the plates BM A 697 (Kinch, Vroulia fig. 128), CVA Rodi 1, II D h pl. 3 (Italia 414), from Naucratis (JHS 44 1924, 187 fig. 11), from Al Mina (JHS 40 1940, 11 fig. 5), cup from Histria, Lambrino, Les vases archaïques d'Histria figs. 32–8, or the fragmentary oinochoe BSA 29 pl. 10, 7, p. 265. They are also found in Fikellura ware: amphora BM A 1310, Pfuhl fig. 131; BSA 34, 22 no 16. The 'lyre nose' in some Rhodian plates recalls the Arenberg gold torc, no. 70, or the Stanwick horse, *pl. 248, b*.

Partial gorgoneia are actually not an abbreviation[2] of the complete face, but originate in a pair of eyes: the eyes are the start: they grow a nose, often wrinkled, occasionally tusks (Rhodian plate from Al Mina) or a mouth with bared teeth (Attic black-figured oinochoe Berlin F. 1922, Neugebauer, Führer Vasen pl. 33, p. 77; AM 25 1900, 89; Jacobsthal, Ornamente pl. 34, b, c; Besig 86 no. 112). In the Attic eye-cup, Beazley and Magi, Raccolta Guglielmi 65, three black dots on the forehead turn the face into a gorgon's head (Beazley on no. 66). This sort of game is most common on eye-cups:[3] the eyes are there, the painter adds an ornamental nose, connects its alae with the ears by swinging spirals, human or animal, draws a flower, bud, or palmette between the eyebrows. The game in the Rhodian Euphorbos plate (BM A 749, Rumpf JdI 48 1933, 76; Pfuhl fig. 117; Besig 94 no. 181) goes the opposite way: here the eyes are the ὕστερον, an addition to the spirals and the lozenge-chequered triangle which grow from the upper circumference and come down between the shields of Menelas and Hektor. Related in principle is the Cheshire face under the handles of the Attic black-figured amphora BM B 260 (Jacobsthal, Ornamente pl. 39, d, p. 52; Besig 86 no. 113—with an interpretation less circumspect than mine). The ghastly face which decorates the shoulder of a sixth-century amphora of local make from Syracuse, Necropoli del Fusco, *pl. 219, g* (from Not. Sc. 1893, 463) stands by itself: it might be a Siculan bogy.

I should finally mention partial faces on Celtic bronze coins: Blanchet figs. 5 and 22.

After this dissective description of details the Celtic heads have to be seen as units.

A glance at the poor and monotonous figurines of the previous period makes it sufficiently clear that modelling, characterization, and the way the heads were used for tectonic purposes are inconceivable without strongest foreign influence.

Here as elsewhere in Early Celtic art it is not always possible to disentangle Southern and Eastern elements and to decide clearly for South or East.

[1] Laconian pottery: hydria BM B 58, AZ 39 1881 pl. 11, 3; BSA 34 pl. 44, a; Roscher 1,1714. Cup Louvre E 669, AZ l.c. pl. 12, 2; Roscher 3, 2390 fig. 3. For other Laconian gorgoneia see Besig 80, 81. A horned gorgoneion is painted on the back of the Protocorinthian lion-alabastron from Syracuse, Necropoli del Fusco, Not. Sc. 1893, 470; Friis Johansen, Les vases sicyoniens pl. 41, 5; Maximova, Les vases plastiques pl. 45, no. 166; NC 80 fig. 23 A; Besig 77 no. 19.

[2] The most radical abbreviation of a human face is the 'SOS' on the neck of certain Greek amphorae of the seventh and sixth centuries B.C.: Beazley, Raccolta Guglielmi p. 50.

[3] Rumpf, Chalkidische Vasen pls. 177–82, 192, 195; AM 25 1900, 56 and 57. The lion's head above the nose of the mask in the Phineus cup (AM 25 1900, 43; Rumpf l.c. pl. 43, Langlotz, Vasen Würzburg pl. 26) recalls the Phoenician terracotta mask from Tharros BMC Terracottas B 393 (photographs Archaeologisches Seminar Marburg 2275–7) with the lion's head on a square plaquette, at the same place.

The decoration of fibulae with heads follows an Italian fashion,[1] also the setting of heads on rings.[2] The use of heads as handle-attachments in flagons (nos. 382, 385, 387) derives from their Etruscan prototypes, but the handle-animal of the Lorraine flagons, no. 381, being of Persian kind,[3] it is permissible to ask if their handle-masks did not come from the same Oriental quarter: see for instance the Persian amphora in Berlin and Paris.[4] The setting of two faces joining foreheads in the gold finger-ring from Rodenbach, no. 72, faithfully copies an Etruscan gold ring,[5] *pl. 252, b*: the heads themselves are East-inspired.

As I have already said, the circular friezes of heads on the phalera from Hořovic, *pl. 218, g*, and the silver from Manerbio, no. 87, reflect classical models like the silver omphalos-phiale from the second kurgan of the Seven Brothers,[6] the gold omphalos-phiale from Kul-Oba, *pl. 219, d*, the silver egg-phiale with emblema from Ancona.[7]

The accessories of heads are partly of Etruscan, partly more probably of Oriental origin. The Hathor coiffure reached the Celts by way of Etruria.[8] The heads in the open fields of the gold openwork from Dürkheim, no. 28, wear a palmette-crown, its straight outline is only the result of the technique of stamping.[9] The crown is either of Persian or Etruscan origin: possible Persian models are heads of Bes, as the attachment of the Persian silver amphora just mentioned, the gold plaque from the Oxus, Dalton pl. 12, no. 32; Pope pl. 116, c, or the impression of a gem from Ur, Ant. Journal 12 1932 pl. 77, 2. From Etruria there is the bronze patera in New York, Richter, Bronzes no. 580, with a snake-footed demon who wears such a crown.[10]

Physiognomically there are two classes of heads: in one—comprising the pillar from Pfalzfeld, no. 11, the gold bracelet from Schwarzenbach, no. 58, the girdle-hook from Schwabsburg, no. 351, &c.—the faces, despite certain Celtic peculiarities, look like those of average human beings and may well be descendants of Etruscan heads like those in the spirals *pl. 252 a*[11] or the attachment-heads of the beak-flagons which are common in Celtic tombs:[12] see JL pls. 1, 5; 2, 21; 3, 31; 5, 40, 41; 6, 48; 7, 66. Positive evidence of Etruscan influence on this class of Celtic faces is the likeness between the attachment-head of the beak-flagon from Klein Aspergle, no. 385, and the silenus on Etruscan stamnos-handles, *pl. 220*: both are a conglomerate of protuberances. These stamnoi being among the more frequent imports in Celtic tombs,[13] the likeness must be more than mere coincidence, for most probably the ivy-wreath, a common border-pattern in these handles, was the model of that on the Weisskirchen sword no. 100, *P 379*.[14] Another motive seems to have influenced Celtic masks: in these stamnos-plaques the space between the silen-head and the handle-root is not infrequently occupied by a pair of stylized eyes, copying those on Greek eye-cups:[15] they either appear clear and well shaped, *pl. 220, d*, with indication of pupil and tear-gland—though the latter is usually misplaced—or in a rudimentary form, as in the

[1] p. 127. [2] p. 123. [3] p. 37.

[4] p. 40, note 1. [5] pp. 90, 125.

[6] Minns fig. 107; Rostovtzeff, SB 314; Luschey 138, no. 3, and 140. Date of grave 450–440 B.C. (Schefold 12, 17).

[7] Not. Sc. 1910, 353; AA 26 1911, 161, 162; Luschey 132, no. 3.

[8] p. 15.

[9] I cannot say whether the four diagonal wings joining the corners of the field and the loops between them are improvised or a Celtic interpretation of a foreign model: if the model was Etruscan, one might think of such a Silenus head as that in the oinochoe of the school of the Micali painter in Göttingen

(Jacobsthal, Göttinger Vasen pl. 1, 5; Beazley and Magi, Raccolta Guglielmi p. 81, no. 32) where, however, the four diagonals clearly signify ears and hair.

[10] An isolated Greek example is the frontal head of Dionysus on the white kotyle in Copenhagen, AJA 33 1935, 479 fig. 4: Beazley drew my attention to it. Compare Tarentine terracottas, AZ 40 1882 pl. 13, 5; BMC Terracottas pl. 13, 3.

[11] New York, AJA 44 1940, 435 fig. 7 top left, p. 436 fig. 10; Richter, Etruscan Art fig. 106. I am indebted to Miss Richter for the photographs. See p. 123.

[12] p. 136. [13] pp. 136 ff.

[14] p. 88. [15] p. 20.

stamnos[1] *pl. 220, a.* In this vase the motive comes very close the Celtic leaf-crown, and formal connexion is conceivable. A line might also be drawn from the crown of the mask on the Weisskirchen girdle-hook, no. 350, to the head-spirals of the silens on the Weisskirchen stamnos, *pl. 220, b,* and on a stamnos in Munich, *pl. 220, c.*

The Celtic heads of this class are not 'portraits': on the physical appearance of the Gauls we have the evidence of Hellenistic sculptors and writers. They are not intended to be 'natural', though the sleepy old man with the pod-beard, no. 387, the revolting moon-faces, no. 34, the 'negroes', no. 93, are not farther from nature than strongly stylized caricatures.

Here a word on the little Janus-head from Nauheim, no. 369, and its classical connexions. It was found in a cemetery dated by fibulae, pottery, &c., about the second century B.C. It is uncertain whether it had an aperture on top where a piece has broken away, and whether it was a pendant or a receptacle: if the latter, it could only be used as a container of a solid substance, for the nostrils are open. Its provenience from a Celtic cemetery, its Janus shape, the lack of ears, and certain stylistic features prove its Celtic origin, but otherwise its character severs it from the Celtic heads with which we have dealt. Seen from the front the outline is nearly circular; profile and bottom view show that where the two faces join, they have a strong triple frame, hatched and beaded, all round, up to the eyebrows. The low receding forehead, contoured above by a beaded arch and below by the jutting eyebrows, is modelled like a piece of architecture. The snub nose has a narrow bridge and fleshy alae. Cheeks and chin are flat or even hollow. The enormous curve of the mouth touches the nose, lower and upper lip join in an arch at the corners, which are almost level with the eyes. The hatching of the upper lip, here as in other cases, possibly means hair. The modelling is more vigorous than in earlier Celtic heads. The head also differs from them in character, and strongly resembles Greek silenoi and masks of Greek comedy, though I cannot point to exact models.[2]

The faces in the second class have a stronger physiognomy and, with the animals, give Celtic imagery its signature. Examples are the girdle-hook from Langenlonsheim, no. 353, the brooches nos. 312, 313, 314, 316, the Lorraine flagons, no. 381, the gold finger-ring from Rodenbach, no. 72. These faces are quite appropriately called masks, for stylization and overstylization are common to masks of many ages and civilizations. They look weird and fear-inspiring, ferocious and inhuman—some subhuman, on the verge of man and beast. The uncanny and horrible has rarely been shaped with such vigour and in so original a way: this is achieved by overstressing essential parts of the faces, by strong articulation of the units, by the use of beaded and hatched contours.

The Eastern character of the masks is strikingly obvious, but whereas Celtic animals follow Oriental prototypes more or less closely, the masks are not copies of definite Eastern models, but a new creation in a 'Celtic Orientalizing Style'—I shall explain this term presently.[3]

A definition and assessment of Celtic heads, stylized or not, is difficult, and there are more questions than answers.

What is the significance of the heads? Early Celtic culture is not illumined by literature:

[1] Other examples are Berlin, Antiquarium 1389 (pupil omitted) and 6474/5 (glands omitted). Karlsruhe 620 (Schumacher pl. 9, 22; Wagner, Bronzen pl. 15) and a piece in the Vatican, Alinari 35553, draw the gland more correctly, but reduce the pupil to a boss. Elaborate eyes, correctly drawn, appear on the handle-plaque of the stamnos from La Motte-Saint-Valentin, Déchelette, La Collection Millon pl. 30, p. 107 fig. 15; here, instead of a silen's face, horns blended with floral forms appear between the eyes: compare Karlsruhe 616 (Schumacher pl. 9, Wagner, Bronzen pl. 11); Museo Gregoriano i, pl. 7, 5; entirely floralized on Karlsruhe 624. The model was in the nature of the Etruscan amphora Munich, Sieveking-Hackl 835, pl. 32. Zahn, Das Fürstengrab von Hassleben (Römisch-Germanische Forschungen 7) 93 needs correction.

[2] Robert, Die Masken der neueren attischen Komödie, passim.

[3] p. 158.

even the mythological narrative on the silver cauldron from Gundestrup[1] is dark and must remain unexplained.

We simply do not know if works like the Pfalzfeld pillar, the statues from Holzgerlingen and from Heidelberg once stood on tombs or in sanctuaries, or both, like the Greek kouroi: but their size, Janus shape, and head-crown prove them to be images of superhuman beings, gods or deified mortals.

Janus shape is a case of εἶδος πολύγυιον, a form in which the divine manifests itself all over the world, and there were double figures within the horizon of the Celts.[2] But it is unnecessary to look for Southern or Eastern models, for there is no special feature in these Celtic Januses pointing abroad, and the formal problem of duplication could easily be solved by the Celts without foreign inspiration or teaching. Nor have the theories put forward on the nature of θεοὶ πολύγυιοι[3] any value for an understanding of Celtic twin-heads or twin-statues: the *interpretatio Graeca* and *Romana* in Timaios and Suetonius[4] should warn us.

It may be said once more that the tricephalic heads common in the later phase are alien to early Celtic art.[5]

For an understanding of the leaf-crown it should be noticed that large-size sculptures from lands so distant from each other as Provence and Germany wear it in the same stereotyped form. It is admitted to be more than mere 'ornament'.[6] It is easy to find ethnographical parallels, but these would be of little help. I should only like to say that Greek archaic art characterizes gods, demons, and heroes by head-tendrils.[7]

If we had only the few stone heads, matters would be easier. But even here problems arise: for instance, the head that once crowned the Pfalzfeld pillar was certainly of the same divine nature as the other monumental Januses: but have the heads surrounded by ornament, repeated on the four sides, the same dignity, or do they belong to the sphere of the numerous heads that adorn implements?

The only heads of mortals are those under and in the jaws of beasts on the Salzburg flagon and the Glauberg torc, for in the normal course of events in myth gods and heroes triumph over monsters and are not devoured by them. But I hear a sceptic's voice: does not Nordic mythology know the god, doomed to tragic death and ruin, slain by monsters?

Only the minority of heads in vessels, rings, brooches, or girdle-hooks wear a leaf-crown of the shape shown by the monumental sculptures. Most of them are beardless: are they different from the bearded? Is the variation of the crown mere ornamental play or, as in Egypt, the expression of a difference in nature and personality? Many heads, and among them the most impressive ones, have no crowns: has that a meaning?

In cases where an object is meant to be looked at from both sides, is the Janus-shape still to be taken seriously? To mention a concrete instance: is the Janus character of the youth supporting the Hochheim mirror, no. 373, a true mythological feature?

[1] JdI 30 1915, plate facing p. 1.

[2] Hanfmann 18.

[3] Schweitzer, Herakles; Lullies, Die Herme 66.

[4] p. 10 n. 4.

[5] Schweitzer l.c. p. 66; Cook, Zeus 2 323 ff.

[6] Gössler, Festschrift für Seeger 208 rightly contradicts Knorr's thesis (Germania 5 1926, 17) that the leaves are wings and these heads 'Proto-Mercurii'. But even he is inclined to take the leaves for stylized hair.

[7] Artemis and sphinxes: Wolters, Festschrift H. Woelfflin 168 ff. On Laconian vases the head-tendrils are not only worn by sphinxes (e.g. BSA 34 1933/4, pls. 44, c, 45, a), but also by a rider, probably a ἥρως (London cup, ib. pl. 45, b). The banqueting ὅσιοι—I keep this traditional interpretation against Lane, BSA l.c. 158—in the Louvre cup E 665, CVA France I, III D c pl. 3, 2 (France 25); Lane pl. 42, b, are about to receive the distinctive tendril and a wreath from the flying demons and sirens in attendance, who carry them to the still unadorned banqueters.

Hardly any of these questions can be answered with a plain yes or no.

Works like the jugs from Lorraine or Salzburg, certain fibulae, the girdle-hook from Weisskirchen, the gold bracelet from Rodenbach, or the torc from Glauberg display in a multiplied and intensified form the same elements that appear less condensed in many other vessels, brooches, and the like. These implements, serving for meal, battle, personal attire, are the haunts of demons and beasts, and the same air breathes here as in the Orient and in Greece of the Early Orientalizing period, the later eighth century and the seventh. It will become clear to us that this is not the only parallel which can be drawn between Celtic art and Greek art of that phase.

Here is a world of forms and thought which is genetically older than that of concrete myth: its cradle and everlasting home is Asia. That will become more evident when the Celtic Animal Style is discussed in Chapter 2.

In this world the border-line between pregnant and faded form, between true, significant myth and ornamental play, is blurred.

In Greece we find that sphinxes as monstrous creatures and types are older than the Sphinx of the Oidipody, sirens as 'soul-birds' older than the Sirens of the Odyssey, and Gorgons and gorgoneia older than the Medusa of the Perseus story;[1] and lions or snakes are but the symbols of the 'tremendum', embodiments of great, menacing, dreadful powers.

This sheds light on early Celtic imagery. These masks of man and beasts, whether, as in the girdle-hook from Weisskirchen, the gold bracelet from Rodenbach, in idle, ornamental parataxis, or, as on the Salzburg flagon, the Glauberg torc, in 'action', are the expression of a mythology preceding shaped myth of an age to come. But did this age really come? This haunted and magic world was rejected by the Celts,[2] but—always speaking of their arts, for we are ignorant of their literature—no myth, no figurework took its place.

[1] Besig, Gorgo und Gorgoneion (dissertation Berlin 1937); Hampe, Frühe griechische Sagenbilder in Boeotien 60.

[2] There are interesting survivals of Early Celtic masks on South Gaulish sigillata (Knorr, Töpfer und Fabriken verzierter Sigillaten des ersten Jahrhunderts pl. 30, type 1, p. 44; compare also pl. 90, B (*pl. 219,*) and J; Germania 5 1921, 15), with long pointed beards and a three-leaved palmette at the point, recalling the Pfalzfeld heads, and leaf-crowns of true Early Celtic shape; the piece Knorr pl. 4, V interprets the leaves as feathers. See also Lantier, Comptes rendus de l'Académie des Inscriptions et Belles-Lettres 1932, 302.

The attachment-masks of the Aylesford bucket (BM EIA fig. 135: Archaeologia 52 1890, 361, 363) also have a crown, though of a different shape. Evans, Archaeologia l.c. 361, and Willers, Die römischen Bronzeeimer von Hemmoor 187 wrongly call the device 'helmet', 'Sturmhaube'.

CHAPTER 2

ANIMALS

THE only piece of large-size animal sculpture is the goose from Roquepertuse, no. 2—not a work of pure Celtic art.[1] A few rare pieces are figurines, not attached or subordinate to other objects, for instance the Hungarian boar, no. 371. The horse from Freisen, no. 370, has an eyelet under the muzzle through which a chain probably passed: chains hold the lid of the spout-flagons from Waldalgesheim, no. 387, and Le Catillon, no. 389, and of the beak-flagons from Lorraine, no. 381, here fixed to the jaws of the handle-beast.[2] The lid of the Waldalgesheim vessel probably bore a little animal. This suggests that possibly the horse also stood on a lid, attached to a chain. Its size, 12 cm. long, is too large for a jug, but one might think of the lid of a pyxis—Greek geometric pyxides have lids with one or more horses on them. Here the pyxis, if there was one, may have been of wood. Whether the lost pendant horse[3] formed part of the same box or of another in the grave cannot be said.

The other animals are integral parts of objects and serve manifold tectonic purposes.

For reasons which will presently become apparent, it is not advisable to follow here the method applied in the previous chapter: survey and morphology of the animals cannot be separated from discussion of their origin. Thus we shall be led here to the problem of the Eastern connexions of Early Celtic Art.

I begin with some monuments made under peculiar conditions. The two jugs in Aarau, no. 392, are hybrid works: the vessels themselves were made by a Celt, the handles by a man from Southern lands, employed by the Gauls.[3] It would not be at all surprising to find an 'imported' Etruscan artisan in a Celtic workshop, yet the beasts have nothing Etruscan about them, but have definitely the look of Greek work of inferior quality: as to their date they are not far from the lions of the Nereid monument and that in New York,[4] Gisela Richter, *Animals in Greek Sculpture* fig. 20, all to be dated to the last twenty years of the fifth century B.C.

While these animals are bad Greek originals, the rams' heads at the tip of the gold horns from Klein Aspergle, nos. 16, 17, are Celtic copies: their models were Greek gold rhyta like the one from the fourth kurgan of the Seven Brothers' mound,[5] *pl. 221, a*: in the kurgan was a silver cup with a seated Nike, a work of the early sixties of the fifth century B.C.[6] The rhyton looks a little later, perhaps ten years or so:[7] Schefold 16 has rightly compared the marble ram in Boston, Richter l.c. fig. 141. The gold ram's head from a drinking-horn, found in a mound at Rochava near Staro-Novo-Sélo (region of Plovdiv), *pl. 221, b*, is similar, but, as far as the drawing allows judgement, of inferior quality.

The ram of the guilloche-horn, though this is larger than its pendant, is slightly smaller, coarser in modelling, and poorer in details (e.g. in the partition of the horns). The ridge marking the nose runs through up to the collar, at the cost of the hair on the forehead between the horns, which is shown clearly by the better ram. The treatment of the jaws with a hatched

[1] p. 3.

[2] There is a chained dog on the lid of the late archaic bronze amphora from Gela in Syracuse, Mon. Ant. 17, 451 fig. 321. [3] p. 106.

[4] W. Schuchhardt, AM 52 1927, 147 ff.

[5] CR 1877 pl. 1, p. 16; Rostovtzeff IG pl. 12, B. The photo-graphs are due to the kindness of the late Professor Waldhauer.

[6] CR 1881 pl. 1, 2, p. 6 (poor drawing); Rostovtzeff IG pl. 15, 3 (retouched photograph); Jacobsthal, Melische Reliefs 197.

[7] For the chronology of fifth-century rams see Jacobsthal, Melische Reliefs 136.

triangle between them is also less elaborate. But all in all, the animals still keep enough of their classical models. This becomes clearer by comparing them with the sheep at the foot-end of the Jungfernteinitz fibula, no. 318, the prey of the bird at the other end. It is much further from its foreign model,[1] far more ornamentalized, and of the same style as the other decoration of this brooch. The drawing of mouth, nostrils, eyes, and eyebrows, of the long leaf-shaped ears, of the hair on the forehead, which repeats the rhythm of the eyebrows and of the hair on the back of the skull—all this has analogies in Celtic human heads. Round the throat runs a hatched collar, comparable to that of the bronze handle-animal no. 384. A curl grows from the collar on both sides, followed below by others with the opposite movement: they denote the fleece, this partial representation of an animal's body being a very typical Celtic feature.[2] Curiously enough, the sheep wears a crown, consisting of a hoop with projecting members which recall motives to be seen on the gold bracelet from Rodenbach, no. 59, and the gold torc from Besseringen,[3] no. 41; the sheep's crown is also related to crowns worn by human heads in the 'Weinitz' fibulae from Viniča, Carniola, Treasures pl. 12, no. 54, pl. 14, nos. 65, 68, pl. 15, no. 73, &c.; text p. 34 (von Merhart).

Of other Celtic rams' heads (fibulae nos. 308, 314; bracelet no. 249) I need only mention that at the upper end of the handle of the Waldalgesheim flagon, no. 387. It is modelled in delicate flat relief, which becomes higher in the horns, setting off the handle from the lip of the vessel. If this ram were preserved as a fragment, one would hardly recognize it as Celtic at all.

Before I discuss the general run of Celtic animals, I should like to describe some that are free of the typical stylization or at least confine it to unessential parts.

The bronze from Freisen, no. 370, which I have already mentioned, is not really a good portrait of a horse, but compared with any Hallstatt animal its plastic character is manifest, and it is among the best sculptural creations of Celtic art, though there is a certain lack of uniform conception and an incongruity between profile and subsidiary views. The profile shows the elongated body, which has the shape of a slightly faceted cylinder, and the curving, over-long neck of rhomboid section. The body is the bridge between breast and buttocks, which are natural and fleshy, and the legs are articulated and well modelled. The contour of the head has a faint resemblance to that of birds of the duck type on brooches;[4] the erect ears are spoon-shaped, not hollowed like those of the deer no. 372. Is there not a striking resemblance between this horse and Greek animals on the verge of geometric and early Orientalizing art, such as Neugebauer, Berliner Bronzen no. 138, pl. 15? I shall say more of this.[5]

The Hungarian boar, no. 371, is later: he is not unrelated in style to the horse, but coarser, and the increase in anatomical detail is somewhat latent. The huge mane does not show the bristles, but bears ornament instead—one row of 'horse-shoes' below and one of spirals above them.

The bronze deer no. 372 is one of the most harmonious and pleasing Celtic sculptures. The head is very long. There is little detail—the drilled nostrils, the notch of the mouth, the circular eyes, once coral-inlaid. The erect ear-spoons—here hollowed—are expressive, and so are the jaws with their straight strong contour, passing into the ridges of the 'neck' in a curve on the right, and with a break on the left side. The triangular hollow between the jaws resembles the treatment of this part in the bronze handle-animal no. 384 and in the rams of the gold horns from Klein Aspergle, nos. 16, 17. Beyond, the form becomes abstract and

<hr />

[1] p. 30. [2] p. 37. [3] p. 76. [4] p. 128. [5] p. 161.

ornamental: the neck is an S, broadening downwards. It has a rhomboid cross-section: the ridges separating the four planes are of great sharpness and precision; that along the spine, on the upper half of the S, is accompanied by a groove on each side, possibly a distant reminiscence of a mane.

Here is a masterly balance between the head, which still keeps enough of nature, of the character of a deer, and the beautiful abstract curve of the neck, both harmoniously brought to the same level of style. For the head it is useful to look at pictures of deer on Greek vases.[1] I also show another Greek archaic animal with highly stylized curvy neck, a seventh-century ivory seal from Perachora, *pl. 221, d.*

Celtic art commonly ornamentalizes the animal body by lavish use of floral motives, by beading and hatching: this animal lacks any such feature. There is no other work quite of this style, but the Celtic origin of the piece is suggested by its provenience from the Rhine-Main region and by the use of corals. One feature possibly hints at foreign influence: the faceting of planes is Scythian,[2] and recurs in a less pronounced manner in the horse no. 370.

What was the purpose of this bronze, only 10 cm. high? As the hollow at the lower end and the nail-holes near it prove, it was fixed on a peg, probably of wood. The obvious poise is with the lower edge horizontal: thus it cannot have been fitted on a curved surface, cannot have been one of the ornaments of a helmet,[3] nor one of the protomai projecting from a cauldron.[4] A likely interpretation is that it was one half of a lyre-shaped attachment like those from Faardal, *pl. 236, a,* pp. 55 ff.

The pictures of *birds* in Celtic art are less interesting for their form or beauty than for the historical conclusions one can draw from them.

To set coarse little birds singly or in rows on bronze implements of any description was a favourite fashion of the preceding age in South and North.

A duck with coral eyes sits on the beak-tip of the Lorraine flagons, no. 381, two very 'general' birds walk up the lyre of the girdle-hook from Hölzelsau, no. 360. In the Swiss bronze comb, no. 375, birds are used as 'acroteria', as on the wooden, bronze-mounted barilia from the Celtic cemeteries near Ancona.[5] Most frequent is a group of two confronted birds, often flanking a central ornament. In the round of the fair-lead from Waldalgesheim, no. 156b, a pair of birds stand on the enamel-inlaid cross-bar, with huge coral eyes and a long crest-feather, their wide-open bills touching each other: they are quarrelling. They are fancy birds and built of the same stuff of which the openwork round the ring is made.[6] They remind one of those children's toys—'Cut the ornament into pieces and make a pair of birds!' On the gold torc from Besseringen, no. 41, the eagles with their heads turned back—this a motive of importance on which I shall comment presently—flank the five balusters in the middle. On the North Italian fibula no. 297, two ducks with a boss between them; they are asleep, their heads repose on the feathers and the feet are drawn in. The girdle-hook from

[1] Ionic amphora Athens, Collignon-Couve 658; photograph German Archaeological Institute, N.M. 673. Eretrian amphora, Athens, FR 3, text fig. 104; Zervos, L'art en Grèce³ fig. 153: for the date see Rumpf, Chalkidische Vasen 146. Oinochoe of Kolchos, Berlin F. 1732, W.V. 1889 pl. 1; Hoppin, Handbook of Black-figured Vases 157.

[2] Lioness from Kelermes, Rostovtzeff IG pl. 9, 1; id. AS pl. 5, 2; Borovka pl. 12; Ebert 13 pl. 27 A, c. Gold stags: from Kul Oba, Borovka pl. 34; Ebert 13 pl. 32 A, a; from Kostromskaja Stanitsa, Borovka pl. 1; Ebert 13 pl. 27 B, a; Fettich, Arch. Hung.

[3] pl. 6; from Tápiószentmárton, Fettich l.c. pl. 7; Rostovtzeff AS pl. 5, 1. See also the bronze of peculiar Scythian style from Garčinovo (Bulgaria), ESA 9, 197 (Filow); Arch. Hung. 15 (Fettich): Schefold 40 dates it 480/70 B.C.

[3] Déchelette 1156: Diodorus 5, 30, 2.

[4] Greek cauldrons with griffin protomai reached the North: Tumulus de la Garenne, Sainte-Colombe, Déchelette fig. 221; Ebert 4 pl. 61, 37, and 6, 129; AM 45 1920, 138.

[5] pp. 110–11.

[6] p. 83.

Münsingen, no. 365, is decorated with a pair of slender birds with curved beak and a crest on the head, looking outwards, the tails ending in a circle like those of the birds in the torc from the Marne, no. 239, and in the chape no. 102, here coral-inlaid. They stand out plain against the stippled background; the artist has cleverly used their curves for contouring the plaque. Another pair of birds, looking at each other, possibly appears at the bottom, above the three large circles. In the openwork girdle-clasps from the Ticino, no. 361, and the piece from the same workshop found at Ensérune, no. 362, the birds look at the stylized palm-tree[1] in the middle. A plain version is given by the bronze ring from Balf, Márton pl. 3, 5, which I take for Celtic and not, as Márton does, for Hallstatt.

A group of six torcs from the Marne shows two birds flanking a 'wheel', a 'Sacred Tree', or the like: I illustrate two of them, nos. 239 and 240. The others are: Déchelette fig. 195, 1 (Tumulus de la Motte d'Attancourt); fig. 563, 1 (Pogny); fig. 563, 2 (Sarry); one from Les Jogasses, tomb 78, in Épernay. The birds of the openwork plaque attached to the coil of the Swiss fibula no. 293 flank a central ornament, similar to that in some of the Marne torcs: the huge eyes, once coral-inlaid, are weightier than the body, which in its extreme stylization recalls the Waldalgesheim birds. The same is true of the herons on the cheek-pieces of the helmet from Carniola, no. 152. They also look at each other, though separated by the face of the warrior wearing the helmet. As the enamel knobs on the cheek-pieces indicate, the helmet is not earlier than the first century B.C., contemporary with the finds from Mont Beuvray and the Hradisht.[2]

Finally I mention bird-groups on swords from La Tène. On the sword, Vouga 41/2, fig. 7j there are two pairs of coarse birds, one hanging downwards and degenerate. The birds on no. 107 are carefully drawn; they have long beaks, crests, and eyes done in concentric circles. They are half birds, half tendrils, related to the dragons on nos. 121–5. The birds on no. 110 have an atrophied body, just a tendril, no more than an appendix to the heads.[3]

The group of antithetic birds is of Southern origin and came to the North already in Hallstatt. The bronze pectoral from Moydons-Papillards, Chilly (Jura), Déchelette fig. 251, with 'bird-acroteria', was found together with a La Tène brooch and is on the verge of the two periods.[4] Late Hallstatt are the two fibulae from Uffing (Bavaria), Ebert 3 pl. 104, e, and from Hallstatt, Sacken pl. 14, 16; Ebert 5 pl. 22, 1; BM EIA fig. 36, 4.

I illustrate some Southern examples. *Pl. 221, c* shows a detail of the Early Attic hydria from Analatos, a work of the latest eighth century B.C. (J. M. Cook, BSA 35, 166, 205). There are already groups of antithetic birds on geometric vases: like the recumbent quadrupeds they are among the first 'swallows' from the East. *Pl. 221, e* is part of a late archaic mirror from Sicily. The model was Egyptian: mirrors of the eighteenth and nineteenth dynasties (Catalogue général des antiquités du Musée du Caire, Bénédite, Miroirs pls. 8, 9) have plastic birds, back to back, perched on the handle beneath the disk. Other examples of antithetic birds are: silver-mounted bronze chest from the Tomba del Duce, Vetulonia, Not. Sc. 1887 pl. 18; Montelius pl. 188, 1; Ducati fig. 142; Karo, AM 45 1920, 106 ff. Faliscan kantharos in Hamburg, AA 32 1917, 97–8 fig. 26 a. Protocorinthian aryballos, Branteghem collection, JHS 11 1890, 179 fig. 2; Friis Johansen, Les vases sicyoniens 61 fig. 42. Protocorinthian lekythos in Boston, AJA 5 1900 pl. 6; Friis Johansen l.c. 146; Payne, PV pl. 11, 1, 3; Schweitzer, Herakles 64 fig. 17. Relief pithos, Blinkenberg, Lindos

[1] Jacobsthal, Ornamente 99. [2] Henry, Préhistoire 2, 79, 80.
[3] p. 53. [4] p. 82.

pl. 42 no. 927. Dafni situla, first half of the sixth century B.C., CVA Rodi 1, II D m pl. 1, 5 (Italia 423). Late archaic marble lamp in New York and Boston, JHS 60 1940 pl. 7 and p. 43 fig. 21; p. 42 note 25 (J. D. Beazley).

Persia: seal cylinder, Ward p. 339, no. 1134; Roes, Geometric Art 54 fig. 41. Gold band from the Oxus, Dalton no. 47, pl. 13; Pope pl. 117, B; Luschey 52 note 307 and 69 note 393. The bird group decorating the tiara of Tigranes on coins (BMC Coins Seleucid kings of Syria pl. 27, 6; Hill, Select Greek Coins pl. 18, 2) follows Persian tradition.[1]

Scythia: little stamped gold birds, some turned to the right, others to the left, once sewn on a band in groups, from Olbia, AA 29 1914, 255; Zahn, Sammlung L. von Gans no. 920, pl. 30, pp. 31 and 35. There are also elaborate single birds from the East with the head turned back: Siberian bronze knife, Tallgren, Collection Tovostine fig. 17. Scythian bronze from Garčinovo (Bulgaria),[2] ESA 9 197 ff. (Filow).

Origin and migration of the motive are easy to reconstruct. It occurs in Egypt of the eighteenth and nineteenth dynasties, in Greece from geometric times onwards, in seventh-century Italy; the Persian and Scythian examples are not earlier than the fifth and fourth centuries or even later. The bird-group originates in the Near East, whence it reaches the West and the Far East: *pl. 221, g* illustrates, in Professor Yetts's drawing, an ornament on a bronze rectangular vessel (*fang i*) of Yetts's Early First Phase, and *pl. 221, h* the decoration of the rectangular base of a bronze food-vessel of the *kuei* class (the background of spirals is omitted), Yetts's Middle First Phase. Jades, difficult to date, are figured in Salmony, Jade pl. 16, 1, 3; pl. 25, 1.

Whether the Celts got the birds from Italy or from the East or from both sources cannot be decided.

Another bird-motive points in the same direction, the handle-attachments of the Ticino flagons, no. 393, and of a bronze cup from the same cemeteries, Ulrich pl. 75, 13, JL pl. 25, a. These birds are 'Siamese twins'. On no. 393 *d* it is difficult to say what kind of animal the artist had in mind: the creatures have cockscombs and feathers on their bodies, but the heads have more of horse, if not of camel. These double birds are a member of the large family of compound animals: in the Celtic jug from Castanetta, no. 394, we see two compound horse-protomae (JL pl. 18). The source of these motives is Etruria: bronze amphorae in Hamburg, JL pl. 31, c, d, and from Croix-des-Monceaux, Conliège (Jura), Déchelette fig. 432. Handle of oinochoe, Allard Pierson Museum, Algemeene gids pl. 37, no. 772 (there wrongly called Campanian and dated to the fourth century B.C.). Vulci tripod, Mon. Ant. 7 pl. 9. Bronze from Spina, Aurigemma pl. 70 (Mercklin, JdI 48 1933, 123). Bridle-bits, BPI 38, 106 (Cupramarittima) and in Mainz ("South Tyrol").[3] Pottery: Micali, Monumenti inediti pl. 29, 1, pl. 30, 2 (bucchero). Faliscan urn, CVA, Copenhague fasc. 5 pl. 201, 3. Faliscan kantharos Hamburg, AA 32 1917, 97, 98 fig. 26. The same motives are also frequent in the backwater of Carniola, Treasures pls. 13 ff., pl. 25 no. 139. The compound animals invade Greece and Italy from the Orient in the seventh century B.C.[4]

[1] My attention was drawn to the coin by Beazley.

[2] p. 27 n. 2.

[3] 1 Behn, Mainzer Zeitschrift 1927, pl. 7, 1, p. 104, is wrong in attributing these pieces to a region 'between the Italic and East Alpine civilizations'. The style is normal Etruscan and the object is simply one of the not at all infrequent Etruscan imports in the Tyrol.

[4] I refer to Roes, Geometric Art, who displays a large material, which only needs more careful treatment and ar-rangement; to Zahn in Anatolian Studies presented to Sir William Ramsay 442, and to V Müller, Orient. Literaturzeit. 1925, 785. The Etruscans found the motive in the Early Archaic arts of Greece: most of the examples come from Sparta: Orthia p. 266 (lead); pl. 32, 4, 5 (clay); pl. 172, 1 (ivory). On some of them the πότνια ἵππων appears, either in full figure, or only her head between the protomae (Rostov-tzeff, Syria 12 1931, 48 ff.). Other Greek examples are: Olympia, Bronzen pl. 51, no. 875; Fouilles de Delphes, 5, text

The bird masking the coil of the brooch from Jungfernteinitz, no. 318, is the best of Celtic birds and important because it can be proved to be a copy of a definite Eastern model. It pounces on the sheep at the other end of the fibula, described on p. 26. It has a short curved beak and large, carefully engraved eyes. Round the neck is a collar like the sheep's. The talons are strongly ornamentalized and resemble those of the handle-animal in the bronze flagon no. 383, a work from the same workshop.[1] They and the body are covered with little punched squares, the sickle-shaped wings and the palmette-tail, which is set off from the body by a hatched collar, with basketry patterns like those on the knee of the bow. It is a good bird of prey—though zoologically indefinable, and a beautiful ornament, in harmony with the other decoration of the brooch. It needs no comment to show that its model was a work like that figured in *pl. 221, f*: the Greek, slightly Iranizing, silver ornament of a cuirass from the second kurgan of the Seven Brothers' mound, dated about 450/40 B.C.;[2] see also the Greek Iranizing gold mountings of wooden rhyta from the fourth kurgan of the Seven Brothers' mound, Rostovtzeff IG pl. 13 (Schefold 39).

Birds are often used for tectonic purposes, as finials: this is not a Celtic invention, but has forerunners in Greece and the Orient.[3] They are most frequent in swords and in fibulae. In the swords a pair of birds form the frame of the chape at the point. The most ornate examples are the Weisskirchen sword, no. 100, where the eyes and bodies are coral-inlaid; and the chape no. 102, in openwork and with corals. In Hungarian swords (Dolgozatok pls. 24, 51, 55) and in a good many coarse unpublished pieces from Saint-Jean-sur-Tourbe and other places on the Marne, in Saint-Germain, their form is blurred and the bodies have grown together at the tip of the sword. Similar is the treatment in the sword from La Tène, no. 106: here the upper ends of the chape have also been given the form of birds' heads. The bird-finials of fibulae[4] are either ducks or like eagles, with curved beak, which makes a difference to the general rhythm of the brooches. The ducks have Hallstatt forerunners.[5] The eyes are mostly large circles, often with coral, sometimes more almond-shaped and beaded.[6]

The clay flask from Matzhausen, no. 402. The lenticular flask is a common shape in Early Celtic pottery.[7] Some of them bear little patterns, but this is the only one with figure decoration, and it is the only case of a Celtic animal-frieze in a strict sense, for the urn from Bétheny (Marne), to judge from the reproduction, Déchelette fig. 661, 3 (here *pl. 217, d*), and also the French urn no. 410, repeat the same animal, the first a horse, the latter a creature combining the head of a 'dragon' (with hypertrophic jaw-bones) and body and hooves of a horse.

Here we have, instead, a group of two quadrupeds (deer?), the heads turned back; two boars, facing each other (faintly recognizable in the plate); bird; grazing deer; bird; grazing stag; hare; wolf. The arrangement and choice of the animals is rather casual, but neither

130 fig. 488. The motive rises from the minor arts into architecture: compound bull protomae of the capital in the palace of Artaxerxes Mnemon at Susa, Sarre pl. 37; Pope pl. 101.

[1] In this context I should like to draw attention to the mirror-figure in the BM, Jantzen, Bronzewerkstätten in Grossgriechenland und Sizilien pl. 19, 78, p. 47 no. 9 where the 'cushion' is formed by a compound of two lively, well-executed swans or geese. [1] pp. 41, 74, 108.

[2] Minns fig. 105; Rostovtzeff SB 314; Schefold 17.

[3] I refrain from giving lists of Greek implements ending in birds' heads; for the East I refer to L. Curtius, Assyrischer Dreifuss in Erlangen, MJ 1913, 15.

[4] Besides the examples in the plates see AuhV 1, 4 pl. 3; Trierer Zeitschrift 13 1938, 229 pl. 9. See p. 128.

[5] Déchelette fig. 187.

[6] Fibula no. 299; fibula from Monsheim, Behrens no. 175; from the Steinsburg, Déchelette fig. 269 middle right.

AuhV 5, text to pls. 50 and 57; PZ 24 1933, 139.

more nor less so than in the 'assorted animals' of classical Orientalizing style, and, moreover, a handleless flask which has no front or back does not ask for more than such a menagerie. The beasts are drawn with uneven skill: the boars, the wolf, and the hare look uncouth and improvised; the geese, one walking quietly, the other excited and screaming, have character; the grazing deer and stag are moderate; the antithetic group of deer (?), in its build and curves, has a strong Southern smack. Nothing here has a particularly Celtic look, indeed one might almost say that the horses on the Hallstatt sword, no. 96, despite their general Venetian appearance, bear a clearer Celtic mark in the little patterns on the buttocks.[1] The ornamental treatment of the haunches and shoulders has analogies in various Orientalizing arts. The hatched bands across the body and neck also occur in the South and the East.[2] The zigzags on the body of one of the antithetic animals are a motive which appears in some backward arts of Italy. I illustrate, *pl. 222, a, b* two boars engraved on helmets. They share with the Matzhausen animals the cross-bands, the zigzags, here set along the mane, and the stylization of the legs; the drawing of the feet is also not unlike. The helmets belong to a class of which ten are published by Lipperheide. They are the following: (*a*) Lipperheide 66 and 501, (*b*) 67 and 506, (*c*) 69 and 508, (*d*) 71 and 505 (*pl. 222, a*), (*e*) 72 and 502/3 (*pl. 222, b*), (*f*) 504, (*g*) 74 and 507, (*h*) 75 and 510, (*i*) 509, (*k*) 78 and 511/12.

Of these (*b*), (*f*), and (*i*) have no provenience, (*a*) is said to have been found in Sicily, (*c*) on the Save in Carniola, (*e*) in Lucania, (*g*) at Syracuse, (*h*) at Vulci, and (*k*) at Canosa. The provenience of (*d*) 'Athens?' is doubtful, but not impossible.[3] The distribution is not at variance with a supposed Etruscan origin. The date, as for instance the lions indicate, is about early fifth century B.C.; (*k*) only, which bears a certain resemblance to Etruscan engraved cistae and beakers,[4] is a work of the fourth. They are of different style and quality: nos. (*g*), (*h*), and (*i*) look more 'Greek', but even these betray Etruscan make by some little features of the ornament.[5] (*c*) is a transitional piece between these and the next group, to which (*b*) already belongs, though still slightly better than the average which is represented by (*a*), (*d*), (*e*), and (*f*): the 'rhinoceros master' practises a bizarre style otherwise unknown to me. That he was Etruscan is most clearly proved by the sphinxes (*pl. 222, b*): the male sphinx wears a cap-shaped helmet, and both have an additional raised human arm.[6] For the Assyrianizing (Phoenicizing?) ornament on (*e*) and (*a*) I know no Etruscan analogy.

A second Italic example of beasts with zigzags on the trunk is the disk RM 34, 1920, 2,[7] and a third a fourth-century South Italic girdle-hook in Hamburg[8] (AA 32 1917, 78 fig. 17). But whatever the explanation may be, the animals on the clay flask stand closer to the helmets.

There are possibly two other links with Italic metalwork—the girdle-plaque from Magdalenska Gora, Treasures pl. 8 no. 19, a bad local copy of a better piece, where the animal cut off by the left frame has a certain likeness in curve and movement to the antithetic beasts in the flagon, and with the mirror from Castelvetro (Annali 14 1842 pl. H, p. 74; Ducati

[1] pp. 1, 2, 45.

[2] Luristan: Pope pl. 37, B. Greece: Engraved Boeotian fibulae, Hampe, passim, about 700 B.C. Etruria: incised impasto urn from Poggio Sommavilla (Sabini), Not. Sc. 1896, 481. Incised bucchero in Boston, Fairbanks pl. 94, no. 684. Painted Etrusco-Corinthian amphora, Louvre C 566, Morin-Jean 148 (panther with row of chevrons along the trunk). Eastern Europe: silver from Craiova in Berlin, PZ 18 1927 pl. 4, nos. 7, 8; ib. 19 1928, 177. Silver plaque from Panagurishte,

see p. 36. Silver beaker from the Danube, *pls. 226, 227*. For neck-collars see pp. 26, 41, and *pl. 239, c*.

[3] p. 116 n. 10.

[4] Dealt with by Baumgärtel, JRAI 67 1937, 258.

[5] For the heart-leaf on no. (*g*) see JL 46; for the little appendices to the lotus-flower on (*h*) Jacobsthal, Ornamente 185.

[6] Rumpf, Die Wandmalereien in Veji 47; RE s.v. Sphinx, p. 1736, 6; 1745, 16 (Herbig); Kukahn, Der griechische Helm 52. [7] p. 82. [8] p. 147.

pl. 153, fig. 397; Bertrand and Reinach, Les Celtes dans la vallée du Po et du Danube fig. 55) which also places the figures on a wavy ground-line.

The obvious conclusion to be drawn from these observations is that the potter—or the metalworker who did the job for him?—had before him and closely copied an Italic bronze vessel with friezes. The resemblance to those unlocalized Etruscan helmets is stronger than to Venetian works. Apparently there were many local Etruscanizing schools, interconnected, in North Italy.[1]

The Glauberg torc, no. 246. This piece was found on a hill-fort in Oberhessen, about 20 km. north-west of Frankfort on Main, which was probably a Celtic oppidum, but the torc is not stratified.[2] Only the front piece of the torc is preserved. It is one of the very few Celtic rings with figure decoration.[3] The figures are modelled with equal care on the right, the left, and the bottom side. The upper surface is somewhat flattish. There are three human heads, two set on the outer perimeter of the torc and not forming part of the story, the third standing lower—sticking in the acute angle of the open jaws of the lions. These are galloping towards the middle; their hindquarters pass softly into the hoop, their hindlegs, energetically thrown back, stand in flat relief on its right and left side; tails are not indicated. The lions appear upright if the torc is poised with the human heads hanging downwards and vice versa: this hampers a quick and unambiguous interpretation of the picture.

Celtic is the Janus shape of the heads, to a certain extent also the outline of the faces.[4] One can also point to the French torc, *pl. 218, f*[5] with groups of three heads, and to the gold bracelet from Rodenbach, no. 59, showing Januses flanked by wild animals. Un-Celtic are the poloi and the style of the lions.

Study of details will reveal the source of these forms. In *pl. 222, c, e* I illustrate two Persian gold rings, bought at Aleppo, in the Louvre (Dalton text, fig. 2), and from the Isthmus of Corinth in Karlsruhe.[6] The second piece gives the impression of fifth-century work, the first of fourth-century work with good analogies among the finds from the Oxus. The Aleppo lions have the same layer-mane as the Glauberg ones, of a slate-like structure. The manes on the other ring have a plainer pattern. Another example of the first type of mane is shown by the Scytho-Thracian bronze from Brezovo,[7] *pl. 222, d* (Schefold 56: 'not earlier than third quarter of fifth century B.C.'; Luschey 90, note 525). Another feature of the Aleppo lions well compares with the Glauberg lions: the stretched hind legs standing in

[1] Kersten (PZ 24 1933, 155) following Reinecke comes near the truth: I should only like to replace 'Este' by 'unknown school of North Italy' and rule out Eastern influence. I need not repeat here my criticism (JRS 28 1938, 68) of Pittioni's thesis (WPZ 21 1934, 102) that the Bavarian potter studied and copied Corinthian pots. The idea of Corinthian vases in the North is long-lived and very difficult to eradicate. I had thought to have definitely eliminated from the map of genuine imports the 'find' from Ostenfeld near Straubing (Bavaria) (Germania 18 1934, 15): the Corinthian skyphos has been raised from the dead by Professor Altheim (RM 54 1939, 10, footnote): even Payne's authority is no argument: to take this pot for a genuine import is to swallow the rest of the find, Attic fifth-century ware, &c., and to explain how those people at this god-forsaken place came to be engaged in long-distance trade for about a hundred years, a fact without parallel in the North.

[2] H. Richter, Der Glauberg, in Volk und Scholle (Darmstadt 1934).

[3] p. 122.

[4] p. 13. [5] p. 16.

[6] AA 5 1890, 6; Schumacher, Bronzen in Karlsruhe no. 1074, pl. 2, 7; Dalton fig. 3; Archiv für Orientforschung 9 pl. 5 fig. 10 (Pudelka); Pope pl. 122, J. Found in 1887 when the canal was dug, one of the few Persian objects from Greece: on gems from Greece: Furtwängler 3, 117; Beazley adds a gem with an archer in Oxford from Anogaia (Laconia). Maximum diameter of the ring 10·6 cm., minimum 7·9; of hoop, square in section, 0·9 cm. Gold less pale than that of Celtic jewels. Slightly out of shape, strong traces of wear. The hoop, from the lions' collars, open on top all round: there was probably inlay of base metal, hidden by a gold cover which is gone.

[7] RM 32 1917, 27; Ebert 2 pl. 70, b; Rostovtzeff SB 539.

relief on the flanks of the hoop. Other Persian examples are the gold torc from the Oxus, Dalton no. 116, pl. 1; Pope pl. 113, A; Filow, Die Grabhügelnekropole bei Duvanlij fig. 217; the amphora from Duvanlij, *pl. 227, c*. With them goes the Persian silver handle from Nimrud, *pl. 227, b*: I shall come back to them on p. 37.

The story itself, a wild beast devouring a man, has two Celtic analogies. One is late, the double dragon[1] on the silver cauldron from Gundestrup (JdI 30 1915, plate facing p. 1, top, second plaque from left). The other is the jug in Salzburg, no. 382: here the handle-animal presses its jaws on the head of a man, and the two little animals on the lip of the flagon have the tail of a devoured beast sticking in their mouths.

Italy[2] is full of voracious beasts, walking about with legs or arms of men dangling from their mouths. The monuments have been carefully studied by Nachod, Der Rennwagen der Italiker 16, Rumpf, Die Wandmalereien in Veji 44, Hanfmann 27, and I therefore limit myself to illustrating a piece of special importance. *Pl. 223* is the handle of a bronze oinochoe from Perugia, once in Dodwell's possession, now in Munich. Its total height is 20 cm. Missing is a small part of the left leg of the lion with the adjoining piece of the lip of the vessel. Of the vase itself only a tiny fragment is preserved, still adhering to the attachment and held by two rivets. The whole is cast solid in one piece. The engraved detail is well seen in the photographs. It is a very good Etruscan work of the sixth century B.C. The engraved palmette resembles those of 'Rhodian' oinochoai, JdI 44 1929, 198 ff. The lion has its model among a class of un-Greek bronze animals made in a still undefined province of Asia Minor where currents from Syria, Persia, and elsewhere met.[3] The human head points in the same direction. For reasons which will become apparent, I take it for granted that the handle-animal of the Salzburg jug does not copy an Etruscan bronze of this type, but that both depend on the same Eastern model.

Greek examples of voracious animals are far less numerous than Italic. They are: (1) Attic stamped gold bands of about 800 B.C., Copenhagen, AZ 42 1884 pl. 9, 2; Athens, AM 18 1893, 126, and a fragment from Eleusis, Eph. Arch. 1885 pl. 9; BMC Jewellery no. 1219, pl. 13 and text fig. 22: the last word on them is Kunze 205. (2) Attic geometric kantharos, Copenhagen, roughly contemporary with (1), AZ 43 1885 pl. 8, CVA Copenhague 2 pl. 74, 5: head and trunk of the man have already disappeared. (3) Boeotian geometric amphora, Louvre, RA 34 1899, 5 fig. 2, pl. 3: a man in the lion's mouth. (4) Boeotian fibulae of early seventh century B.C., Hampe pls. 8, 10, 11: lions devouring men or deer. Nos. (5)–(7) show snakes, devouring a man or, no. (7), an ibex. (5) Early Corinthian alabastron, *pl. 224, a*, Bonn, AA 51 1936, 351/2. (6) Attic lekythos, Berlin 3764 *pl. 224, b*, Neugebauer, Führer Vasen p. 16; Payne, NC pl. 53, 7; Haspels, Attic black-figured Lekythoi p. 1 (Payne and Haspels quote an incorrect number). About 600 B.C. (7) Embossed bronze plaque from Olympia, JdI 52 1937, Bericht über die Ausgrabungen in Olympia pl. 29, p. 90. Late seventh century B.C. (8) Early Corinthian alabastron, Louvre, Payne, NC no. 461, CVA Louvre 9, III C a, pl. 33, 1 (France 599): a hunter whose skull is already in the lion's jaws. (9) Kotyle Munich 221 of middle-Corinthian 'sub-geometric' dot-style, man-eating snake.

The source of motive—and story?—in Greek and Italic art is the East. I begin with

[1] p. 44.

[2] The Iberian fibula Déchelette fig. 353, 1, a horse with a man's head in its mouth, copies Italian models.

[3] Kunze, AM 60/1 1935/6, 228, note 1; Luschey, Berliner Museen 59 1938, 77; the closest analogy is a bronze lion in Paris, Petit Palais, unpublished, photograph Archaeologisches Seminar Marburg nos. 1017/18.

[4] J. M. Cook, BSA 35, 206.

literary evidence, first a Pahlavi text of the ninth century A.D., but based on old tradition: West, Pahlevi, i, ii (Max Mueller, The Sacred Books of the East 18, 375); H. S. Nyberg in Oriental Studies in honour of Pavry (Oxford 1933), p. 336 ff.: 'When I looked among the teeth of Gandarep, dead men were hanging in his teeth.' The Persian version has the variant 'horses and asses' for 'dead men'. Mr. R. C. Zaehner comments on the passage as follows:

'The text in question is from the Pahlavi Rivayat, which cannot be earlier than the ninth century A.D., since it draws from the great Pahlavi works still extant; these were themselves written for the most part in the ninth century. However, it is not disputed that these are based on lost Sassanian material. The Persian "horses and asses" I know in Hormazyar, Persian Rivayats i, p. 62 (text), Bombay 1922; Fr. Spiegel, Traditionelle Literatur der Parsen, p. 339, no. 1.

'Of this prose version I can say nothing except that it is in the main very close to our Pahlavi passage and based on it. The Pahlavi reads "*martōm i murtak*—dead men" with no variant. The Persian verse version, which must be late, runs as follows. "I slew that hideous demon whose name was Gandarab; he was a tyrannous disaster and a marvel. His head reached the shining sun and people called him 'golden-heeled' ('sea-heeled'—*zareh-pāšan*), for the sea (*daryā zareh*) reached his heels; his place was in the sea, the mountains, and the valleys. When he entered the water in the Chinese sea, the water ⟨reached⟩ the knees of the accursed demon. When he caught a fish from the sea and water, he would roast it at the sun. When he moved towards the Ocean, he raised the fish out of the water, the fish were roasted at the sun: the whole world wailed for fear of him. He would eat twice six men at once and easily bring them down into his stomach. Of every sort of men and four-footed beasts he destroyed all creatures from the world. His body was like the river Nile and lions and elephants were like gnats to him. His head touched the sky: there is no monster like him on earth. For nine days and nine nights I did bitter battle with that ill-omened demon. For nine days and nine nights I did battle in that field with that good-for-nothing. I captured him from the deep sea and I bound his two hands with the loop of my lasso, I made his head soft with my heavy mace and carried him from the sea to the dry land. His body was like Mount Elburz: he was terrified at the blows of my heavy mace. When I struck my spear into his teeth, I saw asses and horses chewed up in them. Asses and horses, hanging from his mouth, I saw in the teeth of that dark-souled villain. I cut off his head with my sharp sword, his body was sliced up by my sword. When from on high he fell to the earth, many men perished beneath him. Had I not slain that demon, he would have destroyed the whole world, all men and beasts would have been annihilated by him in the world from end to end."

'This is, however, not so discouraging as it looks. The legend of Kursasp and Gandarβ is exceedingly ancient: it is well known to the Avesta (v. Darmesteter's translation, SBE xxiii pp. 63 and 295, and Index under Kərəsāspa and Gandarəwa). Gandarəwa goes back to the Indo-Iranian period since he is known to the Rig-Veda as Gandharva (Keith, Religion and Philosophy of the Veda, Harvard 1925, i, p. 179), and is extensively developed in subsequent Vedic and Sanskrit literature.

'I can think of a possible explanation for the discrepancy between the "dead men" of the Pahlavi and the "horses" of the Persian. The asses are probably a later addition. Now in the Avesta the two most important exploits of *Kerəsāspa* (Kursasp) are the slaying of Gandarəwa and of the dragon Srvara [Yasna 9. 11. Yašt 19. 40] (SBE xxxi p. 234 and xxiii p. 295). Srvara is an epithet rightly translated by Bartholomae as "gehörnt". The dragon is described as "horse-devouring, man-devouring". It seems that Gandarəwa and the dragon were at some period identified, for in Yašt 19. 40 five manuscripts read *Gandarəwəm* for *nərəgarəm* (man-devouring) of Geldner's text. Thus we know that this Gandarəwa was known to Iran as early as 1200 B.C.—the separation of Iranians and Indians cannot well be put much later—and that in the Avesta this or a kindred creature devoured horses and men. The Yašts of the Avesta are usually dated 500–400 B.C., but they probably represent a very long period of oral transmission. Benveniste is of the opinion that the "theogonies" chanted by the Magians in Herodotus were the Yašts.'

And read Amos 3, 12: 'Thus saith the Lord: As the shepherd taketh out of the mouth of

the lion two legs, or a piece of an ear; so shall the child n of Israel be rescued that sit in Samaria in the corner of a couch,' (About 740 B.C.)

As in many analogous cases the Eastern monuments are scantier than their Western reflections and even later. I give a list: (1) Assyrian bronze candelabrum in Erlangen, L. Curtius, MJ 1913, 1 ff. Seventh century B.C. The bull-feet supporting it stick in the mouth of ducks: birds do not feed on bulls, the ducks may have taken the place of lions' heads. (2) Carved wooden group on the lid of a brewer's copper from Gordion, A. and G. Koerte, Gordion pl. 5; Ebert 14 pl. 61 BB, e; Rumpf, Wandmalereien in Veji 45. Here *pl. 225, a*. Phrygian local work of sixth century B.C. (3) Persian ring, *pl. 222, e*; see above, p. 32. The lions devour ibexes.

There is a much greater wealth of Oriental material if one does not confine one's interest to monuments showing the final stage of the sad story. In the Entemena silver vase[1] or on Babylonian cylinders, for instance, one sees the lion about to devour ibex or stag, its muzzle already in or near his jaws: the fuller version of the short form in the Persian gold ring; lion or dragon snapping at a man's head: Ward, p. 169. The story is also told again and again in Luristan bronzes:[2] the monsters and victims here are of various kinds and the form of the tale is strongly influenced by the shape of the decorated objects.

These Luristan groups—or their Syrian prototypes still to be determined—were the model[3] of the Rhodian fibula, *pl. 225, d*, which will take us back to the Glauberg torc. Berlin M. Inv. 8171, Blinkenberg fig. 114; 7.8 cm. long. Cast in one; the plaque hammered flat; on it, engraved false spirals.[4] The human head is flat on the back; it has full lips, a fleshy, slightly hooked nose, and large ears. The eyes, like those of the lion, are hollow. The patina here differs from that covering the rest of the brooch, there was probably inlay here. Above the forehead—clearer in the drawing—a sort of low polos, recalling those of the Glauberg heads. The lion has the mouth open, the tongue out; the paws are joined, forming a bow. The motive of an animal head cabossed, with the paws on either side, comes from the same Eastern source as the other elements of the brooch. There is the Luristan dagger, Godard pl. 9. From Asia the motive migrates to Greece: our brooch and a handle of an archaic oinochoe, Olympia, Bronzen 923, pl. 55; to Italy: Etruscan bronze flagon, JL pl. 30, a, and to Russia: gold ornament from Chmyrev kurgan, Minns fig. 61. Ural: Borovka pl. 65 and Rostovtzeff, Skythika pl. 9, no. 47; Aspelin, Antiquités du Nord Finno-Ougrien nos. 569, 574; AA 46 1931, 399, 400; IPEK 1932/3 pl. 20; see also H. Schmidt, Festschrift für Bezzenberger pl. 8, 5; Strzygowski, Der Norden in der bildenden Kunst Europas 49, pl. 6, 1.

The fibula figured here was purchased at Smyrna, but must have been found in Rhodes: for the *stipe votiva* from Ialysos contains a set of them, one an exact pendant of the Berlin piece, the others arranging the same elements, human and lion's heads, one birds around the bow. I had the impression[5] that the human head on one looked more 'Daedalic' and less 'Syrian' than that of the brooch figured.

The migration of monsters, devouring men or tame animals, is not confined to Greece

[1] L. Curtius, Die antike Kunst 1, 220, 229.

[2] Beside Godard see Moortgat, Bronzegerät aus Luristan (Staatliche Museen zu Berlin, Vorderasiatische Abteilung, 1931); Rostovtzeff, IPEK 1931, Dussaud, Syria 1934, 187 and Pope, p. 254 ff.

[3] For Luristan imports in Greece see Payne, Perachora 1, 139; Möbius, Marburger Studien 162. On Syrian figure-decorated fibulae see p. 127.

[4] Blinkenberg's drawing is incorrect here as in other details.

[5] This highly important find is still unpublished. I had no opportunity of studying the objects with due care.

and Italy: they also invade Eastern Europe—not, as it seems, Scythia proper, but there are two examples in the sub-Scythian civilization of the Balkans. The first of these is on the gold helmet from Prahova (Rumania), Acta Archaeologica 1, 255, figs. 18, 19:[1] the helmet itself is still unpublished and I have to rely on drawings, repeated in *pl. 225, e*. On one of the cheek-pieces, a κριοβόλιον, a translation of a Greek rendering of this scene (such as the fifth-century Thespian marble relief in Chalkis, JdI 28 1913 pl. 27, or the electrum stater of Cyzicus, von Fritze, Nomisma 7 1912 pl. 5, 4) into a barbaric Thracian style, similar to that of Herakles and Cerberus and the Siren on the silver plaque from Panagurishte[2] (RM 32 1917, 40 fig. 25; Rostovtzeff SB 540, and Social and Economic History of the Hellenistic World 1 pl. 15). The other cheek-piece shows a winged beast of prey with the hind leg of an ox in its mouth. For the huge circular eye see the silver ornament from Bulgaria in the British Museum, *pl. 230, f*, and the silver beaker[3] *pls. 226–7*, found in the Danube downstream from the Iron Gates; for the outline of the muzzle the bronze ornament from Brezovo *pl. 222, d*, and for the drawing of the claws the silver relief from Craiova in Berlin,[4] PZ 18 1927 pl. 4, nos. 7, 8; ib. 19 1928, 177, and the silver beaker: the fantastic winged beast on the bottom of the beaker, *pl. 227, a*, has again a hind leg with the haunch in its jaws.

The migration reached China: bronze in the Stoclet collection,[5] *pl. 233, c*. I should also like to add a bronze of Chou date:[6] its upper part, a group of a standing monster, biting into the head of a kneeling man, who holds a cock, is of interest to us because of its resemblance to the handle-animal of the Salzburg flagon and its prototypes in the Near East.

Chino-Siberian are a bronze buckle, PZ 22 1931 pl. 2, no. 6, the bronze[7] *pl. 225, b*, a lion with a ram's head, and the jet carving, *pl. 225, c*, in the BM, British and Mediaeval Department, with a label 'Odessa'. 3·6 cm. long. Below the trunk, a circular hole of 0·4 cm. athwart: the group was probably an amulet and worn on a string. The old label from the hand of Forsdyke 'hippopotamus cuddling a baby' is too good a description to fall into oblivion: the hippopotamus is a clumsy lion, and the baby is an eagle with rams' horns.[8]

The second invasion of Europe by the voracious beasts in the Middle Ages is not my concern here.

To return to the start, the Glauberg torc and the Salzburg flagon: the man-eating beasts are definitely of Eastern origin. Did the Celts just look at those oriental creatures and take them over as funny 'motives', or was there a transmission of stories and myths with them? This is a question which we cannot answer. The torc was linked with Persia by the treatment of the hind legs,[9] and the poloi had their counterpart in the East-inspired Rhodian fibula. The style of the torc has no analogy in Celtic art: it is coarse

[1] See also Griesmaier, Wiener Beiträge zur Kunst und Kultur Asiens 9 1934, fig. 6, to p. 52; Nestor, 22. Bericht RGK 1933, 151; Rostovtzeff SB 488, note: his statement that form and technique of the helmet are Ionic is absolutely unfounded.

[2] I cannot see here any relationship to Celtic style, as Rostovtzeff does.

[3] In the Brummer Gallery, New York. I have not seen the original. I owe the photographs to the courtesy of Professor Zahn. Height about 18 cm., diameter about 15·5 cm. Griesmaier in Wiener Beiträge zur Kunst und Kultur Asiens 9 1934, 49 ff.; The Dark Ages, Loan Exhibition of Pagan and Christian Art, Worcester Art Museum 1937 no. 66; Rostovtzeff SB 534; Nestor, 22. Bericht RGK 1933, 150. The inscription incised in

Greek characters on the bottom, Griesmaier l.c., fig. 9, probably Thracian, is not interpreted. On the ornament see p. 58.

[4] p. 31 n. 2.

[5] p. 49.

[6] Bronze pole-top (?), Salmony, Loo pl. 2, no. 3, p. 10; Hentze, Frühchinesische Bronzen und Kultdarstellungen pl. 5 and fig. 56—both with fantastic interpretation. A pendant is in the collection of Mrs. Sedgwick.

[7] The Siberian bronze *pl. 225, b*, about 10 cm. long, is no. 373 in Sotheby, Catalogue of Early Chinese Bronzes, &c. April 1941, no. 373; the photograph was kindly provided by Mr. A. B. J. Kiddell. Many examples in Minusinsk, one said to be of copper, is published in Otchët Imp. Arkheol. Kommissii 1898, 69 fig. 117. [8] p. 43. [9] pp. 32–3.

work, but it is not difficult to translate into gold of the quality of the bracelet from Roden-bach, no. 59. It is possibly the work of an artisan from the East, employed by the Celts.[1]

I follow another line and begin with the animals of the Lorraine flagons, no. 381. All three of them are of the same breed, wolf-like. Those crouching on the lip are complete or relatively complete: hind legs are not shown; behind the haunches comes a thick tail with vertical hatches and at its tip a large matrix once coral-filled. They have the mouth closed, the upper lip projects, they have no fangs. The handle-animal is an animal from the head down to the shoulder, then it becomes a curved rod of circular cross-section with an orna-ment at the zenith of the curve and ends below in a mask.[2] But though abstract in shape, the rod, like the legs and the neck, is flecked all over with engraved strokes, denoting the animal's pelt. The legs end upwards in spirals, a motive on which I shall have to comment presently. The claws, set off by a plastic ring, have the form of a fan or palmette. The huge heads are square in section and framed by strong, jutting stippled contours, denoting jaw-bones, muzzle, eyebrows, and ears. The contours are drawn in two lines, the one running from the tip of the under lip to the spot where the jaw-bones touch the ear, the other from the upper lip to the innermost point of the ear-scroll. Within them stand the vertical planes of the cheeks, those of the handle-animal vertically hatched, those of the others stippled. The eyes are now hollow, but were once filled with large coral studs. The bird's eye view shows that nose and forehead together have an outline like a shoe-last, outside followed by a groove, which once held a red enamel band. The 'last' is the base of the rising mane.

The Oriental character of these animals is manifest, and easy to prove by study of details. When dealing with the Glauberg torc, I had already pointed out that it is Persian to keep the form of the ring and to set the hind legs of the animals against it in more or less flat relief: I had exemplified this on Persian gold rings (*pl. 222*).[3] The same principle was applied by the Persians to handles of vessels. I illustrate two of them. (1) Silver amphora, once gilded, from Duvanlij (Bulgaria), in Sofia and Plovdiv.[4] *Pl. 227, c*, shows the two handles; one has a horizontal spout: this amphora combines the qualities of a container and a pouring vessel. Very similar vessels are represented in the reliefs of the palace of Xerxes at Perse-polis, Pope pls. 92, B; 93, A; Filow, Die Grabhügelnekropole bei Duvanlij, figs. 213–15. This and the finds in the grave, pottery and bronzes, give the Duvanlij amphora a date in the second quarter of the fifth century B.C.[5] (2) Handle of a silver amphora from Nimrud in the BM,[6] *pl. 227, b*, in the shape of a winged bull. The hatched 'beard' along the jaw-bones appears in identical form in Achaemenid silver rhyta,[7] the drawing of the wings has its closest analogy at Persepolis in the door-relief with Darius killing the winged horned lion, Dieulafoy, L'art antique de la Perse pl. 17, Sarre pl. 16, Pope pl. 95. The Nimrud bull

[1] p. 156.

[2] p. 21.

[3] The Greek gold bracelet from the Great Bliznitsa with running lionesses, Minns fig. 317, the Greek silver armlet with running rams from the Tamán peninsula, Rostovtzeff IG pl. 15, 2, and the Siberian gold bracelet, Borovka pl. 57, A give the 'naturalized' version of the Persian 'tectonic' type. The bronze ring Pope pl. 57, C, of peculiar style, need not be earlier than these.

[4] Bull. Bulgare 3 1925 pl. 2; ib. 4 1926/7 pl. 3 with drawings in the text; Filow, Trebenischte fig. 118; Filow, Die Grab-hügelnekropole bei Duvanlij 46 ff., 200; Rostovtzeff SB 536;

Brehm in Strzygowski, Der Norden und die bildende Kunst Europas pl. 14; Die Antike 10 1934 pl. 7; Pope pl. 117, A; Luschey, index, and AA 53 1938, 764.

[5] Schefold, Gnomon 1936, 574; Luschey 90.

[6] I owe the photograph to the courtesy of the Keeper

[7] p. 39. Also in the Persian akinakes from Chertomlyk, Ginters pl. 10, a. By the way, the bronze ibex in Berlin, Blümel, Tierplastik fig. 22 (KiB 28, 4), is not Egyptian and not '600 B.C.', but Persian and fifth century B.C.: he has the same hatched beard, and the modelling of the muzzle is also very Persian. Compare the Persian bronze weight in Berlin, Blümel, Tierplastik (first edition, 1933) pl. 15.

was probably the spoutless handle of an amphora like no. (1): the handle-animals of the tribute-vases on the Xerxes frieze seem also to be winged bulls.

It is apparent that the handles of the Lorraine jugs copy Persian models, but the abstract rod has gained ground at the cost of the animal.

The spiral ears, too, have a traceable Oriental ancestry. I do not understand why all the examples of which I know come from Siberia and China[1] and none from Scythia: I illustrate, *pl. 228, a,* one of the two identical sides of a Chinese bronze sword-hilt in the Louvre:[2] it is a work roughly contemporary with Early Celtic art. The gorgoneion is of Western origin;[3] its likeness to Celtic animals or masks is not confined to the spiral ears: the scrolling eyebrows,[4] the hatched forehead[5] in both are other features which prove connexion and contact of the two distant civilizations.

The mane of the Lorraine animals has the shape of a highly stylized palmette (*P 406*). Those of the crouching beasts are poorer and less clear than that of the handle-animal. In order to see the real and intended form of the palmette, one has to look at the grooves, once standing out in red enamel. Then one realizes a 'palmette tree': a broadening, triangular base (between the ears of the beast), a top leaf, and three pairs of side leaves with a sickle-like upward swing. This rhythm first appears in Greek ornament of the last three decades of the fifth century B.C., but it was then confined to high-class ornamentation of buildings and stelae, and was not in general use before the fourth century B.C.[6] If this interpretation of the pattern should be true, it would provide us with an absolute date for the jugs, and possibly for other works connected with them.[7]

Now is the moment for mentioning an object which gives the best analogy for such a mane in the shape of a palmette tree: the gold bracelet from Vogelgesang,[8] Silesia, *pl. 228, c.* The heads at its ends are doubtless meant to be lions, but the deep furrow between eyes and mouth makes them look more like κήτη. In the gaping mouth the teeth appear, two sets of three to four, touching each other. The under lip is left plain, the decoration being confined to the outer side of the ring. The upper lip bears an ornament of two elaborate spiral ribbons, running symmetrically from the middle to the right and the left. Above the furrow are the eyes, bulging and with strongly convex brows. Between them rises the palmette mane. The trunk of the tree is formed by four calices, one stuck into the other, the uppermost taller than the rest; each of the calices has a double top contour, or, as one might also say, consists again of two, the upper sticking in the lower. This reminds one of the motives studied on p. 88 and also recalls the treatment of the middle part of the lyre ornament on the

[1] Ananyino culture: Borovka pl. 64, A. Altai: Borovka pls. 60, 62; Rostovtzeff, Skythika pl. 9 (wood). Wooden psalion from Pazyryk, AJA 37 1933, 37, pl. 3; IPEK 11 1936/7, 100; see here p. 54. Minusinsk: Borovka pl. 44, A; Merhart, Bronzezeit am Jenissei pls. 10, 11; pp. 162, 164. Sino-Siberian bronzes: Salmony, Loo, passim; Rostovtzeff, Skythika pl. 7. There are already examples in Chinese archaic bronzes of Yetts's First Phase, also in archaic jades, as Salmony, Jade pl. 27, 2, but their date, and often their authenticity, are controversial.

[2] Aréthuse 1 1923 pl. 17, 3, p. 92; 25 Jahre Römisch-Germanische Kommission pl. 14, fig. 46.

[3] It migrated either via Siberia or—less likely—the southern way: see the gorgoneia figured by von Le Coq, Bilderatlas zur Kunst und Kulturgeschichte Mittelasiens pls. 94, 95. [4] p. 13. [5] p. 14.

[6] Jacobsthal, Ornamente 177; Möbius 17.

[7] pp. 89–143.

[8] Schlesiens Vorzeit 7 1898, 335 (Reinecke); ib. Neue Folge 9 1928, 12 (Jahn and Jacobsthal); Déchelette 2, 759; 3, 1597, no. 11; Ebert 14, 159, 160, 176; Rostovtzeff SB 488, note; Márton pl. 30, 3. The ring was found in 1819 at Vogelgesang, Kreis Nimptsch (Silesia), on a field which also yielded several ingots of gold, so it probably formed part of a hoard. It was stolen in 1841, but electrotypes had been made, and my description and photographs were made from one of these. External diameter 7·7 cm., internal 6·3 cm. Maximum thickness of ring 1·5 cm., minimum 1·25 cm. The ring is said to have been of solid pale gold. Its shape is circular; along the upper side, except the decorated part, runs a sharp ridge. The lions' mouths end with a straight cut; between them is a narrow gap; here the ring is slightly out of plumb.

silver gorytus from Solokha, AA 29 1914, 279/80 fig. 102; Ginters pl. 8. On top grows a palmette with eleven leaves round an ogive-shaped kernel; in front of the latter two small leaves stand. So much for the trunk. At each side five sickles swing sideways, four upwards, the lowest drooping and following the curve of the lion's eyebrows. Their intervals are filled with shorter leaves which are like those standing in front of the nucleus of the top palmette, and are tied together by motives resembling the calices.

The ring has wrongly been taken for Celto-Scythian, Celto-Greek (Rostovtzeff), or Scythian (Reinecke, Jahn, and Jacobsthal). It has nothing whatever to do with the Celts, and I myself was just as wrong.[1] What is Greek here has passed through a medium which is difficult to define. The spiral bands on the upper lip have a certain analogy in the Luristan hatchet, Godard pl. 23, no. 68, where they are still recognizable as a form of the 'palmette muzzle' which characterizes Hittite-Syrian lions and their descendants.[2] The gold lion-ring from the Rhine, no. 61, shows similar spirals used for stylization of the upper part of the lion's face, certainly also a symptom of influence from Oriental quarters. The palmette mane has doubtless a Greek component: Greek is the top palmette, and the lateral sickle-leaves reflect Greek ornament of the fourth century B.C.;[3] but no Greek palmette of this type has straight leaves in the intervals between the sickles. It is obvious that these Greek features are but the façade of something un-Greek. In *pl. 228, b*, I show the decoration of the dagger of Tut-ench-Amun,[4] built of the same ingredients as the ornament of the gold ring: in the middle the trunk, consisting of calices, crowned by a sort of palmette, and at the sides sickle-leaves with fillings in the intervals. This must be more than mere coincidence. But which was the way that led from Egypt of the eighteenth dynasty to the still undefined region where the gold ring was made? These trees in blossom are an Egyptian creation, which had a great influence on the Sacred Trees in different provinces of Asia.[5] The style of the bracelet is without analogy, as far as I know, and one can only localize and date it by indirect arguments: where are we likely to find this combination of, first, lions which have an analogy in a Luristan bronze, second, a Sacred Tree, which probably copies a Hittite or Syrian model, and third, a slight Greek façade? I believe, in a fourth-century Persian workshop still unknown to us, certainly not one of those in which the Achaemenid jewels were made.[6]

I study other stylized manes. That of the Duvanlij lions (*pl. 229, b*) is a chain of pairs of hatched leaves with little spirals at the points, one leaf sticking in the other,[7] and below a feather-tail in layers. The former motive recalls Persian leaf-chains of more floral character, such as the glazed tiles from Susa, Perrot and Chipiez, Persia fig. 66, Dalton 14 fig. 48, or in gold, Dalton pl. 11, 25.[8] Hair in this stylization appears in similar form on back and breast of Persian ibexes or goats of the fifth and fourth centuries B.C.: (1) silver rhyton from the fourth kurgan of the Seven Brothers' mound, CR 1877 pl. 1, 5; Smirnov, L'argenterie orientale pl. 4, 15; Sarre pl. 48; Pope pl. 113, B; AA 53 1938, 765, fig. 2. (2) Silver rhyton from Kazbek, Smirnov, l.c. pl. 3, no. 13. (3) Silver amphora from Armenia or the south

[1] Two shapeless fragments which had escaped the melting-pot and had been kept for years in the Berlin Museum were sold, as Professor Unverzagt was kind enough to tell me, in 1922. I have therefore been unable to check the result of stylistic examination by chemical analysis; see p. 130.

[2] Payne, NC 67, 171.

[3] pp. 38, 89.

[4] Carter, Tut-ench-Amun 2 pl. 88; Watzinger, Die griechische Grabstele und der Orient 14.

[5] Watzinger l.c.; see also the gold ear-ring from Enkomi, BMC Jewellery no. 525, p. 28 fig. 5.

[6] I should like to refer once more to Luschey, who has treated these problems with great thoroughness and success.

[7] p. 88. [8] See also P 381.

coast of the Black Sea, in Berlin and Paris.[1] The patterns here (*pl. 229, a*) are livelier in drawing. The amphora is a work of the fourth century B.C.: a fragment presumably belonging to it in Berlin, AA 7 1892, 113,[2] shows tendrils in pure Greek style of the third quarter of the century.[3] A fourth-century date is indirectly proved by the style of the palmette engraved on the handle-plaque of the pendant from the Oxus, Dalton pl. 5, 10, text fig. 42.

Of Celtic manes, that of the Salzburg animal, no. 382, follows Persian models most closely. It runs from the eyebrows down to the root of the tail, and is formed by a chain of leaf-pairs, dryly stylized, every second pair hatched, thus recalling the gold ornament from Klein Aspergle, no. 23, also the palmette under the attachment-head of the beak-flagon from the same site, no. 385,[4] and the wings of the Weisskirchen griffins, no. 350. Do archaic Greek manes, like that of the lion on the Amandola dinos,[5] *pl. 229, c*, reflect the same Eastern prototypes? An eastward migration of the manes seems also to have taken place: the Tao-t'ieh, *pl. 229, e*,[6] though of Han date, is hardly unconnected with Western art: the scrolling eyebrows also have striking Celtic analogies,[7] and the hatching of the eye-sockets reminds one of the girdle-hook from Langenlonsheim, no. 353.[8] The motive is still alive in the Gundestrup cauldron: see the lion in the Cernunnus plaque, JdI 30 1915 plate facing p. 1.

To finish this digression: it should not be forgotten that all these mane patterns are but the stylization of a natural model, and I show in *pl. 229, d*, a picture of a lion in the London Zoo.

I now give a complete description of the animals of the Salzburg flagon, details of which have already been studied here and there on the foregoing pages. First the handle-beast. The handle proper is square; it begins above the attachment-mask, slightly increases in volume, and passes upwards over into the animal's body. It is adorned on the upper surface with astragaloi,[9] with beading at each side. It rests on a broader, flat base, which starts at the top of the spiral-decorated attachment shield and reaches the lip of the jug; on the last part of its way it supports the crouching animal. A reminiscence of the Persian solution of the problem is the way in which the animal still forms part of the abstract handle: its body is of a certain, temperate squareness, the mane is level with the astragaloi and is their continuation, and though the legs are now modelled in the round and severed from the handle, *two* tails stand in flat relief against the vertical handle-surface. The beak-flagon from Castanetta, no. 394, a product of a local Alpine workshop,[10] simplifies and spoils this well-thought-out pattern: here the 'bridge' under the animal is interrupted and the boar has to jump over the abyss. The mane of the Salzburg beast, lying along the back as a flat cover, has a side-frame of beads and below them of engraved circles. The shoulder has the shape of a Celtic leaf with a foot-scroll:[11] it has a very precise double contour and is hatched across, like the tails and the eyebrows—all the parts look as though they were made of the same stuff. These eyebrows,

[1] Berlin: AA 7 1892, 113 ff.; Blümel, Tierplastik fig. 70; AA 53 1938, 765/6 fig. 1; Pope pl. 112, A. Louvre: Alinari 23851; Froehner, Collection Tyszkiewicz pl. 3; Sarre pl. 49; Pope pl. 112, B. Luschey 57, note 330.

[2] Furtwängler, Die antiken Gemmen 3, 118.

[3] Möbius refers for the flat, broad acanthuses to the stele from Thymbra, Möbius pl. 20, a, and for the barren scrolling side-tendrils, to the South Russian stele ib., pl. 63, a, which Schefold, Untersuchungen 70 unconvincingly dates before the middle of the century. Compare also rhyton from Karagodeuashkh, Ebert 6 pl. 64, 6. [4] p. 89.

[5] Dall' Osso 93; Marconi and Serra 57, 58; Dedalo 1 1920

plate facing p. 156; Payne, NC 353; Neugebauer, Katalog der statuarischen Bronzen Berlin 1, p. 81; AM 57 1932, 6, note 1. See also the bronze handle in Dresden, AA 10 1895, 225.

[6] From the left pillar of the grave of Shên at Ch'ü-hsien, province of Sŭch'uan, Segalen, Mission archéologique en Chine Atlas 1, pl. 21. Kümmel, Die Kunst Chinas, Japans und Koreas fig. 11. Professor Yetts dates it in the latter part of second century A.D.

[7] p. 13. [8] p. 13.

[9] p. 72.

[10] Germania 19 1935, 131 where I have corrected the mistake made in JL 57. [11] p. 83.

by the way, very fleshy and ending in plastic scrolls, have again Chinese analogies; see, for instance, the bronze vessel in the Chicago Art Institute, Rostovtzeff AS pl. 22. The claws resemble those of the animals on the gold bracelet from Rodenbach and, as in the Lorraine jugs, they are set off from the legs by a ring, here reduced to two engraved lines. The little beasts on the lip of the flagon are miniature copies of the handle-animal. Their mane, reaching down to the tail-scroll, is drawn in longitudinal engraved lines, and the treatment of the victim's tail is similar. They have small, leaf-shaped ears.

The handle of the flagon from Borscher Aue,[1] no. 383, follows classical tradition, in so far as it is an animal throughout, from lip to tail, and not a Persian compromise between rod and living form. It is a beast of prey, but no portrait of a definite species. The gaping mouth has a plastic, hatched outline, ending below at the short under lip in a spiral knob which rests on the rim of the vessel. The alae of the nose are protuberances, contoured by engraved double lines which swing upwards over the cheeks, and end, beside the eyes, in a little circle. The slanting eyes are plastic almonds, the pupil, it seems, was engraved. The sharp bridge of the nose passes upwards into the eyebrows, which reach the ring separating head and body: they consist of several engraved lines, partly hatched and beaded. The small ears are erect. Neck, flanks, and back are covered with basketry patterns,[2] denoting the pelt. Along the spine stands a scalloped crest, recalling saurians. The legs are stippled. Some ribs are engraved in double lines. The forelegs are atrophied; the three (or four) toes, with engraved divisions across, grasp the rim of the vessel. The hind legs are of normal size and shape; their outline is marked with incised lines and rows of circles; round the 'knee' is a double circle. The claws resemble those of the bird in the fibula from Jungfernteinitz, no. 318, a work of the same artist.[3] The legs end in plastic scrolls which form the top frame of the attachment-shield, and from the scrolls grow toes, shaped like those of the forelegs. The same occurs, less over-stylized, in the griffins of the Parsberg brooch, no. 316, also a product of this or of a closely related workshop. The legs bear spirals: those on the haunches are clear in the photographs, those on the shoulders are badly corroded. Between the haunch-spirals and the tail a leaf-shaped groove which compares with those in the little animal from Waldalgesheim, no. 387, where they denote ribs. The tail ends in a head of which only the ears are clearly visible: the motive is not infrequent in seventh-century Italy;[4] for the East see Rostovtzeff AS 13, note 11.

This animal, easily the most elaborate in Celtic art, contrasts with the following piece, a handle without special provenience in the BM, no. 384. It must also have belonged to a flagon—beak- or spout-flagon, for amphorae or hydriai were not, to our knowledge, made by the Celts. The length of the hind legs being unknown, the angle of inclination cannot be determined. It is a wolf or a hound, stretching himself while jumping or running at full speed. The rather natural rendering of the body, without any ornamental motive on it, might suggest an origin in an inferior classical workshop, but there are some un-classical features: the plastic, hatched contour of the jaw-bones, the vertical strokes along the upper forelegs, and the hatched collar round the neck.[5] The triangle on the throat recalls the modelling of this part in the deer no. 372[6] or in the rams from Klein Aspergle, nos. 16, 17.[7]

[1] My description would be shorter if I had not to rely on reproductions: the Keeper of the Jena Museum, Professor Neumann, withheld permission to study the original.

[2] p. 74.

[3] pp. 30; 74; 108.

[4] Bronze disks: Mühlestein 150/1 with references. Faliscan urn, AA 32 1917, 100 fig. 27, 27a, and others.

[5] pp. 26, 31. [6] p. 26. [7] pp. 25–6.

The style resembles that of the presumptive model[1] of the Matzhausen flagon and of the Scythianizing horse-triquetra[2] from Carniola, *pl. 239, c.*

I describe groups of *confronted fantastic animals*, griffins and others, mostly in openwork technique.

The girdle-hook from Weisskirchen, no. 350, shows two pairs of griffins, one flanking the central mask turned towards the middle, the 'acroteria'-griffins outwards; all have their heads turned back. The posture of the outer pair is the normal of seated animals, that of the others is awkward: they are squatting with their hind quarters on the coral-incrusted pedestal and put their forelegs on the feet of their neighbours. The wings, starting from the shoulder spirals, have the shape of sickle-palmettes;[3] every second layer is hatched.[4] The haunches are not stylized. The claws are of usual Celtic form. The corner-griffins lay their thick tails upon shanks and claws. The heads are a failure, the greater part of them being taken up by the colossal eyes which project over the profile. The eyes of the inner griffins have little circles at both corners, those of the outer griffins only at the inner corners. They have the sockets below the eye hatched: see the girdle-hook no. 353 and the Chinese piece, *pl. 228, a.* Over the hatched eyebrows the hair, cross-hatched, falls down on the shoulders. Above it a scrolling curl grows, meeting that of the neighbouring animal and thus repeating the motive of the spiral-pair above the mask in the middle. The curved beaks, for their greater part, disappear behind the tips of the wings. The Orientalizing character of these beasts is obvious.

The openwork plaque covering the coil of the Parsberg fibula, no. 316, consists of a pair of animals, turned outwards, but looking back. They have no wings, and their heads are not those of griffins proper, but they are otherwise closely related to the beasts on the foregoing girdle-hook. Their posture with the buttocks remaining at a distance from the ground is the same as that of certain Greek sphinxes.[5] The tails touch each other and have on top a little disk—a variant of the popular trio of circles.[6] Animals back to back with their tails forming an ornament are not infrequent in classical art: see here the Etruscan lions *pl. 232, a.*[7] The hair on the body is engraved in horizontal, on the breast in vertical strokes. On the haunches and shoulders there are large plastic spirals. The treatment of claws and 'knees' is almost the same as in the flagon no. 383. The head is set off by a narrow collar round the short neck. The mouth is wide open, the upper lip looks like a beak, the under lip, with a large circle on it, is rather shapeless. A lock stands up on the head: it curls less than in the Weisskirchen griffins.

Similar creatures appear in two bronze girdle-hooks from France, no. 359, from Somme-Bionne, and *pl. 230, b* from Hauviné (Ardennes). The posture is again a transition from standing or sitting to squatting. The Somme-Bionne animals also use their tails as a support. The bodies are not stylized and, though clumsy, are rather natural. The head consists of a huge eye with concentric circles and dots, the open griffin-beak, and a lock, this time given the form of a Celtic leaf. Between the locks stands a third 'eye', from which a two-leaved flower hangs downwards. The strut between the breasts has no meaning. The pendant, *pl. 230, b,* shows a remarkable variant: the forelegs are not represented as legs, but have become the

[1] pp. 31–2. [2] p. 59.

[3] pp. 88–9. [4] pp. 88–9.

[5] Jacobsthal, Melische Reliefs 89; see also the sphinx crowning the Megakles stele in New York, Bull. Metr. Mus. 1940, 179; AJA 45 1940, 160. [6] p. 67.

[7] See also the Ficoroni cista, WV 1889 pl. 12, and the fourth-century mosaic, Olynthus 5 pl. 6, p. 10; RM 52 1937 pl. 44, p. 168. See below, p. 48; the motive in principle is as old as the fourth millennium B.C.: Weber, Altorientalische Siegelbilder figs. 558, 559, 561.

side-leaves of a three-petalled flower, filling the gap between the beasts and the base: a feature which has a later analogy in the ornamental treatment of the hind legs of two animals on the sword from La Tène, no. 111. The two girdle-hooks are the work of one and the same workshop in the West, but with Eastern connexions.[1]

The gold bracelet from Rodenbach, no. 59, is decorated with four crouching animals, their heads turned back, each pair flanking a Janus. They are rams with an eagle's beak:[2] I have already given an Eastern example *pl. 225, c*. The relation between abstract ring and organic animal form is again Persian: the breast of the outer beasts passes over into the ring without a contour drawn. The haunches have the shape of a 'drop-leaf', pointing downwards, and the same motive is to be seen in the 'axil' between them and the shanks: similar fillings at the same spot occur in the gold plaque from Siberia in the Hermitage, Borovka pl. 46, A; see also the use of such pointed leaves for a similar purpose in the gold dagger from Elizave-tovskaja Stanitsa, of the middle of the fifth century B.C. (p. 45, 4, C 1, 4); one might also compare the bull in the reliefs of the palace of Xerxes at Persepolis, Sarre pl. 21. In the Greek Iranizing gold mountings of wooden rhyta from the fourth kurgan of the Seven Brothers' mound the 'axil' between body and wings of the animals is filled with a palmette (Rostovtzeff IG pl. 13; Schefold 6, 39). The form of the claws has close analogies in various phases of Scythian art and had already occurred in Celtic works. The legs, on their outer side, are contoured by beads; the bead line along the forelegs goes upwards round the shoulder and then descends in a garland, which hangs on the breast and is fixed with its other end at the point where the horn touches the outline of the neck. This description only applies to the central beasts; the others have a double bead line here, and the space between them hatched—probably an attempt to mask the precarious passage from animal into ring. These bead-garlands are copied from Scythian models such as the fifth-century bone-carved animals from Tamán in Berlin,[3] *pl. 230, a*. There is a similar use of bead lines in the Siberian gold plaque Borovka pl. 46, A, which had already been quoted for other patterns occurring in the Rodenbach bracelet.

SPIRAL-SNOUTS AND DRAGONS. Heads of this species of fantastic animals are seen in a clear and elaborate form in the fibula from Ostheim, no. 315, and in the sword from Hallstatt,[4] no. 96: here only the under lip scrolls, in other cases both lips. The source of this feature is Scythia: I illustrate, in *pl. 230, f*, a silver four-whirligig in the BM[5] and refer to openwork bronzes from Elizavetinskaja Stanitsa, *pl. 230, d, e*, of the fourth century B.C. (Schefold 45), to Siberian examples (Merhart, Bronzezeit am Jenissei), and to Scytho-Chinese bronze buckles, Rostovtzeff, Skythika pl. 7, nos. 33, 34.[6]

Dragons in full figure with spiral muzzles, more or less clear, occur in the following monuments:

(1) The Swiss girdle-clasps nos. 361 and 362, which have already been studied on p. 28, because of the birds beside a palm-tree. To get the animals clear of the meaningless ornament round them is no easy job, more difficult still in the related girdle-hook from Este, no.

[1] p. 154.

[2] See above p. 36. For the transformation of birds' heads into rams' heads see Fettich in Arch. Ert. 43 1929, 358 and p. 99 fig. 33.

[3] Brehm in Strzygowski, Der Norden und die bildende Kunst Europas pl. 10, 5; von Sydow, Die Kunst der Natur-völker und der Vorzeit 474; Blümel, Tierplastik pl. 47, with

a wrong date '7/6th century B.C.'. Brehm calls the animals 'South-Russian La Tène': such a style does not exist, the beasts are purely Scythian. [4] pp. 1; 115.

[5] Dalton, p. lvii fig. 36; Rostovtzeff AS vignette after p. 112; Acta Archaeologica 1, 254 fig. 17; ESA 11, 97 fig. 6; Die Antike 10 1934, 45 fig. 17; Schefold 58 and 63. See below p. 59.

[6] For the spiral ears of no. 34 see above p. 38.

363, with similar creatures, not to speak of that from the Valais, no. 364, with a 'sea-horse'. In the best-preserved piece, no. 361*a*, it is, however, possible to identify two rampant dragons with horse-like bodies, the hind leg—only one is shown—set on the top leaves of the tree: whether part of the ornament between the long necks is meant to signify the raised forelegs is doubtful. The head shows clearly: it is set off from the neck with a 'collar', has a circular outline, the mouth gapes, the under lip ends pointed, the upper lip with a spiral; a long curling lock hangs down from the nape.

(2) The roll of the swingle-tree of the chariot in the Dürkheim grave,[1] no. 166. All that is preserved is the central, figure part of the openwork which once filled the whole of the almond: the missing ornament can easily be restored on the model of the openwork of the Weisskirchen dagger, no. 100, or the Schwabsburg girdle-hook, no. 351. Two rampant dragons are represented, with their heads turned back, together forming an upright lyre: an unsurpassed union of animal and ornament, a masterly design. The dragons have long curved lips and erect curved ears. The stylized shoulders and haunches will be described later on. The forelegs—if there were any—are missing: like those of the Swiss dragons (nos. 361, 362) they seem to grow into one with the filling ornament, of which a fragment comes down between the bodies. On the left, clearer than on the right, one sees the long hind legs reaching the edge of the almond, and, near by, what is to be understood as a stylized tail. For the twisted body and the inversion of legs there are Eastern analogies: the lion in the fifth-century gold dagger from Elizavetovskaja Stanitsa (p. 45, note 4, C 1, 4) ; the horse on the Siberian gold plaque, Borovka pl. 46, A, and Rostovtzeff AS pl. 15, 1; bronze plaque, Salmony, Loo pl. 40, 4 with a pendant in Minusinsk, Otchët Imp. Arch. Kommissii 1898, 69 fig. 118. *Pl. 230, e* shows a fourth-century openwork from Elizavetinskaja Stanitsa. Put this dragon upright, give him a pendant, and you have the Dürkheim bronze. Scythian examples of antithetic monsters in openwork are the bronze ornament from the same place, *pl. 230, c*; the gold from the Alexandropol kurgan, Minns fig. 42; Ebert 13 pl. 36 B, e (Schefold 31, and Rostovtzeff SB 382, 403), here *pl. 230, h*.

A coarse Celtic copy of a Scythian original is the bronze pendant of a brooch from Viniča, Carniola,[2] *pl. 230, g*. The two rampant horned dragons[3] put their legs against a debased Sacred Tree. The strut between the lips occurs in similar form on the bronze from Elizavetinskaja Stanitsa, *pl. 230, d, e*, and denotes fangs.

One of the rare reflections of Eastern style in France is given by the two friezes of the clay beaker from the Marne,[4] no. 411. Engraved, pairs of confronted dragons, surrounded by primitive filling ornaments: the whole the translation of Scythian models into the backward style of Marne pottery.

A special class consists of dragons with one body and two heads. The finest and clearest specimen is the bronze openwork from Cuperly, no. 200, again an Eastern intruder in France. The chape of the Hallstatt sword,[5] no. 96, should possibly be given the same interpretation. Their descendants are the man-eating double dragon on the Gundestrup cauldron[6] and the goat-devouring two-headed monster on a billon coin from the Jersey hoard, de la Tour pl. 27, 10408; see also Pič, Le Hradischt de Stradonitz pls. 16, 3; 17, 7, 10. The motive has its roots in the Orient, where there are countless open rings or ring-like

[1] p. 121.

[2] Treasures pl. 19 no. 102; R. Lozar, Glasnik, Bull. de l'Association du Musée de Slovénie 15 1934, 89; Beninger in Zeitschrift für Kunst und Kulturgeschichte Asiens 9, 42 and fig. 9.

[3] Beninger l.c. 'horses'.

[4] Déchelette 1464, 3 quotes a pendant, figured in a publication inaccessible to me.

[5] pp. 1; 115.

[6] p. 33.

devices with animal heads at both ends.[1] I confine myself to quoting a few Southern examples: bronze urn from Vetulonia, Circolo del Cono,[2] *pl. 236, f*, seventh century B.C. Openwork chape of a roughly contemporary sword from Capena: Mon. Ant. 16 1906, 403 fig. 27; Mainzer Zeitschrift 2, 1907, 51; Behn no. 647, pl. 10; Moretti, Il guerriero italico di Capestrano pl. 6 no. 4. Etruscan painted beaker, Munich no. 942, fig. 174, after 500 B.C.

Finally, pairs of dragons on Hungarian and Swiss swords. Those on nos. 121, 122 go closely with the animals on the French clay beaker no. 411; the filling and connecting ornaments show that the artist was aware of the lyre character. The beasts on nos. 123, 124, 125, and on two Swiss swords, from Tiefenau (Bonstetten, suppl. pl. 12, no. 6; Kemble, Horae Ferales, p. 176) and from Münsingen (Wiedmer-Stern pls. 29, 30) give the protome of the dragon with a foreleg. The motive is related in principle to the birds on the swords from La Tène, nos. 107, 110.[3] Its source was Scythia: see the little gold plaque, once sewn on a carpet, from the Volkovtsy kurgan, Minns fig. 77, no. 407, and clearer Ebert 13 pl. 39 D, c, p. 96.

Hitherto I have purposely refrained from describing an important feature of Celtic animals, the *ornaments on the haunches and shoulders*. I now fill this gap. There are two main types, but also hybrid forms. The first type develops the ornament out of the natural shape of these muscles. This is shown in a rather plain form by the animals in the gold bracelet from Rodenbach, no. 59, where only the 'axil'-fillings have no model in nature, or by the flask from Matzhausen, no. 402, which draws double contours with hatching. The horses on the sword from Hallstatt have the haunch-leaf filled with floral motives or spirals, and similar is the treatment of the shoulders of the dragons from Dürkheim, no. 166. The second type shows spiral muscles. The direction of the spirals varies and sometimes they appear only on shoulders or haunches. Examples: Parsberg fibula, no. 316; fragment of Weisskirchen fibula, no. 317; animal from Waldalgesheim, no. 387; brooch from Langenlonsheim, no. 319; girdle-hook from Weisskirchen, no. 350, where the spiral muscles form part of the wings as well; handles of bronze flagons from Lorraine, no. 381, and from Borsch, no. 383 (haunches). Enriched spirals are to be seen in the same animal (shoulders) and in the Dürkheim dragons (haunches).

The source of these ornaments is Scythia and Persia. I give a detailed survey of the monuments in note 4. Neither of these peoples invented them: they borrowed them

[1] For the pieces from the Hradischt quoted see Borovka pl. 44, A; and Salmony, Loo pl. 25, 2.

[2] p. 56. [3] pp. 28, 53.

[4] A few remarks in Zahn, Das Fürstengrab von Hassleben 92, 93, and Kunze 157. I select some typical specimens without, however, arranging them in morphological order.

A. *Early Orient.* (1) Painted goblet from Nihāvand, Pope pl. 6, A (2) Basalt relief, Hogarth, Carchemish pl. B, 10. Hittite, about 2000 B.C. (3) Reliefs from Malatia, Ebert 8 pl. 41, a; KiB pl. 62, 4; Ed. Meyer, Reich und Kultur der Chetiter pls. 6, 7. Hittite, late second millennium. (4) Assyrian sculpture, especially of the eighth and seventh centuries B.C., is full of these motives: I need not quote examples. (5) Luristan: Godard no. 170, pl. 42; no. 182, pl. 48 (the latter showing an un-Luristan style, leading on, it seems, to the animals from Vettersfelde); Pope pl. 32, A; 34, A; 38, C; 53, A.

B. *Persia.* Lion-bull relief from the Palace of Xerxes at Persepolis, Sarre pl. 21. Oxus, Dalton nos. 10, 11, 12, 18 (see Luschey 63), 23, 24. With them go, more or less closely, gold jewels from Siberia, such as Minns figs. 188–91 (the last better in Borovka pl. 56, F); Borovka pl. 46, A = Rostovtzeff AS pl. 15, 1, and their reflections in textiles: Borovka pls. 73, 74 and Rostovtzeff AS pl. 24, 1, 2. Gems: Furtwängler pl. 12, 3 (Lippold pl. 82, 7); Furtwängler pl. 12, 50 (Lippold pl. 81, 10); Lippold 81, 9; Ward no. 1123; Furtwängler pl. 64, 16 (Lippold pl. 86, 4), which is also of Graeco-Persian style, and not 'Ionic' (Furtwängler). Rostovtzeff IG pl. 16, 1. It is easy to see that there was first an Assyrian tradition and that the Achaemenid goldsmiths introduced a new kind of stylized muscles, based on inlay technique. Two Greek pelikai of Kerch style copy Achaemenid animals: Leningrad 1873, Schefold, Untersuchungen no. 381, pl. 5; Luschey 74, and that illustrated in *pl. 231, c* (see p. 48).

C. I. *Scythia &c.* (1) 'Proto-Scythian' recumbent ibex of carved bone from Ephesus, Hogarth, Excavations at Ephesus pls. 21, 5; 23, 2; p. 163, 2; Minns fig. 182 bis; Poulsen, Der

from the older arts of Asia. Here once more it turns out that most of the Eastern material preserved is relatively late, later than the first Western reflections in the late second millennium B.C. The second wave reaches the West in the eighth and seventh centuries B.C.: Greece; and also Etruria, where the motives grow like weeds. The Celts received these ornaments from Persia and Scythia in the fifth and fourth centuries B.C. The eastward migration to China and then the westward migration in the Middle Ages is beyond the scope of this study.

Double Beasts

The tiny bronze from the Weisskirchen grave, no. 317, is a fragment of a fibula which like its pendant from Parsberg, no. 316, had the coil masked by an openwork plaque.[1] It is a lion with one head and two bodies, missing for their greater part. They were crouching, the forelegs bent with the 'shanks' under the body. The face has an owl-like expression as cats often have. The stylization of eyes and forehead leaves no doubt that the brooch is a work of the artist who made the girdle-hook from the tomb, no. 350. The lion heads at the ends of the gold band from Dürkheim, no. 27, are coarse copies of this type.

I cannot give this Celtic animal its place in history, nor answer the question how it came to the Celts without displaying a large material, covering many centuries and many lands in Europe and Asia.[2]

Orient und die frühgriechische Kunst fig. 112; Schefold 67: not before the end of the seventh century B.C. The rosette occurs in Luristan bronzes, the silver ibex-handle from the Oxus, Dalton no. 10, and elsewhere. (2) Axe from Kelermes, Rostovtzeff IG pl. 8; AS pls. 3 and 4; Ebert 6 pl. 82; sixth century B.C.

Of fifth-century date are: (3) gold stag from Tápiószentmárton, Arch. Hung. 3 pl. 7; Rostovtzeff AS pl. 5, 1 and SB 520, 531. (4) Gold dagger from Elizavetovskaja Stanitsa, Borovka pl. 22, A; Ebert 13 pl. 33 A, a; Ginters pl. 7, b; Schefold 62. (5) Silver vase from Kul Oba, Ant. du Bosphore Cimm. pl. 34, 1, 2; Schefold 42. (6) Sword-sheath from the same site, Ebert 13 pl. 31 B, e; Ginters pl. 22, c. (7) Gold plaque from Berestnjagi, Schefold fig. 58, p. 53. (8) Bronze animal legs from Brezovo &c., RM 32 1917, 26; Ebert 2 pl. 70, c, d.

The following pieces are fourth century B.C.: (9) gold animal leg from Chmyrev kurgan, Borovka pl. 19, D. The same treatment of muscles occurs in bronzes from North China and Mongolia: Rostovtzeff AS pl. 25; Borovka pl. 70. (10) Bronze pole-top from Melitopol, Borovka pl. 28; Ebert 13 pl. 35 B, c. (11) Bronze girdle-clasps from Alexandropol kurgan, Rostovtzeff AS pl. 12, 1, 2; Skythika pl. 6, nos. 25–7; Ebert 13 pl. 36 c, a, b. (12) Bone carving *pl. 230, a* (p. 43). (13) Silver plaque from Panagurishte RM 32 1917, 40 fig. 25, see here p. 36.

C. II. *Siberia and China.* There are countless examples in Sino-Siberian and Chinese bronzes, see Salmony, Loo, and Merhart, Bronzezeit am Jenissei, passim. The motive, as Professor Yetts kindly informs me, is already frequent in Chinese Early-Archaic bronzes. There are numerous examples, but not datable, in jades, Salmony, Jade, passim. Even animal wings, exactly like those in the Weisskirchen girdle-hook, no. 350, occur in jades, Salmony l.c. pls. 16 and 18.

D. *Greece.* (1) Cretan gem, Furtwängler pl. 3, 24.

(2) Kraters from Enkomi in the BM. (*a*) C 397, BMC Vases I, 2 figs. 135a, b; CVA fasc. 1, II C b pl. 7, 1 (one side also Roscher 4, 1340 fig. 4). (*b*) C 417, BMC Vases I, 2 fig. 148; CVA l.c. pl. 10, 1.

The following are seventh century B.C.: (3) Ivory, Orthia pl. 152, 2 b. (4) Bronze corslets from Olympia, Olympia Bronzen pls. 58, 59; Pfuhl fig. 135. (5) Oinochoe from Aegina, BM A 547, JHS 46 1926 pl. 8; Pfuhl fig. 97; Jacobsthal, Ornamente pl. 9, c. (6) Bronze stag, Berlin, Neugebauer, Katalog statuarischer Bronzen 1, 136, pl. 14; Kunze, AM 60/1 1935/6, 228, note 1. (7) Bronze handle of cauldron from Samos, Phot. German Archaeological Institute Athens, Samos 713/14: Head of horned man on body of winged lion, forerunner of the Persian handle-type, above 40, n. 1; see Kunze l.c.; related to an unpublished goat-handle from Camirus, BMC Bronzes, 143, photograph Archaeologisches Seminar Marburg 2241.

Sixth century B.C.: (8) Cyprus: oinochoe, Berlin, Berichte aus den Preussischen Kunstsammlungen 1930, 149, figs. 2, 3, and Louvre, RA 34 1899, 4 fig. 1.

E. *Italy.* (1) Silver-mounted cista from Praeneste, Tomba Castellani, Conservatori, Stuart Jones pl. 77; Ducati, Storia figs. 144, 145; Mühlestein 21, 22. (2) Bronze handle from Foligno, Berlin, Neugebauer, Führer Bronzen p. 68; Oe J 7 1904, 162, 163 figs. 73, a, b; Mühlestein 153. (3) Etruscan and Faliscan buccheri: e.g. Mon. Ant. 4 1895, 198, 209–10; = ib. 10 1901, 183/4; Louvre C 563, Pottier pl. 25, 5; Morin-Jean 150; Louvre C 562, Morin-Jean 149; AA 32 1917, 100, 101, figs. 27, 27 a; Not. Sc. 1898, 52 fig. 3 = Montelius pl. 207, 10. (4) Italic bronze disks RM 25 1920, 2 figs. 1–3. See p. 82.

[1] p. 128.

[2] Literature: JHS 2 1881 pl. 15, p. 318 (Murray); S. Reinach, Anthropologie 7 1895, 655, 699. Delbrueck, Beiträge zur Kenntnis der Linearperspektive 23, 2; Pottier, Revue de l'art ancien et moderne 1910, ii, 442; L. Curtius, Beiträge zur Geschichte der altorientalischen Kunst (Münchener Sitzungs-

Where not stated otherwise, the animals are sphinxes.

A. THE NEAR EAST. The only early double animals known to me are the double goat on the bitumen basin from Susa in the Louvre, *pl. 231, a* (Contenau, Musée du Louvre, Antiquités Orientales i pls. 48, 49; idem, Manuel d'archéologie orientale 2, fig. 564; R. de Mecquenem, Rev. d'Assyriologie 21 1924, 113 and fig. 6; Pope pl. 17, E) and the double bull on the basin Pope pl. 17, D. Neck and head form the projecting spout of the vessel, and the two crouching bodies are set in flat relief on the wall of the basin, one to the right, one to the left.

The odd combinations of victorious hero and defeated beasts, grown together, on some very archaic cylinders of the fourth millennium B.C. (Delaporte, Cat. des cylindres orientaux de la Bibliothèque Nationale pl. 1, 1; L. Curtius, Münchener Sitzungsberichte 1912 fig. 21, pp. 57, 69 (Weber, Altorientalische Siegelbilder p. 26)) are of a different kind.

There seems to be not a single example from Syria or Phoenicia.

After an interval of nearly 2,000 years follows a Persian octagonal seal cylinder, preserved in a drawing only, Layard, Le culte de Mithra pl. 49, 3, showing a 'contraction' of two single male, bearded sphinxes with Persian crown, facing each other, such as appear on the carnelian scaraboid Ant. du Bosph. Cimm. pl. 16, 10 = Lippold pl. 79, 2 and on the stone Sardis 1, 1, 87 fig. 86 A.[1] For this class of Persian gems see Furtwängler 3, 117 and 124. Fifth–fourth century B.C.

B. GREECE. I. *Cretan gems.* (1) Furtwängler pl. 3, 23 (Evans, The Palace of Minos 4 fig. 577), double lion. (2) Annuario 8/9, 160 fig. 170, from Zakro, double lion. (3) Furtwängler pl. 3, 24; Evans l.c. fig. 576,[2] double griffin. (4) Deltion 4 1918 pl. 5, 2, from Gournia, double bull. (5) Furtwängler 3, 55 fig. 38: three bulls with one head, inscribed in the round.

II. *Eighth and seventh century.* (1) Late geometric amphora, end of eighth century, from Rheneia, Exploration archéologique de Délos, fasc. 17, pls. 1, a; 3, a. Two rampant goats, grown together with their necks, but with two heads: they do not belong here in a strict sense, but well illustrate the fluctuation of types at this period. For two goats with one head see below IV (5) and p. 147. (2) Ivory plaque from the Argive Heraeum, Waldstein 2, 351 fig. 5 A; Payne, NC p. 51 note 8, p. 88. Double sphinx with Gorgon head, Ionic? See the single type, Orthia pl. 102, 1; Besig 44. (3) Bowl from Arkades, Annuario 10/12, 172 fig. 192, *pl. 231, b.* Crouching lions. (4) Chigi oinochoe, Late Proto-Corinthian, Payne, NC no. 39 and PV pl. 27. (5) Alabastron, Payne no. 94. Transitional style. (6) Early Corinthian: (*a*) Alabastron, Payne no. 440. Double siren with Gorgon head. (*b*) Alabastron, Newcastle-on-Tyne, Black Gate Museum. Double siren (information from Professor Beazley). (*c*) Aryballos, Payne no. 543. Panther-bird.

III. *Sixth and early fifth century* B.C. (1) Alabastron, Payne no. 1210, Late Corinthian. Panther-bird. (2) Pseudo-Corinthian olpe, Payne p. 51, note 8; 91, note 13; 205. Panther-bird. (3) Bronze horse-cuirass, Karlsruhe, Schumacher no. 787, pl. 16, 22; Wagner, Bronzen pl. 26; Jantzen, Bronzewerkstätten 27, no. 12, p. 31. From Apulia. Mid-sixth century.

berichte 1912) 57, 69; Friis Johansen, Les vases sicyoniens 131; Zahn in Anatolian Studies presented to Sir William Ramsay 442; V. Müller, Orientalische Literaturzeitung 1925, 785; For Indian and Chinese material see Rostovtzeff AS 91, 111, 13; for the West in the Middle Ages: Bernheimer, Romanische Tierplastik, passim.

This chapter was written before the following papers were published: Déonna, RA 31 1930, 28 ff.: his useful lists are arranged zoologically; von Lorentz, RM 52 1937, 178 gives some additions; Roes, BCH 1935, 313.

[1] Compare the gold ornament Sardis 13, 1 pl. 1, no. 1.

[2] The lion–bull fight on the lenticular sard in Boston, Beazley, The Lewes House Collection of Ancient Gems no. 2, pl. 1 (Evans, The Palace of Minos 4 fig. 575 where the bull is called a sheep), is an amusing variant of the design.

(*3a*) Bronze 'ankle-guard' from Olympia, Illustrated London News 1938, p. 1232. Earlier sixth century. (4) Clay arula from Caulonia, Mon. Ant. 23, 765/6 fig. 40; Van Buren, MAAR 2, 25 no. 5; Reinach, Rép. de la sculpture 5, 2, p. 404, 2. (5) Chalcidian amphora, Louvre E 807, Rumpf no. 173, pls. 157, 158; Morin-Jean fig. 154. Four deer with one head. (6) Cornelian scarab, Furtwängler pl. 8, 34 (Lippold pl. 78, 4). Ionic: Payne, NC 51, note 8 dates it too early ('seventh century'). (7) Turquoise-coloured paste, Geneva, RA 31 1930, 56 fig. 9.[1] Double sphinx with Gorgon head. Probably East Greek. (8) Electrum hekte of Cyzicus, Babelon, Traité 2, 2 no. 2723, pl. 176, 4; von Fritze, Nomisma 7, 10 no. 128, pl. 4, 14. Quarter-hekte in Boston, von Fritze, l.c.; Regling, Sammlung Warren no. 1524, pl. 35.[2] (9) Bronze foot of implement, Berlin, RM 38/9 1923/4, 439 fig. 24. Early Classical style.

IV. *Later fifth and fourth century* B.C. (1) Attic tomb-reliefs, Conze no. 1005, pl. 195 and no. 1347, pl. 282, double sphinx on base of loutrophoros no. 859, pl. 154, and no. 860, figured in text, as acroterion. (2) Clay antefix from Pella, Cousinéry, Voyage dans la Macédoine 1 (1831), plate facing p. 99; Broendsted, Reisen und Untersuchungen in Griechenland 2 pl. 41, pp. 193, 297. About 400 B.C. (3) Tarantine capitals, AA 42 1927, 271, 273; Klumbach, Tarentiner Grabkunst no. 225, pl. 29; no. 226, pl. 30; Quagliati, Il Museo Nazionale di Taranto 58. (4) Tarantine clay arulae, Van Buren, MAAR 2, 25, pl. 17; Pagenstecher, Unteritalische Grabdenkmäler pl. 18, b (inverted). (5) Bronze girdle-hook from Tiriolo (Bruttii), Not. Sc. 1927, 35, pl. 251, double goat, rampant. See p. 148. (6) Fragment of early fourth-century oinochoe from the Pnyx, P. 47, unpublished: on garment of male: charioteer? (Information from Professor Beazley.) (7) Mosaic from Olynthus, Olynthus 5, 10 ff., pl. 6; RM 52 1937, 168, no. XX, pl. 44. (8) Gold and silver ornaments from South Russia. Of pure Greek workmanship are the gold diadem from Olbia, Minns fig. 288, and the silver fragments from Mastjugino,[3] Izvestiya 43 pl. 3, the latter a work of the third century B.C., as comparison with the South Russian grave-stelae, Möbius pl. 65, p. 73, shows. Scythian, more or less barbarized imitations are: the gold diadem from Chertomlyk, Recueil d'Antiquités de la Scythie pl. 36, 1, p. 97; Schefold 26 ff. Date 380–360 B.C. Gold stamped plaques, sewn on garments, Ant. du Bosphore Cimmérien pl. 22, 10, 11 (Kul Oba), and Collection Khanenko pl. 26. (9) Kerch krater of special shape, Louvre G 529, CVA Louvre fasc. 5, III 1 e, pls. 7, 8 (France 383, 384); Alinari 23691; Schefold, Untersuchungen zu den Kertscher Vasen no. 136; RM 52 1937 pl. 47, 1, p. 182. Date: 370–360 B.C. (10) Kerch pelike, Cabinet des Médailles no. 408; Schefold, Untersuchungen no. 550; Pfuhl fig. 606. Here *pl. 231, c*. Lion-griffin.[4] Date 330–320 B.C.

C. PRE-ROMAN ITALY. (1) Capuan antefixes: Koch, Dachterrakotten pl. 12, 3; Altmann, Grabaltäre 230 fig. 186; Victoria and Albert Museum,[5] 819. 1870 (Payne, NC p. 51, note 8). (2) Reliefs from Tarquinia in Florence, Mühlestein fig. 205. Standing double lion. (3) Cippi from Chiusi.[6] (*a*) *pl. 232, a*. Pietra fetida. 61 cm. high, 45 cm. broad; Doro Levi, Il Museo Civico di Chiusi pp. 17 and 147. Double lion. (*b*) *pl. 232, b*. Marble. 48 cm. high, 42 cm.

[1] I owe an impression to Mr. Déonna.
[2] The 'médaillon en or, acheté à Smyrne, au Cabinet du Roy', figured in Cousinéry, Voyage dans la Macédoine, 1831, 99, listed in RA 31 1930, 55 no. 8, is one of these coins.
Circumstances have prevented me from using Russian publications and from checking notes. I was also unable to study the gold relief from Bulgaria, quoted RM 52 1937, 178, no. 8: the drawing in Reinach, Rép. de la sculpture 6, 147, 5 does not allow judgement.
[3] See Ebert 13, 85.
[4] Schoppa, Die Darstellung der Perser (Diss. Heidelberg 1934) 44 calls the beast a sphinx.
[5] Sir Eric Maclagan kindly provided me with a photograph: Payne gives the piece too early a date, seventh century.
[6] I am indebted to Professor Minto for photographs and measurements.

broad; Levi l.c. p. 17: double sphinx. (*c*) Pietra fetida; Levi l.c. fig. 15. (4) Etrusco-Corinthian amphora, Vatican, Albizzati pl. 14 no. 127. Double lion. (5) Etrusco-Corinthian alabastron, CVA Oxford 2, III C pl. 4, 28 (Gr. Britain 387); Payne, NC p. 51, note 8. Double lion. (6) Etrusco-Corinthian alabastron, Geneva, RA 31 1930, 48, 49. Double lion. (7) 'Pontic' amphorae in Vatican and British Museum, Ducati, Pontische Vasen, pls. 8, a and 13. Double lion.[1] (8) Bucchero amphora, Louvre C 567, Pottier pl. 26; Morin-Jean fig. 175. Double lion. (9) Bucchero one-handled cups in Corneto, phot. Brogi 18481; Matz in Bossert 1, 221 fig. 1. Sphinxes climbing. (10) Bucchero tripod, CVA Copenhague, fasc. 5, pl. 215, 3 d. Double lion. (11) Bronze oinochoe, Berlin, JdI 44 1929, 221 fig. 26. Double lion. (12) Bronze feet of cista, Berlin, Oe J 7 1904, 171 fig. 85; Reinach, Rép. de la sculpture 4, 447, middle. (13) Bronze attachment from Todi, Villa Giulia, Mon. Ant. 24, 848 fig. 2; Studi etruschi 10 pl. 8 no 9. Ἱππαλεκτρυών: frontal horse head with two bodies of a cock. Sub-Etruscan are (14) Italic bronze disk, RM 35 1920, 2 (see p. 45 n. 4): indefinable double beast. (15) Este situla, Mon. Ant. 10 pl. 4; Montelius pl. 55, 3: winged double lion.

D. ROMAN. (1) Campana reliefs, von Rohden-Winnefeld pl. 62, 2, p. 168, and a piece in Tübingen, AA 42 1927, 29, 30. Augustan. (2) Pompei, Casa del Menandro, Maiuri, Casa del Menandro p. 61 fig. 22, b. (3) Marble capital in San Pietro in Grado, Pisa, Gaz. arch. 1877 pl. 10, p. 57; Pernice 56. BWP 9; AA 42 1927, 275 fig. 6; RM 38/9 1923/4, 439, 3. First century A.D. (and not fourth century B.C., as some writers believe). (4) Marble krater, Piranesi, Vasi e candelabri 1 pl. 46; AA 42 1927, 276 fig. 7. The vase was in Piranesi's possession: it must be an eighteenth-century fake; the ornament is a literal copy of the Pisa capital, no. (3). (5) Silver crescent from Lauersfort, Matz, 92. BWP 3 fig. 1. Claudian. (6) Roman tomb-altars, from Augustus to the Flavians, Altmann, Römische Grabaltäre figs. 40, 41, 65, 67-70, 72-6; see also Bollettino d'Arte 1925/6, 329, 331 fig. 2, 3. Double sphinxes at the four corners. Gaz. arch. 1878, 15, pl. 5; JHS 8 1887, 330, pl. 15, 11; RA 1930, i, 61 fig. 10, 4 (double griffin). (7) Polos of Ephesian Artemis, Thiersch, Artemis Ephesia no. 34, pl. 35, 2, 3 and pl. 38, 2. Antonine. (8) Finials of bronze handles, Bibliothèque Nationale, Babelon et Blanchet no. 771; Cat. Vente Warneck, Hôtel Drouot, 13.–16. juin 1905 pl. 29; Reinach, Rép. 4, 447, 6. Of special kind is an unpublished bronze in Parma: the bodies of the crouching sphinxes join the bust of a woman, with her human arms on her stomach. (9) Altar dedicated to the Matronae, Bonn, BJ 135 pl. 5; pp. 136–7: three goats with one head. (10) Mosaic in Carthage, RA 1902, ii pl. 20, 2; Musée Alaoui suppl. 1 pl. 6, no. 172; Daremberg-Saglio, s.v. musivum opus fig 5238· four horses with one head.

E. FAR EAST. China:[2] Rectangular bronze vessel of Yetts's Early First Phase (about 13th century B.C.), Yetts, The Cull Chinese Bronzes fig. 13 b, here *pl. 231, d*. Despite extreme ornamental decomposition the motive is clear; spiral ears, spiral shoulders and haunches are recognizable. Bronze, Brussels, Stoclet Collection,[3] *pl. 233, c* (H. d'Ardenne de Tissac, Animals in Chinese Art pl. 16, B; Borovka pl. 72, A; Ausstellung Chinesischer Kunst Berlin 1929 no. 75 (with too late a date); Cat. Internat. Exhibition of Chinese Art London 1935/6 no. 413). About fourth century B.C. (Professor Yetts). Double lion-griffin with head of

[1] I faintly remember an Etruscan·black-figured stamnos in Bonn, late sixth, if not fifth century B.C., with a squatting double lion, one male, one female, but I have neither a photograph nor notes.

[2] Rostovtzeff AS 91 describes the bronze figured in pl. 28, 1—replica Salmony, Loo pl. 22, 2—as a hare with one head and two bodies: I see on the left a normal stag or deer with the head in front view and large ears, on the right a beast attacking.

[3] Professor Yetts informs me that the Stoclet bronze has a pendant in the Hakuzuru Art Gallery, Mikage, Japan, Umehara pl. 67, of plainer technique, not inlaid with silver.

ibex in mouth, see above p. 36. Sino-Siberian bronze, Salmony, Loo pl. 17, 7: double bear. Part of tomb-shrine, Han period, dated 114 A.D., d'Ardenne de Tissac, l.c. pl. 12; Kümmel, Die Kunst Chinas, Japans und Koreas fig. 10; Ausstellung Chinesischer Kunst Berlin 1929, no. 130. Double lion with a rider on each back.

India: Capital of Gupta dynasty, fifth century A.D., Ostasiatische Zeitschrift 1914, 12 fig. 6. Squatting double lions at the corners.

I draw the conclusions from the foregoing catalogue. (1) The Cretan bulls, B I (5), the Chalcidian deer, B III (5), the Roman goats, D (9), and Roman horses, D (10), were given a place in my list, but they belong to the compound animals which are the proper subject of this study only in so far as they also have one head and more than one body: they differ in essence: you can amuse yourselves by connecting in turn this or that body with the head, but the game leads to a momentary decapitation and elimination of the two other animals. These triads are far more frequent in medieval arts, in the West and the East, here often in tapestries. There was no continuity between the Cretan, archaic Greek, and Roman examples: the monsters were swept westwards in discontinuous waves from the East.[1]

(2) Sphinxes outnumber other animals: from the fourth century B.C. onwards they are *the* type of double beast. Lions are rare in Greece—B I (1), B II (3)—and very frequent and predominant in pre-Roman Italy; they also occur in the Far East. Of other animals there are griffin, B I (3); lion-griffin, B IV (10) and Far East; siren, B II (6 b); gorgon-sphinx, B II (2); gorgon-siren, B II (6 a); panther-bird, B II (6 c), III (1), (2), and others. Some of them are 'ephemerae', typical of an age of fluctuating, unstabilized form and experiment.

Recumbent animals as in the Celtic bronze occur only in the following monuments: bitumen basins (A), the seventh-century vase from Crete, B II (3), *pl. 231, b*, and, less clear, the Chinese examples (see *pl. 233, c*).

(3) The vast majority of double animals are two-dimensional, either painted or in relief, and only a few are in the round, decoration of corners, most of them Roman, D (6), or Oriental (Indian capital, Chinese bronze). And there are very many of them in medieval architecture. The thesis that double animals owe their existence to material or decorative conditions needs no refutation, and the idea that they are a naive attempt to show an animal as complete as possible is equally unfounded, for what does a second body, the reflected image of the other, really add?[2] Actually they are the contraction of two single antithetic animals: the Cretan gem, B I (1), has a pendant with two separate lions (Furtwängler pl. 3, 22); so has the Persian gem (see A). The double owl on the fourth-century Athenian diobols (see below) is preceded by a very rare issue of the fifth century, showing the owls opposed to each other but not actually linked. A Corinthian aryballos, Morin-Jean fig. 86, has a picture of two antithetic cocks, with their combs grown together, but otherwise 'self-existent'; the artist had a very simple reason for stopping here: there was no formula for a cock's head in front view, as there was for owls or lions.

The interpretation of the double animals as contraction of their single counterparts touches only the formal aspect of the problem: in essence they are brothers and sisters of those fantastic animals with one body and two heads—monsters combining members of different species. Εἶδος πολύγυιον means intensification of power, accumulation of faculties: a

[1] V. Müller, AM 50 1925, 51.

[2] Delbrueck, Beiträge zur Kenntnis der Linearperspektive 23, 2 put Murray's theory right and realized the connexion between double-bodied animals and the antithetic group. Sir Arthur Evans, Archaeologia 52 1890, 367 came near the truth, but then went the wrong way, taking the double animal for the πρῶτον 'which became rationalized into two separate but closely-confronted figures each with a head of its own'.

beast with two bodies is stronger and more formidable than a one-bodied. The double animals lack mythical individuality, have been unable to secure for themselves a place in myth—the double lion-griffin with the Arimasps on the Kerch pelike, *pl. 231, c*, is an exception—and were doomed to remain in a misty sphere of haunt. As time goes on, they become more and more pleasant 'ornaments', at the most with a slight residue of religious or superstitious significance. The compound bulls, goats, deer, horses, however, are certainly not more than an amusing puzzle.

There is a class of double animals where 'twinning' serves a practical, prosaic purpose. On Athenian diobols of the fourth and following centuries the double owl is a mark of value, like the triple thunderbolt on a gold trihemiobolion of Pisa (Num. Chron. 19 pl. 14, 7; Jacobsthal, Der Blitz, Münztafel fig. 20, p. 27), the double trident of Troizen (BMC Coins Peloponnesus pl. 30, 21, 22), and, in certain cases, the triple silphium of Cyrene (BMC Coins Cyrenaica, introduction p. 254; Regling, Sammlung Warren no. 1354).[1]

(4) The migrations. I need not repeat here what I have pointed out on p. 46 in my discussion of stylized animals. Here again the same phenomenon of discontinuous waves rolling over Europe from the East. The first in the late second millennium B.C., the second at the period of the Early Orientalizing style. Then in the fifth century B.C. a gap, significant of the attitude of classical art towards monsters of any kind. In the fourth century B.C. monsters, among them double beasts, invade Greece again. The inventories of the Treasury of Artemis Brauronia for the third quarter of the fourth century B.C. mention parti-coloured kandyes which were either imports or imitations or both (IG[2] 1514, 19; 1515, 11; 1523, 8, 27; 1524, B, col. 2, 180, 202, 204, 219). This is well illustrated by Attic vases of the first half of the fourth century, B IV (6), (9), showing double sphinxes inwoven or embroidered on chitons of a charioteer and Arimasps. On the Kerch pelike Schefold, Untersuchungen no. 375, pl. 23, painted in the twenties (Schefold p. 68), the Amazon wears a kandys, decorated with a frieze of 'tendril-goddesses' (L. Curtius, RM 49 1934, 224 ff.). And the Persian origin of the double lion-griffin on the late-fourth-century vase B IV (10) can be proved with great certainty. Two single seated lion-griffins, facing each other, are to be seen on the Persian gem, Ward fig. 1114; Layard, Le culte de Mithra pl. 54, A 13. Our creature (*pl. 231, c*) is awkwardly drawn, the head—mouth, ears, and horns—reflects better Greek models of a lion-griffin in front view, such as the gold staters of Panticapaeum[2] (Minns pl. V, 16; Rostovtzeff IG pl. 18, 5; Hill, Select Greek Coins pl. 61, 4; Metr. Mus. Studies 4 1932, 118 fig. 9) or the guttus BMC Vases 4, G 80, p. 249 fig. 30 (RM 49 1934, 227 fig. 4). A clear mark of Persian origin is the spiral muscles.[3] The pendant of the double lion-griffin in *pl. 231, c* is the single type on the Kerch pelike, Schefold, Untersuchungen no. 381, pl. 5, painted in the seventies (Schefold p. 141), reflecting Persian models in inlay technique.[4]

There are still some double beasts with traceable Oriental pedigree, the corner-lions and -sphinxes of the late-archaic Etruscan cippi *pl. 232, a b*: their immediate model was probably Greek. Apart from the Indian capital (E), the closest analogy for the Chiusi lions is

[1] Athenian diobols: Svoronos, Les monnaies d'Athènes pl. 17 (fourth century B.C.), pl. 21 (third century B.C.). On the fifth-century issue see above p. 50. At Sigeion (BMC Coins Troas, Aeolis and Lesbos pl. 16, 8–10) and at Miletopolis (BMC Coins Mysia pl. 21, 1, 6, 7, p. 91, 1, 2, 5) the type occurs on coins of more than one denomination. It is also used as a moneyer's symbol on one of the Corinthian issues (BMC Coins Corinth nos. 346/7), where there is no question of its being a value-mark. I owe much of this information to Mr. E. S. G. Robinson and am also indebted to Dr. Liegle for advice and impressions of coins.

[2] For their chronology see Schefold, Untersuchungen 65.

[3] p. 45.

[4] 45 n. 4, B, end.

a neo-Persian column-base, *pl. 232, c*, from the 'Pavilion of the Forty Columns' at Isfahan, built about 1600 A.D. by Abbas the Great.[1] What is the affiliation between the Chiusi cippus of about 500 B.C. and the Isfahan base of A.D. 1600? I presume that the base copies an old-Persian model, either directly or with a Sasanian intermediate. The date of the Chiusi cippi is probably early in the fifth century B.C.: thus the Persian original must have been made in the reign of Darius or Xerxes, and must have reached Etruria via Greece.

To strengthen my case, I mention another example where, by a very indirect method, the Oriental origin of an Etruscan tectonic motive can be proved. The cippus from Settimello in Florence,[2] *pl. 233, a*, a work roughly contemporary with the Chiusi cippi, shows four lion-atlantes at the corners. Their oddly distorted posture has a striking analogy in the top piece of the Easter candelabrum in San Paolo, Rome, *pl. 233, b* (Bernheimer, Romanische Tierplastik fig. 12; Phot. Anderson 20995/7), so striking that Bernheimer was induced to believe that here in the thirteenth century A.D. an Etruscan cippus was copied, an assumption which cannot be ruled out, for Nicolo Pisano in his Goliath relief at Perugia (Swarzenski, Nicolo Pisano pl. 82) copies an Etruscan urn with a representation of Eteokles and Polyneikes of the type Körte 13 ff. (Martha, L'art étrusque fig. 251; Roscher 3, 2677–8). But here again it is more likely that the Etruscan cippus follows an early Oriental model and that a medieval descendant of this was copied again in the West of the thirteenth century A.D.[3]

To return to the fibula from Weisskirchen: its general look is Eastern and the only close analogy for a double beast with spiral-muscles is the Greek apographon of a Persian original, *pl. 231, c*. That the Persian work passed through Scythia before it reached the Celts is possible, though not too likely, for the preserved examples of Scythian double animals, B IV (8), are barbaric imitations of Greek works.

Animal and floral ornament. In my description on p. 42 ff. of the girdle-hooks from Hauviné, *pl. 230, b*, from the Ticino, nos. 361, 362, from the Valais, no. 364, and of some dragons, I have already touched upon a problem which I should like to discuss in full: the blend of animal and floral form, with the share of the two components varying: floralized animal, and animalized floral ornament. What I have in mind is not the use of little leaves or flowers for adorning or stressing articulation-points of an animal body, but cases like the Hauviné bronze, where the forelegs have assumed the shape of leaves and form part of a three-petalled flower.

From here the way leads to the sword from La Tène, no. 111. The animals form a pyramid, skilfully adapted to the complicated outline of the field. On top a stag, galloping, looking back, below, two antithetic deer. The bodies are embossed; heads and hind quarters protuberances; legs, tails, and antlers engraved. Like other Celtic animals they are 'two-legged'. The atrophied hind legs of the deer are spirals, recalling the forelegs of the animals from Hauviné, *pl. 230, b*; the antlers of the stag are tendrils. Similar tendrils rise from the buttocks of the deer: though much stylized, they must be interpreted as tails, like

[1] Sarre, Denkmäler persischer Baukunst pl. 69; Bernheimer, Romanische Tierplastik pl. 27, no. 91, p. 99. The following information is due to Professor Sarre: 'The figured column is one of four which had their original place at the corners of a water-reservoir which Coste saw still intact in 1867, and figured in Monuments modernes de la Perse pl. 41 (p. 31). Since then alterations have taken place: after the disappearance of the reservoir the four bases supported the wooden columns of the porch of the pavilion. The base figured here, without a column on top, is either one of these, in 1900 still in situ, or a fifth piece found since.'

[2] Mühlestein 238; Die Antike 1 pl. 24; Alinari 31151; Jacobsthal, Ornamente 67, 83; Dohrn, Die schwarzfigurigen etruskischen Vasen 60.

[3] The group decorating the base of the candelabrum came from the same source.

the spiral tails, hanging downwards. The spirals growing from the mouths of the deer have the same form as the tails and the hind legs; like them, they are mere ornament and have nothing to do with the twigs in the mouth of animals on Este situlae.[1] The double tails and the spirals in the mouth have numerous later analogies on Gaulish coins (Blanchet and de la Tour passim) and in metalwork related in style to these, the fragment from Levroux (Indre), Déchelette fig. 657, and the buckets from Aylesford and Marlborough, Déchelette fig. 658.

The 'tendril-birds' on the swords nos. 107, 110 show an increasing share of the floral element, and with the swords from La Tène, *pl. 233, d*, and from Cernon-sur-Coole no. 113, we are definitely in the other sphere—animalized floral ornament. Here the tendrils are perceptible and substantial, and only their offshoots have assumed the shape of birds' heads.

Certain girdle-hooks will lead us to the centre of the problem. An isolated type is the piece from the Marne,[2] no. 355 *i*. The shape is a variant of the type with a lotus-flower in openwork, no. 355 *e, f, h*: at the sides, snakes' heads, with engraved eyes, growing towards the horizontal bar, probably inspired by similar motives on imported Etruscan beak-flagons: see JL pl. 8, p. 45. Of greater interest is no. 355 *a*, showing a lyre, its top scrolls interpreted as birds' heads. One might think that this was nothing more than one of the bird-finials common in fibulae,[3] here applied to another implement: as a matter of fact, zoomorphic lyres are a definite type of ornament which has its origin in the Orient: the piece from the Marne is one more evidence of sporadic Eastern influence in France.[4]

The girdle-hook from Hölzelsau on the Inn, no. 360, is the most representative piece of the class. It is the largest Celtic clasp preserved: the technique is the same as in the pieces from the Ticino. It was apparently made in a workshop far from the centre which produced clasps of the kind and quality of the Weisskirchen or Schwabsburg ones. From the bar rises a large lyre and on top of it is a smaller lyre, hanging downwards, its foot parts are contracted into an arch, to which the hook is attached. The involutions of both lyres are transformed into animal heads, with large engraved eye-circles and erect ears; the mouths of the top animals are modelled more coarsely. On the outer side of the lyre-arms, little birds with long tails climbing. Within stands a manikin—in the plate upside down—arms and legs bent outwards, his hands touching or holding the muzzles of the beasts. Related to the Austrian piece is the girdle-hook from Este, no. 363 *a*. Here the basic form is obscured by that ambiguity which made the description of the clasps from the Ticino so difficult. Much flourish[5] grows round the 'skeleton' and is interlaced with it. One can, however, make out an upright lyre with animal heads at both ends: the beasts have huge eyes, wide-open beaks, those on top a crest.

The animalized lyre is again a motive which originated in the Near East and migrated westwards and eastwards at various periods. I display the material.

Persia. Silver bowl, *pl. 234, a*, from Ialysos,[6] one of two, found in graves 61 and 72. A

[1] Against Sir Arthur Evans, Archaeologia 52, 369.

[2] Other specimens of the type, from Hauviné (Ardennes) are figured by Déchelette fig. 524, 8, 9.

[3] p. 128.

[4] p. 154.

[5] The heart-shaped motive inside the lyre, touching with its downward point the central matrix near the bottom, is related to those in the openwork disks from Langenhain, no. 183, *PP 313 b, c*; p. 79.

[6] Mr. Laurenzi was kind enough to give me the material before publication in Cl. Rh. 8, figs. 168–9. I can now refer to Luschey's treatment of the bowls (pp. 61 ff.). He has come to the same result I had myself reached many years ago, and I differ from him only slightly in judgement on details.

third was found at Kazbek (Caucasus).[1] The Kazbek find is of most intricate nature, and the Caucasian bowl has been given dates varying from 1000 B.C. down to Hellenistic times. The context of the Rhodian tombs indicates a date about 500 B.C., and the style of the bowls confirms it. There are six bird-lyres, filling the intervals of the six drop-shaped bosses. The lyres touch the plain, off-set rim of the bowl; at the bottom they keep at a distance from the omphalos and bear large seven-petalled palmettes, circumscribed by a double-contoured arc, which rests on the birds' heads. The opposite axil is filled with a five-leaved palmette; from its top rises a lotus flower with two side-leaves and a little palmette as filling. The birds are good portraits of anserines. The palmettes—those inside slightly stiffer and their leaves radial—have a late-archaic character. The arrangement of a palmette with an unconnected lotus on top has two analogies in the third quarter of the sixth century: the Chalcidian amphora Louvre E 797 (Rumpf no. 35, Jacobsthal, Ornamente pl. 16, b) and the affected Attic amphora in Florence, no. 1818 (Mon. Ant. 7, 342 fig. 22; Karo, JHS 19 1899, 161 no. 14; Jacobsthal l.c. notes 53 and 58). The bowls are Persian works made in the reign of Darius.

Scythia, Siberia, China. Bronze openwork from Elizavetinskaja Stanitsa,[1] *pl. 234, b.* The lyre is formed by two stags: the motive is related to that of the Dürkheim dragons which I have described on p. 44. The haunches are engraved on the bottom plaque, the hind legs rise vertically within the lyre. The short forelegs are cut off by the antlers, whose ramifications give the bronze a very Scythian frame. In *pl. 234, c* I illustrate a piece from the same find:[2] here the lyre is not animalized, and strictly, it is the antlers of the stag's head that form the bottom part of the pole top: it is one of those three-storey lyres common in late fifth-, and especially in fourth-century, Greek ornament.[3] Silver horse-trappings from Krasnokutsk,[4] *Pl. 234, d,* despite disfiguring additions and asymmetries, show a two-storey lyre, the top pieces of the upper lyre being 'spiral-snouts'.[5] *Pl. 234, e* is still farther away from a lyre proper; the animal heads here are those of griffins; the filling ornament clearly reflects Greek fourth-century forms. Gold openwork ornament from Siberia,[6] *pl. 234, f.* It consists of two identical halves, overlapping in the middle. The first storey is a half-circle, ending in animal heads with curved beaks and long erect ears. From this rises a lyre, its foot part cut off, the upper part formed by the same animals as the lower. At both ends a panther bites a snake whose head is easier to make out than its tail. This story of an animal with a head seen from above, biting into another beast's body,[7] appears also in an Ordos bronze in Stockholm, Östasiatiska Samlingarna,[8] *pl. 235, a.* The diagonal is an S which ends in animal heads; the middle of the S, at the same time the centre of the plaque, is marked by a large circular boss. The 'tails' forming the other diagonal make no sense. The closest analogy is the bronze Salmony, Loo pl. 17, 1. Other examples of a zoomorphic S are a wooden psalion from Pazyryk (Altai),[9] AJA 37 1933 pl. 3, p. 37 and the Scythian bronzes Borovka pls. 8, D and 18, C: I illustrate, *pl. 235, e* a detail of a Chinese wine vessel (Yetts, The Cull Chinese Bronzes fig. 23), Yetts's Late Third

[1] To the list of publications, Luschey l.c., add: Zakharow in Swiatowit 15 1933, 105, 106, and Ebert 12, 418 (Tallgren). The Kazbek bowl, in a bad drawing and with a wrong label, in Pope 1, text 372.

[2] Borovka pl. 7, D; Bossert 1, 137. Rostovtzeff AS 33 wrongly believes that this pattern occurred to the Scythians without Greek influence. [3] p. 86.

[4] Minns figs. 45, 56; RM 32 1917, 69 fig. 58; PZ 18 1927, 43 fig. 19; ib. 19 1928, 169.

[5] p. 43.

[6] Minns fig. 193; Dalton p. lix, fig. 37; Strzygowski, Asiens bildende Künste 397.

[7] Compare Salmony, Loo pl. 23, 5, 6: snakes seen from above and forming a kind of lyre, bite into a frog. See also Yetts, Eumorfopoulos Collection 2 pl. 47 no. B 153.

[8] I am indebted for the photograph to the Keeper; I owe the knowledge of the bronze to Mr. Charles Schuster; the measurements are not known to me. [9] p. 38 n. 1.

Phase = fourth to third century B.C.; a jade, Salmony, Jade pl. 27, 2, is decorated with an S, with a bird's head at the one end and that of a dragon at the other, but the date of the piece is uncertain. In Celtic art there are the following examples: (1) The S with bird-finials on the bow of fibula no. 311. (2) Fibula no. 315A. (3) The ornament from La Tène, no. 205, with two pendants, Vouga pl. 32, 2 (whence Jahrbuch des Bernischen Hist. Museums 27 1937, 84), and 3, which show the animal character more clearly.

In *pl. 235, c* I illustrate an embroidered silk from a tomb at Noin-Ula (Mongolia), which is dated to 2 B.C.[1] The bottom parts of the lyre—if one can still speak of a lyre—are heads of fantastic birds: it is not difficult to see the Hellenistic model beneath the Chinese veneer.

Greece. (1) Attachment of late Protocorinthian oinochoe in Munich 235, fig. 20, Payne, NC no. 34; here *pl. 235, b*. One can easily imagine that the model was plastic, like the attachment of the late Corinthian oinochoe Payne, NC no. 1404, p. 214 fig. 98: there snakes, here birds' heads, as finials of a motive which is not exactly a lyre, but related to it. (2) Fragments of a Caeretan hydria in the Louvre, *pl. 235, d*, Pottier, Mon. Piot 33 1933 pls. 7 and 8, p. 24, note 7; CVA Louvre 9, III F a, pl. 12 (=France 620). The ornament attached to the vertical handle is one of those Ionic lyre compositions which are the forerunners of fifth- and fourth-century forms. Analogies are to be found on Clazomenian sarcophagi[2] and in Samos (anthemion, Antiquities of Ionia chapter 5 pl. 6 fig. 1[3] and stele, AM 58 1933 Beilage 15, 1).[4] The uppermost part of the two-storey lyre is cut off by the handle: see the restoration in CVA l.c. It differs from all lyres described hitherto: they had only zoomorphic head and bottom scrolls, here the whole is animalized throughout: the ends are heads of geese with red bills, and the dots denote the particoloured feathers of the neck; this recalls the plastic handles of the late Corinthian oinochoe Payne fig. 98, which I have just quoted: there also one of the snakes has spots all over the skin.

The last ornaments were already not exactly lyres. I append some related Greek zoomorphic motives.[5] (3) Greaves from the Lykaion, Eph. Arch. 1904, 207/8.[6] Archaic. Bird-tendrils. (4) Cypriote torso in Berlin, AZ 21 1863 pl. 171. Fifth century B.C. Embroidered on the garment, a gorgoneion the snakes of which form a lyre. Compare BMC Sculpture 1, part 2, C 18. (5) Bronze cuirass from Elizavetinskaja Stanitsa, Rostovtzeff IG pl. 14, Schefold 20. About 400 B.C. (6) Gold horse-nasal from Tsymbalka barrow, Minns fig. 54; Ebert, Südrussland fig. 39 and p. 145. Fourth century B.C. A much earlier attempt to use the gorgoneion-snakes for ornamental purposes is to be seen on an amphora of Nikosthenes, Louvre F 99, CVA Louvre 4, III H e pl. 32, 1, 3 (France 198). I should also like to mention the snakes of kerykeia: AM 63/4 1938/9 pls. 17 ff.[7]

Etruria. Bronze ornament of chariot, New York, Bull. Metr. Mus. 1939, 42 fig. 2; Studi etruschi 13 1939, 433 pl. 32, 4: the lyre is formed by two snakes, whose tails support an 'acanthus' palmette (JL 42). Date late first half of fifth century B.C. Intertwined snakes are on two amphorae in Leyden, Brants 2 pl. 16, 7, 8; Dohrn, Schwarzf. etr. Vasen 144 nos. 24-5.

The North. The last zoomorphic lyre I should like to discuss was found at Faardal in

[1] Ausstellung Chinesischer Kunst Berlin 1929, no. 1236; ESA 9, 259 (Werner).
[2] Jacobsthal, Ornamente pl. 118, 1 b, p. 150; JHS 56 1936 pl. 3. [3] Jacobsthal, Ornamente 150.
[4] The appearance of birds' heads in the bottom ornament is deceptive.
[5] The gold finger-ring, Berlin, Furtwängler, Beschreibung

der geschnittenen Steine no. 150, should be mentioned here, a work of the sixth century B.C., with certain features which possibly point to Phoenician influence. The bezel has the shape of a lozenge, related to *PP 186* ff., with side scrolls transformed into birds' heads.
[6] The objects are not to be found in the National Museum of Athens. [7] See Addenda.

Jutland (Denmark),[1] *pl. 236, a.* It is 11.3 cm. high and 9.5 cm. broad; the pieces were cast separately and assembled; below is a flat peg with a rivet-hole. The horns of the right beast are now missing. In *pl. 236, b–d,* I illustrate a pair of similar bronzes from the find, slightly taller, each with its own peg: put together they also form a lyre-like ornament. One head has furrows on the forehead: whether Kjaer rightly assumes that this points to a different sex of the animal I am unable to say. A third piece, *pl. 236, e,* about 7 cm. long, has the body of a snake, and the head resembles that of a horse and bears a crest. The pegs are set aslant. The three bronzes, alike in workmanship and style, were fixed on one or more biggish implements. Kjaer (by letter) states that there are traces of a resinous substance on the pegs of the two-part lyre.

The bronzes form part of a hoard which contains the following other objects. A 'hanging bowl' (Kjaer 239 fig. 7), corresponding to that in *pl. 238, b.* They belong to Montelius's type F (Ebert 5, 118 pl. 26; 9 pl. 138); their date is Montelius VI = S. Müller VIII, i.e. about seventh century B.C. Then (Kjaer 241 fig. 8) a bell-shaped 'pectoral' like the piece *pl. 238, c,* contemporary with the hanging-bowls (Ebert 9 pls. 137, d and 138). Furthermore, an imported girdle (Kjaer 244–7 figs. 10–13) of roughly the same date. Finally a cast bronze statuette of a woman, kneeling, with a fringe-girdle, necklace, pigtail, and gold-plated eyes, also an import (Kjaer 253 figs. 21–3). A fringe-girdle is also worn by the pot-carrying woman on the bronze razor from Itzehoe (Undset, Das erste Auftreten des Eisens in Nordeuropa 305 fig. 27; RA 1909, ii, 114; Ebert 3 pl. 121, e; Kühn 314) and by the bronze statuette of a juggler in Copenhagen, Kjaer 263 fig. 29 (Hanfmann p. 125) which is connected with Etruscan figurines such as Hanfmann fig. 2, or more probably with their Oriental models. The technique of the eyes, as Professor Valentin Müller informs me, points eastwards. But it is not yet possible to define the country from which the statuette came. Its age might well be the same as that of the other parts of the hoard.

The Faardal find being a hoard, each part of it has to be treated separately: but there is no reason to give the bronzes which concern us a later date than the rest of the find. Kjaer (p. 260) asked if they were not attachments of an Etruscan early-seventh-century bronze urn like that from Vetulonia, *pl. 236, f*: his answer was in the negative because the urns were too flimsy, but at any rate these vases give a useful hint, and quite possibly the Faardal lyres were the lateral handles, and the snake the lid-handle of similar vessels. But these were not Italic: the birds resemble many Hallstatt birds in Italy and elsewhere; the animal heads have no real analogy, yet their style might be explained by the following assumption. The model was one of those Oriental animal lyres of the kind that in the fourth century B.C. influenced Scythian bronzes such as *pl. 234, b, d, e,* and was then copied by a Hallstatt artist who added one of his beloved birds. Where is uncertain, but surely not in Italy. A parallel process of translation and blend is illustrated by the devices *pl. 237, a,* discussed on p. 57, and the girdle-hook from the Inn, no. 360, provides an analogy of the fifth or fourth century B.C. Thus the Faardal lyre is an apographon of an Oriental archetype earlier than the Persian silver bowl *pl. 234, a,* and possibly earlier than the Protocorinthian copy of a related motive (*pl. 235, b*).[2]

I shall presently discuss other Orientalizing ornaments of Nordic bronzes, *pl. 238, b, c.* That this wave from south-east Europe swept more substantial goods to the North than 'motives'

[1] Kjaer in Aarbøger 1927 = Mémoires de la Société Royale des Antiquaires du Nord 1929, 231 ff. (I quote the latter); Rosenberg in Danske Studier 1929; Arne and Tallgren in Mannus 24 1932, 18; Bjorn in Fornvaennen 1933, 332. I am obliged to the Keeper of the National Museum in Copenhagen for photographs and information; Professor V. Müller was kind enough to discuss points with me.

[2] Tallgren l.c. thought of an origin from a civilization with Hallstatt and Scythian ingredients. For sporadic Eastern influences in Hallstatt I refer to pp. 159–60.

is, I think, proved by the find from Eskelhem, Ebert 3, 124, which is dated by a hanging bowl of late type to the same period as the Faardal hoard.[1] The openwork disk, Ebert 3 pl. 23, points indirectly to seventh-century Italy, but the bridle-bits and the side pieces pl. 24, a, d, like those from Eastern Prussia, Ebert 9 pl. 219, e, probably came North from the steppes and the Puszta together with imported horses.[2]

To return to the object from which I started, the girdle-hook from the Inn, no. 360: the animal-lyre is a loan from the East. The manikin is not an improvised Celtic addition: lyre and man, both, come from the same source. He is a late descendant of the Δεσπότης θηρῶν, frequent among the Luristan bronzes.[3] No exact Oriental archetype is preserved but, as in other such cases, an Italic apographon: the Etruscan seventh-century bronze urn[4] *pl. 236, f* shows a little man, strongly geometrized, standing within a zoomorphic lyre.[5] And there is another class of Etruscan early-seventh-century bronzes, useful for my purpose, *pl. 237, a* top pieces of cup-handles.[6] Most of them are preserved fragmentarily, but there is a complete example from Vetulonia, tomba di Franchetta (Montelius pl. 197, 9); see also the handle from Spadarolo, Montelius pl. 96, 10 a, Hanfmann 59, no. 7, and a copy in clay, the urn from Chiusi in Copenhagen, CVA Danemark 5 pl. 212, no. 3. They combine, in obvious imitation of Oriental models, such as Luristan bronzes,[7] an upright thready human figure with a more or less animalized ring in which the figure stands and which it grasps. The sex is mostly uncertain, although in some cases earrings or breasts (see the urn in Copenhagen)[8] indicate a female. And like the girdle-hook these rings are decorated outside with little animals. The Etruscan, here as elsewhere, copied 'Syrian' models and embellished them with birds, &c. The question whether in the girdle-hook the addition of birds to the Oriental image of The Man in the Lyre is a Celtic feature or a feature of the model, and what exactly the model was, is unanswerable. But there is possibly a clue to the archetype of the Celtic clasp: among the Italiote fourth-century girdle-hooks clearly inspired by Oriental models[9] is one from Aufidena (Mon. Ant. 10, 345 fig. 72, b) with two openwork lyres very similarly arranged, though not zoomorphic; but there may have been others with animalized lyres. Thus it is likely that the Celt was not the first to apply the motive to the decoration of a clasp, but had before him an Eastern girdle-hook, already combining all essential features of the Austrian piece.

The zoomorphic lyre is *one* case of animalized ornament, another is the *animal tendril*, *pl. 233, d*. This motive is also of Oriental origin and the ways and periods of migration correspond to those of other Eastern motives in Celtic art. Again a wealth of Western apographa—and the Oriental archetype lost.

[1] For the chronology of the find see Moberg, Zonengliederungen der vorchristlichen Eisenzeit in Nordeuropa 38, 68, with pl. 4 and p. 71 fig. 12.

[2] For the material from SE. Europe see Ebert 14 pl. 10 c, 1; 24/5. Bericht RGK pl. 41, nos. 11, 17, p. 96; WPZ 19 1932, 25; 21 1934, 108; 25 1938, 129.

[3] Hanfmann 84; Charbonneaux, Préhistoire 1, 224; Luristan: Godard passim; Rostovtzeff, Syria 12 1931, 48.

[4] The piece, in Florence, was published in Not. Sc. 1895, 313 fig. 28; Montelius pl. 180, 14: from Vetulonia, Circolo del Cono. A complete list of the urns was given by Hanfmann 84.

[5] Other examples of zoomorphic lyres in seventh-century Italy are: Lid of bronze situla, Benacci 2, Montelius pl. 76, 30. Lid of bronze vessel from Novilara, Montelius pl. 150, 11.

Stamped on a clay urn, Fondo Arnoaldi, Montelius pl. 85, 4.

[6] *Pl. 237, a* illustrates the following pieces: (1) From Vetulonia, Florence, Not. Sc. 1900, 492; Roes, Geometric Art fig. 11, a. (2) From Vetulonia, Florence, Roes fig. 11, b; Hanfmann 61 no. 1. (3) From Capodimonte, Not. Sc. 1928, 439; Hanfmann no. 4. (4) Berlin, Roes fig. 10, a; Hanfmann no. 7, fig. 13. (5) BM, Roes fig. 10, b; Hanfmann no. 3.

[7] Godard, passim; JHS 53 1933, 295 fig. 19; AA 48 1933, 304 fig. 16; Payne, Perachora 1, 139.

[8] Blinkenberg and Johansen in CVA, l.c., text, take the figure for a male and think that a penis, separately wrought, was inserted in the hole; but the breasts are definitely feminine. Another such ornament of a clay urn, figured on the same plate, no. 4, is very coarsely copied from a bronze of the type Not. Sc. 1900, 482. [9] p. 147.

There is first a LM III sherd, *pl. 237, b* (Furtwängler-Loeschcke, Mykenische Vasen pl. 36, no. 364):[1] the offshoots of the spirals are necks and heads of birds. The second migration took place in the seventh century B.C.: *pl. 237, c*, a painted urn from Afrati (Annuario 10/12, fig. 122; JHS 44 1924, 278 fig. 6), a relief pithos from the same site (Annuario l.c. 51), a fragment of one (ib. fig. 49), show the Running-Dog pattern with lions' or snakes' heads. Of even more importance for the history of ornament in general, though not for our purpose, is the oinochoe from Afrati, *pl. 238, a* (ib. fig. 63b): a frieze of hanging arcs with lions' heads at their junctures.[2]

About the same time these motives percolated to Northern Europe. In *pl. 238, b, c* I illustrate two of those bronze ornaments[3] that also formed part of the Faardal hoard. In the bottom row of the hanging bowl the animals with tongue out are very clear, less so in the top row and in the lower frieze of the other piece; in the upper row of the latter the motive is not a continuous chain, but a repetition of single monsters with a snake-like body, recalling the Faardal bronze *pl. 236, e*. The patterns doubtless came overland from South Russia.[4] From there and the adjacent countries we have the following. (1) Gold bands, forming the frame of a leather cap, *pl. 239, a*; from Ositnjažka, gov. Kiev, Collection Khanenko, livr. 6, pl. 5, no. 563a; PZ 18 1927, 1; Ebert 13 pl. 38 C, c. (2) Silver beaker from the Danube, *pls. 226–7*. (3) Bronze hilt of dagger from the Kuban, *pl. 238, d* (Uvarov pl. 39). (4) Sino-Siberian bronze, Salmony, Loo pl. 26, 4. In Scythian bronze horse-cheek-pieces from Chertomlyk, Chmyrev, and Ogüz (JdI 41 1926, 176, Beilage 3) the Running-Dog is vaguely animalized; and there is a certain connexion between these zoomorphic Running-Dogs and the animalized antlers of Scythian stags like those from Garčinovo (ESA 9, 197 ff.) and from Axjutintsy (Minns fig. 75; Ebert 13 pl. 39 F, c; PZ 18 1927 pl. 6, 2; Rostovtzeff SB 454; Schefold 40). There is also the gold diadem from Kul Oba (Antiquités du Bosphore Cimmérien, ed. Reinach, pl. 2, 3, p. 42; Studniczka, Tropaeum Trajani 101 fig. 59), a local Greek mid-fourth-century work, inspired by Oriental models: κήτη growing out of the axils of tendrils.[5]

As in analogous cases Oriental textiles, βαρβάρων ὑφάσματα might have played a role in the transmission of the motives: none of course is preserved, but we have a copy of one, a mosaic in Delos by Asklepiades of Arados in Phoenicia, *pl. 239, b* (Mon. Piot 14 1908, 197, pl. 12,13; Studniczka, Symposion Ptolemaios' II 53; JHS 58 1938, 213 fig. 5): the similarity between the dragonized Running-Dog here and in the Nordic hanging bowl *pl. 238, b* is striking.

Equivalent to the zoomorphic Running-Dog and a variant of it are rows of single elements set at intervals.[6] Late eighth- and seventh-century examples are: (1) Aryballos from Cumae, Payne, PV pl. 5 no. 6 (eagle-protomae). (2) Oinochoe from Perachora, Payne, Perachora pl. 26, 2, 3, p. 95 (goat-protomae). (3) Faliscan urn, CVA Copenhague fasc. 5 pl. 195, 2 (eagles). (4) Faliscan urn, Hamburg, AA 32 1917, 99, 100 figs. 27, 27a (lions and debased birds). (5) Caucasian axe, *pl. 238, e* (ESA 9 103 fig. 46) and another in Vienna (WPZ 21 1934 pl. 1, 2), with disconnected dragon-protomai.

[1] Boehlau, AM 25 1900, 77, note 3.

[2] Related in principle to animal-tendrils is the relief from Tello, Ward 215 fig. 651, E. Douglas Van Buren, The Flowing Vase fig. 34, and the similar piece in the BM, fig. 35, showing a frieze of bowls set at intervals and the water flowing from pot to pot, the whole giving the effect of an 'ornament'. In a certain sense also the lapis-lazuli seal-cylinder Louvre AOD 124, Ward no. 1047, belongs here. I see on it a sort of stylized pergola of vines with grapes; above, the 'roof', with birds sitting on it at intervals; the whole on the border of 'landscape' and animal-tendril.

[3] (b) Montelius, Die älteren Kulturperioden, I, Methode figs. 241, 245; idem, Om den nordiska bronsålderns ornamentik (K. Vitterhets Historie och Antiquitets Akademis Månadsblad 1881, 17 ff. figs. 70, 73); Behn, Altgermanische Kunst pl. 3. (c) Lindenschmit pl. 46, 8; Behn, l.c.; Scheltema, Die altnordische Kunst pl. 14, 1. See also Sprockhoff, Handelsgeschichte der Bronzezeit pl. 32; Boehlau, PZ 19 1928, 80. [4] p. 57.

[5] On κήτη see Boehringer, Die Münzen von Syrakus 84.

[6] For sickles and curls, not animalized, see p. 71 and *PP* 125–34.

Such friezes bent into a round—an *animal whirligig*—occur in the following objects: Seventh century B.C. Bronze bowl Tyszkiewicz, Pfuhl fig. 134; Payne, NC 271, note 1 (griffins). Bronze bowls, Olympia, Bronzen pl. 52 no. 883, and Perachora pl. 51, p. 154 (griffins). Rhodian dish from Naucratis JHS 44 1924, 199 fig. 31 (griffins). Wheel of a miniature clay chariot from the unpublished *stipe votiva* of Ialysos (four lion-protomai). Rhodian plate from Naucratis, JHS 44 1924, pl. 7, 9; p. 197: the reconstruction of the animals is difficult and it is not even certain that the design belongs here.

Sixth century B.C. Fragmentary plate from Sanctuary of Demeter Malophoros, Mon. Ant. 32 1927 pl. 86, 9; middle Corinthian, first quarter of the century: six (?) foreparts of lions and horses, in alternation, round gorgoneion. Attic dinos, Akropolis 606 (Graef pl. 32; Beazley, Attic Black-figure 14): three lion and three horse protomai (bridled), alternating. About 560 B.C. Fragmentary Siana cup, Akropolis 1773 (Graef pl. 87): a puzzle. Amphora of Amasis, Berlin inv. 3210, Adamek, Unsignierte Vasen des Amasis pl. I; JdI 44 1929, 115 fig. 5; Neugebauer, Führer Vasen pl. 29; Beazley, Attic Black-figure pl. 9, 1: Athena's shield with lions and horses round the gorgoneion. Panathenaic amphora, Akropolis, Graef pl. 59, no. 923 a: horses and griffins instead. Panathenaic amphora, Brussels, CVA III H e pl. 13, 3a (Belgique pl. 26) with false restoration, the original state shown in Gerhard, Etruskische und kampanische Vasenbilder pl. B, 15: Athena's shield-device is a whirligig formed by three heads, necks, and wings of birds.[1]

The animal whirligig has the same history and origin as most of the motives described in the foregoing pages.[2] I know of only two specimens in Early Celtic art,[3] and they come from an outlying country, Carniola, from Magdalenska Gora, *pl. 239, c* (Treasures pl. 7 no. 20): as pointed out by Merhart, ib. p. 32, they copy Scythian models, one is illustrated in *pl. 230, f.*

Let us stand back and see the problems unobscured by lists and details. The Celtic Animal Style has a physiognomy of its own, and even a layman, looking at the beasts of the Lorraine flagons, of the Weisskirchen girdle-hook, and at others of their kind cannot fail to realize their Eastern character. There can be no question of Italy having been the source of this style: where there are analogies for certain Celtic features, both reflect the same Oriental works. In the main the repertory is a selection from the Scythian: the Celts, however, did not take over the Scythian menagerie lock, stock, and barrel: there is no Celtic example of the coiling beast (*Rolltier*) or of 'leg-ornaments', or of animals parasitic on other animals' bodies. The other source was Persia. The how, when, and where of these contacts will be discussed in Chapter 6.

I have occasionally described heads which could not clearly be defined as human or animal.[4] These were extreme cases. But there is throughout a great likeness between masks and animals. The animals are borrowings from the East, they are the πρῶτον; the human masks the ὕστερον, with no Oriental prototypes: the Celts created Man in the image of Beast.

[1] My attention was drawn to the vase by Professor Beazley.

[2] For morphology and origin of zoomorphic whirligigs I refer to Zahn in Anatolian Studies presented to Sir William Ramsay 447, 2; Rostovtzeff SB 451, 1; Schefold 58 and 63; Roes, RA 1934, 135 and IPEK 11/12 1936/7, 85.

A man whirligig decorates the interior of a black-figured Attic cup from Naucratis, JHS 49 1929 pl. 15, 3, p. 272: four busts of frontal gesticulating satyrs conjoined; Beazley and Payne refer to a lip-cup in Marseilles (photograph Archaeologisches Seminar Marburg 1296) with four heads of Athena clamped by the helm-crests.

[3] In later Celtic art animal whirligigs appear on Gaulish coins. Birds: de la Tour pl. 34, no. 8497; pl. 36, nos. 8868 and 8885–81 (Dict. arch. de la Gaule, coins no. 115); John Evans, The coins of the ancient Britons pls. E, 4 and N, 13. Horses: de la Tour pl. 34, no. 8486; Rev. num. ser. III vol. 3 1885 pl. 6, 4. Indistinct quadrupeds: de la Tour pl. 34, nos. 8503, 8505.

[4] To these should be added the clasp of a chain from a woman's grave at Loisy-sur-Marne (Bull. de la Société d'anthropologie de Paris 1899, 573–4 figs. 7, 8), apparently of the second or first century B.C.: the fantastic creature is possibly double-bodied.

CHAPTER 3
GRAMMAR OF CELTIC ORNAMENT

FOR the sake of clearness and the reader's convenience I illustrate this chapter by drawings, often simplified. I am not unaware of the danger of this method, but I trust that the reader himself will always take the trouble to cast a glance at the objects as they appear in the plates. The grammar is a morphology of Celtic forms, and comparative only so far as I display some analogous material from other civilizations, without, however, discussing in full the problems of origin and chronology of Celtic art: this will be done in chapters 5 and 6. I should also like to apologize for pedantry and verbosity; but I have found that even competent prehistorians are at a complete loss how to read and describe these ornaments: everything is a 'palmette'. And worse, some recent writers (whose books and papers I have deliberately ignored) discuss the deepest mysteries of style without taking pains to understand and to analyse first what they are talking about.

LIST OF PATTERNS (*pls. 261-79*)

(Quoted *P, PP*)

1 no. 153 *d* 2 no. 21

3 Bronze girdle, Schaeffer fig. 187, 77

4 Bronze girdle, Schaeffer fig. 187, 141

5 Bronze girdle from Hallstatt, Sacken pl. 10

6 Clay urn from Braubach, AuhV 5 text 336 fig. 4, left

7 Pottery from Hallstatt, Sacken pl. 22

8 Clay cup from Braubach, Reinecke fig. 11; AuhV 5 pl. 8, no. 135; text 337 fig. 5

9 Clay urn from Hatzenhof (B. A. Parsberg), AuhV 5 pl. 50, no. 905

10 Clay cup from Husineč, near Klattau (Bohemia), Reinecke fig. 8 b

11 Clay jug from Dürrnberg, WPZ 19 1932, 42 pl. 17

12 no. 18 13, 14 no. 170

15 no. 185

16 Clay urn from Schrotzhofen (B. A. Parsberg), AuhV 5 pl. 50, no. 906

17 no. 405

18 Clay urn from Thurnau (Oberfranken), Reinecke fig. 8 a; PZ 24 1933, 137 fig. 9, 8
See also pottery from Ranis (Thüringen), Mannus Bibliothek 5, 21 fig. 19. Impasto urn, Montelius pl. 379, 14

19 no. 397

20, 21 Bronze ornaments from Lousoi, Oe J 4 1901, 57

22 Bronze Olympia, Bronzen pl. 32, no. 621, Furtwängler, Kleine Schriften 1, 346 fig. 2

23 Boeotian fibulae, Hampe pls. 4, 5, nos. 62 a, 62 b

24 Silver diadem, Orsi, Templum Apollinis Alaei 97 fig. 58

25 Italo-Corinthian pottery: CVA Cambridge 1, III C pl. 4, 40 (Gr. Britain 242)
Compare CVA Copenhague 2 pl. 95, 12; CVA Madrid 1, III C pl. 2, 1, 2 (Espagne 11); Munich 628, pl. 27, and others. Bucchero: CVA BM 7, IV B a pl. 13, 3 (Gr. Britain 444). Faliscan: Hamburg, AA 32 1917, 99 fig. 27. See also the bronze openwork from Montecalvario *pl. 243, d*

26 Gold plaque from Tomba del Guerriero, Tarquinia, Montelius pl. 288, 13; Mühlestein 54
Compare gold from Vetulonia, Pinza, Materiali &c. fig. 308; Karo in Milani, Studi e materiali 2, 107 fig. 64

27 Silver cauldron from Tomba Bernardini, MAAR 3 pls. 12 ff.; Mühlestein 16-19
Compare silver disk from Tomba del Guerriero, Montelius pl. 289, 9; glass bead from Fondo Arnoaldi, Bologna, Montelius pl. 84, 5

28 Silver cauldrons from Tomba Bernardini, MAAR 3 pls. 27-30
Compare bronze shield from Tomba Regolini-Galassi, Montelius pl. 337, 15; Mühlestein 122

29 Gold fibula from Tomba Regolini-Galassi, Montelius pl. 340, 5; Mühlestein 58
 Compare bronze fragments from Tomba Pania, Chiusi, Montelius pl. 224, 2, 3 (JRS 25 1934, 140), and others
30 Venetian situla, Déchelette fig. 664
31 no. 399
32 Gold bracelet from Pipe, Vienna; see *pl. 241, b*
33 Pottery from Glastonbury, Bulleid, Gray and Munro pl. 85, P 270
34–42 Ornaments of Roman brass basins
43–53 Torcs:
 (43) from Pleurs, Morel pl. 25, 3; Déchelette fig. 516, 6
 See also BM EIA fig. 60, 2 and Mém. Soc. Ant. France 44 1883, 126 (from Aulnizieux)
 (44) From Sens, Rev. des Musées 27 1930, 69 fig. 5, 2
 (45) Troyes no. 512, pl. 42, from Rouillerot, comm. de Rouilly-Saint-Loup, arr. Troyes
 (46) no. 242
 (47) Troyes no. 520, pl. 43, from Saint-Loup-de-Buffigny, arr. Nogent-sur-Seine
 Similar Morel pl. 38, 3
 (48) Morel pl. 26, 1
 (49) Sens, Rev. des Musées 27 1930, 69 fig. 5, 3
 Similar CdM, Babelon-Blanchet no. 1513, from Neuville-sur-Vannes, arr. Troyes
 (50) Morel pl. 26, 2
 (51) Sens, l.c. fig. 5, 1
 (52) no. 243
 Similar Album Caranda, Les fouilles d'Armentières, (2) 1882 pl. 30 no. 10
 (53) Saint-Germain no. 22164, from Bussy-le-Château
54 Clay urn from Eppelsheim, Behrens 179
55 no. 218 56 no. 387
57 Fibula from Ranis, Mannus Bibliothek 5, 18
58 no. 226
59 no. 41
 Other examples of zigzag leaves: Pillar from Pfalzfeld, no. 11. Helmet from Écury-sur-Coole, no. 138. Fibulae nos. 300 (*P 149*) 327, 328; Márton pl. 7, 8. Torcs no. 235; from Sarry, Marne, Déchelette fig. 563, 2; no. 231, Hungary. The ornament engraved

in the chariot-horn no. 168 also belongs here: the leaves have a rather floral character
60 Helmet, Berlin, Friederichs no. 1019
61 Black-figured Attic lekythos, Haspels pl. 2, 2 b (about 560 B.C.)
62 Late Corinthian hydria, Vatican, Payne 1443
63 Fikellura oinochoe, BSA 34 1933/4 pl. 16, c; p. 43
64 Ionic dinos, BCH 1893, 427 fig. 2
65 Black-figured Attic lekythos, Haspels pl. 14, 3 (about 525–500 B.C.)
66 Red-figured Attic aryballos, Not. Sc. 1932, 146 fig. 10
 On *PP 61–6*: the following Greek vases show the same motive. (*a*) Late Geometric fragment from Phaistos, Annuario 4/5 1924, 171 fig. 7. 8. (*b*) Middle Corinthian. Pyxis, Payne, NC 887, pl. 35, 7. Pyxis, CVA California 1, pl. 9, no. 5. Flask, Payne, NC 1072. (*c*) Little-master cup of Antidoros, Hoppin 53; Beazley, GGA 1932, 6 note 1. (*d*) Droop cup, JHS 52 1932 pl. 3, no. 86, p. 66 fig. 8; plate ib. p. 69 fig. 11. (*e*) Two black-figured cups, Hesperia 5 1936, 268 figs. 16, 17. (*f*) Nikosthenes and contemporaries: Hoppin 179, 217, 221; CVA Louvre 4, H e pl. 33, 13 (France 199); pl. 34 (France 200); pl. 36 (France 202). Oinochoe BM B 632, Jacobsthal, Ornamente pl. 47, a. (*g*) Oikopheles dish, Hoppin 299; Charites, Festschrift für Leo 456 (degenerated). (*h*) Early classical bell-krater from Al Mina, JHS 59 1939, 9 no. 26, BARV 428
67 Pottery from Glastonbury. (*a*) Bulleid 509 fig. 3; (*b*) fig. 1
68 Sword from the Thames, BM, Proc. Soc. Ant. 25 1913, 58 fig. 3
 Compare the Hunsbury sword, Romilly Allen, Celtic Art 97; Leeds, Celtic Ornament fig. 13
69, 70 Pottery from Canewdon, Proc. Preh. Soc. 1938, 164 figs. 1 and 4
 Compare pottery from Glastonbury l.c. 509 fig. 163; from Hengistbury Head, Hampshire, Kendrick and Hawkes, Archaeology in England and Wales 1914–31, p. 181; 21. Bericht RGK 1931, 147. Ireland: Journal R. Soc. Ant. Ireland 66 1936, fig. 14 facing p. 209; Proc. R. Irish Academy 43 1935 191 ff. See also the chariot from Dejbjerg and related motives on bronze girdle-

plaques from Schleswig-Holstein, Déchelette fig. 390; Ebert 5 pl. 105

71–4 nos. 16, 17 75 no. 24

76 *a* no. 150 76 *b* Helmet in Erbach

77 Helmet New York, Richter, Bronzes no. 1552
 Add to nos. 76, 77 the helmets CdM, Babelon and Blanchet no.2019, Ebert 5 pl. 90, a; from Martres-de-Veyre (see p. 116 n. 10); from Sanzeno, Not. Sc. 1931, 427 fig. 25

78 no. 143 79 no. 30

80 Torc, Fourdrignier, L'âge du fer &c., Congrès d'Enghien, Fédération arch. et hist. de Belgique 1898 fig. 3

81 no. 216 82 no. 44 83 no. 386 (a)

84 Rhodian relief pithos, Blinkenberg, Lindos, text 259 fig. 32, 7

85 ib. fig. 32, 8

86 Fragment of Rhodian relief pithos, Louvre

87 Rhodian Late Geometric pot, Cl. Rh. 6/7 fig. 38

88 Geometric Protocorinthian krater, Payne, PV pl. 1, 2

89 Situla Arnoaldi, Montelius pl. 100, 1; Grenier, Bologna 318–19
 On *PP 84–9*. Other 'sentry-boxes' are: Rhodian: Cl. Rh. 4 fig. 339 and fig. 345 (CVA Rodi 1, II D e pl. 3, 3 (Italia 410). With hooks like *P 85*: Louvre A 396, Pottier pl. 13; CVA Rodi 1, II D e pl. 4, 1 (Italia 411); see also Cl. Rh. 8 fig. 15. Protocorinthian: AM 22 1897, 295 fig. 20; CVA Oxford 2, III C pl. 3, 9. Laconian: BSA 34 1933/4, 106 fig. 3. Bronze: basin from Trebenishte, Filow figs. 75, 80; Dodona, AM 63/4 pl. 36. Italy: disk in Florence *pl. 244, a*
 The sentry-boxes on Capuan bronze casseroles (Willers, Die römischen Bronzeeimer von Hemmoor fig. 35, pp. 81, 208, and Neue Untersuchungen fig. 44) are geometrized kymatia

90 Bronze 'palette', one of a pair, Saint Gall Museum, from Montlingerberg, Jahresberichte der öffentlichen Sammlungen Sankt Gallen 1912/13 pl. 1. 30·5 cm. long. Twisted handle with a ring at the end, which stands at an angle with the oval. The engraved Z on the root of the handle is more likely a mark of the artist or the owner than decoration. The pendant is less complete. See Montelius pl. 180, 13 (Vetulonia, Circolo del Cono); Randall MacIver, Iron Age in Italy pl. 19, 11, 12 (Como); PBI 54 1934, 107; AA 50 1935, 524 (Pavia);

Germania 20 1936, 244 (a piece exported to Upper Austria: Lorch)

91 no. 402

92 Clay flagon from Höfen (B. A. Parsberg); Germania 20 1936, 171 figs. 2, 2a

93 no. 74 94–5 no. 229 96 no. 376

97 no. 252 98 no. 211 99 no. 11

100 no. 283 101 no. 228 102 no. 230

103 no. 46

104 Bohemian torc, AuhV 5 text 333 fig. 3, *a*

105 no. 96 106 no. 316

107 Fikellura amphora, BSA 34 1933/4, 80 fig. 15, 4 (simplified)

108 no. 233 109 no. 224

110 Fibula Troyes, BSPF 1916, 468

111 no. 212

112 Early Attic amphora, Neugebauer, Antiken in deutschem Privatbesitz no. 142, pl. 59
 Compare Hesperia 2, 592, 595; 5, 35. Possibly the bronze openwork ornament Blinkenberg, Lindos pl. 29, no. 698, belongs here. See p. 82

113 Rhodian relief pithos, Cl. Rh. 4 fig. 358

114 no. 382 115 no. 184 116 no. 136

117 Clay urn from Caurel-les-Lavannes (Marne), Déchelette fig. 661, 1 (the neck-pattern, omitted here, is *P 250*)

118 no. 100 119 non exstat

120 Northampton amphora, Clazomenian, Burlington Fine Arts Club Exhibition 1904 pl. 90; Beazley, Papers of the British School at Rome 11 1929 pl. 1; Endt, Jonische Vasenmalerei pl. 2, 16

121 'Pontic', Endt l.c. pl. 2, 37; Ducati, Pontische Vasen pl. 17, b

122 Etruscan omphalos-cup Munich 994, pl. 44
 Very much the same on an Etruscan amphoriskos in Hamburg, AA 43 1928, 350 fig. 66

123 Droop plate JHS 52 1932, 69 fig. 11

124 Bronze from Comacchio, PZ 25 1934, 98 fig. 59, c

125 Early orientalizing Cretan, Annuario 10/12 fig. 460

126 Hair of gorgoneion from Thermon, Payne, NC 80 fig. 23, D

127 Painted Etruscan oinochoe from Bocchoris tomb at Tarquinia, Montelius, pl. 295, 15; AM 45 1920, 109; Ebert 3 pl. 28, c

128 Bucchero skyphos from Tarquina, Montelius pl. 284, 5

129 no. 55 130 no. 141 131 no. 140

132 no. 24 133 no. 401 *h*

134 no. 401 *i*

135 no. 214

Compare the frame-pattern of the bronze girdle from Watsch, Ebert 3 pl. 121, g; 14, 256

136 no. 104 137 no. 17 138 no. 301

139 Bronze, Schaeffer fig. 88 (see *P 284*)

140 Celtic helmet in New York

141 no. 147 142 no. 16 143 no. 395

144–6 no. 390 147 no. 101

148 Rivet-head from La Gorge-Meillet, Fourdrignier pl. 8

149 no. 300 150 no. 357

151 Clay urn in Châlons-sur-Marne, from Sogny, tomb 16, Thiérot, Tombes marniennes à Sogny-aux-Moulins, Rev. anthrop. 1930, 5 fig. 3 ('gravés d'une pointe très fine')

152 no. 382 153 no. 377 154 no. 398

155 no. 47 156 no. 381

157 Bronze mounting plaque from Castelletto sopra Ticino, Mainz, Behn no. 1080, fig. 17

158 no. 315 159 no. 387 160 no. 184

161 Helmet, from the Neckar, AuhV 4 pl. 55, 2

162 Silver torc from Trichtingen, Gössler, Trichtingen

163 no. 157

164 Helmet in America, unpublished (see *P 367 b*)

165 Phaleron vase Würzburg, Langlotz no. 56 pl. 4

166 Clay 'barrel-oinochoe', Florence, Minto, Marsiliana d'Albegna pl. 51; Ebert 8 pl. 11, a

167 Engraved impasto vase from Tarquinia, Montelius pl. 284, 4

168–73 Este pottery, Sundwall, Villanovastudien pls. 97 and 95

174 Bronze Hallstatt girdle from Panges (Côte d'Or), Déchelette fig. 357

To 174 (stippled) and 165 (hatched) compare Rhodian gold ornament BMC Jewellery pl. 13, no. 1159. Bronze basin AM 63/4 1938/9 pl. 26, p. 152 (both seventh century B.C.)

175 Bronze Hallstatt girdle, Schaeffer fig. 31, pl. 6

176 Gold ornament, Berlin, PZ 19/20 1928/9, 157. The motive, more regularly drawn, is frequent. Early archaic: Chigi vase, Payne, PV pl. 28, 1, on the shields. Cycladic, Mon. Ant. 32 pl. 80. Bronze statuette of woman from Brolio, Mühlestein 181, 183 (blurred), on girdle, and possibly on sleeve; about 600 B.C. (Hanfmann 89). The other bronze 'palette' from St. Gall (see on *P 90*). Later are the following Etruscan examples.

Frame-pattern of Felsinean stelae, Mon. Ant. 20, 563, 597, 601, 651. Mirrors, Gerhard 211; Bull. comm. 46 1918, 233 and AA 41 1926, 326, Beilage. Bronze buckets, Dall' Osso 253 and BMC Bronzes no. 650, p. 107, fig. 18; EIA fig. 24. Volterra krater RM 30 1915, 158 fig. 19. North: Pottery, Dordogne, Déchelette fig. 330; from Degenfeld (Württemberg), BM EIA fig. 39, e.

177–8 no. 386 (b) 179 no. 381

180 Hallstatt C clay cup from Dietkirchen (North Bavaria), PZ 24 1933, 101 fig. 1, 7

181 no. 145

182 Bronze torc from Saalfeld, Meiningen, AuhV 4 pl. 3, 1

183 no. 157

184 Bronze torc, Fourdrignier, L'âge du fer &c., Congrès d'Enghien, Fédération arch. et hist. de Belgique 1898 fig. 3

185 no. 4 (B) 186 no. 419

187 Gold ornament from Fourth Shaft-grave at Mycenae, Karo, Schachtgräber pl. 66, no. 669

188 Ivory, Orthia pl. 143, 2

189 Ivory, ib. pl. 157, 1

190 Late Geometric pithos from Knossos, AM 22 1897, 236 fig. 4

191 Early Attic, Hesperia 1/2, 577 fig. 35

192 Cretan globular aryballos, Berlin F. 307, AM 22 1897, 239, pl. 6; Pfuhl fig. 56

193 Early Orientalizing Cretan, BSA 29 1927/8 fig. 34, no. 47

194 Same style, ib. pl. 13

195 Rhodian relief pithos, Cl. Rh. 4 fig. 336

196 Rhodian Late Geometric bowl, CVA Rodi 2, II D e pl. 6, 1 (Italia 472)

197 Rhodian Late Geometric oinochoe, ib. pl. 5, 1 (Italia 471)

198 Laconian imitation of Rhodian bird-bowl, BSA 34 1933/4, 115 fig. 9.

199 Urn from Oedenburg, Déchelette fig. 335

200 Rhodian oinochoe, CVA Copenhague, pl. 77, 1; Kinch, Vroulia 205 fig. 88, b; Jacobsthal, Ornamente 91; JdI 48 1933, 71, no. 7

201 Cypriote spout-jug, CVA BM 2, II C, c pl. 18, 8 (Gr. Britain 62); sixth century B.C. The contouring white dots omitted in drawing

202 'Pontic' oinochoe, Munich 923, pl. 33 and fig. 162; Ducati, Pontische Vasen p. 25; Dohrn, Die schwarzfigurigen etruskischen Vasen 147, no. 86a. A variant of the pattern, Lau, Die griechischen Vasen pl. 21

203 Sword from Melgunov, Ginters pl. 2, d; Ebert 13 pl. 34 A, d

204 Lausitz pottery, Ebert 7 pl. 198, k

205 Hallstatt bronze girdle, Schaeffer fig. 186, no. 27

206 Another, ib. figs. 24; 187, no. 103

207 Another from Hallstatt, Sacken pl. 10, 7

208 Bronze girdle-hook from Giubiasco *pl. 242, b*

209–10 Two clay urns from Écury-sur-Coole, Châlons-sur-Marne, Thiérot Collection

211 no. 32

212 Bronze Hallstatt girdle, Marseilles *pl. 250, d*

 Add to *PP 186–212*. (A) Cretan. Matz, Frühkretische Siegel pl. 12, 3.

 (B) Eighth century B.C. Theran amphora, Dragendorff, Thera 2 figs. 341 and 342. Early Attic, CVA Berlin 1, pl. 8, 2 (bungled).

 (C) Seventh century B.C. Greece. Gold plaques from Ephesus, BMC Jewellery pl. 9 nos. 827, 840–1, 877, 880; pl. 10 no. 1049. Gold bracelet from Delphi, BCH 63 1939 pl. 32, p. 102. Olympia, Bronzen pl. 42, no. 748, pl. 43, no. 754. Pottery: Shield-device on Euphorbos plate, Pfuhl fig. 117; JdI 48 1933, 76. Etruria. Fibulae, in Perugia, Montelius pl. 250, 2; compare Not. Sc. 1914, 43, 44 (Terni); Not. Sc. 1917, 80 (Populonia). Girdle from Falerii, Montelius pl. 307, 7. Gold pendant, AA 43 1928, 409/10 figs. 125, 126. Latent in Montelius pl. 82, 6 (Bologna, Arnoaldi).

 (D) Sixth century B.C. Shield-device on bronze relief, Dresden, AA 4 1889, 104. Painted on breast of terracotta, F. R. Grace, Archaic Sculpture in Boeotia figs. 38, 41; Winter, Die Typen der figürlichen Terrakotten 1, 9 fig. 2. Gold plaque from South Russia, Ant. du Bosphore Cimmérien pl. 22, 14; Furtwängler, Der Goldfund von Vettersfelde 40 (no provenience, date not quite certain). Earrings of kore 675, Payne and Young pls. 49, 50; Alexander, Jewelry p. 24. See also the gold finger-ring Berlin, Furtwängler, Beschreibung der geschnittenen Steine no. 150, discussed on pp. 55 n. 5; 125.

 (E) Fifth–fourth century B.C. Gold plaques of Greek Iranizing style from South Russia in New York, Alexander, Jewelry no. 102.

 (F) From other countries. Axe from the Koban, WPZ 21 1934 pl. 5: goes with the type in the Etruscan pieces (C). Fragment of pot from Prennertshofen (B.A. Beilngries), Oberpfalz, AuhV 4 pl. 67, 5; 'Lausitz' style.

 The lozenge sketchily engraved on the back of the gold 'spoon' from Klein Aspergle, no. 23, recalls that on the bronze girdle in Marseilles, *pl. 250, d P 212*

213 no. 139 214 no. 401 *k*

215 no. 401 *o* 216 no. 90

217 no. 381 218 no. 96

219 Hungarian gold ring, Gössler, Trichtingen fig. 6

220 no. 217

221–3 Early Attic pottery: (221) CVA Berlin 1, pl. 3, 2. (222) JdI 2 1887, 46 fig. 6. (223) CVA Berlin 1, pl. 2, 3

 There are countless examples of *P 221* in Villanovan pottery. For *PP 223, 227, 228* compare also Este I, Montelius pl. 50, 10; Villanova, Montelius pl. 92, 15, 16; Arsenal, Bologna, Montelius pl. 87, 6; Bisenzio, Montelius pl. 254, 15 and others

224 Boeotian amphora, CVA Copenhague 2, pl. 68, no. 2b

225 Rhodian relief pithos, ib. pl. 66, 1

226 Early Corinthian aryballos, Payne, NC no. 485 A text 287 figure

227 Early Corinthian aryballos, ib. no. 481, text 287 fig. 123 bis

228 Late Corinthian hydria, Vatican, ib. no. 1443

229–33 Laconian II patterns, BSA 34 1933/4, 124 fig. 12

234 Hallstatt urn from Bois de Langres, Déchelette fig. 247

 See also the urn from Diarville, Meurthe-et-Moselle, ib. fig. 219, 4

235 Sword from Novilara, Montelius pl. 146, 9; Randall MacIver, Iron Age in Italy 112 fig. 30

236–7 Bronze disk in Florence *pl. 244, a*

 For *PP 236, 244, 247* compare the seventh-century Greek bronze basin AM 63/4 1938/9 pl. 26, p. 152

238–42 Este III ornaments, Sundwall, Villanovastudien 95, 9; 97, 11; 100, 6; 100, 19; 100, 16

243 Bronze girdle, Schaeffer fig. 47

 Similar, a Swiss girdle, Ebert 11 pl. 132, 15. Italy: pot from Tarquinia, Montelius pl. 275, 4. The motive was studied by Kunze 93.

244 Bronze cista from Klein Glein, PZ 24 1933, 239 fig. 19 (see also figs. 23 and 27b)

245 no. 34 (31, 32)

 Compare the patterns of Hallstatt girdle Schaeffer figs. 110 h, 187 nos. 128, 131, and the urn from the Marne Déchelette fig. 659, 2

246 no. 221 247 no. 34 (29) 248 no. 375

249 Fragment of bronze beak-flagon from Dürrn-berg, Salzburg, WPZ 19 1932, 47

250 Painted urn from Caurel-les-Lavannes, Déchelette fig. 661, 1 (see *P 117*)

251 no. 96 252 no. 413

253 Urn from Breuvery in Châlons-sur-Marne, Thiérot, Nécropole gauloise de Breuvery (Marne) (1925), plate facing p. 12

254 no. 413 255 Sword, Vouga fig. 7 n

256 no. 401 *m*

257 no. 4 (A) (Gérin-Ricard pl. 4, 15)

258 no. 15 259 no. 132

260 no. 133 261 no. 414

262 no. 135

263 Spear-head from Sopron-Wienerhügel, Dolgozatok pl. 42, 2

264 no. 156 *f* 265–6 no. 129

267 no. 32 268 no. 389

269–70 no. 141 271 no. 395

272 no. 391 273 no. 25

274 Glass bead from Hatvan-Boldog, Dolgozatok pl. 52, 27, p. 157

275–6 no. 59 277–8 no. 41

279 no. 90 280 no. 61

281 no. 404 282 no. 217

283 no. 400

284 Bronze, Schaeffer fig. 88 (see also *P 139*). Nessel ib. p. 97 gives the following description of the piece: 'Objet très curieux en bronze doré à l'extérieur'—which I doubt —'en forme de cône, haut de 4.2 cm. Aux bords quelques petits clous qui servaient sans doute à fixer l'objet sur un corps probablement en bois. L'adhérence semble avoir été assurée en outre par une substance de mastic dont il y a beaucoup de traces. Corne à boire? sceptre?'

285 no. 250

286 Fibula, Troyes, BSPF 1916, 468

287 Sword, Vouga fig. 7 c

288 no. 132 289 no. 199 290 no. 376

291 no. 189: see *pl. 117*

292 Sword, Vouga fig. 7 k

293 no. 367

294 Fibula Münsingen, Wiedmer-Stern pl. 16, 4

295 Bronze basin, Tonnère, BAF 1920, 103 pl. 1, *pl. 249, a*

296 Attic gold band, BMC Jewellery no. 1219, p. 102 fig. 22

297 Bronze girdle from Este, Montelius pl. 52, 1; Randall MacIver 15 fig. 4

298 Relief pithos, Cl. Rh. 4 fig. 358 (see also figs. 345, 363, and vol. 8 fig. 190–1)

299 Limestone base from Nesactium, Pola, Gnirs, Istria praeromana 118 fig. 71 a; idem, Führer durch Pola 166; Duhn 2 pl. 23, d

300 no. 34 (6) 301 no. 18

302 The same, in Celtic

303 The same, in Greek

304 no. 34 (5)

305 The same, in Celtic

306 The same, in Greek

307 Sword from Varenna (Lake of Como), Montelius pl. 64, 14

308–9 no. 143 in Celtic and Greek

310 Compass-construction of the motive discussed p. 78

311 no. 157

312 Sword, Vouga fig. 7 f

313 *a–c* nos. 181, 182, 183 in Greek

314 no. 32 315–16 no. 382

317 no. 399

318 Celto-Venetian dagger *pl. 216, b*

319–20 no. 315 321 no. 72

322 no. 376 323 no. 355 *c*

324–5 no. 18

326 Sword, Vouga fig. 7 o

327 no. 92 328 no. 387

329–30 no. 19 331 no. 144

332 Ivory box from Chiusi, Tomba Pania, Montelius pl. 225, 7; Boehlau, Aus jonischen und italischen Nekropolen, plate facing p. 119; Graeven, Elfenbein 5–9; Mühlestein 53

333 Bucchero amphora, Berlin F. 1545, Milchhöfer, Anfänge der Kunst in Griechenland fig. 49; Roscher 2, 1057; Baur, Centaurs 113, no. 282

334 Painted clay basin from Veii, Not. Sc. 1928, 101 fig. 11

335 no. 387

336 Oinochoe of the Dutuit painter BM E 510, JHS 33 1913 pl. 9; BARV 205, 8; Jacobsthal, Ornamente note 335

337 Euphronios' Arezzo krater, BARV 16, 5; FR pls. 61, 62; Jacobsthal, Ornamente pl. 118, c (the drawing here is normalized)

338 Melian amphora, Conze, Melische Tongefässe pl. 1, 4; Riegl fig. 67

339 no. 382 340 no. 23 341 no. 196

342 no. 184 343–4 no. 171

345 Torc from Sommepy, Fourdrignier, L'âge du fer &c., Congrès d'Enghien, Fédération arch. et hist. de Belgique 1898 pl. 3 fig. 5

346 no. 251 347 no. 53
348 no. 332 349 no. 333
350 no. 245 351 no. 322
352 no. 207 353 no. 43
354–5 no. 44 356 no. 351
357 no. 95 358 no. 206
359 no. 144 360 no. 198
361 Torc, Fourdrignier (see on *P 345*) fig. 3
362 Torc, Troyes, BSPF 1916, 468
363 Torc from Lisieux, BSPF 1908, 642
364 no. 355 *g* 365 no. 18
366 no. 185 367 *a* no. 18
367 *b* Helmet, America (see *P 164*)
368 no. 162 369 no. 32 (*pl. 27*)
370 no. 30 371–2 no. 34 (1–4, 15–19)
373 no. 153 *b*
374 Amphora of the Dutuit painter, Louvre G
 203, BARV 205, 1
375 no. 385 376 no. 32 377 no. 23
378 Fibula from Hunsbury, Northamptonshire,
 Arch. Journ. 69, 427 fig. 3; Arch. Cambr.
 1927, 83 fig. 16; Leeds, Celtic Ornament
 fig. 8
379 no. 100
380 Bronze girdle from Büsingen, Konstanz;
 Bonstetten, suppl. pl. 3, 1; Wagner, Funde
 und Fundstätten in Baden 1, 17
381 Akinakes from Chertomlyk, Minns fig. 51;
 Ginters pl. 10, a; Luschey, notes 307 and
 315, p. 65. See above, 37 n. 7
382 Clay bowl, Thiérot, Nécropole gauloise de
 Breuvery (Marne) plate facing p. 8
383 Late Geometric oinochoe, Orthia 62 fig. 35
384 no. 73 385 no. 167
386 no. 60 387 no. 24
388–9 no. 20 390–1 no. 22
392 Gold ornament from Chlum in Prague, Pa-
 matky 21 1904/5 pl. 29, 4; Schranil pl. 45, 4;
 Stocky pl. 20, 2; JL 32
393 no. 41 394 no. 382
395 no. 96 396 no. 199
397 no. 316 398 no. 157
399 no. 158 400 no. 34 (11–14)
401 no. 139 402 no. 26
403–4 no. 42 405–7 no. 381
408 no. 168 409 no. 100
410 no. 18 411 no. 145
412 no. 350 413 no. 227 414 no. 226
415 Seal-cylinder, Délégation en Perse 8, 59;
 Ward 1228; Weber fig. 596 (Elam, fourth
 millennium B.C.)
416 Fayence pyxis from Susa, Rev. d'assyriologie

19, 228; Åberg, Bronzezeitliche und früh-
 eisenzeitliche Chronologie 4 fig. 19
417 Late Geometric Laconian, BSA 34 1933/4,
 106 fig. 3
418 Early Orientalizing Cretan, BSA 29 1927/8,
 279 fig. 34 no. 50
419 East-Greek cup, Cl. Rh. 6/7 pl. 3, p. 19
420 Ionic amphora from Olbia, Izvêstiya 1906, 148
 fig. 94
421 Lucanian nestoris BM F 176, Trendall, Früh-
 italiotische Vasen pl. 14, b
422 Graeco-Scythian gold band from Ryzhanovka,
 Minns fig. 74; Ebert 11 pl. 40, 9 p. 174;
 Schefold 29, Compare Rostovtzeff IG
 pl. 16, 4
 Add to *PP 413–22*: Bronze ornament from
 Brolio, Dedalo 1922 ii, 489, where the circles
 have become ellipses. The find being a hoard,
 this particular piece cannot be dated. Vol-
 terra kraters, Berlin 3986, Jacobsthal, Orna-
 mente pl. 149, and 3987, Bieńkowski 30 fig.
 44. Possibly the Greek model of the Siculan
 amphora, *pl. 219, g*, had an ornament of this
 kind
423–5 no. 381
426 Urn from Les Saulces-Champenoises (Ar-
 dennes), Déchelette fig. 661, 2
427 no. 104
428 Urn from the Marne, S. Reinach, Saint-
 Germain, Guide illustré fig. 144 (from
 fascimile: original in the Bérard collection)
429–31 no. 140 432–3 no. 275
433 *a* Helmet, Castle Erbach 434 no. 103
435–6 no. 156 *a* 437 no. 156 *b*
438 Urn from Sogny (Marne) in Châlons-sur-
 Marne, Thiérot, Rev. anthrop. 40 1930, 4
439 no. 55 440 no. 207 441 no. 55
442 no. 156 *e* ii 443 no. 414
444 no. 156 *e* i 445 no. 43
446–7 no. 156 *d* 448–9 no. 156 *b*
450 no. 43 450 *a, b* no. 377
451–3 no. 247 454–6 no. 15
457 no. 156 *f* 458 no. 212
459–63 Bronzes from Comacchio: (459) no. 401 *b*;
 (460–3) PZ 25 1934, 97–8
464–5 no. 136 466–7 no. 143
468 Bronze basin from Les Saulces-Champenoises
 (Ardennes) *pl. 249, b*
469 no. 189
470 Clay 'stamnos' from Saint-Pol-de-Léon (Finis-
 tère), RA 18 1891, 385 fig. 2; Déchelette
 fig. 663, 1; Márton 52 fig. 12, 3

471 Bronze hanging bowl from Cerrig-y-Drudion, Denbighshire, National Museum of Wales, and part in St. Asaph Museum. National Museum of Wales, Guide to the collection illustrating the prehistory of Wales (W. F. Grimes) fig. 38, p. 197, no. 461; Ant. Journ. 6 1926, 277; Kendrick and Hawkes, Archaeology in Great Britain and Wales 1914–31, 184 fig. 71; Hawkes, 21. Bericht RGK 150 fig. 146; Leeds, Celtic Ornament fig. 1; Journ. R. Soc. Ant. Ireland 66 1936, 213

472 no. 116 473 no. 270
474 no. 267 475 no. 175 *a*
476 no. 175 *b*

GEOMETRIC ORNAMENT[1]

First some *'graphic' peculiarities*. Dotted lines occur frequently, on metal and on clay. Most common are beaded lines: beading deprives a line of its flow and movement; this agrees with the 'static' character of Celtic ornament. Tremolo lines have historical importance. Their serrated ductus derives from a peculiar handling of the punch: this engraver's trick was already fairly widespread in 'Hallstatt' crafts in South and North[2] (*pl. 240, a, b*). The Celts do not confine it to the plain ornaments with which we are concerned here, as for instance nos. 90, 135, 358, 391, but also practise it with curvilinear, floral ornaments: nos. 100, 378.

CIRCLES, DISKS, AND DOTS are used as finials, as accentuation of joints, or as filling of spaces. They often also adhere to flowers and palmettes, incidentally spoiling their organic character. The same static tendency leads to replacing involutions of tendrils by closed circles. The following motives are noteworthy: a border of contiguous circles, as seen in the girdle-hooks from Schwabsburg, no. 351, and from Thüringen, no. 352, related to scale-borders. Circles connected by arcs: part of the Waldgallscheid chariot, no. 153, *d* (*P1*); pattern engraved on the amber inlay of the gold ornament from Schwabsburg, no. 21 (*P 2*); clasp from Berru, no. 177.

There are hundreds of examples of three circles forming a pyramid ∴, far less frequent are 3 + 2 + 1 and 4 + 3 + 2 + 1. The motive serves manifold purposes, standing upright or hanging downwards; it likewise accentuates axes, finials, joints; it fills spaces or axils. It also invades animal or floral ornament: it is latent in the griffins of the Parsberg brooch, no. 316, and in those of the girdle-hook from Somme-Bionne, no. 359; put on a stem it functions as Sacred Tree in the torc no. 240.

The pattern also occurs in archaic Scythian art: gold dagger-sheath from Tomakovka (Furtwängler, Goldfund von Vettersfelde 39; Minns fig. 45 (XXVI, 16); Ginters pl. 4, c; Schefold 62), gold pendant from Vettersfelde (Furtwängler l.c. pl. 1, 2). Later are the gold plaques from Bobritsa, Bobrinskoj, Smêla pl. 18, 7, Khanenko pl. 58, and from Sinjavka, Minns fig. 84 (Rostovtzeff SB 438).

The trios of circles when used for tectonic purposes grow in size: chapes nos. 93, 94, 98; cheek-pieces of helmets, nos. 141, 144, 145, 146, 147; attachments of a beak-flagon, no. 393 *b*,

[1] The classification 'geometric' and 'floral' ornament is a compromise: in point of fact the two classes overlap and some forms fit into neither. There is also arbitrariness in the sequence of the species; *P 156* is misplaced: it ought to appear with the flowers *PP 364* ff.

[2] (*a*) Greece. *Pl. 240, a* and compare Orthia pls. 121, 1; 166, 2. See also Olympia, Bronzen pls. 18, 20, 36. Waldstein, The Argive Heraeum pls. 99, 103, 104, 108, 132. Boeotian fibulae, Hampe pls. 10 ff.; Blinkenberg figs. 207, 210. (*b*) Italy. Bronze mounting from Castelletto sopra Ticino, *P 157*. (*c*) North. *Pl. 240, b* fragment of bronze girdle from Anet, Bonstetten, Suppl. pl. 15, 4. Bronze razor from Bois de Langres, Déchelette figs. 247, 1; 369, 10; pl. 6 no. 9. Girdle-hook from Essey-les-Eaux (Haute Marne) *pl. 251, a*. Fibulae from Uffing (Upper Bavaria), Ebert 3 pl. 104, e; Hallstatt, Sacken pl. 14, BM EIA fig. 36, 4 (see p. 28). Bronze cup from Les Favargettes, no. 396. Silver bracelet from Glasinač, Mitt. aus Bosnien u. der Herzegowina 6, 17 fig. 16. All Late Hallstatt.

of a spout-flagon, no. 389.[1] The motive is already used as handle-attachment in the late Hallstatt cup from Les Favargettes, no. 396, and its pendants from Este (Not. Sc. 1896, 312 fig. 6) and from St. Andrae near Etting, Upper Bavaria (Naue, Hügelgräber pl. 36, 1). If the disks increase in depth they become three balls: torcs *PP 43, 45*.

SCALLOPS AND SCALES. *PP 3* ff. It is not always possible to draw a clear line between the two kinds.

Scallops. Either downwards (hanging) or upright (standing). The arcs are either continuous or disconnected at the joints. The joints are accentuated by circles, dots, upright esses (*P 9*), star flowers (*P 10*), palmettes (*P 11*). The frieze of hanging lotus buds (*P 12*) belongs to a different stratum and family of ornaments; it is a common classical pattern: the source is possibly Este: see *P 31*. The arcs are mostly not abstract and thin, but garland-like, increasing in volume towards the middle. Sometimes they bear decoration: *PP 7, 8*—the latter shows wave lines, probably derived from the ornamentation of more elegant metalwork.[2]

PP 20–31 suggest that the source of these Celtic motives was in Southern arts of the seventh and sixth centuries B.C.[3] The ornaments are very persistent: see the decoration of brass basins of the second century A.D.[4] *PP 34–42*; British pottery also, from Glastonbury (*P 33*) and elsewhere, is full of them.

Scales. They are either thin, immaterial lines, compass-drawn or of equal thickness throughout, not swelling, and they lack accessories. They almost always stand upright and serve as a frame, exceptionally (*P 15*) they fill a field. Interlaced half-circles are not frequent (*PP 18-9*). The shingle-wise arrangement in the upper row of *P 19* has analogies in the 'trellis-work' of torcs (*PP 47, 48, 52*).

There is a strong resemblance between the decoration of the Dürkheim lid, *P 19*, and the Thracian gold pectoral from Brezovo, Bull. Bulg. 8 1934, 5 fig. 2,[5] here *pl. 240, c*. There is no reason to believe that the Celt copied an Eastern model: both works carry on the same tradition.

For the prehistory of scales I refer to *PP 20* ff.,[6] for their survival to *PP 34–9*.

ZIGZAG LEAVES (*PP 54–70*). In its original shape the ornament is formed by two rows of half-circles, so interlaced that the vertex of each arc is touched or almost touched by the point where two arcs of the opposed row join. But one can also read it as a zigzag band of lancet-shaped leaves, and this floral character has got the upper hand in *P 58* and even more so in *P 59*; see also *P 149* (p. 73) and the top row of the lower part of no. 192.

It is again likely a priori that the immediate source of the Celtic motive lies in archaic Italy, though in point of fact the Italic examples (see *P 27*) show it in a form hardly favouring the

[1] Déchelette 1454 erroneously describes the ornament as 'palmette trilobée'.

[2] *PP 466–8*; p. 95.

[3] The silver band from the temple of Apollon Alaios of which part is shown in *P 24* might well, as Orsi, Templum Apollinis Alaei 96 assumes, be a cheap work of the fifth century B.C., but if so, the motives are at any rate a survival of archaic style. The pattern at the tapering end is related to that on the top part of the spear-head from Hundersingen, no. 128. Compare also the Late Hallstatt bronze girdle from Montlaurès, *pl. 250, d*.

[4] I am greatly indebted to Dr. Nass who very kindly allowed me to see the complete material collected for his intended publication of this important class of vessel and to

copy his drawings. 'Most of the bowls were found in the Palatinate, many come from the Limes castella, from Württemberg, Baden etc. One was found on Kastell Holzhausen, destroyed in 230 A.D. Isolated pieces from the Marne, from Switzerland and Aquileia, about six from Germania libera; none from the East (Bohemia etc.)' (Dr. Nass). For the question where the ornaments hid for centuries, the occurrence of *PP 28, 38* in mosaics, Pernice, Die hellenistische Kunst in Pompeji 6 pls. 30, 1, 3; 31, 2, is of interest: mosaics often repeat textiles: see pp. 58; 81 n. 1.

[5] The photograph was kindly provided by Professor Filow.

[6] For the history of the motive in Greece I refer to Payne, NC 19, 2, and to Bulas, BCH 56 1932, 388. There is no need to deal with it, as the Celts certainly followed Italian tradition.

reading as zigzag leaves, the interlaced opposed scallops remain at a distance from each other. On the other hand, Greece,[1] especially pottery of the sixth century B.C., is full of the motive (*PP 61–6*).

P 32 shows part of the decoration of the gold armlet from Pipe. These Hungarian double-anchor bracelets have been much discussed and very various opinions on their chronology have been put forward: Márton 90; Oe J 11 1908, 259 ff. (Ebert). There are three pieces of special interest to us: (1) From Magyarbénye, Budapest, National Museum, Márton fig. 24. (2) From Pipe, Vienna, Naturhistorisches Museum, Arch. Ert. 14 pl. 35; Ebert l.c. 271 fig. 122; Pârvan, Getica pp. 338–40. (3) From Hungary, Arch. Ert. l.c. pl. 35, 2; Pârvan l.c. The bracelet from Bellye, Ebert l.c. fig. 121 is different.

I illustrate no. (1) in *pl. 241, a*, and no. (2) in *pl. 241, b*. (1) Thickness of flukes in middle 0·5 cm., at ends 0·3 cm. Maximum internal diameter of armlet 7·2 cm. Colour gold, yellow to greenish. Certainly not cast, but hammered out from a rod. Cross-section of ring round, inside slightly flattened. Decoration not cast, but punched and engraved. The edges hammered into flanges, as is especially clear on the reverse. The three false rivets not cast with the bracelet. (2) Technique identical. Colour of gold greenish, like old brass. Traces of tools everywhere, particularly of hammer on the back of flukes. Decoration on ring blurred by wear.

The ornaments clearly reflect the same stratum of forms on which, in this chapter, we hit again and again, and prove a date in the seventh (or sixth) century B.C.

The scales on the gold horn from Klein Aspergle, nos. 16, 17 (*PP 71–4*), differ from the type studied before:[2] they are, so to speak, more material, have double outline and fillings. This is not the result of their being embossed and not engraved, but points to a different origin: their source is Southern metalwork: the stratum in which they have their roots is clearly indicated by the neighbouring astragalus on the horn no. 16 (*P 142*).[3] Related to them are *P 75* and that of the openwork gold ornament from Dürkheim, no. 28.

Scales cannot be separated from *kymatia* or *tongue patterns* (*PP 78–82*), set in rows or 'collars': some are abstract, others (*P 82*) lively and leaf-like. On the Canosa helmet (*P 78*) one row—against classical rule—stands upright: compare also the Ticino flagons, no. 393 *a, c*.

The engraved Celtic decoration of the Etruscan beak-flagon from Weisskirchen (*P 83*) combines scales and rows of triangles, those at the bottom forming a shingle-pattern which recalls the treatment of scales in *P 19*; on their apices and on those of the scales stand vertical strokes, connecting them with the upper frame.[4] *PP 84* ff. show the Southern models, 'sentry-boxes' of different shape, sometimes with scales on top: the immediate source was probably again Venetian (*P 89*).[5]

SPIRALS. A. *S-spirals, single.*

(*a*) *Upright.* One at each joint of garland: *P 9*. In groups: *P 91*. In rows: *P 92*; frame

[1] The only Greek example in metalwork of which I know is in the bronzes from Lousoi, *P 20*. Persia: silver rhyton from the Kuban, Smirnov, L'argenterie orientale no. 15, pl. 15 (not clear in Sarre pl. 48). Phoenicia: silver cauldron from Tomba Bernardini, MAAR 3 pls. 12–18; Mühlestein 16 ff. Silver bowl from Chiusi, Montelius pl. 227, 3; Mühlestein 25.

[2] The horns, as pointed out on pp. 25; 114, are copies of Greek ones: these are most densely distributed in Southern Russia and Thrace. Some of them bear scale-decoration; the dog-rhyton with scales Rostovtzeff IG pl. 12, c, comes from the same grave as the ram-rhyton which is discussed on p. 25. From Trebenishte: Filow pl. 6 and Oe J 27 1932, 11, 12. From Karagodeuashkh: Minns fig. 121 and Ebert 13 pl. 30 B; Rostovtzeff SB 325. Compare the beakers from Trebenishte, Filow pl. 6; Oe J l.c. figs. 15–18. In all these pieces the scales are interpreted as feathers.

[3] p. 72.

[4] The same pattern in the chariot from Kaerlich, *P 13*.

[5] The 'sentry-boxes' with strokes on top have travelled as far as the Altai mountains: Aspelin, Antiquités du Nord Finno-Ougrien no. 581.

pattern on bracelet from Tarn, no. 275, *PP 432, 433*. *Sources*. Italy: Montelius pls. 85, 2, 9; 92, 7, 10, pottery from Fondo Arnoaldi, Bologna, and Villanova; bronzes from Villanova pl. 89, 9, 10. Faliscan bucchero oinochoe in Mainz, Behn no. 486, pl. 6, 1. Ivory pyxis, Minto, Marsiliana d'Albegna pl. 18, fig. 14; Mühlestein 52. Silver plaques from Tomba Barberini, MAAR 5 pl. 8: in the two last objects the pattern looks like the remnants of a dishevelled guilloche, slightly aslant. Bronze plaque from Castelletto sopra Ticino, *P 157* (double esses).

Greece: Rhodian relief pithos Cl. Rh. 8 fig. 23 and a variant, Kinch, Vroulia pl. 22, 2, 4.

North: bronze girdle, Schaeffer figs. 149, 187 no. 129; Gold cup from Cannstatt, Paret pl. 4.

(*b*) *Horizontal*. (1) *Single*, more or less adorned: *PP 93–5*. (2) *In rows*, either moving in one direction or alternating: *P 96*. Girdle-hook from Weisskirchen, no. 350, on top of the mask. Cuirass on the Pergamene balustrade, no. 132. Torc no. 209. On the bracelet from Bologna, *P 97*, the spirals are set in two rows, recalling Villanovan motives such as Montelius pl. 91, 24 or Sundwall, Villanovastudien fig. 11, no. 17.

B. *The running spiral*. Only the torc no. 211, *P 98*, shows the pure shape. The character is mostly obscured by the peculiar Celtic swell of the ribbon. Where there are two opposed rows in counter-movement, one is tempted to read them not as single rows but as the lyre-motive which results from their combination (see *PP 339* ff., p. 85). The pattern on the Valais ring, *P 100*, shows false spirals—a relapse into geometrism, typical of provincial art. A peculiarity is illustrated by *PP 101–4*, see also the crescents from Brunn, no. 377: here each of the spirals has its own involution, the one lying above the other; together the involutions form a motive which appears in a particularly clear shape in the Bohemian torc *P 104*, where the 'clasp' consists of two opposed lyres, and what one might describe as two peltae, point to point; in a somewhat obscured form the ornament is to be seen in the sword from Simunovec, no. 119, near the left edge. On the anthropomorphic interpretation of the pattern see p. 19.

C. *The wave tendril* (*Wellenranke*), *PP 108–11*. *P 107* gives a Greek example, chosen at random. *P 111* geometrizes the pattern, substituting circles for involutions, and even the treatment of the fillings has a close parallel in Greek ornament on the border of geometric and Early Orientalizing style, in an Early Attic amphora, *P 112*, of the late eighth century B.C., the more interesting as due to coincidence and not to concrete connexion.

D. *The Running-Dog* is rare, and seldom appears in the form familiar to classical art: *PP 113 –18*. In most cases the Celtic swell affects the pattern deeply: it does not run, but creeps lazily; sometimes additional features conceal the basic rhythm (*PP 115, 117*). Here again, when two rows move parallel, in opposite direction, the interpretation as lyres is equally possible or even more likely: see *P 342* and p. 85. The rhythm of Celtic Running-Dogs seems to have analogies in Southern Hallstatt arts: *P 113*, and see also the gold armlet from Magyarbénye *pl. 241, a*.

E. *Serpentines*. Elaborate in the bronze ornament from Comacchio, *P 124*, and coarse in the Ticino flagon, no. 393 *d* (handle). The rhythm is frequently applied to wire bracelets: Switzerland: Ulrich pl. 67, 15, silver. Viollier pl. 21, 98, 99. Italy: Montefortino, Mon. Ant. 9 pl. 7, nos. 25, 21, pp. 674, 679, the latter silver. Germany: Bretzenheim, Behrens 205. Wölfersheim, Kr. Friedberg, AuhV 5 pl. 57 no. 1061. France: Schaeffer fig. 170, A. Saint-Germain no. 33307, from Bussy-le-Château, and others in the same museum.

The motive has its roots in archaic Southern ornament:[1] *PP 120–3*.

[1] The painted white serpentines on Attic black- and red-figured lutrophoroi are a survival, recalling the snake: Richter and Milne, Shapes and Names of Athenian Vases fig. 40; CVA Louvre 8, III 1 c pl. 56 (France 512) and others.

CURLS.[1] *PP 129–34.* They can be interpreted as a variant of the Running-Dog, though they are mostly intermittent. Some look like Phrygian caps, some like sickles; those in the Amfreville helmet (*P 131*) are floralized: there is a tuft of four leaves on the ground and the design of the curl itself renders midrib and veins.

Curls belongs to the stock of Southern and Eastern Orientalizing ornament: *PP 125–8.* Other examples are: Italy: Faliscan kantharos, AA 32 1917, 97, 98 fig. 26 a. Clay puteal from Marzabotto, Montelius pl. 107, 15. Gold pin from Vetulonia, Karo in Milani, Studi e materiali 1, 267 fig. 36 and Pinza, Materiali per l'arch. toscano-laziale fig. 321. Persia: gold plaque, Dalton no. 32, pl. 12 (stylized hair of a Bes). Caucasus: Mat. Arkh. Ross. 34, p. 38 fig. 9. On animalized curls see p. 58.

GUILLOCHES. The most ornate example is round the foot of the Lorraine flagons, no. 381. The strands themselves are corals, in bronze sockets, the almonds in their centres are filled with engraved eyes, and on the other flagon they are filled with spirals instead, which enhance the leftward movement of the pattern; the spandrels between the cable and the frame are filled with stiff, wiry half-palmettes. Even more elaborate though plainer in technique are the engraved four-strand cables on the Ticino flagons no. 393 *b, d.* The guilloche on the sword from Sanzeno, no. 104, *P 136,* has double outline and is cross-hatched. Otherwise the design is simpler, e.g. in *P 135,* where the ring-dot patterns in the centres probably signify the pupils of eyes. Sometimes the continuity is broken and the cable becomes a chain of interlaced spirals, as in the engraved patterns beneath and above the coral guilloche of no. 381. One of the Celtic guilloches stands apart, that in the gold horn from Klein Aspergle, no. 17 (*P 137*). It looks like a row of interlaced horns, cross-hatched and bead-contoured.

The cable pattern, in the Orient as old as the fourth millennium B.C., finds its way to Greece in the eighth, to Italy in the seventh century B.C. The Celts borrow it from archaic Italy. The four-strand cable on the Ticino flagons (no. 393 *b, d*), however, reflects Etruscan fifth-century metalwork; their shape corresponds closely to the patterns on the Celto-Etruscan helmets nos. 147, 148.[2] The odd treatment of the motive in the Klein Aspergle gold horn no. 17 (*P 137*) has an analogy in the late eighth-century sherd from Phaistos, Annuario 4/5, 171 fig. 7, 5, but this is hardly more than accidental.[3] If this Celtic motive should not be a spontaneous invention, one could point to Persian motives like those on the gold dagger-sheath from the Oxus (Dalton no. 22, p. 10 fig. 45) as a possible model.[4]

The angular guilloche will be dealt with on p. 75.

ROPE PATTERNS.

A. In one direction. Exceptionally used for filling a panel: *P 138* and fibula from Münsingen, Wiedmer-Stern pl. 12, 4; Viollier pl. 3, 117 (coral-carved). Otherwise as frame: gold band from Eygenbilsen, no. 24 (*P 132*). Gold openwork from Dürkheim, no. 28 (bottom right). Gold bracelet, no. 55 (*P 129*), contouring the buffers. Beak-flagon in Salzburg, no. 382, edge of attachment. Girdle-hook from Schwabsburg, no. 351 (left). Chariot-horn from La Bouvandeau, no. 168. Pillar from Pfalzfeld, no. 11 (*P 99*). Pattern on garment from

[1] I refer to my remarks in PZ 25 1934, 77. The motive in the Waldalgesheim gold bracelet, *P 129*, has a good analogy in an unpublished bronze torc in Reims, which I am unable to describe in detail or to figure: the Keeper refused permission to study it.

[2] Other Etruscan examples are: bronze beaker from Filot-

trano in Ancona: Dall' Osso, plate facing p. 258, and, less clear, JRAI 67 1937 pl. 26, 1, 2.

[3] Kunze 91, note 5; compare the Late Geometric Rhodian vessel CVA Copenhague 2 pl. 65, 10.

[4] Luschey 63, note 358.

Roquepertuse, *P 185*. There are many examples of ropes in the Celto-Italic helmets dealt with on p. 117, and in glass bracelets, see e.g. Viollier pl. 34.

Though these ropes are not entirely alien from classical architectural and other decoration, they are far more frequent in outlying provinces of the ancient world. Scythia: bronze pole-tops, Borovka pls. 24, 25 (sixth century B.C.). Gold necklet from the Great Bliznitsa, Minns fig. 320, first half of fourth century B.C. (Schefold 22). Italy: examples in architecture have been collected by Studniczka, Tropaeum Traiani 79. Earlier than these, seventh century B.C., are fibulae, like Montelius, série A pl. I, 4; IV, 26; pl. 123, 15, 16 (related to *Wendelringe*). The iron implement Montelius pl. 240, 14, from Orvieto, with a reversing twist pattern (see below) cannot be dated. From the regions in Italy with which the Celts were in early touch we have the mountings of armour from Bergamo, no. 134 *a*, a brooch from Este, Montelius pl. 51, 2, and the Este situla in Providence, Bull. Mus. of Art, Rhode Island School of Design 28 1940, 6 (twisted feet of ὑποκρητήριον). The Celts being fond of twisting, it is not at all certain that the ropes are a loan and not their own invention.

B. *With reversion in the middle* (*PP 139–41*). The motive has forerunners in Late Hallstatt; In *pl. 241, c* I illustrate two rings of the Hunsrück-Eifel culture, forming part of the find to which the ring *pl. 248, c* belongs, and I refer to the Alsatian bronze ring Schaeffer fig. 165, 3 and to an iron toilet-instrument from Haulzy (Marne), Déchelette fig. 370, 4. *P164* can be interpreted as the geometric equivalent of these reversing ropes.

On the tubular bars of girdle-hooks (Hölzelsau, no. 360; Weisskirchen, no. 350; Praun-heim, *pl. 251, c*), in the Alsatian bronze, *PP 139, 284*, round the rim of the beak-flagon from Klein Aspergle, no. 385, the rope motive degenerates into flatness and coarseness.

ASTRAGALOI. I draw two, *PP 142, 143*. Others are: (1) Sword from Marson, no. 93, edging the plaque with the three masks. (2) Sword from Hallstatt in Oxford, no. 97. (3) Coral-carved in the bronze tube in Châlons-sur-Marne, no. 202 (B). (4) Bronze ornament Troyes no. 371, pl. 35, from Molins, arr. Bar-sur-Aube. (5) Fibula from Nechterzheim, no. 305, on the outer ridge of the foot part, not visible in the reproduction. (6) Beak-flagon in Salzburg, no. 382 (*P 339*), along the ridge of the handle.[1] (7) Gold 'acroteria' from Schwarzenbach, no. 34 (7–14), *Pl. 30*, blurred.

They copy classical fifth-century models with varying faithfulness and care. The astragalus seems already to have reached the North in the late phase of Hallstatt, as suggested by the ivory handle from Buchheim (Baden), Déchelette fig. 367, 1, or by the bronze bracelet from Hallstatt, BM EIA fig. 33, 2: but it is also possible that the technique of turning created the motive, independently of Southern influence.[2]

The more or less related patterns on the tubular bars of girdle-clasps cover a wide range: at the one end the forms are rather carefully modelled (Schwabsburg, no. 351; Marne, no. 355 *b*) at the other end coarsened so that finally only groups of engraved strokes remain, Gotha, no. 352; Langenlonsheim, no. 353; Hermeskeil, no. 354; Hölzelsau, no. 360; Praunheim, *pl. 251, c*.

STAR-ROSETTES. The ornament is seen in its purest form on the spout-flagon from Eygen-bilsen no. 390. It is compass-drawn. There are three variants: (1) *P144* middle; (2) *P145* (3) used twice as frame in (1) and once in the border round the foot of the flagon, *P146*. The pattern is done in 'red-figured' technique, the leaves being reserved and standing against a

[1] The handle-ridges of Greek sixth- and fifth-century metal vases often show related motives, see Neugebauer, RM 38/9 1923/4, 341 ff. passim.

[2] This is the opinion of Weickert, who kindly discussed the problem with me: he also approves the date given to the classical models of Celtic astragaloi. On the appearance of such classical motives in Northern Hallstatt see Reinecke, AuhV 5, 149.

background which is roughened with the punch. *P144*, middle, shows six-leaf stars, inscribed in a circle, and six leaves adhering to its circumference. But you can read the ornament in many other ways: this is inherent in this class of motives, which were given the name of *unendlicher Rapport* (repeat-patterns) by Riegl—motives continuable towards the four points of the compass and characterized by this sort of puzzling ambiguity. *P145* can be read either as a chain of four-leaf stars, or as a sequence of circles with four leaves sticking to the circumference[1] and with a ring-dot pattern in the centre, or as two opposite rows of zigzag leaves (see above, p. 68 and *PP 54–70*). Of these three interpretations the first is undoubtedly to be given the preference. The third motive is one of those zigzag leaf-chains, but looking closely one notices that a pair of two leaves is always separated from its neighbours by a tiny gap and that this interruption is also stressed by the one- or three-circle motives above or below them.

The following variants of this pattern are found in Early Celtic art. The first variant appears in the openwork from Somme-Bionne, no. 192—look at the intervals; in dishevelled form in the coral-incrusted ring from Weisskirchen, no. 101, *P147*; and still less recognizable in the openwork disk from Langenhain, no. 182. The rivet-head from La Gorge-Meillet, *P148*, lacks the six peripheral leaves. On the bow of the fibula no. 300, *P149*, only part of the motive is still compass-drawn, the lateral leaves are partly drawn freehand and have assumed the peculiar Celtic character. In the girdle-hook from Rodenbach, no. 357, *P 150*, the process of floralization has gone farther: the stars are separated from each other by triglyphs. The urn from Sogny, *P151*, shows a chain of four-leaves. The two-leaf frame-pattern *P144* has two analogies, on the shoulder of the Salzburg flagon, no. 382, *P152*, and at the end of one of the crescents from Brunn, no. 377, *P 153*: the motive on the Milan bird-askos, no. 398, *P 154*, is a member of the family, but is much livelier in form and movement.

Compass-drawn leaf stars belong to the same stratum of ornament as we always touch when tracing the origin of this class of Celtic forms. The leaf stars have their roots in the arts of the East, and invade Greece and Italy in the eighth and seventh centuries B.C. After Kunze, who has gone deeply into the problem,[2] there is no need for discussion or lists of monuments. I should only like to show the most magnificent example of the pattern, a Boeotian fibula in Berlin, *pl. 242, a*: six overlapping circles inscribed in a large circle, the background hatched, a very refined and skilful construction.[3] I append a short list for seventh-century Italy. Ivory box, Minto, Marsiliana d'Albegna pl. 16, p. 223 fig. 14 C. Bronze from Tomba Regolini-Galassi, Cervetri, Montelius pl. 339, 13. Bronze from Chiusi, ib. pl. 228, 1b. Shield-devices: of uteles feluskes, from Vetulonia (CIE 5213; Buonamici, Epigrafia etrusca pl. 16 fig. 24; Mühlestein 197; Blakeway, JRS 25 1934, 142, 143; Hanfmann 49; Möbius, RE s.v. Stele, 2322), and of the warrior on the stele from Monte Qualandro, Mühlestein 201. From the area of direct contact with the Celts we have the plaque from Castelletto, *P157*.

The star patterns survive down into Roman times (BMC Paintings and Mosaics, pp. 71–2;

[1] See also gold ornaments from Klein Aspergle, no. 32.

[2] p. 125. A few additions to Kunze's Greek and Eastern material: geometric plate from Samos, AM 58 1933, Beilage 33, 2 p. 110. Cretan: Payne, BSA 29, 279 fig. 34, no. 41. Fikellura: BSA 34 1933/4 pl. 17b, p. 43; Homann-Wedeking, Archaische Vasenornamentik fig. 7; fragment in Scheurleer collection, The Hague; Lambrino, Les vases archaïques d'Histria fig. 333. The vase-painters draw the pattern freehand and do not use compasses. Shield-devices: votive clay shield from Proto-Attic deposit, Hesperia 2, 612 fig. 79; ivory, Orthia pls. 109–10 (Poulsen, Der Orient und die frühgriechische Kunst fig. 116); black-figured Attic amphora (second quarter of sixth century B.C.), Tübingen, Watzinger pl. 5; Attic cup (same date), Cl. Rh. 8 fig. 105, pl. 5. Another example of compass-drawn continuous star-rosettes is in Phoenician ivories of the sixth century B.C. from Acebuchal (Spain), RA 35 1899, 155, 251, 281.

[3] Hampe pl. 5, 2. On the reverse of this brooch and on the other piece in Berlin, Hampe pl. 4, some of the circles are bungled, and trial lines are visible.

Pernice, Hellenistische Kunst in Pompeji 6 pls. 33, 38, 44) and beyond: O'Neill Hencken, Proc. Royal Irish Academy 43 1935, 209, gives a useful list.

CHEVRONS. A row of zigzag lines in simplest form appears on the top part of the Hallstatt sword, no. 96: double-contouring is confined to one side of the chevrons, thus introducing a one-way movement into the pattern. The motive on the little stud from Leimersheim, no. 380, shows dots at the points of the zigzag. *P 158* fills the triangles with a dot. Those on the Waldalgesheim flagon, *P 159*, bear a circle and a dot on top: here—quite logically—one of the horizontal borders has gone. *P 159* is unequivocal, a row of triangles, all pointing upwards (in other zones also downwards, see *pl. 191*), while *P 158* can be read as a chain of interlaced triangles, pointing alternately up and down: this reading comes to the fore when the perpendicular lines are drawn as in *PP 160–2*. Stippling or hatching is another means of stressing this character, see *P 163* and, not figured here, an urn from Sefferweich (Eifel), Trierer Zeitschr. 10 1935, 37 fig. 4. *P 164* is a ἅπαξ λεγόμενον. For its interpretation see p. 72. *PP 165–76* illustrate the source of the motives with sufficient clearness.

CHEQUERS. The engraved Celtic decoration of the imported Etruscan beak-flagon from Armsheim, no. 386 (*b*), *PP 177, 178*, consists of two rows of plain squares. Incidentally, the bungled ornament, covering throat and beak, compares with the decoration of the Schwabsburg brooch, no. 289, which, for its part, depends on Hallstatt models.[1] In some cases the chequers are variegated by change of colour and material: wood and bronze, spout-flagon no. 395; wood, bronze, and iron, chariot from Kaerlich, Germania 18 1934 pl. 1, 1–5; bronze and coral, Lorraine flagons, *P 179*: this ornament is a chequer-maeander,[2] copying either fifth-century Attic vases or sixth-century Etruscan pottery: the chequer-maeander has already reached the North in Late Hallstatt, as *P 180* shows. Or the chequers are differentiated by hatching: see the mane of the handle-beast no. 383 and the decoration on the bow of the fibula no. 318;[3] see also the golden sun on the sword in Mainz, no. 89. This treatment recalls basketry-work, which played a great role in later Celtic art of the British Isles.[4] Archaic Italic forerunners are the sword from Novilara, Montelius pl. 146, 9; Randall MacIver, The Iron Age in Italy 112 fig. 30, and the gold foil of leech-brooches from the Regolini-Galassi tomb, Pinza, Materiali per l'archeologia toscano-laziale figs. 120, 121.

ROWS OF SQUARES AND OBLONGS WITH DIAGONALS. In *P 181* the lines are thin, the four quarters of each square are filled with little circles.[5] In *P 182* and *P 183* the diagonals are swelling ribbons.[6]

LOZENGES. The pattern *P 184* shows that the previous motive, by omission of the vertical partitions, grows into a chain of rhombi. Further examples are the girdle-clasp from Giubiasco, *pl. 242, b*, where the points carry dots,[7] or the gold band round the silver rings no. 60, *P 386*: here the chain is a substitute for the normal carriers of flowers.

Single lozenges: on the sword no. 91; on the Roquepertuse garment, *P 185*, here as centre-piece of hatched squares; in the Hungarian urn, no. 419, *P 186*, subdivided into four smaller

[1] See p. 127.

[2] Eilmann, Labyrinthos 24.

[3] That this is an argument for the attribution of the two works to the same artist or school has been pointed out on pp. 30; 41; 108.

[4] On the hanging bowl from Cerrig-y-Drudion, *P 471*, see p. 95.

[5] There are numerous archaic Greek analogies, e.g. geometric Laconian, BSA 34 1933/4 pls. 22, b, 25, g. Rhodian oinochoe, ib. pl. 18. The motive of a square with diagonals and fillings, either single or in rows, is very common in many arts, and some of Miss Roes's constructions, JHS 57 1937, 248, are therefore dangerous.

[6] The same, less pronounced, in the girdle-hook from Bofflens, no. 358.

[7] Compare the button from Leimersheim, no. 380; see above.

rhombi, tendril-filled and with 'cog-wheels' at the corners: this motive actually belongs to the story[1] told in *PP 187–212*, the story of a lozenge with scrolls and the like at the four corners. Some of these patterns suggest that the lozenge itself is the *prius* and the adornment of the corners additions; others interpret the motive as four 'cup-spirals', enclosing a lozenge. Quite possibly the motive, from the beginning, had two roots. The way leads from Mycenae to archaic Greece and Italy and thence to Hallstatt and La Tène; a late survival occurs on those brass bowls, *PP 40* (and *41*).

Lozenges in chains. In *P 213* they stand plain against a hatched background: the motive is frequent in Hallstatt arts.[2] *P 214* gives it elaborate fillings; *P 215*, from the same find, resolves the rhombi into circles and dots. A continuous 'two-dimensional' network of lozenges, filled with swastikas, decorates the helmet no. 135, *P 262*, and the Hungarian spear-head, *P 263*.

Zigzag bands, forming lozenge rows, may become angular guilloches (*P 216*): at the junction each ribbon is alternately in the foreground and the background. The same feeling is expressed by designs such as *PP 217, 218*. A rare variant is the decoration of torc no. 217, *P 220*, where the two crossing bands have assumed the shape of lancet leaves, those running in the second plane having half the length of the others; a torc from Berru in Mainz (Mainzer Zeitschrift 29 1934, 91 fig. 10, 3) bears similar decoration.

MAEANDERS, STEP AND STAIR PATTERNS. The repertory of Celtic maeanders is poor and narrow. *P 245* shows one of plainest shape;[3] *PP 250* and *251* apply the tier principle: the former resembles merlon motives,[4] the latter, an interlacement of three-tier maeanders, has classical analogies. Very numerous are interrupted maeanders, such as the chequer-maeander on the Lorraine flagons (*P 179*), or on the stole of the squatting man from Roquepertuse, no. 4 (A),[5] and rows of hooks, either with a one-way movement, *PP 246–9*, or in opposed pairs, *PP 252, 253*: these can also be read as steps, leading up to a platform, a motive illustrated more or less clearly by *PP 256–8*. *PP 254, 255* show a flight of steps, on the latter hatched, as in an architect's sketch of a staircase. In *P 256* the filling palmettes spoil the meaning of the steps, and in *PP 258, 260* the motive is highly ambiguous and T's and crosses come to the fore. A cross with stepped outline stands on the back of a tombstone from the necropolis of the Senones at Montefortino,[6] *pl. 243, b*, and the Gaulish cuirass represented in the Pergamene balustrade, no. 132, *P 259*, is probably decorated with a stepped lozenge. Notice also the stepped contour of the stole of the man from Roquepertuse, no. 4 (A).

[1] First discussion of the problem AM 22 1897, 233 ff. (Sam Wide); then Dragendorff, Thera 2, 163.

[2] A few examples. *Greece*: Crete, eighth century B.C.: Pfuhl fig. 37; Payne, BSA 29, 270 fig. 32 no. 25; pls. 19, 21. Rhodes: AM 22 1897, 238 fig. 6; CVA Rodi 1, II D e, pl. 2, 2 (Italia pl. 409) (can also be read as two opposed rows of chevrons). Sixth-century terracotta revetments, 41.BWP 1881 pl. 1, 1 and 2, 6. *Italy*: Etruscan (and not, as some writers have assumed, Celtic) gold ring from Weisskirchen, *Pl. 254, d*. See p. 140. *North*: Hallstatt pottery, Württemberg, Déchelette fig. 332 and IPEK 1930 pls. 2 ff. Hungary, Déchelette figs. 217, 233, 335. Metalwork: Déchelette figs. 278, 340, 362 (the last also Henry, Les tumulus du département de la Côte d'Or fig. 30). Bronze ring of Mehren culture, Trierer Jahresberichte 1882–93 pl. 2 and p. 6.

[3] This type of maeander appears on an urn from the Marne, Déchelette fig. 659, 2, and, enriched by half-palmettes, on a pot of the following period, Déchelette, Vases ornés de la Gaule 1, 140; Hubert, Les Celtes 139 fig. 8; Anthropologie 1903, 402.

[4] JHS 58 1938, 214, note 35. For analogies in basketry-work and neolithic pottery see Bremer, PZ 16 1925, 25 ff.

[5] p. 5.

[6] *Pl. 243, b*, from Mon. Ant. 9, 684 fig. 22; Montelius pl. 151,1a,b;Linckenheld,Les stèles funéraires en forme de maison figs. 28, 29; Jacobsthal in Schumacher Festschrift (Mainz 1930) pl. 21, 3, 4, p. 190 and in JRS 29 1939, 98. Limestone, 81 cm. high, 27 cm. broad, and 18 cm. deep. Preserved, the bedding only; the cross itself was of metal. The stone cannot be connected with any particular grave, but they are all of the same date, the last years of the fourth century B.C. See p. 144.

PP 221–44 illustrate the history of all these motives in Greece, Italy, and in the North.[1]

SWASTIKA. In its basic form it only appears as filling of larger patterns (*PP 216, 262, 263*), possibly also in the gold openwork from Dürkheim, no. 28, though I do not feel sure about the reconstruction of the fragments. The other type, complicated and with tails, *PP 264–6*, is a derivative of maeanders and has a long prehistory in Hallstatt.[2]

SOME ODD MOTIVES. There are, first, patterns which look like drops or alembics and have one or more dots above or below. I illustrate some of them in *PP 267–72*, and refer to the gold balls from Grauholz, no. 38, to the gold band from Dürkheim, no. 27, and to those from Schwarzenbach, no. 34 (38–40), where they resemble exclamation marks. In *P 273* they have hatched acorn-like cups and are arranged on the scale principle. The glass bead *P 274*, from Hatvan-Boldog (Hungary), well dated by a pair of bracelets in the grave, Dolgozatok pl. 52, 29, 30, suggests that possibly the motives in question are, so to speak, drawings of ornaments in the round. I also call attention to the bronze ornaments, Wissensch. Mitt. aus Bosnien und der Herzegowina 3, 166 fig. 515. I am unable to say whether these motives have a Hallstatt ancestry, but would mention the vase-shaped ornaments on the gold band from Corneto, Bocchoris Tomb, Montelius pl. 295, 2, and the little plastic vases on the gold ring in Berlin which I shall discuss presently.

Certain ornaments of peculiar shape decorate gold rings: a 'cigar'- or 'cartridge'-belt the gold torc from Besseringen, *P 277*, egg-cups the bracelet from Rodenbach, *PP 275, 276*, and balusters the Besseringen torc, *P 278*. The closest analogy for these balusters, also in the round, is a bronze chain from a Celtic chariot tomb at Rappenau (Baden) *pl. 243, c.*[3] More commonly the balusters occur in pairs, opposite each other and flanking some central motive: *P 279*; fibula from Münsingen, no. 340; chariot-parts from Besseringen no. 155, *f, pl. 95*, Waldgallscheid, no. 153, *d*; see also the torc Viollier pl. 12, no. 21, p. 120, no. 66.

The habit of decorating gold rings on top with plastic ornaments carries on Hallstatt tradition: there are gold earrings with a row of hour-glasses from Les Moussellots, Déchelette fig. 363; Henry, Les tumulus du département de la Côte d'Or 75 fig. 30; PZ 20 1929, 160 fig. 2, and the gold ring in Berlin, ib. 157 fig. 1, made in seventh- or sixth-century North Italy.[4]

WHIRLIGIGS. One of them was the swastika. But now I study curvilinear whirls of which the Celts were so fond. I put aside the swell and other features which give them their specific look, and consider their build. I refrain from discussing their long and most interesting after-history in later Celtic art.[5] There are three- and four-part whirligigs, the latter much less frequent. Both comprise two essentially different kinds. I make this clear by comparing two four-part whirls *PP 280* and *281*, because these show the phenomenon more clearly. We call the scrolls, as they follow each other, *a, b, c, d;* in *P 280 a/c* and *b/d* form pairs: it is a cross of S-spirals, related to the swastika. In *P 281 a/b, b/c, c/d, d/a* are interconnected: a continuously running S-spiral encloses a space shaped like a sort of curve-sided square. In the first case the movement radiates from the centre, in the second it whirls round a central area which remains inactive—both principles familiar to us from fireworks.

As to details: first some of the *four-whirligigs*. *P 282* is a variant of *P 281*: the four spirals

[1] The hooks of the type *PP 242, 243* have been discussed by Kunze 93. See also Dohrn, Die schwarzfigurigen etruskischen Vasen 73.

[2] There is a splendid discussion of these motives in M.

Mayer, Apulien 213 ff.; see also Eilmann l.c. passim.

[3] See also the toilet-instruments from the Marne, Déchelette fig. 547. [4] *P 176* shows the hatched triangles of the ring.

[5] Leeds, Celtic Ornament, passim.

are not continuous, each starts with a scroll and ends in a tail swinging towards the circumference. The Val Comonica whirligig, *pl. 217, c*, omits the scrolls: flattened out, it would become a Running-Dog. The ornament of the sieve, *P 283*, is not different in principle from the motive in the painted cup, *P 281*; the scrolls at the four corners have been replaced here by swinging elaborate tendrils such as often occur with three-whirls, *PP 292–5*.

The following motives are ἅπαξ λεγόμενα. The middle row of the lower part of the openwork plaque from Somme-Bionne, no. 192, shows circles, filled—if you look at the solid bronze parts—with four revolving crescents, or—if you heed the open spaces between—with four revolving 'commas'. Crescent-whirls are familiar to sixth-century Greek vase-painting.[1] On commas inscribed in a circle, in pairs, or in triads, see below, p. 78. The pattern on the girdle-hook from Bofflens, no. 358, puts a whirligig consisting of four leaves into a square. A close analogy is offered by the decoration of the middle panel of the Alsatian bronze *P 284*, where the motive admits two readings: you can either see four such whirls, one in each corner, or give preference to the four-leaf star in the centre and to the two two-petalled lotus flowers growing from the side frame towards the centre.

Three-part whirligigs. Looking for examples which show the radial type in its pure shape, one discovers that there is always an irregularity (*PP 285–8*): from scroll *a* to *b*, and from *a* to *c* runs a well-rounded, normal S-line, but on the way from *b* to *c* is a break, more or less sharp.[2] The obvious reason is that one cannot give this type a regular, symmetrical form without enlarging the centre and giving it the shape of a concave-sided triangle. I will not enter into a study of the ingenious and pleasant variation of these patterns, I should only like to adduce an essential point. There are differences between *PP 289–91*—to which the bronze bracelet from the Tarn, no. 275, should be added—on the one hand, and *PP 292–4* on the other—to quote only extreme cases. The former are curve-sided triangles enclosed by S-spirals: whether these are thin, immaterial lines or ribbons (*PP 289, 291*) is in the main irrelevant. They 'stand' and are not whirligigs in a proper sense. It is easy to see or feel that the patterns *PP 292–4* have a greater potential rotation. Here the triangles at the corners pass into tendrils, swinging elastically backwards: the swing is more intense where, as in *P 292*, the tendrils are barren than where, as in *PP 293, 294*, they grow flowers, leaves, or fans.

Chains of whirligigs. Three- and four-part whirligigs are common in Hallstatt arts of different regions of Europe, as single motives or in chains and repeat-patterns:[3] see *PP 296–9*. The only motive occurring in Celtic art is the chain, running horizontally; there are no nets covering a space in all directions. *PP 300–6* show the ornaments of gold vases from the Schwarzenbach find: one in Celtic interpretation, the other in Greek. *P 300* is a chain of left-handed three-whirls. This is the purest of the three patterns; there is only one addition of floral kind—a leaf clings to the top spiral of every second whirl. Why not to each of them? Because, as a closer look reveals, two triangles always stick together, share the vertical spiral, and form together a quadrangular whirligig, in which this S-spiral is, so to speak, the

[1] BSA 34 1933/4, 73.

[2] The Greek who represented the Celtic cuirass in the Pergamene balustrade, no. 132, *P 288*, made a blunder over the pattern: the third spiral runs in the wrong direction.

[3] The four-part whirligig of the type appearing on the clay vase from Thalmässing, *P 281*, is as old as the Bronze Age: Boehlau, PZ 19 1928 pl. 19, 1, 2; pp. 68, 69; AA 50 1935, 666; Zervos, L'art en Grèce fig. 19; Matz, Frühkretische Siegel pl. 1, 10b; pl. 5, 1a. The same is true of the three-whirls:

Boehlau l.c. pl. 23, 3, 4; Matz l.c. Archaic art in South and East. Three-whirligigs as single motives in Greece: Proto-corinthian Macmillan lekythos, Payne, PV pl. 22, 1. Bronze finger-ring, Payne, Perachora 1 pl. 79, 31. Caucasus: Uvarov pl. 40, 12. Venetian: lid of urn, Ebert 3 pl. 25, b; Duhn 2 pl. 15, p. 82. For chain- and repeat-patterns of four-whirls see *PP 296–9*. A repeat-pattern of three-whirls is to be seen in the Caucasian bronze plaque Mat. Arkh. Ross. 34 pl. 16.

diagonal. A similar motive is seén in the lower frieze round the Canosa helmet, no. 143 (*PP 308, 309*), here somewhat latent. The Celts were not the first to find this variant; long, long before, the Greeks, playing with whirligigs, drew similar patterns: see Cycladic and Cretan examples, PZ 19 1928 pl. 19, pl. 22, 13, also 14. *P 301* is built of the same material as *300*: take the triangle with the adhering leaf in *300*, turn it clockwise round the bottom scroll[1] as pivot, until the top scroll nearly touches the ground; then do the same with another such triangle, but in the opposite direction. The result of this new combination of units is an alternation of downward two-petalled lotuses and upright lyres. The chief caesura lies at the former, and is stressed by the pointed filling-leaves in the top axil. You can either give heed to the triangular whirls and neglect the rest—*P 302*—or you can look at the lyres and flowers and ignore the whirls—*P 303*—or, if you like, you can try to do both at once. I shall have more to say on this important phenomenon of ambiguity.

The elements of *P 304* are triangular whirls without adhering leaves; the pairs are similar to those in *P 301*, but the angle at which they have been set is different, for the scrolls at the major caesurae are kept at equal distance from top and bottom line and the axils are filled with a rising heart-shaped leaf and a falling drop in the counter-axil. Again there are two possible readings, illustrated in *PP 305* and *306*.

I have already mentioned the ornament in the Canosa helmet, *PP 308, 309*, a chain of long-drawn-out quadrangular whirligigs with 'diagonals'—the same motive as in *P 300*: lyres arise as a by-product, pointing alternately up and down and bearing cup-spirals on top. The *interpretatio graeca*, *P 309*, is what Riegl has called *intermittierende Wellenranke*.[2]

The motive on the sword from Varenna, *P 307*, is an excerpt from such a chain; that such chains were known to these armourers is shown by the decoration of the sword from San-zeno no. 104 (*P 427*).

On the role whirligigs play in the context of tendrils I shall speak on p. 92.

Finally I have a word to say on a motive which occurs independently in the ornament of many countries and ages;[3] in Celtic art it is not too frequent. It consists of two intensely revolving *comma-leaves* closely clinging together *within a circle*. It is the result of a simple construction[4] (*P 310*): inside a larger circle two others are drawn which have their centres on the diameter of the first and have half its radius; then one draws an S-curve following first the right arc of the upper and then the left of the lower circle. Except for a unique variant with three instead of two comma-leaves, *P 311*, the pattern in Early Celtic art never occurs by itself, but only as a member of larger configurations. Most of these are lyres, and our pattern the interpretation of their head-scrolls. Examples are *PP 117, 312, 329, 330* (half gold, half coral), *341, 342, 344, 356, 464, 465, 469*; further, the haunches of the left dragon in no. 166, and the bronze ornament from Mairy, no. 379, where the bottom leaves of each of the two opposed palmettes have assumed this shape, so that, in deviation from the classical model, the lowest leaf of the palmettes swings upwards instead of drooping.

There still remain two patterns which may appropriately be mentioned here, *concave-sided triangles* and *quadrilaterals*, often inscribed *in a circle*. Triangles: *P 433, a*, nos. 275, 344 (see also the brooch Wiedmer-Stern pl. 12, 10), 351 (upper tip of the openwork), 401, *d, e*. Quadrilaterals: no. 335 (see also the brooches Morel pl. 27, 3 and Wiedmer-Stern pl. 12, 8).

[1] I say scroll: actually the scrolls here, as often, have been replaced by circles: see p. 67.

[2] Riegl 182.

[3] Zahn, Das Fürstengrab von Hassleben (Römisch-Germanische Forschungen 7) 88.

[4] Kaiser Wilhelm II, Die Chinesische Monade.

Both are often a by-product in those repeat-patterns with leaves attached to the circumference of a circle, mostly in openwork technique. Triangles: nos. 169, *b*, *c*, *f*, 180, 192. Quadrilaterals: nos. 153, *f*, 169, *e*, *g*, 193, *a*, *b*.

OPENWORK. Hitherto I have been studying ornaments regardless of the material and the technique in which they are made. Now I must deal with a class of motives which are so closely associated with material and technique, namely openwork, that one cannot study the one without the other. The patterns adorning these works belong in the main to those I have been dealing with, and some of them have been described already: but this does not mean that the technique was not applied to other, floral, ornaments of the kind I shall study in the following pages.[1] I am concerned here with flat ornaments cut from a sheet of bronze (in only a few cases gold)[2] and not with openwork in higher relief, such as, for instance, the chariot-parts from Waldalgesheim, no. 156, *b*, *e* ii, iii, the girdle-hooks from Weisskirchen, no. 350, Hölzelsau, no. 360, Este, no. 363, the Ticino, no. 361, the Valais, no. 364, and a very few others. The list of plastic openwork in Early Celtic Art is short: this technique became popular and important in later Celtic and Roman provincial crafts, which are not our concern.

A technique related to openwork is shown by the sieve no. 400 (*P 283*): the knowledge of patterned sieves probably came to the Celts from Eastern and Southern Europe where some have been found.[3]

One has to bear in mind that openwork requires a background; only then do the patterns and their intended ambiguity come out. I have made experiments and put some on a red cloth: the effect is the same as in coral-incrusted pieces like the ring of the sword-frog from Weisskirchen, no. 101 (*P 147*), &c. The lining is rarely preserved.[4]

I describe some works of interest, first the disks from Langenhain, nos. 181–3. Within the limits of the comparatively poor workmanship of this set, no. 181 is the best. The bronze ornament is clear, and one is hardly tempted to read the intervals, though these are not shapeless either; the decoration of this as of the other disks in the find is full of irregularities and not done with compasses: the measurements of the units, and the distances, vary, and the motives of the different zones are not related to each other. The pattern *P 313 a*, the Celtic equivalent of a Greek circumscribed palmette, is the sole decoration, upright in the outer zone and downward in the inner; in the outer, at the ends of the two chief diameters it is replaced by simple rings, in the inner, at the ends of one diameter—not coinciding with those of the outer zone—the axil between two adjoining 'palmettes' is filled with a lotus-leaf. These Celtic circumscribed palmettes occur in a slightly different shape in the girdle-hook from the Marne, no. 355 *b*, and it is worth noticing that the ornament engraved on the spearhead from Hundersingen, no. 128,[5] though of more fluid movement and despite the change due to interlacing, is related to it.

Nos. 182 and 183 are of inferior quality. The first has one frame-zone with radial strokes,

[1] Examples of floral ornament are: the dagger from Weisskirchen, no. 100; girdle-book from Schwabsburg, no. 351; chariot-parts from Waldgallscheid, no. 153 *d*, from Besseringen, no. 155, from Dürkheim, no. 166, from Kaerlich, no. 167, from La Bouvandeau, no. 171, &c.

[2] See nos. 18, 24, 26, 28.

[3] Filow, Die Grabhügelgruppe bei Duvanlij fig. 157; found on top of a hydria of the third quarter of the fifth century B.C., Filow l.c. pl. 16; BARV 713, 73. A bronze sieve from a fourth-century grave, Filow l.c. fig. 195. Silver sieve from a grave at Tamán, dated by a gold stater of Alexander, AA 28 1913, 185/6 fig. 12. Bronze sieve with simple perforation pattern from Olbia, AA 29 1914, 241 2, fig. 58. For Italy see G. Richter, Etruscan Art fig. 87, p. 30, note 30; on a patterned strainer from Hallstatt p. 175, note 2.

[4] For instance at Waldgallscheid, see p. 181, or at Somme-Bionne: Morel 48, Déchelette 1192.

[5] It is impossible to date either this or the bronze girdle from the mound, no. 133, earlier than the bulk of La Tène works, see Bittel 118.

the second two: within the frame a pattern of interlaced 'hearts'; the whole design is a variant of no. 181, and can easily be translated into Greek: *PP 313, b, 313, c*. The design is somewhat obscure. The disk from Septsaulx, *pl. 251, f*—to judge from the reproduction published and without having seen the original—seems to be of similar nature.

The decoration of no. 187 is clear and unambiguous: in the middle a star of eighteen rays and round it two rows of opposed scallops.[1] The ornament of one of the bronzes from Ville-sur-Retourne, no. 194, is constructed out of the same material, but is coarser in technique. No. 188 marks the chief diameters by four pointed leaves, and puts in each interval a circle filled with a concave-sided square: this circular design can also be interpreted as the pattern I have studied on pp. 72 ff.—if you observe the intervals and not the bronze. The decoration of the disk from Berru, no. 186, is simple, but skilful: round the central depression two circles in openwork with a twig pattern,[2] and drop-shaped corals arranged in two rings, the corals marking the ends of the diameters, the orientation of which is indicated by that of the coral in the centre. Of the two Rhenish bronzes nos. 190 and 191 the former is the better work; the geometric pattern, neat and unambiguous, needs no description. The basic shape of these and of the ornaments from Ville-sur-Retourne is a pair of circles with a half-circle below them. The bronze from Somme-Bionne, no. 192, has three circles on top. One might fill pages with analyses of the possible readings of its ornaments: instead I confine myself to a few remarks. In the three top circles—looking at the white intervals— once red—'butterflies', like those in the coral-incrusted ring from Weisskirchen, no. 101 (*P 147*), or, paying attention to the bronze parts, an inner concentric circle filled with a concave-sided square, overlapped by four irregular arcs which grow from the outer circumference and are filled with concave-sided triangles. The large half-circle forming the bottom of the ornament is divided into three rows; the crescent-whirls in the middle row have already been mentioned (p. 77); and on p. 68 it was said that the ornament in the top row is a variant of the motives illustrated in *PP 54* ff. One of the bronzes from Ville-sur-Retourne, no. 194, has a strong resemblance to the Somme-Bionne motives. I refrain from describing in detail the bronze from Waldgallscheid, no. 153, *f*, and its unpublished pendant from Saint-Jean-sur-Tourbe, tomb 85, in Saint-Germain (inv. no. 27639): they have the same contour as the Somme-Bionne plaque, but their workmanship is coarser. The numerous openwork fragments from Somme-Bionne, no. 169, are of better quality and of great precision; some of their motives have already been dealt with.

I now describe two bronzes of clever design and careful execution, first the disk from Somme-Bionne, no. 180. Along the rim eight crescents, their points inward, one higher up than the other—in principle the same scallops as were dealt with on p. 68. Four times, at the ends of each quadrant, a circle fills the space between the compact central field and the rim, but it is cut by the crescents and passes over into them: the engraved lines indicate how the artist wished the pattern to be read. On the higher points of the crescents, a pair of upright opposed crescents; three times they form a circle, the fourth pair is bungled, and, from lack of space, forms an ellipse. The fillings, for their greater part, are concave-sided triangles, not always of symmetrical form, but sometimes respecting and favouring the reading of the intervals as leaves. Four times, opposite the pairs of smaller upright crescents, a two-petalled lotus with a straight bottom line pointing downwards. This shape of lotus occurs in the following works: disk from Cuperly, no. 185 (*P 366*); ornament from Ville-sur-

[1] p. 68. [2] See also the patterns in the bronze from Cuperly, no. 200.

Retourne, no. 194; gold cup from Schwarzenbach, no. 18 (*P 367, a*); top knob of a helmet (*P 367b*); a tendency to reduce and straighten the bottom part of lotuses is also sensible in the ornament of the bracelets from Lunkhofen, no. 60 (*P 386*).

The disk from Cuperly, no. 185. Round the compact centre a trellis-work of twenty-six interlaced ogives, which has an analogy in a painted urn from Hilterwald, near Trier, dated to the later phase of LT II by Hawkes and Dunning, Arch. Journ. 87 1930, 187, 194 fig. 9, 1.[1] In the ring outside the ogives, four convex bosses with red enamel, which fills an openwork of four rows of scales arranged shingle-wise, with a star in the middle (*P 15*). The foot-points of the outer scales do not touch the circumference, but stand on little lozenge-shaped leaves.[2] Between the bosses, two large two-petalled lotuses[3] (*P 366*) contoured by openwork lines which are a sequence of arcs and related to the twig pattern in the disk no. 186; a ring of the same kind frames this zone.

These two works give the impression of compass-construction. But while the patterns in the Eygenbilsen flagon, no. 390 (*PP 144–6*) and others of their kind are really done with compasses,[4] it is different here. In *pl. 243, a* I have made the experiment of drawing the Cuperly ornament by compass, adapting my three radii to a single geometric progression, and I have tried the same game with the Somme-Bionne pattern. Comparison with the original shows a strong deviation from the constructed, correct shape, and proves that all these ornaments were drawn freehand and merely express a natural taste for playing at experiments with circles. This statement is of general importance: some mathematicians,[5] studying classical and post-classical ornaments, especially repeat-patterns, for their own purposes, have naïvely assumed that they were drawn with full mathematical consciousness. The truth is that these peoples no more worked with scientific insight than bees do when building honeycombs.

Openwork in wood, bone, ivory, and metal is a technique used in many arts.[6] In principle

[1] Analogies in other arts are: Later Celtic art, the gold torc from Broighter (see note 4, and p. 99, note 3); bone flake from Lough Crew, Journ. R. Society of Antiquaries Ireland 55 1925, 22 fig. 18 (cf. below, note 4). Roman mosaics from Pompei, Pernice, Die hellenistische Kunst in Pompeji 6 pl. 38, 5, from Corinth, AA 41 1926, 411–12 fig. 5, and from Balácza (Pannonia), Oe J 25 1929, 4 fig. 2. Albrecht Dürer: Geissberg, Die Einblattholzschnitte des 16. Jahrhunderts pl. 19 no. 23; see also Jessen, Der Ornamentstich 39.

[2] Other examples of this shape are: pillar from Pfalzfeld, no. 11, above the heads; Lorraine flagons, no. 381, on the stopper (*P 156*); gold torc from Oblat, no. 47 (*P 155*).

[3] p. 87.

[4] See p. 73. A pair of Celtic compasses was found at Celles, dep. Cantal, Ebert 14, 539, another at Lough Crew (or Sliabh na Caillighe), Co. Meath, together with very numerous bone flakes. The most complete publication, in Journ. R. Soc. Ant. Ireland 1925, 15, was made from notes and drawings, at a time when the pieces had disappeared: they have, as Dr. Raftery kindly informs me, been recently rediscovered. Some are knives, others seem to be trial-pieces (Leeds, Celtic Ornament 135), the whole find probably coming from a workshop. The patterns are circle-made. Above, note 1, I had already noticed a rare ornament which also appears on another Irish work, the gold torc from Broighter: another link with the torc is the ornament l.c. 17 fig. 3 (also illustrated by Romilly Allen,

Celtic Art, opp. p. 150, and Mahr, in Bossert 5, 15, 1): as comparison with the development of the torc, Archaeologia 55, 401 (Sir Arthur Evans), whence Leeds, l.c. fig. 35, shows, the run of the two patterns is very similar. The flake l.c. 20 fig. 12 closely resembles the best of Irish brooches, found in the same county, Kemble, Horae ferales pl. 21, 1; Journ. R. Soc. Ant. Ireland 1923, 13 fig. 8, 6: compare the left-hand part of the flake with the head of the fibula: even the trumpet-joints recur. The date of the flakes is in the first century B.C.: this is suggested by the likeness of some motives to Glastonbury pottery.

[5] A. Speiser, Theorie der Gruppen von endlicher Ordnung (2. Auf lage) 1 ff., 77 ff. More judicious is M. Dehn, Das Mathematische im Menschen, in Scientia 1932, 135.

[6] Remarks in Jacobsthal, Melische Reliefs 105. Some additions: IPEK 1926, 186, p. 81. Islamic: bronze lid in Kassel, Bieber no. 401, pl. 51: for years I took the piece for Celtic until Professor Möbius and Professor Kühnel, by comparison with the Early Islamic bronze hanging bowl in the Louvre (Longpérier, Archéologie orientale 1, 456; Migeon, Manuel d'art muselman fig. 182; Migeon, L'orient muselman (Musée du Louvre) vol. 2 pl. 20) convinced me of its Islamic origin. Gothic art: for tracery patterns see Ungewitter-Mohrmann, Lehrbuch der gotischen Konstruktionen; Ueberwasser, Die Baseler Goldschmiedrisse, in Jahresnachrichten der öffentlichen Kunstsammlungen Basel 1928/30.

there were always two domains in Europe from which the Celts took their models: the gold openwork from Dürkheim, no. 28, has a good analogy at Trebenishte, *pl. 240, d*, which seems to me Thracian; the patterns set on the maeanders have a strong Hallstatt look, and a pendant, not figured here, with stippled chevrons, looks even more Hallstatt.[1] But this is an exception: as a rule, Eastern arts confine openwork technique to animal ornament, and there is hardly an example of the geometric openwork which I am studying here.

The real source of technique and patterns which concern us was the Hallstatt of Italy and the North.

Italy.[2] In *pl. 243, d*, I show a fragment of an Etruscan chariot from Montecalvario[3] (Not. Sc. 1905, fig. 12 b, plate facing p. 231), and in *pl. 244, a, b* disks, forming part of armour of a special type, most frequent in Samnium, but found also in Umbria, Picenum, and elsewhere. The larger plaques, with a diameter of 20–25 cm., covered breast and back of the warrior (as illustrated most clearly by the Aufidena tombs), the smaller, measuring between 8 and 10 cm., dangled from chains. The disks *pl. 244, a*, in Florence, came from near Perugia, the grave-group being unknown (Milani, Il R. Museo arch. di Firenze pl. 120, p. 298). The piece *pl. 244, b*, in Ancona, has no specified provenience, but was certainly found in Picenum.[4] The openwork pattern here consists of two pairs of overstylized birds confronted, recalling the fair-lead from Waldalgesheim, no. 156, *b*. The motives in the larger disks *pl. 244, a* compare well with those in the plaques from Langenhain, nos. 181–3, and others. These Italic bronzes, whatever may be their date—certainly not before the fifth century B.C.[5]—are representative of that archaic Southern stratum to which Celtic art owes so much; they combine openwork technique with other stylistic features which Celtic and those arts have in common: broken esses,[6] scale and sentry-box patterns,[7] serrated lines,[8] &c.

Greece. There are the modest zigzag and other patterns decorating the stands of horses, birds, &c. (Olympia, Bronzen pls. 13, 14). Otherwise examples are rare: Payne, Perachora i, pl. 82, 26, p. 182; Waldstein, The Argive Heraeum pl. 105 no. 1830; Blinkenberg, Lindos pl. 29 nos. 698, 699; for 698 see *P 112*: the piece bears a strange resemblance to Roman openwork such as AuhV 1, 10 pl. 6; 2, 4 pl. 3.

North. The bronze ornament shown in *pl. 244, c* is one of a good many found in women's graves in Eastern France and Switzerland;[9] as Déchelette 864 saw, they have their only analogies in Picenum. With it goes the bronze pectoral from the forest of Moydons-Papillards at Chilly (Jura), Déchelette fig. 251 (p. 866), which is Late Hallstatt in style, but was found in a tomb together with a LT brooch.[10] I would also mention the chariot from Ohnen-

[1] *Pl. 240, d* is Filow fig. 18, the pendant mentioned is fig. 19. I owe the photograph to Professor Filow.

[2] As said above I do not deal here with openwork in the round, and I take no notice of Italian works such as the girdle-clasps Mühlestein 154; from Murlo, Not. Sc. 1926, 167 (Mühlestein 142), or the numerous other examples collected by Hanfmann, passim. It should, however, be noticed that there is a great similarity between the seventh-century girdle-clasp in Florence, Montelius pl. 376, 2, with dishevelled animals, and the Celtic one, no. 364.

[3] Compare the patterns of the Kaerlich chariot, *P 14*, with those in the clasp from Castrocaro, Not. Sc. 1896, 451.

[4] Ancona, inv. no. 46450. Diameter 8·5 cm., thickness 0·03 cm. It is almost identical with the pieces from Aufidena, Mon. Ant. 10 1901, 321 2 fig. 59. The most complete treatment of this class is in AA 44 1928, 452 (Mercklin). See also Duhn 562;

Gisela Richter, Bronzes, New York no. 1575, with reference to a piece in Copenhagen; Richter, Etruscan Art fig. 2. Other unpublished pieces known to me are in London, Oxford, and Boston.

[5] Behn l.c. p. 11.

[6] pp. 69–70.　　　　　　　　[7] p. 69.

[8] p. 67.

[9] *Pl. 244, c* is Geneva M. 51/54. From Viège (Valais). Diameter 17·8 cm. The 'umbo', projecting on obverse and reverse, with the four zones in openwork, is cast. The four flat outer rings are now connected with the central part, but were loose in antiquity; on the outermost ring an ancient repair. Add to Déchelette l.c. two pieces in Ancona, dall' Osso 192, from the necropolis between Grottammare and Cupra-marittima; 200, same provenience.

[10] On the birds on top of the pectoral see p. 28.

heim (Alsace)[1] and refer to the modest openwork patterns of the bronze horn from Mergel-stetten *pl. 250, b*, p. 113.

Yet there is one object in openwork, the fair-lead from Waldalgesheim, no. 156, *b*, which possibly points to another source: in *pl. 245, a* I illustrate a Koban bronze: on another important connexion of Celtic and Caucasian arts see p. 134. The fibula with the animalized S-spiral on the bow,[2] no. 311, may also be a reflection of these Eastern models. The open-work spirals on top of the girdle-hook no. 350 compare with the Ordos bronzes ESA 9 1934, 262, 263.

FLORAL ORNAMENT

In the preceding chapter it was not always feasible to eliminate forms which have their proper place in this. The word floral only implies that most of the motives treated here, not all of them, are derived from classical floral ornament and are opposed to the mainly abstract, geometric forms dealt with before.

The '*fish-bladder*' has always been spoken of as the shibboleth of Celtic ornament. The term had been used before for similar motives in Gothic tracery. But if one studies real fish-bladders[3] and compares them with the Celtic patterns, it appears at once that the term was not well chosen. Zahn's suggestion[4] to christen the motive 'pear' or 'almond' certainly marks a progress towards precision, but an objection remains: pears and almonds have a straight middle axis, whereas one—and a very important—characteristic of our ornaments is the comma-like swing of their middle axis. I am at a loss to find a good adequate name, covering all variants: 'comma-leaf', 'curved almond', each of them only meets one of the shapes; if I were a botanist, I would simply say: 'Gallofolium a, b, c, d'. Zahn has seen and established that this type of leaf appears sporadically—and disappears—from Egyptian times onwards. The Celts did not borrow it from abroad: they created it independently, out of their own rhythmical feeling.

We have already met the compass-constructed pattern of two comma-leaves, clinging to each other, within a circle (*PP 310–12*, p. 78). But this was exceptional; as a rule the leaves are drawn freehand. It is convenient to study the basic types where they occur isolated. I therefore choose certain gold ornaments from Klein Aspergle (*P 314*): we have only to strip them of the little attached circles. Of these patterns two are not our concern: the drop-leaf (*d*) has nothing particularly Celtic about it and occurs similarly in Greek ornament, and (*e*) is merely its duplication. (*a*) and (*b*) differ in one respect only, (*a*) is round and (*b*) pointed below; both are contoured by an arc on the outer side, and by an S-curve on the inner. It is but a matter of 'quantity' that the comma-swing is less pronounced here than in other cases. The outline of (*c*) consists of two S-curves with a counter-movement. All these types occur occasionally in isolation, but more frequently they are used as Celtic substitutes for parts of flowers, or of palmettes, and (*c*) plays a great role as Celtic equivalent of ribbons, arms of lyres, or of tendrils.

A variant asking for comment is illustrated in *PP 315–26*.[5] The leaves, either of type (*a*) or (*b*), have grown a spiral at one end. They mostly form pairs; in *PP 322–5*,[6] where the tips

[1] Ebert 2 pl. 181, b; 9, 166 (with references). [2] p. 55.

[3] Rauther, Zur vergleichenden Anatomie der Schwimm-blasen der Fische, in Ergebnisse und Forschungen der Zoologie 5, 60.

[4] Die Silberteller von Hassleben und Augst (in Römisch-Germanische Forschungen 7) 88 ff.

[5] See also the Waldalgesheim gold torc, no. 43, the crescent from Brunn, no. 377, and the armlet from Dux, Much, Atlas der K.K. Zentralkommission pl. 87 no. 17.

[6] To be added: chariot-horn from La Bouvandeau, no 168 (inner side of horn); disk from Écury-sur-Coole, no. 189; Alsatian bronze, *P 284* (right and left).

of the leaves touch each other, one can read them equally well as 'cup-spiral'. *P 326* has a close analogy on the buffer of the Waldalgesheim gold torc, no. 43.

I think it prudent not to overrate the similarity of these leaves to those, set back to back, as handle-ornament of Fikellura amphorae (*pl. 245, b, c*) or of Etruscan bronze jugs (*pl. 245, d, e*), though one of these was found in a Celtic grave, at Weisskirchen.[1] The possibility of an influence from these quarters cannot be wholly denied, but a look at Cretan seals[2] with astonishingly similar motives makes one cautious.

LYRES. They have their roots in spiral ornament, but they early entered into symbiosis with palmettes and flowers. For this reason they may be treated here, and I begin with them because of the important part they play in Celtic ornament.

Isolated lyres are rare. Those with zoomorphic interpretation of the scrolls have their own history and ancestry[3] and are not our present concern. Huge single elaborate lyres—only their impressions remain—stand on the temple parts of the helmet from Amfreville,[4] no. 140. In groups, loosely connected, lyres decorate the gold finger-ring from Rodenbach, no. 72, or the sword no. 92 (*P 327*). I also mention an unpublished clay flask from Dürrnberg, tomb 15, in Salzburg,[5] with a decoration of stamped single horizontal lyres in oblong panels round the lower part of the body of the vase.

More frequent are *bands of lyres*. Those engraved on the foot plaque of the Waldalgesheim flagon, no. 387 (*P 328*), are barren.[6] The sketchy engraved pattern on the girdle-hook from Schwabsburg no. 351, *pl. 167*, gives them a livelier and more floral character. The four beautiful lyres on the gold lid from Auvers, no. 19 (*PP 329, 330*), closely related in style to those on the Amfreville helmet, also have floral fillings; the frieze is here bent circlewise: this causes alteration, which I shall discuss presently.[7]

Let us compare the Celtic lyre bands with those on a work which has a classical tinge, the Celto-Etruscan helmet from Umbria,[8] no. 144 (*P 331*): there the lyres are subordinate to the palmettes, one might say that they were the twigs and the palmettes the blossoms, while in the Celtic ornaments the lyres, even if sprouting, are all and everything. This difference gives a clue to the source of the Celtic patterns: in the Italian arts of the seventh and sixth centuries B.C. rows of more or less barren lyres are a common motive[9] (*PP 332–4*).

The highly elaborate ornament engraved on the Waldalgesheim flagon, no. 387 (*P 335*), needs description. I give a simplified and, I fear, somewhat wooden drawing of the upper frieze; the lower varies in some details. It is a double band: apart from a slight difference of the fillings, the upper and the lower row are, so to speak, the reflected image of each other.

[1] JL pl. 18; Jacobsthal, Ornamente pl. 21, *c*, p. 39; a useful conspectus of the Fikellura handle-ornaments of this type has been given by R. M. Cook in BSA 34 1933/4, 83. An archaic Greek bronze oinochoe with an attachment of this type, in Budapest, was possibly found at Mitrovica, Márton figs. 27–9, p. 68.

[2] Boehlau in PZ 19 1928 pl. 22 nos. 18–21; Matz, Frühkretische Siegel pl. 12, 9.

[3] pp. 53 ff.

[4] For their Southern prototypes on helmets see p. 117.

[5] Inv. 6581. 31·5 cm. high. Clay greyish-brown; quality medium. The impressions of the mould are flattish. The other decoration of the flask consists of the garlands treated on p. 68. Another example of single lyres: the bronze torc from Sulevič (Bohemia), Mitt. Anthrop. Gesellsch. Wien 19 pl. 1, 15.

[6] See also the sword from Langugest in Teplitz, Schumacher, Verzeichnis der Abgüsse &c. mit Gallierdarstellungen fig. 1, 10; or a torc in Munich, inv. no. 1913/14, known to me from a drawing (see p. 100 note 2).

[7] p. 91.

[8] See also the helmet from Montefortino, Mon. Ant. 9 pl. 6, 21.

[9] Jacobsthal, Ornamente 67, note 104; Dohrn, Die schwarzfigurigen etruskischen Vasen aus der zweiten Hälfte des sechsten Jahrhunderts 59. Examples from the civilization-fringes: Gold scabbard of dagger from Tomakovka, Furtwängler, Goldfund von Vettersfelde 38 (Kleine Schriften 1, 503); Schefold 62: latest sixth century B.C. Spain: dagger, Archivo Español de Arte y Arqueología 7 1931 pl. 18; Junta Superior 1931, no. 4 pl. 74.

It is a sequence of lyres, spaciously arranged. While the S-shaped arms of lyres normally stand vertical so that the perpendicular from the top scroll touches or nearly touches the bottom scroll, here they stand slanting, at an angle of about 45°. There is much room for filling within the lyres, and even more in the wide intervals between two neighbouring ones. The fillings within the lyres are different in the upper row and the lower. The former has the pair of leaves with foot-scrolls which I have just been studying (*PP 322–5*), and on top of them two leaves swinging sideways. In the lower row, two leaves forming a downward 'heart' and, growing from its point, two leaves, slightly differing in shape from the corresponding pair in the upper row. The wider field between the lyres is filled with a cross of four smaller lyres; the head-scrolls of the vertical pair are the foot-scrolls of the horizontal, the head-scrolls of the horizontal are the foot-scrolls of the big lyres, and the foot-scrolls of the vertical the head-scrolls of the big lyres; and again the field is closed above and below by a pair of leaves, this time of the type *P 314 b*. The fillings have their like in the ornamentation of the gold cup from Schwarzenbach, no. 18, the small gold disk from Klein Aspergle, no. 23 (*P 377*), the gold torc from Dürkheim, no. 42 (*P 403*), the girdle-hook from Schwabsburg, no. 351, the Alsatian bronze, *P 284*, and elsewhere.

A similar interlacement of larger and smaller lyres decorates the Münsingen fibula no. 333 (*P 349*); here the rhythm, and the character of the filling half-palmettes, definitely point to a classical fourth-century model. The pattern of the fifth-century Waldalgesheim flagon lacks floral accessories and is incomparably more Celtic. I am inclined to seek the proto-types of the entire engraved ornamentation of this vessel—the triangles (*P 159*), the plain lyres (*P 328*), and our interlacements—in one and the same stratum of archaic Southern decoration. It is not difficult to strip the ornament of the Dutuit painter's oinochoe, *P 336*, painted about 500 B.C., of the palmettes and flowers, and it is easier still to see a way to the Celtic motive from the ornament on Euphronios' Arezzo krater, *P 337*. The immediate model of the Celts was probably Etruscan metalwork, but no example, as far as I know, is preserved.

Vertical lyre-compositions. A. *Continuous bands.* When two spiral bands run parallel, but with opposed movement, they can also be read as a chain of lyres in which the head-scrolls of one lyre are always at the same time the foot-scrolls of its neighbour. By certain tricks and fillings the pattern can be freed of ambiguity and the interpretation as two unconnected bands be excluded. These ornaments go back to Egypt and Crete, and I figure an example taken from a Greek vase of the first half of the seventh century B.C., *P 338*. It is an innate, easily understood feature of these ornaments to appear almost always upright.

The pattern in the bronze torc, no. 211 (*P 98*), admits both interpretations; one may even say that the central beaded line, cutting the pattern across, favours the reading as two parallel spiral bands.[1] In the handle-attachment of the flagon from Salzburg, no. 382 (*P 339*), the ornament starts at the bottom with pairs of lyres, but then the mask forms a barrage and the river streams round it in two arms. In the gold ornament from Klein Aspergle, no. 23 (*P 340*), which looks like a duplication of the lower part of the ornament below the mask in the Salzburg attachment, the three-petalled filling palmettes favour the interpretation as lyres. Some lyre bands, such as those from La Gorge-Meillet, no. 196 (*P 341*), that in the disk from Saint-Jean-sur-Tourbe, no. 184 (*P 342*), or those in one of the hame-mountings from La Bouvandeau, no. 171 (*P 343*), are formed by two of those 'lazy' spiral bands

[1] p. 70.

which I have noticed on p. 70; in *P 344* the loops replacing the scrolls assume the shape of two comma-leaves in a circle.[1]

B. *Closed compositions of lyres*. Pls. *245, f, g, 246, a* give a selection of ornaments on Attic and Italiote vases of the fifth and fourth centuries B.C. The Celtic lyre chains reflect archaic Southern ornament; the closed compositions of lyres copy models of classical style. It is unlikely that the Celts drew their inspiration from vases, indeed it is hard to guess what their models were—possibly Italic bronze works, though I cannot establish this by examples.[2]

(*a*) *Two lyres, foot to foot*. Lyres without or almost without trimming: torc no. 215, the style wiry like that of the pendant from Sommepy, *P 345*, where one lyre is bungled and runs the wrong way. Torc in Sens, Rev. des Musées 27 1930, 68 fig. 3, no. 2 (not figured here). Bracelet in Marseilles, no. 251 (*P 346*): the lyres separated by the knob between them.[3] Hame-mountings from La Bouvandeau, in one, *P 343*, top: in the other, *P 344*, you can either take the second and third lyre and see them as a pair of the foot-to-foot type, or you can connect the second with the first as a pair head to head. More ornate are the following: gold bracelet from Zerf, no. 53 (*P 347*): the lyres are hatched inside, and so is the one pair of palmette-leaves; the curve of the two little leaves, which—against classical practice— are attached to the tip of the central palmette-leaf, shows that the Celt fancied them to be growing not upwards but downwards. The patterns on the Münsingen brooches nos. 332 (*P 348*) and 333 (*P 349*) are the richest and most beautiful of all. I have already mentioned the latter when speaking of the interlacement of two larger lyres with a cross of four smaller ones. There are two smaller lyres in *P 348* as well, within the larger lyres, head to head, but much flourish obscures the structural forms. One has the impression that these ornaments are derived from fourth-century models, such as *pl. 246, a*, the palmettes in *P 349* having definitely a fourth-century cut. The ornament of the torc no. 245 (*P 350*) belongs in construction to this class, but substitutes two masks, facing each other, for the bottom scrolls.[4]

(*b*) *Two lyres, head to head*. It must be accidental that no Celtic example shows the type in so clear a form as the classical models, *pl. 245, f*. On the brooch from Eschersheim, no. 322 (*P 351*), the lyre-pairs have their heads clamped at the sides by a sort of fan. In the torc no. 207 (*P 352*) the construction is overshadowed by accessories of Waldalgesheim Style.

(*c*) *Lyres in tiers*. Two lyres, sharing one pair of scrolls, and on top a crowning palmette: gold torcs from Waldalgesheim, no. 43 (*P 353*); from Filottrano, no. 44 (*PP 354–5*); girdle-hook from Schwabsburg, no. 351 (*P 356*); sword from Ameis-Siesbach, no. 95 (*P 357*). In the torc no. 206 (*P 358*) the pattern is much overgrown by motives of the Waldalgesheim Style. The ornaments of the helmet from Umbria, no. 144 (*P 359*), and of the coral-inlaid bronze from Somme-Tourbe, no. 198 (*P 360*), also pertain here.

One type 'contracts' the lyres: the torcs *P 361* and *P 362* show three tiers, the bottom and top lyres upright, the lyre between them downwards, the latter lacking head-scrolls. In *P 361* the top lyre is complete and there is a marked caesura between it and the rest; in *P 362* there is another contraction at this place. The ornament of the Lisieux torc, *P 363*,

[1] p. 78.

[2] The East is out of the question. The bronze pole-top from the Kuban, *pl. 234, c*, of the early fourth century B.C. —see p. 54—goes with the ornament of the torc *P 361*, and copies a contemporary Greek model. Incidentally, the decoration of the Caucasian bronze openwork girdle-clasp,

Uvarov pl. 134, 4; ESA 1934, 89 fig. 30 reflects archaic Greek ornament.

[3] The drawing exaggerates the dimensions of the knob. Similar is the bracelet from Saint-Remy-sur-Bussy, Morel pl. 36, 10, 11.

[4] p. 19.

is constructed on the same principle. See also the Hungarian spear-head no. 131. A classical model of this type is illustrated in *pl. 246, a*.

FLOWERS. Celtic flora, compared with classical, is poor. There is also a lack of organic growth about these flowers, their floral character is often impaired by the attachment of dead circles and the like; they look dishevelled, or like elements which join for a moment to form a flower but are ready to part and to enter into contact with other forms near by.

Flowers with two leaves are far more numerous than with three. The leaves have mostly the shape of the comma *P 314 a*. Some flowers do not look different from classical lotuses. The relief flower of the cast part of a girdle-hook from the Marne, no. 355 *g* (*P 364*), certainly copies flowers such as decorate the attachments of Etruscan bronze beak-flagons (JL pl. 5 no. 43) or the handles of Etruscan bronze basins, discussed on p. 138. The treatment of the bottom part of the lotuses on the gold cup from Schwarzenbach, no. 18 (*P 365*), also reflects a model from the same quarter: see JL pl. 5 no. 43, found in France.[1] The flowers with a straight-contoured bottom, *PP 366, 367, a, b*, have already been mentioned on pp. 80-1. The flower on the Belgian linch-pin, no. 162 (*P 368*), is remarkable for the spiral scrolls at the tip of the petals and for the wide gap between the leaves, another example of which is given by the gold ornament under the handle of the Attic cup from Klein Aspergle, no. 32 (*P 369*). In the gold disk from Ferschweiler, no. 30 (*P 370*), the two leaves have grown into a 'bell'; there is an analogy in an unpublished bronze in the museum of Mont-de-Massan, found at Aubagnan (Landes) in a grave said to contain Late Hallstatt objects.[2]

Some flowers have a rather fantastic look and defy the attempt to refer them to classical models or to describe them in terms of classical ornaments. For instance the gold ornament from Schwarzenbach, no. 34 (1-4) (*P 371*): the way in which the 'earthworms' coiling round the leaves pass above into a pair of small leaves is strongly against classical feeling; on the other hand, the pendant, *P 372* (15-9), and *P 373* remind one of a certain type of Greek flower (*P 374*) which was in fashion in the ornamentation of red-figured vases of the first quarter of the fifth century B.C.[3] The capricious flowers from Klein Aspergle *PP 375-7* are certainly all drawn from the same pattern-book: the little palmettes in *P 377* occur also in *P 340*, the three ridges on the trapezoid 'stem' of *P 376* have their like in the gold plaques *pl. 28*, and the 'cup' formed by the top leaves of the piece appears at Schwarzenbach (*P 325*) and elsewhere.

Some odd forms. The four flowers on the stopper of the Lorraine flagons (*P 156*) grow on stiff stems, they have the outline of a pelta, their central leaves are lozenges with concave sides: the tips of the lateral leaves join those of their neighbours and form an arc with them.

All these flowers were lotuses, more or less Celticized. There are a few of a different kind. The star-flowers growing from tendrils in the lyre on the gold torc from Waldalgesheim (*P 353*) are directly copied from those in the ornament of the imported Campanian bronze bucket found in the same grave, no. 156 *h*;[4] and also the three pairs of hatched flower-like motives filling the outer axils of the lyre are clearly taken from the bell-flowers drawn in

[1] I have discussed this variant of lotus in Ornamente 167, note 315. The snake motive of another girdle-hook from the Marne, no. 355, *i*, also depends on the ornamentation of the Etruscan beak-flagons: see p. 53.

[2] See also p. 88 note 1. I owe the knowledge of the piece to Mr. H. N. Savory. [3] Jacobsthal, Ornamente 171.

[4] See p. 157. Compare the silver amphora from Chertomlyk, Jacobsthal, Ornamente pls. 142 and 143; for its date see Schefold 28: 400-380 B.C. On Attic tomb-stelae, in the middle of split-palmettes, Möbius pl. 11, b, pl. 12, a, pp. 39 and 88. The earliest example of this flower-type is to be seen on an Attic tomb-stele of the last quarter of the fifth century B.C., Möbius pl. 7, b, pp. 19 and 88. The same motive seems to occur in the bronze ring from the Waldalgesheim tomb, no. 156 *f*, in a debased form—one more proof that all the objects of the find are from one workshop (see p. 157).

perspective, which serve a similar purpose in the decoration of the bronze bucket. The daisies in the band round the same torc (*P 445*) surely reflect classical ornament of this period. The same flora occurs in the Belgian gold torc no. 45, and, dishevelled and almost unrecognizable, in the gold bracelets from this find, no. 56.[1]

Finally, a word on a motive which ought to have been dealt with before. In the Early Celtic brooch from Hunsbury, *P 378*, it has the shape of a vertical row of hearts with foot-scrolls, keeping at a distance from each other; on the frame of the dagger from Weisskirchen, no. 100 (*P 379*), the heart-leaves overlap: when we were children we made such wreaths, pinning leaves with fir-needles. The Celts may have become acquainted with the ornament by looking at the handle-plaques of Etruscan bronze stamnoi *pl. 220, a, b, d*, of which so many found their way to the North.[2] Or it came to them from the East: I illustrate in *P 381* a detail of the Persian akinakes from Chertomlyk[3] which has other Persian analogies: glazed tiles from Susa, Perrot-Chipiez 5 fig. 146; Riegl fig. 44; Dalton fig. 48. Gold dagger-sheath from the Oxus, Dalton no. 22, fig. 45. Gold plaque, Dalton no. 25, pl. 11. Related is the frame-ornament of the bronze girdle from Büsingen in Konstanz, *P 380*, which is very late Hallstatt on the border of the two ages.

The ornament painted on the cup from Breuvery (Marne), *P 382*, and the border-pattern of the bronze mounting of a knife-case from Viniča, Treasures pl. 12 no. 50, are a geometrization of a wreath of this kind, or—equally possible—they descend from geometric ornament such as *P 383*.

Most of the flowers stand by themselves. Pairs, bottom to bottom: gold finger-ring from Zerf, no. 73 (*P 384*); top to top: bronze ornament of the Kaerlich chariot, no. 167 (*P 385*). Row of unconnected lotuses: bracelets from Lunkhofen, no. 60 (*P 386*); gold ornament from Ferschweiler, *P 370*. The motive in the gold strip from Eygenbilsen, *P 387*, is a copy of a classical one, with an alternation of palmettes and lotuses—only the S-ribbons on which they stand are Celtic.

PALMETTES. Palmettes of classical shape appear in hybrid works: helmet from Umbria, *PP 331, 359*. But also in some purely Celtic works: girdle-hook from the Marne, *P 323*; sword from Ameis-Siesbach, *P 357*, and others. The following also have a Southerly look: the palmettes crowning the masks in the gold openwork from Dürkheim, no. 28 (coarsely done); those on the Münsingen fibula, *P 349*, or on the painted Armorican vase, *P 470*. The palmettes engraved on the throat-shield of the Lorraine flagons, *PP 423–5*, those on the torc from Lisieux, *P 363*, on the bronze plaque from North Italy, no. 401 *m* (*P 256*), though wiry and withered, have, like the others, comparatively dense foliage, whereas the normal Celtic type confines the number of leaves to three only: see *PP 393* ff.

Another characteristic is the hatching of leaves, so to speak an attempt at 'polychromy': gold bracelet from Zerf, *P 347*, gold ornaments from Schwarzenbach, *P 372*; the wings of the

[1] Little circles or disks as substitutes for flowers, used as finials of tendrils, are also seen in the Amfreville helmet, no. 140 (*P 429*), in the bronze from Brunn, no. 377 (*P 153*), in the bronze from Aubagnan (Landes), quoted on p. 87, and possibly on the bronze bird in Milan, no. 398.

[2] That this motive is not Greek but Italian has been observed by Matthies, Pränestinische Spiegel 31. Add to his list: Etruscan black-figure column-krater in Moscow, JHS 43 1923, 175; Beazley and Magi, Raccolta Guglielmi 81 no. 28, first half of fifth century B.C., and a cippus from Castiglioncello

(Volterra) in Florence with such a wreath all round. The pattern is also familiar to the Samnites: bronze ring from Aufidena, Mon. Ant. 10, 305/6 fig. 15. It occurs on Hungarian silver rings, Pârvan, Getica figs. 371, 384.

[3] Luschey incorrectly compares the motive of the Chertomlyk sword with that on the Rhodian and Kazbek bowls (see p. 54). The related Greek patterns are quoted in Jacobsthal, Ornamente 154, note 295. The decoration of the Oltos amphora, BARV 34 no. 4, is better seen in Pfuhl fig. 362 than in Ornamente pl. 44, a.

griffins from Weisskirchen, *P 412*, which have the shape of half-palmettes.[1] Like the lotuses, the palmettes often have circles or disks attached to the petal-tips or to the bottom: Eygenbilsen gold strip, *P 387*; gold plaque from Weisskirchen, *PP 388, 389*; attachment of Salzburg flagon, *P 394*; nave from La Gorge-Meillet, *P 398*; clay flagon in Salzburg, *P 11*, and others.[2] A good many palmettes, like their Southern models, have a double outline.

Palmettes seldom stand by themselves. They are mostly used as finials, crownings, upright or downwards, or as fillings of gaps. Loose, in rows, they appear on the French naves *PP 398, 399*; in tendrils in *PP 387* (alternating with lotuses), *403, 404*. Palmettes in pairs, bottom to bottom: bronze from Mayrie, no. 379, where the bottom leaves have assumed the shape of two commas in a circle, the motive discussed above on p. 78. Chariot-horn from La Bouvandeau, *P 408*: on the outer side of the horn the lateral palmette-leaves have foot-scrolls. The palmettes on the knee of the handle in the Lorraine flagons, *P 407* and, less stylized, those on a fibula from Saint-Sulpice tomb 57 in Lausanne (ASA 1915 pl. 1, 13; Viollier, p. 131), are clamped together at the sides by a sort of cup spiral, a motive recalling the treatment of lyres in the brooch from Eschersheim, *P 351*.

Some variants call for comment. Nave from Silléry, no. 158 (*P 399*): one pair of leaves is detached, these are of the foot-scroll type; the leaves of the other pair grow together at the bottom and form a sort of alembic.

The gold ornaments from Schwarzenbach, no. 34 (7–14) *pl. 30*, look like acroteria in miniature. There are two types: one, illustrated in *P 400*, with an analogy on the helmet from Reims, no. 139 (*P 401*), and a second, with bottom leaves of the same kind, but inverted and drooping (11–14). Actually they recall Greek antefixes: Collignon, Le Parthénon pl. 73, 3; A. H. Smith, The sculptures of the Parthenon p. 70; AA 51 1936, 307 (Zuechner). The models of the Celts were probably miniature gold plaques of this shape, like those from South Russia (Olbia, AA 28 1913, 198 fig. 39) and from Italy, Marzabotto (Montelius pl. 109, 2; Ducati, Touring Club Italiano, Le vie d' Italia, agosto 1930, 14).

The palmette under the handle of the beak-flagon from Klein Aspergle, *P 375*, has leaves overlapping and not distinctly detached from each other. It is related to the stylized mane of the handle-beast of the Salzburg flagon, no. 382. A strange coincidence is its resemblance to the tuft of sea-weed which Amphitrite on the Sosias cup in Berlin (BARV 21, 1; FR pl. 123, Pfuhl fig. 418) has fastened to her 'lady-trident'.

The palmette-mane of the animals of the Lorraine flagon, *P 406*, is dealt with on pp. 38, 143.

'*Sprung palmette*'.[3] Examples are: the band round the Waldalgesheim gold torc, *P 450*; the Comacchio bronze *P 463*; less clear, the engraved ornament on the throat-shield of the Lorraine flagons, *P 423*.[4] Comparison with the palmette of an Attic fourth-century grave-stele *pl. 246, b*, chosen at random, shows the typical change that the Southern form has undergone in the hands of a Celt: the leaves have gone and a closed-up configuration remains: the flowers of the Waldalgesheim pattern are certain proof of a Greek fourth-century origin of the motive.

Half-palmettes. How they grow from axils and then cling to contours, curved or straight, is illustrated in *PP 409–12*. Add to these: torc from Unteriflingen no. 229 (*P 95*); sword from Hallstatt no. 96 (*P 105*); helmet from Canosa, no.143; basin from Les Saulces-Champe-

[1] The same principle is applied to the mane of the beast of the Salzburg flagon, no. 382; see p. 40.

[2] The same little three-leaved palmettes, together with scallops, appear in a bronze girdle plaque, which is apparently Celtic, from Cañada de las Cabras in Spain, RA 35 1899, 269 fig. 69.

[3] Riegl 210 'gesprengte Palmette'; Möbius pls. 10 ff.

[4] p. 90.

noises, *pl. 249, b*. The palmette-leaves, as a rule, have the shape of the Celtic comma. Some look more classical, for instance those within the S-tendrils on the Weisskirchen dagger, *P 409*, or those in the upper zone of the Canosa helmet, *P 466*. The leaves of the palmettes near the bottom contour of this strip have a middle rib and are not detached from each other; they are copies of acanthus leaves, here fairly close to their models, in the basin from Les-Saulces, *pl. 249, b*, more Celticized.

There are good Greek examples of this particular form from the years 425 to 350 B.C.: sarcophagi from Sidon, Möbius pl. 1, here *pl. 246, c*; Erechtheum antefix, Möbius pl. 4, b, and grave-stelae, Möbius, passim.

Because of its historical interest I here append *P 413*, the ornament of the Hungarian torc no. 227, two stiff antithetic palmettes filling the intervals between coral disks. I tell the history of the motive in *PP 414–22*. The immediate source of the Celts was certainly Etruscan fifth-century gold jewellery: see BMC Jewellery pl. 21 no. 1419 and the piece in New York, AJA 44 1940, 435 fig. 7 and 436 fig. 8; Richter, Etruscan Art fig. 106: this formed part of the Vulci find containing the gold finger-ring *pl. 252, b*, which served as model for the Rodenbach ring, no. 72.[1]

After this lengthy survey of dissected forms, a description of some ensembles might be welcome: it may also shed light on some essential features of Celtic ornament.

The throat-shields of the Lorraine flagons. I show the upper parts of (a) and (b) in *PP 423, 424*, the lower part of (b) in *P 425*; the drawings mark coral in black. The shield is an elongated lozenge, divided by a horizontal bar of five lines: the top and bottom lines consist of coral oblongs, the lines between are chequer-maeanders.[2] Above and below the bar, a roughly triangular field; in the lower field coral incrustation plays a greater role than in the upper, where more is left to engraving. I describe *P 423*. The ornament rises in two tiers, or in three if you count the top leaf as one. Coral and bronze, incrustation and engraving work with and against each other. In the bottom tier—looking at the corals—there is a three-petalled palmette, the central leaf of which stands on a sort of pedestal; beside it, on the ground, two motives which are probably meant to be closed-up half-palmettes. This storey is enclosed by an engraved arc. The bronze intervals between the coral leaves show an engraved 'sprung palmette';[3] the foot-scrolls also are decorated with engraved patterns. The upper tier is a lyre standing on the lower; the lyre has no foot-scrolls, its middle is a circular coral, the field round this is stippled; outside, an engraved lancet frame. On top a downward leaf; the axils at the foot of it are filled with a motive similar to one on the painted urn from Saint-Pol-de-Léon, *P 470*. The central top leaf has a stippled frame; from the rounded upper contour of its inner field a spiral hook grows downwards; this hook breaks up the otherwise scrupulously observed bilateral symmetry of the ornament; the only analogy is given by the cheek-piece no. 145 (*P 411*), where the motive is one of the proofs of the Celtic origin of this class of helmets. The motive inside the top leaf was used by the engraver at many other points on the throat-shield, and in the coral guilloches round the foot of the jugs: sometimes it is a real half-palmette, though wiry, sometimes just a row of strokes, more or less straight, adapted to the shape of the decorated field and repeating its outlines; it has good analogies in the sword no. 126 and in the hoop of the torc no. 225—to speak of objects illustrated here.[4]

[1] p. 125. [2] p. 74. [3] p. 89.
[4] See also the bronze torc from Spiez, Bonstetten pl. 5 no. 3, and less clear Viollier pl. 12, 21, p. 120. The motive seems to occur also in the carved corals decorating no. 202. There are analogies in certain phases of ancient ornament: I need only quote the Kerch hydria in Munich of the last quarter of the fourth century B.C., FR pl. 40, Jacobsthal, Ornamente pl. 116, a, Schefold, Untersuchungen no. 188, p. 124. My former

The cup from Schwarzenbach, no. 18. The cup itself, probably of clay, is lost:[1] what is preserved is the gold mounting, consisting of three parts, the plain rim, the bottom part, a continuous surface with decoration in flat relief (*P 301*) giving the vessel a firm stand, and the wall portion in openwork—our concern here. It is framed by a narrow frieze of lotus buds, above hanging, *P 12*, below upright. The clay in the open spaces was certainly coloured, most likely red.[2] There is a difference in principle between bronze openwork—like nos. 133, 154, *f*, 180–3, 188, 192–5—and the gold cup (or other related ornaments such as the strips from Waldgallscheid, no. 26 (*P 402*), and from Eygenbilsen, no. 24 (*P 387*)): in the first class there is ambivalence between the compact bronze forms and the intervals, each of them effecting a pattern which can be read separately and has a meaning in itself. In the second class the ornament is merely based on the gold parts, which are either compact spaces or the beaded contours of intervals. These intervals, taken alone, would not make sense; some of them, those contoured by gold lines, have an intelligible shape and a meaning, the others are merely gaps, bits of more or less shapeless background.

The lower zone of the cup runs in two tiers. Below, alternately two-petalled lotuses with set-off bottoms[3] (*P 365*), and three-leaved palmettes, hanging from the joining tips of two neighbouring lotuses, which bear circles instead of scrolling involutions. The lotus flowers are the pedestal of the motives in the upper tier: on their petal-tips stand other lotuses, three-leaved (*P 367a*), the lateral petals gold-contoured, the pointed central leaf in compact gold; the treatment of their bottoms has its like in the Celtic flora of this phase. From their tips, which again bear disks, a pair of opposed leaves (*P 324*) hang, reaching into the opening of the lotuses below and supported by them.

The upper zone is a repetition of the motive shown in *P 325*. It is in principle a pair of leaves like those used in the lower zone, hanging from the tips of the petals. But here there is much variation and flourish: the bottoms of the leaves are set off like those of the lotuses in the lower zone. The leaves stand at a different angle, more nearly horizontal, so that their tips with the attached circles remain at a great distance and the 'cup' has lavish fillings: there is a compact pointed gold leaf growing upwards from the axil below, and two opposed half-palmettes swing from the petal-tips towards the middle and reach the upper frame. Where they meet, two of these 'cup spirals' are always clamped below by a compact axil-leaf, and by another, gold-contoured, above; the latter taken together with the circles can also be read as one of those hearts which in their normal shape have foot-scrolls.[4] In *P 410* I show another combination of the elements, not primarily intended, but possible, because it compares well with the shape of the little gold acroteria from the find, *P 400*.[5]

This beautiful consummate ornament which, as a whole, has no analogy elsewhere does honour to the creative power and imagination of the Schwarzenbach master.

The lid from Auvers, no. 19 (*PP 329, 330*), is decorated with four lyres which grow from the centre towards the rim. Between the foot-scrolls stands a sort of alembic upside down; from the axils of the head-scrolls commas swing upwards. At the points where the foot parts of two neighbouring lyres touch each other, a leaf drops from the circumference, a long leaf in one diameter of the disk, and a shorter in the other diameter, which is marked at its ends by coral studs. This is *one* reading, the primary, doing justice to the lyres and putting them in the foreground. A second reading is the following (*P 330*): we now see four three-petalled lotuses

interpretation of this motive (Die Antike 10, 32) needs correction; the Kerch vase is of no use for dating the Lorraine flagons.

[1] p. 111. [2] p. 79. [3] p. 87.
[4] p. 88. [5] p. 89.

upright, growing from the circumference; they consist of what were before the axil-filling commas and the drop in the gap between the lyres. The physiognomy of the lyres has now changed, they have decomposed, new lyres rise instead, standing on the circumference, with a wide interval between their foot-spirals. The second reading is somehow seconded by the accents of coral inlay.

The gold plaque from Weisskirchen, no. 20. The artist surely wished the pattern to be read as four masks with huge floral crowns at the ends of the two chief diameters (*P 388*). The concurrent reading, shown in *P 389*, is possible, but far-fetched, because it destroys the head-crowns and indirectly dissects the masks, which are important in themselves and, moreover, stress the axes of the composition. In the gold plaque from Schwabsburg, no. 21, a work by the same artist, the two readings are equivalent: the masks have been replaced by corals, and at these points the ends of the diameters are no more emphasized than those of the diagonal diameters.

PP 390, 391 render *the gold ornament from Klein Aspergle*, no. 22, in two interpretations: they need no further comment. Incidentally, the Bohemian gold ornament *P 392* is a work of the same style and school.

TENDRILS. A wave tendril (*Wellenranke*),[1] *P 107*, is the basic form of all classical ornament; it is one of the few motives which the Greeks took over from the arts of the Cretans. In its simple shape it is a running wave line with spiral offshoots, branching off at its highest and lowest point. It may grow flowers and palmettes at the spirals and the axils may be filled with them. A wave tendril can be either 'one-dimensional' or 'two-dimensional': by this I mean that it can either run in one direction, like chain patterns, or can bend and swing over a panel, thus becoming an ingenious, flexible instrument for filling and decorating a space of any shape. *PP 108, 109* show the motive in its bare and abstract form, *111* geometrized, *110* enlivened, the Swiss brooches nos. 331, 334, 335 in a more ornate form. See also the sword no. 105; and its pendant *pl. 233, d*, where the spirals have become animal heads.[2]

An '*intermittent wave tendril*' (*intermittierende Wellenranke*, Riegl) is a chain of separate S-spirals moving against each other, with the foot-scrolls on the ground and the head-scrolls touching the—actual or virtual—upper border, thus effecting a waving rhythm; where two spirals meet they bear palmettes, or lotuses, growing alternately upwards and downwards, which clamp the S-spirals together. Examples are the ornament on the helmet from Umbria, no. 144 (*P 331*), which I have already described when dealing with chains of lyres; the gold strip from Waldgallscheid, no. 26 (*P 402*), where the fragmentary preservation of the piece leaves some doubt on the reconstruction. In a more Celtic shape it occurs on the helmet from Canosa, no. 143 (*PP 466, 467*), on the helmet from Berru, no. 136 (*PP 464, 465*), the gold torc from Waldalgesheim, no. 43 (*P 450*), the urn from Saint-Pol-de-Léon, *P 470*.

The gold ornaments from Schwarzenbach, *PP 300* ff., were chains of whirligigs.[3] I now illustrate in *PP 426* ff. *triangular whirligigs in the context of tendrils*. *PP 426, 427*: the underlying rhythm is a wave tendril: each triangle flows into the next at two corners, and ends dead with a scroll at the third. *P 429* can easily be translated into Greek (*P 430*), and then compares well with the ornament of the black-figured Attic amphora *pl. 246, d*: the vase ornament is 'two-dimensional', but can without difficulty be flattened out. At one point the clash between the two readings, and the priority of the Celtic interpretation, become felt: while

[1] Riegl 113 ff.; I refer to my remarks on p. 70. [2] pp. 53, 57. [3] p. 77.

the Attic tendril has a left-handed (or its counterpart, not figured here, a right-handed) movement throughout, in the Celtic pattern the spirals branching off at the rounded top part of the loop run against the movement of the tendril, for the simple reason that primarily they are not an offshoot of the tendril but belong to the whirligig, and as such they are all right. Some motives occur again and again: a loop flanked by a whirligig (*PP 429, 431, 432, 435, 436, 439, 440, 443*, with variants in *PP 434, 437*). Sometimes a tail grows from the third corner of the triangle instead of a scroll: the tail is either plain as in *PP 428, 431, 435* (bottom left), or bears leaves of a special shape, adhering to the frame: the appearance of this motive in *P 438* links the otherwise different decoration of this French painted urn with the other patterns. A peculiarity of the 'Waldalgesheim master' are eights with 'fore- and background', *PP 441, 442, 444, 445, 447*: such interlacement motives are rare in classical art, but familiar to the 'barbarians'.[1]

A classical tendril runs, flows; a Celtic is 'static'. A classical tendril consists of the tendril itself and what is growing on it, offshoots or axil-fillings: you can cut them off and the tendril remains: poorer, but it still exists. If you try the same operation with a Celtic tendril, it goes to pieces. This is an anticipation of an important development in late antique and post-antique art.[2] *Pl. 246, e*, shows a stucco border from the mosque of Ibn Tulun (A.D. 876–9) and Riegl's translation of the ornament into Greek.[3] The Islamic pattern well illustrates one feature of the Celtic: compare it with those on the Swiss silver brooch no. 331: in both cases the palmettes filling the axils have closed up and grown together with the tendrils. But they differ in this respect: the Islamic pattern, though the surgery is drastic, can still be dissected into the tendril proper and the palmettes: the coalescence of the two elements in the Celtic ornament has gone much farther.

The whirligigs are not the only motive that coalesces with tendrils: fans, single (*PP 435, 436, 446, 447, 448, 449*) or in pairs—then equivalent to sprung palmettes (*PP 450, 450, a, b, 451, 452*)—and, as we shall see presently, flowers, do the same. I best study the nature and importance of this coalescence by analysing a typical piece, the North Italian bronze no. 401 *b*, *P 459*: the object itself is one of those comma-leaves that pass into a fan; the fan is the closed-up form of what a Greek would treat as shown in *pl. 247, a*. At the rounded end the pattern starts with a fan, which from the punched drop in the middle and the filling circles and dots, is clearly meant to consist of two halves, an equivalent of a classical sprung palmette. It grows from the ribbon which runs diagonally across the field: at its upper end the ribbon passes into a triangular whirligig. This acts as a 'trivium'; out of its two other corners tendrils flow again into the left top corners of fans; these fans act as a 'bivium', the tendril flowing out of their foot piece; the left fan continues towards the pointed end of the object in the shape of a swollen ribbon which ends with two attached leaves; similar, but simpler, is the continuation of the right fan. I need not describe the detached motive above the large diagonal ribbon.

In a Greek tendril, as in nature, sap and movement stream through the twigs. Here the *interpretatio Graeca* of the pattern as twigs and flowers (or palmettes) is abortive. I have already spoken of the 'bivia' and 'trivia': one does more justice to these ornaments if one forgets their floral origin and sees them as a winding stream flowing into banked-up lakes and out again. But all these comparisons fall short of the real character of the ornaments. These Celtic

[1] Jacobsthal, Ornamente 199; Zahn, Bull. of the Bachstitz Gallery 1929. Without analogy and very important are the patterns on Iberian girdle-clasps, Ebert 10 pl. 147, a, c, f.

[2] Riegl 254 ff.; 304.
[3] Riegl figs. 167, 167a.

tendrils, quite apart from their origin and from all details, have become an unsurpassed instrument of decoration, utterly flexible, adaptable to any field, purpose, and technique. *PP 460–3* illustrate the decoration of other pieces of the find and show features which are also to be seen at Waldalgesheim: for instance, the tendrils growing from the third corner of a triangle and running dead towards the rim, or leaves sticking to the outline of the field.

The style described in the foregoing pages is appropriately called the *Waldalgesheim Style*, because it appears in numerous objects of gold and bronze from this well-dated grave. It covers distant provinces of Celtic art, yet handwriting and taste of the different schools and masters vary much. It is remarkable how well the sword from Gallia Transpadana, *P 427*, goes with the French urn, *P 426*, and how close the gold bracelet from Waldalgesheim, *P 439*, is to a torc from the Marne, *P 440*, or the Waldalgesheim gold torc, *P 450*, or to the bronzes from Brunn in Austria, *P 450, a, b*. The bronzes from Comacchio, no. 401 (*PP 459–63*), have a physiognomy of their own, and are the work of an artist of great imagination and skill. Related to the crescents from Brunn is the gold torc from Zibar (Bulgaria), no. 46 (*P 103*): the scalloped frame, however, and the punching of the ground connect it with the ornaments of the urn no. 414 (*P 443*), which are apparently a bungled copy of ornament on good metalwork. The decoration of the neck-guard of the helmet from Silivas, no. 142, looks rather untidy, but can easily be retranslated into the style of Waldalgesheim or Comacchio. The tendrils of the sword from Hatvan-Boldog, no. 118 (Dolgozatok pl. 54), and those on the dagger from Szendrö, AuhV 4, pl. 25, 7; Márton, pl. 14, 2, p. 50, have an analogy in the fillings of the ornament on the neck-guard of the Amfreville helmet, no. 140. Another important centre of the style was Switzerland: fibulae nos. 334, 336, 339, the silver brooch no. 331, and other pieces.

I have discussed the coalescence of whirligigs and palmettes with tendrils: the same happens with flowers: to *PP 451–8* add the sieve from the Marne, no. 400 (*P 283*), and the swords from Mitrovica in Mainz, *pl. 247, b* (Mainzer Zeitschrift 2 1907, 46), and Kis-Köszeg, no. 115. On the swords the motive looks rather slovenly. The pattern appears at its best in the pillar from Waldenbuch (*PP 454–6*); the master certainly drew from the repertory of metalwork. I describe it for this and for another reason: only a detailed study of forms can date this puzzling monument and link it up with the Waldalgesheim Style. *P 454*: two two-petalled lotuses, one upright, one downward, connected by a diagonal swell-ribbon which is not detached from the flowers, but passes over into their outer leaves. The other leaf of each lotus scrolls at the bottom and grows with its tip into the ribbon. The tips of the outer leaves, where they touch the vertical border of the panel, are not pointed and do not really end here, but look as if they were going on and were just cut off by the frame. In *P 455* two opposed flowers, placed horizontally, grow on short stems from the left lower corner and the right upper and, as in *P 454*, they stick to the upper and lower frame with the cut-off tip of one petal. The tip of the other leaf of each flower forms a scroll corresponding to the bottom scrolls in *P 454*. The diagonal connexion is here not a ribbon as there, but itself a lotus leaf. In *P 456*, which I need not describe in detail, the obliteration of flowers and tendrils as separate characters has gone farther still. I am aware that to speak of flowers, leaves, and tendrils, to use verbs connoting movement, such as 'grow', &c., is a distortion of the inorganic and static character of these ornaments. These artists thought little of flowers and twigs, they had vaguely floral rhythms in their minds; and this explains why the patterns formed by the deepened background are no less sonorous and intelligible than the relief-forms described above.

This treatment of floral forms, by the way, originates in the earlier phase of Celtic art: in the

bronze openwork of the chariot from Kaerlich, no. 167 (*P 385*), the lotus leaves at their tips continue as tendrils, and here there is the same ambivalence of 'positive' and 'negative' forms.

When studying the basic types of Celtic floral forms, I have stated that type *P 314 c* covers a wider field than leaves only and is used for tendrils or ribbons as well. Examples are given in *PP 403, 404, 464–71*. There is much variety in the way the '*leaf-ribbons*' or '*leaf-tendrils*' join the palmettes which they connect, and in their treatment. In *P 470* the rim is stippled, in *PP 464–469* the inner field; in *PP 466, 467, 468* this is filled with wave lines, like the leaves of similar shape in the glass bracelet Viollier pl. 34, 14 (better Bonstetten, Suppl. pl. 5, 3), or the garlands in the clay cup from Braubach, *P 8*. The crescents from Brunn, no. 377 (*P 450 a,b*) give the leaf-ribbons a middle rib.[1] The most elaborate filling is seen on the painted urn from the Basle Gasfabrik, ASA 21 1919 pl. 3, a motive which appears in a withered form in *P 471*. The objects quoted belong to different phases: the gold torc, *PP 403, 404*, is the earliest, *PP 464–70* and the bronzes from Brunn are fourth century, the urn from Basle probably second century B.C. The hanging bowl from Wales, *P 471*, has been dated by R. A. Smith to the fourth century B.C.:[2] the upright palmettes remind one of the pot from Brittany, *P 470*, and make one also think of the bronze torc from Lisieux (Calvados), *P 363*. The triangular shape of the intermediate leaves of the downward palmettes recalls the treatment of the crown over the handle-mask of the Lorraine flagons and that of the top palmette of the lyres in the Amfreville helmet, preserved in impression. The acanthus half-palmettes have a good analogy in the Canosa helmet, *P 466*, and the basketry-work with chevrons and squares stands closer to earlier examples than to the shape it has in British works of later age. I should not be surprised if in fact the bowl were a French work, say about 300 B.C.

THE HUNGARIAN SWORD STYLE

I give the style this label because most of the objects in which it appears are swords, and almost all of them Hungarian; there are, however, links with Western works, especially the swords from La Tène. The style is a development of the Waldalgesheim Style and presupposes its existence.

The most striking feature of these sword ornaments is their intentional, skilful asymmetry. It is natural that an armourer set to decorate a scabbard should draw the longitudinal midline and that the ornament should respect it and work it out, as is the case with all swords in the early phase and with many in this. But often enough the tendrils creep diagonally over the field, from top right to bottom left.[3]

The swords from La Tène give examples of asymmetrical decoration in a less refined manner. The scabbard from Bevaix, no. 112, draws a diagonal from top left to bottom right and fills the right half with equidistant horizontal strokes. Nos. 105 and 108 give the tendrils a diagonal frame; the step pattern *P 255*, set on a diagonal band, is certainly the direct copy of the decoration of a linen band slung this way round a sword, as seen in traces on the sword Vouga pl. 7, no. 11 and the sword from Münsingen, Wiedmer-Stern pl. 26, no. 56; see also Ebert 11 pl. 135, 10. These more or less primitive motives on Swiss swords suggest at least how the idea of asymmetrical decoration might come into an armourer's mind.

[1] Compare the bronze leaves no. 154 A, B.

[2] R. A. Smith, Ant. Journ. 6 1926, 279; Kendrick and Hawkes, Archaeology in England and Wales 1914–31, 184. Examples of ribbons with midribs in the Plastic Style are seen in nos. 274 and 275.

[3] Notice that in the British sword from the river Witham in the Duke of Northumberland's collection at Alnwick Castle (Kemble, Horae ferales pl. 18 no. 10; Leeds fig. 3; Burlington Magazine 65 1939, July), which follows this tradition, the movement is rightward.

In the sword from Bölcske, no. 116, the ornament of the scabbard-top is constructed symmetrically and goes with that of some swords from La Tène. The decoration of the adjoining portion of the scabbard-sheet (*P 472*) consists of two halves, alike apart from shape and proportion of details: one has a right-handed and the other a left-handed movement, thus achieving a diagonal run of the whole ornament—from top right to bottom left. The two halves are separated by a narrow cross-band with wave lines which have their like in no. 104 and in swords from La Tène.[1] Corrosion has somewhat spoilt the bottom tier of the lower half and the top tier of the upper; my drawing and description therefore make one ideal pattern out of the better-preserved portions. The ornament rises in two stories, the lower consisting of two rounds, the upper of one, circumscribed by tendrils: they meet at the central triangle which acts as 'turn-table'. Some features of Waldalgesheim occur: tendrils carried over and under, figures of eight, used here as small fillings only, and 'horns' similar to those on Comacchio bronzes. New are the two-winged flowers, working as trivium like the triangle in the middle. New also the character: Waldalgesheim tendrils are slack and substantial, these are thin and precise, energetic and elastic.

Related in the delicacy of the engraving are two swords from Jutas, both of them badly corroded. I only show that from tomb 1, no. 117, in a photograph taken from the original, and in another from the cast in Budapest with the tendrils redrawn: some mistakes in details will be easily corrected by comparison with the first photograph. The general construction of the pattern is symmetrical, but the distribution of the fillings is loose and without pedantry. Another sword from the same cemetery, tomb 4, not figured here, defies interpretation and reconstruction; it covers the whole of the scabbard-sheet with tendrils running diagonally, and is apparently a work of the same master as no. 117.

Less sure in line and composition and somewhat dishevelled are the ornaments of the swords from Simunovec, no. 119, and from Kis-Köszeg, no. 115. The latter makes lavish use of the flower motive discussed on p. 94, and is thus linked up with the sword from Mitrovica *pl. 247, b*, which in its symmetrical composition goes with no. 117.

The best sword of this style comes from the Marne, from Cernon-sur-Coole, no. 113. Both sides of the iron scabbard are decorated, but only the ornament on the back is well enough preserved for reproduction. The pattern is hung on the lower medallion of the staple, which bears a relief-ornament of a type that might appear in this form in any object of Waldalgesheim Style. The engraved pattern is pushed towards the left edge of the scabbard and has its centre of gravity there, but it has a less diagonal movement than in the Hungarian swords of the type. The engraving is masterly and precise; the hatching is a feature which does not occur elsewhere; the birds' heads as finials of tendrils have an analogy at La Tène,[2] but I am unable to link this artist definitely with the Swiss or Hungarian school.

A different weapon ornamented in the 'Sword Style' is the spear-head from Csabrendek, no. 130. The piece being much corroded, one has to turn to Márton's drawing, which I repeat in *pl. 247, c*, though I do not know how true it is.

Islamic ornament has already done us a good service towards the understanding of essential characteristics of the Waldalgesheim Style.[3] I must now call attention to the likeness of the Hungarian ornaments to Saracenic: in *pl. 247, d* I show a late, but typical example, the wall-paintings of the Tshiragan Palace (built by Sultan Abdul Aziz in 1863–7), with Riegl's conspectus of the single motives.[4] Though fully aware of the danger of such comparisons one

[1] Vouga fig. 7. [2] *pl. 233, d.* [3] *pl. 246, e; p. 93.* [4] Riegl 260 fig. 138.

cannot but remark an astonishing similarity and give the Hungarian ornaments the name of 'arabesques'.

The Swiss swords, though related to the Hungarian and contemporary with them, have a repertory of their own which I will not study in detail.[1] The spear-head no. 129, is a work of the same Swiss school: the swastika $(PP\,265,\,266)$[2], is a conservative feature, like the step pattern on the sword from La Tène, $P\,255$, or the parallel horizontals on the sword no. 112. The Swiss swords were exported (and imitated?) because of their high quality.[3]

THE PLASTIC STYLE

The ornaments studied hitherto were more or less two-dimensional: either engraved, or if in relief, then low enough to make a linear drawing without impairing their character. Forms in the round were dealt with only once,[4] but they were of such a kind that the modelling did not call for special comment.

I have already observed a certain peculiarly Celtic tendency to swell, but it was confined to the outline of more or less two-dimensional ribbons or leaves: if they were done in relief their plastic shape did not differ too much from what a classical artist would have given them: I am thinking of works like the gold torcs and bracelets from Waldalgesheim, the torc from Oblat, no. 47, the finger-ring no. 74, and some bronzes. All these are forerunners of the style I am about to discuss. This tendency to swell achieves its plastic expression only in the period now to be treated.

The first characteristic of the style is well illustrated by the bronze torcs nos. 222 and 223 and the bracelets nos. 277 and 278. Most expressive is the close-up of no. 222. In a classic or even in a Celtic ring, such as no. 219, the plastic parts can be thought away from the ring proper, and the ornamentation, engraved or in relief, is a surface decoration. Here the spirals are not set on the surface of a body as an additional ornament, here there is no clear border-line between the decoration and what it decorates. If you try to cut off the spirals, you cut into the flesh. The whole ornament is burgeoning, all is in *statu nascendi*, all is growth and flux, making one think of plastic dough or a gnarled tree.

Sober description of 'motives' has its limits: the following dangerously vague remark might not be out of place. A classic work is the image of things after they have gone through a process of distillation; a classic form is the result of abstraction of all that is inessential to a Greek mind, it exhibits the pure ἰδέα. A Greek perceived the organic structure of a plant, the law behind the puzzling multiformity. A Celt did not care what lay below the surface; he did not take the surface as accidental, obscuring the idea of a tree or a plant; he was attracted by their wild, weird forms, reflecting the dark and mighty power of Nature who reveals herself when the buds burst in springtime, when the storm tosses the gnarled trees. . . . Let us return to earth: as no. 222, *pl. 132*, shows, activity is confined to the outside and stops at the back of the ring where it touches the wearer's skin.

Another characteristic work of this style is the Swabian linch-pin no. 159 with 'crockets'.

An interesting nuance of the Plastic Style is represented by a number of gold bracelets and

[1] More material is to be found in Vouga; see also Wiedmer-Stern pls. 25 ff.

[2] p. 76.

[3] The sword from Sanzeno, no. 104, has some motives which appear identically at La Tène; the whirligig-chain $(P\,427)$ is a conservative feature. Germany: Bittel pl. 4, 2, p. 74. Sword from Weinheim (near Alzei) in Mainz, Mainzer Zeitschrift 28 1933, 97 fig. 14. France: from the Loire in Nantes, BAF 1913 pl. 1, p. 15.

[4] p. 76.

torcs which were found in the South-west of France and one (no. 62) in Hungary; we need not here ask where they were made. The first class of them comprises nos. 62, 65, 66, 67: of these 65 and 67 confine the plastic decoration to a small portion of the ring which is otherwise twisted: no. 64, figured here for the sake of completeness, is a pure torc, lacking adornments. No. 67, certainly a work by the same hand as no. 66, much resembles a torc from Montans (Tarn) for which, lacking photograph and information, I must refer to Déchelette fig. 589, 2. No. 66 goes closely with the Hungarian torc no. 62: here the hoop, in its whole length, is covered by ninety 'teeth', on the Hungarian piece by over forty, those of the finials not included. The units, flat on the back, are subdivided by grooves into five parts, the finials, where the decoration goes farther round the ring, into seven. The patterns resemble those on the surface of human molars, others are more like flowers: here again one can only say that the Celt was vaguely thinking of some natural model.

Must not the gold ornaments *pl. 248, a*, found in the beehive tomb at Mezek in Thrace, like the bronzes nos. 164, 176, belong to the Celtic chariot-burial in the grave, and are they not related to our rings? at Mezek strung, in France and Hungary soldered on the rings.[1]

The second set of these gold rings comprises nos. 68, 69. No. 68 is in principle an eight-part boss-ring as is frequent in bronze; the plain bridges between the bosses are saddle-shaped rolls, a form not unknown to Greek toreutics.[2] The rolls are not perfectly symmetrical in shape, being higher on the left side and only here set off by a beaded line: this gives the ring a half-hidden right-handed movement. The torc no. 69, in combining relief decoration with torsion, goes with nos. 65 and 67, but has only two twists between the 'flowers'.

The gold ring from Aurillac, no. 63, is the best example of this style and among the most perfect works of Celtic jewellery. The hoop itself is skilfully disguised by the thicket. At a closer glance one discovers the catch, marked by a vertical arrangement of the units, and not far away, bottom left and top right, the naked convex finial-heads of the two hoops which carry the ornamentation. If one takes pains one can even follow the hoops on their way round the ring and see something of their turns—but the artist intended to give the idea of a thick wreath. The single motives, often accompanied or separated by beaded lines, are difficult to describe in words; they resemble scrolled leaves and recall the crockets of the linch-pin no. 159, and their descendants are in Celtic works in Great Britain and Ireland. The Aurillac bracelet is quite unlike a classical work, where the leaves or flowers or fruits—each of them nameable and distinguishable—would not form such a maze, but would be arranged on 'architectural' principles. The baroque unrest and tropical exuberance of the bracelet remind one of India or China.

Judgement on the gold torc from Frasnes-lez-Buissenal no. 70, once in the Aremberg Collection, but now untraceable, entirely depends on the bad drawings repeated in *pl. 51, a–h*; and the photograph, borrowed from Déchelette fig. 586, is of little use. The ornament, in high relief near the buffers, consists of two contracted lyres of the type dealt with on p. 86. The upper has its foot-scrolls wide apart, and its arms are accompanied outside by smaller spiral bands; the lower lyre is narrow: what grows at right and left I cannot tell from the drawings. The wide inner space of the upper lyre is filled with the head of an animal which

[1] Bull. de l'Inst. Bulgare 11 1937 fig. 32. The photograph was kindly provided by Professor Filow. The treatment of the central part of other such gold ornaments from the find, l.c. fig. 30, 8–11, recalls that of the analogous barrel-shaped parts of no. 58, or no. 42; compare also no. 87; other examples occur in those silver fibulae frequent in the Balkans: Blinkenberg 224 ff.; Déchelette fig. 590, 1, 2. The motive goes back to seventh-century arts: Waldstein, The Argive Heraeum pl. 62, Perachora 1 pls. 74–5 (pin-heads).

[2] Jacobsthal, Ornamente 58; Buschor in FR III, text p. 266.

in former descriptions is called a horse and might be a bull. It is bedded in ribbons; one ribbon, in the shape of an Ionic capital, lies above the eyes, another comes down the forehead, and a pair run from the nostrils up to the foot-scrolls of the lyre. Slanting eyes, but hardly so slanting as these, occur occasionally elsewhere;[1] the stylization of nose and nostrils is much as in the bronze horse from Stanwick,[2] *pl. 248, b*. The plastic twisted ribbons are treated like those in the bracelet no. 277; the form of their rolled ends recalls certain motives in the Aurillac bracelet, no. 63, and in related works. The torc forms part of a gold hoard: the Celtic gold coins in it, as Dr. Pink kindly informs me, point to the second quarter of the first century B.C., but this is no objection to dating other parts of the hoard earlier, and I should like to place the torc in the third or second century B.C., conscious, however, that this is guess-work.[3]

The 'Aurillac Style', for good reasons, is confined to gold, but there are cast bronze rings with motives that also recall floral models. In nos. 262, 263, 264 one sees waving stems and berries.[4] Nos. 259 and 260 arrange the berries in threes; they are more voluminous, and are set at intervals, articulating the ring.[5] The decoration of no. 261 shows groups of three balls, set on plaques standing aslant on the two strands which form the bracelet, and between the plaques there are bridges, level with the plane of the ring. The ornament is very refined, and is influenced by the class of rings I shall have to study soon. It is instructive to look back to the innocent one-dimensional axial treatment of the three balls on torc no. 245.

The bronze ring *pl. 248, c*, a product of the Hallstatt D Hunsrück-Eifel I culture, suggests that this fashion has its roots in the previous phase.[6]

The style I shall next describe is applied to massive cast bronze bracelets—or foot-rings—and to a few objects of another kind. The rings, in their heaviness and possibly in features of decoration, carry on a fashion of Hallstatt age.[7] They have been called 'Eierringe', 'Schalenringe' by German archaeologists; Déchelette (1222) speaks of 'bracelets à demi-oves ou demi-sphères creuses'. Some of them, no. 275 and no. 279, preserve the ring proper as the body and adorn the surface; the majority are chains of globular units, 'strung', only narrow bridges being left between them. Number and shape of the parts, always hollow inside, vary: the very good plain piece no. 265[8] consists of three only. Here they have the form of half-eggs, in other cases of hemispheres; no. 272 has squares with chamfered corners. The globes may become smaller and smaller: there is a Hungarian specimen with as many as twelve.[9]

[1] p. 13.

[2] BM EIA fig. 159. 9·4 cm. high. Cross-section a half-circle, open at the back, but with a 'lid' on top; all bent out of one sheet of bronze, including the wings, which are perforated and have a nail still sticking in one of the holes.

Beazley draws my attention to the overstylized horses with slanting eyes on bronze horse-nasals in Karlsruhe (Wagner, Bronzen pls. 26, 27 and Schumacher no. 780 ff. pl. 16, nos. 19, 20, and pl. 22).

[3] Of interest, though of no avail for the chronology of the torc, is the occurrence of the pattern *pl. 51, figs. d, e, g* in the gold torc from Broighter, Co. Londonderry (Archaeologia 55 pl. 22, pp. 399 fig. 5, 401 fig. 7; Mahr in Bossert 5, 15; Marburger Studien für Merhart (1938) pl. 79), which is commonly believed to be a work of the first century B.C.

[4] Compare the piece from Kosd, 24/5. Bericht RGK pl. 56 fig. 2 and the examples from Bohemia, Déchelette fig. 517.

[5] Compare also AuhV 4 pl. 13, 2, 3, and Dolgozatok pl. 31,

1. See also AuhV 2, 5 pl. 1, nos. 2 and 3. A bronze finger-ring from Ornavasso with berries, Bianchetti, I sepolcreti di Ornavasso pl. 13, 5. On a rare variant with coarse figure decoration see Pič, Le Hradischt de Stradonitz 63, note 96 and Tschumi, Jahrbuch des Bernischen Hist. Museums 27 1937, 82, and idem, Die ur- und frühgeschichtliche Fundstelle von Port im Amt Nidau (1940) 5 fig. 5. Compare the plainer rings from Casaletto, near Lodi, Montelius pl. 65, 4, 5.

[6] Dr. Neuffer informed me that the type is an intruder in this part of the Rhineland and more frequent in the country south of Mannheim, whence three specimens are known to him.

[7] Déchelette fig. 338.

[8] Specimens from Hungary: Márton 38 fig. 5 (Nagyhörcsök), 40 fig. 6 (Varasszentiván); 24/5. Bericht RGK pl. 56 figs. 6, 7 (Kosd). The Sword Style ornament of the second piece refutes Márton's early date (p. 42).

[9] Márton pl. 13, 4.

Much of course depends on the distance at which they are set from each other and how much of the 'string' appears between them.[1]

A good start is the bracelet from the Tarn, no. 275. It bears eight ellipsoid medallions, four broad, four narrow. They have a plastic frame with engraved upright esses. The ground is roughened with the punch. The smaller medallions (*P 433*) are decorated with a two-part spiral band: the central involution, common to both spirals, bears a concave-sided triangle. The motive on the larger medallion (*P 432*) is one of those tendrils with triangular whirligigs studied on p. 92. I put this bracelet at the beginning of the series: the motives show close connexion with the past: in linear drawings they do not look much different from those on fourth-century works. What is new here is best realized by comparison with bracelet no. 250. There is a certain likeness of taste in the use of frame lines, here beaded, and of patterns: a two-part spiral across the ring, and triangular whirligigs in the lateral fields. The decisive difference is not so much an increase of volume and relief as a heightened instinct and art of thinking in three dimensions, of rational modelling: this will become clearer after a study of other works in this series.

The Bohemian ring no. 279 confines the decoration to two opposite quarters of its circumference, one of them being the detachable lock. On the cushion between the saddles there is a spiral similar to those on the Tarn bracelet; the involutions bear engraved almonds, probably set for eyes; the ground is roughened with little engraved circles.[2]

The ring from Longirod, no. 274, like the one from the Tarn, has eight strung members, four big, four small, the latter plain. In the two preceding pieces surface ornaments stood on a neutral even plane, now the plastic conception goes down to the ground and the whole body assumes a truly three-dimensional shape. Across the bosses, in the longitudinal axis, runs a spiral, the ribbon of which has the profile of a saddle-roof; at the involutions its planes form a plateau on which the globes are set eccentrically. As a consequence of the curvature of the surface the flats slope and the 'eyes' look outwards. The remaining spaces above and below the spirals, once the neutral ground, have now become highly complicated solids, a kind of pyramid with curved sides, their shape depending on that of the ribbons and the flats.

No. 270 shows hemispheres; the ornament in flat projection (*P 473*) is one of the triangular whirligigs often mentioned: it rises with a narrow rim, set off slightly, from an oblate plaque. The treatment of the involutions and bosses is the same as in the preceding ring, the 'eyeballs' are again placed eccentrically, their axes here standing at an angle of 60° to their base. The central field is a pyramid with curved sides. Its two-dimensional equivalent is a motive like that on a gold ornament from Klein Aspergle, no. 32 (*pl. 28*), or in one of the Comacchio bronzes no. 401, *o*, a triangle the centre of which is connected with its three corners. The spaces between the circumference of the boss and the whirligig are similarly shaped in no. 274: their form might also be interpreted as a slightly three-dimensional fan with a midrib.

In no. 268 and no. 269 the transformation of the rounded shape of the bosses into polyhedra has gone farther than in the Longirod bracelet no. 274 and in no. 270. A description of the complicated solids would be too long: suffice it to say that on the surface of the body there are three eyes, diagonally placed; the eyeballs on no. 269 are just globes, in no. 268

[1] I refer to the material from North Italy: Montelius pls. 59, 10 (Este); 65, 2 (Oulx, prov. di Torino); 112, 14 (Marzabotto); 113, 5 (Saliceto di San Giuliano); &c.

[2] A similar ring in Munich, inv. no. 1913/14, known to me from a drawing by Dr. Kersten, decorates the ring beside the saddles with a lyre pattern; see p. 84, note 6.

the notion of 'eye' is obscured, and here the balls are replaced by those medallions with plastic triskeles which were used on a larger scale as the sole decoration of no. 270.

No. 267 (*P 474*) sets as centre the medallion already known to us from two other rings, but its modelling is coarser and blurred; on the oblate sloping top and bottom surface there is an eye; an eye also stands upright to left and right of the medallion; its lower lid, marking the end of the ornament, is drawn straight; it is less elaborate than the other eyes, which have double-contoured lids and have their eyeballs set on a low platform. These five parts are connected by a ribbon: it starts at the right corner of the left upright eye, touches its upper lid, goes round the medallion down to the bottom point; there it branches into two ribbons, one running upwards to the left corner of the top eye, the other, touching on its way the upper lid of the upright side eye, to the right corner of the top eye.[1] The remaining intervals are again filled with configurations of the kind we have already met: they can be read as plastic fans or as a sort of pyramid with curved sides.

No. 266 is the masterpiece of this style.[2] Above and below, the same medallion: between the two, looking outwards, the eye. The shape of these units and the angle of their axes are the result of their being set on a plane which has a highly complicated movement: in *pl. 146* centre, the inclined spiral is seen turning as it runs round them from top right to bottom left. The medallion, as the combination of the different views in the plate shows, consists of two hills, divided by a deep winding valley; at each end of this valley, and on opposite sides of it, stands an eye with no eyeball; the remainder of the hill is occupied by lobes and the oft mentioned fan or pyramid. The eye which separates the two medallions has its axis set diagonally; it has no pointed corners, its outline is an ellipse, and the eyeball is also an upright ellipse; there is a pyramid to left of the eye and another to right.

I need not comment on no. 271 or no. 273, coarse rings.

This style was applied to the decoration of objects other than bracelets. Related works are: (1) linch-pin no. 159.[3] (2) Linch-pin no. 161.[4] (3) Bronze nail with globular head, AuhV 2, 10 pl. 3, 5, in Hanover, no provenience given. (4) Set nos. 163, 175; on its origin see p. 184. (5) Set from Mezek, nos. 164, 176. (6) Bronze nail-head from a chariot tomb at Christurul-Secuesc (Hungarian: Székelykeresztúr, Com. Udvarhely), Dacia 3/4 1927–32, 360; Dolgozatok pl. 57, 8, p. 162; date: third century B.C. (Nestor, 22. Bericht RGK 1932, 154). (7) Bracelet from Sopron, no. 258. (8) Fibula no. 347, from Kosd. (9) Hungarian fibula no. 346 (and its pendant, once in Zurich, AuhV 5 pl. 20 no. 346). (10) Girdle-hook from Hungary,[5] Márton 34 fig. 4, p. 77, *pl. 219, f.*

The following are Swiss: (11) Iron phalera from La Tène, no. 203. The helicoid central boss seen directly from above resembles a crescent-wheel, but the nail-head, the starting-point, is set eccentrically and the three tracks slope downwards one after the other, the first to leave taking the longest way and forming the ground plateau. (12) The bronze beak-flagon from the Ticino, no. 393 d. On each side of the neck is a snail-shell comparable with those on the Hungarian bracelet no. 7. The motive is of importance for the chronology of these flagons.[6] (14) Glass beads:[7] *pl. 248, d.*

[1] The flat projection in *P 474* leads to a disfigurement: actually the corners of two neighbouring eyes touch each other, and one ridge of the pyramid between them runs towards the same point.

[2] I must confine myself to the few pieces of which I have been able to make or obtain satisfactory photographs; this was not the case with the Bohemian ring figured by Schránil pl. 47, 24.

[3] pp. 97, 98. [4] p. 18.

[5] p. 18. The girdle-hook AuhV 2, 5 pl. 1, 6, without provenience, looks Hungarian. [6] pp. 107, 109, 136.

[7] Viollier pl. 32, 12, p. 121, no. 72; see also Déchelette fig.

The distribution of the finds suggests that the centres of the Plastic Style were Hungary, Bohemia, South-east Germany—to a lesser extent Switzerland: the contribution of other regions is negligible.[1] Déchelette (1223) has called these works 'très tourmentés' and others will go farther in their dislike: we must understand them before we judge them.

The mathematical mind, which in a former phase had expressed itself in flat openwork patterns, now works in three dimensions. Needless to say that these polyhedra and the like are no more a creation of conscious mathematical construction than were the two-dimensional motives.[2] Some of these works, none more than no. 175 *a, b*, masterfully blend two elements which are normally thought to be incompatible, the most rational construction and the wildest fancy, nay magic: it is no chance that the weirdest of all Celtic masks appear in the context of this style.

Hitherto all has been 'ornament', more or less accessory to bodies which could exist as well without it. It is otherwise with the yoke from La Tène, no. 172. It is free of such adornments and consists only of what is required for its purpose and function: the two bows lying on the necks of the draught-cattle with a knob at the end for slinging the traces round, and the bridge between. Comparison with a classical yoke preserved, the bronze yoke from Chianciano in Florence,[3] Annali dell' Istituto 1882 pl. T; Alinari 17060, is instructive: it articulates the members sharply and treats the bows and the cushion-rolls in which they end to right and left like a piece of architecture, like consoles. There may have been other classical yokes even more ornate. The effect of the Celtic yoke is neither shapeless nor dull; it satisfies the eye and, what is more important, the neck: it has the inconspicuous beauty of a good tool whose plastic form results from its functional structure. All is soft and round, without break or caesura: the bridge has its middle marked by a ridge; but its two rolls do not assume the shape of balusters, which the Celts often use under similar conditions.[4] The rolls continue as the spine of the bows, bedded between the tilted edges, the bows lay smoothly on the necks of the draught-cattle. The Gaulish yokes from Pergamon, no. 173, are plainer and more edgy. It is a strong proof of the intensity of Celtic artistic civilization that a local cartwright (La Tène was quite an unimportant settlement) was able to give this modest wooden implement so perfect a form.

A similar movement of planes and a similar fashion of modelling occurs in bronzework of this period: (1) Saddle-spirals on the scabbard from Roje, no. 114. (2) Bracelet from Méry-sur-Seine, *pl. 248, e*. (3) Bracelet from Épagny in Fribourg, no. 278. (4) Torc from Mareuil-le-Port (Marne), *pl. 248, f*. (5) Bridle-bit-handles from La Tène, no. 204.

These plastic principles were brought to perfection in the following phase, in the arts of Great Britain and Ireland.

Here again the question of origin has to be raised. Certain motives of the Plastic Style are not unrelated to those in the previous periods of Celtic art. But it is otherwise with the prin-

573; Seligman, Bull. of the Museum of Far Eastern Antiquities Stockholm 10 1938, 29. The type is not confined to Switzerland: AuhV 5 pl. 14, nos. 237 e (Nienburg, Weser), 240 (Heppenheim, Kr. Worms). It carries on Hallstatt tradition: Déchelette fig. 364, 4.

[1] The bracelet no. 275 was found on the Tarn, but is hardly of French origin. On the wrong French label of the set nos. 163, 175 see p. 184. A boss-ring from Niederolm near Mainz, Mainzer Zeitschrift 26 1931, 131, 132. From Alsace, Schaeffer fig. 143. From Loisy-sur-Marne BSA 1899, 572 fig. 6. Italy:

on p. 100, note 1 I gave a list of boss-rings from various sites in Gallia Cispadana and Transpadana. See also Duhn, Ebert 6, 292. There is a drawing of one by Thomas Burgon (in the Ashmolean Museum) 'Naples'.

[2] p. 81.

[3] Daremberg-Saglio s.v. jugum, fig. 4154. The chariot and the statues to which it belongs date from the third century B.C.: Amelung, Führer 252; Nachod, Der Rennwagen bei den Italikern 38; Mercklin, JdI 48 1933, 100.

[4] p. 76; P 279.

ciple of the style itself, and here the answer is an unexpected one: if one looks at certain Hallstatt rings, massive and highly plastic, such as Déchelette figs. 337, 338, at the bronze ring of the Hunsrück-Eifel culture,[1] *pl. 248, c* or if one compares the bronze bracelet from Münsingen,[2] no. 280, with *Wendelringe*, the similarity goes too far and too deep to be mere casual coincidence. But while geometric motives of Celtic art are most frequent at the beginning and then gradually recede, here tendencies of a bygone age hide during the early phase and come to the surface as time goes on. The problem is even more complicated: I have the impression that a certain manner of movement of planes and certain 'baroque' tendencies are anticipated in metalwork of archaic Italy.[3] I am, however, unable to offer a sound historical explanation: prehistorians may discuss and check the truth of this observation.

I sum up the more important results of this chapter without yet drawing the full historical conclusions.

Despite the strong particular physiognomy of Celtic ornament, and despite all disguise, the foreign models are unmistakable and can be exactly traced. Before I deal with these *origines* and with the different layers of Celtic forms, I should like to warn the reader against the danger of cheap *a priori* constructions. Do not believe that Celtic art, like Greek art of the eighth and seventh centuries B.C., grew out of a Geometric style which gradually became infiltrated by curvilinear forms until the old-fashioned elements completely disappeared. Do not believe that there are early works of pure 'Hallstatt' character. Do not believe that the following phases reflect subsequent strata of Southern ornamentation reaching the Celtic regions one after the other. Facts look different. It cannot be repeated often enough that there was never an early period where the geometric motives were used by themselves: if there are some early objects in which they stand alone it can always be proved that these are not older than others with curvilinear decoration. In fact the two components exist in close and friendly symbiosis in the same works. I quote: Lorraine flagons, no. 381 (*PP 156, 179, 217, 405-7, 423-5*). Sword from Hallstatt, no. 96 (*PP 105, 218, 251, 395*). Chariot-horn no. 168 (*P 408*). Helmet no. 139 (*PP 213, 401*). Gold from Schwarzenbach, no. 18 (*PP 12, 301, 324-5, 365, 367 a, 410*), no. 34 (*PP 245, 247, 300, 304, 371, 372, 400*). The geometric motives persevere into the following phases though slowly ebbing: ring from Waldalgesheim, no. 156f (*PP 264, 457*); pillar from Waldenbuch, no. 15 (*PP 258, 454-6*); bronzes from Comacchio, no. 401 (*PP 124, 133-4, 214, 215, 256, 459-63*); spear-head no. 129 (*PP 265, 266*).

Worth noticing is the persistence of some technical Hallstatt features. Tinkering[4] is confined to the early phase, but the tremolo lines still appear in so mature a work as the Weisskirchen dagger, no. 100, or on the plaque from Hohenfeld, no. 378.

Geometric patterns, rectilinear (chevrons, steps, stairs, sentry-boxes, lozenges, &c.) or curvilinear (scales, scallops, serpentines, guilloches, star-rosettes, lyres, &c.) have their analogies in the classical Orientalizing styles of the late eighth, seventh, and sixth centuries B.C. Though it is not my present concern, I should like to lay my finger on a problem which, as far as my knowledge goes, has never been seen or stated. These patterns are of such a nature that one would expect to find part of them in the geometric styles proper of Greece and Italy:

[1] p. 99.
[2] Compare the ring from Sulevič, Mitteilungen der Anthrop. Gesellschaft Wien 19 pl. 1, 11. See my remarks on the principle of torsion on p. 72. Torsion applied to the bows of fibulae: no. 326; Saint-Sulpice, tomb 10, in Lausanne; Viollier pl. 2, 65, p. 128; ASA 1914, 263. On Italic forerunners see p. 72.
[3] E.g. serpent brooch, Montelius pl. XX, 282. Similar observations made by Leeds, Celtic Ornament 49.
[4] pp. 107-8.

instead they never occur in geometric pottery or bronzes, but form the geometric component of the Orientalizing styles of the post-geometric centuries. Some of them are not even confined to Greece and Italy, but appear in Phoenicia, Persia, South Russia, the Altai mountains.[1] I am at a perfect loss to offer any explanation for this surprising fact.

When I called the geometric forms of Celtic art a 'Hallstatt stratum', I did not imply that they were taken by the Celts from Hallstatt arts in the North. I used the term in a 'European' sense, to denote those parallel styles of the eighth, seventh, and sixth centuries B.C., the Orientalizing style in Greece and Italy, late Hallstatt in the North.

The search for prototypes of the Celtic motives led to the following result: in most cases they were traceable in Greece, Italy, more rarely in the North. Greece as potential direct source has to be eliminated, and (a very important statement) in the North they are so scanty and confined to the latest Hallstatt that they are doubtless intruders from the South: a prelude to their full reception in La Tène. The real source was Italy. The facts are so conclusive, the collected material so cogent, that the few cases where Italic parallels cannot yet be traced are no argument against my thesis. But is there not a gap of more than a hundred years between the Orientalizing period and the beginning of Celtic art? This is true only so long as one thinks of central and advanced provinces such as Etruria, which kept up with the progress of times and arts in Greece and where, in point of fact, that stratum of forms did not long survive the seventh century B.C. But the early contact between the Celts and Italy actually took place in the North of the peninsula, in backwaters like the land of Este;[2] here this stratum of forms was very persistent: I shall return to the problem presently.

While the geometric motives appear in Celtic objects in a form little differing from their originals, others have undergone a deep change which makes it more difficult to see their classical prototypes.

The following patterns can be traced more or less certainly to definite subsequent layers of Southern ornamentation. To archaic and sub-archaic art (the latter lasting in Etruria and other provinces of Italy into the fifth century B.C. and even beyond): the interlaced lyres of the Waldalgesheim flagon,[3] types of lotuses[4] and palmettes, certain kinds of scale patterns, such as in the Klein Aspergle scale-horn,[5] guilloches,[6] &c. As to the source of these motives: direct contact with Greece is again out of the question, and if here and there I have quoted Greek vases as analogies,[7] I have done so from lack or ignorance of Italic material: the Celts certainly had Greek vases in their hands, but I doubt whether the artists paid much attention to their ornaments or took inspiration from them. Etruscan metalwork must have played the greatest part: in some cases this has been established.[8]

Southern crafts of the late fifth and early fourth centuries are reflected by the astragalus of one of the Klein Aspergle horns or by the scarce acanthus leaves. The following motives copy ornament of the high and late fourth century B.C.: sickle-palmettes, half-palmettes, sprung palmettes, daisies and bell-flowers, vertical lyres in tiers. Perhaps the insertion of heads in tendrils points to familiarity of the Celts with such fourth-century motives.[9]

I must dwell once more upon the interrelation of these layers. In high and central civilizations with a steadily flowing development the past is past, or only lives transformed, and each new wave swallows the last: in backward arts the waters are stagnant. The physiognomy of Celtic style is mainly determined by the great loan of archaic and sub-archaic classical forms

[1] pp. 67; 69 ns. 1, 5; 73 n. 2; 84 n. 9. [2] p. 160. [6] p. 71. [7] pp. 74; 85; 87.
[3] pp. 84–5. [4] p. 87. [5] p. 69. [8] pp. 69; 71; 87; 88; 123; 125. [9] pp. 16 ff.

in the early days, and not by the subsequent reception of a few late fifth- and fourth-century motives, which only careful analysis is able to detect. While in Etruria Greek sub-archaic art, tarrying through the fifth and fourth centuries B.C., is immediately followed by a reception of Hellenistic art,[1] the Celts, after the end of the fourth century, closed their eyes to foreign arts and resisted temptation. Early ornaments, such as the gold lid from Auvers, no. 19, the Eygenbilsen band, no. 24, have still a strong classical look and stand to their Greek—indirect —prototypes as Persian, Cypriote, or Etruscan works do. In the Waldalgesheim, the Sword, the Plastic Style, the foreign borrowings have undergone a deep change and are handled with sovereign freedom: there was no need any longer to look for models or inspiration.

[1] Messerschmidt, JdI 45 1930, 62; RM 43 1928, 155 ff.

CHAPTER 4

A SURVEY OF IMPLEMENTS AND SOME REMARKS ON THEIR TECHNIQUE

ALTHOUGH my primary concern is not the civilization of the Gauls, but their arts, a survey of some kinds of implements illustrated may shed light on their style, their chronology, and their connexion with foreign cultures. There are, however, two obstacles, already complained of: almost all the tombs from which these works came were opened at a time when the technique of excavation and observation was still unrefined. Moreover, the reconstruction and the purpose of many objects must remain uncertain because we have no literary or pictorial evidence: how different all this would be if we had vases or reliefs with representations of people and their chariots and horses, their weapons and ornaments, or descriptions by writers!

METAL VESSELS

In the graves the imported vases outnumber those of native workmanship. Between stand the flagons from Aarau, no. 392, which are of Celtic shape, but made by a Greek in a Celtic workshop,[1] the beak-flagons from Weisskirchen and Armsheim, no. 386, Etruscan imports, embellished—but not too successfully—with engraved patterns by a Celt, and the Attic cup from Klein Aspergle, no. 32, mounted by a Gaul with gold ornaments.[2]

The proportion between imported and native vessels and the overwhelming preponderance of bronze is due to burial customs and to conditions of preservation; if the diggers had been well enough trained to recognize fragments and traces of wood, the Ticino spout-flagon, no. 395, would not be the only one preserved. Pottery is scanty in the graves except on the Marne.

All the metal vases in the tombs were for banquets, first real banquets, and, afterwards, banquets in the beyond: they were filled with wine and given to the dead: the dead Gaul was believed to drink with a companion, hence so many double sets of plate in the graves.[3]

The variety of types is not great. The plate in Tonnère,[4] *pl. 249, a*, and the basin from Les-Saulces-Champenoises,[5] *pl. 249, b*, *P 468* (Déchelette fig. 655), stand apart: they may have served the same purpose as the imported Etruscan basins[6] (Déchelette figs. 644–5), which are slightly larger. The shape of the vases to which the animal-handle, no. 384, the Dürkheim lid, no. 397, and the foot now wrongly mounted on no. 388 belonged, must remain uncertain.

Spout- and beak-flagons. There are four spout-flagons, three complete and one—or two?[7]—fragmentary: nos. 387, 388, 389, 390. The Aarau flagons, no. 392, are a cross-form of a spout- and a beak-flagon. Their body-curve has a general fifth-century look; the handle-

[1] p. 25. [2] p. 157.

[3] Pairs of vessels: Klein Aspergle: two horns, two Attic cups. Aarau: two jugs. Rodenbach: two basins (JL 26). The two beak-flagons from Lorraine, no. 381, found together with two stamnoi (*pl. 253*), are clear proof that the find comes from a chieftain-grave; see p. 200.

[4] BAF 1920, 103 pl. 1.

[5] From chariot grave. Diameter 28 cm., height 6·5 cm.; bronze less than one millimeter thick (Déchelette 1455). As

Mr. A. Thiérot kindly informs me, the basin is now in the possession of Mme de Niort, *née* Bérard, at Carcassonne.

[6] p. 138.

[7] In the collection of the late Freiherr von Diergardt there was a piece not unlike the lower part of the Eygenbilsen vase, with a diameter of 28 cm.; it shows a row of rivet-holes along the upper edge. The collection contained a good many other La Tène objects: the fragment may well have been part of another spout-flagon.

lionesses are the work of a Greek and recall late-fifth-century animal-sculpture.[1] A second-rate Greek artist who did bad business at home and had an adventurous mind might try his fortunes abroad and find a job in a transalpine Celtic workshop: as others went to Scythia and made gorytoi, daggers, horse-nasals, &c., for the natives, Scythian in shape, Greek in decoration, so this Greek would work clumsy spout-jugs with a Greek handle for his Gaulish employers.

The wooden bronze-mounted spout-flagon from Molinazzo d'Arbedo, no. 395, is decorated with chequers formed by little bronze squares, which are hammered into the wood: this has an analogy in the Kaerlich chariot.[2] The shape of the flagon occurs without much difference in pottery: six of these clay spout-flagons also come from the Ticino cemeteries (Ulrich pls. 8, 6; 9, 1; 25, 10; 35, 6; 51, 13; 60, 11; Ebert 8 pl. 98 A, k) and two from France, no. 407 and another from Aussonce (Ardennes) (Déchelette fig. 654, 3).[3] The 'spectacle-handle' of no. 395 is a Hallstatt C feature:[4] I figure two Bavarian Hallstatt pots, *pl. 249, c, d.* The motives on the horizontal bronze bands, the astragaloi (*P 143*) and the others (*P 271*), related to those on the Catillon spout-flagon, no. 389 (*P 268*), and on the bronze plaque from Langenhain, no. 391 (*P 272*), have been dealt with before.[5] The handle has a trapezoid attachment comparable to those of bronze and clay beak-flagons from the Ticino;[6] here the attachment cuts rudely into the decoration of the horizontal strips. The embossed ornament of the trapezium consists of a leaf above and a two-petalled lotus below, both pointing down: they give the impression that the Swiss artisan was little familiar with flowers of this kind. The decoration of the spectacle-frame is a clever adaptation of similar forms to the particular conditions of this panel. The rhythm of the flowers vaguely recalls other Swiss works, the outline of the bronzes from La Tène, Vouga pl. 33, 2 and 5, and the bungled ornaments attached to the plastic helices[7] on the neck of the Ticino bronze beak-flagon, no. 393 *d.*

The spout-flagon from Waldalgesheim, no. 387, is the most elaborate piece. To the discussion of details in the foregoing chapters I would only add that the cast openwork round the lower end of the handle is not unlike the two-tier lyres[8] and is possibly connected with those openwork spirals which are seen round the attachment-figures of Greek bronze vases or mirrors.[9]

The Catillon flagon, no. 389, is much plainer; the tinker technique and the decoration have a strong Hallstatt flavour.[10] The flagon in Nuremberg, no. 388, lacks decoration of any sort; its profile stands between the Waldalgesheim and the Catillon jug. The Eygenbilsen vase, no. 390, resembles the Catillon in shape, the Waldalgesheim jug in ornamentation.

[1] p. 25. [2] p. 74.

[3] Habert, Catalogue du Musée archéologique de Reims (1901) pl. 1 fig. 4: 32 cm. high, ' terre roux-jaunâtre, marbrée de terre noirâtre'. I could not find the vase in Reims: it probably belongs to the objects destroyed in 1914–18.

[4] The vase *pl. 249, d,* from Oberpoering: Bayrischer Vorgeschichtsfreund 3 1923 no. 24, plate; Wagner, Formen aus Grabfunden der Hallstattzeit (Stufe C) p. 14. The photograph of the pot, *pl. 249, c,* from Beilngries, is due to the courtesy of the staff of the Vor- und frühgeschichtliche Staatssammlung, Munich, but I have no other information. Other such Hallstatt C vases are: Bonstetten pl. 17, 3 and 5; and two unpublished, one in Halle (from Klosterschule) and one in Nancy—of the latter Dr. Dehn kindly gave me a drawing. As often, this Hallstatt type is not confined to Europe: Caucasus, Chantre,

Recherches archéologiques dans le Caucase 3 pl. 22; Luristan, Godard pl. 67; ESA 9 1934, 85 fig. 29.

[5] p. 76.

[6] JL 54 ff.; see the clay flagon pl. 27, no. 133.

[7] p. 101.

[8] p. 86.

[9] Weicker, Seelenvogel 131 fig. 56 (Roscher 4, 628 fig. 22); RM 38/9 1923/4, 373 fig. 11; AA 44 1929, 261/2 figs. 23–5; AJA 43 1939, 190 fig. 1; Filow, Grabhügelnekropole bei Duvanlij figs. 85, 86; Allard Pierson Museum, Algemeene gids pl. 37, no. 765. Compare also mirror-handles, AA l.c. fig. 23 and Jacobsthal, Ornamente pl. 141.

[10] For the decoration of foot and lid see p. 76 and *P 268*; for the attachment and its relation to the bronze cup from Les Favargettes, no. 396, see p. 68.

They all belong to the early phase: at Le Catillon and at Eygenbilsen we have the evidence of the other objects in the graves;[1] at Waldalgesheim the spout-flagon is an heirloom and earlier than the other contents of the burial.[2]

Vases with a spout are so widespread in so many countries of the world and in so many ages[3] that one need hardly look for foreign models, the less so as the Celtic jugs differ from the type used in the South and the East during these centuries: the Celtic jugs have the spout high up near the rim, while in the Mediterranean ones it springs from the shoulder.[4]

Beak-flagons. The Klein Aspergle jug, no. 385, copies an Etruscan model so faithfully that one might think it was classical, but for its decoration: the attachment, which points to the same workshop that produced the gold ornaments from the find, the monsters on the rim, which go with those on the rim of the Rhön flagon, no. 383, and the patterns on the vertical surface of the rim, which recall those round the rim of the Salzburg flagon, no. 382. The body of the Rhön flagon is not preserved; the mane of the handle-animal is related to a motive on the bow of the fibula from Jungfernteinitz, no. 318, and the two works were most probably made in one workshop.[5] The two flagons from Salzburg—of one only a small but characteristic fragment, *P 249*, remains—and the pair from Lorraine, no. 381, are inseparably connected: the same concave, over-elongated body, the same relation between diameter of shoulder and of bottom, the shoulder slightly convex and set off from the body with a sharp break, the similar curve of the handle, and a similar distribution of the lavish plastic decoration. The Lorraine jugs are the work of a superior artist and are of higher quality: not only have they coral and enamel inlay, but they are purer and more precise in outline, and the plastic ornament is set with more discretion and sobriety. The Salzburg flagon has a certain barbaric exuberance, and its shape, like that of the Austrian clay pendant, no. 406, lacks the vigorous tension of the Lorraine jugs. The shape of these vases is eminently Celtic, it is instructive to compare them with pottery, for instance with the urn from Mesnil-les-Hurlus, no. 409.[6]

Six beak-flagons from the cemeteries in the Ticino (no. 393) and Misox valleys, and one found near Como, are the product of local workshops, blending Etruscan with Celtic and local elements in a manner which characterizes these subalpine backwaters of Gallia transpadana.[7] Examination of style and technique tells us more of their historical position than an inscription in North Etruscan alphabet engraved on the handle of one of them.[8] The shape follows more or less closely that of the Etruscan beak-flagons which occur frequently in these tombs, but these Celtic flagons are pieced together of single bronze sheets with exposed joints, the typical technique of Hallstatt artisans. Without repeating here in detail former observation on single motives and their connexion with Etruscan and Celtic style, I link them up with related works and make some additions. The jug from Castanetta with

[1] p. 136. [2] p. 143. [3] Buschor, MJ 1919, 27.
[4] Orient. Sumerian: Ebert 14 pl. 43 I. Aurel Stein, The Indo-Iranian Borderland, JRAI 64 1934 pl. 20, 4. Byblos: Ebert 14 pl. 43 L, c. Luristan and Caucasus: see p. 107 note 4. Cyprus: Bronze: New York, Richter, Bronzes no. 481. Clay: CVA, Louvre 5, II C b pls. 21–4 (France 344–7); BM 2, II C c pls. 18, 19 (Gr. Britain 62, 63); Cambridge 2, II C pl. 13 (Gr. Britain 492); Copenhague 1 pl. 28: the spout with plastic additions: sixth to fourth centuries B.C. Greece: Annuario 10/12 fig. 236, and with plastic animal head at tip of spout, fig. 93; BSA 29 1927/8, 249 fig. 15: on Cypriote in-

fluences in Crete see p. 248, I (Payne). Laconian III: Samos, unpublished, but mentioned BSA 34, 125, 136. Lemnos: the jug, AM 31 1906, plate facing p. 60, p. 63, looks not earlier than the fourth century B.C., probably later. [5] pp. 30, 41, 74.
[6] On the vase represented on the Este situla in Providence, *pl. 254, a*, see p. 137.
[7] For details I refer to JL 55 ff., where, however, the accent has not always been set in the right place.
[8] Ib. pl. 23, p. 58; on an inscription engraved on an imported Etruscan flagon see Whatmough, ASA 40 1938, 121; Howald and E. Meyer, Die römische Schweiz 186.

the boar, no. 394, is a provincial copy of a model which was a pendant of the Salzburg flagon. The compound creatures as attachments have been discussed on p. 29. The mask at the handle-base of no. 393 *d* is a barbarous attempt to copy one of the masks which often decorate this part of Etruscan beak-flagons: one could not say that it was Celtic. The most typical feature of these jugs are their huge attachment-plaques, sometimes nailed on the body regardless of engraved ornament which they rudely cover. That of no. 393 *d* is an oblong, which comes well down towards the foot of the vase; the clay jug from the Ticino, JL no. 133, pl. 27, copies this with simpler means. The other jugs arrange concentric circles, sometimes interpreted as 'suns' with rays, in twos, threes, or fours, give them a frame, and hang on them dishevelled bits of Southern ornament. Such groups of concentric circles are a fashion not confined to flagons: see the brooches from the same cemeteries, Ulrich pl. 16, 1 or pl. 55, 9, and the set of arms from Bergamo, no. 134: through them one can get a line on to sub-Hallstatt corslets[1] (Préhistoire 3, 93 ff.), which are also fond of ornamental rivet-heads as they appear on the attachment of no. 393 *d*. The rendering of the birds' eyes by concentric circles recalls the girdle-hooks from Hölzelsau, no. 360, from Este, no. 363, and from Münsingen, no. 365. The snail-shells on the neck of no. 393 *d* belong to a later stratum of forms[2] and suggest that the jugs—at least this jug—despite old-fashioned features were made in the period of the Plastic Style.

I cannot finish this chapter on jugs and flagons without a word on the only passage where an ancient writer mentions a Celtic vase. Posidonius (apud Athen. 4, 152 b/c; Jacoby, FGrHist ii A p. 230) describes the symposia of the Gauls: τὸ δὲ ποτὸν οἱ διακονοῦντες ἐν ἀγγείοις περιφέρουσιν ἐοικόσι μὲν ἀμβίκοις, ἢ κεραμέοις ἢ ἀργυροῖς. Probably 'chieftains' had silver vases and other people clay ones. Wine was offered and poured from an ambix.[3] What do we know of these vessels? Of little use is the mention of an ambix among the requisites which in the second century B.C. the club of the Attaists at Teos used for their feasts: CIG 3071; Lüders, Die dionysischen Künstler, Anhang 41 κάδον διμέτρητον, χαλκίον τετραχοῖαῖον καὶ ἄμβικον, λεκάνην εἰς ποτήρια καὶ ἄλλην ποδανιπτῆρα.

Athen. 11, 480, d Σημωνίδης φησὶν ὁ Ἀμόργιος (Diehl fragm. 24), αὐτὴ δὲ φοξίχειλος ⟨Ἀργείη κύλιξ⟩, ἡ εἰς ὀξὺ ἀνηγμένη, οἷοί εἰσιν οἱ ἄμβικες καλούμενοι. τὸ γὰρ φοξὸν ἐπὶ τούτου τάττουσι, καθότι Ὅμηρος ἐπὶ τοῦ Θερσίτου (Β 219) 'φοξὸς ἔην κεφαλήν': an equation where *y*, the Argive kylix, is even more unknown than *x*, the ambix. Thersites had a deformed, sugar-loaf skull: the ambix, as it will become clear at once, also tapers upwards: Semonides' Argive cup must have been a lip-cup of the seventh century B.C.[4] The only real help are the Greek chemists who call an alembic ambix. Dioskourides' (Mat. Med. 5, 110) description of the distillation of mercury where an ambix was used goes probably back to Herakleides of Tarentum who lived about the same time as Posidonius. Another Hellenistic definition of an ambix is in the Latin version of Philon of Byzantium 'vas . . . sic formatum, ut in medio sit amplum, in summo strictum, cuiusmodi sunt amphorae quae in Aegypto fiunt'. More instructive is pictorial evidence, the ancient illustrations of the Corpus Chemicum: see Diels, Die Entdeckung des Alkohols, Abhandlungen der Berliner Akademie 1913, 33, and more complete,

[1] On their connexion with the cuirass of the Grézan warrior see p. 6 n. 6.

[2] p. 101.

[3] Trüdinger, Studien zur Geschichte der griechisch-römischen Ethnographie (Diss. Basel 1918) 95 erroneously translates 'Becher'.

[4] I need not interpret Schol. Iliad Β 219 which quotes Semonides in a fuller form and offers stupid interpretations of φοξίχειλος. Liddell–Scott, φοξός, gives the useful testimonies of the Medici Graeci; for Φόξος as proper name and its derivatives see Bechtel, Griechische Personennamen aus Spitznamen 21.

Taylor, JHS 50 1930, 136. The ambix-like Gaulish vessel was a carafe, more or less like a Chianti bottle. Of Celtic flagons preserved the type no. 402 comes nearest the vase mentioned by Posidonius.

The *bird-askoi*, no. 398, are of a very particular style and the objects found with them in the tomb are of little avail for dating them. The bird—the curves, I think, suggest a pigeon —consists of two symmetrical halves, each bearing ornament: that on the side not figured here varies in small details. The start of the pattern is a large circle set on the breast, where it swells and has its largest extension; from the circle a pair of leaves with a drop in the axil rise towards the left, one leaf swinging upwards, towards the bird's neck, the other towards the tail. Both leaves have their upper outline set off. The shape of the lower leaf is that of *P 314, c,* the upper looks less typically Celtic. The lower has the tip marked by a dot and continues here in a tendril which swings backwards and ends in a knob,[1] and in a comma-leaf, which is strongly contoured but not modelled inside: from it a pointed leaf of slightly irregular form grows towards the tail end of the bird. The breast is decorated with two pairs of smaller leaves rising at right angles from the larger: these are of triangular cross-section and have a sharp midrib; the outer leaves are crescent-shaped; the inner leaves soon lose their profile, flatten out, and coalesce, forming an arc which runs round the large circle mentioned earlier.

The fragments are the remains of other, similarly decorated bird-askoi in the grave; to how many pieces they belong cannot be established without experiment. One fragment is probably a mouthpiece, fitting into the bird's neck; the long fragment is possibly one of the bird's legs, fitting into the holes of the plaque with the toes and the spur.

There are details enough for which I have quoted Celtic analogies, but the modelling of the larger leaves and the whole rhythm have not their like and reveal the hand of an artist of unusual classical training. This makes judgement on the date difficult: my first impression (PZ 25 1934, 104) was that of 'Roman-Celtic style with analogies in certain works from Great Britain, an illustration of the civilization of Gallia transpadana in the age of Catullus and Livy'. There is, in point of fact, an affinity with works such as the Wandsworth shield (Kemble, Horae ferales pl. 16, 1; Leeds, Celtic Ornament fig. 2 top; Arch. Cambr. 1928, 281–2; Burlington Magazine 75 1939, 28), but the chronology of related bird-askoi and the presence in the grave of fifth–fourth-century Etruscan bronzes[2] tell against so late a date: I reserve judgement.

These are the only Celtic bronze bird-askoi. In clay there are the following: (1) *Pl. 249, e,* once in Reims and surely from the Marne region. (2) *Pl. 250, a,* in Épernay, reproduced from Abbé P.-M. Favret, Note sur un vase zoomorphique (1909) figs. 1, 2, 3. From Saint-Memmie (Marne). Length 42 cm., height 26·5 cm., 'capacité environ 8 litres'; Favret states that the eyes and ears were painted red. (3) No. 403, in Châlons-sur-Marne, certainly found somewhere near by. (4) A fragment of the head of a similar piece in the same museum. (5) *Pl. 249, f,* in Zurich, from the Ticino graves (Cerinasca d'Arbedo), Ulrich pl. 26 no. 13, p. 188. Height and length about 17 cm.

These Celtic bird-vases are a Hallstatt inheritance and reflect Mediterranean bird-askoi which go back to the Bronze Age; see M. Mayer, JdI 22 1907, 207 ff.

Finally some peculiar Celtic vessels from Italy for which, lacking reproducible pictures, I must refer to JRAI 67 1937 pl. 27, 2, 3; pl. 25, 2. The graves of the Senones near Ancona

[1] pp. 87; 88 n. 1. [2] pp. 145–6.

yielded some wooden bronze-mounted *barrels* which, as the dishevelled tongue pattern and two pairs of ducks set as 'acroteria' on the upper horizontal surface suggest, are of Celtic make.[1] The barrels imitate Etruscan models, which, for their part, copy Italiote ones. I mention some of these. Clay, Naples, Heydemann 3382, Patroni, La ceramica antica dell' Italia meridionale 103 fig. 68. Clay, from Locri, Not. Sc. 1913 suppl. 41 fig. 53; about 400 B.C. There are three bronze barrels, one in the Walters Art Gallery, Baltimore, Stud. etr. 12 pl. 51, and two in the Villa Giulia, presumably from Etruria or Latium, but none has a label. In the Ficoroni cist a (WV 1889 pl. 12 a, Pfuhl fig. 628) the keg represented may have been substituted by the Oscan engraver for a vessel of Greek form (Robert, Archaeologische Hermeneutik 109).[2]

For *sieves* and their foreign models I refer to my remarks on p. 79.

Few *gold vases* have survived. The horns from Klein Aspergle, nos. 16, 17, the cup from Schwarzenbach, no. 18, the lid of a box from Auvers, no. 19, the rim and plaque of a little vase from Kaerlich, no. 33. Whether the strips from Eygenbilsen, no. 24, Somme-Bionne, no. 25, Waldgallscheid, no. 26, were once mountings of vessels, is impossible to establish.

Of the Schwarzenbach cup only the gold net is preserved; the cup itself was probably of clay—the gold-mounted Attic cups from Klein Aspergle show that the Celts liked this combination of material. The cup probably had an omphalos, like the flask from Matzhausen, no. 402. The simple idea of a semi-globular cup might have occurred to the Celts without foreign models. But it is also possible that they followed Hallstatt tradition: there are the gold cups from the Cannstatt chieftain-grave[3] and that from Altstetten-Zurich;[4] the latter has also a set-off plain rim, but the rim-profile of the Schwarzenbach cup has a much more classical look. The Zurich cup has a good seventh-century analogy, the silver cup from the Praenestine Tomba Castellani in the Victoria and Albert Museum.[5] That the clay intervals were certainly coloured, imitating inlay, has been said on pp. 79, 91.

The *gold horns* from Klein Aspergle, nos. 16, 17, are the mountings of the points of ox-horns. Caesar[6] describes the silver-mounted bison-horns of the Celts in first-century Gaul. Shape and size of the gold parts give no clue to the breed of the oxen.[7] I had already stressed the fact that the horns are a pair.[8]

Athenaeus 11, 476 gives plentiful, sensible information on drinking-horns: the horn was a primitive vessel; as time went on, it was more and more confined to Dionysus, Silens, Centaurs, but it always remained in use among backward peoples in the North, the Thracians, the Macedonians—King Philip II—Perrhaebians, Paphlagonians, often of gold or silver, or mounted with precious metal.[9]

[1] See p. 28 and JRS 29 1939, 99.

[2] For history and 'pre-history' of 'barilia' see Behn, Die Ficoronische Cista 39; Hallo, Altfranzösische Barilia, Repertorium für Kunstwissenschaft 51, 162; Sprockhoff, Germania 17 1933, 249. There is an impasto vase from Marsiliana d'Albegna (Minto pl. 51; Ebert 8 pl. 11, a; *P 166*) which is a cross-breed of a barrel and an oinochoe.

The piece from Cumae, figured in Archaeologia 37, 331, often quoted by writers on the subject, is not a 'barile', but a pilgrim's flask, a shape which has a history of its own: see Hallo l.c. 162, 163 and here p. 140 n. 4. Should not the oddly-shaped Corinthian vessel from Chalkis, published by Mrs. Karouzou-Papaspyridi in BCH 61 1937, 355 fig. 3, be a barile on wheels? On wheels affixed to vessels see Benton, BSA 35, 119.

[3] Paret pl. 4, p. 12.

[4] Déchelette fig. 312; Ebert 8 pl. 82, c; Viollier, CPF 7 1911, 422, 423 (good details); Bossert 1, 57 fig. 3.

[5] Mon. Ant. 15, 565 fig. 166; Rosenberg, Granulation 1, 6; Duhn 512.

[6] De Bello Gallico 6, 28 (urorum cornua) studiose conquisita ab labris argento circumcludunt atque in amplissimis epulis pro poculis utuntur.

[7] In central Europe at the time in question there were the bison and the aurochs, and of domesticated races *Bos taurus longifrons* and *Bos taurus primigenius* (information from Professor Hilzheimer). [8] p. 106 n. 4.

[9] On Aeschylus frg. 185, quoted by Athenaeus for the Perrhaebians, see Kranz, Stasimon 76. Some Greek material

The finds corroborate Athenaeus' report. From Trebenishte, situated in the country of the Illyrian tribe Dassaretioi, neighbours of the Macedonians and Paeonians, there are two silver horns (Filow pl. 6 no. 35, and Oe J 27 1932, 11, 12 figs. 12, 14). The silver beakers Filow l.c., pl. 6 no. 36, and Oe J l.c., pp. 13, 14 figs. 15–18 came from the same workshop: they were made by Greek artists for the natives. From the neighbourhood of Plovdiv (Rochava near Staro-Novo-Sélo) in Thrace comes the gold tip of a horn in the shape of a ram's head, *pl. 221, b*: it might be the copy of a Greek piece like the one from the Seven Brothers, *pl. 221, a*. The silver horn from Poroina in Rumania (Odobesco, Le trésor de Pétrossa 1, 498 fig. 205; Gössler, Trichtingen 17, note 6; Rostovtzeff SB 490) is of a particular Scythian style, related, it seems, to the fragmentary silver relief from the Ogüz kurgan (PZ 19 1928, 182). The use of drinking-horns in the Balkans persisted down to the first century A.D., as shown by the reliefs of the marly limestone ossuaries from Ribič (West Bosnia), PZ 27 1936, 213 fig. 1.[1]

By far the largest number of gold and silver horns come from Southern Russia. Only the gold or silver mountings of the horns are preserved. Some are of Greek, others of Scythian or hybrid workmanship. I quote a few.

Fifth Century B.C. (*a*) Elizavetovskaja Stanitsa, Ebert 14 pl. 15 b; Rostovtzeff SB 472; Schefold fig. 38, p. 33. (*b*) Seven Brothers, second kurgan, Rostovtzeff SB 314; fourth kurgan, *pl. 221, a*. Rhyton with dog-finial, Rostovtzeff IG pl. 12, C. Plaques of a rhyton, Rostovtzeff IG pl. 13; Borovka pl. 20, A. (*c*) Solokha, Ebert 12 pl. 85, b; Rostovtzeff SB 372; Schefold 25. (*d*) Mordvinov kurgan, Rostovtzeff SB 374.

Fourth century B.C. (*e*) Karagodeuashkh (1) Minns fig. 121; Rostovtzeff SB 325; Schefold 21. (2) Ebert 6 pl. 64, b; 13 pl. 30 B. (*f*) Merdzany, Ebert 13 pl. 29 A; Schefold 21.

Scythians are seen drinking out of a horn in no. (*e*) 1, in the relief of a gold diadem from a grave at Panticapaeum (third century A.D.), Minns fig. 325; Ebert, Südrussland fig. 117; p. 337; Rostovtzeff SB 223, and in gold plaques from the Kul Oba, Ebert 13 pl. 32 A, c, d.

I add a list of horns from other border-civilizations.

Russia outside Scythia. Aspelin, Antiquités du Nord Finno-Ougrien no. 579 (Perm) and 581 (Altai);[2] Tallgren, Collection Tovostine fig. 61—all of them miniature horns, made for the dead.[3]

Caucasus. Uvarov p. 349. Tallgren, IPEK 1930, 54; Gössler, Trichtingen fig. 12.

Cyprus. Bronze Age clay horns, Syria 13 1932, 350 fig. 2; Illustrated London News 1932, 928 fig. 3, a pair.

Northern Europe. (*a*) Lausitz culture. Two miniature clay horns from Zaborovo, Ebert

collected by Buschor, Das Krokodil des Sotades, MJ 1919, 30. On a good many fifth- (and early fourth-) century vases members of the thiasos still handle drinking-horns.

There is the following evidence for gold or silver votive horns in Greek sanctuaries. Hecatompedon: IG² 237, 59 and 1407, 38, quoted by Athenaeus l.c. Ephesian Artemisium: Hogarth pl. 7, 51; miniature gold horn (the other two gold horns there, Hogarth pl. 9, 15, 16 'once fitted on the horns of figurines of oxen'). Olympia, Treasury of the Byzantians: Polemon apud Athenaeum 11, 480a, a pair: the context suggests gold or silver. Delos: Inscriptions de Délos 442 B, 204. Sanctuary of Apollo at Branchidae: IG ii, 2852, 44; gold or silver, inscribed Διὸς Σωτῆρος.

Precious Macedonian horns were carried in L. Aemilius Paullus's triumph in 167 B.C.: Polybius (Plutarch, Aemilius Paullus 32).

[1] These ossuaries give the clue to the understanding of the much discussed 'stelae' from Jezerine, Mitteilungen aus Bosnien und der Herzegowina 3 1895, 182 and 516 pl. 12; Ebert 6 pl. 51; von Sydow, Propylaeenkunstgeschichte 1, 460 fig. 3. The other fragment: Mitteilungen &c. 5 1897, 337 pl. 70. See also Möbius, RE s.v. Stele, col. 2322, line 26; Syme, JRS 26 1936, 79; Salis, Neue Darstellungen griechischer Sagen, Picenum, Sitzungsberichte der Heidelberger Akademie 1936/7, 64.

[2] On the patterns see p. 69 n. 5.

[3] Whether the Chinese have drinking-horns proper I do not know; they have rhyta reflecting Western prototypes, see Seligman in 'Custom is King', Essays presented to Dr. R. R. Marett (1936).

14 pl. 64 B, a; Mannus 4 pl. 12, 63, p. 86. (*b*) Two cast bronze horns from Prenzlawitz (Kreis Graudenz), found with an imported Italic bronze urn, Ebert 10 pl. 102; Sprockhoff, Handelsgeschichte 92–3. (*c*) Prauster Krug (Kreis Danziger Höhe), PZ 7 1915, 163 fig. 38; Sprockhoff 23. (*d*) Cast bronze point of horn, with bird and attached clackets from Hahnefeld (Sachsen) in Dresden, Bierbaum, Mitteilungen des Landesvereins Sächsischer Heimatsschutz 21 1932 (*e*) Bohemia,[1] Pič, Die Urnengräber Böhmens 73 fig. 35, 5; p. 98 fig. 44, 6; pl. 33, 10; Pamatky arch. 17 (1897), 509, pls. 53 ff.; Willers, Die römischen Bronzeeimer von Hemmoor 80, 2. (*f*) From Staudach, Willvonseder, Oberoesterreich in der Urzeit fig. 72, bronze mountings of two horns. (*g*) From Gunzenhausen (Mittelfranken), AuhV 5 pl. 69 no. 1303, two miniature clay horns, found with Hallstatt C pottery. (*h*) From Mergelstetten (Oberamt Heidenheim), Württemberg, in Stuttgart, *pl. 250, b*; published before, in a drawing, Altertümer im Königreich Württemberg Heft 2, O.A. Heidenheim pl. 1, 4.[2] Bronze cast. Length 11·5 cm., diameter of disk near end 3·2 cm. Cross-section oval; the ring at the point is of iron. No traces of horn or other substance remain. It is likely that in the triangular intervals the ox-horn was coloured, the contemporary pottery of this region being very fond of polychromy. The decoration naïvely imitates that of a Southern model, such as the ivory horn from the Praenestine Tomba Barberini (MAAR 5 pl. 9; Mühlestein 33, 34), which has the same rows of openwork triangles, but their intervals filled with amber. Like the ivory horn, with gold and silver mounting, from Populonia, Not. Sc. 1914, 450,[3] the Praenestine horn is a hunting-horn[4]—there seems not to be a single Italian drinking-horn. That hunting- and drinking-horns are decorated on the same principles has been observed by Hubert Schmidt in his study of bugles in PZ 7 1915, 85 ff. (*i*) From Dürnau (Württemberg), Reinerth, Das Federseemoor pl. 47, 1, p. 164.

Later, from finds of the early centuries A.D., are the following:[5] (*k*) From Seeland, Nordisk Fortidsminder 2, 1 fig. 21/2 (a pair). (*l*) From Hoby, ib. 1923, 150 fig. 29. (*m*) From Varpelev, silver mountings of two horns, Willers, Die römischen Bronzeeimer von Hemmoor 61. (*n*) From Espe, a pair, S. Müller, Nordische Altertumskunde 2 fig. 27, p. 66. (*o*) From Skudstrup (district of Hadersleben), PZ 22 1931, 181; Forschungen und Fortschritte 8 1932, 289: two horns of Bison priscus, inside residue of beer and mead. (*p*) From Hagenow (Mecklenburg), Willers l.c. 126. (*q*) From Hankenbostel (Hanover), Willers l.c. 79. (*r*) From Lübsow (Pomerania), PZ 4 1912, 142, 144 fig. 11, pl. 13; Kossinna, Deutsche Vorgeschichte 3 (Mannus Bibliothek 9), 204: two silver-mounted horns. (*s*) From Moritzow (Pomerania), Kunkel, Vorgeschichte Pommerns in Bildern pl. 85; Mannus 5. Ergänzungsband 1927, 124; IPEK 1931, Mitteilungen pl. 1: bronze mounting of horn, in the shape of an ox-head. (*t*) From Rubocken (Kreis Heydekrug), Ebert 9 pl. 231: preserved, embossed silver mounting of mouth, and bronze foot-stand of a horn. (*u*) From Ronneburg (Livonia), Ebert 13 pl. 7, s. (*v*) From Biegnitz (Silesia), Altschlesiens Vorzeit 4, 148: clay. (*w*) From Reisau (Kreis Nimptsch), Silesia, Mannus Bibliothek 22, 82 figs. 12, 13. (*x*) From Freudenheim, near Mannheim, AuhV 5 pl. 64 no. 1175, p. 371 (with other useful references), first century A.D.

[1] For reasons stated above, I am not informed on the exact chronology of the Bohemian material.

[2] I owe photograph and facts to the courtesy of Professor Gössler.

[3] For the date of the grave see Karo, AM 45 1920, 119, note 2.

[4] Rightly stated by Delbrueck, AA 25 1910, 184. I am indebted to Dr. Technau for examining the horn; he remarks that not far from the mouth it becomes so narrow that there is hardly room 'for a glass of wine'.

[5] My list is incomplete: there are more horns from Scandinavia (and possibly elsewhere), but the books in which they are published were not accessible to me.

This survey of horns in Early Europe teaches us several things: (1) pairs of horns are frequent in graves and sanctuaries: the occurrence of drinking-horns in pairs can be explained by the fact that animals, apart from the unicorn, have two horns. (2) There are plenty of metal-mounted horns. (3) Italy and Greece as source of Celtic horns are out of the question, Greece for general and special reasons, Italy because the Italians, it seems, did not drink out of horns. The Klein Aspergle horns copy an Eastern model, as is proved by the following facts. Gold-mounted horns are typical of the Scythian area. The rams' heads imitate Greek models, either pure Greek or Graeco-Scythian, as shown by comparison with the rams from the Seven Brothers or that in Plovdiv. Scale patterns occur on the Trebenishte horns. The principle of decoration is without analogy. Περισκελίδες,[1] horizontal bands round the horn, at a distance from one another, are common in drinking- and hunting-horns, but there is no example of jutting collars. The shape of the collars has an analogy in the gold bracelet from Dürkheim, no. 57. The vertically running strips on the horn sections between the collars are also unique: where a horn lacks horizontal caesurae, its whole body is covered with a net of scales or lozenges (horn with dog finial from the Seven Brothers, above no. (b)); or there may be a tendency to vertical decoration such as fluting: see the silver horn from Trebenishte, or—to quote not a horn proper but a rhyton—that from Bashova Mogila, JdI 45 1930 pl. 10; Filow, Die Grabhügelnekropole bei Duvanlij 66.

The Klein Aspergle horns are among the weaker works of Celtic craftsmanship: there is a sensible lack of proportion of the parts, done piecemeal, and the whole looks somewhat laboured.

WEAPONS

Any study of *swords* must still rely on Déchelette's lucid treatment of the subject (1109 ff.). But a few remarks on decoration of swords will not be out of place.

Figure decoration of scabbards is rare.[2] The sword from Marson, no. 93, confines it to a small 'heater' with three masks. The Este engraver of the sword from Hallstatt, no. 96, extends the pictures over the whole length of the scabbard, adapting the Venetian practice of figure-decorated daggers to the long Celtic sword.

The best of the early swords are those from Vert-la-Gravelle, no. 90, and from Weiss-kirchen, no. 100. The scabbards of both have a strong, well-profiled frame; that of no. 100

[1] See the Hecatompedon inscription referred to on p. 111, n. 9. Liddell–Scott s.v. περισκελίς II calls the horn in the Athenian treasury a 'cup'. Frankenstein, RE 11, 264 takes the περισκελίδες for a tripod-shaped stand.

[2] The bronze-mounted iron scabbard of a sword from Mihovo, Carniola, published by Beninger in Beiträge zur Kunst und Kulturgeschichte Asiens 9, 35 ff., puts problems which I cannot solve. It was found in an incineration tomb with pottery of the first century A.D., but shape and style of the sword are clear proof of an earlier date. The scabbard is subdivided into three panels. In the top panel, a cow with a bird on her back (there is no need to follow Beninger in giving this everyday motive, which is pretty common in many arts, a mythological interpretation). In the bottom panel there is perhaps a man in frontal view, very fragmentarily preserved and difficult to understand. In the central panel, two opposed horses climbing up a withered Sacred Tree. There are hundreds of antithetic rampant animals in Oriental and Orientaliz-

ing arts, but horses of this kind are rare: I had already drawn Beninger's attention to the late-seventh-century ivory, Orthia pl. 112, 1, p. 215. A still closer analogy is the early-seventh-century Cretan relief vase from Afrati, Annuario 10/12, 65 fig. 45, 48. Two confronted winged horses upright are seen on the handle of a sixth-century bucchero oinochoe from Chiusi, Annali dell' Instituto 1884 pl. D; Montelius pl. 231, 1 b.

It is difficult to localize the oriental component of the sword: the double contours recall the animals on the hatchet from Kelermes (Rostovtzeff IG pl. 8, 1, 2; id. AS pls. 3, 4; Ebert 6 pl. 82, a) where antithetic animals climbing up a Sacred Tree also appear. The Scythian sword from the Buerov kurgan, Tamán (Ginters pl. 23, a, b; Rostovtzeff IG pl. 24, 5; Ebert 10 pl. 112 B, d; Rostovtzeff SB 548), of Hellenistic date, is a good analogy for the subdivision of a scabbard into panels. The engraved concentric circles in the Carniolan sword are a motive too common in many backwater arts to be used as a criterion. The sword is Eastern, but remains a puzzle.

bears a pattern (*P 379*). No. 90 covers the whole surface of the sheath with geometric ornament (*P 216*); the Weisskirchen sword, the most ornate of all, draws a midrib, decorates each half with a tendril, and adds openwork above and below. In the coarse Filottrano sword, no. 103, a tendril runs almost the whole length of the scabbard. The swords from Marson, no. 93, Somme-Bionne, no. 94, and Ameis, no. 95, confine the decoration, embossed or engraved, to the part near the hilt. The swords no. 91 and no. 92, both of poor quality, show three embossed plaques, at the top, at the chape, and in the middle; they were the decoration of the leather sheath which has gone. The triangular space near the point is sometimes set off and given an horizontal upper border which in some cases acts at the same time as a strut between the vertical scabbard-frame parts: nos. 90, 91, 94, 97, 103; see also the sword from La Gorge-Meillet, Fourdrignier pl. 10. The chapes show much variation: certain plastic tendencies here found their first expression.[1] The chape of the Hallstatt sword, no. 96, clings to the outline of the tapering scabbard and has the form of a double-headed 'dragon',[2] while that of the sword from Vert-la-Gravelle, no. 90, follows the 'wing' type which is the development of a Hallstatt form.[3] Sometimes the finial of the scabbard-point is formed by three disks: those of the swords from Marson, no. 93, and from Somme-Bionne, no. 94, are of modest size, those of no. 99 are large and heavy, no. 98 stands between them. Coral inlay is common: Marson, no. 93, Somme-Bionne, no. 94, Ameis,[4] no. 95, Weisskirchen, no. 100. Figure chape-ornament: the 'dragons' of the Hallstatt sword are unique, birds are the rule: no. 102, which has a plainer pendant from Champagne, Morel pl. 38, 1, fills the arc of the chape with a pair of birds in openwork: normally the birds stand outside, one on the right, one on the left; those on the Weisskirchen sword, no. 100, are carefully executed, but on the whole they are coarse and blurred: Dolgozatok pls. 24, 43, 44, 51, 55; Déchelette fig. 386, 1.

The decoration of the swords of the following period has been discussed in great detail.[5] The Hungarian sword, no. 127, die-stamped all over, is *sui generis*: it may have been influenced by a Scythian sword like that from Prokhorovka, Rostovtzeff IG pl. 24, 4; Ginters pl. 23, f; Ebert 10 pl. 112 B, a, b, where even similar patterns occur.

Rings of sword-frogs: there was no. 101, from Weisskirchen. For that belonging to the Ameis sword, no. 95, see Baldes–Behrens, Katalog Birkenfeld pl. 9, 5; p. 53. Many from the Marne are in Saint-Germain: no. 33283, from Bussy-le-Château, is very similar in shape to the piece from Weisskirchen. See also Weinzierl, Langugest 22 fig. 3 a, b.

Spear-heads with ornament on the blade or the socket are rare: the pieces published here, nos. 128–31, and *P 263*, are probably all that have survived. The Swiss, no. 129, confines the decoration on front and back to the right half of the blade—a very Celtic feature.

Shields of the early phase do not exist, and those of the following, at least on the Continent, lack decoration.[6]

Cuirasses. No. 134 are the bronze mountings of leather corslets. The cuirass represented in the Pergamene balustrade, no. 132, has Celtic ornamentation,[7] but is otherwise Greek: the Gauls who fought against Antiochos Soter already wore bronze corslets (Lucian, Zeuxis

[1] p. 102. [2] p. 44.

[3] Déchelette 1108. The continuity between Hallstatt and La Tène swords is splendidly illustrated by the lavish material from the Marne cemeteries in Saint-Germain.

[4] Chape of No. 95, Baldes–Behrens, Katalog Birkenfeld pl. 9, 6, p. 53; see also those from Enns, in Linz, Mahr, Die La Tène Periode in Oberoesterreich, Mitteilungen der Prähist.

Kommission der K. Akademie der Wissenschaften Wien 2 1915 pl. 3, 1, p. 32; from Silivas in Kluj (Klausenburg), PZ 16 1925, 210; Ebert 11 pl. 38 B, a; Dolgozatok pl. 55.

[5] pp. 95 ff.

[6] Déchelette 1167. Morel's assumption that the crescents from Étrechy, no. 376, belong to shields is unfounded.

[7] *pp. 259, 288;* pp. 75; 77 n. 2.

(Antiochos) 8). The cuirass in the Canosa grave is Greek:[1] *pl. 258, c.* The corslet worn by the warrior from Grézan is related to a certain Late Hallstatt type.[2]

Helmets. There are two groups. Group (A) comprises helmets the Celtic origin of which is proved by their purely Celtic outline or ornament. (1) Reims, no. 139; (2) Amfreville, no. 140; (3) Écury-sur-Coole, no. 138; (4) Tronoën, no. 141; (5) Silivas, no. 142; (6) Canosa, no. 143; (7) Hungarian, no. 137; (8) La Gorge-Meillet, no. 135; (9) Berru, no. 136; (10) Cuperly,[3] *pl. 77.*

Nos. (1)–(6) have the same shape: there are differences in profile and accessories, cheek-pieces, neckguard, top knob, crest carriers. These parts are not always preserved: the Tronoën helmet is the only one that has its cheek-pieces; they go with the cheek-pieces of group (B). These six helmets, Celtic copies of group (B), were manufactured in the North: the Canosa helmet was exported to the south, the Silivas to the East. The Reims helmet looks early, the others, all of them contemporary, later. The helmets from Amfreville, Tronoën, Canosa are costly pieces and bear decoration of gold, coral, and enamel.

Nos. (7)–(10) have a peculiar long-drawn-out shape; of similar, not identical, form is a helmet represented on the Pergamene balustrade.[4] The Cuperly and Hungarian casques are plain, that from La Gorge-Meillet bears a well thought-out geometric ornament: the helmet may have come from a workshop related to that in which the sword from Vert-la-Gravelle, no. 90, was made. Its geometric decoration is no argument for an early date.[5]

Group (B) comprises helmets the Celtic origin of which is less easy to prove.[6] This class is very large; of the casques figured here, nos. 144–51 belong to it. Most of them have no provenience, but there are labels enough to give an idea of their distribution.[7] The majority of them come from the Celtic cemeteries near Ancona, some from other Italian and Sicilian sites:[8] the helmets of class (A) were certainly worn by Gauls, those of class (B) either by Celts fighting on Italian soil or by warriors of other nationality to whose taste this good armour appealed: the Canosa burial gives an example of interracial exchange of weapons of different origin.[9] Some of these helmets were exported to Tyrol, Carinthia, Carniola, Istria, Germany, France, and Spain.[10] Even if these exports were missing, the afore-mentioned Northern copies of Southern originals (group (A), 1–6) would be proof enough that the Gauls in the North were familiar with the type: as the Celtic imitations of Etruscan beak-flagons would clearly show that the Celts knew them, even if we had not the direct evidence of the Etruscan originals from tombs in the North.

The helmets of this group are in part of bronze, in part of iron. Some of the iron helmets were always plain and without bronze mounting, but this is often difficult to decide because the iron core of bronze-mounted pieces has panned so much that the bronze decoration has almost gone.

[1] p. 146. [2] p. 6 n. 6. [3] Déchelette fig. 490, 5.

[4] Alt. v.Pergamon 2 pl. 43. Bosch-Gimpera informs me that two helmets of this type have been found in Spain. [5] p. 103.

[6] Déchelette 116c ff.; Ducati, Storia di Bologna 332 ff.; Baumgärtel, JRAI 67 1937, 274 ff.; JRS 29 1939, 98: the opinions vary much.

[7] Déchelette l.c.; Mercklin, RM 38/9 1923/4, 129.

[8] Selinus: no. 149. Locri: Not. Sc. 1927, 359. Sicily: New York, Richter, Bronzes nos. 1549 and 1551.

[9] p. 151.

[10] Add to Déchelette and Mercklin l.c.: France: Vademay (Marne), in Saint-Germain, Lipperheide 226. 'Lyon', in Saint-Germain, Lipperheide 246. The helmet from Martres-de-Veyre (Puy-de-Dôme), Déchelette fig. 489, 2, is reproduced in good photographs in L'Illustration 19th August 1939. Tyrol: Sanzeno, found with sword no. 104. Lipperheide 229. Moritzing, found with the situla no. 399, Lipperheide 228, better Orgler (cited to no. 399) fig. 16. Istria, Lipperheide 241. Spain: D. L. Siret, Villaricos y Herrerías pl. 14 no. 42 (Running-Dog on neck-guard). The helmet New York no. 1552 is said to have been found in Attica: this can neither be ascertained nor refuted. For Etruscan inscriptions on helmets of this class see Not. Sc. 1889, 295; Lipperheide 238; Ducati, Storia di Bologna l.c.

The shape of these helmets is a cap well fitting to the skull, more or less pointed on top; the low neck-guard forms an integral part of the casque: the whole gives the impression of a product no longer in the stage of experiment or improvisation. It is quite possible that the type is a refinement of old Italic prototypes.[1] Most of the helmets end above with simple top knobs, others (nos. 147, 148) with high crest carriers;[2] the Canosa helmet has also tubes at the sides for fixing plumes; the stout tubes of New York, Richter, Bronzes no. 1552, possibly held horns: the existence of helmets with horns at a later time is proved by the statue of a Gaul from Delos (Bieńkowski 30), by representations on rings and gems,[3] and by Roman reliefs from Southern France, Déchelette figs. 484, 485.

The decoration in group (B) consists of three classes of forms: (1) purely Etruscan; (2) purely Celtic; (3) Celto-Etruscan. The second are rarest and most difficult to trace. All three appear in the same pieces, sometimes one prevailing, sometimes another.

Etruscan. Row of tongues (kymatia):[4] no. 144. Long tongues, round the point: Montefortino, Mon. Ant. 9 pl. 6, 2; Lipperheide no. 232. Band of lyres ('intermittierende Wellenranke'):[5] nos. 144 and 146. Double-cable pattern:[6] nos. 147, 148; San Ginesio, Not. Sc. 1886 pl. 1, 2; Montefortino, Mon. Ant. 9 pl. 6, 2; Lipperheide no. 232. Frieze of leaves round the point, one up, one down: no. 148. Frieze of palmettes and lotuses round the point: no. 147. The cockade on the front of the helmet from Montefortino, Mon. Ant. 9 pl. 6, 4, 4 a, p. 661, bears embossed flowers and foliage which compare well with Italiote ornament like that of late-fourth-century Apulian vases. All these ornaments have analogies in other Etruscan toreutic works of the fifth and the fourth centuries B.C.; the leaves in the front part of no. 150 also look Etruscan.

Celtic. The ornamentation of the top knobs (*PP 76, 77, 367 b*). The rope pattern round the bottom rim (*PP 140, 141*). A geometric motive consisting of oblique strokes with change of direction at intervals on an unpublished helmet in an American museum (*P 164*). Probably also the herring-bones on New York, Richter, Bronzes no. 1551. The pattern round the lower boss of the cheek-piece no. 145 (*P 181*) and the similar pattern round the cockade above the cheek-pieces in the casque from San Ginesio, Not. Sc. 1886 pl. 1, 2. The frieze round the helmet in Mannheim, *P 161*. The interpretation of the attachment in the Selinus helmet no. 149 is uncertain: it either belongs to the zoomorphic lyres[7]—if there are actually animal heads—or it is to be connected with Villanovan motives like that on the lid of a bronze cista from Fabriano, Mon. Ant. 36 pl. 4.

Etrusco-Celtic. The ornament on the temple part of no. 144 (*P 359*) is typical. Other examples with lyres in this place are nos. 139, 140: an Etruscan casque, Berlin, Neugebauer Führer Bronzen, p. 13, Lipperheide 192, puts one lyre on the front. The motive in no. 144, *P 359*, is a two-tier lyre,[8] though with some odd features; its foot-scrolls have been sacrificed to the large cockade. The fleshiness and the swell are Celtic. The filling palmette in the lower tier, like those in the lyre band round the helmet, is classical.[9] The upper tier is filled with a head: the insertion of heads into floral ornament is Southern and Celtic;[10] the head has nothing particularly Celtic about it and is unlike the normal Celtic masks, but possibly the two engraved lines round the neck mean a torc and the artist thought of a Gaul.

The cheek-pieces are not always preserved. In rare cases they have the shape shown here

[1] Baumgärtel l.c. 275.
[2] A helmet of this type, from Italy, in Nuremberg, Auh V 4 pl. 55, 1.
[3] pp. 118 n. 1; 125.
[4] p. 69.
[5] pp. 84; 92.
[6] p. 71.
[7] p. 53.
[8] p. 86.
[9] p. 88.
[10] p. 16.

by no. 149,[1] asymmetrically curved, scalloped, and pointing to the front. These are mostly plain: the other type, which interests us because of its ornamentation, is more frequent (nos. 141, 144–7). The cheek-pieces of this kind which I have had the opportunity of examining give the embossed bronze plaque an iron lining. The three circles have a cut-out hole in the middle, through which the iron has panned, sometimes forming globular protuberances; originally there must have been inlay here, but I have never seen a piece where it was preserved. If this should be so, it would be one of the Celtic features of this class. The motive of the three circles itself is eminently Celtic,[2] though it also occurs sporadically elsewhere.[3] In rare cases three plain circles with embossed concentric rings are the only decoration of the cheek-pieces (New York, Richter, Bronzes no. 1550; Mon. Ant. 9 pl. 6, 3; JRAI 67 1937 pl. 22, 5; Lipperheide 229, 230, 233–5; from Sanzeno in Innsbruck (found with sword no. 104)); as a rule, the plaques are filled with ornament round the bosses. The circumscribed palmettes on the helmets from Montefortino, Mon. Ant. 9 pl. 6, 2; from Carniola, Lipperheide 231, Coutil, Les casques étrusques, &c. 217; in Rome, RM 38/9 1923/4, 129 fig. 21, and on others enumerated there, are classical, Etruscan.[4] The patterns on the cheek-pieces of the following casques are a blend of Etruscan and Celtic style: (1) no. 144; (2) no. 145; (3) no. 147; (4) San Ginesio, Not. Sc. 1886 pl. 1, 2; (5) Perugia, Not. Sc. 1880 pl. 2, 6; (6) Montefortino, Mon. Ant. 9 pl. 6, 11 (Montelius pl. 154, 3; RM l.c. 132). The material of the motives is classical, the treatment Celtic, the share of the two ingredients differing. I only mention the half-palmettes on nos. 144, 145, 147, the spiral on no. 145, centre top (P. 411) which impairs the bilateral symmetry of the ornament;[5] Celtic also is the frequent use of beaded lines.

The helmets of group (B) are clearly the result of collaboration between Etruscan and Celtic artisans in an Italian workshop.

Belts and Clasps. The Celts wore leather belts fitted with bronze. In some graves bits of leather were found still sticking to the clasps.[6] A few pieces stand apart: the belt from Hundersingen, no. 133, is a square openwork plaque with two hooks at the one end: it was fastened with eleven nails at each end to the leather strap, which it covered at its full width and over about a quarter of its length. Two belts, in Stuttgart (*pl. 250, c*) and Marseilles (*pl. 250, d*),[7] mentioned on pp. 68 n. 3; 75 because of their decoration, are thin bronze sheets, which also had leather lining; they stand on the border of Hallstatt and La Tène. As a rule,[8] the bronze

[1] Other examples of this shape of cheek-pieces are Lipperheide 238, 240–5; Montefortino, Mon. Ant. 9 pl. 6, 22; Bologna, Montelius pl. 111, 3; BM Guide Greek and Roman Life fig. 61; the Gaul from Delos, Bieńkowski fig. 43, and the Gauls on the Etruscan krater, ib. figs. 44, 45 (see pp. 144–5). As said above, this type is commonly plain: an exception is the helmet in Naples, Lipperheide no. 242. These cheek-pieces are of importance for the problem of the 'neck-guard'. Those with the three circles are constructed symmetrically, 'neutral': there is no front and back; a helmet with such cheek-pieces can be donned both ways. The asymmetrical type makes sense only when pointing to the front. Many of the helmets of this type preserved in museums show the cheek-pieces so mounted that the neck-guard would actually cover the nape of the warrior, and it is unlikely that this is throughout the result of modern mounting. On the other hand, the helmet of the Gaul on the Etruscan krater in Berlin (Bieńkowski l.c.) and that of the statue from Delos (Bieńkowski l.c.) have the 'neck-guard' in front.

[2] p. 67.

[3] Oscan corslets: Weege, JdI 24 1909, 150; a variant: Jacobsthal, Ornamente 131, note 241; Möbius 77.

[4] The motive also occurs on a strigil from Filottrano, see p. 145.

[5] p. 90.

[6] No. 357; see also the Hungarian piece mentioned on p. 119, n. 5.

[7] Stuttgart, no provenience. 7·5 cm. high, length still 16·6 cm. Marseilles, from Montlaurès. 3·2 cm. wide, length still 24 cm. Broken at the right end, at the other, tapering, end, a spike 4·5 cm. long. Along both edges numerous holes in groups; in ten of them there are still wire rings, through which a leather string was drawn. The surface covered with punched coarse decoration, wave lines, lozenges with circles at the four corners (*P 212*), and chequer-squares. For other such belts see Déchelette fig. 355. The same system of fastening was applied to Hallstatt bronze earrings: Déchelette fig. 343.

[8] The little hook from Herrnsheim, no. 366, is possibly not part of a belt: compare the devices of similar shape,

fittings of Celtic belts are of different construction and of lesser extension: a hook part, and a ring—which, curiously enough, is rarely preserved.[1] The construction in its simplest form becomes very clear from the piece found at Essey-les-Eaux (Haute-Marne)[2] *pl. 251, a*: both the hook and the square (which has its edges turned round and forms a 'case', into which the leather strap was pinched) are cut out of a single sheet of bronze; the girdle-clasp from Trieb (Hesse),[3] *pl. 251, b* has a case of the same construction: otherwise it follows the rule of Celtic girdle-clasps, which consist of three separately wrought parts: (1) the hook proper, cast and often given ornamental form; (2) the case, a hammered bronze sheet with the edges folded round and holding the leather belt; (3) a tubular boat-shaped bar with slots, which has its place at the hook side of the case. The hook part with one to three tongues[4] fits into the slots of the bar no. (3) and continues beyond the case, fastened to it and the leather strap with rivets; the matrices of these rivets are often filled with corals.[5] In exceptional cases nos. (2) and (3) are made of one piece of bronze. No. (2), the case, is sometimes plain (no. 352 and the girdle-hook from Hesse, *pl. 251, b*).[6] The clasp from Praunheim, *pl. 251, c*, has here a pattern of concentric circles;[7] no. 351 decorates the case with engraved lyres;[8] the patterns of the girdle-hook from Bofflens, no. 358, are shown in *pl. 170*. No. (3), the tubular bar, bears a decoration varying from elaborate tongues to debased rough strokes; I have described these patterns on p. 72; the bars from Rodenbach, no. 357, and from Bofflens, no. 358, have a triglyph-metope pattern instead. The upper edge of the case is normally straight and plain; no. 352 scallops it, and in no. 351 it continues in an openwork triangle.

Much ingenuity is spent on the decoration of the hook. No. 350, exceptionally, masks it with a cast plaque in openwork inlaid with coral: the plaque has the width of the belt. The cast hooks vary greatly in shape and size. The simplest is that of no. 352; that of the girdle-hook from Mehrstetten, Bittel pl. 9, 6, is similar, only that here the end has possibly the form of a bird's head. Human heads are frequent: nos. 351, 353, 354; compare also the Hessian piece *pl. 251, b* and that from Želkovice, Schránil pl. 45, 27, p. 217. The most numerous class enlarges the size of the hook and gives it the shape of a triangular plaque in openwork, which at its base has almost the breadth of the case and in length reaches or surpasses its height. My plates show many examples of floral or mixed decoration of this part (nos. 355, 356, 360–3); pure figure decoration is rarer: in *pl. 230, b* I illustrate the hook from Hauviné (Ardennes), which is a close pendant to the piece from Somme-Bionne, no. 359.[9]

without figure decoration, from a Celtic tomb at Introbbio (prov. of Como), Montelius pl. 65, 17, and from la Tène, Vouga pl. 8, 30 ff. Similar dress fasteners from Scotland, Proc. Soc. Ant. Scot. 55, 187 fig. 21 nos.11, 12 (Traprain Law); ib. 58, 12 fig. 2 (Drumashie); compare also ib. 15, 109 fig. 6.

[1] A clasp with the ring preserved from Magdalenska Gora, in Ljublana, Müllner, Typische Formen aus der archaeologischen Sammlung Laibach pl. 27, 7, almost identical with the piece from the same site, Treasures Carniola pl. 9 no. 42.

[2] Déchelette fig. 359, 2.

[3] Kunkel fig. 195, 10.

[4] Three tongues: no. 350; two tongues: no. 355 a; one tongue, in the middle, is the norm.

[5] In the girdle-hook from Stomfa, Dolgozatok pl. 46, 3, the head of the rivet on the front of the case has the shape of a human head; Márton, p. 154 notices the presence of leather, but he did not realize that the object was a girdle-clasp.

[6] See also the piece from Mehrstetten, Bittel pl. 9, 6.

[7] The girdle-hook from Želkovice, Schránil pl. 45, 27, p. 217 bears simple geometric decoration.

[8] The Hungarian piece quoted in note 5 has engraved tendrils (Márton l.c.).

[9] I give a list of related hooks. No. 355 (d): a piece once in the Diergardt Collection, in 1935 for sale in the Cologne Museum. No. 355 (e), (f), (h): RA 41 1902, 193 fig. 21 (Chassemy, Aisne) and several others, all from the Marne, in Châlons-sur-Marne and Épernay; less close Behrens no. 206 (Hahnheim). No. 355 (i): Déchelette fig. 524, 8, 9 (Hauviné, Ardennes) and, without zoomorphic interpretation, Schaeffer fig. 182, 19; Behrens no. 205 (Bretzenheim). Between 355 (i) and 356: Behrens no. 171 or 172—the book is not accessible to me (Schwabsburg); Ulrich pl. 33, 22 (Molinazzo d'Arbedo); Carniola, Treasures pl. 28, 144. The clasps ib. pls. 7, 14 and 9, 42 lead on to the type of my no. 363.

In AuhV 3, 12 pl. 4, text it is said that the gold ornament from Klein Aspergle, no. 22, was found lying on the iron girdle-hook figured in pl. 4, no. 4, 5, but I do not see how one could take them for two parts of a clasp.

Chariots and horse-trappings. The Gauls buried warriors of distinction, chieftains, with their chariots and sometimes with their horses, as did the Etruscans of the seventh and sixth centuries B.C. and the Hallstatt peoples in the North. The Celtic chariots had two wheels and were drawn by two horses. For reasons repeatedly stated we are unable to give the manifold chariot-parts and trappings their proper names and to form an idea of the appearance of such chariots or of the horses in their caparison. So I cannot do more than comment on a few objects of stylistic or other interest.

These chariots are the work of highly trained cartwrights: the hinges from Horhausen, no. 154 *f*, the flanged parts of the Besseringen chariot, no. 155 *a–d*, and other pieces are of perfect technique. Comparison with the late Hallstatt chariots, collected by Paret, proves close connexion with those of the previous age, in construction,[1] but not in decoration. The chariots from Kaerlich, Besseringen, Horhausen, Waldgallscheid were made in the same factory; the naves from La Gorge-Meillet, no. 157, and Sillery, no. 158, probably also come from one workshop. On the other hand, as a study of linch-pins or of certain horse-trappings shows, factories far apart were in touch with one another, and certain devices, in shape and decoration, were almost identical in Germany and France, in Germany and the East.

I give a list of some chariot-parts.

Naves. La Gorge-Meillet, no. 157, Sillery, no. 158.

Linch-pins. (*a*) Waldgallscheid, no. 153 *b*; (*b*) Waldalgesheim, no. 156 *g*; (*c*) River Erms, no. 159; (*d*) Grabenstetten, no. 160; (*e*) Niederweis (Eifel), no. 161; (*f*) Leval-Trahegnies, no. 162; (*g*) Saint-Germain, no. 163, of unknown provenience, but certainly Eastern like the whole of the find to which it belongs;[2] (*h*) Mezek, no. 164; (*i*) Nanterre, Déchelette fig. 502, 7. Of these no. (*f*) stands apart: it has a rounded head instead of a square. No. (*a*) recalls the linch-pin of the Etruscan chariot from Montecalvario, *pl. 251, d*; this chariot had already been mentioned because of its openwork decoration (*pl. 243, d*).[3] The Celtic linch-pins are fairly uniform in size, shape, and technique. It is instructive for the relations between the factories in distant areas that no. (*c*), from Württemberg, goes with no. (*h*), from Bulgaria; no. (*f*), though found in Belgium, has an Eastern look; no. (*d*) is provincial in character and without proper analogies; no. (*i*) comes from a chariot grave later than the others.

Roll of the swingle-tree. (*a*) Waldgallscheid, no. 153 *d, e*; (*b*) Besseringen, no. 155, *f, g*; (*c*) Dürkheim, no. 166; (*d*) Kaerlich, no. 167; (*e*) Armsheim, chariot grave, Auh V 3, 3 pl. 2, 10, 11; Behrens fig. 170, 8–10; JL 20; (*f*) Hillesheim, Forschungen und Fortschritte 1930, 246; (*g*) Trier, from Schwarzerden, Jahresberichte des Trierer Landesmuseums 1934, 156 fig. 23; (*h*) chariot grave from Sablonnière, Album Caranda 1877 pl. F; (*i*) chariot grave from the Marne, *pl. 251, e*; and possibly (*k*) Morel pl. 12, 7, 8; p. 30.

Most of these pieces have been known for years, but it was the careful excavation of the Kaerlich grave that gave the clue to the purpose of these devices. There and at Armsheim (no. *e*) both rolls are preserved, otherwise only one or even only the openwork parts fastened to the swingle-tree. No. (*e*) have been mistaken for bridle-bits, no. (*g*) was thought to be a Late Celtic mirror-handle; and (*c*) had the fate to be attached by Lindenschmit as a sort of appendage to the Etruscan tripod from the Dürkheim tomb, though the presence of an iron tyre of 1·13 m. diameter (Auh V 2, 2, text to pl. 2) made it sufficiently clear that there was a chariot

[1] It is instructive to compare no. 154 *c* 1 with the Swabian Late Hallstatt chariots, Paret pl. 9, 3–5. [2] p. 184.

[3] p. 82. Compare the linch-pin from Sesto Calende, Montelius pl. 62, 11, and, earlier, those in Benacci ii graves at Bologna, Montelius pls. 76, 18; 80, 9: in the latter a pair: they seem to refute Duhn's statement (Ebert 2, 111) that there were no chariots in these graves.

in the grave.[1] The roll, save for the fittings at the upper end, is plain, the Dürkheim piece alone has a beautiful decoration inside: if the horses were pulling, the Gaul on the chariot saw the dragons rampant.[2]

Cast traces of very good workmanship are in the Horhausen tomb, no. 154 *l*.

Fair-leads.[3] (*a*) Waldalgesheim, no. 156 *b*; (*b*) no. 175; (*c*) Nanterre, no. 174 *a*. No. (*c*) is later than (*a*) and (*b*) and is the earliest of the future standard type, illustrated in Déchelette fig. 510. (*a*) and (*b*) give the impression of individual creation and experimenting; no. (*b*) is of small size, and ring and saddle are set at a right angle.

Chariot-horns. Waldalgesheim, no. 156 *a*; La Bouvandeau, no. 168; they have their place on the body of the chariot, as is best shown by the chariot from Dejbjerg.[4]

Yokes. No yokes of horse-drawn chariots are preserved. Those from La Tène, no. 172, and those represented on the Pergamene balustrade, no. 173, belong to ox-drawn carts. The arcs of the latter differ in shape and size: the Galatians put ox and cow to their carts. The Galatian yokes look more rustic and somewhat edgy.[5]

The pair of curved devices in openwork with coral inlay, no. 171, from the tomb at La Bouvandeau which yielded the chariot-horn no. 168, are actually the mountings of leather-covered wooden *hames* of a type still seen to-day on draught horses. In Saint-Germain the three pieces from the grave are reconstructed as a fantastic chariot-pole (Déchelette fig. 505).

Much else remains, ornamentation of body or wheels, but names and use remain conjectural.

Even more precarious is a precise identification of the very numerous *horse-trappings*. There are a good many disks or phalerae of a size varying from about 6 cm. to well over 20 cm., most of them in openwork, sometimes with addition of coral, rarely plain, and, if decorated, only with plastic concentric circles (Han-du-Diable, no. 178). On the back they have tongues, staples, shanks, or two iron bars set at a right angle.

By far the greatest part of the phalerae come from the Marne, &c.; pieces from Germany, Langenhain, nos. 181–3, and from the Treveri (Sefferweich),[6] are closely related to the French. From Bohemia, from a chariot-burial at Hořovic, comes a set of phalerae of various size,[7] of which the piece with the masks, *pl. 218, g*, forms part; from Gallia transpadana the silver phalerae no. 84: they are later, but their decoration with a ring of masks[8] is a clear sign of connexion with earlier models.

The bridle-bit from Septsaulx (Marne), *pl. 251, f*, shows one phalera, of about 12 cm. diameter, *in situ* and gives a clue to the location of the pair from Saint-Jean-sur-Tourbe, no. 184, and of others. In the chariot tomb at Somme-Bionne, nos. 180 and 192 were, as Morel 48 (Déchelette 1192) reports, found near the bridle-bit, with some leather still adhering. On the Hallstatt sword, no. 96, one sees phalerae along the bridle.

There are many other ornaments, crosses on chains, tongues or studs, which adorned the leather parts of the harness all over the body. The iron handles from La Tène, no. 204, dangled down from the bridle-bit and were held by the man leading the horse.[9]

[1] I have to correct the misstatement in JL 22. [2] pp. 122–3.
[3] Déchelette 1196; Rostovtzeff, Syria 13 1932, 321.
[4] Ebert 2 pl. 181, a; see pp. 12, 61 (on *pp. 69, 70*). A chariot with horns, fair-lead, &c., from Kappel near Buchau was published in Fundberichte aus Schwaben 1935, Anhang 1 p. 30. (Information from Dr. Neuffer, but I was unable to study the book.)
[5] p. 102; Braungart, Die Südgermanen, takes the yokes from La Tène for 'germanisch'; his attributions of yoke types to Germanic tribes are absolutely unfounded. Yokes of our type are widely distributed: wall-painting in the thermae of Titus, Daremberg-Saglio s.v. jugum fig. 4153; in 1935 I saw one on a farm in Tuscany.
[6] Trierer Zeitschrift 10 1935, 35 (Dehn).
[7] Anzeiger für Kunde der deutschen Urgeschichte 1865, no. 5 (not accessible to me). [8] p. 16.
[9] This piece has later, but exact, analogies: Ritterling, Das

These Celtic horses in their caparison, covered with a wealth of shining bronze, coral, and enamel, the leather of the harness gaily coloured, must have made a beautiful show.

It is agreed that this kind of caparison was borrowed from the East at various times by various European peoples.[1] Thus it is quite permissible to form an idea of the appearance of Celtic horses from representations in other arts. There are Sasanian reliefs, there are Sarmatian original phalerae, there is a picture of horses with a phalera on the breast-strap in a Scythian fourth-century textile from Noin-Ula (Mongolia).[2] Furthermore, a Greek phalera of the same century from a rider's grave,[3] and several tombstones of Roman horse-soldiers.[4] Here once more the actual Asiatic centre from which the ornaments spread is unknown. The Celts certainly borrowed the fashion from the East, as the Greeks and the Romans did, but from where exactly cannot be established.

PERSONAL ORNAMENT

Torcs. The ancient writers often mention the torcs as the distinctive ornament of the Gaulish warriors, and Greek statuary and Celtic coins confirm it: but it cannot be denied that by far the greatest number of the torcs preserved were found in the graves of women.[5] Their average diameter[6] is 13 cm., thus fitting a slim woman's neck; among the bronze rings few exceed these dimensions (nos. 238, 239). The gold torcs from some chieftain graves in Germany are larger: the torc from Waldalgesheim has a diameter of 18·7 cm., that from Besseringen of 20·4 cm., and the torc from Dürkheim of 21·2 cm. These were certainly worn by the warriors buried there.

The torcs were either open in front, elastic enough to be passed round the neck without breaking, or closed, and if so, they have either a detachable portion or were fastened at one point by mortise and tenon.[7]

The material is bronze and gold; silver is very rare and confined to certain regions:[8] here only no. 85 from South-eastern France.[9] Though the gold rings excel in elaborateness and precision of work, they have so much in common with the bronze torcs that sometimes the same pattern-books seem to have been used for both: compare the gold torc no. 39 with bronze ones: Troyes pl. 43 no. 521 (from Saint-Loup-de-Buffigny, canton de Romilly, arr. Nogent-sur-Seine), pl. 59 no. 765 (from Isle-Aumont, Aube); Viollier pl. 11, 17. Or compare the gold torc from Clonmacnois, no. 49, with the bronze ring no. 212. This is only so in the early phase; in the Plastic Style material plays a greater part, and forms like those of the gold torcs and bracelets nos. 62–9 are inconceivable in bronze.

On the whole, rings, torcs—and bracelets, to speak of bracelets already here—avoid that excess of masks and monsters which gives the brooches and girdle-hooks so weird a character. The Glauberg torc, no. 246, and the gold bracelet from Rodenbach, no. 59, are lavishly decorated with human heads and animals; the torcs nos. 41, 239, 240 show birds in groups: when the artist set these figures on the ring he thought of the wearer: they appear upright when looked at by the person who wore the ring, and the same is true of the 'egocentric'

frührömische Lager bei Hofheim i.T., Annalen des Vereins für Nassauische Altertumskunde 40 1912, 392 fig. 107; Mahr, Zu den sogenannten prähistorischen Steigeisen, Finska Fornminnesföreningens Tidskrift 39 1934, 26.

[1] Rostovtzeff in Recueil Kondakov 257; AS 42 and 59; SB 542.

[2] AA 41 1926, 357–8; Rostovtzeff AS pl. 24 A, 2; Die Antike 3 1927 pl. 7. [3] Pernice, 56. BWP 27.

[4] Steiner, BJ 114 1905, 16 ff.; Ebert 11 pl. 56, c; Germania Romana fasc. 3 pls. 6 and 7.

[5] Déchelette 1209; for Hungary see Márton 38, 39.

[6] A gold torc from near Siena, Studi e materiali 3, 310, 318 fig. 1, has a diameter of only 10 cm.; see p. 144 n. 2.

[7] For a study of these gadgets I refer to Jahn, Die Kelten in Schlesien. [8] p. 130.

[9] It compares with the torc from La Tène, Vouga pl. 21, 10.

arrangement of the birds in the fibula no. 297 and the dragons in the roll of the swingle-tree no. 166.

The Orientalizing type of rings with animal heads as finials is rare: represented here only by the fragmentary gold ring no. 61.[1]

The bracelet from Pössneck, no. 249, interrupts the twist three times, by a human head, a ram's head, and a knob with ornament.

One motive is of historical importance, human heads set on the hoop, their noses parallel to the run of the ring: nos. 208, 208 A, B; Schaeffer fig. 167, pl. 27. In the gold arm-rings from Dürkheim, no. 57, and from Schwarzenbach, no. 58, two heads, forehead to forehead, mark the three caesurae: the armlets from Hermeskeil, no. 248, from Schwieberdingen, Germania 19 1935, 292 fig. 2, 2, pl. 39, 4, 5, and Chassemy (Aisne), RA 41 1902, 185 fig. 12, 1, copy this in a coarse manner. The heads in the Dürkheim ring do not touch each other, but have cushions and a jutting collar between them, those in the Schwarzenbach ring a 'barrel'. In *pl. 252, a* I illustrate a gold-plated bronze spiral,[2] one of a pair, a very good Etruscan work of late or belated archaic style. Etruscan jewels of this kind were the model of Celtic rings with masks. The Etruscan heads all stand upright, the Celtic heads form antithetic pairs. I spoke of 'Janus in flat projection': this idea may really have played a part in the transformation of the Etruscan prototype, which, for its part, reflects Oriental models: see the rings, Herzfeld, Iran and the Ancient East fig. 271, and Pope, pl. 56, D, where lions' heads terminate the hoop and support the buffers.

Projecting ornament in figure- or 'trellis'-work (*PP 46–53*) is—with the exception of tripartite torcs (see below)—confined to the throat section.[3] Some torcs have a decoration of coral, nos. 226, 227, 238;[4] others of enamel, nos. 228, 229, 230, 232, 234, 235. If the torc has buffers, the matrices flank it; if it has an invisible mortise-and-tenon catch, one of the matrices marks the centre of the throat part.[5] Enamel filling is occasionally applied to the grooves of relief tendrils.

The most numerous class are buffer-torcs. Buffer-torcs, otherwise plain, are rare: in gold nos. 39, 40; in bronze the torcs in Troyes, nos. 521, 765, just quoted. More commonly the hoop beside the terminals bears relief decoration: the plates give examples and more could be cited. The nape point is often accentuated by a swell of the ring or by relief ornament of varying height and extension, and there is frequently a sub-caesura half-way between it and the upper end of the relief ornament which creeps up the hoop above the buffers.

A variant is the twisted torc: nos. 64, 65, 67, 240; see also RA 41 1902, 185 (Chassemy, Aisne); Déchelette fig. 515, 4 (Étrechy). The twisting is exceptionally confined to sections of the ring, as here in the gold torc no. 69; see also the bronze torc from Molins, canton de Brienne, arr. Bar-sur-Aube, Troyes no. 365, pl. 35. The lock of twisted torcs is often very

[1] p. 39. See also the bronze torc from Vieille-Toulouse, BAF 1887, 195; Morel pl. 37, 1, p. 151; Déchelette 1210, note 4 and 1217, note 4 Gössler, Trichtingen 28. The silver ring from Mâcon with animal heads, mentioned in The Dark Ages, Worcester Art Museum (1937) no. 65 is not a bracelet, as said in the description, but having a diameter of 16·6 cm., certainly a torc; I have been unable to obtain a photograph from Messrs. Brummer.

There is a bronze ring with boars' heads as finials in Bowdoin, Acc. no. 27, 7, of which Professor Beazley showed me a photograph: it looks Celtic.

[2] New York. Alexander, Jewelry no. 40; Richter, Etruscan

Art fig. 30, p. 10. I owe the photographs to Miss Gisela Richter. The gold-plated bronze ring BMC Jewellery no. 1366, pl. 17 comes from the same workshop.

[3] A torc with trellis-work at the throat point only: AuhV 5 pl. 50 no. 887, from Klein-Alfalterbach (Oberpfalz).

[4] There is also a torc from Niedermockstadt in Giessen which is closely related to nos. 226 and 227.

[5] Other examples of the first type are: from Wallerfangen, Aus'm Weerth 34; from Gerenyás puszta, Márton pl. 9, 7. Of the second type: from Nackenheim, Behrens no. 201; Viollier pls. 13, 14; Ulrich pl. 49, 10; from Gyoma, Márton pl. 10, 8.

simple, nay primitive: Morel pl. 38, 5; Album Caranda 1879 pls. Q, R; 1888 pl. 84, 1; 1890 pl. 117, 1; RA 41 1902, 189, from Chassemy, Aisne; Schaeffer fig. 165, 3 (see below). No.238 decorates the flat catch-plaques with coral. Twisted rings with buffer-finials are no. 209; the torc from Armentières, Album Caranda 1882 pl. 31, 1; CdM, Babelon and Blanchet no. 1565 (with drawing in the text); Morel pls. 13, 9; 19, 6. The afore-mentioned torc Schaeffer, fig. 165, 3, reverses the twisting at the nape point; a motive often seen round the edge of helmets;[1] no. 214 is, *cum grano salis*,[2] a twisted torc.

All the torcs described hitherto follow the principle of bilateral symmetry, more or less stressed. Another system of decoration is tripartition: nos. 241, 242, 244, 245, the three latter belonging to the class with jutting ornament. Other examples are Morel pl. 38, 10; Revue des Musées 27 1930, 68, 3 (in Sens); Troyes no. 412 pl. 37 (Plessis-Barbuise, arr. Nogent-sur-Seine); no. 512 pl. 42 (Rouillerot, *P 45*) and of another type, more frequent among bracelets, Morel pl. 38, 13; Déchelette fig. 516, 3 (Marne).

So much for the shape of torcs. Their embossed or engraved ornament has been studied in Chapter 3. For the manifold variation of buffers, disks, balls, balusters, knots I refer to the plates.

Bracelets. The Celtic bracelets are the ornament of people of elegant build. The Dürkheim gold armlet, no. 57, has a diameter of only 5–5·7 cm., the Lunkhofen rings, no. 60, of 5·4–5·5 cm., thus fitting a very slim wrist; some go up to about 8 cm.

I need not discuss plain bracelets like the gold one from Hillesheim, no. 52, and many others of this kind in bronze. I only mention the Lunkhofen silver rings, no. 60, because of their ornamented gold lock, and the gold wire bracelet from Waldgallscheid, no. 50, because of the loop which, like that of the gold torc no. 40 and like the Gordian knot at the nape part of a twisted bronze torc from Manerbio in Brescia,[3] is a charm; the knots of torcs or bracelets such as nos. 55, 219, 241, 244 have become mere ornament, and artist and wearer were hardly aware of their once magic significance.[4]

The buffer type to which the majority of torcs belong is in the minority here. There are, however, the gold pairs from Waldalgesheim, no. 55, and from Belgium, no. 56, and a good many bronze bracelets: from Mainz, Behrens no. 191; from Budenheim, ib. no. 198; Viollier pl. 19 and pl. 21; Dolgozatok pl. 31, 4, 5, and others. Tripartition, on the other hand, is here frequent: of gold rings I figure the pieces from Zerf, no. 53, from Dürkheim, no. 57, from Schwarzenbach, no. 58; of bronze rings nos. 249, 250, 251, 254.

Of special types I mention the twisted gold ring from Waldalgesheim, no. 54, which has analogies in bronze, for instance the bracelet from Andelfingen, Viollier pl. 16, 26, the gold wire ring from Sopron, no. 71, the ball-ring from Waldalgesheim, no. 247.[5]

Finger-rings. There is a good survey in Déchelette 1264 ff. He has clearly stated that the Celts copied Southern models.

Of the rings figured here those from Rodenbach, no. 72, and from Zerf, no. 73, belong

[1] p. 72.

[2] See description on p. 188.

[3] See text to no. 84.

[4] P. Wolters, Zu griechischen Agonen 7; id., Archiv für Religionswissenschaft 8 1905, Beiheft 1 ff.; Heckenbach, De nuditate sacra, etc. 104. Compare the Iberian silver torcs, P. Paris, Essai sur l'art et l'industrie de l'Espagne primitive 2 pl. 7, and Arquivos do Seminario de Estudos Galegos 4 1932 pl. 5 (from Mondoñedo). I also mention the silver bracelet from

Montefortino, Mon. Ant. 9 pl. 7, 21; Montelius pl. 155, 7: one cannot always exclude the possibility that the loop served a rather profane purpose, namely to shorten a ring and fit it to a slimmer wrist or neck.

[5] Other examples of this type, but the balls without ornaments, are: from Mainz, Behrens no. 191; from Budenheim, ib. no. 198; Bittel pl. 15; from Alteburg, Mannus Bibliothek 5, 79; from Wölfersheim (Kr. Friedberg), AuhV 5 pl. 57 no. 1063 (Kunkel fig. 192); Viollier pls. 17 ff.

to the early phase, like two important pieces, known to me only from insufficient publications, the gold rings from Lahošt (Loosch) in the Trmice (Türmitz) Museum, Schránil pl. 45, 1, p. 216, with a frontal head in high relief, and another from the region of Hořovic, ib. pl. 45, 5, p. 216.[1]

The treatment of the bezel and the adjoining parts of the hoop vaguely recalls classical models: see BMC Finger-rings no. 34, pl. 1 and text-fig. 8; the bronze rings from Rosarno Medma, Not. Sc. 1914, Suppl. 138, the silver rings from the sanctuary of Demeter Malophoros, Mon. Ant. 32, 343, and from Tarentum, Not. Sc. 1936, 135 fig. 24; the gold ring, Berlin, Furtwängler, Beschreibung der geschnittenen Steine no. 150.[2] The bronze ring from Perachora, Payne pl. 79, 30, compares with the frontal mask of the Lahošt ring.

The decoration of the Rodenbach finger-ring, a Janus-head in flat projection, has Celtic analogies.[3] But comparison with *pl. 252, b*, proves that it is the copy of an Etruscan model. The piece figured[4] is a work of the later years of the second quarter of the fifth century B.C. The Silenus heads are separated from each other by an inset, a carnelian with an eagle carrying a serpent in its beak; the stone is not a masterpiece and inferior in quality to the finger-ring itself. The heads are embossed, the rest of the ornamentation is in beaded wire, soldered on: there are four 'Ionic capitals' round the bezel, and at the sides a two-petalled lotus with filling leaves. The Etruscan model explains the odd stop-gaps between the two heads on the Rodenbach ring: the Celtic ring lacks inset—the Celts at this early phase do not use stones—the Celt fills the gap with flowers growing from the noses, and the lyres to left and right are a substitute for the Etruscan lotuses. The very instructive translation of a classical Silenus into Celtic is dealt with on pp. 21; 161.

The gold ring from Étoy, no. 74, is of Waldalgesheim Style and has affinity with the gold torc from Clonmacnois, no. 49. The bronze ring from Les Pennes, no. 284, is as poor as all the finds from this site and its ornament repeats in flatter relief that of the bronze bracelets found in the same oppidum, no. 276.

The gold ring from Filottrano, no. 75, bears a certain resemblance to Gaulish coins which are not earlier than the third century B.C.: the ring was cut by a die-sinker.[5] The same probably applies to the silver ring from Oberhofen, no. 81. The stamped device on the strigil from Bologna, Montelius pl. 111, 1, with the signature Ollooro[6] looks like the copy of a Celtic signet. In two other cases the Gauls had their rings engraved by second-rate Italian artists: there are two silver finger-rings at Montefortino, tomb 40, Mon. Ant. 9 pl. 7, 27 and 28: on one the portrait of an old Senon with a beard (by no means 'lavoro barbarico'), on the other a Celtic helmet with horns, to be compared with Furtwängler pl. 28, 81 (Bieńkowski 30); see also Furtwängler text 3, 285, 3.[7]

[1] Schránil describes the latter as follows: 'Hohler Goldring mit plastischer Verzierung, die sich zu einem dekorativen Täfelchen verbreitert, auf dem ein Reliefornament mit Schneckenwindungen in S-förmigen Motiven angebracht ist. Die Zwischenräume auf der Grundfläche des Reliefs sind mit kannellierten Bändern ausgefüllt.' [2] pp. 55 n. 5; 64. [3] p. 16.

[4] New York, AJA 44 1940, 435 fig. 7 top left and 436 fig. 10. I am indebted to Miss Gisela Richter for the photographs and permission to publish them. Another jewel from the same find is quoted on p. 90.

[5] In JRS 29 1939, 98 I followed Dr. Pink, who connected the ring with the coins of the Longostaletes: to-day I cannot see more than a general resemblance to Gaulish coins.

[6] p. 145.

[7] A word on the other finger-rings and stones from Montefortino: not having seen the originals in Ancona I depend on the drawings in Mon. Ant. 9, which make judgement on details and style difficult. Brizio l.c. 732 gives a survey of the material.

(a) pl. 3, 6; Montelius pl. 152, 3 gold ring with glass paste. I wonder if Brizio (667) describes the paste correctly: 'left arm over the head pouring liquid into the patera which the right hand holds'. I seem to see the left arm coming down beside the body, and what is above the head has not the shape of a human arm, but rather looks like a snake drinking out of the patera. For the form of the ring see BMC Finger-rings p. xlii, C xxiii.

The gold finger-ring from Filottrano, no. 76, is made in a wire-twisting technique which the Celts at this phase practised in gold, silver, and bronze.[1] Compare the gold ring from Münsingen no. 77, and the piece from Muri, no. 78: the type of no. 78 is frequent in Switzerland, France, Bohemia, and elsewhere: Déchelette fig. 544, 1–6; see also BMC Finger-rings no. 1448, pl. 33, from the Morel Collection and thus certainly from France. The type is very old: Cretan gold ring, BMC l.c. no. 874, p. xxxvii fig. A iii, and p. 143 fig. 119; and it is also still common in Roman times: Henkel, Die römischen Fingerringe des Rheinlandes no. 324, pl. 16; see also Henkel pl. 29, where Celtic tradition cannot be ruled out.[2]

Fibulae. The material is bronze, with the sole exception of two pieces (nos. 324 A, 331) which come from regions where silver was used to a certain extent.[3] It might be expected that the Celts, fond of gold ornaments, would have followed the fashion of those luxurious gold fibulae in the Etruscan 'chieftain graves': no Celtic gold brooch is actually preserved: nevertheless one is always tempted to translate the Jungfernteinitz fibula, no. 318, or that from Parsberg, no. 316, into the nobler metal. Inlay of coral is very common and not confined to any special period; enamel is rare.[4]

Measurements. The smallest are the animal-fibulae nos. 320 and 321, which only measure 2·3 and 2·9 cm. respectively. The average length of Celtic fibulae is between 3 and 6 cm. Nos. 303, 308, 323, 324 A are about 9–11 cm. long. By far the largest piece of all is the North Italian brooch no. 297, which has a length of 15·4 cm.

Only the brooches of the early phase have a lavish decoration of human and animal heads:[5] they have been studied in detail in Chapters 1 and 2.

It has often been stated that the type represented here most clearly by no. 303 is a derivative of the Certosa brooch; Déchelette 1247 rightly criticizes those who believe that there was only one prototype. The Schwabsburg brooch, no. 289, for instance, is obviously a descendant of the Hallstatt boat type—with the foot shortened—and this not only in

(*b*) pl. 5, 2, p. 681 engraved gold ring: Athena.

(*c*) pl. 5, 7, p. 681 globolo scarab: chimaera (?).

(*d*) pl. 7, 11, p. 678 ellipsoid medallion forming part of a necklace (pl. 7, 15), clay with thin sheet of gold on front and reverse which backs uplaid glass pastes, on one quadriga, on the other Eros: what he is actually doing could only be told from study of the original.

(*e*) pl. 7, 16, p. 690 gold ring with engraved dolphin (?).

(*f*) pl. 7, 23, p. 734 fig. 29, p. 690 silver ring with inset agate: Dionysos leaning on a pillar, a bunch of grapes in the left hand.

(*g*) pl. 7, 29, p. 705 silver ring with carnelian: two warriors fighting; from the same grave as the two silver rings mentioned above in the text.

(*h*) pl. 8, 6, p. 692 gold ring with onyx: rider with led horse, above palm-branch (?).

(*i*) pl. 9, 6, p. 699 gold swivel-ring with agate: cornucopia (?).

None of the engravings are really good, and the scarab (*c*) is definitely bad. No. (*g*) alone has an Etruscan smack, all the others show the general style of Italian glyptic in the third century B.C.; nos. (*d*) and (*f*) belong to the better products in this class.

Superior to the rings from Montefortino is a gold ring from Filottrano, of which Edoardo Galli very kindly gave me a photograph: on the bezel, which is a pointed ellipse, a sea-horse is engraved.

Contemporary with these rings is the silver finger-ring from

Horgen near Zurich, Déchelette fig. 546, 1; Viollier pl. 28, 31.

[1] Gold: Hungarian bracelet no. 71. Silver: bracelets from Montefortino, Mon. Ant. 9 pl. 7 no. 21; from Ornavasso, Bianchetti, I sepolcreti di Ornavasso pl. 12; Déchelette fig. 449, 3; from Giubiasco, Ulrich pl. 67. Bronze: bracelets from Montefortino, l.c. pl. 7 no. 25 (whence Déchelette fig. 448, 3). From France: Déchelette fig. 519, 9, 10 (Marne and Hautes-Alpes). From Bussy-le-Château, Saint-Germain no. 33307 and others in the same case. Épernay, from Corroy, St. Mard. From Germany: Wölfersheim (Kreis Friedberg), AuhV 5 pl. 57, no. 1061 (Kunkel fig. 192). See also the Hungarian girdle-clasp no. 368.

[2] No. 80 is of a type occurring in Roman arts. Tschumi l.c. has already referred to Henkel l.c. pl. 1, 21 and pl. 16, 317. On Celtic influence on Roman finger-rings see Henkel's remarks to nos. 474–6.

[3] Silver fibulae are frequent in Northern Greece and the Balkans: Déchelette 1348; Blinkenberg 229; Márton pl. 28, 4; p. 81 fig. 22. North Italy: Ornavasso, Déchelette 1349. Marzabotto, Montelius pl. 112, 9 (= série A pl. 12, 162). Cenisola, ib. pl. 12, 168. Ticino, Ulrich pp. 28–30. Hradisht, Pič, Le Hradischt de Stradonitz 31. See also AuhV 5, p. 74.

[4] Traces of enamel in the grooves on nos. 308 and 316; see below p. 133.

[5] On the chronology of the brooch from Champ du Moulin, no. 293, with two birds see p. 128.

general shape, but also in decoration: Hallstatt boat-fibulae show a similar system of lines engraved on the bow.[1]

Southern origin of the figure decoration is likely. That animal-fibulae[2] like no. 320–1[3] reflect Italic models is generally known; the Langenlonsheim brooch,[4] no. 319, can be connected with the silver piece from the Tomba Bernardini (MAAR 3 pl. 8 no. 18, p. 23; Pinza, Materiali pl. 20). The source of the average Celtic mask- and animal-brooches was apparently Villanovan Italy: *pl. 252, c–e* give examples.[5] Their models were not Greek: in Greece figure decoration of fibulae is rare: there are some late geometric Rhodian ones with poor Hallstatt birds, Blinkenberg 90–5, or the unique piece with snake heads at both ends, ib. fig. 257; the elaborate Rhodian fibula, *pl. 225, d*, stands alone and clearly reflects an Eastern type.[6] The models of Italian figure-brooches were Syrian: in *pl. 252, f*, I illustrate a mask-brooch from Ras Shamra, to which my attention was drawn by Claude Schaeffer; it belongs to a type of Λ-shaped fibulae, frequent in Syria (Blinkenberg pp. 243 ff.): as a rule, they lack figure decoration. The fibula from Bologna, *pl. 252, e*, doubtless copies such a Syrian mask-fibula.

Déchelette (1245 ff.) and Beltz[7] have studied shape and mechanism of Celtic brooches and drawn valid conclusions from them for chronology: out of thousands of specimens preserved and hundreds published I have selected and illustrated not those which a pre-historian would choose for typological purposes, but those which give the clearest idea how the basic form was adorned and how the Gauls gave artistic shape to this modest implement.

A fibula is an asymmetrical device: the head with the coils of the spring is the heavier part: there is a tendency through the ages to bring head and foot part into balance, by adding weight to the lighter side where the pin-catch is.

There is hardly any example of a Celtic fibula—I am speaking of the period with which we are concerned—showing the bare form—bow, spring, and pin-catch—unadorned.

Of the three sides from which a brooch can be looked at, none is ever neglected. Where I content myself with figuring one of the two profile views, the reader may be assured that the corresponding side is equally well executed and decorated; and, in contrast to Southern fibulae, the upper side is hardly ever unadorned: even pieces like nos. 289, 290, 292, 293, 294, which were surely meant to be looked at from the left or the right, have coral inlay on top, and brooches of the type illustrated here by nos. 301, 302, 303, 304, 308, 309, 310, 311, &c., give more, or at least no less, sense from above.

I begin with fibulae which, in the tradition of the boat or leech type, have a symmetrical

[1] From Como, Randall MacIver, Iron Age in Italy pl. 16, 11. From Oppeano, Montelius pl. 49, 1. From Este (period III), Montelius pl. 54, 5. From Tyrol, Mon. Ant. 37, 271/2 fig 86. From Carniola, Treasures pl. 25 no. 154. From Vetulonia, Montelius pl. 181, 3. From Fermo, dall' Osso 100. From Saint-Ours, commune de Meyronnes (Basses-Alpes), Déchelette fig. 349.

[2] Déchelette 1249, 1 rightly states that the Ticino fibulae with figure decoration are late. Another centre of brooches with human heads and animal protomai is Carniola: Treasures passim. See above p. 26. The piece in Oxford, Ashmolean Museum Report 1939 pl. 6, with the horse protome was purchased from a dealer and said to have been found at Hallstatt, but it is actually Carniolan, and the same is true of the two other pieces bought with it.

[3] See also the pieces from NE. Bavaria, PZ 24 1933, 131 fig. 8 nos. 8–10. I am now inclined to take no. 320 for an Italic import. See Dohan, Italic Tomb-groups in the University Museum (Pennsylvania) 62 no. 43. See Addenda.

[4] Related to it is the fibula from Staffelberg (NE. Bavaria), PZ 24 1933, 131 fig. 8, no. 11: the bow has the shape of an animal with a spiral on the haunch, but the head is that of a man, looking back. See p. 59.

[5] (c) From Terni, Not. Sc. 1916, 214 fig. 20. (d) From Populonia, ib. 1925, 349 fig. 4. (e) From Bologna, Sepolcreto Arnoaldi Militare, tomb 16: Not. Sc. 1890, 230; 1898, 383 fig. 23. Length 2·5 cm. Time Benacci II. I owe the photograph to Professor Ducati. [6] p. 35.

[7] Zeitschrift für Ethnologie 1911, 664 and 932.

bow, the centre of which is sometimes stressed on the keel and on the flanks (nos. 287–97). The tendency towards symmetry is so strong that the bow beyond its tapering ends continues on both sides in an upward swing towards the middle. Apart from some cases where they have the shape of knobs or cones[1] (nos. 287, 288), these finials are mostly interpreted as human heads, or neck and head of a bird,[2] some resembling ducks, others more like eagles. In a few fibulae the finials are half-way between an abstract, ornamental form and a bird's head. As a rule, there are either human heads or birds on both sides; only the brooch from Weissenturm, no. 294, has a bird here and a mask there. The masks are sometimes turned to the outside, sometimes to the inside. Two pieces stand apart, the North Italian fibula no. 297, and the Swiss brooch no. 293. The former shows archaic residues, typical of this region, the long-drawn-out foot, the glass beads attached, and the conical bosses on the bow: the pair of sleeping ducks differ from ordinary birds in Celtic art.[3] The Swiss piece has been given a late date by some writers, but I should link it with early fibulae: the attached openwork plaque has its only analogy in the brooches from Parsberg, no. 316, Weisskirchen, no. 317, Langenlonsheim, no. 319, and the beading of the birds' heads recalls the early fibula no. 299 or that from the Steinsburg, Déchelette fig. 269, middle right.

The brooch from Schwieberdingen, no. 292, stands between the strictly symmetrical fibulae and the asymmetrical: a bird on both sides, but that above the spring does not grow from the body of the brooch, it is neckless and only put on the bow.

The majority of Celtic fibulae belong to the asymmetrical type where the bow and the terminal at the foot together form an S-curve which has its zenith and the maximum of swell nearer the coil (nos. 298–316). There are two classes: the first confines decoration to the terminal at the foot (nos. 298–302), the second balances asymmetry by adorning the head part as well (nos. 303–18): this class comprises the most ornate fibulae and the most attractive ones—though this is a matter of taste. Figure decoration now extends to the bow; pieces like nos. 304, 308, 309, 312–14, 316, and 318 are meant to be looked at from above. In both classes there is great variety in the finials: cones,[4] birds,[5] mammals,[6] spiral snouts;[7] human heads are frequent:[8] I have described them all in Chapters 1 and 2. A rare variant (nos. 316, 317, 318, and possibly 319) hides the spring behind an attached animal-decorated plaque.

[1] On cones as finials of the asymmetrical type see n. 4.

[2] Other examples are: Baldes-Behrens, Katalog Birkenfeld pl. 9, 1; Kunkel fig. 195, 9; Schaeffer fig. 74 f. See p. 30.

[3] p. 27.

[4] A few examples: Germany: NE. Bavaria: PZ 24 1933, 161, 162. Württemberg: Bittel pls. 10, 11. Thüringen: Mannus Bibliothek Heft 5, 41 fig. 64; AuhV 4 pl. 14 nos. 12, 13. Bohemia: Dux, Déchelette fig. 533, 11, 12, 14, 17. Hungary: Márton pls. 5 and 6 and Dolgozatok passim. Italy: Montelius pls. 112, 6; 113, 8. France: Schaeffer fig. 21, a (Haguenau). Déchelette fig. 533, 13 (Bussy-le-Château, Marne) and no. 16 (Ciry-Salsogne, Aisne). Troyes nos. 318, pl. 31 (Mailly, arr. Arcis-sur-Aube); 414, 415, pl. 37 (Plessis-Barbuise, arr. Nogent-sur-Seine); 477, pl. 41 (Ramerupt, arr. Arcis-sur-Aube). Morel pls. 13, 1; 14, 1, 5; 26, 3; 27, 8. Switzerland: Viollier pls. 1 and 4–8, passim. Other examples: Zeitschrift für Ethnologie 1911, 677 ff.

[5] See also: Behrens no. 175 (Monsheim), to be compared with the fibula from the Steinsburg, Déchelette fig. 269; AuhV I, 4 pl. 3 no. 8 (Déchelette fig. 533, 7) (Kreuznach); Baldes-Behrens, Katalog Birkenfeld pl. 9, 3 (no provenience given);

AuhV I, 4 pl. 3 no. 9 (Nienburg, Weser); ib. no. 4 (Bavaria); PZ 24 1933, 131, fig. 8 nos. 4–7 (NE. Bavaria); Ebert 3 pl. 106, a (Streitberg, Oberfranken); AuhV 5 pl. 20 nos. 322, 323 (Upper Bavaria), 324 (Oberpfalz); Bittel pl. 10; AuhV I, 4 pl. 3 no. 5 (Sigmaringen). Bohemia: Schránil pl. 45. Hungary: Dolgozatok pl. 23, 2.

[6] Ram: Bittel pl. 1, c 3 (Hochdorf), and possibly Schránil pl. 45, 7. Deer: PZ 24 1933, 131 fig. 8 no. 13. Horse (?): Schuchhardt, Vorgeschichte in Deutschland[2] 214 (Pottenstein, NE. Bavaria). Wolf: no. 315 A. Fantastic or zoologically uncertain animals: Bittel pl. 1, c 4 (Mörsingen); Dolgozatok pl. 39, 1. The Ticino brooches with insect-like creatures (Ulrich pl. 20, 1 and 33, 10) seem to belong to a later phase.

[7] No. 315; see p. 43.

[8] Compare also: Pl. 218, d (Monsheim); PZ 24 1933, 131 fig. 8 no. 12 (Emhof, NE. Bavaria), in style near the fibula from Hausbergen no. 296; AuhV 5 pl. 20 no. 320 (Riekofen, Oberpfalz); Schránil pl. 45 no. 2; Reinecke 73 fig. 4 (Chejnow). For the important fibula from Kyšicky I have to refer to the insufficient reproductions Déchelette figs. 287 and 533, 3; Reinecke 73 fig. 3.

It is not difficult to see that these brooches are the product of a few inter-connected workshops.[1]

Nos. 322 ff. are of later date than the preceding brooches. Many of them come from Münsingen—'Münsingen fibulae' would be an appropriate name for the class—or sites near by, some from Germany (nos. 322, 324, 325–7, 344), the silver brooch no. 324 A from Carniola, others from France, Bohemia, and Hungary.[2] I show a relatively large number of them because of their importance for the ornament of the Waldalgesheim Style. The bow of these fibulae, wholly covered with well thought-out relief ornament, is constructed symmetrically: but this is counterbalanced by the foot-finials, large, coral-inlaid disks, which swing back towards the bow and touch it.

The last fibulae in my series illustrate some variants of interest. The accent of the decoration shifts from the bow, now left plain, to the large coral disks: nos. 343–5, which the Hungarian brooch no. 346, and its pendant AuhV 5 pl. 20 no. 346, imitate in bronze.[3] The process finally leads to the total disappearance of the fibula proper: it atrophies and hides on the back of a disk, which has a precious decoration of gold, or gold and coral (nos. 348, 349); in one piece there is amber as well as gold and coral.[4]

MATERIAL AND TECHNIQUE

I append a few remarks summing up observations made in the descriptions of the objects figured.

For *textiles* see p. 111.

Wood. I do not propose to speak of sculpture in wood, which certainly existed, but is not preserved, nor of speculations whether it had an influence on sculpture in stone. The wood in the tombs has perished by the tooth of time, save tiny fragments, especially of chariot-parts; in one case larger portions of a wooden vessel survive—the spout-flagon no. 395. As a rule, just the bronze mountings of wooden implements remain: no. 401, or the bronze strips of a helmet no. 134 *a* 1, which has a pendant in the Ticino cemeteries, Ulrich 433; Germania 20 1936, 102, and, of different shape, in Carniola: Treasures p. 116, no. 133. Conditions at La Tène were more favourable: we have the yokes no. 172 and the wooden vases Vouga pl. 29. The wood in the Waldgallscheid grave (see p. 181) was partly ash, partly a kind of maple, either *Acer campestre* Linn. or *Acer pseudoplatanus* Linn. Analysis of wood in the Ticino graves: Ulrich 43.

On analysis of Celtic *leather* see to no. 153, *l.* The leather strap preserved with the clasp no. 357 is probably ornamented: interesting specimens of patterned leather are figured in Habert, Cat. du Musée arch. de Reims (1901) pl. 3, p. 85, but I feel uncertain about their period.

[1] The fibula from Ostheim (Rhön), no. 315, has an unpublished pendant in Frankfort, Inv. X, 4284: it was purchased from the Milani Collection, together with the Bronze Age sword AuhV 3, 8 pl. 1, 1 (Behrens, Bronzezeit Süddeutschlands 84 no. 109), which was found at Eschwege (Rhön): possibly the fibula has the same provenience: Eschwege is not far from Ostheim.

[2] For the full material from Münsingen see Wiedmer-Stern; a few pieces in AuhV 5, p. 335. Related: Haguenau, Schaeffer figs. 21, a; 70; Swiss brooches: Viollier pls. 2 ff. A brooch from Dürrnberg in Salzburg: Mitt. Anthrop. Gesellschaft Wien 1929, 173 fig. 10, 8. For Hungary see Márton pl. 5, 3 and pl. 7, 8; Dolgozatok pl. 34, 3.

[3] Compare BM EIA fig. 62 (Pleurs); CIA 1874, 421 (Grand-Serenne, Basses-Alpes). On the style of the Hungarian brooches see pp. 101; 132.

[4] The type has been dealt with by Henry, Les tumulus du département de la Côte d'Or 83, where she adds the fibula RA 1899, I, 376, 'Marne' (Saint-Germain no. 18070), and in fig. 33 illustrates a piece from Mauvilly. The fibula from Saint-Sulpice, tomb 48, in Lausanne, is described on pp. 131 and 132. Diameter of the plaque (without spikes and coral studs) 3·5 cm., bronze cast, 0·2 cm. thick; the pattern is embossed in the bronze and a gold sheet hammered on (see p. 131). In the centre, a bronze pin, still holding a conical piece of amber (diameter 1·3 cm., height 0·5 cm.); there was a coral stud on top of it, now lost. Round the edge, 23 corals—some missing—on bronze spikes. Soldered on the back a tiny fibula: its foot has a coral stud on each side.

Stone. The material used is local lime- or sandstone, once (no. 10) basalt-lava. The technique is poor. It is obvious that the mason who made the pillar from Pfalzfeld, no. 11, was unable to give it a regular shape and was not familiar with architecture in stone. The Januses from Holzgerlingen, no. 13, and Heidelberg, no. 14, are also rough work, the menhir from Waldenbuch, no. 15, shows more skill. In Provence technique is higher and reflects Greek influence and teaching; there are marks of chisel (no traces of drill); the remains of colour on nos. 1, 2, 3, 4, and 6 are not really a particular characteristic of these works, for the sculptures from Germany also were certainly coloured.

In *casting* and *embossing bronze* the Celtic craftsmen were not inferior to average Southern or Eastern metal-workers; besides, they could rely on a respectable Hallstatt tradition in the North:[1] it is instructive to compare La Tène and Hallstatt chariots.[2] *Compasses* were in general use,[3] also the *turn-table*.[4] The technique of *soldering* was perfect: there is hardly ever a visible joint, except on the tinkered jugs from the Alpine backwaters of the Ticino valley, no. 393. In some cases the Celts, instead of solid bronze casting, put a thin embossed bronze *veneer* on an iron core.[5] Combination of wood and bronze is a common technique.[6]

Iron embossed is rare: it becomes increasingly common for scabbards in Switzerland and Hungary.

Precious metals. Silver. I show only a few objects: nos. 60, 84–7, 324 A, 331. Switzerland,[7] Eastern France,[8] North Italy[9] were the regions where the Celts made silver jewels, and a certain number come from the East.[10] In the North silver is very rare: there are two little silver chains from the Klein Aspergle grave, AuhV 3, 12 pl. 5 fig. 6; JL 31, and of later date those of the Nauheim 'Silenus' no. 369.

Gold. For the wealth of the Celts in gold and its origin there is literary evidence: Posidonius apud Athen. 6, 233, d, e; Diodorus 5, 27; Strabo 7, 2, 2 (Jacoby, FGrHist iiA, pp. 241, 254, 303).[11] Analysis cannot ascertain the provenience of gold, but only its composition. I have the following assays at my disposal:[12]

	Au %	*Ag* %	*Cu* %
(1) No. 55, bracelet, from Waldalgesheim	97·719	1·628	0·651
(2) No. 26 (Waldgallscheid)	80	13	under 7
(3) From a grave at Wallerfangen	80	over 13	under 7
(4) No. 68, bracelet, from Lasgraïsses	75·5	24·5	

[1] Reinecke in AuhV 5, 149; see p. 158.

[2] p. 120. [3] See nos. 397, 401, and others.

[4] Pernice in Oe J 8 1905, 51; Dehn in Trierer Zeitschrift 10 1935, 37. See nos. 153, *g*, 156, *a*, 178, 181–4, 187, and often in matrices which now lack inlay.

[5] Nos. 156, *g*, 157 (probably also 158), 159, 163, 165. No. 165 and no. 201 have the templet coarsely modelled on the iron core. Iron scabbards with ornamented bronze plaques: nos. 91, 93. Embossed bronze strips on iron helmets: nos. 141, 143–6.

[6] Vessels, &c.: nos. 389 (stopper), 395, 401. Helmet: no. 134 *a*, 'mosaic' of iron and bronze plaques in wood of chariot-parts from Käerlich, Germania 18 1934, pl. 1, 1–5, p. 10. See above p. 74.

[7] Here nos. 60, 86, 331. See Ulrich passim. Silver bracelets from the Valais in Zurich.

[8] No. 85. On the silver torc from Mâcon with animal heads as finials see above p. 123 n. 1.

[9] Nos. 84, 134 (*a*). Bianchetti Ornavasso, passim.

[10] Déchelette 1349; Gössler, Trichtingen, passim; Archaeologia 69, 128; Pink, Die Münzprägung der Ostkelten und ihrer Nachbarn (Dissertationes Pannonicae ser. 2 fasc. 15) 127.

[11] Trüdinger, Studien zur Geschichte der griechisch-römischen Ethnographie 90 ff.; Déchelette 1345. Important authentic information on large quantities of gold in rivulets in the Hunsrück mountains—a veritable central area of chieftain-graves—in Aus'm Weerth 29, note 2. On gold mines in France see Blanchet 31 ff.

[12] I am indebted for analysis of (1) to the Deutsche Gold- und Silber-Scheide-Anstalt, Frankfort on Main, of (2) and (3) to Professor Gerlach, Director of the Physical Institute of the University of Munich. Analysis of (4), quoted by Déchelette 1339, 3, was made in the École des Mines in Paris. Professor Gerlach, at my request, also analysed gold from Dürkheim and Rodenbach, but he could only inform me at the eleventh hour that its composition was purer than that of (2) and (3): after 1935 our correspondence was cut off by *force majeure*.

An interesting comparison is with Scythian gold, which is remarkably less pure: the gold stag from Tápiószentmárton (Arch. Hung. 3 pl. 7) contains gold 46·98 per cent., silver 51·17 per cent., copper 1·63 per cent., iron 0·03 per cent. (Jahrbuch der Ungar. Archaeolog. Gesellschaft 2 1926, 278). Ancient writers tell us of showy, heavy solid-cast gold torcs,[1] but the torcs and other gold jewels which have come down to us in the graves are comparatively flimsy and consist of gold sheets of medium thickness with a lining or on a core of base metal or other substance. Torc no. 41 has a filling of putty, no. 42 of soft lead, as proved by analysis, in other cases the weight of the objects, or probing, suggests the same.[2] The lead coils forming part of the Sefferweich hoard (Dehn, Trierer Zeitschrift 10 1935, 39 fig. 8, m) were most probably destined to fill gold rings. No. 70, according to Couhaire's statement, had inside a viscous substance and an iron core. No. 61 has the mouthpiece reinforced by the bronze device shown in the text p. 171. Nos. 16, 17, 19, 20, 21 mount the gold sheet on bronze, no. 22 on iron:[3] nos. 19, 20, 23, 140, 349, and a pendant of no. 349, a brooch from St. Sulpice, tomb 48 (ASA 1914, 269; 1915 pl. 1, 4, p. 7; Viollier p. 130) have the pattern embossed on the bronze templet and the gold hammered on it. The bronze pins fastening the corals of torc no. 226 have also gold foil hammered on them; the gold of brooch no. 348 has a layer of bitumen underneath; no. 34 (27) is the wooden (?) core of one of the gold heads of the find, and the gold hemispheres no. 38 were possibly once connected one and one on a wooden globe.

Marks of the *goldsmith's hammer* are frequent, the trace of the *turn-table* is to be seen on the terminals of the torcs nos. 43 and 44. An exception is the technique of the finger-ring no. 72: for the pattern does not appear on the back, so the ring was not beaten but cast.

Most gold works, especially torcs, bracelets, and finger-rings, are wrought with great skill and care; flaws are rare: in the torc from Dürkheim, no. 42, and the bracelet from Zerf, no. 53, the decoration along the ridge is unfinished and only scribed in places.

It is worth noticing the negative fact that the Celts do not practise granulation as the Etruscans did so skilfully: bead-rows are always hammered out of gold wire.

Combination of materials. The silver bracelets no. 60 have a gold catch, the silver finger-ring no. 86 a gold foil on the bezel. A gold band adorns the bronze helmet no. 140, and possibly adorned no. 143. The fragile openwork no. 28 was possibly fastened on wood or leather; the tiny gold plaques from Klein Aspergle, no. 32, partly on leather or textiles; some of them are still fixed on the Greek cups. Combination of metal (tin and bronze) and clay was practised in Late Bronze Age and Early Hallstatt pottery from Swiss Lake-dwellings;[4] well known are the Este III pots decorated with nails.[5] The gold net no. 18 was laid on a cup either of clay or wood, and the same is probably true of the gold rim and plaques no. 33.

Inlay. Amber had been the great fashion of the previous age in South, East,[6] and North. The Celts very rarely use it to decorate metal, apparently because they preferred the

[1] Gössler, Trichtingen 27.

[2] Nos. 39, 44, 58, and others. Bronze rings are sometimes filled with wood: BM EIA 63; two bronze armlets from Münsingen in Bern have a core of vine-wood (information from Professor Tschumi).

[3] The same practice in Hallstatt: AuhV 5 text 149.

[4] Ebert 14, 537; Déchelette 388. Lead figurines laid on clay vases from Rosegg (Carinthia), Ebert 11 pl. 32, a, p. 156.

[5] Montelius pls. 58, 7; 59, 17; Duhn 2 pl. 10, b.

[6] Kelermes, Borovka pl. 12; Dalton p. lviii; AA 20 1905, 58; Rostovtzeff IG pl. 9, 2; Ebert 3 pl. 7, a; PZ 18 1927, 81.

effect of red on bronze and gold. I know the following examples: the amber disk on no. 21 with an engraved ornament (*P 2*), recalling an engraved amber plaque from Jezerine, which was found in association with an early LT brooch (Wissensch. Mitteil. aus Bosnien und der Herzegowina 3 fig. 100); an unpublished object in Saint-Germain, no. 13135—a bronze ring of about 2–3 cm. diameter with a convex amber, bearing an engraved concave-sided quadrilateral; the disk-brooch just quoted, from Saint-Sulpice, grave 48, which has an amber cone as centre and on top of it a coral, a combination of material also shown by a pin from Hundersingen, AuhV 5 pl. 27 no. 474.[1]

Coral.[2] There is incredible confusion of coral and enamel in catalogues and even in special studies: in point of fact it is always possible and even easy to tell the one from the other without complicated physical methods,[3] and I have never handled an object where there could be any doubt. Another inveterate mistake was that the Celts first used coral only, and later enamel as a substitute when through increasing demand for coral in India it became scarce in Europe. The truth is[4] that coral was more frequent, but that from the beginning both materials were used and occasionally in the same objects. The coral has mostly bleached and has become brittle and cracky, but sometimes it preserves its original glossy red surface. It was cut in little plaques or little balls, the limits of size being given by the small dimensions of the utilizable stem of a coral tree: only the lumps used for decoration of no. 202 are of larger size, the objects certainly being a rarity and precious. Coral balls are used as finials of the spring-backing of fibulae, nos. 292, 310, 326, on spikes round the circular plaque of disk-brooches, no. 348, and their pendant from Saint-Sulpice,[5] often as eyes of birds (the plates show several examples), as eyes of human heads in nos. 201, 381, *pl. 218, d*, and otherwise. Square plaques in sockets occur in nos. 171, 350, 381. The Celts used also to cut curved plaques and sometimes made floral or other ornaments of them: nos. 101, 201, 228, 238, 294, 306, 340, 350, 381, probably 153, *b*. The brooch no. 342 is covered all round with oblong plaques, coarsely ornamented with circular depressions. The corals were fixed either by pinching them into sockets, or by pins, which often have ornamented heads, or by means of putty or bitumen, especially where the distance of the coral from the bottom, resulting from the curve of the object, requires a bedding: nos. 101, 186, 290, &c. In the early phase the corals have a plain surface and their only effect is their red colour: if, very exceptionally, they are carved, carving is confined to notches (torc no. 226). In the later fourth century B.C. the fashion changes, the corals are no longer inlay, but 'uplay', protruding above the surface, often in tiers, and are seldom plain: all this is well illustrated in the plates. Besides notches, chevrons (no. 344), concave-sided triangles (no. 344), quadrilaterals (no. 335 (?) and Morel pl. 27, 3), now wave tendrils (no. 334), astragaloi (no. 202 (*b*), and even highly elaborate ornaments of the Waldalgesheim Style are carved in coral (no. 202 (*c*).[6] It looks as if the Hungarian bronze fibula no. 346 and its pendant AuhV 5 pl. 20 no. 346 were cheaper

[1] Behn, Propylaeen Weltgeschichte, Das Erwachen der Menschheit 166 speaks of pearls used by the Celts: on this as far as I know, the archaeological record is absolutely silent.

[2] Déchelette 1331, 1548; Ebert 7, 47; RE s.v. 'Koralle'; Daremberg-Saglio s.v. 'corallium'.

[3] S. Reinach, Revue celtique 20 1899, 20 says that without application of 'certain technical methods' it is often impossible to distinguish coral from certain 'pâtes vitreuses': I have never seen any such substance used by the Celts.

[4] Recently pointed out by Henry, Préhistoire 2, 71. She

herself wrongly describes the inlay of nos. 101 and 350 as coral and 'émail champlevé': there is definitely no enamel in these objects.

[5] See above pp. 129 n. 4; 131.

[6] A coral pendant, 2·4 cm. long, with a carved spiral design, was found at Montlaurès: Héléna, Les origines de Narbonne fig. 165. A fibula from Münsingen, tomb 86, Wiedmer-Stern pl. 12, 4; Viollier pl. 3 no. 117 has on the bow a coral with a carved rope pattern; see p. 71.

substitutes for precious coral-decorated pieces, or at least expressed the same taste in other material.

Coral incrustation is an invention of the Celts, unknown to all the peoples whose arts had an influence on them.[1]

Expert analysis of Celtic coral has not succeeded in detecting its origin. Pliny, N.H. 32. 21 mentions coral from Drepanum in Sicily, the Aeolian islands (Lipari), Naples, Graviscae (Etruria), and the Stoichades (Hyères, Provence). The route of the coral trade was certainly the same as that of other Southern imports: coral in Late Hallstatt and La Tène times most likely came to the Celts from Italy through the Etruscan agents who were the importers of Italian bronzes and Greek pottery and probably wine and ore.[2] I do not even believe that in the La Tène period Champagne bought Stoichades coral via Marseilles.[3]

It is probable, though beyond proof, that coral inlay, like the more or less shapeless coral amulets in the graves, had a magic meaning: the coral stud attached to the footstand of the Lorraine flagons, no. 381, and not meant to be seen, looks very much like a charm.

Enamel.[4] Early Celtic art uses red enamel only. The red has invariably faded, but if moistened it regains its original bright colour. Its application is twofold: either as inlay or uplay.

Inlay: the liquid enamel is poured into rectangular slots in the bronze, and after congelation is ground down level with the surface of the bronze. There are the following examples of larger spaces with enamel filling of this kind: helmet no. 140 (lower zone and neck-guard), fair-lead no. 156, *b* (enamel not preserved), no. 185, no. 381 (stopper); and the long grooves of no. 155, *a* and *d*, where only the resinous bedding remains (see text), were certainly enamelled. The Celts gave the enamel a bedding, especially when owing to the curved shape of the object the distance between bottom and surface was great: nos. 156, *b*, 185, 186, 381. More frequently narrow grooves or circular holes are filled with enamel. Traces of such decoration are preserved or assumed with certainty in the following objects: nos. 162, 168, 224, 229, 234, 236, 308, 316, 381.[5]

Uplay: bumps, mostly with a depression on top, profiled, in tiers, radially notched, fastened in matrices, or without them by pins in the centre: nos. 140, 228, 237, 329— to speak only of cases where the bumps are preserved. Enamel *and* coral is—or was—to be seen in nos. 156, *b*, 186, 228, 381.

Of the two manners in which enamel is used groove-enamel comes first; the uplays are but a clever—and possibly cheaper—substitute for corals, without, as far as my knowledge goes, a model or analogy in the arts of other peoples. The inlay technique has its model in

[1] Unique are the gold jewels with coral and turquoise inlay from Novocherkask, Borovka pls. 37, 38; Rostovtzeff IG pl. 26, AS pl. 14, p. 49, SB 577: their date is controversial, but at any rate they are later than Early Celtic art. A list of doubtful examples of coral inlay in the East was given by Reinach l.c. 22. No Greek example is known to me; what Pindar, Nem. 7, 116 had in mind is an unsolved problem, the scholiast thought of coral. There are coral trees in Greek sanctuaries, apparently dedicated to the god as θαυμάσια: one from the Samian Heraeum is in the Vathy Museum (as Th. Wiegand informed me, unstratified); another from Megara Hyblaea, Ebert 7, 48 (Duhn). For the picture of a coral tree in the Vienna Dioskourides see JdI 51 1936, 133.

Though I do not deal here with coral amulets, I should like to mention the presence of shapeless pieces of coral in excavations in Provence: Saint-Jean, Marseilles: Clerc, Massalia i, 287. Ensérune: Mon. Piot 27, 52. Montlaurès: according to information from the late Professor Rouzaud several pieces were found together with a vase of the twenties of the fifth century, the Amazon cup of the Marlay painter, Compte rendu de l'Académie des Inscriptions 1909, 993, BARV 769, 56. Of these three finds only the first should be non-Celtic.

[2] p. 142.

[3] This was the view of Reinach l.c. 221 and Déchelette 876.

[4] Henry, Préhistoire 2, 65 ff.: the chief concern of the paper is the later period of Celtic art.

[5] Close examination of the flagon from Borscher Au in Jena, no. 383, will probably prove the same.

the enamel-filled bronzes from the Koban;[1] on other connexions of the Celts with the Caucasus see pp. 83; 159–60.

The liking for polychromy, the application of red enamel to bronze and of corals to gold and bronze is definitely among the Oriental features of Early Celtic art.[2]

[1] Tenesheva, Enamel and Incrustation (text in Russian), Seminarium Kondakovianum, Prague 1930; ESA 5, 141; von Jenny in Bossert 4, 16, 17. Enamelling in other civilizations with which the Celts were in contact is so sporadic and so different in application that none of them can possibly have influenced Celtic crafts. Scythia: see Ebert 13, 80; Borovka on pl. 12: inlay in eyes and nostrils of the Kelermes lioness; Rostovtzeff IG 57 ff., 236, no. 8. Greece and Etruria: BMC Jewellery p. lvi; Payne, NC 96, 1. What the inlay of Olympia, Bronzen 848 and 925 really was, is hard to say. War prevented me from examining the originals in the BM mentioned by Marshall in BMC l.c. But they are gold, and the Celts do not apply enamel to gold. And the enamel on these jewels is not red, but white, green, and blue. Persia: I have not examined the traces of inlay in the objects from the Oxus find or in related jewels, but there also the combination of materials, gold and enamel—if there is enamel—would differ from the Celtic practice.

[2] Dalton, Archaeologia 58, 237; Zahn, Sammlung L. v. Gans, on no. 92.

CHAPTER 5

CHRONOLOGY

FOR generations prehistory has established a chronology of Celtic civilization by a method always applied to arts which lack the evidence of writing and literature and where, for absolute dates, one has to rely on pegs provided by imports from civilizations with a well-established chronology, or on exports found abroad, stratified and associated with datable objects. The dates were taken from Italian or Greek works found in the Celtic tombs. In the preceding pages I have deliberately ignored the imports, and have tried to see what the Celtic works themselves tell us about their dates. It was possible to establish three phases: (1) The Early Style, based on a sub-archaic stratum of Southern forms. (2) The Waldalgesheim Style, reflecting certain classical fourth-century motives. (3) The Plastic Style and the Sword Style, which continue and develop the Waldalgesheim Style. Of these only the second bears a clear time-mark: the first style must be earlier, and the third styles later than it.

These results must be checked by study of the associated imports. There is, as far as I know, no import or other dated object associated with a work of the third period: for the tomb at Mezek was not intact,[1] and the find from Frasnes-lez-Buissenal, containing fifty-two gold coins of the Morini and Nervii and the gold rings no. 70, is a hoard: the rings are works of the third or second century B.C.[2] and the coins were struck in the second quarter of the first century B.C.[3] For the two other phases we have numerous valuable pegs, Southern imports in Northern tombs and, so to speak, Celtic imports in Celtic burials in Italy and the Celtiberian region of France: here only weapons and certain other implements are Celtic, and the majority of the objects in the tombs are classical.

I begin with a list of graves in the North which contain Celtic works together with Southern imports.[4]

GERMANY

Ameis-Siesbach no. 95: beak-flagon.
Armsheim parts of a chariot (p. 120): beak-flagon no. 386 (*b*) and basin.
Besseringen nos. 41, 155: beak-flagon.
Dürkheim nos. 27, 28, 42, 57, 165, 166, 397: beak-flagon, tripod, and stamnos (*pl. 253, a*).
Ferschweiler no. 30: beaker[5] (*pl. 254, c*).
Horhausen nos. 51, 154: beak-flagon.
Kaerlich nos. 33, 167, 170: beak-flagon.
Klein Aspergle nos. 16, 17, 22, 23, 32, 385: stamnos (*pl. 220, a*), ribbon-cista, Attic cups.
Remmesweiler-Urexweiler no. 31: beak-flagon.
Rodenbach nos. 59, 72, 357: beak-flagon, basins, pilgrim-flask (*pls. 254–5*), Attic kantharos.
Schwarzenbach A no. 58: beak-flagon.
Schwarzenbach B nos. 18, 34: beak-flagon, Greek bronze amphora.
Waldalgesheim nos. 43, 54, 55, 156, 247, 387: Campanian bronze situla, no. 156, *h*.
Waldgallscheid nos. 26, 29, 50, 153: beak-flagon.

[1] p. 151.
[2] p. 99.
[3] Blanchet 605, no. 279. Fig. 300: Morini; figs. 305–6: Nervii. As Dr. Pink points out to me, the inferior quality of the gold and the style suggest the late date given above.

[4] I refer to Langsdorff's detailed catalogue in JL, and for imported pottery to my lists in Germania 18 1934, 14 ff.
[5] The beaker was found at Ferschweiler, but I am not absolutely certain if in the same grave as the gold: circumstances prevented me from inquiring.

Weisskirchen A nos. 20, 100, 101, 290, 317, 350: beak-flagon no. 386 (*a*).
Weisskirchen B no. 98: beak-flagon, stamnos, Etruscan gold band (*pl. 254, d*).
Zerf nos. 53, 73, 301: beak-flagon, basin.

BELGIUM

Eygenbilsen nos. 24, 390: beak-flagon, ribbon-cista.

FRANCE

Basse-Yutz or Niederjeutz (Lorraine) no. 381: two stamnoi (*pl. 253, b, c*).
La Gorge-Meillet nos. 135, 157, 196, 197, 199: beak-flagon.
Marson nos. 83, 93, 413: the earrings no. 83 are exactly like those from Hradiste, district of Pisek, which
 are associated with a beak-flagon, JL 32 (Ebert 2 pl. 46).
La Motte-Saint-Valentin nos. 355 (*c*), 374: stamnos, Attic kantharos.
Somme-Bionne nos. 25, 94, 169, 180, 192, 195, 359: beak-flagon, Attic cup.

SWITZERLAND

Grauholz no. 38: ribbon-cista.
Grossholz ob Ins (Anet) nos. 35, 36, 37: ribbon-cista, Etruscan granulated bead (*pl. 32*).

BOHEMIA

Chlum gold ornament,[1] *P 392*: beak-flagon and basins.

There are also Etruscan beak-flagons from the Celtic graves on the Ticino, but they are
of little value for giving these intricate tombs an absolute date.[2]

Among the imports the Attic vases are the best-dated works. The priestess cup from
Klein Aspergle *pl. 26*, a second-rate piece, was painted about 450 B.C., and the plain cup from
the tomb, *pls. 26, 27*, is contemporary. The cup from Somme-Bionne, Morel pl. 9, 1; JL
pl. 34, a, is a bad and ugly work of the twenties of the fifth century B.C. The scale-kantharoi
from Rodenbach and La Motte-Saint-Valentin can be dated about 450 B.C.[3]

More frequent than pottery are bronze vessels, almost all of them Etruscan. There are
the following types.

(1) *Beak-flagons* are, as the list shows, by far the most numerous vessels in the Celtic
graves. They were made in the first half of the fifth century B.C. in an Etruscan workshop,
which was either at Vulci, or situated elsewhere but closely connected with the Vulcentine
bronze industry.

(2) *Stamnoi*. The stamnos from Dürkheim (*pl. 253, a*) is the most ornate of them: it has
plastic handle-attachments, two youths with a wing at one foot sitting side-saddle on a sea-
horse.[4] This stamnos was made in the early years of the second quarter of the fifth century
B.C., in the same workshop from which the tripod found in the same grave came, probably
at Vulci. The stamnoi, as a rule, have handle-plaques of the type shown in *pl. 220*, more
rarely, leaf-shaped as those of the two stamnoi from the Lorraine tomb,[5] *pl. 253, b, c*, or

[1] p. 92. [2] p. 109.
[3] JL 62. Rodenbach kantharos: AuhV 3, 5 pl. 1; Linden-
schmit pl. 43, 8; Sprater fig. 126; Déchelette, Collection
Millon fig. 19; Ebert 11 pl. 29, b; JL pl. 40, a; Bassermann-
Jordan, Geschichte des Weinbaus[2] fig. 91. Kantharos from
La Motte-Saint-Valentin: Déchelette l.c. pl. 31.
[4] Sprater fig. 123; Ebert 2 pl. 215, 8, 9; Déchelette fig. 437;
JL 22. Part of the handles in Budapest. On sea-horses as
handle-ornament see Jacobsthal, Ornamente 116, note 200,

and Jantzen, AM 63/4 1938/9, 151, 1; on this manner of
sitting on horses, Haspels 54, footnote, where the handles are
erroneously described as forming part of the tripod from the
grave.
[5] Archaeologia 79 1929 pl. 1; Die Antike 10 1934 pl. 6.
The stamnos *pl. 253, c*, is 41·3 cm. high, the other, *pl. 253, b*,
37·2 cm. Both have a little depression in the centre of the
slightly concave under-surface of the foot-stand: see Pernice,
Oe J 8 1905, 53 note 7.

Karlsruhe, Schumacher no. 619. The two Lorraine stamnoi well illustrate the two extremes of shape: *pl. 253, b*, has a very short neck, a horizontal shoulder, a concave-curved body, and a marked foot-stand; the other, *pl. 253, c*, rises with the body directly from the ground, has convex contours and a roundish unbroken shoulder: there are many transitions between the extremes. Of the two types the first appealed more to Celtic taste, as is shown by comparison with the Lorraine flagons, no. 381, the Salzburg flagon, no. 382, the clay jug no. 406, or the clay urn from Mesnil-les-Hurlus, no. 409. There is possibly another reflection of this type, the vessel standing on the ground in the frieze of the Venetian situla in Providence, *pl. 254, a*:[1] a Celtic vase represented in an Este picture is not surprising, since Venetian and Celtic civilization and arts are connected.[2] In point of fact, the vase is not the representation of a stamnos proper, but of a 'stamnos-situla', which was a very frequent Etruscan type: it lacks horizontal handles, but often has two movable handles on top. A study of stamnoi would be incomplete without a study of stamnos-situlae.

The stamnoi in Celtic graves are Etruscan, but their models were Italiote. Strangely enough, no Greek bronze stamnos seems to have come down to us, either in Greece proper or in Magna Graecia: in Campania, however, there is the Paestan wall-painting with two gold stamnoi, Annali 1865 pl. N, p. 330; JdI 24 1909, 116 no. 30, p. 130. For a history of the stamnos one has to rely on pottery. In Attica, from the end of the sixth century B.C. to the twenties of the fifth, two shapes were made: the more common of these is well illustrated by Richter and Milne, Shapes and Names of Athenian Vases figs. 64–8, and by Langlotz, Frühgriechische Bildhauerschulen pl. 14: thick-set or slender, the body tapering downwards, set on a projecting, more or less richly profiled foot-plaque. The less frequent type, from the times of the Kleophrades painter and the Berlin painter down to the Kleophon painter,[3] lacks a pedestal and rises directly, or with a slightly set-off torus, from the ground: hence a different body-curve results, occasionally slightly concave and resembling that of the Etruscan vessels. This was the shape which the Greeks in Italy carried on when in mainland Greece the stamnos went out of fashion. There are the following examples of Italiote clay stamnoi. (*a*) Boston, Trendall, Frühitaliotische Vasen pl. 23, p. 40 no. 52; last quarter of the fifth century B.C. (*b*) CdM, de Ridder 949, Giraudon 8132; fourth century B.C. (*c*) Taranto, unpublished, noticed by Beazley: A, seated youth and woman; B, seated woman and youth; contemporary with (*b*). (*d*) 'Gnathia', Tillyard, Hope Vases 337 pl. 43; later fourth century. The piece in Naples, Trendall l.c. p. 38, no. 260, a late work of the Dolon painter, is not a stamnos proper, but a cross-breed of a nestoris and a stamnos. The stamnoi in the Paestan fresco are of the normal Attic type, which otherwise does not occur in Southern Italy, although it does in Etruria: there are clay stamnoi of the latest fifth and of the fourth century, deriving from Attic: Giglioli pl. 249, 4, 5; pls. 274, 1, 2; 276, 2–4; Ducati, Studi etruschi 8 pl. 29, p. 119; CVA Villa Giulia 1, IV B r pl. 1–4 (Italia 37–40) and 2, IV B t pl. 1–4 (Italia 93–6) (dated too late in the text); Beazley and Magi, Raccolta Guglielmi pl. 33 no. 113; see also New York, Richter, Etruscan Art fig. 140.

The Etruscan bronze stamnoi, as the ornamentation of their handle-plaques shows, were

[1] p. 108, n. 6.

[2] p. 160.

[3] Beazley was kind enough to give me this list: (1) Kleophrades painter, BARV 125, 49. (2) Kleophrades painter, 125, 56. (3) Berlin painter, 139, 125. (4) Hermonax, 318, 18. (5) Triptolemos painter, 239, 2. (6) Troilos painter, 190, 5. (7) Troilos painter, 190, 6. (8) Troilos painter, 190, 8. (9) BM E 439, CV pl. 19, 3. (10) Oreithyia painter, BARV 325, 3. (11) Persephone painter, 652, 4. (12) Christie painter, Copenhagen, 693, 28. (13) Christie painter, Harvard, 693, 29. (14) Group of Polygnotos, 695, 2. (15) Guglielmi painter, 703, 1. (16)–(20) Kleophon painter, 784, 1, 2, 5, 6, 7.

made in the second quarter of the fifth century B.C. They often appear in Italian tombs together with other typical Etruscan bronze vessels of the same period. Populonia, Ducati pl. 142 fig. 369, p. 339 note 51. Bologna, Ducati, Dedalo 9, 323 ff.: with bronzes and Attic vases of the third quarter of the fifth century, a volute-krater by the Niobid painter, BARV 418, 7, a cup by the Euaion painter, BARV 529, 72, and the cup Bologna 391.

Stamnos-situlae: Spina, tomb 128, Aurigemma pls. 25 and 99; Beazley, JHS 56 1936, 91: bronzes and Attic vases of the third and even the fourth quarter of the fifth century B.C.[1] Certosa, tomb 27, Zannoni pl. 19: bronzes, and rf. cup Bologna 367, time of Pamphaios. Tomb 117, pl. 54: bronzes, rf. cup Bologna 370, about 450 B.C. Tomb 151, pl. 63: bronzes, rf. cup of second quarter. Tomb 154, pl. 64: bronzes, cup Bologna 371, BARV 590, 13, about the sixties or so. At Todi, Mon. Ant. 24, 857, a stamnos-situla seems—the stratification is doubtful—to be associated with the same kind of bronze vessel as elsewhere. At Ca Morta, Como, one was found with a Celtic chariot, Rivista arch. di Como 99/101 1930 pl. 5; AA 45 1930, 380; 46 1931, 630: probably the fibula in the grave would tell more about the date, but the publication quoted was not accessible to me.

The stamnoi, unchanged in shape, last into the fourth century B.C. The piece from Montefortino tomb 8 (Mon. Ant. 9 pl. 4, 8; Montelius pl. 152, 10; Déchelette, Collection Millon, p. 120 fig. 18, 3; Dedalo 13 1933, 276) clearly reveals its late origin by the figures on the handle-plaques, the tendril goddess, here not flanked as usual by lion-griffins but by climbing goats.[2] At Filottrano two almost identical stamnos-situlae, JRAI 67 1937 pl. 21, 1–3, were found in grave 1 and 2, burials of the latest fourth century B.C.: they are either fifth-century works or were made in the fourth from old models. The same is true of the stamnos-situla ib. pl. 24, 1, 2 from grave 2;[3] I do not feel sure about the date of the stamnos-situla with the sea-goats from grave 10, ib. pl. 21, 4. The most ornate stamnos-situla of all, Karlsruhe, Schumacher 632, pls. 9 and 18 (Not. Sc. 1886 pl. 1, p. 41; AA 5 1890, 6; Ducati pl. 214, fig. 527; Dedalo 13 1933, 269, 271), from San Ginesio, is of Etrusco-Campanian style and, I think, of the fourth century B.C., though said to have been found in the same tomb as the oinochoe Karlsruhe, Schumacher 527, pls. 10 and 17 and p. 97 (Not. Sc. l.c., AA l.c. 5), which is about a hundred years older.

In the first half of the fourth century B.C. metal stamnoi were represented in the frescoes of the tomba Golini[4] (Conestabile pl. 11; Montelius pl. 249, 2) and the tomba dell' Orco (Mon. Inst. 9 pl. 15). There is a group of fourth-century painted stamnoi of this shape: see Giglioli pl. 274, 5; AA 19 1904, 54 fig. 7; Ducati pl. 252 fig. 615. The clay stamnos on a stand from Monteriggioni near Volterra, Studi etruschi 2 pl. 31, p. 153, is a faithful copy of a bronze stamnos with a Silenus head on the plaque, but of uncertain date, the objects in the tomb, as Bendinelli states, covering the last three centuries B.C.

(3) *Bronze basins*, either plain or with an engraved Running-Dog pattern all round, handle-less or having two upright handles with leaf-shaped attachments, often occur in Celtic graves,[5]

[1] The two kraters (BARV 696, 23 and 699, 23) of the forties, the cup between them (BARV 729, 67) of the twenties, the four cups with white ivy (right, round the calyx krater) possibly later, also the Etruscan phallos-vase (bottom row).

[2] Möbius pl. 64, a; p. 72; Möbius, AM 51 1926, 117 ff.; L. Curtius, RM 49 1934, 222 ff. A πότνια θηρῶν flanked by two climbing goats occurs on a Syrian ivory of the fourteenth century B.C., Syria 10 1929 pl. 56; Schaeffer, The cuneiform texts of Ras Shamra-Ugarit pl. 16, p. 19; Kunze, AM 60/1

1935/6, 226 note 1; the goddess holding the goats by the hind legs on contemporary gold plaques, Schaeffer l.c. p. 48 fig. 9.

For the other contents of the Filottrano grave see also Dall' Osso 235; for the chronology of the cemeteries of the Senones p. 144.

[3] For the representation see JRS 29 1939, 100.

[4] Kaschnitz-Weinberg, RM 41 1926, 165.

[5] In the list, above, pp. 135–6, I have already mentioned those

mostly as a set of two or three: Déchelette figs. 644–5; JL pl. 28, a, b. The vessels were made in the workshop which produced the beak-flagons.[1] Apart from their frequent association with beak-flagons in Northern tombs the finds in Italy provide a clear date. At Spina a pair of handles was lying in tomb 128: see above, p. 138. The Bologna grave which contained such a basin (Dedalo 9, 343) is well dated to the forties of the fifth century by Attic vases (see above, p. 138).

(4) The *handle from Rodenbach*,[2] *pl. 254, b*, is that of a one-handled pan or strainer, as completely preserved examples show: Museo Gregoriano pl. 12; Giglioli pl. 313, 4; Filottrano, JRAI 67 1937 pl. 24, 3–5. These are of the fourth century B.C., like New York, Richter 727; Karlsruhe, Schumacher 468 pl. 8, 34; Bologna (Phot. Arch. Seminar Marburg 416). The Rodenbach piece has a mid-fifth-century palmette like those of contemporary paunchy oinochoae,[3] one of which was found in the often-quoted grave 128, at Spina, Aurigemma pls. 25 and 99.

(5) The *beaker from Ferschweiler, pl. 254, c*, is 7 cm. high, solid casting, rather heavy; on lip and torus of foot, a pattern of vertical strokes. Traces of the high handle remain—the rabbet filed in the lip, and the rivet, which fixed the lower part of the handle, with the impression of the attachment round it. Vases of similar form, but all less squat, occur in Italy, in association with bronzes of the second quarter of the fifth century B.C.: at Ca Morta (Como), JL 14, with a beak-flagon; at Fraore-San Pancrazio (prov. di Parma), Montelius pl. 98, 1, with a beak-flagon (JL no. 58, p. 14); at Città Castellana, with beak-flagons and an Etruscan patera of the same date: New York, Richter, Bronzes nos. 570–3, 488–90, 578–80. There is one at the Certosa, grave 89, Zannoni pl. 44, 3, p. 174; Montelius pl. 103, 13: the tomb was robbed in antiquity, the tombstone remains, Zannoni pl. 44; Montelius pl. 101, 8; Mon. Ant. 20, 439.

(6) The best and largest Etruscan bronze in the North is the Vulcentine *tripod from Dürkheim*, Sieveking, Antike Metallgeräte pl. 16, JL p. 22.[4] There is another in tomb 128 at Spina: Aurigemma pls. 99, 103; Not. Sc. 1924 pls. 14, 15.

Beside these Etruscan bronzes found in recorded graves together with Celtic works, there are a few *isolated finds* worth mentioning.[5] A very good Etruscan mid-fifth-century work is the pair of handles from Borsdorf in Hesse, Bulle, Der schöne Mensch pl. 90; Kunkel fig. 183.[6] They formed part of a basin: a completely preserved basin of the type was found

from Armsheim, Rodenbach, Zerf, and Chlum. Others come from the following sites: Hermeskeil, JL 23. Loisnitz, Oberpfalz, Déchelette 1600 no. 14. Bohemia: Hořin, Déchelette fig. 644, 3. Hradiste, near Pisek, JL 32, note 1; Ebert 2 pl. 46, 2. France: Bussy-le-Château, Déchelette fig. 644, 2. Han-du-Diable, Saint-Germain no. 4748. Lyon, Saint-Germain, Salle S. Reinach no. 11645 (one handle only).

[1] JL 46, 64.

[2] JL 26; I figure the piece, because the reproductions published are inadequate.

[3] JL pl. 31, a; p. 48, 1.

[4] To the references add Ferri, Arte romana sul Reno fig. 83 a, b.

[5] A mid-fifth-century import in Denmark is the bronze handle with a Silenus head from Langaa: the illustration in Ebert 7 pl. 187, a allows no judgement whether it is Greek or Etruscan.

[6] There are two types of these handles: one, with naked wrest- lers: Borsdorf (see text); Boston, Bulle, Der schöne Mensch, text 179; Pernice, Die hellenistische Kunst in Pompeji 4 pl. 9; Bologna, Palagi 1960, inv. VII, 38, photograph Archaeologisches Seminar Marburg 414–15. The second type, of inferior quality, makes the wrestlers 'Eteokles and Polyneikes', by giving them cuirass and dagger (one of the heroes, for the sake of symmetry, fights with the weapon in the left hand). This type is represented by the basin from Filottrano, cited in the text, and by the following handles: Louvre, de Ridder 2631, pl. 95; BM no. 674, and one in Vienna, to which Beazley drew my attention: Sacken-Kenner, Bronzes pl. 45, 7.

Pernice l.c. 37 takes the basins for Italiote, and Neugebauer, Gnomon 2 1926, 474 and AA 52 1937, 498 has followed him; but in point of fact they are Etruscan (Jacobsthal, Ornamente 185, note 344). The wrestlers were made in the third quarter of the fifth century B.C.: I feel less sure about the date of the Theban brothers.

in the Celtic grave 2 at Filottrano which yielded the gold torc no. 44 (JRAI 67 1937 pl. 20, p. 239; Dedalo 13 1933, 272, 273). Then attachments of stamnos-situlae, with or without the handles preserved: the piece from Schwetzingen in Karlsruhe inv. c 2021, Wagner fig. 177, has analogies at Filottrano, JRAI 67 1937 pl. 21, 4 and pl. 24, 1, 2, and at Todi, Mon. Ant. 24, 857–8. Slightly different are one in Châlons-sur-Marne from the Marne (unpublished) and that of the completely preserved stamnos-situla from Mirkovice, Schránil pl. 44, 5; related, a piece from Meulan, Seine-et-Oise, in Saint-Germain, Salle S. Reinach, no. 8509 (unpublished).

The Celts, rich in gold and skilful goldsmiths themselves, did not buy *Etruscan jewellery* on a large scale: there are two finds from Switzerland, the bead from Grossholz, no. 37, and two pendants from Jegenstorf (Déchelette fig. 379, 1 and p. 1596, no. 3; Ebert 4 pl. 61, no. 36), characteristic examples of Etruscan granulation and not later than the sixth century B.C. Furthermore the ring in Bonn, *pl. 254, d* (Déchelette fig. 439, 7; JL pl. 36, b, p. 28; CAH Plates, 3, pp. 22, 23, no. f), from the grave at Weisskirchen which yielded the chape no. 98. It is made of a paper-thin gold sheet, now partly squashed and mounted on a wax cylinder; height 2·9–3 cm., perimeter 15·7 cm., diameter 4·7 cm.; no joint visible. Too narrow and flimsy for an armlet. Reinecke 74 and de Navarro, CAH l.c. wrongly took it for Celtic. The same seated sphinx, wearing a helmet with horns, is repeated ten times round it: helmeted sphinxes are typically Etruscan[1] (Kukahn, Der griechische Helm 52). The sphinxes have a late-sixth-century look. These are the only pieces that have come down to us. That the Celts had more is suggested by the kinship of the Etruscan jewels *pl. 252, a, b*, with their Celtic imitations, but it is equally possible that not Etruscan jewels, but jewellers, familiar with these forms, were 'imported'.[2]

Of Italic objects other than Etruscan the following were found in Celtic graves.

(1) *Pilgrim-flask from Rodenbach, pls. 254–5.* Restored and surface doctored. Diameter of round 29·4 cm., flask across 5·2 cm. Its separately wrought parts are: (*a*) the side part, one sheet of bronze, the edges turned inside for reinforcement, the plastic midrib hammered out of it; the ends of the sheet overlap and are fastened with two rivets, which are seen in the plate. (*b*) Front and back: the rim catches that of the side part; the central boss and the rings round it are beaten. (*c*) The neck, only in part ancient, has a collar fastened with six rivets. (*d*) The two staples for the strap, their wings hammered flat, each fastened with two rivets; the wings bear simple punched patterns. The rings on front and back and the band along the side part show chevrons, chequers, wave lines, &c., most of them die-stamped. The animals on one side are stags, those on the other have mane and twig-tail: the engraver probably meant stallions.

The flask, in shape and technique, follows Etruscan models[3] of the first half of the seventh century B.C., such as: (*a*) *pl. 255, c*, Tarquinia, Tomba del Guerriero, Mon. Ant. 15, 687 fig. 205; Montelius pl. 289, 6. (*b*) Tarquinia, tomb of 23rd January 1884; Montelius pl. 281, 12. (*c*) Tarquinia, tomb of 8th March 1883; Montelius pl. 282, 13. (*d*) *Pl. 255, d*, Visentium, Mon. Ant. 21, 419 fig. 5. (*e*) Vulci, Mus. Greg. pl. 10; Montelius pl. 377, 3. (*f*) Volterra, Montelius pl. 170, 5. (*d*) and (*e*) both decorate the broadest ring with a

[1] p. 31.

[2] p. 157.

[3] Mingazzini, Vasi della collezione Castellani text 110, no. 331 and Dohan, Italic Tomb-groups in the University Museum (Pennsylvania) 9, no. 2 and 84, left no. 3 give lists of Etruscan bronze and clay flasks of this type, and discuss their Egyptian origin and their analogies in the Eastern Mediterranean. On p. 111, n. 2, I quoted a clay pilgrim-flask from Cumae and referred to Hallo, Altfranzösische Barilia, Repertorium für Kunstwissenschaft 51, 162.

triglyph-metope ornament, and in (*e*) every other metope is filled with a little quadruped of general appearance—the only case of figure decoration in these vessels. There is a difference in shape between the Etruscan flasks, which are strongly convex on both sides, and the Rodenbach one, which is flat.

The actual origin and date of this late descendant of the archaic flasks become clear, as Reinecke, l.c., was the first to see, by comparison with two helmets: *pl. 256, a*, in Florence, from Oppeano near Verona (BPI 4 1878, 105, pl. 6; Zannoni pl. 35, nos. 57–9; Mon. Ant. 10, 111–14; Montelius pl. 49, 2; Bertrand and Reinach, Les Celtes 97; Daremberg-Saglio s.v. 'galea' fig. 3460; Déchelette 769; Lipperheide 123; Ebert 5 pl. 88, b). *Pl. 256, b*, in Berlin, Antiquarium, L. 91, from the Po, near Cremona (AA 20 1905, 26 fig. 15; Neugebauer, Führer Bronzen, p. 16). The patterns are almost the same as in the flask, but the horses and riders, though also suffering from atrophy of limbs, are far from the underfed, bungled beasts on the flask, and the centaur, with his well-rounded contours, stands close to his Etruscan models. The flask is an inferior work of the workshop from which the helmets come. The objects found with the Oppeano helmet, Montelius pl. 49, 1–6, indicate a date Este ii–iii (Duhn, Ebert 9, 197). Helmets of this type are worn by Venetian warriors on the situla Mon. Ant. 10 pl. 3, and there is another link with Este: the centaur with sickle-wings and human forelegs, who grasps the tail of the horse in front of him, recurs on the situla Benvenuti, Mon. Ant. 10, 14 fig. 24; Déchelette fig. 294. Flask and helmets were produced by some local industry in North-east Italy: the Venetian was the most important and successful of these industries, but by no means the only one:[1] they blended Etruscan and belated Villanovan elements. The exact place of the workshop is unknown, the date of helmets and flagons is probably about 500 B.C. The flask is therefore earlier than the other imports in the Rodenbach grave.

(2) The *ribbon-cistae* from Klein Aspergle and Eygenbilsen are also products of an un-localized workshop in North-east Italy: Reinecke, Bronzegefässe der jüngeren Hallstattzeit, Altbayerische Monatsschrift 3, Heft 5, 124 ff.; Ebert 14, 539; Sprockhoff, Zur Handels-geschichte der germanischen Bronzezeit 137. The cistae appear in Late Hallstatt and last into La Tène: in the two graves quoted and at Mercey-sur-Saône (JL 35) they are associated with Southern imports of the first half of the fifth century B.C. In the Certosa di Bologna their association is similar.

(3) The *bucket from Waldalgesheim*, no. 156, *h*, is a Campanian work of the very late fourth century B.C.: Züchner 98. BWP 24. Another of the kind comes from Montefortino[2] tomb 35, Mon. Ant. 9 pl. 11, 8; Montelius pl. 153, 5; Déchelette fig. 646, 2.

To these vessels should be added the following, Italiote, bronzes. The amphora from Schwarzenbach in Berlin, Antiquarium (Neugebauer, Führer Bronzen, p. 78, pl. 27; RM 38/9 1923/4, 365, 432; Ebert 11 pls. 115, 116); for the grave see Baldes-Behrens, Birkenfeld 51. It is a Greek work of South Italy, made in the second quarter of the fifth century B.C.

Though there is no other record of the find beyond the provenience given in AuhV 2, 9 to pl. 2, 2–5, I mention here the girdle-clasps from Edendorf, Hanover, in Hanover: they belong to the Italic fourth-century type dealt with on pp. 147 ff.: they must have formed part of the armour of Celts, like those from Puszta-Orond, Hungary (see p. 148).

I draw the conclusions from my survey of imports in recorded Celtic graves. The situla

[1] Déchelette 769 and other wrongly classify the helmet from Oppeano with the Este works proper.
[2] p. 152.

from Waldalgesheim, no. 156, *h*, alone is of fourth-century date;[1] the other imports are of the first half of the fifth, with the exception of the Attic cup from Somme-Bionne, painted in the twenties, and the two pieces of Etruscan sixth-century jewellery. The bulk is Etruscan bronzework, a few pieces are products of a North-east Italian workshop, and there is a small quantity of Greek pottery and a Greek bronze amphora. All these vessels form part of symposiastic outfit:[2] the wine in them has evaporated, but in some stamnoi resin and pitch, ingredients of retsinato, vino picato, were established by chemical analysis.[3]

There is no longer need to refute the inveterate thesis that these imports reached the Celts via Massilia:[4] they came across the Alps and the importers were the Etruscans. We are ignorant of the organization of Etruscan trade with the North, and it is impossible to know whether they went peddling themselves or sent their agents from Gallia transpadana on this unpleasant journey: the latter is more likely, for why should the Etruscans have troubled to take North such stuff as the pilgrim-flask from Rodenbach? Certainly the export of a few ready-made articles or small quantities of coral,[5] &c., cannot possibly have been profitable, and these were rather the by-product of a trade in other commodities—just as the Chinese and Japanese for a long time only exported products of their handicraft together with tea, the essential merchandise. The actual wares exported in this instance might have been ore and wine. Many a transport of oxen-drawn carts with big wineskins,[6] looking like that on the Roman sarcophagus relief in the Lateran (Benndorf-Schöne 490; Garrucci pl. 32; Daremberg-Saglio, s.v. vinum, fig. 7514; AZ 1861, 151, note 25) may have crossed the Little St. Bernard and the eastern passes of the Alps. What the North paid in return we cannot tell, but it should be borne in mind that there was an important north–south trade on the same routes: before the route across France was opened at the end of the fourth century B.C., tin reached the mouth of the Po, whence the Greeks fetched it, along the Rhine and Ticino.[7]

The almost complete identity of Etruscan bronze vessels at Spina and elsewhere in North Italy[8] with those in Celtic transalpine graves—ladles, candelabra, and some other types are missing in the North—shows that the agents of the bronze factories at Vulci, &c., success-

[1] There is possibly another, which came to my knowledge through the courtesy of Mr. Christopher Hawkes. It is said to have been found at Dalheim, Luxemburg, a globular bronze flask with a long cylindrical neck, complete with stopper and chain: Hawkes compares it with the flask from Montefortino Mon. Ant. 9, 693–4 fig. 23; Dall' Osso 230; Ducati pl. 251 fig. 608, p. 510; it is coarser and now covered with a thick crust, which possibly hides ornamentation. Other fourth-century imports from Italy are the girdle-clasps from Edendorf, Hanover, discussed above.

[2] p. 106.

[3] For the residues in the stamnos from Weisskirchen and in the spout-flagon from Waldalgesheim see Aus'm Weerth 17, 2; BJ 43 1867, 125, and Déchelette, Collection Millon 123; for Klein Aspergle AuhV 3, 12 pl. 6, text: 'leichte zunderartige Masse, welche sich als ein wohlriechendes Harz, wie Myrrhen oder Olibanon erwies'.

[4] I have done this in JL 66 (where 'Grosser Sankt Bernhard' was a misprint for 'Kleiner St. Bernhard') and in Préhistoire 2, 49. Pro Massilia: Furtwängler, AA 4 1889, 43; Reinecke; de Navarro, Antiquity 1928, 423 and 1930, 131. Contra: Willers, Neue Untersuchungen über die römische Bronze-

industrie von Capua &c. 27 who writes: 'Klarheit lässt sich nicht durch aesthetisches Raisonnement über die Anmut oder Geschmacklosigkeit der keltischen Ornamentik gewinnen, noch weniger durch so unschuldige Einfälle, wie sie jüngst geäussert wurden, die La Tènekultur habe sich von Massilia aus über West- und Mitteleuropa verbreitet, also etwa wie die Cholera. Weiter hilft nur eine Methode, die auf sorgfältiger Verarbeitung der einzelnen Gegenstände mit Abbildung der wichtigsten Stücke und einer genauen Fundstatistik beruht.' Schuchhardt, Ebert 3, 162, has gone so far as to take the whole of Celtic art for the result of Eastern, Danubian, influences and to believe that the use of the Greek alphabet in the Helvetian muster-roll (Caesar, B.G. 1, 29) and at Bibracte came to the Celts from the East. [5] p. 133.

[6] Bassermann-Jordan, Geschichte des Weinbaus² 2, 718, 728 on transport of wine in skins over long distances; see also Héron de Villefosse, Le transport du vin dans des outres, in Bull. arch. 1917, 50.

[7] Cary, JHS 44 1924, 166; Wikén, Die Kunde der Hellenen von dem Lande und den Völkern der Apenninhalbinsel bis 300 v. Chr., p. 52.

[8] pp. 138 ff.

fully made the same offer to customers in North Italy and in that Celtic industrial centre which supplied the needs of the chieftains.[1]

What now is the relation between the Celtic objects of Early Style and the imports found in the same tombs?

Works of Early Style are associated with fifth-century imports. At Waldalgesheim, where the imported bucket, no. 156 *h*, and the Celtic objects are of the late fourth century, the spout-flagon, no. 387, definitely a work of Early Style, is a foreign body in the grave: it was apparently in the family for generations before its deposition[2] at the end of the fourth century B.C. In the Weisskirchen tomb A the association of the girdle-hook, no. 350, the brooches, nos. 290, 317, and the gold plaque, no. 20, with the Etruscan beak-flagon is in accordance with the rule, but considering the style of the engraved S-tendrils I wonder if the dagger no. 100 is not somewhat later: if all items in the tomb really belong to one and the same burial, the dagger would give its *terminus ante quem non* and suggest that the bulk of the objects were the property of an old man—or whatever else the explanation may be.

The value of dated imports for the chronology of undated or vaguely dated native works found with them has often been overrated. A Greek vase of this period can be dated within five years or so, an Etruscan bronze within twenty-five years or so. The imports give the *terminus ante quem non* for the burial of which they form part, but the burial may be later. That the journey from Italy to the North caused much delay has often been assumed, but is beyond proof and not even likely.

I choose three examples, the finds from Rodenbach, Klein Aspergle, and Somme-Bionne, and make two assumptions: (*a*) 'Herr von Rodenbach' and 'Herr von Klein Aspergle' bought kantharos and cups, painted at Athens in 450 B.C., in, say, 445 B.C., from their Celtic dealers, drank out of them from their twenty-fifth year to their seventieth, died, and were interred with them in 400 B.C. The analogous figures for 'M. le Comte de Somme-Bionne' and his cup would be: 420, 415, 370 B.C. (*b*) The Etruscan and other imports, manufactured mainly in the first half of the fifth century B.C., were swept northwards by the same expansion of Etruscan trade in the later years of the century, as is sensible in the tombs at Spina, Bologna, &c.: the dates of the burials would be accordingly later, say, 380 and 350 B.C.

The Early Style uses archaic and sub-archaic classical forms: how long these lasted in an outlying civilization is hard to say. The Celtic works of this style may be earlier than the imports associated with them—which is not likely—or they may be later, or they may be contemporary. Only the Lorraine flagons bear a time-mark:[3] the manes of the beasts are shaped as a palmette of a kind which came into existence about 425 B.C., but was not at once in general use and cannot have been copied abroad before, say, the early fourth century B.C. Though this observation is not strong enough to support the thesis that all works in the early manner are as late as these, it is slightly in favour of the second alternative.

Can one draw conclusions from the different state of preservation of the gold jewels as to the interval between their leaving the workshop and being buried? The bracelet from Zerf, no. 53, and that from Schwarzenbach, no. 58, are abraded, and the second was also repaired in antiquity,[4] like nos. 39 and 45. Others look quite fresh. It is an instructive fact that of

[1] p. 157.

[2] The report of a husbandman on the discovery of the grave, Aus'm Weerth 9, cannot be used as an argument for two burials (Behrens, Katalog Bingen, p. 25; Schumacher in Ebert 14, 247).

[3] pp. 38; 89.

[4] Should not the 'case' at the nape point of the torc from Clonmacnois, no. 49, which in shape and technique is without analogy in Celtic art, be an ancient repair of later age? But of which I am unable to say.

the two identical armlets from Waldalgesheim, no. 55, one is much less well preserved than the other: it is possible to buy a pair, wear one and treasure the other. These observations but prove what would naturally be assumed, that in many cases there must have been years between the time when a jewel was made and bought and its deposition in a tomb.

Thus the Southern imports do no more than generally confirm that chronology of Early Celtic art which could be established by study of its classical elements.

I survey the Celtic graves in Southern lands: the majority of objects in these are always classical.

Ensérune is a Celtiberian oppidum, with a cemetery, in the Département Hérault: there the girdle-clasp no. 362 was found in the same grave as the cup by the Jena painter CVA Collection Mouret pls. 1 ff. (BARV 881, 33),[1] painted at Athens about 400 B.C. That provides a date for the pendants of the girdle-hook in the Ticino necropolis, no. 361, and indirectly for the clasps from Hölzelsau, no. 360, and from Este, no. 363.

In *Italy*[2] the most richly furnished Celtic tombs are those of the *Senones* round Ancona, at Montefortino, Filottrano, San Ginesio, Osimo, &c.[3] I have illustrated the following objects from them: gold torc no. 44; gold finger-rings nos. 75, 76; sword no. 103; helmets nos. 146–8, and I have discussed other objects on various pages.[4] In general character these cemeteries differ little from those of other peoples in this part of Italy, and they contain few Celtic implements: helmets, swords, torcs, and finger-rings—fibulae are scanty. Less than a hundred years after the battle of the Allia these Senones were deeply Etruscanized and Hellenized, even in essential spheres of life, as the tombstone from Montefortino *pl. 243, b,* shows: it has an Etruscan façade, the Door of Hades, and puts the old-fashioned Celtic symbol[5] shyly and shamefacedly on the back. The grave-groups are only known in part, but obviously all these tombs are roughly contemporary; they must be earlier than 283–282 B.C. when the Senones were annihilated or driven out of Italy by the Romans (Polybius 2, 19, 7 ff.). The actual date of the graves is indicated by Attic and Italiote pottery of the very end of the fourth century B.C. A still later date,[6] at least for tomb 2 at Filottrano which yielded the gold torc, is possibly given by the finger-ring no. 75.[7]

The Gaulish necropolis at *Bologna*, from which the bronze ring no. 252 comes, gives the impression of being roughly contemporary with the graves of the Senones. Not having at hand Brizio's publication (Atti e Memorie della R. Deputazione di storia patria per la provincia di Romagna, 1886–7, 457 ff., pls. 5–7) and relying on notes taken years ago, I am insufficiently informed on the tomb-units, but, as in Picenum, the tombs obviously do not cover too long a period, so that dates provided by single objects are, within a certain limit, valid for the whole necropolis. I mention a few pieces of chronological or other importance. The mirror Brizio pl. 5, 41; Montelius pl. 111, 5; Körte pl. 80, 1, is not earlier than the late fourth century B.C.: it was found in the same grave as the krater Brizio pl. 5, 7; Montelius pl. 111,

[1] Mon. Piot 27 1924, 51; CVA Collection Mouret, introduction; Héléna, Les origines de Narbonne 181 ff.; fig. 173 (two Celtic swords). If this site had been excavated with the care it deserves, we should have most valuable information on association of Celtic objects and Greek and Iberian vases: AA 45 1930, 219.

Unfortunately the oppidum of Les Pennes, whence the bracelet no. 276 and the finger-ring no. 284 come, though decently published by Abbé Chaillan, was not methodically explored either.

[2] The gold torc from near Siena, Milani, Studi e materiali 3, 310, 318 fig. 1, similar in shape to no. 40, only 10 cm. in diameter (see p. 122, n. 6), was found with pottery which cannot be dated: Reinecke's date 'third century B.C.' (AuhV 5, p. 294) is unfounded.

[3] I refer to my review in JRS 29 1939, 98 of Dr. Baumgärtel's paper on Filottrano JRAI 67 1937. On the chronology of the Senones graves see also Ebert 6, 291.

[4] See Index 4 and pp. 28; 111. [5] p. 75.

[6] The Etruscan mirror, Mon. Ant. 9 pl. 5, 16, Montelius pl. 153, 13 cannot be dated with certainty, but has its place rather after than before 300 B.C.

[7] p. 125.

8, which was made in the region of Volterra in the first half of the third century B.C.[1] One of these kraters, Berlin Inv. 3987, Bieńkowski figs. 44, 45, has on both sides a picture of a Gaul wearing a helmet[2] like that found in the Bologna necropolis (Brizio pl. 6, 26; Montelius pl. 111, 3). The oinochoe, Brizio pl. 5, 4; Montelius pl. 111, 7, the skyphos, Brizio pl. 5, 5, and the askos, pl. 5, 8, belong to a kind of local Italian pottery which at Spina, in the course of the fourth century B.C., takes the place of Attic ware (Aurigemma pls. 57 ff.; Beazley, JHS 56 1936, 90); a similar askos, Mon. Ant. 9 pl. 10, 17, was found at Montefortino. The lamp Brizio pl. 5, 19, fits into the picture. In the same grave as the oinochoe quoted was the strigil Brizio pl. 5, 31; Montelius pl. 111, 1. For strigils at Montefortino see Mon. Ant. 9 pls. 9, 2; 10, 1, 2, 4, 12 (the last Montelius pl. 155, 13): there, p. 742, Brizio gives a list of strigils in Gaulish graves of men and women. The Bologna piece has stamped on it twice an ellipse with dishevelled, very Celtic-looking animals, obviously taken from a signet,[3] and between the ellipses the (retrograde) inscription ΟΛΛΟΩΡΩ: Ollo is a Celtic root: Dottin, La langue gauloise 110, 276, 292; what ΩΡΩ is I cannot tell. The strigil from Filottrano, tomb 12, JRAI 67 1937 pl. 26, 6, bears the same inscription;[4] here the inscribed panel is flanked on both sides by a circumscribed palmette which often recurs in the same shape on the cheek-pieces of Celto-Etruscan helmets.[5] ΟΛΛΟΩΡΩ is the signature of the Celt who manufactured strigils for Celtic customers: he uses Greek, not Etruscan, letters. If my interpretation should be correct, this would be the earliest Celtic inscription known.[6] The signature on the strigil from Montefortino, as rendered in Mon. Ant. 9 pl. 10, 12 (Montelius pl. 155, 13), makes no sense and defies reading.

The bird-askoi no. 398 were found at *Castiglione delle Stiviere*, near Sirmio on the Lake of Garda, in the territory of the *Cenomani*, together with the following objects:[7] (*a*) Candelabrum *pl. 256, c*. (*b*) Jug *pl. 257, a*, 18 cm. high. The lid, 7 cm. in diameter, has a handle which passes through two eyes soldered on the lid-plaque (not visible in the photograph). (*c*) Pan, *pl. 257, b*. Maximum diameter about 24 cm., height 7 cm., thickness of bronze 0·3 cm. (*d*) Three basins, one only illustrated, *pl. 257, c*. Diameter between 30 and 33 cm., height about 4·5 cm. Inside, engraved concentric circles. Traces of hammer. (*e*) Basin with convex lid, *pl. 257, d*. Diameter about 19·5 cm. Height about 7·5 cm.; diameter of lid-hole 6·8 cm. Near the contour of the hole, inside two small engraved concentric circles, factory- or owner-mark. (*f*) Profiled foot of wooden (?) implement, *pl. 257, e*. Maximum diameter about 20 cm., height 8 cm. A wooden rod fitted into the tube and was fixed with nails; three nail-holes are still visible near the rim. Two other pieces of the find, (*g*) and (*h*), are illustrated in *pl. 201, (5), (6)*; their diameter is about 8 cm., their height is unknown to me: they resemble no. (*f*) and seem to be mountings of some implement.

Of these bronzes nos. (*d*)–(*g*) are, so to speak, timeless and I have been unable to find analogies for them. The pan no. (*c*) is not unlike some pans frequent in North Italy and also exported to Germany and Great Britain: these are somewhat later and dated to the second century B.C.: the material has been collected and carefully treated by Sir Arthur Evans, Archaeologia 52 1890, 379, and Willers, Die römischen Bronzeeimer von Hemmoor

[1] RM 30 1915, 154 ff. (Albizzati); on pp. 63, 66 I quoted these kraters because of their ornamentation.

[2] p. 118 n. 1. [3] p. 125.

[4] Baumgärtel l.c. p. 264 misreads the inscription on the strigil from Filottrano and calls it incised.

[5] p. 118.

[6] The other Celtic inscription of Hellenistic date, second century B.C., is the base from Montagnac (Hérault), Dottin, La langue gauloise 159, no. 32 bis; AA 45 1930, 235.

[7] Photographs are due to the courtesy of the Keeper of the Museo Sforzesco and Professor Alda Levi-Spinazzola; I am also indebted to Dr. Jastrow for measurements.

106, and Neue Untersuchungen zur römischen Bronzeindustrie. The candelabrum, (a), belongs to a numerous class of subarchaic Etruscan candelabra.[1] At Bologna (Dedalo 9, 32 ff.) one is associated with Attic vases of about the forties of the fifth century B.C.; another, Certosa tomb 117, Zannoni pl. 54, with a rf. Attic cup, Bologna 370, of about 450 B.C.; in tomb 206, pl. 76, and tomb 351, pl. 117, with very late black-figure of about 500 B.C. At Spina they are accompanied by vases mainly of the third quarter, but in some cases going down into the fourth quarter of the century: Aurigemma pls. 95, 99,[2] 105, 109, 117, 124, 132, 135. The jug, no. (b), has an analogy at Montefortino, Mon. Ant. 9 pl. 4, 14, in grave 8, which yielded one of the situlae discussed on pp. 137-8 and the stamnos mentioned on p. 138, both definitely dated to the later fourth century. Another such oinochoe, from Sanzeno, is in Innsbruck.[3]

The bird-askoi are of a style otherwise unknown which I cannot date, but certainly later, probably much later, than the associated Etruscan bronzes.[4]

The helmet no. 143 was found in a tomb at *Canosa*, together with a wealth of pottery, bronze and iron weapons, gold, and glass: the objects being scattered over various museums and many of them having disappeared, one has to rely on old photographs,[5] and publications, in the first instance on Cozzi, Not. Sc. 1896, 491 ff. and Naue in Naues Prähistorische Blätter 10 1898, no. 4. Cozzi 491 and 493 gives ground-plan and section of the grave, which consisted of six chambers. On Canosan chamber-tombs in general see Max Mayer, Apulien 301. Cozzi's list of objects from the tomb is incomplete, but adds something to what one learns from Naue and the photographs.

Pl. 258, a is a view of the chamber in which the helmet was found, obviously, as comparison with Cozzi 493 fig. 2 shows, the largest and principal room (no. 2), measuring about 3·50 by 4·50 m. (see his ground-plan fig. 1a). Scale and perspective are somewhat arbitrary and distorted, but the skeletons (which lack skulls), the spears, and the cuirass seem to lean against an elevated sill which runs along the vaulted back wall. The corslet is at right angles to the spears. The helmet lies on the sill. Most of the objects can be identified from the detailed photographs: the skeleton on the left wore the girdle *pl. 258, d, 1*. Cuirass, helmet, and spears lie beside the middle skeleton. One of the bridle-bits lies at his feet, to the right of the Skylla askos. The skeleton on the right is half hidden by the vases; the bronze basin with small vases in it is not figured or mentioned elsewhere. In the drawing I seem to observe the outlines of what is possibly a bronze object: it lies across the hidden left wrist and hand of the right skeleton, continues to the left below the left femur and to the right (with a scalloped contour), behind the slanting oinochoe; I also see at the right edge of the chamber, level with the upper part of the ulna, a curved bronze object with a plaque at one end which looks like a handle: this is already doubtful: other traces defy description and interpretation.

Armour: (1) The helmet, no. 143. (2) The cuirass, *pl. 258, c*, in Hamburg, Museum für Kunst und Gewerbe. Brinkmann, Jahrbuch der Hamburger wissenschaftlichen Anstalten 27 1909, 90 ff.; Hagemann, Griechische Panzerung, I. Der Metallharnisch 46 figs. 56, 57, p. 66 fig. 76; Ebert 10 pl. 13, a. (3) The girdle, *pl. 258, d, 1, 1 a*, 98 cm. long, 10 cm. broad; along the edges numerous close-set holes for fixing leather lining; nine ancient repairs with

[1] Messerschmidt, AA 48 1933, 327; for the birds on the feet of the candelabrum see L. Curtius, MJ 1913, 20.
[2] On this grave 128 see also pp. 138-9.
[3] I owe a photograph to Professor von Merhart.

[4] p. 110.
[5] *Pls. 258-60, a* reproduce photographs preserved in the archives of the Berlin Antiquarium.

small bronze plaques fastened by bronze or iron rivets (Naue). The girdle deserves comment. The insufficient drawing becomes clear by comparison with *pl. 260, b, d, e*, pieces without provenience in the former Diergardt Collection (11·5 cm. long). See also Karlsruhe, Schumacher no. 725 (drawing in text), 726 (Wagner, Bronzen pl. 30); AA 45 1930, 403 fig. 44, p. 409; Márton pl. 4, p. 17; New York, Richter, Bronzes no. 1580. The elongated triangular attachment of *pl. 260, e* is decorated with a stiff palmette. Another type of hook is illustrated in *pl. 260, b, d*: the hook is here not an animal head, but a simple arrow. The palmette-leaves have 'eyes', like peacock-feathers.[1] The coarsely engraved snake on the arrow-hook of *pl. 260, b, d*, appears in a clearer form in Karlsruhe 723 (drawing in Schumacher's text), where the attachment has the shape of a lyre with a palmette inside and another on top: a related motive in openwork is shown by the piece from Aufidena, Mon. Ant. 10, 345/6 fig. 72 b.

Of special interest are the hooks with figure decoration. In *pl. 260, c* I illustrate one with two 'kouroi' standing on animals' heads, from the former Diergardt Collection (9·4 cm. long), which has a pendant at Aufidena, l.c., and another in Karlsruhe (Schumacher 722 pl. 13, 16; Wagner, Bronzen pl. 29, 3) with naked women. A piece in Mainz (inv. 11243), from Italy without detailed provenience, shows a single kouros, coarser than the piece in Villa Giulia, Syria 13 1932, pl. 62, 4. Or the attachment consists of animals: *Pl. 260, f* is a piece without provenience in Bonn, Akademisches Kunstmuseum, Inv. C 62; others are: Mon. Ant. l.c.; Montelius pl. 374, 3; Rostovtzeff AS pl. 12, 3; id., Le centre de l'Asie, la Russie, la Chine et le style animal (Semin. Kondakov., Prague 1929) pl. 6, nos. 31, 32, and Syria 13 1932 pl. 62, 1; Not. Sc. 1927 pl. 25, b, p. 351; Berlin, Friederichs 1041, 1042: climbing goats with reversed heads, treading on rams' heads. The hook proper has two analogies in Sigmaringen, from Italy, AuhV 2, 9 pl. 2, 6, 7. A variant of the type in Montpellier (Phot. Arch. Seminar Marburg 1338–9) has the same animal heads at both ends and a sort of kymation between them; compare also the piece in Paris, CdM, Babelon and Blanchet no. 1792. An important variant, from Tiriolo, a goat with one head and two bodies, has been discussed on p. 48. In Hamburg, Museum für Kunst und Gewerbe (AA 32 1917, 78), there is a pair, without provenience, 11 cm. long, gilt, each with a running lion in profile, flat and engraved.[2]

Silvio Ferri, Not. Sc. 1927, 351 ff., was the first to notice the Oriental features of the animals, and Rostovtzeff (AS 58, note 1, and Le centre de l'Asie, l.c.) drew attention to the resemblance between these Italic girdle-hooks and Scythian ones. The observation, based on the type shown in *pl. 260, b*, can be confirmed by the occurrence of the double beast and by the likeness between the Hamburg piece quoted and the Chino-Siberian clasps, Rostovtzeff, Skythika pl. 5 no. 23, p. 38, and Salmony, Loo pl. 19. The fact of these influences on Italy and the way they reached it remain a mystery: Scythian models are out of the question, and it is more likely that an unknown art of Asia was the source.

The date of the girdles, from style[3] and from context of finds, is fourth century B.C.

[1] Similar stylization is seen in the tongues round the lower part of the Este situla, Mon. Ant. 10, 73–4, fig. 24, and in the palmette-shaped animal-wings on the scabbard from Este, Not. Sc. 1882 pl. 7, no. 25 (p. 31), whence Montelius pl. 59, 12. Other scabbards of this class are *pl. 216, b* (*P 318*); Not. Sc. 1896, 308 figs. 3, 3a, whence Mon. Ant. 10, 307–8 figs. 33, 34. See also the Celtic torc no. 216 and the bronze from Comacchio no. 401 *l*: in PZ 25 1934, 87,

I gave a list of Greek and Italic examples, to which should be added a Phoenician one, the silver bowl KiB 104, 3; 107, 5.

[2] Kusel compares Berlin, Friederichs 1035; she wrongly takes them for Etruscan fifth-century works.

[3] The ornament of Karlsruhe 717, Wagner, Bronzen Karlsruhe pl. 29, with acanthus-leaves in the axils of the palmettes, and the engraved decoration of the piece Mon. Ant. 10, 349/50 fig. 74, point to the first part of the fourth century B.C.

Their distribution[1] gives no clue to the situation of the workshop in which they were made. Known proveniences are as follows: Apulia, Karlsruhe 716, 719–21, 723, 725; Canosa, 715, 717, and the piece from which I started. Calabria, Reggio, AA 45 1930, 403 fig. 44, p. 409. Lucania, Altavilla Silentina, Not. Sc. 1937, 148. Bruttii, Tiriolo, Not. Sc. 1927 pl. 25, b, p. 351. Campania, Pompei, Mau, Pompeji[3] p. 406, o (quoted AA 32, 1917, 79, but inaccessible to me). Samnium, Aufidena, Mon. Ant. 10 1901, 342 ff. (Duhn 563). Hungary, Puszta-Orond, Márton pl. 4, bottom. Márton (p. 17) excludes the find—the girdle and two boat-brooches—from the list of Celtic finds in Hungary and takes it for Late Hallstatt, before the coming of the Celts: in point of fact, the wearer must have been a Celt who got the girdle from Italy. Germany, Edendorf (Hanover),[2] AuhV 2, 9 pl. 2, 2–5: also armour of Celts.

(4) Four iron spear-heads in Berlin, Antiquarium *pl. 258, d, 2, 3, 5, 6*; in all of them there are still remains of the wooden shafts. *No. 2*: 44·5 cm. long; a piece of leather still adhering to one side. *No. 3*: 38·8 cm. long, traces of rough linen in the rust on one side. *No. 5*: 40 cm. long. These are not unlike one from Aufidena, Mon. Ant. 10, 360 fig. 79, a. *No. 6*: length of preserved part about 32 cm. At the bottom a socket which grows upwards into a spear-head of square section: Naue rightly sees in it one of the Italic forerunners of the Roman pilum: see Kropatschek, JdI 23 1908, 86.

According to information from Zahn there were four bridle-bits; Naue l.c. 56 speaks of two, 25 cm. long, and illustrates one (*pl. 258, d, 4, 4 a*); the view of the grave, *pl. 258, a*, shows one, lying on the ground.

The following commentary on *glass* and *gold* in the tomb is a contribution from Robert Zahn.[3]

'*Glass.* Cozzi l.c. 495: "Vetro. 18) Un piatto ricomposto dai frammenti, avente tracce di colori e di doratura nella parte esterna, alto m. 0·08, diam. m. 0·27. 19) Cratere a doppio manico, ricomposto interamente dai frammenti; alto m. 0·21, diam. alla bocca m. 0·16. 20) Frammenti di un piatto di pasta vitrea a vari colori." The first of these, Cozzi's no. 18, is a millefiori plate, published in G. Sangiorgi, Collezione di vetri antichi, Milano-Roma 1914, no. 225 pl. 45;[4] in polychrome reproduction by Jules Sambon, Le Musée 3 1906, 491 pl. 71, 9 (wrong provenience "Cumae", repeated by Kisa, Das Glas 522, note 1); see also Dalton, Archaeological Journal 58 1901, 248 (who in note 1 refers to glass vessels of the same kind in Deville, Histoire de la verrerie pl. 8 a).

'Two glass bowls of Megarian shape with rich decoration of tendrils and leaves in the technique of Christian gold glasses, in the BM, Dalton l.c. pl. 5, p. 247 and id. Byzantine Art and Archaeology p. 613 fig. 388, p. 614, note 1; Wuilleumier, Le trésor de Tarente pl. 10, 5, p. 30. Zahn, Die Silberteller von Hassleben und Augst, Römisch-Germanische Forschungen 7, 92, on the ornament: "certainly imports from Alexandria".[5]

'M. Mayer, Not. Sc. 1898, 217, in a report on the tomb, speaks of "una coppa emisferica di un finissimo materiale traslucido, biancastro, che era ripiena di una massa sciotta, che qualcuno dichiarò essere amianto." Certainly glass: identical with one of the bowls in the BM? "amianto" also mentioned in Cozzi's report on chamber 3 "tracce di tessuto d'amianto"; see also the traces on one of the spear-heads.

'*Gold. Pl. 260, a* Berlin Antiquarium inv. no. 30219, 399, ex Gans Collection. (1) Pair of earrings, the pigeons hammered out of gold sheet, enamelled. (2) Pair of earrings, with disks: these and the

[1] The statement in Mon. Ant. 10, 347 that there are such girdles from Greece is unfounded.

[2] p. 141.

[3] Zahn with the kindness he has shown me for forty years gave me the whole material that he had collected for a prepared publication of the grave. To him and to Dr. Weickert I also owe the photographs reproduced in *pls. 258, 259, 260, a*. For obvious reasons it must be explicitly stated that this collaboration took place at a time when I was still professor in the University of Marburg.

[4] Sangiorgi nos. 222, 223, pls. 43 and 44 shows two other millefiori glasses with the provenience 'Canosa'; also mentioned by Froehner, Verrerie, Collection Charvet, p. 51, note 2; see also Kisa, Das Glas, p. 523, note 2.

[5] Association of millefiori and gold glass in a tomb at Tresilico, AA 29 1914, 200.

pigeon pendants cut out of a dark stone. Cozzi l.c. p. 494 (from chamber 3); Collection M. Guilhou, Cat. Vente Sambon et Canessa, Mars 1905, no. 81, pl. 6. Compare BMC Jewellery no. 1917, pl. 33. (3) Gold mounting of a staff which is not itself preserved. Cozzi p. 494 "un grazioso pendaglio di oro lavorato a giorno"? The closest analogy is the sceptre from Tarentum in the BM l.c. no. 2070, fig. 65; Cook, Zeus 2, 762, figs. 708, 709; p. 763, note 1. Other examples of gold-wire network are: BM l.c. 2030, pl. 39; Murray, Excavations in Cyprus pl. 13, 7, p. 82, Tomb 73 (7) (fifth to fourth century B.C.); Fontenay, Bijoux p. 150; Vernier, Catalogue général du Musée du Caire, Bijoux et orfèvreries no. 53205, pl. 91; Ant. du Bosphore Cimmérien pl. 12, 3, tomb of third century B.C., see Reinach, p. 20: cylindrical members of collier; see also one from the Hellenistic tomb at Eretria, AM 38 1913, 327 fig. 12 and one in Zahn, Sammlung Baurat Schiller, Cat. Lepke 2008, no. 125, pl. 53: the net consists of gold wires, bent in wave lines, soldered together, at the crossings little gold balls. The net was worked flat and then bent cylinder-wise; at the joint, small square gold cross-bars.

'Forerunners of the technique are the Egyptian earrings in Berlin, Schaefer, Aegyptische Goldschmiedearbeiten no. 92 a–c, pl. 1 a and 14; M. Rosenberg, Geschichte der Goldschmiedekunst, Granulation, Heft 2, p. 39, fig. 61.'

Pottery. Cozzi's report (l.c. 494) is rather provisional and incomplete: Naue l.c. 49 speaks of 32 vases: actually the photographs reproduced in *pls. 258–9* show at least 36. A. D. Trendall was kind enough to comment on them, as follows:

'Skylla askos, *pl.259, a, b* (*258, b*). The askos is a comparatively common shape in the vases of the so-called Canosan style. By this I mean not the ordinary sort of Apulian red-figured vases, usually with a good deal of decoration in white, which have been found in great numbers at Canosa, but the later sort with figures usually in white against a deep pink background, with blue used for adjuncts or decorative details. This style, as far as I know, does not occur elsewhere in South Italy and may well be local. The Skylla askos is of the usual type—a winged horse either side, a head in front, and on the top a plastic Skylla. There are two excellent examples, also from Canosa, in the Bari Museum, on one the head in front is in thin stucco relief, on the other it is similar to our piece, but wears a pointed cap. Another close analogy is Boston 99.541: the Skylla has a fish in her left and probably a φιάλη μεσόμφαλος in her right hand (unless the omphalos is a fruit).[1]

'This type of vase seems to belong to the first half of the third century B.C. I should put it later than ordinary Apulian red-figure, which must have ended about 300 B.C. The relation between the Canosan colours and those used on the vases from Centuripae (Richter, Metropolitan Museum Studies 2 1930, 187 ff.) is interesting. The latter must, I imagine, have been to some extent influenced by the former, but as their chronology is still disputed we can hardly use them as an argument for the date of Canosan. I do not, however, see the necessity to carry the date of these polychrome vases as late as has often been done, not at least into the second century B.C. There are not very many of them, so their period of manufacture cannot have lasted indefinitely.

'The pyxis with the relief scene on the lid, *pl. 259, a, b* is also quite a usual type. Naue describes the relief as "nebeneinander sitzendes Liebespaar mit Eros". Others in Bari, though the relief is less well preserved. Sometimes they are hardly decorated in paint at all—just the relief scene on the lid. Relief scenes make their appearance on Apulian vases quite late—cf. a very late volute-crater in Naples, the red-figure part of which is so crudely done as certainly not to date much before 300 B.C. Such a date would fit the pyxis well enough and confirmation could be had, I imagine, from the many not dissimilar terracotta figure-plaques of the later fourth and earlier third centuries.

'*Pl. 259, c*. Upper row: late-looking Gnathia vases of the early third century. The skyphos in the centre perhaps from the end of the fourth. Centre: this type of oinochoe with plastic head, tall handle, and plastic decoration in white and yellow seems to come in about the end of the fourth century, to be supplanted later by the more elaborate polychrome type as the oinochoe *pl. 259, e*, middle, to which Patroni, Not. Sc. 1899, 300 has already compared one in Naples. The kantharoi figured below are common Apulian from ca. 330 B.C. onwards: they usually show a woman's head arising from a flower,

[1] Dr. Caskey kindly examined the Boston vase for me and gave me a photograph.

surrounded by tendrils, or an Eros seated on flowers, or, more rarely, a Sphinx. Other examples are Naples Stg. 483, 82420, 82429, H. 2867 and many in other museums—all those I have seen coming from Canosa. To establish the date we may compare the heads with those figuring on the necks of the great Apulian volute-craters and amphorae from about 330 B.C. till the end of the century.

'*Pl. 259, d*, top centre. Diameter 55 cm. (Naue). Plates such as these begin 325 and last till the end of the century. The usual subject is a chariot with white horses, driven by Nike, and below man, Eros, and woman: a variant is Eos as driver, as here. This type is generally a little later, and from comparison with similar plates in Naples and elsewhere probably to be dated about 300 B.C. Oinochoai: the two showing the chariot with white horses are of a popular design contemporary with the plate above (cf. Naples H. 2336, 3417, 3512). As a variant one sometimes finds a larger vase with two registers. All about the last twenty years of the century—some even perhaps first decade of third, as the designs are exceedingly crude. Parallel with these runs a series of just the same shape showing mythological or battle or erotic scenes. There is an excellent series in Bari, mostly of Canosan provenience: 1016, Perseus and Andromeda; Herakles' entry into heaven; battle; murder of a king. Also a battle scene at Leipzig. The style is just the same as that of the latest volute-kraters. For the decoration on the neck compare also the type of plastic female head; they are not far apart in date.

'The lekane with the woman's head is of a type too common to dwell on.

'The fish-plate is pure Apulian: I noted some of the principal points of this type in my review JHS 57 1937, 268 of Lacroix's book on fish-plates: last quarter of the fourth and quite well on in it.

'*Pl. 259, e*, right and left. A well-known brand of vases of which the splendid examples in the BM were published in CVA BM 7, IV D a, pls. 18–19 (Gr. Britain 473–4). This sort of vases, together with those in *pl. 259, f* belongs to the second phase of Canosan pottery, i.e. after the red-figure had passed away, and may be of local manufacture, though they have been found in other places than Canosa. The two oinochoae with woman's heads are parallel in style and date to the askos mentioned above and use just the same colour scheme. There is an admirable series of them from Canosa in the Bari Museum, colours almost perfectly preserved. The big central one is the polychrome equivalent of the red-figured chariot-plate *pl. 259, d*.

All of this class known to me have chariot scenes on them and elaborate decoration on the shoulders. Colour: pink, white, grey, blue. There are four in Bari from Canosa (see Jatta, RM 29 1914 pl. 8).

'Macchioro (RM 25 1910, 168) gives a chronology of "Vasi canosini" by which he means mostly just ordinary late Apulian with white heroon or stele scenes. These of course come before the vases in the polychrome technique and I have no doubt that dating them in the last third of the fourth century B.C. covers them quite fairly. I see no reason to suppose they lasted far into the third—a few years possibly, but not, I think, more, being quite ready to put a full stop to Apulian red-figure about 300 B.C. The earliest possible date will not be before that of the first great volute-kraters, about 325 B.C.

'Just how far down into the third century one can put the polychrome vases is a more difficult problem. Jatta deals with it (RM 29 1914, 125) quite well, though perhaps putting too much faith in the empiric chronology of Macchioro. He compares his tomb with ours for its vase contents. I think there is no great reason to prolong the manufacture of the polychrome wares far into the second half of the century —as I said before, not enough survive to give rise to the belief in manufacture on a very extensive scale. The Medusa type, *pl. 259, f*, do perhaps go on longer, as after a while they lose their colours and appear in plain clay. The terracotta figures which decorate them seem to fit in well with a third-century dating, but on these I have little to go on except a study of the current types in Naples and Taranto.

'In general one could give the pottery in the tomb a range of fifty years from about 330/320 B.C. and probably not stop too early—though if you wanted to date the latest polychrome pieces down to 250, I think it would be difficult to prove you too late with the evidence at the moment available. The Hadra finds are not really much help, but as their date seems pretty certainly the first half of the third century, that at least is something to go on.'

Two vases of local manufacture, a 'funnel-vase' and an askos, are faintly, but sufficiently recognizable in *pl. 258, a* (and in *pl. 258, b*): the class has been dealt with by Mayer, Apulien 301, pl. 38.

So far I have examined the contents of the grave regardless of their distribution in the single chambers. Information on this point is insufficient and even contradictory: Cozzi was obviously not on the spot during the dig and relies on what he was told by the administrator of the fondo on which the grave was unearthed. Chambers 5 and 6, as he explicitly states, were empty, and the objects were lying in 1, 2, 3, and 4. Of these 3 contained the gold staff, and the pair of earrings with the 'colombe di granato', *pl. 260, a*, probably also the other pair: apparently a woman's burial. For chamber 2 we have the evidence of the old photographs reproduced and a passage in Naue's report, at variance with them. He speaks of three skeletons, one accompanied by a helmet, a cuirass, a girdle, four spears, two bridle-bits, and 32 vases. The drawing shows the cuirass, the helmet, the spears and one bridle-bit lying by one skeleton, the girdle by another. Naue mentions 32 vases found with the skeleton: in the view of the tomb *pl. 258, a*, 15 are represented, and in *pl. 258, b* (which looks like a reconstruction for the purpose of sale), in its left part following as closely as possible the arrangement of the items *in situ*, I count about 20. But this is irrelevant for the date of chamber 2, for among the vases which quite certainly come from this very chamber there are enough to provide us with a date in the first half of the third century. The helmet like some of the vases is late fourth century B.C.; it is definitely the only Celtic object in the grave: there are neither horse-trappings nor sword. It can neither be proved nor refuted that the wearer of the helmet was a Celt. It is quite imaginable that in the highly international civilization of South Italy in this age a warrior of any race wore this beautiful exotic piece of armour. It is equally possible that the burial is that of a Celtic condottiere, for instance of one serving in Agathokles' (361–289 B.C.) army (Diodorus 20, 11; G. T. Griffith, The Mercenaries of the Hellenistic World 199), and there are other possible explanations. Gauls are frequent among the plastic groups on the monstrous Canosan 'Tussaud' vases: Bieńkowski, Les Celtes dans les arts mineurs 80 ff.

Most probably this six-chamber tomb was originally built for a native family and used by them, before the intruders occupied chamber 2 and laid their bodies in an alien nest: Celts at least had no scruples about violating graves: Pyrrhos' Celts plundered the tombs of the kings of Macedonia at Aegae (Diodorus 22, 12; Plutarch, Pyrrhus 26, e); and how Gauls behaved at Mezek in Thrace we shall see presently.

The chariot-parts nos. 164, 176 were found in a beehive tomb, Mal-Tepe, at *Mezek* in South Bulgaria near the Greek frontier, on the eastern spurs of Rhodope.[1] With them in the grave were numerous Greek objects, some datable to the fourth and third centuries B.C. The find would be of great importance as the only one in which works of the Plastic Style were associated with classical objects—were it not that the contents of the tomb are scattered over the chambers, which themselves contained more than one burial; thus there is no external evidence which objects formed part of the Celtic burial. Nevertheless I should like to survey the essential items because it will appear that the historical conditions of a Celtic chariot grave in Thrace well agree with the assumed third-century date of the Plastic Style.[2]

There were the bones of horses in the dromos (Filow l.c. 109) and of the chariot the linch-pins, no. 164, the terrets, no. 176, *a, b*, and the device no. 176 *c*, the purpose of which is not clear to me[3]; possibly the buckle, Filow l.c. fig. 70 (p. 111, no. 33) also belongs here. That

[1] Filow, Die Kuppelgräber von Mezek, Bull. de l'Inst. Bulgare 11 1937, 1 ff. Professor Filow most kindly provided me with the photographs and information on the objects.

These pages were written in 1938, as a contribution to a volume published in Athens *in memoriam* Tsounta, and I had the proofs in 1940: will the volume ever appear?

[2] p. 135.

[3] pp. 101; 132.

the gold beads *pl. 248, a* are related to the members of the gold ring from Herczegmarok, no. 62, and probably Celtic, was pointed out on p. 98.

The life-size bronze boar,[1] *pl. 260, g*, though found outside the tumulus, was certainly once, as rightly stated by Filow, in the grave: it obviously belonged to the Celtic burial, boars, as totem or (and) food, being common in Gaulish graves.[2] Devambez thinks highly of it as a Greek fifth-century work: to me it looks rather dull and provincial: it is hard to say how long this sort of fifth-century style was still practised in the provinces. He is wounded and was perhaps once a Calydonian boar, part of a group, before the Gauls, ransacking one of the coastal towns (Polybius 4, 46) tore him from the base—he still has iron pegs, 10 cm. long, below the feet—and put him into the chieftain's grave.

There are no other objects in the grave definitely belonging to the Celtic burial.[3] At the utmost one might assign to it the bronze bucket, Filow figs. 60, 61, which is later than that from Waldalgesheim and a work of the third century B.C.: the Celts, as the finds from Waldalgesheim and Montefortino show, were fond of these situlae; but it might be otherwise: the buckets were also exported in large numbers to the Balkans and beyond (AA 51 1936, 416; Zuechner 98. BWP 24).

Mal-Tepe is a good analogy to Canosa: a Celtic intruder in a monumental grave not built for him. After their defeat in 276 B.C. by Antigonos Gonatas the Gauls settled for a while in Thrace and founded the 'realm' of Tylis (Polybius 4, 46): the warrior buried in the Mal-Tepe may well have been one of these Gauls. If that should be so, it would agree with the date of the Plastic Style suggested for stylistic reasons, and would corroborate it.

[1] RA 1908, I, 1 ff.; Devambez, Grands bronzes du musée de Stamboul pls. 3–5; Filow figs. 34, 35.

[2] Márton 29; for the Yorkshire tombs see Archaeologia 60, 264–5 (Greenwell).

[3] On the silver pectoral, l.c. figs. 75–7, AA 46 1931, 419, 20 fig. 2, Filow writes: 'related in technique and style to the helmet from Amfreville, but without Celtic elements in the decoration'. I refer to my remarks in PZ 25 1934, 86 note 28: the pectoral is definitely of Italiote style: the woman's head in the centre of tendrils, the friezes of heads, the flowers, all have countless parallels in the arts of South Italy; a certain stiffness in the treatment of the palmettes and lack of perspective and third dimension in the tendrils possibly suggest that the piece was made on this side of the Adriatic: on transadriatic connexions see Praschniker, Oe J 21/2 1922/4, Beiblatt 203. An Etruscan terracotta statuette in Hamburg, AA 32 1917, 91 fig. 16, wears such a pectoral, closely imitating a South Italian model: Mercklin's date, fifth century, is too early. For the perfume-containers hanging from the pectoral of the pendant, l.c. fig. 17, see Hanfmann, AJA 1935, 189; JRAI 67 1937 pl. 19, pp. 236, 237, 261. The Phoenician terracotta from Ibiza, Colomines Roca, Les terracuites cartagineses d'Eivissa pl. 18, seems to wear a similar pectoral of the first half of the third century B.C.

The two gold ornaments with a staple on the back, Filow figs. 27, 28, are also purely Greek, and not, as Filow 110, 1 says, Thraco-Scythian: they recall the Spartan relief, Möbius pl. 72, a, a work of the late third century B.C. The bronze oinochoe figs. 55, 56, p. 111, no. 18, is provincial, but not un-Greek.

CHAPTER 6

CELTIC CRAFTS, THEIR ORIGIN AND CONNEXIONS

IT is not difficult to see that in the Early Style certain works are products of one school, workshop, or master. The reader may find out for himself the affinities of gold plaques and strips, torcs and bracelets, and try attributions. It is equally obvious that certain bronzes of Orientalizing style—girdle-hooks, brooches, and vessels—were made by a few artists and some of them by one man (nos. 312–18, 350, 353, 381, 383, &c.). As is shown by comparison of the beak-flagon no. 385 (handle-palmette *P 375*) with gold plaques from the same find (*PP 376, 377*), or of the double-lion brooch no. 317 with the lions' heads of the gold band no. 27,[1] the same workshops produced gold and bronze, or at least used the same patterns.

Similar observations can be made in the Waldalgesheim Style. The gold torc and bracelets from Waldalgesheim, nos. 43, 55, came from the same workshop as the gold torc from Filottrano, no. 44, and the set from Belgium nos. 45, 56 was a later work of this school or master.[2] The bronze torc no. 241 goes with the gold bracelets no. 55, and the gold torc no. 49 with the bronze torc no. 210. The patterns are not confined to metal-workers: masons and even potters use them as well. The floral ornament of the Waldenbuch pillar, no. 15, is related to the bronzes from Waldalgesheim no. 156, f, 247;[3] certain motives on the pillar from Pfalzfeld, no. 11, have analogies in bronze. The decoration of the clay urn from Alsópél, no. 414 (*P 443*), is a misinterpretation of good patterns in metal.[4]

It is not surprising, but should be noticed, that some objects stand apart and defy attribution to schools or masters. For instance, the fragmentary gold lion-ring no. 61, the linch-pin from Grabenstetten, no. 160, the Glauberg torc, no. 246, the 'silenus' from Nauheim, no. 369, the Milan bird-askoi, no. 398, the clay flagon from Matzhausen, no. 402, and a few others.

It may also happen that works not produced by a single artist or workshop nevertheless represent a single type. Déchelette, in figs. 404, 717, gives a conspectus of minor objects found in certain oppida of the first century B.C., some in France, others in Bavaria, Bohemia, Hungary, showing complete identity or likeness. They were surely not made in some centrally situated workshop and exported thence to those distant provinces: they were manufactured on the same pattern in the several oppida. It was not different some three hundred years before.[5] Openwork horse-trappings in Germany and France have the same look; the coral-inlaid bronze torc no. 226 comes from the Palatinate, its counterpart no. 227 from Hungary;[6] disk-brooches from the Marne (no. 348), from Hungary (no. 349), and from Switzerland, Saint-Sulpice (mentioned on pp. 129 n. 4; 131; 132) are alike in shape, technique, and decoration. Certain ornaments appear in identical form in regions far apart, see *PP 267–72*—or study the distribution of Waldalgesheim motives.

Works of Early Style are most frequent in Germany, Austria, Bohemia, Belgium, and France, much less frequent in Switzerland and Hungary, almost nil in Italy and—less surprising—in the British Isles. The Orientalizing works of the Early Style are confined to a still smaller area, to Germany, Austria, and Bohemia, they occur very sporadically in

[1] p. 46. [2] p. 88. [3] p. 94. [4] p. 94. [6] There is a similar torc, unpublished, from Niedermockstadt, Hesse, in Giessen.
[5] See Déchelette figs. 385, 386.

France[1] and, what is worth noticing, are not represented in Hungary.[2] Objects of Waldalgesheim Style have been found in Germany, Austria, Bohemia, Hungary, Rumania, Bulgaria, Switzerland, Belgium, France, and Italy: the real centre of the style was on the Rhine, in Switzerland and France. In the third period the centre shifts eastwards and southwards, the Rhine and France seem to become unproductive. Sword Style and Plastic Style are focused in South-east Germany, Bohemia, Hungary, and Switzerland. The finds of these styles from other provinces, France, Italy, the Rhineland are few and not of high quality.

Some of these observations call for comment. The finds in the easternmost countries of Europe are imports: the helmet from Silivas, no. 142, of pure Waldalgesheim Style, came there from the West, the nail of Plastic Style in the chariot grave at Christurul-Secuesc, mentioned on p. 101, probably came from Hungary. The finds in Bulgaria illustrate Celtic adventures in Thrace during the latest fourth century B.C. and the early third. The gold torc from Zibar, no. 46, probably Hungarian,[3] of late-fourth-century style, might have been worn by one of the Gauls who fought the Illyrians (Theopompus frg. 41) or Cassander in Thrace (Seneca, Quaest. Nat. 3, 11, 3; Pliny, Nat. Hist. 31, 53). The chariot parts from Mezek, nos. 164, 176, have their analogies in works of the Plastic Style in Hungary, Bohemia, South-east Germany: from one of these lands came the warrior who drove the chariot into battle in the seventies of the third century B.C. The iron sword from Dobralevo, district Orěchovo, an isolated find, Ebert 2 pl. 108, d, must belong to the same period.

In the West, Belgium is not a stylistic province with a character of her own, the spout-flagon no. 390 and the gold rings nos. 45, 56 go most closely with the Waldalgesheim find; the linch-pin no. 162 points eastwards; the gold ring no. 70 is connected with the Aurillac Style,[4] but cannot be associated with any particular object.

As to France outside the Marne-Seine area and East: The South is barren, the few Celtic objects from Provence, the bracelet no. 276 and the finger-ring no. 284, works of the third period, are poor and local products. The girdle-hook from Ensérune, no. 362, is an import and was made in the workshop from which the pendants found on the Ticino, no. 361, came.[5] The finds definitely disprove the assumption that Massilia played a role in the origin of Celtic art.[6] The North-west of France produced respectable works of the second phase, pottery (*P 470*), the torc *P 363*, the hanging bowl, which was exported to Wales (*P 471*). The helmet from Brittany, no. 141, is probably an import from the region where the Amfreville helmet, no. 140, was made. The origin of the masterly gold bracelet from Aurillac, no. 63, and of the gold rings from Toulouse, nos. 64 ff., which are closely related to that from Hungary, no. 62, is doubtful. The bronze bracelet from the Tarn, no. 275, must not be severed from the numerous rings of this style in the East, and may have come thence.

Celtic Italy is an unproductive province. Good works, the torc from Filottrano, no. 44, the helmet from Canosa, no. 143, the elaborate pieces in the Comacchio find, no. 401, all of Waldalgesheim Style, are imports from transalpine workshops, the bad sword from Filottrano, no. 103, as well—if it is not a local imitation. The gold finger-ring from Filottrano, no. 75, was engraved by a Celtic die-sinker, either on the spot or abroad.[7] The bulk of objects in the tombs at Montefortino,[8] Bologna,[9] Marzabotto, and elsewhere are average stuff, κοινή of the late fourth and the third century B.C., not different from the furniture of Celtic graves at this period in Switzerland, Hungary, or Bohemia.

[1] No. 200 (p. 44); no. 355, *a* (p. 53); no. 359 and *pl. 230, b* (pp. 42–3); no. 410 (p. 30); no. 411 (p. 44). [2] See below p. 158. [3] p. 94. [4] p. 98. [5] pp. 28; 43. [6] p. 142. [7] p. 125. [8] p. 144. [9] pp. 144–5.

A third class of finds in Italy comprises hybrids. The helmets, described at length on pp. 116 ff., and certain strigils are Etrusco-Celtic.[1] Veneto-Celtic are the situla no. 399 and the dagger *pl. 216, b*: their Celtic elements are of Early Style; otherwise the Early Style is very meagrely represented in Italy: there are just the two girdle-hooks from Este, no. 363, and the fibula with the sleeping ducks, no. 297. The armour from Bergamo, no. 134, like the objects from the Ticino graves, is a typical product of some subalpine local industry which blended belated Hallstatt with Celtic and Etruscan ingredients. The bird-askoi from the Lake of Garda, no. 398, are decorated in a style without analogies, but have their like in Switzerland and France.[2] Later than all these works are the silver horse-trappings from Manerbio, no. 84.[3]

Where were the workshops, where the creative centres? It can be assumed in principle that, if certain objects have their maximum frequency in the graves of a certain region, they were produced there. In the Rhineland the existence of workshops can be established by two finds of half-finished pieces and raw material[4] made at Langenhain (Taunus) and Sefferweich (Eifel), and by the observation that four chariots of identical construction and decoration, those from Waldgallscheid (no. 153), Horhausen (no. 154), Besseringen (no. 155), and Kaerlich (nos. 167, 170), were found at short distances from each other in the basin of Neuwied near Koblenz. Careful excavations in other Celtic lands would probably show the same.

Celtic art has a triple root: Italy, the East, and Hallstatt.

There is evidence for contact with *Italy*: suffice it to mention the following facts: (*a*) The imports. (*b*) The chief type of the Celtic fibula derives from the Certosa type. (*c*) The mask-brooch has Italian prototypes.[5] (*d*) The decoration of rings with human heads occurs similarly in Etruria.[6] (*e*) The gold finger-ring from Rodenbach, no. 72, copies an Etruscan model.[7] (*f*) The Celtic beak-flagons copy Etruscan. (*g*) The animals on the flask from Matzhausen, no. 402, resemble those in a certain class of Etruscan helmets.[8] (*h*) Certain Celtic chariot-parts show the same construction as Etruscan ones.[9] (*i*) The pillar from Pfalzfeld, no. 11, and the tombstone from Irlich, no. 12, reflect Etruscan forms.[10] (*k*) Celtic geometric ornament has the same repertory as the geometric component of Southern Orientalizing styles between the late eighth and the middle of the sixth century B.C.: Greece as source can be ruled out and it can be established that the source was Italy.

The invasion of Italy by the Celts, about 400 B.C.,[11] was less decisive for the rise of Celtic art than one might expect. The finds in Italy, hardly any of Early Style, do not convey the impression that there was artistic initiative[12] with those Gauls who settled in Italy during the first half of the fourth century B.C.: Polybius' description of their low cultural standard at this time deserves credence;[13] the close neighbourhood, however, of certain tribes with the Etruscans and Venetians cannot have failed to intensify already existing contact between

[1] p. 145. [2] p. 110. [3] p. 12.

[4] Langenhain: Nassauische Annalen 37 1907, 245 pl. 1; Sefferweich: Trierer Zeitschrift 10 1935, 35.

[5] p. 127. [6] p. 123. [7] p. 125.
[8] p. 31. [9] p. 120. [10] p. 8.
[11] Duhn, Ebert 6, 286.

[12] I have to correct a serious misstatement in Die Antike 10, 37 where I wrongly suggested that the tiny gold plaque found with a fragment of an Attic krater of about 450–440 B.C. in tomb 5 of the Certosa di Bologna (Zannoni pl. 10/11, 8, p. 57;

Mon. Ant. 20, 435), like its pendants, BMC Jewellery pl. 40, nos. 2090, 2092–4, 2096, was Celtic and evidence of peaceful contact between Celts and Etruscans in the Po valley during the years preceding hostilities (Polybius 2, 17): the ornament is Etruscan, though of special style, and my conclusions were futile.

[13] Polybius 2,17 Διὰ γὰρ τὸ στιβαδοκοιτεῖν καὶ κρεαφαγεῖν, ἔτι δὲ μηδὲν ἄλλο πλὴν τὰ πολεμικὰ καὶ τὰ κατὰ γεωργίαν ἀσκεῖν, ἁπλοῦς εἶχον τοὺς βίους, οὔτ' ἐπιστήμης ἄλλης οὔτε τέχνης παρ' αὐτοῖς τὸ παράπαν γινωσκομένης.

the North and Italy: the strongest proof is the Etruscan influence in the sphere of sepulchral customs (see p. 155 (*i*)).

The Eastern connexions. Celtic Animal and Mask Style are of Oriental origin: it was often as easy to see the East behind the Celtic designs and to find analogies for types and details in the Near and Far East as it was difficult to define precisely country and date of the prototypes. I need not repeat the observations made in Chapters 1 and 2. In some cases Celtic Orientalizing works could be referred to definite, localized, and dated Eastern models: for instance, the gold bracelet from Rodenbach, no. 59, copied such Scythian animals as the bone carvings *pl. 230, a*;[1] the bird on the fibula from Jungfernteinitz, no. 318, had an Iranizing model (*pl. 221, f*);[2] the Glauberg torc, no. 246, copies Persian rings,[3] the handles of the Lorraine jugs, no. 381, Persian ones;[4] the ram finials of the gold horns, nos. 16, 17, reflect Greek horns from Scythia and Thrace (*pl. 221, a, b*).[5] The handle-animal of the Salzburg flagon, no. 382, has a 'Syrian' prototype.[6]

Besides, there are Eastern features[7] in implements, wear, and technique. (*a*) Horse-trappings.[8] (*b*) The torc is the ornament of men in Persia and Scythia.[9] (*c*) Trousers were borrowed by the Celts from the Orient.[10] Posidonius (Diodorus 5, 30, Jacoby F Gr Hist. ii A, p. 304) speaks of the bracae of the Gauls: they already appear in the sword from Hallstatt, no. 96, where the Este engraver surely depicted the people among whom he was then living and not, as Déchelette 1206, 2 believed, his own people, for the Venetians, though τοῖς μὲν ἔθεσι καὶ τῷ κόσμῳ βραχὺ Διαφέροντες τῶν Κελτῶν (Polybius 2, 17, 5) are never seen trousered on the situlae or in other bronzes of pure Venetian make. (*d*) The spout-flagon is possibly of Oriental origin.[11] (*e*) Polychromy is an Oriental feature. The kind of enamelling practised by the Celts has its only analogy in the Caucasus.[12] (*f*) A certain type of openwork is probably Caucasian.[13]

For an understanding of the complex origin of Celtic art it is instructive to turn to the Greek Orientalizing style of the late eighth and the seventh centuries B.C Conditions there were both, like and unlike. Unlike: for there *was* a genesis, the new rhythms gradually supplant and defeat the old geometric forms, there are many intermediate phases and manifold blends of old and new. On the other hand, the similarities are striking. There was a perfect parallelism of development in the various centres, Athens, Corinth, Sparta, the islands; everywhere the same typical transition from geometric to Orientalizing style. Though there are local shades, the whole movement is astonishingly uniform and synchronized, driven by one *agens* which it would be wrong to project on one leading school. And there is still another analogy: the blend of foreign elements from different sources and countries is so thorough and so perfect that it is mostly impossible to trace the exact origin of a particular form, and even less possible to say of what specific kind the models were; the imported objects in the tombs were apparently only a small portion of what the Greeks had in their hands. And the question how the Greek artists acquired the mastery of working ivory and metal is unanswerable.

[1] p. 43. [2] p. 30. [3] p. 32. [4] p. 37. [5] p. 25. [6] p. 33.
[7] Though the contact of the Celts with the civilization and the arts of the East was intense, it is doubtful whether Oelmann (Germania 17 1933, 180) was right in suggesting that the Celtic ambulatory-temple found its way from Iran to the West in these early days. [8] p. 122.
[9] Déchelette 1210; Gössler, Trichtingen 28; Neuffer,

Kostüm Alexanders 34; Kul Oba: Ebert 7, 117. Volkovtsy kurgan: Ebert 13, 96, pl. 39 D, a; Minns fig. 77. Christopher Hawkes (by letter) rightly stresses the fact that in Northern Europe, from the Early Bronze Age onwards, necklets, though of different shape, were a common ornament of men.
[10] On patterned trousers see von Lorentz, RM 52 1937, 208, note 7. [11] p. 108. [12] pp. 133–4. [13] p. 83.

It is unlikely that these questions can be answered for a civilization less well known than that of Early Archaic Greece, and it is prudent to content oneself with stating facts and problems. The most puzzling of them is that the Early Style flashes up, mature, perfect, and sure; there is no genesis, no gradual transition from Hallstatt, no scale leading from works still close to their foreign models through blends with an increasing share of the native component to works purely Celtic. This is not due to a lack of finds or to incompleteness of our knowledge.

What was the role played by the *imports* in the origin of Celtic crafts?

The imported objects were in the hands of the artisans, who were at the same time dealers and importers. Two observations at least show that the chieftains bought Celtic and Southern products from the same shop: the Attic cups certainly came to Klein Aspergle, with the Celtic gold plaques already mounted, and the Campanian bucket came to Waldalgesheim from the same workshop as the Celtic objects in the grave which imitate details of the bucket.[1] The Celtic artisans copied the imported beak-flagons and seem to have picked up this or that motive—the leaf-chains on the handle-plaques of stamnoi[2] and other designs.

It is tempting to draw a picture of a workshop at a 'Latenopolis': along the walls, shelves with rows of Etruscan beak-flagons, stamnoi, basins, and tripods; on another shelf Greek pottery; in the middle of the room, the Celtic master and the apprentices at their benches, staring at a foreign model and sweating over their 'copies'. The picture is attractive, but over-simplifies matters. When discussing the relationship between the gold finger-ring no. 72 or the Celtic rings decorated with heads and their Etruscan models,[3] I left it open whether the jewels or the jewellers were imported.[4] In two cases it could be established that foreign artists were employed in Celtic workshops, a Venetian, who engraved the sword from Hallstatt, no. 96,[5] and a Greek, who made the jugs with the lionesses, no. 392.[6]

A most serious warning not to overrate the part played by the imports is the fact that there is not a single Eastern object in the Celtic graves which are our concern. The association of Celtic works with an akinakes in the grave of a rider at Aiud in Transylvania (22. Bericht RGK 1932, 154) is exceptional and not surprising in that region. The mirror in a Celtic tomb of the late second century B.C. at Dühren, Baden, AuhV 5 pl. 15, no. 280; Ebert 2 pl. 219 (12, 235), even if it were an import from South Russia—which I disbelieve[7]— is of no interest for the period with which I am dealing. An isolated Oriental import of La Tène time, without context, found outside the Celtic domain proper is the gold ring from Vogelgesang, Silesia, *pl. 228, c*;[8] the fragment of a gold ring, *pl. 260, h*, came to the Taunus either in Hallstatt or La Tène times.[9]

How then, if there was no trade with the East and if there were no imports to be copied, can the impressively strong influence of the Orient on Early Celtic art be explained?

The lionesses from Lenzburg, no. 392, are of pure Greek style (that it is a bad style does not

[1] p. 87. [2] p. 88. [3] pp. 123; 125.

[4] p. 140. [5] p. 2. [6] pp. 25; 107.

[7] Rostovtzeff SB 487 is also sceptical. [8] pp. 38–9.

[9] I owe the photographs to the courtesy of the Keeper of the Wiesbaden Museum, Dr. Kutsch. The ring, mentioned in Nassauische Annalen 2, 2 1834, 214, 215, was found on the Dornburg (Taunus). The length of the fragment is 2·3 cm.; it is impossible to find the diameter of the ring, which was more probably a bracelet than a torc. On the lower surface of the terminal is an oblong hole for a joining tenon. The tube consists of a rather thick sheet of gold and has a longitudinal joint on the back. The eyelets and the horizontal band below them are notched gold wires soldered on the sheet. The technique has not its like in Celtic crafts. The closest analogy for technique and motives is the handle of the gold akinakes from Vettersfelde, Furtwängler, 43. BWP 1883 pl. 3, 5 (Kleine Schriften 1 pl. 20, 5). Zahn refers to Rostovtzeff IG fig. 17, p. 130 (middle, right). The motive is not frequent: one of the few examples is in the gold wreath from Teano Sidicino, Mon. Ant. 20, 127/8 fig. 97, once in the Naples Museum, sold by F. X. Weizinger (Sale Cat. V, Sammlung Marx and Sieck pl. 34, no. 950).

matter). The Venetian engravings of the Hallstatt sword bear slight Celtic marks. Among the Celtic works of Orientalizing style none is pure Persian or Scythian: a few, for instance the Rodenbach gold bracelet, no. 59, or the Glauberg torc, no. 246, stand close to their foreign models: the majority display a style, new and fixed, the *Orientalizing Celtic Style*: the analogy with seventh-century Greece is obvious. These works do not look like experiments of Easterners just arrived, or like products of Celtic freshmen: again and again we hit on the same enigma: Early Celtic art has no genesis.

Two other observations make the Eastern problem even more complicated. Objects decorated in this style are most frequent in Germany, Austria, and Bohemia and their frequency very sensibly decreases towards the West. Moreover, one would expect to find them in great numbers where Scythianization was deepest and where a maximum of contact between the Celts and the East was most likely, in Hungary: the truth is that they are almost absent here.

Some motives have their only analogies not in the arts of Scythia proper but in the Altai mountains, Siberia, and China: a fact that defies explanation.

I have purposely stressed the difficulties presented by the Eastern connexions, because they shed light on the problem of Southern influences and on the origin of Celtic art in general: the many imports from Italy and the contacts enumerated make one too easily forget that, as far as the South is concerned, we are no less at a loss to answer the very question: how and where did the foreign influences work on the Celts?

Before returning to these problems, a word may be said on the third root of Celtic art, *Hallstatt*.

Stylistically La Tène breaks with Hallstatt, but there is continuity in other respects which should not be underrated. Reinecke, AuhV 5, 146 has drawn a magnificent picture of Late Hallstatt civilization and crafts: they cover Northern and Eastern France, Northern Switzerland, Southern Germany with the adjacent territories of the southern half of the Rhineland, Nassau, Oberhessen, the regions of Fulda and Werra, Upper Austria, Bohemia, and probably stretch farther eastwards. This is roughly the same area as is covered by Early Celtic art. In these regions Hallstatt craftsmanship was respectably high: bronze-casting, embossing of gold, openwork and other techniques, as application of gold foil on bronze or iron core, were skilfully practised: here there were already workshops and men knowing how to use their tools.

These regions were already in close contact with the South. There was trade: coral, ivory, glass,[1] wine, bronze vessels, and pottery—pottery only to France—were imported, on two routes, across the Alps and—the Greek ware—via Massilia up the Rhône valley.[2]

[1] AuhV 5, 69.
[2] I refer to Déchelette 1595 ff.; Sprockhoff, Handelsgeschichte der Bronzezeit; Reinecke in AuhV 5, 146 ff.; Jacobsthal, JdI 44 1929, 198 and Germania 18 1934, 14. Rademacher's article in Ebert 6, 127 is full of misstatements, omissions, and is of no use.

To the list of Southern imports add the following objects:
Bronze hydria-handle, BM, ML 1620, Morel pl. 25, 2 (Phot. Archaeologisches Seminar Marburg nos. 2992–3), from Bourges, dept. Cher, grave-group unknown. Preserved, top part of handle, cast in one with the protomai of two fawns, which lay on the rim of the hydria. Along the middle of the handle, a row of large astragaloi, framed by bead lines. The fawns have the forelegs sharply bent; their bodies are στικτά, the spots are punched circles. For the sharp median ridge of the nose Neugebauer compares the Spartan bulls, Lamb, Greek and Roman Bronzes pl. 13, a. The date of the bronze is the first half of the sixth century B.C.

Wooden handleless, stemmed cup with very elaborate profiles from Uffing, Naue, Die Hügelgräber zwischen Ammer- und Staffelsee pl. 35, 6, pp. 61, 62, 142, 143; the grave is dated by a bronze situla to the seventh or sixth century B.C. My attention was drawn to the piece by E. Vogt, and Watzinger was kind enough to discuss it with me: he believes it to be Ionic and refers to the wooden bowls from tomb 7 of the Certosa, Zannoni pl. 13, 4, 6, 7; p. 61, which are accompanied

There are also reflections of Southern forms in Hallstatt arts: motives on bronze girdles,[1] maeanders,[2] astragaloi,[3] and certain shapes of profiles given to rings, balls, knobs, &c.[4]

The existence of workshops and skilled craftsmen in these areas was of great importance for the origin of Celtic art. The trade between North and South continued to flourish in the new La Tène age: the 'Greek' route via Massilia and up the Rhône valley was discontinued, the Italian trade-routes took its place: the Etruscans monopolized the trade with the North: they exported the products of Italy—and those of Greece, although these lost in numbers and significance.[5] The occurrence of classical forms in Hallstatt was of lesser importance for the rise of Celtic art: these forms were foreign bodies in the otherwise still rigid geometric style: when the Celts took the decisive step, they drew on the fuller original repertory of the South.

The continuity of Southern connexions in Hallstatt and La Tène is apparent. Nor was the strong Eastern wave that reached the Celts the first to reach Western and Northern Europe: I sum up some statements made in the preceding chapters and add some pertinent facts.

It was established that in the finds from Faardal and Eskelhem currents from East and South-east Europe were manifest; a similar observation was made for the animalized Running-Dog in the Hallstatt ornaments *pl. 238, b; c.* Possibly the Syro-Hittite bronze statuettes from Lithuania (Schernen) Ebert 9, pl. 218, a, and Sweden (V. Müller, Frühe Plastik in Griechenland 116; Hanfmann 34) are not earlier than the seventh century B.C.[6] and were carried North by the same current (Tallgren, Senatne un māksla (Riga 1938), 56).

Scythian influence did not reach the central Hallstatt area which concerns us: its western-most traces are finds from Silesia,[7] among them the gold find from Vettersfelde (Ebert 14 156), of Late Hallstatt date (later sixth century B.C.).

Caucasian influences on Celtic art—enamelling and a certain type of openwork—were preceded by connexions between the Caucasus and Europe in Hallstatt. There is a Caucasian bronze bell from a tomb in Samos, dated by pottery to the years after the middle of the sixth century B.C. (Möbius, Marburger Studien 156), a bronze iron-inlaid pole-top from

by objects of the sixth–fifth centuries B.C. Ionic or not—the cup is good and classical.

An Etruscan bronze statuette of the seventh century B.C. from Pomerania is mentioned by Hanfmann 89, no. 10, others from Germany ib. 90 (the publications quoted were not accessible to me). The seventh-century Etruscan girdle-clasp 'from Rheinhessen' in Mainz, Hanfmann, 35 no. 10 is a 'pseudo-boreale' (JRS 28 1938, 103).

A bronze vessel found in the cremation tomb 682 at Hallstatt, accompanied by typical Late Hallstatt objects (Sacken pl. 24, 1; Oe J 3 1900, 33; Ebert 5 pl. 22, 13; Déchelette 769; Reinecke, AuhV 5, 150). It is a basin with two upright handles on a stand: the type has bronze and clay analogies in Etruscan and Faliscan seventh-century tombs, but whereas those are ὑποκρητήρια, this is a basin, with figures engraved inside which were meant to be looked at and not to be hidden by another vessel put on it. The engraved decoration (Oe J l.c. fig. 3) shows two concentric friezes, in the outer, seven grazing animals, not definable zoologically, and a smaller beast of prey; in the inner ring, five times the same little beast alternating with five 'shepherds', who have very long hair and fringed loin-cloths. V. Müller and Schefold convinced me that the drawing reflects a Phoenician model which passed first through the hands of an Etruscan: Müller compares the waving hair in similar stylization on sixth-century Etruscan black-figure

(Munich 853, Dohrn, Die schwarzfigurigen etruskischen Vasen aus der zweiten Hälfte des sechsten Jahrhunderts 154 no. 237; Munich 869, Beazley in Beazley and Magi, La Raccolta Guglielmi 78 no. 25; Munich 925, Dohrn l.c. no. 193, Beazley l.c. no. 63; Munich 928, Beazley no. 64; Berlin F. 2152, Dohrn no. 186, Beazley no. 6). Then the drawing was copied a second time somewhere north-east of the Apennines.

Problematic are four-figure decorated bronze bushes of a four-wheeled chariot from Wijchen, Holland, in Nijmegen, known to me from Verslag der Commissie ter verzekering eener goede bewaring van gedenkstukken van geschiedenis en kunst te Nijmegen over het jaar 1897 pl. 2, p. 12: Professor Zeiss drew my attention to the pieces and the publication. The bronzes bear resemblance to the Etruscan seventh-century girdle-clasps dealt with by Hanfmann 34, which for their part copy Syrian models. The Dutch pieces reflect either Etruscan or Eastern prototypes—if they are not an import.

[1] *PP 3, 4, 5, 205–8, 212.* [2] *P 180.* [3] p. 72.

[4] Reinecke, AuhV 5 p. 149; on the similarity between Hallstatt and La Tène chariot-parts see p. 120.

[5] p. 142.

[6] Hanfmann, AA 50 1935, 50.

[7] Rostovtzeff SB 487. Vettersfelde, by the way, is now in the province of Brandenburg, but geographically the region forms part of Silesia.

Praeneste, Mühlestein 114, 115, a bronze statuette from Ilsfeld, Württemberg (Bittel pl. 8, 2; Préhistoire 1, 265), which closely resembles the Caucasian material published in RA 1885 pl. 3 and by Zakharov in Swiatowit 15 1932/33, 65; another statuette comes from Lithuania (Tallgren, Senatne un māksla (Riga 1938), 57). Caucasian influences in Late Hallstatt Eastern Europe are traceable in the gold finds from Michalkov, Galicia (Ebert 8, 180),[1] and from Dalj, Slavonia (Oe J 11 1908, 259), and in the animal on the clay urn from Pasha Köi, Bulgaria (Ebert 10 pl. 15).

To resume the thread, the question how exactly the creation of Celtic art was achieved is unanswerable—the act of creation always remains a mystery. What we have gained is a better understanding of the conditions and circumstances which made the origin of Celtic art possible and favoured it.

The Hallstatt peoples received and handled the imported Greek and Italian works passively, and there is little reflection in their arts of these contacts with the South. The connexions with the East were sporadic, too slight to leave traces. Then the Celts awake: open-minded and active, they transform what had before been no more than commerce into a live source of artistic inspiration.

There were three components of Celtic art: the geometric, based on the geometric repertory of Southern Orientalizing styles; the floral, reflecting sub-archaic classical forms; and the Eastern. These three elements do not appear separately, but united in the same objects. This rules out an explanation which otherwise would be obvious, namely, that there were three separate reception areas, one for each of the three components, and that these were then amalgamated in one centre.

The geometric elements must have come from an Italian backwater where they lingered down to La Tène times and with which the Celts were in touch, most likely Este. It was a Venetian who engraved the sword found at Hallstatt—and very possibly made at Hallstatt, which was connected by trade with Este, as shown by a lid of an Este situla found there.[2] Beside the Celto-Venetian sword there were Veneto-Celtic works. *PP 168–73* illustrate the persistence of the old geometric motives in Este.

The Eastern components offer great difficulties. There was no trade with the East, there are no imports, the employment by the Celts of Oriental artisans is doubtful. Yet the Celtic Orientalizing Style has a firm physiognomy. 'The wind bloweth where it listeth, and thou hearest the sound thereof. . . .'

I have confined myself strictly to the art of the Celts and ignored those problems in which Prehistory takes a primary interest, such as the problem of race and the like. Yet I must contradict a recent writer[3] who from arguments which deserve serious consideration has come to the conclusion that the population of Northern Bavaria, Bohemia, &c., where a great number of Orientalizing objects, mask-brooches and others, were found, were Illyrians, and the Eastern Style an Illyrian achievement. In point of fact, works of this style, and among them the best, were found outside this domain, in Baden, Württemberg, and the Rhineland, and it is not permissible to take these for imports from Bavaria or Bohemia. Besides, the Eastern Style, wherever it appears, is always associated with the other components. In my opinion the whole of Celtic art is a unit. It is the creation of one race, the Celts.

[1] Luschey 66.
[2] Sacken pl. 21, 1, p. 96; Mon. Ant. 10, 163; Schneider, Album der Antiken des Kaiserhauses Wien pl. 24, whence JdI 18 1903, 20 fig. 9; Déchelette 768.
[3] Kersten, PZ 24 1933, 168.

EPILOGUE

DURING the first centuries of the first millennium B.C., the Hallstatt period, through the whole of Europe—and beyond—a geometric style was in existence, regionally different in repertory and quality, which satisfied the needs of this particular stage of civilization, but became an insufficient instrument as the standard of material and spiritual life rose. Greece and Italy were the first to free themselves from the geometric fetters: from the end of the eighth century B.C. onwards, by taking over forms of the more advanced art of the Near East, they create the Orientalizing Style—one of the decisive deeds in the History of Man. After three hundred years the same process took place in the North, and it fell to the lot of the Celts to break the might of Hallstatt ice, to invent a new style. Greece now played the role the Orient had once played.

The geographical structure of Europe excluded direct contact between Greece and the barbarians in the North: this explains important phenomena in European history. The 'Hellenization' of the North always worked through channels. In a later age the Romans were the agents of Greece: Greek art never had an influence on the North except through the Roman medium. It was not different when the North, awaking from its long Hallstatt sleep, first took stock of Southern art. The Celts received the classical forms not directly from Greece in their pure Greek shape, but by way of Italy and the East, recoined by the Italians, the Scythians, and the Persians.

The indirectness of the passage of classical forms is more marked in those which took the roundabout Eastern way: most of the floral motives show hardly any sign of having passed through Italy, yet on the animals and masks the East left its stamp. Neither component reflects classical art as it was, when, in the later fifth century and the fourth B.C., these forms reached the Celts, from regions where Greek archaic and sub-archaic art lingered long —Italy, Scythia, and Persia.

Early Celtic art was not a mere result of geographical and commercial conditions, the Celts just receiving what works and forms were brought to them. They were certainly not so completely at the mercy of the dealers or the foreign artisans whom they employed: they could have ordered up-to-date goods if they had wanted to; and they would hardly have cultivated those old-fashioned geometric patterns or so readily adapted the Eastern creatures and given them so much room if they had not agreed with their taste and their state of mind. The Celts not only spontaneously chose and perpetuated them, but—what is more—they retranslated fifth-century works into that bygone style, as is most strikingly shown by comparison of the gold finger-ring from Rodenbach with its Etruscan model. This proves—to say it once more—that the mentality of this first Celtic phase must have corresponded to that of the Greeks and Italians when they, three hundred years before, achieved for the South of Europe what was now achieved by the Celts for the North.

Early Celtic art is an art of ornament, masks, and beasts, without the image of Man. The only narrative, the figure frieze on the Hallstatt sword, was made by a foreigner—with the toleration and to the delight of his Gaulish masters. The Celts were more strict and orthodox in their anticonic attitude than the Scythians, who at least placed orders for representational works with the Greeks, those works which so beautifully illustrate the fourth book of Herodotus. This abstinence of the Celts must be contrasted with the attitude

of Greek Orientalizing art: the Greeks did not content themselves with taking out of the wealth of the East a few fantastic creatures, some lotuses and palmettes, but eagerly appropriated all kinds of narrative types, reshaped them, and depicted the life and deeds of gods and men. The Celts had in their hands painted Greek vases and good bronze figure work: but where is there any reflection of them? They did not decide for Greek humanity, for gay and friendly imagery: instead they chose the weird magical symbols of the East. Here for the first time Northern Europe, as later in the Migration period and—with a new interpretation of the heathen symbols—in Romanesque art, fell under the spell of 'Eurasia'.

The beasts and the masks give the Early Style its stamp, they are far more impressive and prominent than the ornaments which came from the South. It is hard to guess what the Celts read into these symbols, which throughout their migrations from land to land retain their bodies and change their souls. What matters is the fact that in this age the Celts were the westernmost outpost of the vast Eurasian belt, stretching East to China, where there was no anthropomorphic art, where beast and mask were all and everything, where the tale of mythology was told in zoomorphic disguise.[1]

I have established three phases of Early Celtic art: they roughly correspond to subdivisions which prehistorians, working with different methods and for different ends, had already established.

The first phase, the Early Style, is the age of intensest foreign contacts, of ready reception, of apprenticeship. The borrowings from South and East undergo a transformation into a new, firm, and conscious style, but the foreign models are not deep below the surface. The various components, though applied to the decoration of the same works, are not really blended. There is a certain dignified heaviness and gloom about the Early Style.

The second phase, the Waldalgesheim Style, is the classic age of Early Celtic art: it overcomes archaism: the Eurasian features and the geometric patterns recede. By free use of Southern forms the Celts now elaborate a serviceable ornament, particularly a type of tendril which can be brought into any shape and serve any purpose of decoration. Traces of renewed Southern influence, even definite loans, are not entirely lacking, but they are fewer than one would expect to find in an age of political expansion. On the whole, the Waldalgesheim Style is an independent Celtic creation. Compared with the styles which precede and follow it, it is quiet and balanced.

The third phase is very complex. It comprises at least two styles. The 'arabesques' on the Hungarian swords develop features of the Waldalgesheim Style. The Plastic Style is Janus-faced: on one side tree and berry forms, on the other a new, very original calculated plasticity. In addition, the 'Cheshire Style' revives the masks of the Early Style, but gives them a far more uncanny look. Certain plastic forms are possibly a revival of Hallstatt forms. Despite increased connexions with abroad, migrations of tribes, and bodies of fighting men or single mercenaries active in the South and South-east of Europe, there are no longer any loans: by now the Celts were saturated with foreign forms. There is much unrest and a baroque, deeply unclassical note in this style: I do not hesitate to see in it the culmination of Early Celtic art: ἔσχε τὴν αὑτῆς φύσιν.

Early Celtic art stands against a dramatic background of war and wandering—though the skill and refinement of the works give no hint of this. It reflects manifold contacts with civilizations and arts in South and East: a precious supplement to the scanty information

[1] Alföldi, AA 46 1931, 393. Some good remarks on Greek Animal Style: Buschor, AM 47 1922, 92.

on early Celtic history obtainable from ancient writers, the invaluable, only document of the spiritual life of the Celts in an age lacking literature.

There were three unclassical arts in Early Europe: Iberian, Scythian, and Celtic. They are of unequal merit: Iberian art has no importance in the general stream of history; all the Iberians achieved was a sometimes not unattractive blend of Phoenician and Greek ingredients, but before long complete barbarization took place; they never had what one could call a proper style: this was an art without a future, and it is not true that there are Iberian undercurrents in the Roman or Romanesque arts of Spain. With Scythian art it was otherwise. In the first place, its effective range was extraordinarily wide: Scythian art extended as far as China, while in Europe it influenced Celtic art and even left its mark, as it seems, on the Dark Age styles of the Migration period. It was a true style, a Eurasian Animal Style, expressing a particular mentality and religion, but doomed to wither away when touched by the Greeks: it was not a flexible instrument of decoration which other peoples could adopt and adapt to their different artistic needs and aims. Celtic art alone of the three—quite apart from its particular stylistic merit—had a future and a European mission. What was afterwards to become the Roman Empire had already been a sphere of Southern influence. The classical forms and technical achievements disseminated by the Celts over Europe prepared the soil for the following phase when the Celts, this time on a larger scale and with the Romans as powerful agents, dominated the minor arts of the Roman provinces. Incidentally, it must be emphatically denied that, as some recent writers have assumed, there is a Celtic tradition in Gothic architecture or a 'Celtic undercurrent' in Rococo or in those styles of decoration which were in fashion in the early years of this century:[1] the appearance there of some isolated motives or rhythms which also occur in Celtic art is merely one of those interesting phenomena of coincidence and not at all based on a continuous tradition.

The life of the Celts during these centuries was an endless succession of adventures, of migrations, of fruitless victories and bloody defeats, the fate of a race lacking the gift of political organization, unable to found stable empires—but destined to become a ferment in Early European civilization.

We are told that the Gauls were valiant, quarrelsome, cruel, superstitious, and had the gift of pointed speech:[2] their art also is full of contrasts. It is attractive and repellent; it is far from primitiveness and simplicity, is refined in thought and technique; elaborate and clever; full of paradoxes, restless, puzzlingly ambiguous; rational and irrational; dark and uncanny—far from the lovable humanity and the transparence of Greek art. Yet, it is a real style, the first great contribution by the barbarians to European arts, the first great chapter in the everlasting mutual stock-taking of Southern, Northern, and Eastern forces in the life of Europe.

[1] Wimmer, WPZ 19 1932, 82; Portway Dobson, Antiquity 1933, 85.

[2] M. Cato, Originum II (apud Charis. 2, p. 202 K. (=frg. 34 Peter).

CATALOGUE

Nos. 1–15

STONE SCULPTURES

1. MARSEILLES.[1] From Roquepertuse. Gérin-Ricard pl. 4, 19; AA 44 1929, 286; 20. Bericht RGK 1931, 117 (Lantier). *Pl. 1.* Local reddish-white limestone with little mica, easy to work, 'pierre de Coudoux'. The block has been arbitrarily perched on one of the pillars, in which at a later date (see Lantier l.c.) egg-shaped hollows were cut for insertion of skulls. The contours of the horses are coarsely engraved; there is no modelling, but the second head (from left) has the bridle, head- and nose-band painted in red; a red wavy line runs under the heads.

2. MARSEILLES.[1] From Roquepertuse. Gérin-Ricard pl. 3, 1, 2; AA 44 1929, 289 fig. 5, and 20. Bericht RGK 1931 pl. 10, 2, p. 117; Espérandieu no. 7615. *Pl. 1.* Same material as no. 1. Only preserved in fragments: three-quarters is plaster. 62 cm. high, 36 cm. broad, 100 cm. long; dimensions of base 30 : 26 : 7 cm. On red ground black details (opening of mouth and feathers).

3. MARSEILLES.[1] From Roquepertuse. Gérin-Ricard pl. 2; AA 44 1929, 289; 20. Bericht RGK 1931 pl. 10, 1, p. 117; Espérandieu no. 7616. *Pls. 2, 4.* Traces of cutting instrument in many places. Height of (A) 19·7 cm., of (B) 18·1 cm., distance between nose-tips 29 cm. *Pl. 4* shows that the double-head belonged to an 'architrave'. On one side it continues and is wrought in one with the beam; the beam is broken at one end, well polished on the bottom surface (which was visible from below), on top roughly cut; on the opposite side is a hollow, into which a separately wrought beam was mortised. The heads do not stand at right angles to the beam, but are slightly out of plumb. Of the two 'leaves' that once crowned them, the lower end of one is preserved; on the other side the break can be seen. The faces have a smoother surface than the skulls and the side-planes; they bear traces of red colour; black fringes of hair fall down on the eyebrows, on (B) straight, on (A) slanting. The colour has now faded, but appears clearly in the photographs made shortly after discovery.

4. MARSEILLES.[1] From Roquepertuse. There are five statues of squatting men in all, more or less fragmentarily preserved. Material like nos. 1–3. I figure three of them. (A) and (B) were found at Roquepertuse, the one before 1824, the other in 1873, and have been completed by fragments from recent excavations. (C) comes from Rognac, not far away; its original place was certainly in the same sanctuary.

(A) Gérin-Ricard pl. 5, 1, 2; Espérandieu no. 131; Mon. Piot 30 1929, 75 fig. 7. Moretti, Il guerriero italico di Capestrano 14 fig. 11; drawing in Bertrand, Réligion des Gaulois 149 fig. 10 and Déchelette fig. 703. *Pl. 3; P 257.* Height 125 cm.

(B) Gérin-Ricard pl. 5, 3. *Pl. 4; P 185.*

(C) Ib. pl. 6, 1, 2; Espérandieu no. 6703. *Pl. 4.* Still 69 cm. high. The patterns on the garments of (A) and (B), on the back of the stole, and on the front between the folds of the chiton below the waist-line, engraved and painted in red and ochre, are figured by Gérin-Ricard pl. 4, 15 and p. 26.

5. AIX-EN-PROVENCE. From Entremont (Antremont). Espérandieu no. 108. *Pl. 5.*

6. NÎMES. From St. Chaptes (Gard). (A) Mon. Piot 30 1929, 72, 73 figs. 3, 4; Gérin-Ricard Suppl. (1929) fig. 1; Espérandieu no. 7614; 20. Bericht RGK 1931 pl. 14, p. 144. *Pl. 5.* (B) mentioned in the publications, but not figured. Material of both, local whitish-yellow limestone. Height of (A) 54 cm., herm 28 cm. broad, 21·5 cm. deep; (B) 51 cm., 25, 22 cm.: the front is missing. Across the breast of (A), in engraved lines, a band with a bull and two horses, turned to the left; traces of red. Above, a band with zigzag pattern. Round the neck, a line with triangular pendants; the oblique lines over neck and shoulder probably signify hair.

7. MARSEILLES. From Montsalier. Espérandieu no. 36; Oe J 26 1930, 37 fig. 25. *Pl. 6.*

8. BEAUCAIRE. From Beaucaire. Gérin-Ricard Suppl. (1929) fig. 2; AA 45 1930, 231/2 fig. 17. *Pl. 7.* Limestone. Still 77 cm. high, 43 cm. broad, 31 cm. deep. The shaft does not appear in the plate. A cone on one side only.

9. PARIS, market (1928). 'From Southern France.' AA 45 1930, 237/8 figs. 21, 22. *Pl. 7.* Limestone. Breadth 22 cm.

10. BONN. From Solingen (Rhineland). Germania 5 1921, 9; Oe J 26 1930, 36 fig. 24. *Pl. 8.* Eifel basalt-lava. 12·2 cm. high.

11. BONN. From Pfalzfeld. BJ 1906 pl. 2, p. 77 (Koenen); AuhV 5 pl. 54; Germania 5 1921, 14 (Knorr); Germania 16 1932, 34 (Behrens); Ebert 11 pl. 48; Kühn 390; Baum, Die Malerei und Plastik des Mittelalters (Handbuch der Kunstwissenschaft) 2, 7 fig. 5. First drawn in 1608/9 by Dilich, Landtafeln hessischer Aemter zwischen Rhein und Weser (herausgegeben von Edmund Stengel, Marburg 1927) pl. 6, here *pl. 12.* Second drawing in 1739 in 'Der Rheinische Antiquarius . . . von einem eifrigen Nachforscher in historischen Dingen' (Frankfurt a/M. 1739), 486, whence Koenen l.c. 81, AuhV l.c. 310 and Behrens l.c., here *pl. 12.* A third drawing made in 1807 is mentioned by Koenen l.c., but lost. *Pls. 9, 10, 11, 12; P 99.*

[1] Description from the publications quoted.

The pillar is now safe in the Bonn Museum. It has had a very restless existence: from 1845 to 1934 it stood on the wall of the churchyard at St. Goar, from 1807 to 1845 on the St. Goar–Pfalzfeld road, from 1805 to 1807 in Koblenz, some time before 1805 at Schloss Rheinfels. Its original place was in the village of Pfalzfeld in the Hunsrück, where Dilich saw and drew it, east of the church, near the apse. But this can hardly have been its original situation; in the village it would not have survived through the centuries; it was presumably excavated in the territory of Pfalzfeld and to make its magic harmless transported to holy ground. Such proceedings are frequent in these regions (G. Behrens, by letter). During all these wanderings the stone has suffered badly by act of God and by human folly. It is now only 106 cm. high. The old drawings show the loss in height, and the 'Rheinische Antiquarius' (481, 482) says: 'Wherefore the stone must go back to ancient idolatry since, as old people in the village still remember, on top there once stood a human head which had been wrenched off.'[1]

Bunter sandstone, more likely from one of the quarries round Trier than of the more remote ones in the Odenwald, the Palatinate, or the Black Forest. Measurements: Height 148 cm. Diameter of column at top 55–8 cm. The length of the column-shaft, to be seen in the old drawings, but now hidden by the socle, is unknown to me. Original surface and tool marks not preserved. On C top portion scaled badly. Holes everywhere, some of them deep: from raindrops? Also fissures due to frost. The workmanship is far from classical precision—see the sections in *pl. 12*. The upper surface of the column-head is not horizontal and not flat. B joins C at an obtuse angle. The dip-angles of the four trapezia are all different and the dip itself always irregular; on C, above the heads, even before scaling the surface ran away more steeply than on the other sides. Consequently the cable-patterns on the edges of the planes are not straight. Numerous other irregularities and asymmetries of decoration: on B, and to a lesser degree on C, the head is pushed towards the left side and the chin of the mask is out of plumb to the right. The top points of the two leaves over the heads are not level. The distance between mask and the vertical spirals beside it is uneven throughout. The spiral band on the trapezoid pedestal on C runs to the left.

12. IRLICH. From Irlich near Neuwied in the district of Koblenz, a region full of Celtic graves. The stone stood behind the vestry of the old church until its demolition in 1835, was then transported to the new church, and has recently been brought back to its former site, where there is now a crucifix. In old times the stone was said to be a 'Mörderstein', i.e. it gave sanctuary to a murderer who touched it. It is now believed to promote child-bearing. The monument was discovered by Dr. K. H. Wagner,

who very kindly furnished pictures and description. *Pl. 11*. Reddish bunter sandstone, compare no. 11. Still 161 cm. high, diameter of shaft 25–9 cm., at the base of the dome 45 cm. The lowest end of the shaft, once buried, is only roughly hewn, the surface of the rest weathered; on the dome remains of a moulded ring.

13. STUTTGART. From Holzgerlingen (Württemberg). Germania 4 1920, 38 (Beilage zu Heft 1/2); ib. 5 1921, 14; Oe J 26 1930, 35. *Pl. 13*. Local sandstone (Stubensandstein). The body is a parallelepiped with bevelled edges, about 32 cm. broad, 21 cm. deep; the height of the statue is roughly 2·30 m. Split across by frost: so badly weathered that it is hard to tell original surface from secondary tooling: it is, however, clear that the device at the bottom, 21 cm. long, is not a ground-spike but a tenon-joint built into a wall. The figure though janiform has only two arms; on each side the forearm is bent over the stomach; the fingers, all of equal length, are opened. The fragment of the leaf-crown appears in an incorrect position in the photograph and should be set as in Knorr's drawing, reproduced in *pl. 13* bottom.

14. KARLSRUHE. From Heidelberg. Wagner 295 fig. 245; Germania 5 1921, 14 fig. 4 (Knorr); Oe J 26 1930, 42 figs. 31, 32 (wrong indication of museum); Espérandieu, Complément no. 432; Germania 16 1932, 34 fig. 6 (Behrens). *Pl. 14*. Reddish slightly crystalline sandstone. 30 cm. high, 35·5 cm. broad. Broken below. Surface weathered throughout, especially by raindrops on the right side, where the groove has been weathered away up to the top. The vertical furrow between the two halves of the head-crown is somewhat to the right of the median line on the obverse and consequently to the left on the reverse.

15. STUTTGART. Found in 1864 in the forest of Greuten near Waldenbuch (Württemberg). Springer-Wolters, Kunst des Altertums[12] fig. 1022; Germania 4 1920, 11 ff. (Knorr); 18 (Drexel); Oe J 26 1930, 40 fig. 28; Baum, Malerei und Plastik des Mittelalters 2, 9 fig. 6; Ferri, L'arte romana sul Reno fig. 102; PZ 25 1934, 82. *Pl. 15; PP 258, 454–6*. Local sandstone (Stubensandstein). Still 125 cm. high, pedestal 25 cm. high, 47 cm. broad, 31 cm. deep; below hand 43·5 cm. broad, 27 cm. deep. Edges bevelled. Below fracture across. There never was a right arm; the left arm is bent over the stomach, the thumb on top, the tips of the other four fingers curling round the edge. Knuckle modelled on under side.

Nos. 16–83

GOLD

Nos. 16–38. GOLD OBJECTS OTHER THAN RINGS

16, 17. STUTTGART. From Klein Aspergle. JL 31; Gössler, in Ausgewählte Werke aus den Württembergi-

[1] . . . diesem nach kann sie wohl noch von dem uralten Götzendienst herrühren, zumalen, da der alten Leute desselben Ortes Aussage nach vormals oben auf dieser Säule ein Kopf in der Gestalt eines Menschen gestanden habe, der aber davon abgerissen worden.'

schen Landeskunstsammlungen; Die Antike 10 1934 pl. 1, p. 20; Kühn 384. *Pls. 16, 17; PP 71–4, 137, 142.* For convenience I call no. 16 'scale-horn' and no. 17 'guilloche-horn'. The former is 14·5 cm. high, templet measurement at the outer curve 18 cm.; the latter 17·5 cm. and 19·5 cm. respectively. The latter is less well preserved, more seriously dented, and cracked along the joints in some places. The horns were assembled by Lindenschmit, who, however, fixed the terminal heads at incorrect angles, he also placed the bottom part of the guilloche-horn in an incorrect alinement. The technique of both horns is the same.[1] The gold rests everywhere—with the sole exception of the topmost section—on a bronze lining over which its edges are folded; most likely the patterns were embossed in the bronze and the gold foil hammered on, but this could only be proved by dismantling the parts. The collars are in two pieces; the gap between them is due to oxidization. The working procedure was as follows. A curved iron rod was pushed up into the ox-horn at its point, then the uppermost segment, which has no bronze lining, was carefully forced on and fixed by the upper half of the topmost collar. Next came the assemblage of the long segment between the first and the second collar; the segment consists of three longitudinal sheets overlapping and masked at the joints by the bead-rows, which also rest on a bronze strip, the junction probably reinforced by some kind of glue. Then came the mounting of the under part of the first collar and of the upper part of the second. Finally the ram's head was pushed on the iron rod and secured by a gold-plated rivet. The head is hollow at the neck end, the rest of it solid casting; in the muzzle, a little loop and in it some metal which has not been analysed.

That the gold was the mounting of ox-horns is certain from the circumstances of these and of analogous finds. Both horns come from the same workshop, the scale-horn being the better job.

18. BERLIN, Antiquarium. From Schwarzenbach. Ebert 7 pl. 191; Bossert 1, 63, 1; Die Antike 10 1934 pl. 3 and p. 25; Kühn 387. *Pls. 18, 19; PP 12, 301–3, 324–5, 365, 367 a, 410.* Furtwängler (AA 4 1889, 43) was the first to see that the piece is not a flat strip, but the veneer of a hemispherical cup; yet misapprehensions and incorrect drawings still linger on. Now mounted on wood. Diameter 12·6 cm., and 11·8 cm. of the hemispherical cup below the detachable rim; height total 8·5 cm. and 7 cm. without rim. The separately wrought parts are: (*a*) the rim, outside 1·5 cm. high, inside 1·8 cm., at bottom 0·4 cm. thick, folded over bronze core; (*b*) the narrow strip with a frieze of hanging lotus-buds; (*c*) the high panel with two zones of openwork ornament; (*d*) the base with a rather jagged hole (original) in the centre, possibly an omphalos within.

19. CDM. Found at Auvers (Seine-et-Oise) in a tomb the associated finds of which are not known. Déchelette

fig. 694, 1; BM EIA fig. 16; Die Antike 10 1934, 24 fig. 5. *Pls. 19, 20; PP 329, 330.* Traces of iron rust and bronze patina from other objects in the grave. The slightly convex gold foil rests on two bronze plates of similar profile. The lower of them is thicker. The patterns are embossed on the upper and the gold foil hammered on; the edges of the gold are folded over its rim and were also connected by rivets, the heads of which, gold-plated and with coral studs, appear at the ends of one axis. The same rivets hold the base plate, and it is likely that the central coral-inlaid knob, which probably has an iron and (or) bronze core, continued into a rivet. The distribution of coral is clear from the drawing in *pl. 20*, where black indicates coral.

20. MAINZ. From Weisskirchen. Déchelette fig. 585, 2; JL 29; Die Antike 10 1934 pl. 2; Kühn 385. *Pl. 21; PP 388, 389.* Fragmentary above and below. Maximum diameter 8 cm. The gold foil rests on an iron lining 0·5 cm. thick. Lindenschmit states that under the gold there is an equally thin plate of bronze in which the pattern is embossed; this cannot be verified, but is probable from analogies. In the middle, an amber ring, the central depression of which is covered with a gold disk; the five sockets round the boss had certainly some inlay; the analogy of the similar ornament from Schwabsburg (no. 21) suggests that there have been more inlays, but they are not preserved; moreover the terminal medallions are rather shallow and have no pins.

21. MAINZ. From Schwabsburg. Déchelette fig. 694, 2; Behrens no. 172; WPZ 19 1932, 101 fig. 15; Mannus 25 1933, 101 fig. 9; Kühn 385. *Pl. 21; P 2.* Diameter 7·8 and 7·9 cm. respectively. Thick iron lining, corroded and decomposed; above it, a bronze plate, and above that, gold foil. Of the corals the four pear-drops at the ends of the axes are only pinched in; the round studs are fastened with nails, and on two of their heads gold plating is still preserved. In the centre, amber disk with engraved compass-drawn circles and connecting swags; the large pin to secure it is missing.

22. STUTTGART. From Klein Aspergle. Déchelette fig. 585, 1; JL 31; Gössler, in Ausgewählte Werke aus den Württembergischen Landeskunstsammlungen (1929); Ebert 7 pl. 4, a; Die Antike 10 1934, 21 fig. 3; Paret, Urgeschichte Württembergs fig. 18, 2. *Pl. 22; PP 390–1.* 6·9 cm. broad, 4·3 cm. high. The gold rests on an iron plate, much scaled; the iron is exposed in the cut-out spaces of twelve disks and of two spherical lozenges. In some of the disks, traces of bronze pins which fastened corals; possibly the lozenges also had inlay. The ornament was found on a triangular girdle-clasp (AuhV 3, 12 pl. 4, nos. 4 and 5; see text), but it is unlikely that they belong.

23. STUTTGART. From Klein Aspergle. JL 31; Gössler, Mitteilungen aus den Württembergischen Kunst-

[1] I had the opportunity of examining the technique with Professor Gössler and the goldsmith Mr. Biehlmaier.

sammlungen (1929); Ebert 7 pl. 4, b. *Pl. 22; PP 340, 377*. The piece consists of the round and a 'handle'. Round: 3·8 cm. diameter; slightly concave; two rivets with gilt heads. The handle now 8·5 cm. long: it was more complete when drawn for the first publication in AuhV 3, 12 pl. 5, 1. That the two pieces really belong is suggested by their position in the tomb, shown by a drawing made at the moment of discovery and preserved in the museum. That it is a spoon is unlikely because of the shallowness of the round, but what it was is hard to guess. Both parts have bronze lining; the edges of the gold are folded over the bronze. Here also, as in the Amfreville helmet (no. 140), the Auvers lid (no. 19), and other pieces, the pattern was embossed on the bronze, as shown by the drawing (which I borrow from Lindenschmit, AuhV 3, 12 pl. 5, 1 b).

24. BRUSSELS. From Eygenbilsen. De Loë, Belgique ancienne 2, 196 fig. 85, p. 174; Morel pl. 8, 4; JL 33. *Pl. 23; PP 75, 132, 387*. 6 cm. high, still 22 cm. long, curved, now mounted on a curved surface with a chord of about 19 cm. The gold is very thin. The present mounting makes it impossible to verify the presence of original glue on the back as stated by former writers. The edges are cut sharply, but do not follow the beaded outlines of the margin quite precisely.

25. MB. From Somme-Bionne. Morel pl. 8, 1; JL 37. *Pl. 23; P. 273*. 17·5 cm. long, broken to right and left. Very thin foil. Now arbitrarily mounted on an Etruscan beak-flagon from the same tomb.

26. BERLIN, Antiquarium. From Waldgallscheid. JL 23; Morel pl. 8, 6. *Pl. 24; P 402*. Two fragments, one 21·2 cm. the other 20 cm. long, both 3 cm. high, of a gold band once longer; possibly original end at the left side. Foil very thin.

27. SPEIER. From Dürkheim. JL 22. *Pl. 24*. 11·5 cm. long. Very thin gold foil. Some fractures across the band; the middles of the terminal disks—not loops!—are broken away.

28. SPEIER. From Dürkheim. AuhV 2, 2 pl. 1, 5; JL 22. *Pl. 25*. 7·6 cm. broad. Very thin gold foil. Green patina caused by a bronze object in the grave. Composition of fragments more nearly correct in the plate than in former publications. Relation between larger and smaller portion necessarily uncertain. On lower border, a little towards the right of middle axis of lower mask, circular nail-hole. This excludes connexion with a textile found near by in the tomb (AuhV 2, 2, text to pl. 2); the gold must have been mounted on leather or wood.

29. BERLIN, Antiquarium. From Waldgallscheid. JL 23. *Pl. 25*. Diameter 1·4 cm. Thin stamped gold foil. Patterns squashed and very indistinct, possibly triangular whirls as on the bronze knobs from the same grave, no. 153 (*i*).

30. TRIER. From Ferschweiler. JL pl. 35, f, g, h; Steiner, Forschungen und Fortschritte 1930, 246. *Pl. 25; PP 79, 370*. (*a*) 4 cm. high. Gold foil of medium thickness. On back, traces of green bronze patina. A piece of the nose broken away, cheeks and chin dented. Below chin, nail-hole, two others under the side spikes of crown; edges of crown partially tilted upwards. Hair in fringes, eyebrows notched. (*b*) 4·9 cm. diameter. Foil thinner than that of (*a*). Inner edge tilted upwards in places. Pattern die-stamped on obverse. The profile suggests that the disk had its place on a small lid or on a curved part of a vessel. No traces of nails. (*c*) diameter 2·3 cm. Technique as in (*b*). Cutting of edge sometimes does and sometimes does not follow the outline of the tongues.

31. TRIER. From Remmesweiler-Urexweiler. JL 25. *Pl. 25*. 1·4 cm. diameter. Both disks have some sort of appendages at the rim, and these with a third of similar form would form one of those popular Celtic three-circle motives.

32. STUTTGART. From Klein Aspergle. AuhV 3, 12 pl. 6 with text; JL 30; Gössler, Ausgewählte Werke aus den Württembergischen Landeskunstsammlungen 20 ff.; Germania 18 1934, 17. The painted cup: Ebert 7 pl. 1; JL pl. 33; Schaal, Vom Tauschhandel zum Welthandel pl. 11, 1; Die Antike 10 1934, 19 fig. 1 (text incorrect). Attributed to the Amymone painter by J. D. Beazley, Greek Vases in Poland 39 and 80; BARV 551 no. 18. The other, plain, cup, JL pl. 34, c, and Gössler l.c., p. 21 fig. 3. The loose gold ornaments (not complete) AuhV l.c. pl. 5. *Pls. 26, 27, 28; PP 211, 267, 314, 369, 376*. Some of the gold plaques are fixed on the two Attic cups from the tomb, but most of them—plaques, disks, strips—are loose and are figured here in the present state of mounting. I also illustrate some of the ornaments from electrotypes made in the workshop of the Mainz Museum when Lindenschmit restored the find.

Both cups are pieced together out of numerous fragments. The 'priestess cup' is 5 cm. high and has 15·4 cm. internal diameter; some restorations on altar and on feet and chiton of priestess. Red: fire on altar and flame of torch, stem and korymboi of ivy-wreath round the picture. Lavish sketch-lines. The masterly turned rings on the under side of the foot are characteristic of the school to which the painter—and potter—belong. The plain cup is 5·4 cm. high and has 15·2 cm. internal diameter. Its only decoration is a straight laurel-wreath, superposed in yellow colour, now less visible than at the time of discovery (see AuhV l.c.). On the under side of the foot no turned rings, but only concentric painted circles. The gold plaques were mounted on the cups by Lindenschmit, relying on statements of the excavators and his own observations: in AuhV l.c. text to pl. 6, he gives a detailed, not too clear, report. Holes in the clay can still be made out at some points, and there were fragments of small oxidized bronze pins, but their position does not corre-

spond to the fractures in the cups, so that the plaques are not a kind of refined repair such as was practised by the Japanese from the seventeenth century A.D. onwards, but an adornment of the modest Attic clay ware by the luxurious Celts. There must have been a good many more gold plaques on the cups: it is easy to tell which of the loose ones originally belonged. There was also decoration inside: one can still see—in the original—a small gold disk beside the altar and, a little to the right, under the feet of the priestess on the rising wall of the cup, a larger gold ornament. That the present arrangement meets the intention of the Celtic artist is clear in one point at least: the way the two curved leaves bend round the root of the handle of the plain cup is copied from the motive on the handle-attachments of Etruscan bronze stamnoi like *Pl. 220, a, d.* Even in the present mounting, which makes observation of technique difficult, it can be seen that the edges of some of the loose pieces were folded over, and the suggestion that they were fastened on leather or textiles is in accordance with the report (AuhV l.c. text to pl. 6), which mentions traces of textiles in the grave.

33. BONN.[1] From Kaerlich near Koblenz, chariot grave. Germania 18 1934 pl. 1, 13–18, p. 8. *Pl. 28.* Diameter of ring about 4·5 cm. Very thin gold sheet. The ring was folded over the rim of a tiny wooden or clay cup, and the little plaques were nailed on to its body; this is suggested by the similar decoration of the two cups from Klein Aspergle, no. 32.

34. BERLIN, Antiquarium. From Schwarzenbach.[2] BJ 23 1856 pls. 3, 4, 5, p. 131 (Ed. Gerhard); Déchelette fig. 698; Baldes-Behrens, Katalog Birkenfeld pl. 6, p. 51; Ebert 11 pl. 118; Die Antike 10 1934, 39; PZ 25 1934, 88. *Pls. 29, 30, 31; PP 245, 247, 300, 304–6, 371–2, 400. Pl. 29* shows the total find on scale 0·68 : 1; single pieces enlarged are figured in *Pls. 30, 31.* The disk with an eyelet figured by Gerhard l.c. pl. 5 fig. 17 has since disappeared. The foil is very thin; in most cases the edges are folded over. Details: no. 6: in the central conical boss remains of iron and bronze core; edges not folded over; possibly the curved fragments nos. 50–3 were originally parts of the rim of the disk. 15 and 20 were the veneer on front and back of the leather which is partially preserved on both of them. 27: probably wooden (?) core of heads like 25 and 26; surface covered with modern glue, but original traces of copper oxide. 34: a bronze tongue, only the lower part covered with gold. 46: gold, completely black on front, only recognizable on back. 48 fits on 45, originally *one* convex boss. 49: hollow hoop.

35, 36. BERNE. From Grossholz ob Ins (Anet).

Bonstetten pl. 14 figs. 3–7; Heierli, Urgeschichte der Schweiz 373 fig. 362. *Pls. 31–2.* To-day somewhat less complete than shown in the publication cited. Now mounted on slightly domed lining. Diameter 14·8 and 13·8 cm. respectively.

37. BERNE. From Grossholz ob Ins (Anet). Bonstetten Suppl. pl. 14; Heierli, Urgeschichte der Schweiz 373 fig. 361, b; Tschumi, Urgeschichte der Schweiz 129. *Pl. 32.* Found with cordoned bucket, drum-brooch, amber rings, and the granulated Etruscan gold bead, which is 1·05 cm. high and has a diameter of 1·3 cm.: this bead has already been figured by Bonstetten l.c.; Déchelette fig. 379, 2 (see p. 1596 no. 4). A gold chain from the find, figured by Bonstetten l.c. pl. 14 fig. 9, possibly formed part of the jewel to which the balls belong. Thirteen balls are preserved of which only three are figured. The foil is thin; the patterns are partially abraded or squashed and unrecognizable. Diameter about 2 cm. There are fragments of other balls in the museum, now squashed and flat.

38. BERNE and BIEL. Grauholz near Berne, from an inhumation-tomb with fragments of a chariot, a cordoned bucket, lignite rings, &c. Bonstetten Suppl. pl. 14 fig. 1, p. 21; Heierli, Urgeschichte der Schweiz 373 fig. 361, a. *Pl. 32.* The find is scattered, twenty-seven of the hemispheres in Berne, three in the Biel Museum. Very thin gold with stamped patterns. Diameter between 2 and 2·5 cm. They were certainly connected one and one on a wooden core; some of them have small neat holes on top, for a pin; they were presumably pendants of a chain.

Nos. 39–71. GOLD TORCS AND BRACELETS[3]

39. BM. Inv. no. 67. 5–8. 477. Ex Blacas collection. 'From France.' *Pl. 33.* 15·2 cm. Very heavy, probably with lead core. On the nape-point ancient repair at the original joint of the two halves. The bead-rows carelessly punched.

40. BM. No provenience. Archaeological Journal 3, 31. *Pl. 33.* 13·6 cm. Buffer-plates concave with traces of goldsmith's hammer. Thumb-knot ancient, with superstitious significance, compare no. 50.

41. BERLIN, Museum für Vor- und Frühgeschichte. From Besseringen. Déchelette fig. 584, 3; JL 21; Kühn 376, no. 1. *Pl. 34; PP 59, 277–8, 393.* 20·3–20·5 cm. Some dents should indicate *a priori* that the torc had not a metal core, or that the core had shrunk. Inside a cracked joint, from which it was possible to take a specimen of the core for analysis. It was found that the filling is in fact putty, consisting mainly of chalk, with traces of iron oxide and fine sand, and a desiccated oil (poppy or linseed)[4].

[1] Not having seen the find, I have to rely on the description in Germania l.c., and I take the measurements from the photograph reproduced, which I owe to the courtesy of the late Dr. A. Günther.

[2] Four of the ornaments have another provenience, 'Herappel bei Forbach', but it is not clear to which exactly the remark in

the inventory refers.

[3] I give the maximum internal diameter.

[4] At my request Professor Unverzagt had the analysis performed in the chemical laboratory of the museum. From the report: 'The specimen is a yellowish-brown substance, partly crisp, partly malleable. Main ingredient carbonate of lime

Section of torc almond-shaped. Both sides executed with equal care. The torc consists of the following separately wrought parts: (1) the torc itself. (2) The five 'balusters' soldered on the pedestal forming part of the torc; the one on the right side has come loose. (3) Two flat bridges, a filament of connected 'cigars' on a beaded row, soldered on to the side balusters and below on the torc (one bridge loose). (4) The birds, also soldered at their points of contact (one loose and broken away). The multiple bead-row along the upper ridge of the torc ends not far below the lower contact-points of the filaments; here, engraved floral decoration, reproduced in a drawing. On the torc, under each side-baluster, an engraved double chevron pointing upwards, hardly visible in the plate. Of the parts of the balusters level with the birds' heads, nos. 1, 3, 5, bear hatched triangles, nos. 2 and 4 overall cross-hatching. Some details on and above the claws of the birds are also engraved.

42. SPEIER. From Dürkheim. Déchelette fig. 584, 1; JL 22. *Pls. 35, 36; PP 403–4.* 21·4 cm. Some fractures. Specimens taken from a damaged point were submitted for analysis to the laboratory of the I. G. Farbenindustrie: 'There is a core of soft lead; between it and the gold an alloy of lead oxide and lead carbonate, from which talc and paraffin were distilled by benzol.' The torc has some small dents and is not quite true, but this does not seem the result of pressure from without. Cross-section pear-drop-shaped, the point of the drop being on the outside. The decoration has not been finished off: only on one of the three segments between the relief parts are the bead-rows completely modelled, on the others the pattern has only been scribed for modelling.

43. BONN. From Waldalgesheim. Aus'm Weerth pl. 1 fig. 1, 1 a, 1 b; Déchelette fig. 582, 1; Ebert 14 pl. 55, c; Die Antike 10 1934, 27 fig. 7. *Pls. 36, 37; PP 353, 445, 450.* Diameter 18·7 cm., external 19·9 cm. Cross-section of undecorated hoop circular, increasing in diameter towards terminals. Modern repair visible. The blows of the goldsmith's hammer recognizable in many places. Slightly out of centre by wear. The torc, as careful examination shows, was wrought in different parts. (1) The relief-decorated portions of the hoop—with a joint along the inner side—which was then hammered into one with the undecorated large segment. (2) The adjoining smaller cushion. (3) The concave part adjoining it. (4) The buffers. (5) The ornamented base-plate of the buffers, with a tiny hole in the exact centre, certainly the trace of a tool (turntable). The joints between these parts are masked by bead-rows, these probably hammered out of a gold wire.

44. ANCONA. From Filottrano, tomb 2. Dall' Osso 240; Dedalo 5 1924, 10; Ebert 6, 291; JRAI 67 1937 pl. 19, no. 1, p. 236; JRS 29 1939, 98. *Pl. 38; PP 82, 354, 355.* 14·9 cm. Intact, only out of shape at undecorated part of hoop. The torc is heavy and has presumably a base-metal core. No traces of wear. The goldsmith's hammer recognizable in places, especially on the buffer-plates, where the same central tiny hole appears as on no. 43.

45. BM. Acquired in Belgium. British Museum Quarterly 5 1930/1 pl. 7. *Pl. 39.* 13·5 cm. Hollow, dented in places, some holes and cracks. Broken at nape-point; here a bronze wire has been inserted—probably an ancient repair. One of the decorated terminals was clumsily repaired after excavation. It is noticeable that at the terminals the ornament where it touched the skin is better preserved than the rest.

46. SOFIA.[1] Found in 1903 on the bank of the Danube near Zibar (parish Lom). Ebert 2 pl. 110, b. *Pl. 40; P 103.* Diameter 15·2 and 13·9 cm. respectively.

47. VIENNA, Prähistorische Staatssammlung. From Oploty (Oblat), Bohemia. Mitteilungen der Wiener Anthropologischen Gesellschaft 20 1920, Sitzungsberichte 12 fig. 7; Stocky pl. 21, 13. *Pls. 40, 41; P 155.* 14 cm. Solid casting; the ornamented parts seem to have been cast with the torc and then retouched.

48. SALZBURG.[2] From Maschlalpe near Rauris. Jahrbuch für Altertumskunde 1912, 1 ff. fig. 1, 2. *Pl. 41.* Still 14·2 cm. long. Out of a massive cast torc, probably broken and therefore useless for its former purpose, a man has hammered a part into the shape of a punner.

49. DUBLIN. From Clonmacnois (King's Co.). Armstrong, Catalogue of Gold pl. 13, no. 98, p. 29; Journal of the Royal Society of Antiquaries Ireland 53 1923, 15 fig. 9; Archaeologia 55, 405 fig. 8. *Pl. 42.* 13 cm. Two modern fractures in hoop; partially dented. Hollow; joint traceable on the inside. The two buffers beaten together from one sheet of gold. There are six notched gold wires round the ring, not quite closed, beside the knobs of the throat part and beside the 'case' on the nape-point. One part of the hoop (the right-handed one in the picture) is detachable and fits into a circular hole in one knob, while the other end of it fits into a hole in the case; both holes have a diameter of 0·4 cm. The case is circular in cross-section at both ends; its 'body' is not a cylinder, but would be square if it were not for the strips which ascend and return to each of the circular extremities, intersecting on their journey. They bear a serpentine pattern, which is not a gold wire soldered on, but hammered out. On each of the four sides of the case they enclose a central depression which was probably never filled.

50. BERLIN, Antiquarium. From Waldgallscheid. JL 23. *Pl. 42.* 8 cm. Thickness of wire 0·2 cm. Out of shape.

(chalk), traces of iron oxide compounds, small quantities of fine sand, traces of gypsum and chlorides. I was able to detect acrolein, which points to presence of vegetable oils. Test for resin produced negative results.'

[1] Professor Filow very kindly provided me with photographs, casts, and information.
[2] I am indebted to the Keeper, Dr. Silber, for the photographs reproduced.

Half-hitch original and due to superstition, compare no. 40.

51. AROLSEN. From Horhausen. 8 cm. diameter; thickness of wire 0·35 cm. *Pl. 92* (see no. 154).

52. TRIER. From chariot-burial at Hillesheim (Eifel). Trierer Zeitschrift 4 1929, 145 fig. 5; ib. 5 1930, 104; Forschungen und Fortschritte 6 1930, no. 19. (Steiner) *Pl. 43.* 7·7 cm. Cross-section flat ellipse with sharp ridge outside. As good as new save for some undulations of surface where the core has come loose. Joint visible. Only decoration beaded row on ridge.

53. TRIER. From Zerf (Kreis Saarburg, Rheinprovinz). JL 29. *Pl. 43; P 347.* Diameter 7·2 and 6·5 respectively. Hollow. Profile pear-drop-shaped, the point on the outside. In some places the goldsmith's hammer is recognizable. On the ridge at some points and inside over two-thirds of the circumference the joints have cracked. The bracelet must have been worn for a long time, the ornament being much abraded. The decoration along the ridge unfinished and only scribed in places.

54. BONN. From Waldalgesheim. Aus'm Weerth pl. 1, 4. Déchelette fig. 582, 2; Ebert 14 pl. 55, b. *Pl. 44.* 8·2 cm. Intact and true. The joint which must have existed is not recognizable.

55. BONN. From Waldalgesheim. Aus'm Weerth pl. 1 figs. 2–3 b; Déchelette fig. 582, 3, 4; Ebert 14 pl. 55, a, d; Kühn 375. *Pls. 44, 45; PP 129, 439, 441.* Both 6·5 cm. The two bracelets, of which I figure one, are twins, alike in every detail; there are some very slight variants in measurements, as is natural in handiwork. The piece which I do not figure is broken and makes observation of technique easier; it is less worn than the other. The gold is 0·08 cm. thick. The undecorated hoop swells towards the relief portions. The technique corresponds closely to that of the torc from the tomb (no. 43).

56. BM. Same provenance as no. 45. British Museum Quarterly 5 1930/1 pl. 7. *Pl. 46.* Same workmanship and certainly from the same find. A pair: internal diameter 6·9 and 4·8 (the other piece 4·3) cm. respectively. Light, hollow, dented, some holes.

57. SPEIER. From Dürkheim. JL 22. *Pl. 46.* 5·7 cm. Somewhat out of shape, dented at one point. Otherwise as good as new, no traces of wear. Cross-section ellipsoid. Each segment tapers from the base of the masks towards the caesura formed by a torus, and accordingly the beads on the outer ridge become lower and smaller; they have small bored holes on top, too small for inlay. These plastic beads are accompanied by bead-lines, which ascend at the one end to the ears of the mask and join at the other a similar bead-line delimiting the torus mentioned. Beside one of the tori is a joint where one end of the ring was pushed over the other; at this point there is a slight irregularity in the bead-pattern.

58. BERLIN, Museum für Vor- und Frühgeschichte. From Schwarzenbach. Déchelette fig. 584, 4; Berliner Museen 1935, 6 fig. 3; JL 26. *Pl. 46.* 7·2 cm. Somewhat out of shape. Cross-section pear-drop-shaped, the point of the drop being outside where the bead-row runs. Hollow and probably with a base-metal core. Joints not visible. Traces of the goldsmith's hammer. Hair of masks in fine engraved lines, on the inside partially abraded by wear. On one ball and in its neighbourhood traces of clumsy ancient repair which has spoiled the decoration.

59. SPEIER. From Rodenbach. Déchelette fig. 583, 1; JL 26; Die Antike 10 1934 pl. 8; Kühn 376, 2. *Pl. 47; PP 275–6.* 6·7 cm. Occasional traces of green patina from bronzes in the tomb. One fracture. Apart from some dents on the undecorated segment, splendidly preserved; no trace of wear. Cross-section an almond. Both sides executed with equal care. The six egg-cups in the middle and the numerous smaller ones have deep depressions not intended for inlay; two of the latter broken away; they rest on a bridge soldered to the surface of the ring and are interconnected; the locks of the middle animals and the pair of spirals with a 'tail' at the outer end of the relief portion are also soldered on.

60. ZURICH. From Lunkhofen. Archaeologia 47 pl. 5, no. 12; ASA 8 1906, 92 fig. 50; Heierli, Urgeschichte der Schweiz 369 fig. 358. *Pl. 48; P 386.* A pair. 5·4 and 5·5 respectively. Cross-section a pear-drop, the point of the drop on the outside. Joint visible on silver bracelet and on gold catch which consists of a swell, plain, between two cylinders with punched flower-pattern, irregular at the joint.

61. MAINZ. Probably from Rheinhessen, but particular provenience unknown. Behrens 178 (drawing). *Pl. 48; P 280.* 3·8 cm. long; diameter of undecorated portion of ring 1·3 cm.; thickness of gold 0·075 cm. In the grooves traces of the typical white slime from the Rhine bottom. The part with the lion's head is worked separately and consists of an upper and a lower half fitting to each other like the halves of Greek moulded terracotta figurines. In the muzzle is a square hole, about 0·5 cm., probably intended for the catch. For

reinforcement a bronze ring with three offsets has been inserted into the two halves of the mouthpiece (see the drawing in the text). Possibly the ring proper had two halves with a hammered joint.

62. BUDAPEST. From Herczegmarok. Arch. Ert. 1903, 23; CPF Autun, 1907, 826, 827 fig. 3, 4; Déchelette 1342, 1344. *Pls. 48, 49.* Five fractures. In the present state of mounting 9·7–10 cm. The circlet is beaten out

of two sheets of gold, 0·05 cm. thick, top and bottom over-lapping at a central corrugation. Catch: the tenon, as the ring is now set up, stands at an angle of 90° to the direction required to lock it; apparently thinness and elasticity of the gold allowed all this play.

63. CdM.[1] From Aurillac (dépt. Cantal). CPF Autun, 1907, 825 figs. 1, 2; Déchelette 1342. From the Luynes Collection, acquired in 1862. *Pl. 49.* 7·8 cm.; height 3 cm. Weight 192 g.

64–7. TOULOUSE, Musée Saint-Raymond.[2] From Fenouillet (Haute-Garonne). Mém. Soc. arch. du Midi de la France 4 1840–1, 375 (Belhomme); Revue d'anthrop. 1899, 286 (de Cartailhac); Matériaux pour l'histoire primitive et naturelle de l'homme 20 1886, 189; RA 1912 I, 29; Déchelette fig. 588. *Pl. 50.* I figure five intact torcs, the sixth being very badly broken. Not having been enabled to study the pieces at close quarters, I must rely on the statements of the authors quoted. I repeat the descriptions by Cartailhac and Déchelette:

'La face extérieure d'un de ces colliers est revêtue de petits bourrelets en or, garnis chacun de quatre fleurons à quatre pétales disposés en chenille et couvrant le cercle dans toute sa longueur. Un second n'était ainsi orné que dans son tiers antérieur; les autres étaient simples. On a cru aussi reconnaître dans cette élégante et riche décoration la fleuraison du gui du chêne. Ce collier, comme celui de Lasgraïsses, avait deux ouvrants et les fermoirs sont analogues.' (Matériaux l.c.)

'Trois sont fermés chacun de deux tiges réunies par torsion, et munies à leurs extrémités de rondelles présentant, l'une, un panneton-fermoir, l'autre une ouverture en T qui reçoit ce panneton. Un quatrième présente près du point d'ouverture deux groupes inégaux de très petites spirales refoulées et formant fleuron. Un cinquième (fig. 588) est strié en torsade; les deux extrémités sont terminées par des rondelles saillantes, accompagnées chacune de huit demi-anneaux décorés de fleurons ciselés. Enfin le dernier, le plus ornementé de tous, présente dans toute sa circonférence une série de demi-anneaux richement décorés de fleurons; une double rondelle, placée au centre, simule le point de division, mais la véritable ouverture se fait à la partie postérieure.' (Déchelette l.c.)

68. TOULOUSE, Musée Saint-Raymond. From Lasgraïsses (Tarn). Cabié, Bijoux antiques en or découverts à Lasgraïsses, Rev. historique du département du Tarn 1885, 258; Caraven-Cachin, Le trésor de Lasgraïsses, Journal du Tarn 15 jouillet 1885; Cartailhac, Le torques et le bracelet d'or de Lasgraïsses, Matériaux pour l'histoire primitive et naturelle de l'homme 20 1886 pl. 2, p. 182; idem, L'or gaulois, Revue d'anthropologie 1889; de Mortillet, L'or en France, Revue des ét. anc. 1902, 63; CPF Autun, 1907, 824 (Comte Costa de Beauregard); RA 1912 I, 29, Déchelette fig. 587. *Pl. 50.* No measurements

available. Analysis by the École des Mines: Gold 75·50 per cent., silver 24·50 per cent. Inside almost plain and undecorated.

69. TOULOUSE, Musée Saint-Raymond. For provenience and publications see on no. 68. *Pl. 51.* Found with it, sherds of Celtic pre-Roman pottery. Measurements not available. Cartailhac makes the following statements on technique and locking-device: 'Le collier est en deux branches qui s'agrafent entre elles très ingénieusement. Les détails de l'agrafe et du fermoir sont indiqués dans les figures ci-après. On introduit d'abord le tenon (fig. 59 et 60) dans l'ouverture de l'extrémité (fig. 61). Les deux branches sont alors perpendiculaires l'une à l'autre, et c'est ainsi qu'on peut introduire le cou au milieu d'elles. On ramène les tiges à leur direction normale. Le tenon a ainsi tourné dans sa gaine et ne peut plus s'ouvrir. Les deux autres extrémités s'agrafent alors au moyen d'un crochet (fig. 62–63), muni d'un bras central de consolidation qui pénètre avec ce bras dans une gaine (fig. 64–65) creusée dans l'autre branche. Une petite targette ou verrou sert à arrêter cette fermeture dans cette position. La partie antérieure de ce torques est occupée par deux bourrelets ou renflements circulaires, sur lesquels se dressent successivement cinq fleurs d'un dessin original et gracieux. La figure 66 reproduit les découpures d'un petit disque a' b' qui sépare les deux bourrelets; cette plaquette est, à l'intérieur, frisée (fig. 67). Elle est au centre du collier, mais le fermoir est de l'autre côté du bourrelet en a b (fig. 68).

'Ces parures sont l'œuvre d'une orfèvrerie primitive. L'ouvrier a donné d'abord, semble-t-il, aux lames ou feuilles d'or leurs courbures générales; il a dû ensuite obtenir toutes les saillies qui forment les ornements, mais quel a été son procédé? A-t-il travaillé au repoussé? Dans ce cas, l'intérieur serait martelé, et je n'ai pas vu de traces de coups; au contraire, la surface interne a l'aspect du métal fondu; mais comment expliquer avec le procédé de la fusion les creux profonds qui correspondent aux saillies extérieures? Est-il possible de jeter l'or fondu dans un moule et d'en tapisser d'une couche mince, 1 à 3 millimètres, les parois de la cavité? Si oui, l'orfèvre a dû opérer ainsi. Les diverses pièces de la partie centrale, la suite des branches du collier, la face intérieure ont été fabriquées séparément et soudées entre elles après coup. Il peut en avoir été de même pour les divers renflements qui forment le bracelet. Il est proportionnellement plus léger et plus fragile que le collier. La face interne est composée d'une feuille de métal d'un demi millimètre d'épaisseur en plusieurs pièces soudées. La bande entière s'applique contre les bords du reste de la pièce plutôt par sertissage que par soudure, aussi s'est-elle détachée en partie ou même complètement sur plusieurs points. Le ciseau a été certainement employé pour modeler certaines

[1] Jean Babelon very kindly provided me with the above measurements and authorized me to publish the photographs.

[2] I am much indebted to Count Bégouin for the photographs reproduced here.

figures des deux objets, accentuer les arêtes et aplanir les petites marges circulaires au-dessus desquelles s'élèvent les godrons ou les fleurs mamelonnées.'

70. Once BRUSSELS, Palace of Prince Arenberg, present whereabouts unknown.[1] From a hoard found in 1862 at Frasnes-lez-Buissenal (Hainaut). Joly, Annales du Cercle archéologique de Mons 7 1865, pls. 1 and 2; Couhaire, Bulletin de la Société d'Anthropologie de Bruxelles 13 1894–5, 125 pl. 12; Déchelette fig. 586; de Loë, Belgique ancienne 2 fig. 111, p. 201; Blanchet, Traité des monnaies gauloises 2, 605. *Pl. 51.* One has to rely on the publications and to interpret them carefully: there remain, however, difficulties and doubts due to discrepancies of descriptions and drawings. I reproduce Joly's two plates (which, apart from minor details, agree with Couhaire) and Déchelette's photograph. There are two gold torcs: *fig. a* of 12 cm. diameter, plain, it seems, save a small ring round the neck part, decorated with a kind of herringbone pattern. The other torc, illustrated in the remaining figures, has a diameter of 20 cm. (on the plate reproduced the two rings are drawn on different scales). It is not well preserved, has cracked, and got loose at some points. The gold sheet, 0·35 cm. thick, has, as Couhaire states, a filling of a viscous substance and an iron core. In the drawing *fig. b* the buffers remain at a distance, and a tenon sticks out of one. It is difficult to verify the details drawn. *Fig. e* fills the space between the terminals with a member which is shown separately in *d* and *g*: a ring decorated with a row of crosses, each formed by four little globes. The same appears in Déchelette's photograph: *f* puts between the buffers a ring which, when the photograph was taken, was placed on the nape part of the torc. This little ring is adorned with a stylized animal head similar to that on the hoop near the buffers: Couhaire's draughtsman wrongly saw birds here (*fig. h*). Apparently the torc was excavated in pieces, which were assembled in different ways: this would also explain why Couhaire even speaks of three instead of two torcs.

71. SOPRON. From Sopron, Wiener Hügel. *Pl. 52.* Diameter 6·2 and 5·4 cm. respectively. Weight 13·5 gm. The 0·15 cm. thick wire partially hammered to chamfered edges. Found with it, a gold wire finger-ring, undecorated, of 2 cm. diameter, squashed.

Nos. 72–83. GOLD FINGER-RINGS, EARRINGS

72. SPEIER. From Rodenbach. Déchelette fig. 583, 2; Ebert 11 pl. 30, e; JL pl. 35. *Pl. 52; P 321.* Diameter 2·1 cm.; maximum height in front 1·2 cm., on back 0·4 cm. Gold of medium thickness. Edges turned in slightly. If the ring was beaten, the pattern ought to appear on the reverse; actually it does not, and the ring must therefore have been cast.

[1] Mr. Jacques Breuer kindly gave me the reproductions from Joly's rare publication and helped me in many other ways: most of the above statements are his.

73. TRIER. From Zerf, Kreis Saarburg, Rheinprovinz. JL 29. *Pl. 52; P 384.* Diameter 2·2 cm. As good as new. Very thick soft gold. On back of hoop joint. Reverse plain, edges slightly turned in. The ring was not beaten over a templet, but wrought on the goldsmith's anvil and punched.

74. GENEVA. Formerly at Château Grancy. From Étoy (Vaud). Lindenschmit pl. 39, 10; Déonna, Au Musée d'Art et d'Histoire 2 pl. 2, 9, pp. 12 and 46 fig. 15, 2. *Pl. 52; P 93.* Height in front 2 cm., on back 0·5 cm. Diameter 2 cm. On back, joint slightly visible. Hammered.

75. ANCONA.[2] From Filottrano, tomb 2. JRAI 67 1937 pl. 19, 3, pp. 237 and 277 (Baumgärtel); JRS 29 1939, 98. *Pl. 52.* Not having seen the ring myself I borrow the following facts from Dr. Baumgärtel's description. 'Maximum diameter 2·1 cm., minimum diameter 1·4 cm. The ring is shaped as a rectangle with rounded corners, one of the long sides forming the signet. It may have been worn on the upper section of a finger. At the intersections of the ring itself and the bezel, there are small palmettes in relief, much worn down.' On the bezel, griffin rampant to left, neck and belly separated by cross-band. End of tail signified by conglomeration of balls; similar rendering of feet. Above the sagging back crescent; in front and below belly, six-pointed rosette, the former with filling dots between the six rays: this might be the sun, the other a star.

76. ANCONA.[2] From Filottrano, tomb 9. JRAI 67 1937 pl. 26, 5, p. 254 (Baumgärtel); JRS 29 1939, 98. *Pl. 52.* I have to rely on Dr. Baumgärtel's description: 'Diameter 1·8 cm. The metal is darker and more reddish than of the other gold ornaments; one could almost take it for bronze, but for the absence of any trace of verdigris. The alloy may have had a larger proportion of copper. Three strands of wire, about 0·1 cm. thick, are twisted together to form the ring. Their free ends form six spirals, so arranged as to surround a circular space. A tiny gold ball is attached to each of the lowest spirals.'

77. BERNE. From Münsingen, tomb 12, a girl's grave. Wiedmer-Stern pl. 5, 1, pl. 20, 1; Viollier pl. 28, 1; Déchelette fig. 545, 2; AuhV 5, 335 fig. 3, l. *Pl. 52.* Diameter about 1·3 cm. (taken from reproduction).

78. BERNE. From Muri. Jahrbücher des Historischen Museums Bern 9 1929, 59 (Tschumi). *Pl. 52.* 1·8 cm. internal diameter. One piece of gold wire. The hoop has two round-turns and was then hitched and rolled into a coil; the wire was hammered to a kind of astragalus.

79. BERNE. From Muri. Jahrbücher des Historischen Museums Bern 9 1929, 59 (Tschumi). *Pl. 52.* 2·1 cm. diameter, 1·1 cm. high. Two whole and two half laps of gold wire, drawn out at the end and undecorated there;

[2] I am indebted to Dr. Galli for the photographs reproduced.

the rest has a pattern consisting of a mid-rib, between sets of hemispherical and lancet-shaped depressions.

80. BERNE. From Münsingen, tomb 181. Wiedmer-Stern pl. 20, 9, p. 78; Viollier pl. 28, 45; Déchelette fig. 545, 3; Ebert 11, pl. 135, 19. *Pl. 52.* Maximum internal diameter 1·8 cm.; 0·6 cm. high. Gold wire drawn out at the ends, two whole and two half laps. The decoration is a herringbone pattern, becoming lower towards the ends.

81. BERNE. From Oberhofen near Thun. Bonstetten pl. 27, 13; Wiedmer-Stern pl. 23, A; Viollier pl. 28, no. 29; Déchelette fig. 546, 5. *Pl. 52.* Internal diameter 1·9 cm., height of loop on back 0·2 cm. No joint visible. On bezel an animal (horse?), sway-backed, with long tail, to left. Wavy lines for ground and vegetation; in the field triquetra.

82. BERNE. From Rychigen near Worb, tomb 8. Jahresbericht des Historischen Museums Bern 1907, 19; Viollier pl. 28, 5 a. *Pl. 52.* Maximum internal diameter 1 cm. Open on top. Here the two 'astragalized' strands pinched off.

83. BM. From Marson. Morel pl. 3, 13, p. 163; Déchelette fig. 542, 8. *Pl. 52.* Diameter 2·3 cm. Beaten from a sheet of gold and turned over into a hollow crescent, drawn out at one tip to form a bridge pushed into the other.

Nos. 84–7

SILVER[1]

84. BRESCIA. From Manerbio sul Mella, near Brescia. Chance find made in 1927. Historia 1933, 570 (Albizzati); PZ 25 1934, 104. *Pls. 53, 54.* From the same site bronze torc in the same museum. Surface of silver bright, hardly any patina. The silver is relatively stout and its thickness varies within the single pieces. Chuck of turn-table visible on some of the disks. Very precise workmanship, traces of hammer often recognizable on reverse. The disks were given a raised rim by blows of the tap-hammer round it.

The find consists of: (A) Two larger disks, diameter 19·2 and 18·5 cm. respectively, and thirteen smaller of which eleven are completely or almost completely preserved, with a diameter between 9 and about 11 cm. I figure one piece of each set. The disks were fastened on a lining by silver rivets, up to 0·38 cm. long, with a globular head on the obverse and a washer on the reverse; at some of the rivet-holes the circular track of the centre-bit can be seen, possibly the preliminary work for the counter-sinking carried out at other holes. (B) Four fragments of hemispherical cross-section. They were mounted on some lining, probably wood, by two rivets. The two fragments figured in *pl. 54*, 10·2 and 9·15 cm. long respectively, show the shape and the curve. Below, a highly stylized head of a ram; above, the head of a Gaul, differing somewhat from those on the disks; he wears a torc; the side spirals signify ears, the beaded outline over the forehead belongs either to one of those crown-leaves or, as Albizzati assumes, is

the rim of a helmet. (C) Three silver toggle-joints, the figured one 3·7 cm. long, the others smaller, with hanging rings, loops, or perforated plaques which still have rivets in the holes; Albizzati reports that one of them was fastened to one of the disks.

The objects are horse-trappings.

85. GAP. From Pallon au Val Freissinières. Chantre, Études paléo-ethnologiques au Bassin du Rhône, Premier âge du fer pl. 7 fig. 6; Déchelette 1349. *Pl. 54.* Maximum diameter 14·7 cm. The hollows beyond the buffers possibly had inlay.

86. BERNE. From Münsingen, tomb 181. Wiedmer-Stern pl. 20, 10, p. 78; Viollier pl. 28, 30; Déchelette fig. 546, 4. *Pl. 52.* Internal diameter 1·9 cm., hoop 0·4 cm. high, increasing in height and thickening towards the bezel, which has a diameter of 1·1 cm. Its central depression covered by thin gold foil with indistinct representation. Round the picture an engraved wave line. Hoop itself undecorated, on its ends beside the bezel, a snakeline in relief, forming a coil: the ground there is covered with punched dots.

87. BUDAPEST, Kund. From Kosd, tomb 7; from the same tomb, 'astragalus' girdle, brooches with reverted foot, and plain bronze bracelets with globular members. *Pl. 54.* Present length of chain 38 cm. The coral twigs partly red, partly yellowish-white. Three silver 'poppy-heads' are preserved, of 1·8 cm. diameter, with twisted silver wires soldered on, and with lids at top and bottom which are covered with punched dots; a fluted lid belonging to a lost poppy-head also preserved.

Nos. 88–127

SWORDS

88. BUDAPEST. From Dinnyés. Márton pl. 14, 1, p. 51. *Pl. 55.* 11·4 cm. long. Solid casting. On the inside of the guards a slit to take the iron sword-blade. The end of the upper left grip missing. In the centre of the head, a drilled hole with fragmentary iron inset.

89. MAINZ. Dredged from the Rhine. AuhV 4 pl. 2, 3; Déchelette figs. 473, 1; 572, 1. Behrens no. 203. *Pl. 55. (a)* The dirk about 45 cm. long. Hilt of solid cast bronze, the blade of iron; on the pommel a hole for coral. On the front of blade, sun and moon inlaid in thin gold foil; the sun-disk 'basketry-pattern', around star of eight scallops. Along the mid-rib thin gold wire hammered in, and at a distance of 2 cm. from the point transverse silver wire, slightly thicker. (*b*) Iron scabbard, very fragmentary. A piece was still sticking to the front of the blade. Of the greater part only the skin with the engraved pattern is preserved, sticking to the breccia coating in which it was dredged. It is only of the top part that actual fragments remain, and even here the ornamentation is clearer on the scaled-off skin.

[1] See also the two silver fibulae nos. 324 A, 331, and the bracelets no. 60.

90. BERLIN, Museum für Vor- und Frühgeschichte. From Vert-la-Gravelle. PZ 25 1934, 99. *Pl. 56; PP 216, 279.* 69 cm. long, maximum breadth 5·5 cm. The iron sword itself is exposed on the back and at the tang. The surface of the scabbard rises to a mid-rib which flattens out towards the tang. It is unlikely that the disks of the chape and of the transverse bridge were inlaid. The lines of the engraved ornament are in tremolo and the circles in the stippled fields were made by compasses.

91. CHÂLONS-SUR-MARNE. From the Marne, without exact provenience. *Pl. 57.* Total length 70 cm. Badly preserved and broken. Scabbard iron, decorated with three bronze plaques, at the chape, at the root of the tang, and on the middle, where the rhomboid ornament is now out of plumb.

92. BM. Inv. ML 1732. From Bussy-le-Château. Morel pl. 39, 7; BM EIA fig. 56, 2. *Pl. 57; P 327.* 76·7 cm. long. Some restorations in plaster. Preserved, the iron sword and the front of the scabbard. I figure two of the three transverse embossed bronze bands; the middle band, the better preserved, is 4 cm. broad, the upper 2·7 cm.

93. BM. From Marson. Morel pl. 2, 9; Déchelette fig. 457, 7; BM EIA figs. 56, 1 and 57. *Pls. 57, 58.* Length of iron sword 54 cm. Much restored. On chape two corals preserved—there were three. Front of scabbard iron; the bronze 'heater' with the three 'negroes', 4·5 cm. high, in its original position; iron has panned over its rim.

94. BM. From Somme-Bionne. Morel pl. 29, 21; Déchelette, fig. 457, 9; BM EIA figs. 54, 55 (position of transverse bridge not correct). *Pls. 57, 58.* 90·4 cm. long. Front of scabbard bronze. On the back near the handle, an undecorated transverse bridge of bronze. In the matrices visible in *pl. 58*, and in those at the point of the chape, the corals are now missing.

95. BIRKENFELD.[1] From Ameis-Siesbach. Baldes-Behrens, Katalog pl. 9, 6, p. 53; JL 27. *Pl. 58; P 357.* Iron sword with bronze scabbard. No measurements or description available. The pin-holes show that the spaces chiselled out for the pattern were inlaid in coral. For the

chape and two bronze rings which probably belong to the sword-frog see Baldes-Behrens l.c.

96. VIENNA, Naturhistorisches Museum. From Hallstatt, inhumation burial 994, excavated in 1874.[2] Auh V4 pl. 32; Déchelette fig. 297; Much, Atlas pls. 70, 71; Lipperheide 530, 531; Schumacher, Gallierdarstellungen 18; Jdl 30 1915, 28 fig. 10 (Drexel); Ebert 3 pl. 122; Mahr, Das vorgeschichtliche Hallstatt fig. 11. Details are figured in Marc Rosenberg, Geschichte der Goldschmiedekunst, Einführung 17 fig. 18 (the wheel-turners), and Oe J 3, 38 (the wrestlers). See also Studi etruschi 3 pl. 24, p. 138. *Pls. 59, 60; PP 105, 218, 251, 395.* 79·7 cm. long, length of scabbard 68 cm. Preserved are: (1) Iron sword-blade with tang and pommel which has two bronze lateral wings. (2) Front sheet of bronze scabbard. Surface smooth with predominantly black-green patina. In some places the panning iron has cracked it. In the four bronze studs, drilled holes of 0·4 cm. diameter for corals, coral remains in one. The scabbard is engraved in hair-lines; scratches all over the figures. Best preserved, the group of two men with the wheel near the top, fairly well, the horsemen 1 and 2, badly, horsemen 3 and 4, less well, the foot-soldiers and the second group of the persons with the wheel; of the wrestlers at the chape only the right portion is even moderately distinguishable: the middle part has almost gone, and the tail at the left is almost completely abraded. (3) Cast bronze chape, overall length 23·3 cm., from point to beak of monsters 8·3 cm. Heads of monsters flat on reverse, their outline accompanied inside by thin engraved line. Here on back a transverse bridge, 0·5 cm. broad. (4) Portions of iron back piece of scabbard, on its upper part traces of the staple, 11 cm. long, which, as usual, fixed scabbard to sword-frog.

97. OXFORD, Ashmolean Museum. Inv. 1927, 1008. Found at Hallstatt in 1868; no indication of grave-group. *Pl. 61.* The iron sword, preserved in its full length, is 81 cm. long; it has panned much and its mid-rib has impressed its form on the bronze front part of the scabbard and caused cracks. The edges of the scabbard, at a distance of about 3·5 cm., are tricked out inside by a

[1] The photograph reproduced here was made for me by Dr. Kukahn.

[2] The Museum journal gives the following information on the grave: the objects were not accessible; the quotations refer to von Sacken, Über einige neue Funde im Gräberfeld bei Hallstatt, Mitt. Zentral Kommission N.F.I 1875, 1 ff. 'Schwert und Mitfunde kamen zu verschiedenen Zeiten ins Museum. Inv. 48. 323. Eiserne Helmhaube, zur Hälfte fragmentiert, aus sehr starkem Eisenblech mit schwach ausladendem untern Rand. Daselbst sind trotz des knolligen Rostüberzuges noch je 2 Doppellinien, durch einen breiteren Zwischenraum getrennt, zu erkennen. Basisdm. ca. 19 : 21 cm., H. 15 cm., Wandstärke 0·2 cm. (vgl. Sacken S. 3). An den Helm angerostet befanden sich zwei eiserne Lanzenspitzen. Von der einen, am Scheitel befindlichen, ist bloss die Tülle erhalten; die andere, am Rande festgerostete, ist besser erhalten und zeigt Frühlatèneform. L. ca. 16 cm. davon die Tülle 2·8 cm., Breite des Blattes 4·7 cm. (vgl. Sacken p. 4). Inv. 48324. Seiher aus Bronze, aus drei

Teilen bestehend. Diese sind: (1) Ein trichterförmiger Auslauf als Bodenteil des ganzen Stückes, der obere Teil aus ziemlich dünnem, der Trichterzapfen selbst aus stärkerem Bronzeblech. (2) Eine mittels 11 Nietnägeln darauf befestigte runde Siebplatte. Die Sieblöcher stehen in sechs mit den Spitzen konvergierenden Keilen. (3) Ein halbkugeliger Kesselteil aus anscheinend ganz glattem, unverziertem Bronzeblech. Der obere Rand wie bei den hallstättischen Situlen und Cisten eingerollt und jedenfalls durch Einlage verstärkt. An der Aussenseite ein Tragring (Kreuzattache?), an der gegenüberliegenden Stelle der Peripherie, wo das Stück restauriert ist, lässt sich solches nicht erkennen. Randdm. 27 cm., Kesseltiefe 15·5 cm., Gesamthöhe 23 cm., daher Länge des Trichterauslaufes 10·5 cm. (Sacken p. 2; alte Nr. des Stückes 552). Zu diesem Grab gehört auch die bekannte Schwertscheide, ein Hiebmesser aus Eisen und Besatzstücke vom Griff eines junghallstättischen Dolches (vgl. Sacken p. 2, 4, 12).'

neatly engraved line. Only half the chape is preserved; it has slits to receive the sword and the tubular frame of the scabbard. There are two transverse bridges with astragaloi and disks, probably hammered, not cast, which continue on the back into flat bronze strips, one with a nail-hole to hold the material of the back. No coral inlay on scabbard or chape.

98. BONN. From Weisskirchen. Déchelette fig. 439, 6; JL pl. 36, p. 96. *Pl. 61.* Length still 7 cm., thickness 0·7 cm. Interpretation of present and reconstruction of original state difficult. The drawing shows what is iron and what is bronze, the former hatched. The portion above the upper medallions, now scaled into three layers, is not part of an iron scabbard but of the iron sword itself; the iron between the medallions is due to panning of the sword-point. The three bronze medallions with the two curved lateral bridges are cast in one piece. The three smaller gold circles between the larger are now resting on iron, but there must originally have been a lining of leather or textile which has disappeared. The reverse is undecorated. The front of the chape bears six disks of thin gold foil; they have radially hatched rims; the centre of the two upper medallions is an eight-leaved rosette; the disk on the terminal medallion was placed eccentrically after excavation: the former correct position is still indicated by a relief-line on the surface of the bronze and by the point of a nail which also appears on the reverse: it once fastened inlay.

99. MAINZ. Inv. O. 17127. No provenience known. *Pl. 61.* 6·6 cm. broad, about 1 cm. thick. Heavy solid casting. Some traces of panning iron. The upper edge almost straight between the two medallions—more clearly visible on the reverse—is original. The three-leaved palmette below is faintly modelled also on the back.

100. MAINZ. From Weisskirchen. Abbildungen von Mainzer Altertümern 4 (1852), Lindenschmit, Ein deutsches Hügelgrab aus der letzten Zeit des Heidentums, plate; AuhV 2, 8 pl. 3, nos. 1, 2; Déchelette 1109 (with detailed description of the technique, which needs correction); JL 29. *Pls. 62, 63; PP 118, 379, 409.* About 32·5 cm. long. The reverse, not visible now owing to modern mounting, is reproduced from a cast. Comparison shows that the sword was more complete in 1852 than in 1870 and more complete in 1870 than now, the most deplorable loss being the absolute disappearance of the openwork parts. The scabbard is made of a thin bronze plate on each side: the iron sword by panning has cracked it in places. The five corals, except that in one eye of the left bird, have somehow vanished. There are discrepancies between the two drawings (1852 and 1870) of the ornaments on the frame-rib, but it is now impossible to decide between them.

The 1870 drawing of the engraved 'Running Dogs' on the reverse has to be corrected from the photograph, but the drawing of the engraved pattern above them cannot be checked at all. Important, but also beyond verification, are Lindenschmit's remarks (l.c. p. 4) on the openwork: 'Examination of the front of the bronze scabbard shows that the patterns were first scribed and then chiselled.'

101. MAINZ. Ring of sword-frog of no. 100. Abbildungen von Mainzer Altertümern 4 (1852), Lindenschmit, Ein deutsches Hügelgrab aus der letzten Zeit des Heidentums p. 9 fig. 6; AuhV 2, 8 pl. 3, 3; JL 29; Préhistoire 2, 72 fig. 2, 1. *Pl. 63; P 147.* Diameter 4·4 cm. Shaped and decorated similarly on both sides: I figure the better preserved. Bronze plate with circular hole in the centre; both edges scalloped, inside the scallopings, rings of beaded lines. Over about an eighth of the circumference there is a gap in the decorated rim. On both sides the plate carries a convex bronze ring, fastened on to it; a rivet appears over the gap. These rings are in openwork, to receive the coral inlay. The corals are bedded in a layer of stiff substance which can be cut with a knife, probably bitumen.

A similar, but fragmentary, piece was in the grave—part of a bronze ring 1·8 cm. in diameter, also with two 'façades', outer rim beaded, inner scalloped (see AuhV l.c. no. 5).

102. SAINT-GERMAIN. Inv. no. 12808. Presented by Napoleon III; probably from a chariot-burial in the Marne region. *Pl. 63.* In the same group is a pendant (same no.), and a similar fragmentary piece (no. 16603); see also Morel pl. 38, 1. The chape, which has a breadth of 7·5 cm., consists of three separately wrought parts: (1) the knobs on top, cast in one with the four matrices above them; (2) the 'bugle', a bent bronze tube, cracked in the joint on the back; inside an iron core; (3) the openwork with the two birds and four matrices.

103. ANCONA. From Filottrano, tomb 22. Dall'Osso 239; JRAI 67 1937 pl. 30, 6, p. 266; JRS 29 1939, 98. *Pl. 64; P 434.* 67·5 cm. long. Two transverse fractures. The iron of the sword has often panned over the edges of the bronze scabbard-sheet. The slightly slanting cross-strip near the upper edge seems to be a textile, forming part of the sword-frog and rusted on to the scabbard. The curved upper edge is accompanied by a row of stamped circles.

104. INNSBRUCK. From Sanzeno. *Pl. 64; PP 136, 427.* 16·2 cm. long; reverse flat; 2·2 cm. long nail, curved. The rectangular opening was cut out when the scabbard-blade was used for a different purpose (part of a lock? See Oe J 26 1930, Beiblatt 236).

105. NEUCHÂTEL. From La Tène. Vouga pl. 1, 3; Déchelette fig. 463, 1; Kühn 389, 1. *Pl. 64.* 72 cm. long. Preserved, both sides of the iron scabbard, and within parts of the sword, which is only 2·4 cm. broad.

106. NEUCHÂTEL. From La Tène. Vouga pl. 5, 4; fig. 7 d. *Pl. 65.* Iron. 77 cm. long.

107. NEUCHÂTEL. From La Tène. Vouga pl. 1, 1. *Pl. 65.* Iron.

108. NEUCHÂTEL. From La Tène. Vouga pl. 2, 1. *Pl. 65.* Iron.

109. NEUCHÂTEL. From La Tène. Vouga pl. 1, 2. *Pl. 66.* Iron.

110. NEUCHÂTEL. From La Tène. Vouga fig. 7 l; Kühn 389, 3. *Pl. 66.* Only the scabbard, 72·5 cm. long, is preserved. On the two plastic flanges beside the lateral disks simple geometric patterns engraved, indistinct. On the terminal disks of the chape (not figured), whirls similar to those on the upper end, much corroded.

111. NEUCHÂTEL. From La Tène. Vouga fig. 7 m; Déchelette fig. 463, 5; Archaeologia 52 1890 pl. 13, 6 (A. Evans); Kühn 389, 2. *Pl. 66.* The iron scabbard, 82·6 cm. long, consists of two sheets. The demi-palmettes on the flanges beside the three animals continue on the sides and on the back. For technique see Vouga's remarks p. 37.

112. NEUCHÂTEL. From Bevaix (Lake of Neuchâtel). *Pl. 66.* Fragmentary, still 43 cm. long.

113. CHÂLONS-SUR-MARNE. From Cernon-sur-Coole. Déchelette fig. 463, 2, 2 a; Leeds, Celtic Ornament 10; Henry, Préhistoire 6, 85 fig. 13, 2 (drawing). *Pl. 67.* Total length 74 cm. Scabbard iron; both sides are decorated: I illustrate the back twice because its ornament is well preserved, especially on the upper third. The engraved lines are not drawn continuously, but by a succession of many strokes with the punch. The motives on the upper medallion of the staple are the same as on the lower.

114. VIENNA, Prähistorische Staatssammlung. From Roje, Moräutsch, Bez. Littai (Carniola). Isolated find. *Pl. 67.* Bent. Preserved, portion of iron scabbard, on top 6·2 cm. broad, corroded. No engraving, only decoration the two plastic esses. On reverse undecorated frog-staple, 10·7 cm. long.

115. VIENNA, Prähistorische Staatssammlung. From Kis-Köszeg, Bez. Pécs (Fünfkirchen), Kom. Baranya. *Pls. 67, 68.* Bent, broken at the bend. About 77 cm. long. Preserved, considerable part of scabbard, iron or iron-bronze alloy. Engraved parts corroded. Entered with it, chape and a fragment of an undecorated scabbard, neither of which belongs.

116. BUDAPEST. Inv. no. 41/1906. From Bölcske. *Pls. 67, 69; P 472.* Besides two inconsiderable, extremely thin fragments, not figured, the following are preserved: front and back piece of top part, 13 cm. and 16·6 cm. long respectively; fitting to it, fragment of front sheet, about 20 cm. long. On it a transverse zone with a rivet-hole probably marks the position of a bridge. Found with it,

fragments of an iron chain with knob-shaped hook (length 25 cm.), and an iron cleaver, 26 cm. long.

117. VESZPRÉM. From Jutas, tomb 1. Márton pl. 27, 2, p. 49. *Pl. 69* (the detail from cast).

118. BUDAPEST. From Hatvan-Boldog. Márton pl. 27, 1 (the sword); details: Arch. Ert. 1895, 23, whence Pârvan, Getica fig. 322 and Dolgozatok pl. 54; p. 157; see also Zeitschr. f. Ethnologie 37 1905, 371. *Pl. 69.*

119. BUDAPEST. From Simunovec. Arch. Ert. 1902, 428; Zeitschr. f. Ethnologie 37 1905, 374 fig. 4; Déchelette fig. 463, 9. *Pl. 70.*

120. BUDAPEST. From Bonyhádvarasd (Kom. Tolna). 24/5. Bericht RGK 1934–5 pl. 53, 1, p. 112. *Pl. 70.*

121. VIENNA, Prähistorische Staatssammlung. From Talián Dörögd, Kom. Zala. *Pl. 70.* 77 cm. long; height of figures 4·1 cm. Scabbard iron. The ground round the 'dragons' punched. On reverse frog-staple, 6 cm. long, dotted.

122. SUEMEG. Kálmán Darnay collection. From Csabrendek. Dolgozatok pl. 25, 1. The ornamented upper part of the scabbard: Arch. Ert. 1890, 168; Zeitschr. f. Ethnologie 37 1905, 374 (upside down) and Márton 51 fig. 11. *Pl. 70.* 75 cm. long.

123. BUDAPEST. From Kosd. Márton pl. 27, 3; p. 48; 24/25. Bericht RGK 1934–5 pl. 55, 10. *Pl. 70.* Preserved are the sword and parts of the scabbard.

124. BUDAPEST, Kund. Fròm Kosd, grave 2. Mentioned Márton 49. *Pl. 70.* 74·5 cm. long.

125. BUDAPEST, Kund. From Kosd, grave 15. *Pl. 70.* Breadth at chape 6 cm. Bent.

126. VIENNA, Prähistorische Staatssammlung. From Mitrovica (Save). Mitt. Anthrop. Ges. Wien 1890, pp. (10) ff., figs. 3–6; Déchelette fig. 463, 8. *Pl. 71.* Fragmentary. Preserved, upper part of sword with tang, rusted on it, portion of front sheet of bronze scabbard. Still 56·5 cm. long.

127. SZOMBATHELY. From Velem-Szentvid (Kom. Vas). *Pl. 71.* 73 cm. long, with tang. Scabbard bronze. On the undecorated back, a frog-staple, riveted on. In chape-disks no space for corals. Front sheet of scabbard covered all over with stamped patterns, indistinct in the photograph, the object having been lacquered. Three dies were used: concentric circles; heart-shaped palmette; sort of quatrefoil within a lozenge.

Nos. 128–31
SPEAR-HEADS

128. STUTTGART. From Hundersingen. AuhV 5, p. 150; Ebert 5 pl. 132, F; Bittel pl. 4, 1, p. 118 (incorrect drawings); Kühn 371. *Pl. 71.* 31·5 cm. long. Fractures on blade and socket. Bronze, cast. Still in socket, parts

of a wooden shaft which was nailed athwart (two nail-holes in socket and hollow of nail in the wood). The lines of the engraved pattern are coarse and somewhat hesitating. Socket divided by longitudinal grooves into four equal compartments, each bearing the same decoration.

129. BERNE.[1] Commonly said to have been found at Thiel, but according to information from P. Vouga, this is not at all certain; certainly from the lake of Neuchâtel. E. Vouga, Les Helvètes à La Tène pl. 5 (whence Déchelette fig. 480; Mitteilungen aus Bosnien und der Herzegowina 9 1904, 54 fig. 30a, and BM EIA fig. 15) (incorrect). *Pls. 72, 73; PP 265–6.* Iron, 51·5 cm. long. In the socket traces of transverse nail. One edge has been in violent contact with a hard object (in battle?). Patterns (much eaten by rust) engraved on both sides, but confined to the right half of the blade.

130. SUEMEG, Kálmán Darnay collection. From Csabrendek. Arch. Ert. 1890, 243; Zeitschr. f. Ethnologie 37 1905, 374; Dolgozatok pl. 25, 2, p. 132; Hoernes-Menghin, Urgeschichte der bildenden Kunst 569 fig. 1. *Pls. 72, 247, c.* Iron, 17·7 cm. long. I reproduce the drawing published (l.c.), progressive corrosion having spoilt much of the pattern.

131. BUDAPEST, Kund. From Kosd, tomb 1 (accidentally omitted in Márton's inventory of the grave-group in Dolgozatok p. 151). *Pl. 72.* Sharply bevelled mid-rib.

Nos. 132–4
CORSLETS, GIRDLES, ETC.

132. BERLIN, Pergamonmuseum. Detail of Pergamene trophy relief. Altertümer von Pergamon 2 pl. 44, 2, p. 105; Déchelette 1156; Germania 5, 18 (Drexel). *Pl. 73; PP 259, 288.*

133. STUTTGART. From Hundersingen. AuhV, 5 pl. 27 no. 473; Ebert 5 pl. 132, D; Bossert 1, 55, 3. *Pl. 73; P 260.* Bronze 5·8 cm. high. Still 18 cm. long, original length unknown, as the broken parts are not contiguous. Bottom and top frame cast in one piece with the openwork; the sides, wrought separately, have each eleven rivets, two for the horizontal cross-bars, the others for the leather belt.

134. (*a*) BM, (*b*) COLOGNE, ex Diergardt collection. (*a*) from Bergamo, also probably (*b*) because acquired from the same dealer. Germania 20 1936 pls. 21, 22, p. 100. *Pl. 74.* (*a1*) 51–2 cm. (with templet). (*a2*) 14·2 cm. diameter. (*a3*) about 13·5 cm. diameter. (*a4*) 26 cm. (with templet). The silver decoration nailed on the bronze shows in the reproduction. (*b1*) and (*b2*) 11·6 cm. diameter. (*b3*) 42 cm. (with templet), chord 24 cm. (*a1*) was the bronze mounting of a wooden helmet, like that from Giubiasco, Ulrich pl. 82, 2, Germania l.c. p. 102 fig. 1; the other objects formed part of cuirasses.

Nos. 135–52
HELMETS

135. SAINT-GERMAIN. From La Gorge-Meillet. Fourdrignier pls. 7, 8; Déchelette fig. 490, 4; Lipperheide no. 263; S. Reinach, Album des moulages et modèles pl. 26; Romilly Allen, Celtic Art 12. *Pls. 75, 76; P 262.* Bronze. 37·7 cm. high. The numerous fragments of wrought—not cast—bronze are mounted on linen. The helmet consists of the following separately worked parts: (1) The crown. No joints or rivets visible. (2) The neck-guard. (3) The roll-rim, edging the helmet proper and the neck-guard. (4) The cast top knot, in several tiers. (5) Five embossed disks, four large, fixed at the ends of the two axes of the helmet, one smaller at the centre of the neck-guard. The heads of the attached rivets are hollow for corals. The still smaller disks which appear under the rim in a position corresponding to the temples of the wearer were similarly filled with corals and are the lower terminals of a bent rod, the upper end of which is fixed to the rivet of the embossed disk already mentioned and rotates with them (see the drawing in text); they no doubt served as attachment of the ear-pieces which are not preserved. The patterns are engraved in tremolo lines.

136. SAINT-GERMAIN. From Berru. BAF 1875, 91; CAF Arras et Tournai 1880, 73; RA 1875 i, 244 pl. 10; Bertrand, Archéologie celtique et gauloise 355, pl. 11; Déchelette figs. 490, 2 and 656; Lipperheide no. 262; Márton 52 fig. 12, 2; Romilly Allen, Celtic Art 12. *Pl. 77; PP 116, 464–5.* Bronze. Still 29 cm. high. Pieced together from many fragments and mounted on linen. The components are the same as in the helmet from La Gorge-Meillet, no.135. In the disks over the temple part, coral inlay. The bad state of preservation does not allow us either to verify or to redraw the engraved decoration, which is consequently reproduced after Bertrand (l.c.). Nor can the following statement by Déchelette be checked: 'Les premiers archéologues qui ont décrit le casque de Berru, Ch. de Linas, Viollet-le-Duc, Darcel, avaient cru y reconnaître des émaux polychromes, blanc, vert, bleu et rouge. En réalité, comme l'ont constaté par un examen plus attentif M. Germain Bapst et plus récemment M. Coutil, ces prétendus émaux ne sont autre chose que les pâtes résineuses supportant les feuilles d'or estampé qui recouvrent le casque; "par suite de leur séjour dans le sol, elles se sont altérées différemment et ont actuellement une couleur jaune, rosée et grise." (Coutil, Le casque orné d'émaux d'Amfreville-sous-les-Monts, p. 2. Selon le même auteur, le casque porterait des traces d'émaux fixés dans des cloisons de fer.)'

137. BUDAPEST. From Hungary, but provenience

[1] The drawings were provided by Professor Tschumi. Miss Th. E. Haevernick was kind enough to improve them.

unknown.[1] Arch. Ert. 18 1898, 311 (Reinecke); Márton 45 fig. 7, pp. 52 and 61; Pârvan, Getica p. 464 fig. 321. *Pl. 77.* Height still 18 cm.; maximum diameter 17·8 cm.

138. SAINT-GERMAIN. From Écury-sur-Coole, tomb 13, chariot-burial. Thiérot, Les Côtes-du-Marne pl. 5 A. *Pl. 77.* Bronze, three fragments preserved. I have not seen them.

139. REIMS. Once in the Chance collection. Not having seen the piece myself I repeat the description published in BSPF 27 1930, 184. *Pl. 77; PP 213, 401.* 'From a chariot-burial in the cemetery of Marquises near Prunay (Marne); from the same site gold bracelet. Fragmentary and restored. 14 cm. high; median diameter 23·5 cm.; lateral diameter 16 cm. Wrought from 'a thin bronze sheet. Iron attachments for strap, with bronze veneer.'

140. LOUVRE.[2] Isolated find in an old channel of the Seine near Amfreville (1861). RA 1862 i, 225 pl. 5; AuhV 3, 1 pl. 3, 8, 9; Gazette archéologique 1883 pl. 53; Revue d'Anthropologie 18 1889, 288; Revue de l'École d'Anthropologie 12 1902, 66; Déchelette fig. 490, 3; Lipperheide no. 224; Coutil, Les casques proto-étrusques pl. 5; Lantier, Les arts primitifs de l'Europe barbare fig. 31; Márton 52, fig. 12, 1; Préhistoire 2, 74; Die Antike 10 1934 pl. 4; PZ 25 1934, 102 fig. 64; Bull. de l'Inst. Bulgare 11 1937 fig. 78. Phot. Giraudon 28225–7. *Pls. 78–81; PP 131, 429–31.* Height still 16 cm.; median diameter 23 cm., lateral diameter 16·1 cm.; internal circumference 60·5 cm. Missing only the top knob; its seating is preserved. Damaged in two places. No restorations. The helmet consists of the following parts: (1) crown wrought from a bronze sheet of medium thickness, to which the separately made bronze neck-guard is riveted; (2) two iron openwork hoops with enamel above and below: the bronze middle hoop serves as base for gold foil. The openwork of two hoops makes a pattern of tendrils in relief with sharply cut outlines and bevelled seatings for the enamel. On the lowest hoop small bridges connect the tendrils with the tyre above and below, in order to reduce the enamel fields and to give them greater stability. On the neck-guard, instead of bridges, compact fields of bronze have been retained and are adorned with smaller embossed tendrils. The hoops are fixed on the bronze core of the helmet with bronze pins fastening the numerous enamel disks; the gold heads of the pins are decorated with little rosettes. In the plates it becomes clear that the whole pattern of the middle hoop was embossed in the bronze and the gold foil hammered on; the pattern on the gold is naturally less sharp than on the bronze templet. On the temple parts of the helmet two large standing lyres; the lyres themselves, once cut out and filled with enamel, have disappeared, but they have left their impres-

sion on the core. The decoration of the gold band deliberately leaves room for them. Similar impressions of the enamel disks above the gold strip are visible in the photograph.

141. KERNUS. Collection du Chatellier. From Tronoën en Saint-Jean-Trolimon (Finistère). BA 1896, 22 pl. 4; Coutil, Casques antiques 218; JL 58; RM 38–9 1923–4, 132, footnote. *Pl. 82; PP 130, 269, 270.* The larger fragment is about 12 cm. high; the cheek-piece still 7·5 cm. The helmet is wrought from an iron sheet, 0·075 cm. thick, with thin bronze veneer. Remains of coral on top knot and cheek-piece. A third fragment is described, but not figured, by P. du Chatellier, from whose publication the following remarks are borrowed: 'Le no. 3 représente les fragments d'un objet en fer, de 0·001 m. d'épaisseur, recouvert d'une mince feuille de bronze estampée. Malheureusement ici le bronze est beaucoup plus oxydé. L'ornementation de la partie inférieure se compose de trois cercles, entourant une sorte d'étoile en relief, et d'une palmette, au-dessus de laquelle on voit une bande circulaire limitée par deux traits concentriques en relief, tracés au pointillé. Cette bande est décorée d'ornements semblables à ceux de la quatrième zone du casque (le morceau a 0 m. 053 dans sa plus grande largeur). Enfin la partie supérieure de cet objet est ornée de points en relief entourés d'un gracieux enroulement formé par une ligne de grènetis.'

142. CLUJ. (Hungarian KOLOZSVÁR; German KLAUSENBURG.) From Silivas (Hungarian Oláhszilvás), Kom. Alba de Jos-Alsofehér. The grave group is figured and discussed in the publications cited. PZ 16 1925, 211; Archivele Oltenieii, Craiova 5 1926, 50 (von Roska); Pârvan, Getica pl. 26, 2; Márton 50 fig. 10; Dolgozatok pl. 57; PZ 25 1934, 103 fig. 65, p. 101, note 52; Ebert 11 pl. 38 B; 22. Bericht RGK 1933, 153 (J. Nestor). *Pl. 82.* Height 19·5 cm.; median diameter 20·7 cm., lateral diameter 20·7 cm. The helmet is damaged and corroded. Iron. No traces of coral or enamel. The cheek-pieces, now missing, were attached to the helmet with three rivets. The traces of the edge of the neck-guard, once fastened with eleven rivets, are visible inside the helmet.[3]

143. BERLIN, Antiquarium. Found in 1897 at Canosa (Apulia).[4] Naue in Prähistorische Blätter 10 1898, 49 ff., pl. 5; Brinkmann, Jahrb. der Hamburger wissenschaftl. Anstalten 27 1909, 92; AA 20 1905, 29 fig. 19; Neugebauer, Führer Bronzen p. 16; Ebert 7, 248; 13, 424. *Pls. 83, 84, 258; PP 78, 308–9, 466–7.* Height including top knot 25 cm. Median diameter 23·8 cm., lateral 18·6 cm. The helmet is of iron, about 0·5 cm. thick, much scaled. The iron has panned seriously: it has eaten away the

[1] The provenience Turócz, given by Márton and others, is, as the Keeper kindly informs me, unfounded; I am indebted to him for the photograph.

[2] I am greatly indebted to Mr. N. Plaoutine, who kindly

checked and corrected some of my observations.

[3] I have not seen the piece; Dr. von Roska kindly supplied photographs and description.

[4] For the other finds in the grave see p. 146.

bronze in places and has even panned over the rims. The iron crown is covered with two pieces of bronze, the lower of which is a band, 8 cm. high, the upper a hemispherical cup, 8 cm. high, fixed by the top knot, apparently wrought of one sheet and with no visible joint. Between the two bronze parts the iron is exposed for a breadth of 2–2·5 cm.; there was probably a gold band here. On the neck-guard the iron has almost entirely destroyed the bronze veneer, but there are impressions of the embossed ornament. The coral is unusually well preserved and red, only in a few places decomposed and white; its distribution is shown in the drawing, where black indicates corals. The iron top knot consists of a conical foot-part above a ring of 3 cm. diameter, and a rod passing through them; it has a washer inside the helmet. Naue (l.c. p. 51) wrongly maintains that the point originally bore a Nike. For the cheek-pieces, now missing, one has to rely on Naue's plate, an old photograph, and his description: they did not differ from the normal type (compare nos. 144–7); according to Naue they were tilted up when the helmet was found. On them were five 'rosette-like' protuberances and between and beside these, triangular and 'halbspitzovale' enamels (?). The bronze tubes, which held plumes, 8·5 cm. long, are bent sheets; the joints are open. There are eyelets and little rings, still movable, at three places.

144. BERLIN, Antiquarium. From Umbria. AA 20 1905, 29; Lipperheide no. 530; Coutil, Les casques etc. 217 fig. 67; Neugebauer, Führer Bronzen p. 14, pl. 45; Ebert 5 pl. 90,b. *Pl. 85; PP 331, 359*. Height including top knot 19·5 cm., median diameter 22 cm., lateral 20·4 cm. Height of cheek-pieces 13 cm. The helmet is of iron; its surface is much scaled, inside and outside. The lyres have slewed over the cheek-pieces. As in other Celtic helmets there was originally a bronze covering, and possibly some gold as well. Preserved, only the lyres already mentioned and a few fragments of the ornamented bronze band which encircles the lower part of the helmet. The bronze cheek-pieces have iron lining; in their medallions and in those of the lyres are huge iron bosses (on some of them impressions of a textile): these are hardly the result of iron panning only, but I should not like to offer an explanation (see also the following helmets). The construction of the hinge becomes clear by combination of this helmet with the cheek-pieces no. 145: a plaque with a loop at its lower end is soldered inside the helmet and the loop fits into the corresponding gap in the hinge-tube of the cheek-piece, where it is gripped by a pin.

145. BM. Inv. 89.5–9.28. Ex Franks collection. No provenience. BM EIA 23 fig. 18; RM 38–9 1923–4, 133, note 22. I figure only one of a pair. *Pl. 86; PP 181, 411*. 12·5 cm. high, 10·5 cm. broad. Embossed bronze on iron lining, which has much panned. The pins still remain in the hinges.

146. ANCONA. From Montefortino. Mon. Ant. 9 pl. 6, 21. *Pl. 86*. Iron with bronze mountings.

147. ANCONA. From Filottrano, grave 12. Dall'Osso 268; Coutil, Casques antiques (Mémoires de la Soc. Préh. de France 3 1913–14) 214, 215 figs. 74, 75; RM 38–9 1923–4, 132, note 5; JRAI 67 1937 pl. 23, p. 262. *Pl. 87; P 141*. Height (without cheek-pieces and crest) 16 cm., median diameter 23·5 cm., lateral (internal) 19 cm. Bronze. There are some restorations in plaster, and the cheek-pieces were attached after excavation. The medallions on them and those of the disks above are of iron. In the middle of the neck-guard a massive iron knob; inside, a round washer. The iron 'hat-tree', which held plumes or a horse-hair crest, is slotted into the helmet. On the upper part of the cheek-piece, between the two medallions, is a lotus flower, similar to those in the engraved frieze round the upper part of the helmet; on the other cheek-piece, now—rightly?—attached, it is replaced by a motive similar to those on the cheek-pieces nos. 144, 145.

148. ANCONA. From San Ginesio. Not. Sc. 1886 pl. 1; JRAI 67 1937 pl. 23, 2, p. 272. *Pl. 88*. Total height 27·5 cm., median diameter 24 cm., lateral diameter 17·5 cm. One cheek-piece is preserved, not figured here; over the temples impressions of the disk fastening the cheek-piece. In the middle of the neck-guard, traces of round knob. On top, an iron rod with a tube around, passing into a kind of funnel with three openings for attached plumes. The torc-rim at the lower edge of the helmet and the neck-guard has the twist reversed half-way round.

149. BERLIN, Antiquarium. Inv. Lipperheide no. 77. From Selinus. AA 20 1905, 28; Neugebauer, Führer Bronzen, p. 14. *Pl. 88*. About 19 cm. high, median diameter 21·5 cm., lateral 20 cm. The crown has a broad fissure on its front. The conical top part is fixed inside by two corroded iron cross-bars. The cheek-pieces now attached to the helmet by a piece of linen differ in patina and may originally have belonged to another helmet. There are hinges on both sides: on the far side, instead of a hook, three small bosses round a larger. On the lyres, heads of rivets, above, in the middle, a disk; incrustations make it impossible to determine whether it contained a boss or a rivet.

150. SCHLOSS ERBACH. From Italy, no detailed provenience. Generalkatalog der Gräflich-Erbachischen Sammlung im Schloss zu Erbach (1886) p. 39, no. 256. *Pl. 89; P 76 a*. Height 21·5 cm., median diameter 25·4 cm., lateral 18·7 cm. Thickness of bronze 0·2–0·25 cm. Towards the front of the helmet two holes, another hole in the neck-guard. Over the temples, a riveted tubular loop. On the rim where the twist reverses under the holes a motive with three leaves, their veins abraded. Engraved above the holes, an oblong with diagonals. On the crescent-shaped neck-guard, an engraved 'Running Dog'. On top knot scales.

151. SCHLOSS ERBACH. From Italy, detailed provenience unknown. See catalogue cited on no. 150. *Pl. 89*. 19·3 cm. high, median diameter 23·5 cm., lateral 19·9 cm.

Thickness of bronze 0·1 cm. In the middle of the neck-guard, a rivet with a bronze washer. Over the temples, inside, tubular loops riveted on: the rivets filed clean. On the front of the crown, a nail-hole. Torc pattern round lower edge, scales on top knot; whether there was a filling in its depression is uncertain.

152. LJUBLJANA. From Vini Vrh, Sankt Margareten, Carniola. Müllner, Typische Formen aus den archaeologischen Sammlungen des Rudolfmuseums in Laibach pl. 20, no. 1; Déchelette fig. 492; R. Lozar, Führer des Nationalmuseums zu Ljubljana. *Pl. 89.* Cheek-pieces about 11 cm. long; enamel knobs. The other piece, 29 cm. long, 8 cm. high, was, as the nails suggest, fixed on leather; according to information from Dr. Lozar there is an iron peg at one side which probably fitted into a catch. He supposes that the piece did not form part of the helmet (neck-guard), but was a throat-guard.

Nos. 153–205

CHARIOT PARTS AND HORSE-TRAPPINGS

153. BERLIN, Antiquarium. From Waldgallscheid. Friederichs, Berlins Antike Bildwerke 2, 266 ff.; Reinecke 98, note 6; JL 22. *Pls. 90, 91; PP 1, 373.*

(*a*) Two axle-bushes, one seen from top, the other in profile; the latter shows the engraved circles on the outside half more clearly; its left edge is somewhat damaged; here the nave is still movable, in the other piece it is rusted on. The bushes are cast; they are 6·3 cm. long, 5·9 cm. in diameter, and their walls are up to 0·3 cm. thick. They are open on both sides. The naves are disks of 11·4 and 11·9 cm. diameter respectively; the profiled rim is 1·4 cm. high. On the outer, visible, side the same engraved circles as on the bushes. In one of them there is still the moulded head of a nail, 1·8 cm. long, and in its hole remains of wood. In the bushes there is also a hole into which the linch-pin (no. (*b*)) fits; the circular hole has sidewards a rabbet for a wedge (see below).

(*b*) Two linch-pins, 11·7 and 12 cm. long respectively; diameter from 1·3 cm. on top tapering downwards to 0·9 cm. I figure only one. Just below the top, athwart, a nail-hole of oval cross-section on surface and more square inside. On the front of one, a rough spot, probably caused by the above-mentioned wedge. In the hollows of the patterns traces of black, friable substance, certainly bedding of enamel or coral.

(*c*) Not figured here, three bronze rings, all alike, cast, internal diameter 12·9 cm., 2·1 cm. broad, 0·06 cm. thick; inside flat, outside with elaborate profiles. Their purpose and position is best illustrated by the analogous pieces from Kaerlich, Germania 18 1934, 12.

(*d*) Roll of swingle-tree, like the pieces from Kaerlich no. 167 and Dürkheim no. 166. Bronze, solid casting. The hinge rusted in. Engraved circle-patterns faintly

recognizable on the two 'horse-shoes' on the front. (*d*) is to be connected with

(*e*) Bronze openwork ornament, maximum length about 8 cm. As the chariot from Kaerlich no. 167 shows, it was nailed round the hinge on the swingle-tree; one nail is still preserved; round the nail-holes, engraved circles and dots. Preserved with the ornament, the leather gasket, folded double; on it, near the edge, a hole for the nail which fastened it to the swingle-tree.

The following objects cannot be located with certainty on chariot or horses.

(*f*) Bronze openwork ornament, maximum extension 5·8 cm.; for shape and reconstruction see no. 190 ff.

(*g*) Two bronze disks of 5·1 and 4·9 cm. diameter, at the rim about 0·1 cm. thick. On surface, turned concentric circles, in centre spike; back flat and undecorated.

(*h*) Bronze knob, 3·8 cm. high, bronze 0·2 cm. thick; near the base, two nail-holes at the ends of an axis, inside, some wood; on top, coral stud.

(*i*) Four heads of stout cast bronze pins, 1 cm. long. Two figured. Diameter of head about 2 cm. The patterns once bore enamel inlay—a kind of whirligig.

(*k*) Tapering bronze tongue, 6·3 cm. long, on preserved leather; round the rivet discoloration of bronze, pointing to a circular washer. Compare no. 177.

(*l*) I cannot describe in detail numerous fragmentarily preserved objects of completely unknown use, most of them more or less shapeless. I should only mention three cast bronze rings, internal diameter 3·3 cm., 0·5 cm. thick, and fragments of bronze sheets and strips, with and without nails. There are two fragments of a large bronze basin with engraved circles near the edge and flat modillions above them continuing on the upper surface, still 3·7 cm. high; the diameter of the vessel calculated at 31 cm.

Specimens of leather were analysed in the Institut für Gerberchemie der Technischen Hochschule Darmstadt with the following result: the thickness of the membrane excludes goat and sheep and points to cow- or horse-hide. Since the epidermis is missing one must suppose that the tanner worked the hide with a scraper. The hide was tanned with some vegetable agent which cannot be traced by analysis. The wood was submitted for analysis to Miss Holme-Bancroft of the Imperial Forestry Institute in Oxford: it is partly ash, probably *Fraxinus excelsior* Linn., partly maple, either *Acer campestris* Linn. or *Acer pseudoplatanus* Linn.

Because of the scarcity of pottery in chieftain-graves I figure the neck of a large lenticular flask, still 9 cm. high, diameter at mouth 8·7 cm.; clay in fracture rather coarse, on surface well burnished, black to brown, grey in places.

For the gold from the grave see nos. 26, 29, 50.

154. AROLSEN.[1] From Horhausen near Holzappel (Lahn), province of Hesse-Nassau. JL 24 (needs correc-

[1] I owe the photographs and permission to publish them to the kindness of His Highness the Prince of Waldeck and Pyrmont, the description to Dr. E. Kukahn.

182

tion); Forschungen und Fortschritte 1930, 245 (Steiner); Germania 18 1934, 13 (Günther). *Pls. 91, 92.* I do not figure the complete find. I exclude very numerous more or less shapeless fragments of bronze, iron, tyres, wood, &c.; a gold ring from the grave is no. 52.

(*a*) Bush and nave, (*a1*) seen from outside, (*a2*) the other nave, from inside. The bush is 5·7 cm. high and has a diameter of 5 cm. It is closed (compare the different construction of no. 153 *a*): on the outer side is a depression with a central conical knob, which is profiled and hatched; round the knob, engraved concentric circles. Across the bush was a nail, the holes have a diameter of 1·5 cm., smaller holes also near the rim. The construction of the nave is not the same as in the Waldgallscheid chariot, no. 153 *a*; it consists of two parts, a ring, 1 cm. broad, which has an external diameter of 15·5 cm., folded over the wooden hub for 4 cm., and a central disk, also cast, of about 13 cm. diameter, with plastic rings inside and out. On one side a nail is visible; its hole has a diameter of 0·7 cm.

(*a′*) is a nail, 8 cm. long.

(*b*) Two cones, cast and hammered, still 4·5 cm. high, diameter at bottom under 5 cm. The depression on top with central knob resembles the shape of the bushes; round the cone, engraved circles and some nail-holes.

(*c1*) Four 'kalathoi', hammered out of a sheet; only one is figured. 8·5 cm. high. They were nailed, in pairs, on a wooden core with a top diameter of about 6 cm. and a bottom diameter of about 10 cm. The one pair is of stouter material than the other.

(*c2*) Six similar devices, about 7 cm. high; their shape is that of an hour-glass.

(*c3*) Three pieces, two complete and one fragmentary, which have the profile of balusters, maximum height still 9·3 cm.; one of their wooden cores preserved, now somewhat shorter than the bronze parts.

(*d*) A set of sheets, about 0·2 cm. thick, with rows of nail-holes, some with engraved double lines along the rim. All of different curve; one has a crescent shape and is about 38 cm. long. Compare the chariot parts from Somme-Bionne, no. 169 *a, b.*

(*e*) Strips of different breadth with nail-holes and raised rims, accompanied by engraved lines; from its technique one fragment belongs here: it has openwork between the curves, an exact pendant to the pieces from the Besseringen grave, no. 155 *a, b.*

(*f*) Three hinged plates, two complete and one fragmentary, with concave sides, 6·8 cm. high, 6·6 cm. maximum breadth. The hinges themselves are hammered out of the same plate, which becomes thinner here. In the middle a rectangular hole, which caused the break of the incomplete piece. Rims hatched; the engraved pattern inside is a concentric repetition of the outline, with an alternation of plain and stippled fields. To these plates belongs the oblong hinged plate, 3·9 cm. long, 2·2 cm. broad, with a circular hole, figured below.

(*g*) Two cast nails, 1·6 cm. long, with flower-shaped heads.

(*h*) Pointed nail or cotter-pin, 5·7 cm. long, thin bronze veneer on preserved wooden core.

(*i*) Two cast rings of 4·7 and 3·4 cm. diameter respectively, with flanged grooves; at one point a hole, accompanied by a gap in the outer flange; here traces of friction, perhaps caused by a strap.

(*k*) Rings (one figured), of slightly convex profile, with traces of nails; the piece figured has an external diameter of 6·1 cm. and is not completely closed.

(*l*) Two cast traces, one incomplete, the other 28·4 cm. long. On the ridges outside, trace of triangular file; the make of the incomplete piece is less good.

(*m*) See on nos. 154 A, B.

154 A, C. NEUCHÂTEL. 154 B. BONN. *Pls. 93, 94.*

The fragments no. 154 *m, pl. 92,* are probably the clue to similar better-preserved pieces: one, from La Tène, Vouga pl. 19, 1, p. 63, 64, here no. 154 A; length 45 cm., with templet 48 cm.; hammered from a sheet of bronze; open at bottom, where traces of iron. There is also a pair in Bonn, from a grave at 'Abentheurer Hütte' (4, 5 km. W. of Birkenfeld), of which I figure one, no. 154 B. Vouga spoke of 'militaria signa' or decoration of helmets: for this they are too long and too fragile; they are probably also to be connected with chariots—how, I am unable to guess. Another piece from La Tène, Vouga pl. 19, 2, here no. 154 C (length about 22 cm.), possibly goes with them.

155. BERLIN, Museum für Vor- und Frühgeschichte, From Besseringen. BJ 41 1866, 1 pl. 1 (Lohde); AuhV 2. 8, Beilage figs. 13, 15; JL 21. *Pl. 95.*

(*a*) Maximum extension 28·3 cm. On a flat sheet of bronze, 0·1 cm. thick, which has two holes near the lower edge and continues upwards into openwork—somewhat less complete to-day than in 1866—two flanged strips are riveted. The curve was never part of a whole circle. The grooves, 0·35 cm. broad, between the flanges are divided by cross-bridges; their intervals are irregular. In the grooves a black substance which was analysed in the laboratory of the museum: 'Principal component resinous substance, but tests for iron, copper, and silica gave positive results; these are the result of decomposition and were not originally present.'

(*b*) Six pieces, of which two are figured. Average length 16 cm. Same technique as (*a*), but along the inner curve an iron ring, which has panned over the bronze. One must suppose that (*a*) was originally so constructed. The six pieces certainly formed three pairs of 'spectacles', like (*a*).

(*c*) Object shaped like an ink-pot, 2·5 cm. high, diameter at top 3·4 cm., at bottom 3·5 cm. On rim, deep groove between flanges—similar to those of (*a*), (*b*), and (*d*)—round a 'well'; at its bottom a round hole of 0·7 cm. diameter with traces of iron. Near base two rivets fastening the wooden core below the well; some portions of wood are preserved.

(*d*) Nine rings (eight of them figured). External diameter

3–3·1 cm., internal 1·3–1·4 cm., height 0·45 cm. Grooves as last, and same filling as (a). Bridges not cast in one, but inserted, on most pieces four, on one six; some broken away. All the rings have staples underneath, cast with them. Four of the rings have two convergent straight grooves on the under side.

(e) For the 'rings of triangular cross-section and 13·8 cm. internal diameter' I have to rely on Lohde l.c. pl. 1 no. 4. I must also rely on his publication, repeated in the plate, for (f) and (g) which have disappeared; they are the counterparts to the analogous pieces of the Waldgall-scheid and Kaerlich chariots, no. 153 d, e; 167.

The gold torc from the grave is no. 41.

156. BONN. From Waldalgesheim. (a)–(g) are parts of the chariot and horse-trappings, (h) is a Campanian bucket which, contrary to my practice of not figuring imported pieces, I illustrate here because of its singular importance. For gold and a spout-flagon from the tomb see nos. 43, 54, 55, 387, for a bronze bracelet no. 247. All the objects were illustrated by Aus'm Weerth. *Pls. 96–100.*

(a) Two chariot-horns. AuhV 3, 1 pl. 2 figs. 6, 7; Ebert 14 pl. 57 B, g, h. *PP 435–6.* Height of both 19·5 cm. One horn slightly damaged at the foot. In 1932 reassembled afresh, with some very slight restorations. At a distance of about 6 cm. from the lower edge of the collar below the head-piece, a greyish-black discoloration of 1·4 cm. breadth round the horn, caused by a strap. The horns consist of three separately wrought portions: (i) the trumpet-shaped end, cast and turned; trace of chuck visible, possibly once a coral in the hole. (ii) The swan-necked main piece, bronze about 0·08 cm. thick. At the ends of the orna-mented band round the foot, a hole for the nails fastening the horn on the wooden core: traces of this are still pre-served, inside towards the head. (iii) A back-piece over-lapping (ii); bronze here 0·14 cm. thick; cut straight at a distance of 12 cm. from the lower edge of collar of head-piece; it is riveted on (ii), some rivets visible inside; two nails are also seen (on the other horn three): they fastened it to the wooden core; two plastic ribs run along the sides of the piece. (i) was pushed over (ii) and (iii).

I do not figure a fragment of a third smaller horn (Aus'm Weerth pl. 5/6 no. 11). Only the head-piece is preserved, maximum height 2·1 cm., diameter of trumpet 3·5 cm. Cast, trace of chuck; holes for a nail athwart.

(b) Bronze fair-lead. Aus'm Weerth pl. 5/6 fig. 1 and Ebert 14 pl. 57 A, a (incorrect). *PP 437, 448–9.* In 1932 reassembled afresh. 8·7 cm. high. Cast in one piece; shape and decoration the same on both sides, except slight variants in the relief tendrils. The openwork inside and outside chiselled out of a plaque cast with the rest. Cross-section of foot portion semicircular; inside an iron core; the sides withdraw a little from the ends and possibly had inlay in their centres. The ring proper, of circular section, consists of four longer parts, gouged and rasped on front and back to receive the bedding of enamel, and between

them four shorter parts with relief tendrils. The open space inside the ring is divided into a lower segment, empty, through which the reins passed, and an upper with two birds. The dividing cross-bar is prepared for enamel inlay in the same manner as the ring. The birds have coral eyes—one preserved—and a feather on the head; their swan-necks once touched each other in the vertical axis, as can be seen from a trace on the preserved neck; in 1870—see the publication cited—their long legs were still preserved.

(c) Four eyes, 5·8, 5·7, 4·9, 4·7 cm. long. Cast. Form and decoration identical on both sides. The matrices of the enamels turned. One piece has six enamels, one four, one three, and one one; these are fastened by bronze pins with neatly turned heads. The two smallest eyes are filed almost straight on top.

(d) Two bronzes with busts; AuhV 3, 1 pl. 2; BJ 102 1898 pl. 2, p. 158 (Koenen); Germania 5 1921, 14 fig. 3 E; JL pl. 36, c; Ebert 14 pl. 57 A, b, c; PZ 25 1934, 96 fig. 56. *PP 446–7.* Reassembled afresh in 1932 by Hans Piehler of Munich. (i) lacks the middle, (ii) the bottom. (i) 8·9 cm., (ii) 7·5 cm. high (across the chord). Bronze about 0·1 cm. thick. The curve is about the fifth of a circle. Numerous holes, and some rivets preserved. The two rivets visible at the top left hand are in a narrow offset which once projected farther than now, for at its end the ridge which marks the border of the object is missing. The two large holes on the breast are turned; in the one on (i) it may still be seen that the artist bored a small hole right through and reamed it out to half the thickness as a matrix of coral or enamel. The contours hatched through-out, also the fingers except the thumb. The purpose of the bronzes is obscure. Two undecorated bronzes from the find are probably to be connected with them: one exists only in tiny fragments; the other, figured in *pl. 98,* Ebert 14 pl. 57 B, p (incorrect drawing Aus'm Weerth pl. 5/6 fig. 8), 6·5 cm. high, is less curved than the pieces with the busts. The rim is set off by a groove, the upper rim hatched. In the hole on top right hand a nail remains with a stump on the back.

(e) Openwork ornaments. (i) BJ l.c. no. e. *P 444.* Diameter 6·2 cm. and 6·3 cm. respectively (once about 6·6 cm.). Thin cast plaque, chiselled and filed. Traces of turning in the central round. Here, and at the ends of the axes, pin-holes for inlay. Traces of other pins show that the plaque was fastened on a lining.

(ii) BJ l.c. fig. d. *P 442.* 7·4 cm. long, 4·4 cm. broad. Stouter material than (i). Same technique. On reverse, some small bronze rivets. Many traces of iron.

(iii) Fragment of a piece like (ii). Maximum extension still 3·3 cm. Aus'm Weerth l.c. fig. 6 has the piece com-pleted arbitrarily.

(f) Flat ring. *PP 264, 457.* Maximum internal diameter 12·7 cm.; height 1·75 cm. Broken and burst by iron. Mounting modern. Cross-section slightly convex, inside flat. Two nails at the ends of an axis. The development

figured—reproduced from a cast—gives a third of the whole decoration.

(g) Iron linch-pin. 10·1 cm. long. Curve original. In the centre of the knob at the lower end there was a coral. The ornamented bronze plaque on the front of the head, still recognizable in the drawing Aus'm Weerth pl. 5/6 fig. 15, is now completely destroyed by panning iron.

(h) Imported bronze bucket. Aus'm Weerth pl. 3; Ebert 14 pl. 56,b; Pernice, Hellenistische Kunst in Pompeji 4, 28 fig. 39; Die Antike 10 1934, 29 fig. 8; Züchner 98. BWP 25. 23 cm. high, including attachments; internal diameter 15·6 cm. Some holes carefully repaired. Patina exactly the same as in the Celtic works from the tomb. Inside, 9·5 cm. above bottom, a sharply marked ring of rust, possibly due to an iron vessel placed in the bucket. The body is cast; the embossed floral ornament under the handles—with slight variants on the two sides—appears faintly on the inner side; the kymation below the rim is only punched. Base ring and the two handles are wrought separately. The handles are square in section, and are fastened to the vessel by two rivets, the heads of which appear in the openings of the attachments. They are rabbeted where they come down behind the attachments. When lowered, the handles conform to the circumference of the bucket. On the upper surface of one of them, near the attachment, an A in dots, its horizontal bar slightly convex.

157. SAINT-GERMAIN. Bronze chariot-nave from La Gorge-Meillet. Fourdrignier pl. 6 (right); PZ 25 1934, 91 fig. 31. One of a pair, the pendant is figured by Fourdrignier l.c. left. *Pl. 100; PP 163, 183, 311, 398.* Diameter 13·7 cm. Lined on an iron plaque, which has partly gone. The flat ring with the flower patterns is overlapped and held by the two hoops of hemispherical cross-section, which differ in patina from the flat ring. On it, without regard to the patterns, have been placed two knobs and, at the end of the other axis, two loops with a knob on them, through which the linch-pin passes. The linch-pin proper is of iron where it goes through the wooden axle, and only of bronze at the ends.

158. ORLÉANS. From Sillery (Marne). Morel p. 26; Déchelette, appendix V, p. 44, VI, no. 553; PZ 25 1934, 83, note 19. Reproduction and description from cast, Saint-Germain, inv. no. 29820. *Pl. 100; P 399.* Diameter 15 cm. Construction apparently analogous to no. 157. On the one end of the linch-pin an engraved lyre-pattern. A thin movable ring passes through the loop of the linch-pin.

159. STUTTGART. Linch-pin. From the river Erms, at the foot of Schwäbische Alb. AuhV 2, 10 pl. 3 fig. 4; Gössler, Préhistoire 1, 269 fig. 6; Bittel pl. 8 fig. 1, p. 69. *Pl. 101.* 10·7 cm. high, about 6 cm. broad. The iron nail, clinched below, is cast in one piece with the head-plaque, which is overlaid with a sheet of embossed bronze, covering front and sides and folded over the edges of the back: no trace of nail. The left mask is fragmentary; the right, which is better preserved, shows the sketchy rendering of

the eye on the side. Bittel l.c. speaks of a tongue to hold the pin secure; I should not like to say how far he is right; possibly the tongue may be nothing more than the result of the scaling which the iron has certainly suffered; compare, however, linch-pin no. 160.

160. STUTTGART. Linch-pin. From Grabenstetten. Gössler, Préhistoire 1, 268 fig. 5; Bittel pl. 8 fig. 4, p. 63. *Pl. 101.* 12 cm. long, now 8 cm. broad—once, before the fluke was bent out of shape, 9·6 cm. The iron nail has the cross-section of a flat rectangle; below, it fits into a bronze cap, above into the solid cast bronze head-piece, the centre of which is square in section, the flukes plano-concave, the flat in front. In front an iron tongue, half the breadth of the nail, is wedged between nail and cap. The cap ends with a moulded rim below and bears an engraved decoration of two oblongs with diagonals. The mouth of the head is a crude notch. The huge eyes reach back to the temples; the lower contour is a coarsely engraved line. The border-line between forehead and hair is engraved; the hair itself is mainly rendered by parallel verticals, partly in cross-hatching. On the skull, a hole. The neck is very short.

161. TRIER. Linch-pin. From Niederweis (Kreis Bitburg), isolated find. Trierer Zeitschrift 13 1938, 226 pl. 9. *Pl. 102.* 9·4 cm. long, curve original; depth of head-plaque about 0·7 cm. The photograph showing the whole of the linch-pin was taken before cleaning. Bronze, cast in one piece. Reverse of head-plaque flat; front, top, and sides with relief ornaments, also plastic spirals on terminal knob. For the loop just below the head-plaque compare the linch-pin from Nanterre, Déchelette fig. 502, 7, Préhistoire 2, 75 fig. 4, no. 2.

162. Brussels. Two linch-pins. From Leval-Trahegnies. De Loë, Belgique ancienne 2, 231 fig. 108, pp. 196, 197; J. D. Cowen, Proceedings Society of Antiquaries Scotland 69 1934/5, 456. I figure one of the pair. *Pl. 102; P 368.* 9 and 8·2 cm. long respectively. The clinched nail is iron, the lentil-shaped head bronze; under side flat and undecorated. All round, a twisted rim. The lotus leaves above the eyebrows of the mask and the two squares beside their curved tips are hollow and certainly had enamel inlay.

163. SAINT-GERMAIN. Inv. no. 51401. Linch-pin, purchased with the set no. 175 from the dealer Trianta-phyllos, who gave the provenience 'Paris': 'Champagne' in the accession journal of the museum, repeated by Cowen, Proceedings of the Society of Antiquaries of Scotland 69 1934/5, 456, is a conjecture; it is very unlikely that these objects were found in France at all, see p. 102. *Pl. 103.* The head-plaque is 8 cm. broad, about 1 cm. thick, the total height still 5·5 cm.; the pin for its greater part worn away: faint traces show that at the top its original breadth was 1 cm., its thickness 0·5 cm. The whole is of iron and the head-plaque bronze-plated; the decoration

seems to have been modelled in wax upon the iron core and cast in bronze à cire perdue. The front is convex, the back flat, the sides plain. The mask has a wart at the tip of the nose: see no. 175. The cheeks are contoured by an engraved line running from the outer corners of the eyes to the alae of the nose.

164. SOFIA.[1] Found with no. 176 in a beehive tomb at Mezek, in south Bulgaria near the Greek border, Bulletin de l'Inst. Bulgare 11 1937 fig. 23, p. 111 no. 28 (Filow); AA 46 1931, 418 (Welkow). A pair of linch-pins, one of them figured. *Pl. 103.* 12·5 cm. long, depth of head-plaque 1·8 cm.

165. SPEIER. From Dürkheim, chariot-burial. AuhV 2, 2 pl. 2, no. 5 (whence Ebert 2 pl. 215, 5). *Pl. 103.* (a) 3·5 cm. high. Iron with thin bronze veneer. Hair on forehead engraved down to the eyebrows. The outlines of the leaves above the head tricked out with dots. (b) 4·2 cm. high. A profiled bronze knob with two iron nails going through it in both axes. Whether and how (a) and (b) belong is uncertain. That they formed part of the chariot is likely, but cannot be proved. Lindenschmit has used the pieces for a fantastic reconstruction of the Etruscan tripod from the grave as a device regulated like a 'Primus stove' (AuhV l.c.). Another chariot-part from the grave is no. 166.

166. SPEIER. From Dürkheim, chariot-burial. AuhV 2, 2 pl. 2 fig. 3 (whence Ebert 2 pl. 215, 3) and 2, 8, Beitafel, no. 11; JL 22. *Pls. 103, 104.* 28·7 cm. long (including bottom knob and tube above it, restored by Lindenschmit and therefore not figured). Cast in one piece. The frame has the shape of a pointed almond and the cross-section of a rhombus; raised mid-ribs on obverse and reverse. The antithetic dragons and the (now almost completely missing) openwork ornaments are cut out of a thinner plaque which was cast with the frame. The knob above is perforated athwart; diameter of hole 1 cm. Openwork on front lavishly engraved, on reverse plain. Lindenschmit strangely took and reconstructed the device as a kind of appendage to the Etruscan tripod from the tomb. Its actual purpose and the reconstruction of its lower end are clearly indicated by the analogous pieces from Kaerlich, no. 167, and Waldgallscheid, no. 153 d. It is one of the rolls of a swingle-tree: its opposite number is not preserved. The tomb was a chariot-grave, the report (AuhV 2, 2, text to pl. 2) mentions an iron tyre of 1·13 m. diameter.

167. BONN.[2] From Kaerlich near Koblenz, chariot-grave. Germania 18 1934 pl. 2, 1–3, pl. 1, 6, 8, 9, p. 11 fig. 4. *Pl. 104; P 385.* Bronze casting and openwork. 21 cm. long. The two rolls of a swingle-tree: see the reconstruction. At the bottom a ring through which the traces passed. At the top they end in a globular head turning round an iron pin fastening the side balls with which the

openwork fastening the rolls to the swingle-tree is connected.

168. SAINT-GERMAIN. From La Bouvandeau. Chariot-horn. Déchelette fig. 505 (erroneous reconstruction as head-piece of chariot-pole, after Flouest); id. fig. 692 (detail); PZ 25 1934, 94 fig. 54. *Pl. 105; P 408.* 14·5 cm. long, across the chord. Stout bronze, well over 1 cm. thick. On the iron rust on the top, impressions of a textile. The inner hollow not conformable with the curve of outside. At a distance of 0·9 cm. below the twisted collar from right to left a thick nail, carefully filed off, which fastened the bronze on a wooden core of which no trace is left. Between the 'cup' and the 'lid', once soldered together and forming the top part of the horn, there is now a gap, filled with earth, &c. In the concentric circles of the pattern traces of red enamel (Henry, Préhistoire 2, 73 and by letter). The ornament on the inner side of the horn is drawn in thin sketchy lines, with slight irregularities at some points.

169. BM. From Somme-Bionne, chariot-grave. Morel pl. 11; JL 37. *Pl. 106.* Most of the longer fragments belong to tubes split lengthways, with a helical twist. Some have a continuous surface, others are made in openwork. Numerous nails. (a) 9·2 cm. long, (b) 8·8 cm., (c) 5 cm. (d) still 3·6 cm. long. (e) 1·6 cm. long. (f) 1·6 cm. long. Diameter of (g) still 2·9 cm.

170. BONN.[3] From Kaerlich near Koblenz, chariot-grave. See no. 167. *Pl. 106; PP 13, 14.* Bronze openwork. The largest piece is 7 cm. long. They were the decoration of an unknown part of the chariot.

171. SAINT-GERMAIN. From La Bouvandeau, chariot-grave. Two bronze hame-mountings. Déchelette fig. 505 (wrong reconstruction, see bibliography to no. 168); BJ 128 1923, 50 fig. 5, e. *Pls. 107, 108; PP 343–4.* The original curve of the hames is well preserved. Height of both pieces 18·3 cm. At the base a zone with coral inlay, some of the corals still red. The bronze was fastened on the wood (or leather) of the hames with nails; nail-holes on the side-strips, probably also the square holes at the tip—better preserved in one of the pieces—and at the ends of the base served the same purpose. A nail fitting into the square hole at the upper end is preserved; it is 1·7 cm. long and has the shape of a pyramid; its head is conical; outside, engraved diagonal lines; in the matrix traces of a clay-like substance, probably the bedding of enamel. On the lyres dot-lines between engraved parallels.

172. NEUCHÂTEL. From La Tène. Vouga pl. 35, 1, 1 a; Déchelette fig. 509. A second piece, not figured here, Vouga pl. 35, 2. Photographs and description from a cast and based on Vouga's statements. *Pl. 109.* 116 cm. long, length of bows 25 cm. Made of one piece of oak wood, one

[1] I am greatly indebted to Professor Filow for photographs and information.

[2] I have not seen the objects and take the facts from the

publication quoted; the photographs are due to the kindness of the late Dr. Günther.

[3] See footnote to no. 167.

half broken, but assembled with certainty. Seen from top the four oval, counter-sunk holes for the traces appear. Shape and size of the bows point to draught-oxen and not horses. (Kind information from Professor Hilzheimer.)

173. BERLIN, Pergamonmuseum. Detail of Pergamene trophy relief. Altertümer von Pergamon 2 pl. 46, 3; text 114. *Pl. 110*. The different size and form of the bows point to ox and cow (Hilzheimer). l.c. pl. 48, 4, a representation of the left part of a similar yoke with trace and part of chariot-pole.

174. SAINT-GERMAIN. From Nanterre, chariot-grave. Déchelette fig. 510, 1; PZ 25 1934, 86 fig. 45, p. 69, note 4. Préhistoire 2, 75 fig. 4, 3 (Henry). *Pl. 110*. (*a*) One of four terrets. Maximum breadth 7·5. Ring rhomboid in section. Broken below; iron core. Red enamel inlay on both sides. (*b*) Star-shaped ornament, diameter 11 cm. in both axes; outlines accompanied by tremolo lines. (*c*) Six complete and two fragmentary mountings. The piece figured is 14 cm. broad; the curve is seen in the plate.

175. SAINT-GERMAIN. Nos. 51400, 51399, and 51402. Provenience and publication the same as those of no. 163. *Pl. 111; PP 475, 476*.

(*a*) Cowen l.c. fig. 3 (his picture incomplete at bottom). 8 cm. high, internal width at bottom of 'saddle' 3·5 cm.; iron inside. The ring proper runs round an aperture of hour-glass form with an offset rim at each end. The decoration consists of a spiral ribbon, the three medallions being the involutions of the spiral and the masks the result of spiral construction, a very typical case of this Celtic fun. The masks on the saddle have their cheeks double-contoured, with radial strokes between the lines.

(*b*) Cowen l.c. fig. 2. Diameter about 6·5 cm., height of ring 2·5 cm. Incomplete below, iron inside. The construction is similar to that of (*a*); here again the three medallions are the involutions of the spiral ribbons, which are here not plain, but decked with smaller spirals.

(*c*) Small bronze head. 2·9 cm. high. Cast, inside hollow. Behind the forehead, cast in one with the head, a horizontal flat peg of square cross-section; under the very prominent chin a kidney-shaped hole. The purpose of the object and where it was attached is not clear.

176. SOFIA. For provenience and publication see no. 164. *Pl. 112*.

(*a*) Filow fig. 69, p. 111 no. 29. Diameter 7·3 cm. 'Four stout bronze rings with broad appendages.'

(*b*) Filow 63. no. 31, not figured by him.

(*c*) Filow fig. 52, p. 111 no. 15. The purpose is obscure, but the style of the ornament round the top disk is definitely Celtic.

177. SAINT-GERMAIN. From Berru, tomb 18. I figure one of a pair of clasps. *Pl. 112*. 12 cm. long. Central part with the eyelets at top and bottom, cast and retouched. The tongues made of a sheet of bronze of medium thickness, folded over to clasp the leather, which is secured at the end by a round-headed rivet. Compare no. 153 *k*.

178. SAINT-GERMAIN. No. 4614 ff. From Han-du-Diable. Trierer Zeitschrift 10 1935, 42 fig. 9 b, c. *Pl. 113*. One of several such phalerae. 6·3 cm. diameter. Cast in one with the staple on the back.

179. SAINT-GERMAIN. No. 27719. From Cuperly. *Pl. 113*. Diameter 12·5 cm. The roll-rim wrought separately. On the under side a stout staple solid cast. In its central depression a square with concave sides; there was possibly enamel.[1]

180. BM. From Somme-Bionne. Morel pl. 10, 11; Déchelette fig. 506, 2; BM EIA pl. 4, top. *Pl. 113*. 6·9 cm. diameter. Roll-rim, of circular section. On middle of reverse, stout square loop. On obverse, conical head of rivet fastening the loop, with inlay which is missing.

181–3. WIESBADEN. From Langenhain (Taunus).

181. Nassauische Annalen 37 1907 pl. 1 no. 12 and pl. 3 no. 1; p. 249 (Ritterling). *Pl. 114; P 313a*. Diameter 21·5 cm.; 0·15–0·2 cm. thick. In the middle, close concentric circles, made on turn-table. In the centre, a hole now filled with corroded iron. Edge serrated and clenched by roll-rim, made in segments (0·3–0·4 cm. thick).

182. Ib. pl. 1 no. 10 and 3 no. 3; p. 250. *Pl. 114; P 313b*. Diameter 12 cm. Same technique as no. 181.

183. Ib. pl. 2 no. 1 and 3 no. 2. *Pl. 114; P 313c*. Diameter 11 cm. Same technique as preceding numbers.

184. SAINT-GERMAIN. From Saint-Jean-sur-Tourbe. Reinecke 75 fig. 6, note 73; PZ 25 1934, 93 fig. 52, p. 84. One of a pair is figured. *Pl. 115; PP 115, 160, 342*. Diameter 24·5 cm. On back, two iron cross-bars which have panned through the openwork at the end of the axes. The roll-rim, wrought separately, bears geometric decoration. In the centre, a coral. On the openwork patterns, engraved lines with dots.

185. SAINT-GERMAIN. From Cuperly. Déchelette 1192; Préhistoire 2, 72 fig. 2 no. 3. *Pls. 115, 243, a; PP 15, 366*. Diameter about 11 cm. Some fractures. Separately wrought, the flat openwork disk, the central round, the four convex bosses; their domed surface is the filigree for enamel, bedded on paste of unknown composition.

186. SAINT-GERMAIN. From Berru. One of six pieces, one of them figured in Préhistoire 2, 72 fig. 2 no. 2 (where Henry gives 'Cuperly' instead of Berru). *Pl. 116*. The largest is 19·5 cm., the smallest 12 cm. in diameter. Some are reinforced on the back by an iron rod along the diameter, only partially soldered. A smaller round in openwork, convex, with a central depression, is nailed on the plane disk. The decoration of the six pieces is different: the disk figured bears a central coral, and

[1] Miss Françoise Henry (by letter): 'matière grisâtre qui est peut-être de l'émail, mais je n'en suis pas absolument sûre'.

eight others, lentil-shaped, arranged in two zones. They rest on a viscous substance which probably filled the whole hollow between the base disk and the openwork. Henry assumes that it was also the bedding of enamel fixed in those open spaces which were not filled with corals.

187. SAINT-GERMAIN. From Cuperly. S. Reinach, Catalogue illustré 2 fig. 134 (right). *Pl. 116.* 6·9 cm. diameter ; staple on back.

188. SAINT-GERMAIN. From Lépine. S. Reinach, Catalogue illustré fig. 132. *Pl. 116.* 5·7 cm. diameter.

189. SAINT-GERMAIN. From Écury-sur-Coole. Four phalerae. Déchelette fig. 693; Thiérot, 'Les Côtes-en-Marne' à Écury-sur-Coole, Marne (1931) 9. *Pls. 116, 117; PP 291, 469.* The two large phalerae have a diameter of 17 and 14·5 cm. respectively, the two smaller ones of about 6 cm. The former are reinforced on the back by an iron cross-piece. The shape of the knobs is clear from the photographs. Champion's drawings do not quite do justice to the delicate, rippling ductus of the engraved lines.

190. MAINZ. From the Rhine near Mainz. Behrens no. 173; WPZ 19 1932, 100 fig. 14; Kühn 379. *Pl. 118.* 9·6 cm. high, 0·08 cm. thick. Deep black patina. Three rivets on lower circle.

191. MANNHEIM.[1] From the Rhine near Bingen. *Pl. 118.* 10·1 cm. high.

192. BM. From Somme-Bionne. Morel pl. 10, 10; Déchelette fig. 506, 1; BM EIA pl. 4 bottom; Kühn 378, 379; Bossert 1 pl. 63, 2; JL 37. *Pl. 118.* 6 cm. high, 0·1–0·13 cm. thick. On the lower circle, three iron rivets (still 0·3–0·4 cm. long). There are two similar pieces from the grave, Inv. no. 1366 and 1367, the latter a trifle smaller and with slight variants of ornamentation.

193. SAINT-GERMAIN. From Chassemy (Aisne). S. Reinach, Catalogue illustré 2, 249 fig. 136 (no. *a*), fig. 137 (no. *b*); Fleury, Antiquités de l'Aisne 1 fig. 80 (unsatisfactory drawing); RA 33 1877, 170. *Pl. 119.* Some more kindred pieces of the same provenience not figured here. (*a*) Inv. no. 17844. 10·5 cm. broad. (*b*) Inv. no. 17844. 10·2 cm. broad. Both pieces have three loops on the reverse. On the obverse of (*a*) three lines of punched circles. (*c*) Inv. no. 17845. 12·6 cm. broad. On the circles six heads of nails preserved. In the turned disks were corals. All three pieces made of fairly thin sheets of bronze, not too precisely cut out.

194. REIMS. From Ville-sur-Retourne (Ardennes). I have to rely on former publications. *Pl. 119.* (*a*) Déchelette fig. 506, 3 and L'Homme Préhistorique 1909, 186 (Collaye). About 7·5 cm. broad. (*b*) Déchelette fig. 506, 4 and Collaye p. 187. About 9·5 cm. broad. (*c*) l.c. 1908, 276. No measurements given. Collaye's 'traces of gilding' (l.c.) are certainly non-existent.

195. BM. From Somme-Bionne. Morel pl. 10, 8, 9, 12; BM EIA pl. 4, middle left; JL 37. *Pl. 119.* 5·3 cm. high, 0·1–0·13 cm. thick. Circles turned. One of the two pieces still has a disk, which once bore coral inlay, with a square loop fitting into the square hole of the tang.

196. SAINT-GERMAIN. From La Gorge-Meillet. Fourdrignier pl. 4 figs. 8, 9; Revue d'Anthropologie 18 1889, 290 fig. 16. *Pl. 120; P 341.* The shorter piece is 4·7 cm. long, the longer 8·7 cm.; it is not certain if its two halves really belong and if there was not a third piece. Cast and then chiselled. At the upper part of the longer piece the artist has not completed the filing process. Here on the back, a loop cast with it, similar to those of the crosses and the knobs from the tomb (nos. 197, 199). On the lower part, three rivets, filed off behind. The inner contours of the larger lyres of both pieces bear engraved lines.

197. SAINT-GERMAIN. From La Gorge-Meillet. Fourdrignier pl. 4 figs. 1, 2, 6, 7 (with more corals than preserved to-day). *Pl. 121.* I figure five of the ten existing buttons. They have flat tangs similar to those of nos. 196, 199 from the same tomb, either cast with them in one piece or socketed in. Most of the corals are now missing; one piece confines inlay to the top of the otherwise plain button.

198. SAINT-GERMAIN. Inv. no. 33287. From the same chariot-burial at Saint-Jean-sur-Tourbe as the disk no. 184. *Pl. 121; P 360.* There are six pieces preserved: I figure one of them: it is 3·6 cm. broad. The smallest is 2·9 cm. broad. The engraved lines and dots appear in the reproduction. The corals, fastened with pins, still bright and red; on the back a loop.

199. SAINT-GERMAIN. From La Gorge-Meillet. Fourdrignier pl. 4 fig. 3, 3 bis, 5; Déchelette fig. 508; Revue d'Anthropologie 18 1889, 290 fig. 15. *Pl. 120; PP 289, 396.* One of a pair; the other piece, figured Fourdrignier l.c. fig. 4 bis, is less complete. The axes measure 7·4 and 7 cm. respectively. The chain extended has a length of 40 cm. The cross is cast, the open spaces in the arms sharply and steeply bevelled, the matrices of the corals precisely turned. A loop on the back is cast with the cross. In the empty matrices a viscous substance. Only the round corals are pinned. Corals still bright and red. The triquetra at the other end of the chain is a heavy casting, again with a loop on the back. Make and construction of the chain are clear from the picture. The rings of the chain of the other cross, not figured here, are stouter.

200. SAINT-GERMAIN. From Cuperly. *Pl. 121.* 9·1 cm. high. On the 'architrave' three rivets. The contours of the two-headed dragon and the other parts of the openwork tricked out by engraved dots and lines.

201. SPAICHINGEN (Württemberg). From Königs-heim, probably from a secondary, Celtic, interment of

[1] Photograph and measurements due to Professor Gropengiesser.

a child in a Late Hallstatt barrow. Gössler in Seeger-Festschrift 205 fig. 1 and in Fundberichte aus Schwaben 1935, 88 pl. 20, no. 1. *Pl. 121.* Diameter 5 cm. A thin embossed bronze sheet folded over and riveted on an iron disk 0·5 cm. thick; the templet for the mask was coarsely modelled on it. Between the two disks, a layer of putty in order to back those portions of the bronze that are in high relief. In the open spaces, the leaves over the head and the circular ends of the torc, there was once inlay; patterns in engraved dots, at the base two leaves. At the base of bottom, loop, at least 2 cm. long, pinned on; it suggests the existence of another at the corresponding upper portion of the disk.

202. CHÂLONS-SUR-MARNE. Possibly mentioned by S. Reinach, Revue Celtique 20 1899, 26. The exact provenience is unknown, but the objects must have been found in a chariot-grave in the region of the Marne. *Pl. 122.*

(*a*) Bronze tube. 3·4 cm. high, diameter of top part 4 cm. Cast. Inside, not far from the scalloped bottom, a cross-nail. On the upper surface, a coral ring and in the middle, a coral disk with concave surface, held by a bronze pin with rosette head.

(*b*) Bronze ring. 0·6 cm. high, external diameter (including projecting corals) 3·8 cm. Solid and wrought. The outside is flanged and bears on both sides coral astragaloi, of which two-thirds are preserved; they are pushed into the flange.

(*c*) (1) Maximum diameter 5·4 cm., (2) 3·4 cm. The core is a plaque of iron which has panned a great deal, that of (1) is 0·2–0·3 cm., that of (2) up to 0·5 cm. thick. (1) bears carved corals on one, (2) on both sides, fixed with pins. (*c*) (1) is illustrated twice. There is a third piece, not figured here; its maximum diameter is 5 cm. and its technique corresponds to that of (*c*) (1).

203. ZURICH. From La Tène. Vouga pl. 38, 3; Déchelette fig. 716. *Pl. 123.* Iron. 11 cm. diameter, height about 3 cm. Pins with round heads; traces of enamel.

204. ZURICH. From La Tène. Vouga 38, 1 and 2; Déchelette fig. 716. I figure one of a pair of bridle-bit-handles. *Pl. 123.* Iron, about 19 cm. long. The top segment of the 'kidney' hammered flat; where it ends, eyelets for the rings connecting this with the top part. Many traces of enamel preserved. From the same workshop and belonging to the same set as no. 203.

205. GENEVA. From La Tène. Vouga pl. 32, 1, p. 95. *Pl. 123.* Bronze, about 35 cm. long. Purpose unknown.

BRONZE TORCS[1]

Nos. 206–46

206. SAINT-GERMAIN. Inv. no. 27616. From Thuizy, Tombe double (Marne). Fourdrignier, L'âge du

fer, Hallstatt, le Marnien, La Tène, Fédération arch. et hist. de Belgique, communication faite au Congrès d'Enghien (1898) fig. 4. *Pl. 124; P 358.* 13 cm.

207. SAINT-GERMAIN. Inv. no. 20260. From Bussy-le Château (Marne). *Pl. 125; PP 352, 440.* 13·5 cm.

208. BM. Inv. ML 1711. From Courtisols (Marne). Morel pl. 37, 4; Déchelette fig. 515, 6; pl. 9, 7. *Pl. 126.* 13 cm. On buffers faint traces of plastic spirals.

208 A, B. NANCY, private possession.[2] From Vitry-les-Reims. *Pl. 126.* Diameter 13·2, 13·5 cm.

209. SAINT-GERMAIN. Inv. no. 27733, ex Fourdrignier Collection. From Suippes (Marne). *Pl. 126.* 13 cm.

210. FRANKFORT. From Praunheim. Festschrift zur 39. Anthropologen Versammlung Frankfurt 1908, 25; pl. 6; Déchelette fig. 440; AuhV 5 pl. 57 no. 1049; Kunkel 189. *Pl. 127.* 13·5 cm. One break in hoop. Tenon-catch on right and left of central part. Decoration confined to façade.

211. CHÂLONS-SUR-MARNE. From Les Jogasses. BSPF 1925/6, 181. *Pls. 127, 219, h; P 98.* 13·5 cm.

212. COLOGNE. Ex Diergardt Collection. No provenience. *Pl. 127; PP 111, 458.* 13·5 cm. Tenon-catch visible in photograph.

213. SAINT-GERMAIN. Inv. no. 11353. Bought at Le Louvain (Marne). *Pl. 128.* 12·7 cm. Interval between the stoutly built buffer terminals.

214. SAINT-GERMAIN. From Saint-Étienne-au-Temple (Marne). *Pl. 128; P 135.* 12 cm. Heavy casting; good workmanship. The conical buffers are decorated with four double-contoured tongues or leaves with a mid-rib roughly chiselled; the knobs with three coils of a guilloche: the ellipsoid coils with a circle inside may signify eyes. The hoop proper starts round, with plastic decoration (vertical lyres), then becomes square; the four planes are covered with rows of punched dots and separated from each other by ridges; they are twisted so that the plane running from the inside of the torc on the left arrives on its outside on the right and vice versa.

215. BM. Inv. ML 1715. From Prosnes (Marne). Morel pl. 38, 4. *Pl. 129.* 13·5 cm. Scrolls and involutions on buffers and hoops are closed; compass-made circles.

216. BM. Inv. 1717. 'Marne.' *Pl. 129; P 81.* 14·4 cm. The terminals slightly hollowed. The compass-drawn circles on them are set without care. Decoration of hoop confined to its ends, and there only to façade.

217. BM. Inv. 68. 7–9. 5. Ex R. H. Brackstone Collection. The old label 'probably from Ireland' deserves no

[1] I give the maximum internal diameter. Silver torc: no. 85, gold torcs: nos. 39 ff.

[2] Drawings made by G. C. Dunning for Claude Schaeffer, who very kindly authorized me to publish them.

credence: the likeness to nos. 215, 216 suggests an origin in the region of the Marne.[1] *Pl. 129; PP 220, 282.*

218. SAINT-GERMAIN. From Saint-Étienne-au-Temple (Marne). *Pl. 129; P 55.* 13·5 cm. The zigzag leaves on the buffers run all round.

219. SAINT-GERMAIN. Inv. no. 33313. From La Cheppe, Tombe du Mont de Lanaud (Marne). *Pl. 130.* 13·5 cm. Very heavy casting. Interval between buffers. The wave lines and circles run completely round the balls.

220. DARMSTADT. Inv. I A, 2. No provenience known. *Pl. 130.* 14·7 cm. Cross-section circular. The part of the torc which touches the skin is free of decoration. At the nape-point an indistinct punched geometric pattern.

221. DARMSTADT. Inv. no. I A, 1. No provenience known. *Pl. 130; P 246.* 14·6 cm.

222. SAINT-GERMAIN. Inv. no. 33309. From Tombe de Répont, lieu dit Monthéron (Marne). *Pls. 131, 132.* 12 cm. Underside flat.

223. SAINT-GERMAIN. Inv. no. 33321. From Prunay, lieu dit Les Commelles (Marne). *Pls. 131, 132.* 11 cm. Buffers plugged with iron.

224. DARMSTADT. According to the museum journal, provenience 'Brandgrab im Dammelberg bei Trebur' and not, as given in AuhV l.c., 'Schönauer Hof, Gem. Rüsselsheim, Kreis Gross Gerau'. AuhV 5 pl. 57 no. 1052. *Pl. 133; P 109.* 14 cm. Very heavy casting; superior workmanship. Tenon-catch to right and left of terminals; on the left a hole for fastening of pin. In the matrices, which have rough surfaces, pins, 1 cm. long, remain for fastening the now missing enamels. Traces of enamel remain in the grooves of the central part and of the knobs. Cross-section of torc circular at the undecorated part, flattening towards terminals and enlarging towards ornamented nape-part.

225. WIESBADEN. Inv. no. 14046. From Pfaffen-schwabenheim. *Pl. 133.* Reverse flat; inlay missing.

226. SPEIER. From Leimersheim. AuhV 5 pl. 57 no. 1043; Sprater, Urgeschichte der Pfalz 116; Kühn 375, 3. *Pl. 134; PP 58, 414.* 12·5 cm. The buffers just spring apart. Cross-section of undecorated hoop circular, of decorated ends flat. Corals carved, fixed with bronze pins with gilt heads; these are of two kinds: the larger have a layer of embossed bronze with the gold foil hammered on it; on the smaller a gold Maltese cross overlies the bronze background. The simple punched motives at the beginning of the hoop and on the knobs are visible in the photograph.

227. BUDAPEST. From Rácalmás-Kulcstelep. Márton pl. 10, 5, p. 36. *Pl. 134; P 413.* In one matrix, on the left, a coral ring is preserved; at the beginning of the hoop coral leaves were fixed, now also missing.

228. SAINT-GERMAIN. Inv. no. 34182. 'Marne.' *Pl. 135; P 101.* 13 cm. Under side flat and free of decoration. In the three matrices enamel inlay. The enamel has turned brown to yellow on the surface, in fracture it is still cinnabar-coloured and of glassy structure. The enamels are radially notched; the central cake has an enamel button on top, the lateral ones have a large cast bronze knob with plastic patterns as centre. At the beginning of the hoop long corals, one of them missing.

229. STUTTGART. From Unteriflingen. AuhV 2, 5 pl. 1, 1; Bittel pl. 16, 1; p. 18 and 73. *Pl. 135; PP 94, 95.* 13·7 cm. Under side flat and undecorated. Tenon-catch where the hoop begins. In the central and right-hand matrix enamel cones still remain, fixed with pins. In the grooves of the ornament, occasional traces of enamel.

230. STUTTGART. From Michelbach. Bittel pl. 16, 4; p. 16 and 73. *Pl. 135; P 102.* 12·5 cm. Reverse flat and without decoration. Tenon-catch on both sides of central part. In the five matrices there is still enamel inlay or remains of it.

231. BUDAPEST. From Lovasberény. Márton pl. 10, 4. *Pl. 134.*

232. STUTTGART. From Möglingen. Bittel pl. 16, 3. *Pl. 135.* 13·5 cm. Fragmentary. Tenon-catch only beside last ball on the left. In the three matrices enamel cones remain: their pins have serrated heads, and engraved on them a quadrilateral with concave sides. The balls have plastic spirals on the façade and engraved rectilinear patterns on the back. The distribution of the relief tendrils on the hoop is asymmetrical.

233. STUTTGART. From Unteriflingen. Bittel pl. 16, 2, pp. 18 and 73. *Pl. 136; P 108.* 12·5 cm. Reverse flat and undecorated. Tenon-catch at beginning of hoop. The five matrices with vertical engraved lines on their outer vertical surfaces. Only in the small matrix on the left a low enamel cone with pin preserved. Rugged workmanship.

234. ZURICH. From Andelfingen, tomb 1. ASA 14 1912 pl. 1, 1, p. 21; Viollier pl. 14, 28; Kühn 375, 2. *Pl. 136.* 13·2 cm. Tenon-catch at the beginning of hoop. Under side plain. Enamel very well preserved, also in the grooves of ornament. On the heads of the pins that fixed the enamels, wheel-motive.

235. ZURICH. From Andelfingen, tomb 29. ASA 14 1912 pl. 9, 1, p. 44; Viollier pl. 14, 30. *Pl. 136.* 13·3 cm. Tenon-catch on the left of decorated forepart. Reverse flat. All enamels well preserved, the larger in two tiers, the smaller only a cushion; on the heads of their pins, engraved triangles, either with rectilinear or with concave sides; the matrices notched.

236. ZURICH. From Andelfingen, tomb 10, grave of

[1] Christopher Hawkes was the first to see this; he very kindly authorized me to publish the drawing made for a publication of the torc by himself.

a maiden. ASA 14 1912 pl. 4, 1; Viollier p. 135. *Pl. 136.* Enamels intact, traces of enamel also in grooves of ornament. The asymmetry of the decoration results from filing away a section of the torc to fit a girl's neck.

237. BERNE. From Schönbühl (Canton Berne), and not, as often said, from Schönenbuch (Canton Basel). Heierli, Urgeschichte der Schweiz pl. 8, 4; Viollier pl. 14, 29. *Pl. 137.* 13 cm. Heavy solid casting. Tenon-catch on left side of decorated forepart. Six of seven enamels preserved, the smaller in three tiers, the larger a radially notched ring with depression in the middle.

238. SAINT-GERMAIN. Inv. no. 18047. Bought at La-Croix-en-Champagne. *Pl. 137.* 19 cm. Cast; the twisted hoop much retouched by filing. Catch-part flat on back; at its extremities, on both sides, only the bedding of the coral leaves remains.

239. SAINT-GERMAIN. Inv. no. 12985. Acquired by confiscation at Le Louvain. AuhV 2, 12 pl. 4 no. 1; RA 1909, 116 fig. 45; Déchelette fig. 195. *Pl. 138.* 18–19 cm. Cross-section flat, increasing in thickness towards the decorated parts. Balls—not visible in the plate—with engraving and plastic decoration on the obverse alone. In the drilled holes on birds and balls there have been inlays, probably corals.

240. SAINT-GERMAIN. Inv. no. 77024, formerly in Thiérot collection at Châlons-sur-Marne. From Breuvery, tomb 29. Thiérot, Nécropole gauloise de Breuvery pl. 1. *Pl. 138.* 19 cm. The central part with the birds is cast, flat on the back; the plastic bands between the central and lateral birds go right round. The twisted wire is soldered into the cast piece.

241. BM. Inv. ML 1709. From Avon-Fontenay (Marne). Morel pl. 37, 2. BM EIA fig. 59; Déchelette fig. 516, 1. *Pl. 138.* 13 cm. Tenon-catch. Plastic decoration confined to façade; only the cross-ribbons run round the ring, on the under side unaccompanied by the filling tendrils.

242. GENEVA. Inv. B 5870. From the Marne. *Pl. 139; P 64.* 12 cm. At the ends, mortises to fit the tenons of the missing detachable portion of the torc.

243. SAINT-GERMAIN. Inv. no. 12744. From Saint-Étienne-au-Temple. *Pl. 139; P 52.* 13 cm. The detachable part is clearly marked in the reproduction. On the nape-part a quatrefoil in low relief, about half of which is visible in the plate. The long leaves run along the hoop, the short leaves athwart it; the outline is repeated in dots; inside the leaves engraved circles as on the throat portion.

244. MARSEILLES. Inv. no. 801. No provenience. *Pl. 139.* 12–13 cm. Tenon-catch. On the three little rings appended, engraved circles (on obverse alone). The plastic cross-ribbons run round the torc.

245. TROYES. No. 132, pl. 16; BAF 1894, 79 pl. 2 a. Reproduced and described here from cast, Saint-Germain,

inv. no. 34164. From Rouillerot (commune de Rouilly-Saint-Loup, Aube). *Pl. 139; P 350.* 12·5 cm. The reproduction shows only a third of the torc: thus the ring with its three balls and the relief decoration, two human heads, facing each other and forming the central part of two lyres, appear twice more.

246. FRIEDBERG (Hesse). From the Glauberg. Friedberger Geschichtsblätter 1909, 1; 6 1924, 62 fig. 4; Kunkel 198 ff., fig. 186; Behrens, Germania 17 1933, 89 fig. 2; Richter, Volk und Scholle 1934, Heft 10, 8 fig. 6. *Pl. 140.* Chord of preserved fragment (internal) 10·5 cm.; original diameter of torc, as calculated, about 13·5 cm. Patina unusual for Celtic bronzes. Obverse and reverse cast separately, joints inside and outside visible in places. The ends, probably at the mortise-tenon joints, were filed off in ancient times when the torc or its reduced portion was used for a different purpose. The torc at the ends has the cross-section of a hanging horseshoe; the planes of the different portions of the obverse are not level; the make is coarse and careless, with some flaws. The figures are much weathered.

Nos. 247–83

BRONZE BRACELETS[1]

247. BONN. From Waldalgesheim. Aus'm Weerth pl. 2 figs. 3, 4; AuhV 3, 1 pl. 1, 2; BJ 128 1923, 50. *Pl. 141; PP 451–3.* Solid casting; patina typical of all bronzes of this find. 8·1 cm. Between eleventh and twelfth ball, counting from tongue end of clasp, the rigid lead insert is modern and incorrect: there was originally a flexible union at this point. The tongue-shaped flat part, which has a hole, once engaged—presumably with a pin—in a split ball, which is now missing. For the pendant bracelet (9·2 cm.), not figured here, see the publications cited.

248. TRIER. From Hermeskeil. *Pl. 141.* 5·3 cm. Between the buffers narrow interval. Inside plain. Faces: the eyes are neatly drilled holes with two engraved circles round them; above, hanging chevron, probably indicating eyebrows; no mouth or nose. The beaded outline of the face corresponds in curve to the normal Celtic design. A second, almost identical, specimen from the same find (inv. no. 19.188 e), diameter 5·1 cm., is not figured here.

249. DRESDEN, Museum für Mineralogie, Geologie und Vorgeschichte. From Pössneck (Sachsen) Mannus-bibliothek Heft 5, 78 figs. 121, 121 a. *Pl. 142.* 7·9 cm. Solid casting. The twist less marked on the inside. At three symmetrical points there are decorated knobs, and here the inside is flattened and ellipsoid. The horns of the ram, on one of the knobs, are continued beyond their points by engraved lines, and the ridges on the cheek are hatched (hardly visible in the reproduction). At the knob, which bears no figure decoration, the outline of the counter-sunk holes is hatched.

[1] I give the maximum internal diameter. Some pieces are foot-rings. For gold and silver bracelets see nos. 50 ff.

250. SAINT-GERMAIN. Provenience Montsaugeon (Haute Marne). AuhV 2, 12 pl. 4 no. 4; Déchelette fig. 697. *Pl. 142; P 285.* 5·5 cm. Heavy casting.

251. MARSEILLES. Inv. no. 2609. No provenience. *Pl. 141; P 346.* Ellipsoid; 5·6 cm.

252. BOLOGNA. From the Celtic cemetery at Fondo Benacci.[1] Brizio, Tombe e necropoli galliche pl. 6 fig. 32, p. 464; Montelius pl. 112, 17; Bertrand–Reinach, Les Celtes dans la vallée du Po et du Danube 175; Déchelette fig. 519, 3; BSPF 1916, 468. *Pl. 143; P 97.* About 7 cm. Cast. The rusted-up hinge appears on the plate.

253. BUDAPEST, Fleissig. From Kosd. 24/5. Bericht RGK pl. 56, 4. *Pl. 143.* 5·3 cm.; 0·5 cm. high. One of a pair.

254. BUDAPEST, Fleissig. From Kosd. 24/5. Bericht RGK pl. 56, 3. *Pl. 143.* 7·2 cm. The horizontally placed spirals are bronze wires soldered on the body of the bracelet.

255. ZURICH. From Andelfingen, tomb 1. ASA 1912 pl. 1, 2, p. 22 (Viollier); Viollier pl. 23, 133; Déchelette fig. 519, 7; Ebert 11 pl. 135, 11. *Pl. 143.* 5·7 cm. Four enamel disks. The impression of the dead man's skin is visible on the oxidized inner surface (Viollier).

256. BERNE. From Münsingen, tomb 61. Wiedmer-Stern pl. 9, 1; p. 48; Viollier pl. 23, 130. *Pl. 143.* 6 cm. The ring is cut out of one piece of a rather thin bronze sheet. To the left of the enamel disk a rivet is visible holding the overlapping ends. The enamel, originally in three tiers, is abraded.

257. BERNE. From Münsingen, tomb 161. Wiedmer-Stern pl. 10, 3; Viollier p. 118. *Pl. 143.* 6·5 cm. Solid casting.

258. SOPRON. From Sopron, Wiener Hügel. *Pl. 143.* 5·2 cm. The body of the ring consists of four wires soldered together, the two lower of larger cross-section than the two upper. Wire spirals are placed on the ring, alternately horizontally and vertically.

259. KARLSRUHE. From Ilvesheim (O. A. Ladenburg). AuhV 4 pl. 13, 4; Wagner 211 fig. 182. *Pl. 144.* 6·3 cm., ring itself 0·7 cm. thick, of circular cross-section. The bracelet and its ornaments were cast in one, and probably not retouched. The top knobs much abraded. At equal intervals there are eleven groups of three balls, each group being set symmetrically about the circumference of the ring, and each of the balls bears three smaller balls.

260. SOPRON. From Ordódbabot. *Pl. 144.* 6 cm.; 2·6 cm. high.

261. VIENNA, Naturhistorisches Museum. Inv. no. 18513. No provenience. *Pl. 144.* Fragmentary. Maximum diameter still 6·9 cm., internal diameter 4·4 cm. The ring consists of two parallel bronze wires soldered together. Soldered on it, two alternating motives: (1) Two pyramids, each of three balls, on crescent plates, connected by a small button, and set at 45° above and below the horizon of the ring. (2) Level with the horizon a ring projects with a ball soldered on top, and two others on either side, resting on the main ring; the balls bear notches.

262. SOPRON. From Sopron. *Pl. 144.* External diameter 9·4 cm., internal about 6·5 cm. On the body of the ring a spiral wire is soldered, running over and under the protuberances.

263. BUDAPEST, Fleissig. From the region of Déva (Maros Valley). *Pl. 145.* 4·8 cm. The decoration is soldered on the body of the ring, a spiral wire running over and under a repeated motive of four interlaced whirls.

264. BERNE. From Münsingen, tomb 135. Wiedmer-Stern pl. 10, 1; Viollier pl. 21, 94. *Pl. 145.* 6·8 cm. Solid casting.

265. VIENNA, Naturhistorisches Museum. From Kis-Kőszeg. *Pl. 145.* Maximum diameter 11 cm., internal diameter 7 cm., height of bumps 7·8 cm. The shell of the hollow bumps rather thin. One of a pair.

266. NUREMBERG, Germanisches Museum. From Aholming near Plattling (Niederbayern). Anzeiger des Germanischen Museums 2 no. 6, Fundchronik pp. 78, 88. *Pls. 145, 146.* Both rings not circular, but slightly oval. External diameter 13 cm.; 7·4 cm. internal diameter; height of bumps 2·9 cm. Cast; the bumps hollow inside; in the holes remains of a filling consisting of a porous and friable substance, on the surface whitish-grey, inside blackish-grey. The two halves of the bracelet, one with three bumps, the other with two, are connected by a mortise-and-tenon catch.

267. MUNICH, Prähistorische Staatssammlung. From Klettham, Bezirksamt Erding, Oberbayern. AuhV 2, 6 pl. 2, 2; Déchelette fig. 442, 5 and pl. 11, 7; Romilly Allen, Celtic Art, plate facing p. 10. *Pl. 147; P 474.* Two rings, differing in measurements only: 7·2 cm. internal, 13·2 cm. external diameter. I figure the better preserved piece.

268. VIENNA, Naturhistorisches Museum. From Raab. *Pl. 148.* Fragment, only four bumps preserved. Maximum length 14 cm., internal width 4·7 cm., height of bumps 3·7 cm.

269. BUDAPEST. Provenience unknown. *Pl. 148.* 6·8 cm. Filling substance in hollows blackish-grey, friable and porous, stiff. Rugged, powerful workmanship.

270. VIENNA, Naturhistorisches Museum. From Tschejkowitz. *Pl. 148; P 473.* Fragmentary. Length still 8·3 cm.; height of bumps 2·9 cm. Tenon-part of catch preserved.

[1] The fragmentary iron fibula from the same grave is no longer in the museum. (Information from Pericle Ducati, who very kindly supplied the photograph reproduced.)

271. VIENNA, Naturhistorisches Museum.' From Kis-Köszeg. *Pl. 149.* Maximum external diameter 8·7 cm., internal 5 cm., height 3 cm. Much corroded. The bumps perforated in some places, the holes with edges 'blistered': probably not the result of corrosion, but of artifice. Filling substance as described on nos. 266, 269.

272. BUDAPEST, Kund. From Kosd, tomb 45. *Pl. 149.* 5·7 cm. The bands in low relief on the ovals are tricked out with rows of dots.

273. BERNE. From Münsingen, tomb 149. Wiedmer-Stern pl. 10, 4 and 6; Viollier pl. 24, 147. *Pl. 149.* 8·4 cm. 'Weissbronze.'

274. LAUSANNE.¹ From Longirod (Vaud). Heierli, Urgeschichte der Schweiz 408 fig. 418; Romilly Allen, Celtic Art, plate facing p. 10; cf. Wiedmer-Stern p. 69; Viollier p. 127 no. 118. *Pl. 149.* A pair. 5·5 cm., the other 5·7 cm. The smaller members of the former are plain, those of the latter decorated with zigzag leaves in relief.

275. SAINT-GERMAIN. Inv. no. 50206. From the Tarn. *Pl. 150; PP 432–3.* 5 cm. Beautiful smooth green patina. Cast. Masterly technique. The ring consists of four larger and four smaller parts, differently adorned; one of the former is detachable. The background of the plastic ornament is roughed; the contours of the ellipsoid fields are rows of upright esses.

276. MARSEILLES. From the oppidum Les Pennes near Marseilles. Abbé Chaillan, L'oppidum de la Teste-Nègre (Annales de la Faculté des Sciences de Marseille 24 1917) pl. 10 no. 7, p. 51. *Pl. 151.* (*a*) two fragments of a bracelet; 5·3 cm. (*b*) fragment of a similar piece, maximum length still 5·1 cm.

277. SAINT-GERMAIN. From Bussy-le-Château. Romilly Allen, Celtic Art, plate facing p. 10. *Pl. 151.*

278. FRIBOURG. From Épagny. *Pl. 151.*

279. VIENNA, Naturhistorisches Museum. From Bydžov Nový (Bohemia). *Pl. 151.* 5·6 cm. Of the two plastic parts of the ring one serves as catch, with a pin at one end and a hinge at the other.

280. BERNE. From Münsingen, tomb 158. Wiedmer-Stern p. 73; Viollier pl. 23, 140. *Pl. 152.* 9 cm. 'Weissbronze.'

281. BERNE. From Münsingen, tomb 61. Wiedmer-Stern pl. 9, 5 (with incorrect indication of grave), p. 48. There was a pair of rings on each ankle, a large ring, which I illustrate, and a smaller, of the type Wiedmer-Stern pl. 8 no. 7. *Pl. 152.* 7·3 cm. The longitudinal joint on the ridge inside; the rings have a core of vine-wood (statement by Dr. Tschumi). The joint reinforced by a narrow bronze collar, besides a hole for a transverse pin, which is now missing. Decoration outside only.

282. BUDAPEST. From Rácalmás-Kulcstelep. Márton pl. 10, 1, 2; p. 44. *Pl. 152.* 4·6 cm. One of a pair.

283. GENEVA. From Ovronnaz (Valais). Déonna, Au Musée d'Art et d'Histoire 2 pl. 4 nos. 6, 7. *Pl. 153; P 100.* (*a*) Inv. no. 12663. 7·2 cm., height 2·5 cm. (*b*) Inv. no. 12665, 6 cm., height 1·4 cm. It is unlikely that the hollows were ever filled.

Nos. 284–6
BRONZE FINGER-RINGS

284. MARSEILLES. From the oppidum Les Pennes near Marseilles. Abbé Chaillan, L'oppidum de la Teste-Nègre (Annales de la Faculté des Sciences de Marseille 24 1917) pl. 10 no. 8, p. 51. *Pl. 153.* External diameter 3·1 cm., thus fitting on thumb or large third finger of a man.

285. BUDAPEST, Fleissig. From Kosd, from the same grave as the girdle-clasp no. 367. *Pl. 153.* 1·7 cm. internal diameter; height on front 0·8 cm., on back 0·35 cm.

286. MARSEILLES. No Inv. no. No provenience. *Pl. 153.* Internal diameter 2·8 cm. Reverse flat and undecorated. The flower-shaped terminals have notches at the end.

Nos. 287–349
FIBULAE[3]

287. COLOGNE. Ex Diergardt collection. No provenience. *Pl. 153.* 5·3 cm. long. Pin and coil missing.

288. MAINZ. From Bavaria (no detailed provenience). Auh V 1, 4 pl. 3, 7; Déchelette fig. 533, 8. *Pl. 153.*

289. MAINZ. From Schwabsburg. Abbildungen von Mainzer Altertümern 4 (1852), Lindenschmit, Ein deutsches Hügelgrab aus der letzten Zeit des Heidentums 10; AuhV 1, 4 pl. 3, 1, 2; Lindenschmit pl. 30, 21; Déchelette fig. 533, 5; Behrens no. 171, 4; Mannus 25 1933, 102 fig. 10. *Pl. 154.* About 5 cm. long. Of the four corals in the eyes of the birds one only is complete and red. On spine of bow keel-shaped coral and a second, discoloured, on the upper surface of the beak of the bird at the spring-end.

290. MAINZ. From Weisskirchen. Abbildungen von Mainzer Altertümern 4 (1852), Lindenschmit, Ein deutsches Hügelgrab aus der letzten Zeit des Heidentums fig. 3; AuhV 1, 4 pl. 3, 3. Trierer Jahresberichte 1894–9 pl. 2, 4; Déchelette fig. 533, 4; JL 29. *Pl. 154.* 4 cm. long. Decoration uniform on both sides. On the pointed caps of the terminal heads, geometric patterns engraved in parallel lines; the tip of the caps flattened out and outlined by bead-row. On top of bow, almond-shaped depression, filled with viscous substance, probably bedding for coral inlay.

¹ Description from the casts in Zurich.
² Gold and silver finger-rings: nos. 72 ff.

³ The material of the fibulae is bronze, except nos. 324 A and 331 which are of silver.

291. TRIER. Inv. no. G 130 a. No provenience. *Pl. 153*. 3·9 c. long. In the birds' heads and on flanks of bow deeply bored holes (now without pins) for corals.

292. STUTTGART. From Schwieberdingen (O. A. Ludwigsburg). Germania 19 1935, 292 fig. 2, no. 4 a–c, pl. 39 no. 7 a, b (Stroh); Fundberichte aus Schwaben 1935 pl. 19, 1 no. 7 and pl. 20 no. 3, pp. 92 ff. *Pl. 154*. 3·5 cm. long. Solid casting. All corals preserved: on spine of bow; four birds' eyes; finials of iron spring-backing.

293. NEUCHÂTEL. From Champ du Moulin (Lake of Neuchâtel). ASA 1904/5, 88 pl. 3; Déchelette 1249, 1. *Pl. 154*. 9·4 cm. long. Fibula itself solid cast; the attached openwork plaque, cut from a thin bronze sheet, is less complete to-day than in the publication cited. Its hooks, one of which remains, caught the pin going through the eight coils of the under-running spring. Of fifteen corals only five remain; on the bird-plaque the bases of the matrices have partly broken away.

294. WIESBADEN. From Weissenturm. Nassauische Annalen 7 1864, 204 pl. 4. AuhV 2, 4 pl. 2, 4. Photographed from a cast. *Pl. 154*. 4·6 cm. long. Corals on spine of bow, globular on top, leaf-shaped on either side.

295. MAINZ. From Budenheim. AuhV 3, 9 pl. 1, 1. Behrens no. 174. *Pl. 155*. 3·5 cm. long. Heavy casting. Hair of masks engraved as usual. Coral inlay at the following places: one keel-shaped on spine of bow; on each flank of bow three, of which only one is preserved; three on each mask, one on forehead, one on each ear: none of these remain; the eyes were without inlay.

296. DARMSTADT. From Hausbergen near Butzbach, Oberhessen. AuhV 2, 4 pl. 2, 5. Lindenschmit pl. 30 no. 19. *Pl. 155*. About 5·5 cm. long. Solid casting.

297. LONDON, Market (Spink). From North Italy, according to information from a trustworthy dealer. *Pl. 155*. 15·4 cm. long. Solid casting. The two central, conical bosses with their matrices seem to have been wrought separately, but no joint visible. The bow is shallow, at bottom 0·4 cm., at top 0·5 cm. deep. There is only a slight difference in detail between the equally elaborate decoration on the two sides of the brooch. The ducks look back, their heads rest on the wings, they have no feet. At the foot of the fibula the first ring is cast in one piece with the brooch; in it hang two smaller rings of twisted bronze wire. Round the waist between the catch-plate and the first ring a glass bead is placed—how? A second hangs from the outer ring. The basic colour of both beads is an opaque brown; the first bead has deep yellow rings on it, the other blue-green ones as well; here their direction is slightly slanting, their movement more lively.

298. STUTTGART. From Lochenstein. Bittel pl. 10, 3. *Pl. 155*. 3·6 cm. long. Bow and bird's head hollow inside. Spring and pin missing.

299. STUTTGART. From Gerhausen. Bittel pl. 10, 6. *Pl. 155*. 3·5 cm. long. Bow hollow inside. Half the spring-coil missing.

300. TRIER. Inv. St. Wendel 19. From Urexweiler. 1. Bericht St. Wendel 1838, 24 ff.; pl. 1, 5; AuhV 3, 9 pl. 1, 9. *Pl. 155; P 149*. 3·9 cm. long. Solid casting. In the birds' eyes iron pins for corals. Hollow on under side with jagged edges. Beginning of head-piece preserved, pierced for inserting spring.

301. TRIER. Inv. no. G 1396. From Zerf. AuhV 3, 9 pl. 1, 3; JL 30. *Pl. 155; P 138*. 3·3 cm. long. No coral.

302. DARMSTADT. Provenience 'Provinz Starkenburg'. Lindenschmit pl. 30, 17. *Pl. 156*. 5·2 cm. long. Point of right horn broken away. On top of the head the normal leaf-crown. A sharp ridge runs from occiput down to catch-plate.

303. KARLSRUHE. From Oberwittighausen. Badische Fundberichte 1 1925 fig. 4, 3 (Wahle). *Pl. 156*. 10·7 cm. long. Completely preserved, coils and pin still in working order. Solid casting. Under side of bow flat. On top of bow, median ridge which fades out towards mask. The brooch consists of five separately cast portions: (1) bow with catch-plate, (2) pin with a ring which catches the hinge-pin, (3)–(5) three balls; the ball over the mask has two rings catching the end ring of the pin.

304. KARLSRUHE. Inv. no. C 7079. No provenience. *Pl. 156*. Pin and spring missing. Bow hollow.

305. KARLSRUHE. Inv. no. C 505. From Nechterzheim am Rhein (Pfalz). *Pl. 156*. 6·2 cm. long. Pin and coil missing. Solid casting. Bow hollow. Along the outer ridge of the curved neck at foot end, a well-executed astragalus.

306. WIESBADEN. From Altkönig. AuhV 4 pl. 14, 1; Lindenschmit pl. 30, 18; Nassauische Annalen 18 1883/4 pl. 2, 8. *Pl. 156*. 5·3 cm. long. Solid casting. Corals on flanks of bow and on top of mask.

307. SALZBURG. From Dürrnberg near Hallein. Much, Atlas pl. 90, 5; Kyrle, Urgeschichte des Kronlandes Salzburg (Oesterreichische Kunsttopographie 17 1911) 14 fig. 52. *Pl. 156*. 6·8 cm. long. Corroded in parts, especially on decoration. Spring and pin missing. Cross-section of bow convex below, tapering to a point on top, with two engraved lines on either side of the ridge. Over the catch-plate not, as one might believe, a fantastic animal with long beak and horns, but a human mask, looking away from the fibula; its ears are, as often, replaced by spirals growing from the forehead; on the mouth vertical strokes (teeth). The mask at the other end has spiral horns which might equally well be interpreted as eyebrow-scrolls.

308. BERLIN, Museum für Vor- und Frühgeschichte. From Niederschönhausen (Kreis Nieder-Barnim). AuhV 3, 9 pl. 1, 5; Lindenschmit pl. 30, 20; Schuchhardt,

Vorgeschichte von Deutschland 214 fig. 186, d. *Pl. 157.* 9 cm. long. Solid casting. Catch-plate damaged; pin and spring missing; the bored hole for receiving the spring-backing is preserved. Along the nose of the ram's head, a groove, 1 cm. long, 0·2 cm. broad, 0·1 cm. deep, with roughened bed, for enamel. Round the base of the horns, three engraved lines; the nape set off by a ridge and engraved lines; below, half-way between horns and catch-plate, engraved lines round the curved foot. On the upper surface of the bow, next the foot, a man lying on his back, his feet resting over the catch-plate, elbows out. His total height is 4·5 cm., of which the head takes up 1·9 cm. There are five enamel grooves, nearly 0·2 cm. deep: one between the legs, and two pairs between the breast and each of the arms, and on either side of the neck. All engraving abraded by wear. More or less visible: the hair, the tooth-brush moustache, beard, and possibly the pupil of one eye; engraved ring-marks round the neck; outlines of arms tricked out with lines; also hands, knee-caps, and feet. The man seems to be ithyphallic, unless the erect penis is the tongue of the ram. Another similar head, but without body, decorates the fore end of the bow; between the two heads deep enamel groove.

309. KARLSRUHE. Inv. no. C 2668 a. From Rappenau near Sinsheim. *Pl. 157.* 3·1 cm. long. Pin and spring missing. Coarse casting. Bow hollow. Details of mask in rough strokes.

310. STUTTGART. From Schwieberdingen (O. A. Ludwigsburg). Germania 1935, 292 fig. 2, 5 a–d pl. 39, 1 a–e (Stroh); Fundberichte aus Schwaben 1935 pl. 19, 1 no. 6; pl. 20, 3; pp. 92 ff. *Pl. 157.* 4·3 cm. long. Solid casting. Two-coiled under-running spring. Corals: on spine of bow; as finials of bronze spring-backing; as finials of pin traversing the spring-backing at right angle.

311. STUTTGART. From Criesbach. Bittel pl. 10, 7. *Pl. 157.* 4·7 cm. long. Unilateral, under-running coil; pin missing. Bow hollow. Teeth of masks in engraved strokes. S-spiral on top of bow with birds' heads as terminals.

312. KARLSRUHE. From Oberwittighausen. Badische Fundberichte 1 1925 fig. 4, 2. *Pl. 158.* 3·3 cm. long. Solid casting. Pin, under-running spring, and bronze spring-backing preserved. Bow hollow; the edge of the opening outlined by bead-row.

313. KARLSRUHE. From Oberwittighausen. Badische Fundberichte 1 1925 fig. 4, 4; Brehm in Strzygowski, Heidnisches und Christliches um das Jahr 1000, 76, pl. 21. *Pl. 158.* 3·3 cm. long. Solid casting. Pin, under-running spring, spring-backing preserved. Bow hollow inside. The head of the spiral-snout is square in section, as in the handle-animals of the Lorraine flagons, no. 381; on its forehead three engraved circles.

314. KARLSRUHE. From Oberwittighausen. Badische Fundberichte 1 1925 fig. 4, 1; Brehm in Strzygowski, Heidnisches und Christliches um das Jahr 1000, p. 76, pl. 21. *Pl. 158.* 3·1 cm. long. Solid casting. Pin and under-running spring preserved. The balls masking the ends of the spring bear three rows of engraved circles; that on the right has discoid bumps.

315. JENA, Germanisches Museum. From Ostheim (Rhön). Mannus 22 1930, 120 (Eichhorn). *Pl. 159; PP 158, 319–20.* 8·5 cm. long. Pin missing. Spring with eight coils and iron pin preserved on one side.

315A. VIENNA, Heimatsmuseum Floridsdorf. From Vienna, Leopoldsau. WPZ 25 1938, 42 ff. fig. 3. *Pl. 159.* No measurements given.[1]

316. NUREMBERG, Germanisches Museum. From Parsberg (Franken); isolated find. AuhV 5 pl. 50, n. 900, p. 283 fig. 3; Déchelette fig. 533, 1; PZ 24 1933, 133 (Kersten); Bossert 1, 62 no. 3; Die Antike 10 1934, 41 fig. 15. *Pls. 159, 160; PP 106, 397.* 8·8 cm. long. Head-plaque 4·1 cm. broad. Solid casting; bow hollow inside. Contours of plastic parts somewhat carelessly retouched. The engraving gives a general impression of neatness, but, at close quarters, the strokes are seen to be unsure. Pin missing. Traces of enamel still in the left eye of the mask at the foot. The following places were bedded for enamel: (1) Eyes and nostrils of the mask at the head end. (2) On the bow, the circle which forms the centre of the three-leaved palmette. (3) The 'eyes' of the engraved spirals on the catch-plate. Whether there was enamel in the holes of the openwork plaque is uncertain. There is a difference in the treatment of the eyes in the two masks: the foot-mask has a plastic pupil and an iris once enamelled; the head-mask an enamelled pupil and a plastic iris, tricked out with a thin engraved line.

317. MAINZ. From Weisskirchen. AuhV 2, 8 pl. 3, 4; JL 29. *Pl. 160.* 1·7 cm. high. Cast. Reverse flat. Broken on both sides. The fragment was the openwork head-plaque of a brooch of the type here represented by nos. 293 and 316; see also no. 319.

318. PRAGUE, Narodni Museum. From Panenský Týnec (Jungfernteinitz). Reinecke 73 fig. 2; Déchelette fig. 533, 2; Ebert 3 pl. 105, r; Schránil pl. 45, 12, 12 a, p. 214; Stocky pl. 20. *Pls. 160, 161.* 10·2 cm. long, length of bird 2·4 cm., of sheep's head 1·3 cm. The corrosion of some parts is visible in the plate. The cross-section of the bow is cam-shaped (approximates to a concave-sided triangle); it is cast in one piece with the bird-plaque and the sheep's head. Under the bird the bow is hollowed out to receive the spring; it has merely the two preserved coils, without over- or under-run, as is also indirectly proved by the position of the catch-plate which is set slightly askew from the longitudinal axis of the bow. The under surface of bow, catch-plate, and bird is plain. There are no traces of bedding for coral or enamel; the shallow depressions on top of the beads, forming the 'diadem' of the sheep, were

[1] Having been unable to obtain a photograph, I am forced to re-draw the cliché published.

never filled; compare the technique on the Dürkheim gold bracelet, no. 57.

319. BONN. From Langenlonsheim. AuhV 4 pl. 14, 2, 2 b. *Pl. 162.* Badly corroded and now less complete than at the time when the publication cited was made. Still 3·3 cm. long. The bow is a feline beast with human head, crouched on his hind quarters, the head resting on the paws from which the catch-plate is developed. Instead of a mane the animal has a ruff, the comma-shaped hollow behind it originally filled with coral; in the holes on right and left between neck and ruff a white substance, almost certainly coral. It is very doubtful whether the deep slit between head and ruff was ever filled. On the back, a saddle, and on it two bronze balls badly pitted, on one of them probably spirals: there is no question of human or animal head here. On the hind legs, spirals. Behind the saddle, above the backbone, striations, contoured by engraved lines parallel to the outline of the belly. The fragment, now lost, figured in the plate from an old photograph, seems to have borne coral inlay in the comma-shaped hollows; its resemblance to a griffin's head may be mere accident. Whether it belongs to the brooch at all is uncertain: it came to the museum with it and with other bronzes; the patina, however, is certainly very similar. The under surface of the fragment is flat: if it does belong, it must have been part of an openwork head-plaque like those of the fibulae nos. 293, 316, 317 and cannot have occupied the place assigned to it in the drawing cited.

320. KARLSRUHE. The provenience generally given, 'Pforzheim', is not supported by the inventory. AuhV 4 pl. 14, 3; Lindenschmit pl. 35, 26; S. Reinach, Anthropologie 7 1896, 182 fig. 407. *Pl. 162.* 2·3 cm. long. Cast in one piece with the fragmentary ape squatting on the animal's back. Pin, coil, catch-plate missing. Fore quarters flattish, hind quarters have more body. The hind feet pierced by a nail parallel to the long axis of the animal.

321. STUTTGART. From Schwieberdingen (O. A. Ludwigsburg). Germania 1935, 292 fig. 2, no. 3 a, b, pl. 39 no. 3 (Stroh); Fundberichte aus Schwaben 1935 pl. 19 no. 1, 1, pp. 92 ff. *Pl. 162.* 2·9 cm. long. Half of coiled spring missing (not seen on plate). Spring-backing with globular finials. Horse flat, two legs, eyes bored, bands round neck and shoulder.

322. FRANKFORT. Inv. X. 19. 106. From Eschersheim. Westdeutsche Zeitschrift 19 1900, 373; 23. Jahresbericht des Vereins für das Historische Museum Frankfurt 1900, 7. *Pl. 163; P 351.* Still 5·4 cm. long. Corroded. Only bow and piece of catch-plate preserved. Solid casting. Under surface of bow flattened.

323. MAINZ. No provenience known. AuhV 2, 6 pl. 3, 6. *Pl. 163.* 9·1 cm. long. Solid casting. Under side of bow flat. Unilateral spring; pin missing. On the 'lay-side' of the coils an engraved continuous line, on the opposite side a continuous row of little vertical strokes. On the

undecorated portion of the bow descending towards the foot an original hole where the missing end continuing the curved part of the foot was probably fastened.

324. FRANKFORT. Inv. X. 19. 1904. From Eschersheim. Westdeutsche Zeitschrift 19 1900, 373; 23. Bericht des Vereins für das Historische Museum Frankfurt 1900, 7. *Pl. 163.* 7 cm. long. On the catch-plate an incomplete three-leaved palmette. On the matrix over the foot a decomposed white substance, probably coral, between four thin bronze bridges, subdividing the circle of the matrix. Original height of inlay may be inferred from length of the central bronze pin, which ends in a round stud.

324A. VIENNA, Naturhistorisches Museum. From Bodrež (prov. Goricia). *Pl. 163.* 9·5 cm. long. Thin silver sheet. Foot soldered on. Rim of matrix with engraved radial strokes; in the middle, a pin, round it, black substance, which has panned (bedding of enamel?). Objects said to have been found in the same urn grave are preserved in the museum (nos. 32869, 32872, 32876, 32882): they are chronologically heterogeneous—among them is a drumbrooch—but this is not a unique case in these backwaters.

325. FRANKFORT. Inv. X. 19. 105. From Eschersheim. Westdeutsche Zeitschrift 19 1900, 373; 23. Jahresbericht des Vereins für das Historische Museum Frankfurt 1900, 7. *Pl. 163.* 7·3 cm. long. Two-coiled spring, with two lateral finials, cast and decorated, its coral inlay is lost. The central part of the bow is a bar of square cross-section: this hardly represents the original state: it is difficult to imagine how coral should have been applied to this shape; it is more likely that, for unknown reasons, the bow has been filed down here in recent times. The matrix over the foot is filled with a decomposed white substance, probably coral, with faint traces of plastic scrolls, probably the remains of corals as e.g. in nos. 324, 326, 330, 334, 335, 337, 343, 344, 345. The height of the inlay is indicated by the length of the pin in the centre of the matrix.

326. MAINZ. From Hahnheim. Behrens no. 206. *Pl. 163.* 6·5 cm. long; heavy casting. On the foot-plaque (cast in one piece with the brooch), which has a rim in low relief, nine coral sectors and a pinned central coral stud. The spring has corals as terminals of the backing, and one filling the gap in the middle of the coils. All corals are carved. On the catch-plate chiselled vertical strokes inside a triangle.

327. KARLSRUHE. From Sinsheim, tomb 11 or 12. *Pl. 163.* 6·5 cm. long. Pin and spring preserved. Solid casting. Matrix turned, traces of lathe; filling, coral or enamel, missing. Little palmettes (difficult to see in the plate) sprout from the matrix to right and left.

328. BERNE. From Münsingen, tomb 49. Wiedmer-Stern pl. 5, 10; p. 43; Viollier pl. 3, 96. *Pl. 163.* 5·7 cm. long. Solid casting. The filling of the matrix may be

196

coral or enamel: modern tampering has made certainty impossible.

329. BERNE. From Münsingen, tomb 63. Wiedmer-Stern pl. 11, 1; p. 50; Viollier pl. 3, 91. *Pl. 164.* Solid casting. Four-coiled over-running spring. The decoration of bow reaches round almost to middle of under surface. On the foot-disk, bun with horizontal grooves round it; the enamel has turned brown; it is fastened by a pin with a star on the head. On catch-plate plastic pattern.

330. BERNE. From Münsingen, tomb 91. Wiedmer-Stern pl. 11, 9; p. 58; Viollier pl. 2, 48. *Pl. 164.* 5 cm. long. Solid casting. On foot-disk, one coral, bleached.

331. BERNE. From Schlosshalden (Bern). Bonstetten suppl. pl. 13, 8; p. 21; Viollier pl. 2, 53, p. 107. *Pl. 164.* Silver. 6·3 cm. long.

332. BERNE. From Münsingen, tomb 49. Wiedmer-Stern pl. 5, 8, p. 43; Viollier pl. 2, 69; AuhV 5 text p. 335 fig. 3 d. *Pl. 164; P 348.* 8·4 cm. long. Solid casting. Spring-backing with coral finials. Of the corals on the foot-disk only the central one is carved, the others are plain; of the pins fastening them, the central one bears radial engraving, the others little stars; the projection from the disk towards the bow is flower-shaped.

333. BERNE. From Münsingen, tomb 50. Wiedmer-Stern pl. 7, 1, p. 44; Viollier pl. 2, 68. *Pl. 164; P 349.* 6·8 cm. long. Solid casting. On the over-run and the outermost coils of the spring, simple engraved decoration, the same on the catch-plate. Circumference of foot-disk with vertical striations. Corals: round the central bun a ring of two pieces. Professor Tschumi offers the suggestion that the heaviness of this as of other brooches from Münsingen is due to a leaden core, but its presence could be established only by boring.

334. BERNE. From Münsingen, tomb 107. Wiedmer-Stern pl. 12, 2, p. 62; Viollier pl. 2, 52. *Pl. 164.* 8 cm. long. Solid casting. On catch-plate, tendrils. The circumference of the foot-disk is notched. On the coral, a carved wave-tendril; the iron pin has panned over the bleached coral. The part projecting from the foot-disk towards the bow is palmette-shaped.

335. BERNE. From Münsingen, tomb 79. Wiedmer-Stern pl. 11, 11, p. 53; Viollier pl. 2, 67. *Pl. 164.* 6·1 cm. long. Solid casting. On the catch-plate, oblique striations. On the foot-disk, bleached corals, the outer circle consists of three pieces, carved radially; on the central bun, a carved pattern which is either a concave-sided triangle or quadrilateral; the head of the bronze pin is round and notched.

336. BERNE. From Yverdon. Viollier pl. 2, 55, p. 134. *Pl. 164.* 9·2 cm. long. On the foot-disk, remains of the central coral. On the catch-plate, simple plastic decoration. (Description by Tschumi.)

337. BERNE. From Münsingen, tomb 85 (child's burial).

Wiedmer-Stern pl. 12, 6, p. 57. *Pl. 164.* 4·6 cm. long. Solid casting. Vertical striations on the circumference of the foot-disk. The coral bun on it carved; on the circular head of the central bronze pin a concave-sided triangle, the rest of the circle filled with radial strokes.

338. BERNE. From Münsingen, tomb 49. Wiedmer-Stern pl. 5, 11, p. 43; Viollier pl. 3, 98; AuhV 5 text p. 335 fig. 3 g. *Pl. 165.* 4·6 cm. long. Solid casting. On catch-plate four notches. On foot-disk, enamel bun with depression in the middle, fastened by bronze pin with star-shaped head. In the spiral grooves on the bow remains of enamel.

339. BERNE. From Münsingen, tomb 62 (child's burial). Wiedmer-Stern pl. 7, 9, p. 48; Viollier pl. 1, 5, p. 113; AuhV 5 text p. 335 fig. 3 a. *Pl. 165.* 6·8 cm. long. Solid casting. Unilateral two-coiled spring. On the foot-disk, the circumference of which has vertical striations, there is a small, bleached coral.

340. BERNE. From Münsingen, tomb 49. Wiedmer-Stern pl. 5, 9, p. 43; Viollier pl. 2, 74; AuhV 5 text p. 335 fig. 3 f. *Pl. 165.* 7 cm. long. Solid casting. Engraved geometric decoration on catch-plate. There are eight corals altogether, six of which appear in the reproduction: only the stud on centre of bow fastened by a pin.

341. BERNE. From Münsingen, tomb 80. Wiedmer-Stern pl. 12, 3, p. 54; Viollier pl. 2, 70. *Pl. 165.* 8·6 cm. long. Solid casting. Spring-backing with coral finials. The under surface of the bow has plastic oblique striations. The bow has been gouged out on top and side to receive coral bars consisting of several pieces; the walls of the compartments are ridged. The coral inlay of the foot-disk consists of three pieces, remains of radial carvings; on the beak-shaped tongue, projecting from foot-disk and resting on bow, faint traces of coral.

342. BM. Inv. Morel 1632. From Pleurs (Marne). Morel pl. 27, 4; BM EIA fig. 63; Ebert 3, 91. *Pl. 165.* 8 cm. long. Piece of pin preserved. The whole of the bow and even the spring covered with coral. The corals along the backbone of the bow project above the rest.

343. BERNE. From Münsingen, tomb 156. Wiedmer-Stern pl. 14, 8, p. 72; Viollier pl. 3, 80. *Pl. 165.* 8·8 cm. long. Solid casting. Diameter of foot-disk 3·3 cm. Arrangement and decoration of corals appear in the photograph.

344. STUTTGART. From Steinheim a.M. Bittel pl. 10, 20, 21. *Pl. 165.* A pair. 6 cm. and 5·2 cm long respectively. Solid casting. On catch-plate a few engraved lines. Coral in good condition though mostly bleached and red in places only. Both brooches have a triangle with concave sides carved on central bun; the other patterns appear clearly in the photographs.

345. SAINT-GERMAIN. From the Marne. S. Reinach, Guide p. 245 fig. 133. *Pl. 165.* A pair. Diameter

5·8 cm. and 5·7 cm. respectively; maximum height 4·1 cm. and 3·7 cm. The foundation is an iron cone, entirely covered with coral; its under surface is concave and was fastened to a brooch by an iron spike. The corals, which have decomposed in an unusual way, are fixed by little iron pins, which probably had decorated heads. The coral decoration consists of three low tori, enclosing two zones of beehive section; on top, a round knob with a carved pattern of spirals.

346. BUDAPEST. From Bölcske. Márton 93 fig. 25 and p. 33. *Pl. 166.* No measurements available.

347. BUDAPEST, Kund. From Kosd, tomb 37. *Pl. 166.* 6·5 cm. long. The cast knob on the foot part is decorated with three bosses, interconnected by spirals.

348. BM. From Wargemoulin. Morel pl. 36, 6 and 7, p. 150. *Pl. 166.* See also Henry, Les tumulus du département de la Côte d'Or 83.

(*a*) Inv. ML 1703. Diameter 3·4 cm. Fastened on the back of the disk a tiny fibula with six-coiled under-running spring and flat bow. The disk is cut in one piece with the projecting pins fastening the outermost row of corals. The setting of the next row is a circular gold strip with embossed bead-pattern. The decoration of the centre is bedded on a cake of bitumen, once covered with a thin gold skin of which only parts remain. Three longish corals form arcs of the circumference: there were originally six. In the centre of all a round coral knob.

(*b*) Inv. ML 2174. Same provenience. Diameter with projecting pins 2·4 cm., without 1·9 cm. Fibula on back missing; only one of the corals preserved.

349. SOPRON. From Balf. Arch. Ert. 1910, 39; Márton pl. 3, 3. *Pl. 166.* 4·5 cm. diameter. Gold foil, only 0·01 cm. thick, hammered on an embossed bronze layer; bow of fibula riveted to back of disk.

Nos. 350–68

GIRDLE-CLASPS

350. MAINZ. From Weisskirchen. Abbildungen von Mainzer Altertümern 4 (1852), Lindenschmit, Ein

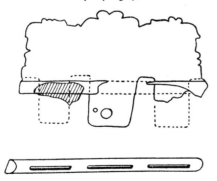

deutsches Hügelgrab aus der letzten Zeit des Heidentums

figs. 4, 5; AuhV 2, 4 pl. 2, 7; Déchelette fig. 525, 4; JL 28; Die Antike 10 1934 pl. 7; Préhistoire 2, 72 fig. 2, 1; Kühn 385. *Pl. 167; P 412.* 6·6 cm. broad. Solid casting. Back flat. Coral inlay: square plaques in the sockets of the horizontal zones below, and lotuses, disks, &c., in the pedestal on which the mask and the hind quarters of two animals rest. No traces of enamel. The cast openwork plaque is continued by three tongues of which only the central one, with two holes, is preserved in entirety. The tongues passed through three slots in the tubular bar which masks the leather straps of which fragments remain (hatched in the drawing). A triangular hook is riveted over a flanged strip to the back of the plaque. On the hook-plate, engraved decoration, concentric circles round a rivet (which is not visible here but appears in front, on the chin of the mask), and leaves of a shape corresponding to those at the attachment of the beak-flagon no. 385. The two coral-encrusted zones are accompanied above and below by beaded lines; traces also of vertical beaded lines on the sockets between the coral squares. At top and bottom of the tubular bar, a torc-pattern reversed in the middle.

351. MAINZ. From Schwabsburg. Abbildungen von Mainzer Altertümern 4 (1852), Lindenschmit, Ein deutsches Hügelgrab aus der letzten Zeit des Heidentums 10; AuhV 2, 4 pl. 2, 1; Déchelette fig. 525, 1; Behrens no. 171; Mannus 25 1933, 103. AuhV 2, 8 Beisatztafel no. 4 and AuhV 3, 1, Beilage p. 23 give the loose top piece. *Pl. 167; P 356.* 5·5 cm. broad. Comparison with Lindenschmit's drawing shows that to-day some pieces of the openwork triangle are missing. Its distance from the base can only be conjecturally calculated by reconstruction of the ornament. (See *P 356.*) The girdle-hook consists of the following separately wrought parts: (1) The oblong bronze plaque with engraved patterns continuing above into the openwork triangle. (2) Thin triangular bar with tongue-pattern. (3) The hook, with the mask, cast, ending upwards in a square tongue slotted through the bar and riveted to the oblong plaque: on the front the rivet-head is a matrix, once certainly filled, on the reverse a simpler stud. On the outside of the hook-pin a coarse geometric pattern in rough notches.

352. GOTHA, Heimatmuseum.[1] From Seeberg, Heilige Lehne, tomb 34. *Pl. 168.* 4·7 cm. broad. The edges of the plaque are folded over on the back, the side ones overlapping the bottom edges, the top being open. The perforation above fragmentarily preserved. The decoration at the bottom is a debased tongue-pattern; above it the same aslant. The cast hook, bearing a geometric engraved ornament, near the bend, forms the stalk of a pear-shaped plaque, which is fastened on the back of the oblong plaque by a rivet with a carefully modelled round stud in front and another of irregular shape behind.

353. MAINZ. From Langenlonsheim. Abbildungen

[1] I owe the knowledge of this piece and of no. 356 to Dr. W. Dehn. The Keeper kindly sent the objects for my inspection.

von Mainzer Altertümern 4 (1852), Lindenschmit, Ein deutsches Hügelgrab aus der letzten Zeit des Heidentums 11; AuhV 2, 4 pl. 2, 9; Déchelette fig. 525, 2. *Pl. 168.* 4·7 cm. long. Preserved, the tubular bar, decorated only on the front, and the cast mask continuing into a tongue, slotted, as usual, through the bar; at its upper end, the rivet that once fastened it to the missing oblong plaque.

354. TRIER. From Hermeskeil. Trierer Jahresberichte 1882–93, 28; pl. 5, 13; Déchelette fig. 525, 3. *Pl. 168.* Still 5 cm. high.- Heavy solid casting. Preserved are the tubular bar (less complete now than in the publications cited), the cast mask, hollow on the back, the rivet, fragments of the plaque, and small pieces of leather.

355. SAINT-GERMAIN. *Pl. 169; PP 323, 364.* (a) Inv. no. 13308. 5·3 cm. high. From the region of Épernay. (b) Inv. no. 22217. 5·9 cm. high. (c) Inv. no. 71441. 7·9 cm. high. From the tomb at La Motte-Saint-Valentin, Déchelette, La Collection Millon pl. 32, 5; Déchelette fig. 524, 4. (d) Inv. no. 27814. 6·5 cm. high. Ex Collection Fourdrignier. (e) Inv. no. 4976. 3·8 cm. high. From Saint-Étienne-au-Temple. (f) Inv. no. 13158. 5·5 cm. high. Presented by Napoleon III. (g) Inv. no. 21552. 3·7 cm. high. (h) Inv. no. 20266. 6·2 cm. high. From Suippes. (i) Inv. no. 13256. 5·2 cm. high.

356. GOTHA, Heimatmuseum. From Seeberg, Heilige Lehne, tomb 34. *Pl. 168.* 6 cm. high. Cast. Tongue broken off, at its base three or four rivets and remains of oxidized iron.

357. SPEIER.[1] From Rodenbach. AuhV 3, 5 pl. 2, e; Sprater, Urgeschichte der Pfalz fig. 129; JL 26. *Pl. 168; P 150.* Only the tubular bar is preserved. 4·7 cm. broad, diameter 0·8 cm. Closed at both ends. In the tube, pieces of a double leather strap, probably sewn not with thread but with thin leather: its front may have been decorated. The view that the leather formed part of the strap of the imported bronze pilgrim-flask associated in the find is groundless.

358. BERNE. From Bofflens (Vaud). Bonstetten pl. 4, 8, 9, 12 (detail incorrect); see also Heierli, Urgeschichte der Schweiz 374. *Pl. 170.* 5·3 cm. broad, 2·1 cm. high. Bronze of medium thickness. Patina beautiful milky green. On lower edge and back iron has panned from outside. On top two rivets with round heads, with rectilinear washers on the back. The left edge is folded over (damaged since Bonstetten's drawing). Below, the edge is bent over to a tube, continuing for 0·5 cm. The engraving is confined to the front: on the plaque the lines are hair-thin, on the tube coarser, corresponding to a difference of style, the 'Hallstatt' of the tube, the curvilinear of the plaque.

359. BM. Inv. ML 1347. From Somme-Bionne. Morel

pl. 9, 5; Déchelette fig. 524, 1; BM EIA pl. 4; Kühn 385; JL 36. *Pl. 170.* 6·4 cm. high. Cast, openwork. Horizontal fracture just above the base. In the tongue under the horizontal bar half a rivet-hole visible. On the bar concentric circles; at the places where the eyes of the griffins are and in the middle, between their ears, concentric circles with dots. The outlines of the ears tricked out with dotted lines.

360. HOELZELSAU, private possession. From Hoelzelsau (Unterinntal). WPZ 10 1923, 28 (Reinecke); Die bildende Kunst in Oesterreich (ed. Ginhart) fig. 82. *Pl. 170.* Length 16·2 cm. Cast, openwork, 0·2–0·3 cm. thick, riveted to a bronze base-plate, 0·2 cm. thick. Preserved, tubular bar with engravings, in the upper row groups of vertical lines, substitute for tongue-pattern, below linear substitute for torc-pattern. The hook-plate with tongue, slotted into the bar, with a large rivet-head at the bottom, probably once filled with a coral. The eyes of the beasts are drilled holes in concentric circles. On the reverse of the tongue a graffito scratched in the form of a capital W. (Description borrowed from Reinecke l.c.)

361. ZURICH.[2] Ulrich pl. 42, 3, p. 547; pl. 31, 15, p. 244; pl. 7, 3, p. 97. *Pl. 171.* (a) From Giubiasco, tomb 29. 11·7 cm. high. (b) From Molinazzo d'Arbedo, tomb 17. 10·5 cm. high. (c) From Castione, tomb 64. 9·2 cm. high. All three pieces openwork, cast, riveted on base-plate. On the bottom bar, small stamped circles. Broken in places and repaired. On the tongues of (a) and (b), the rivets with their heads, large in front and smaller on back.

362. CHÂTEAU DU NÈGRE (Béziers), Mouret collection. From the Celtiberian necropolis at Ensérune. Mon. Piot 27 1924, 51 fig. 4; Héléna, Les origines de Narbonne 272 fig. 166; AA 45 1930, 219. *Pl. 170.* No measurements given, but the clasp must be about the size of no. 361 a, b, c as it obviously comes from the same workshop.

363. ESTE.[3] From north cemetery of Villa Benvenuti, tomb 116. *Pl. 171.* (a) Déchelette fig. 524, 3. Both cast, openwork, reverse flat. (a) 10·9 cm. high, (b) 4 cm. high. (a) A 'zoomorphic' lyre, rising from base-bar, with tongue in the same casting and loaf-shaped rivet-stud, probably once filled. Concentric circles with drilled and countersunk holes at six places on the animal-lyre. (b) has a rivet-stud at upper and lower end.

364. GENEVA. From Lötschental (Valais). Déonna, Au Musée d'art et d'histoire 2 pl. 2, 2. *Pl. 171.* 10 cm. long. Cast, openwork. Vertical fracture with modern repair. Reverse flat.

365. BERNE. From Münsingen, tomb 6. Wiedmer-Stern pl. 2, 4, p. 21; Viollier pl. 29, 5, p. 110; AuhV 5 text 335 fig. 3, 0. *Pl. 172.* 7·5 cm. high. Bronze of medium thickness, riveted on iron, which is preserved in places; E. Vogt.

[1] I owe the photograph reproduced and the description to the kindness of Dr. Sprater.
[2] For photographs and description I am indebted to Dr.
[3] I owe the photographs and the description to the kindness of Dr. Adolfo Callegari.

one rivet still remains in its hole. There are large concentric circles round the rivet-holes, and one between the bottom pair, cleanly drawn by compasses; a group of six similar, but smaller, circles immediately above the bottom row, and two, for the eyes of the birds which appear at each side of the plaque, looking back. The bodies of the birds and the area of the circles are left plain against the pattern of stippled triangles, pointing upwards, which covers the rest of the plate.

366. MAINZ. From Herrnsheim. AuhV 3, 3 pl. 2, 9. *Pl. 172.* 4 cm. high. Cast with the loop; looks like a bottle-opener. The leaves of the crown are filled with an engraved pattern.

367. BUDAPEST, Fleissig. From Kosd. Márton 73 fig. 15; 24/5. Bericht RGK pl. 56, 10. *Pl. 172; P 293.* 4 cm. long, 3·5 cm. broad. From the same grave as the bronze finger-ring no. 285.

368. BUDAPEST, Fleissig. From Kosd. *Pl. 172.* 8 cm. long; height of cone 2·7 cm. The bottom frame of the cone and the two rings attached were cast in one piece. The wire spirals are not cast but soldered together.

Nos. 369–80
VARIA

369. DARMSTADT. From Nauheim. Adamy, Die archaeologische Sammlung Darmstadt (1897) 100; Quilling, Die Nauheimer Funde 48; Reinecke pl. 6 fig. 7; Germania 17 1933 pl. 11, 2 (Behrens). For the grave-group see Quilling l.c. *Pl. 173.* 5·3 cm. high, including eyelet; 4·5 cm. deep, from tip of nose to tip of nose. The two halves soldered together, no joint visible. On top a piece broken away, one of the eyelets missing for its greater part. A ring in the preserved loop appears in former publications, but is now lost. Adamy l.c. states: 'There is a small silver chain, consisting of three parallel wires with notches athwart, soldered together; it was broken loose by force; inside there is still a similar chain sticking to the rusted bronze.' The contours in beadlines; upper lip with vertical strokes; pupils neatly engraved circles; nostrils carefully bored.

370. TRIER. From a chariot-burial at Freisen, Kreis Sankt Wendel. Reinecke pl. 6 fig. 8; PZ 25 1934, 81; Germania 20 1936, 53 (Dehn). *Pl. 174.* 12 cm. long. Solid casting. Missing, the feet, the left ear, tip of tail. No indication of sex. Cross-section of neck rhomboid, the ridges not quite sharp, save that on the neck-line. The shape of the body is on the whole cylindrical, but its gentle curves still have a suggestion of a rhomboid. The rendering of the hind legs is quite life-like; the knee of the right foreleg is strongly stressed. The remaining pricked-up ear, seen from front, is flat and less spoon-like than that of the animal no. 372. The large almond eyes only preserved in traces: the lashes notched, the pupils

just a little bulging. Below the muzzle the trace of a ring broken away. An old report mentions a pendant, now lost.

371. BUDAPEST. From Báta. Márton pl. 17, p. 29. *Pl. 174.*

372. BERLIN, private possession. Found in the Taunus, according to information from a trustworthy dealer. *Pl. 175.* 10·2 cm. high. The bronze has a beautiful, smooth patina, brown, in places greenish, and shows golden where the skin has peeled. Solid casting. The lowest 4 cm. are bored hollow; the hole is an ellipse, its longer axis parallel to the jawbones. Near the end, in the same plane, two holes for a rather large nail running obliquely to the axis. The nostrils neatly drilled, the mouth notched, the eyes precisely bored circles with a small circle at the bottom, apparently a device for coral inlay.

373. HOCHHEIM (MAIN), Schwabe. From Hochheim on the Main. Mannus 25 1933, 89 (Schwabe); Germania 17 1933, 81; pl. 10 (Behrens); Mainzer Zeitschrift 29 1934, 40 fig. 13; Kühn 388. *Pl. 176.* 16·2 cm. high, diameter of disk 12·5 cm. The disk burnished on both sides, but the patina differs. Inside the lower end an iron tube is inserted and kept in place by a rivet; it forms a female joint for a wood or bone handle (compare no. 374). The figure is a Janus in two halves, cast from the same mould, but each of the arms is cast as a whole together with one of the halves of the bust. The four-fingered hand is cleft to receive the disk. The figure wears circlets round neck and wrists; it is uncertain if they signify jewels or only the hems of clothing. The hair is combed askew across the skull. The eyes are large and almond-shaped and bulge. No indication of ears.

374. SAINT-GERMAIN. From La Motte-Saint-Valentin. Déchelette, La Collection Millon pl. 32, 1, p. 141; Archaeological Journal 85 1928, 72 fig. 2; Germania 17 1933, 85 fig. 1, 1. *Pl. 176.* Diameter 18·2 cm. I give a close-up of the front, which is more carefully burnished than the reverse and differs in patina. On the reverse, the trace of a compass-point, and round it four pairs of concentric circles. The cast handle is fastened on the mirror by three rivets, the heads of which appear on the wings and on the central disk, carefully filed off. Within the handle remains more likely of wood than of bone or ivory.

375. LAUSANNE. From near Aigle (1860). ASA 1861 pl. 1, 1; JRS 29 1939, 99. *Pl. 177; P 248.* 9·5 cm. long.

376. SAINT-GERMAIN. From Étrechy (Marne). Déchelette fig. 698, 1. Morel pl. 19, 1; p. 97. *Pl. 176; PP 96, 290, 322.* Three identical or similar pieces, only differing in measurements. Between 10 and 12 cm. broad. I figure two, the more complete from a cast (Saint-Germain, inv. no. 23846), the other from the original.[1] Nail-holes in different places, Morel speaks of a nail as being preserved.

[1] Photograph and information due to Lantier.

377. VIENNA, Niederoesterreichisches Landesmuseum.[1] From Brunn am Steinfeld. *Pl. 177; PP 153, 450, a, b.* 10 cm. long, 2 cm. maximum breadth. Two congruent pieces, obverse and reverse of an object of unknown use, connected and held at a distance of 0·3 cm. by fourteen rivets. Material of obverse stouter. Sharply curved across the waist, slightly along the length. Ground of patterns stippled.

378. MUNICH, Museum für Vor- und Frühgeschichte. Inv. no. 1908. 39. From Hohenfeld (B. A. Parsberg). Isolated find. *Pl. 177.* Rather stout bronze, 0·1–0·2 cm. thick. 7·5 cm. high. Dented and damaged. Two nail-holes and possibly trace of a third near the lower edge. Edge below somewhat serrated, otherwise clear cut. Decoration on both sides, but the drawing surer and more elaborate on one. Tremolo lines as often, but here, exceptionally, also along and within the deep grooves of some lines of the pattern.

379. SAINT-GERMAIN. No. 77055. From Mairy (Marne), tomb 47. *Pl. 177.* Very thin sheet of bronze, broken and now mounted on gauze. 5·8 cm. largest extension.

380. SPEIER. From Leimersheim. Sprater, Die Urgeschichte der Pfalz fig. 131. *Pl. 177.* Diameter 2 cm. Reverse plain. Outer ring with zigzag pattern, with circles at the points. In the middle, low cone with coral, held by pin.

Nos. 381–401

BRONZE VESSELS

381. BM. Reginald Smith, Archaeologia 79 1929, 1 ff.; Illustrated London News, March 30th, 1929, 533 (coloured reproduction); JL 99; Nachrichtenblatt für die deutsche Vorzeit 6 1930, 222 (Keune); Márton 46; Rostovtzeff SB 488, note; Die Antike 10 1934 pl. 5; PZ 25 1934, 95. The oft-repeated provenience 'Bouzonville' is erroneous: according to Dr. Keune's careful statements (l.c.) the objects were actually found at Niederjeutz (Basse-Yutz), on the Moselle, opposite Diedenhofen, by workmen who hid them and took them to Bouzonville (Busendorf). Local rumours that they were not excavated in Lorraine, but brought there in 1917/18 from the Isonzo by German soldiers, are untrustworthy for internal and external reasons. That they are a pair and were found with a pair of stamnoi, now also in the British Museum (*pl. 253*) is a strong proof of their having come from a grave. *Pls. 178–83; PP 156, 179, 217, 405–7, 423–5.*

The jugs are pendants, made by the same artist, with slight variants, partly shown by the figures on the plates, partly detailed in my description.

The measurements are:

	(*a*)	(*b*)
Height (to tip of beak)	37·6 cm.	38·7 cm.
Diameter of shoulder	19·3 cm.	19·0 cm.
Diameter of foot	10·4 cm.	10·5 cm.

(*a*) has lost a piece of the foot, and the coral inlay on the throat-shield is more deficient than in (*b*). (*b*) like the stamnoi, has suffered from the diggers, and the replacement of the broken neck has caused some disfigurement of the profile of the shoulder.

The surface is velvety, olive or moss-green, in some parts gold-speckled—not gilt (statement of the laboratory of the BM); the patina of the cast parts differs. The coral has bleached and become creamy, in other places brownish; where the skin has gone, it has the rough structure of chalk or broken bones. The enamel is now colourless, but regains its ancient deep red if wetted; it is well preserved on the knob, elsewhere only in traces.

The flagons consist of the following separately wrought parts:

(1) The body proper, hammered, as it seems, out of a single sheet of bronze; no joint is visible. Its upper rim is everted, its bottom end being masked by no. (3).

(2) The foot; in the centre of its bottom a matrix of 1·5 cm. diameter with a pin in the middle, for attaching a stud (coral?).

(3) A band in openwork technique round the lowest part of the body, just above the torus of the foot; its vertical joints are visible on (*a*) and (*b*), causing slight irregularities in the ornamentation. Its upper and lower border, filled with square corals between bronze panels, on which engraved circles, the heads of rivets, appear, have convex profile. The corals are pinched into the sockets, and were probably held by putty or some similar substance.

(4) The throat-shield, also in openwork technique. Its upper part closely follows the outline of the beak; the lower half, a hanging triangle, reaches the shoulder of the vessel. The shield is fastened by nails at the right and left corners of the 'lozenge', the nails are masked by corals, of which only the large matrices remain; in the original the side-tongue of the shield appears beside the right matrix.

(5) A single bronze sheet, in the same technique as nos. (3) and (4), covering the circular mouth and the beak; its rim is turned down rectangularly, folded over the rim of the body and fastened on it by little nails, the decorated heads of which stand in the bronze intervals of the coral squares. Notice that the patterns were not engraved until the matrices and the cast animals had been mounted.

There are two apertures, a small one near the tip of the beak, the other circular of 2·54 cm. diameter, with two notches opposite each other; the former served for pouring out the wine, the latter for filling the flagon. There are two possible interpretations of the notches: they were either, as Reginald Smith suggests, air-vents, to facilitate filling by funnel, or they were made to receive the studs of a lid differing from the present one.

(6) The cast parts.

(*a*) The duck on the tip, fixed by a relatively strong nail; the eyes are inset in coral.

(*b*) The crouching quadrupeds, cast in one piece with

[1] The drawing was kindly provided by Dr. Willvonseder.

the matrices of the corals at their tails; they are riveted on; the eyes have coral inlay; the grooves of their manes were filled with enamel.

(c) The beast forming the handle. Two rivets fix the claws, a third the matrix at the lower handle end. The ring of the lid-chain goes through tongue and lower jaw. The under surface of the forelegs is slightly hollowed out, more marked on (b). The protome of the animal gradually becomes an ordinary handle of circular cross-section, but still covered with engraved strokes representing bristles, the under side, however, was unadorned. Half-way down the handle is a double palmette, once filled with enamel. The lower end of the handle is formed by a bearded mask with coral eyes; the ornament above its head was enamelled.

382. SALZBURG. From Dürrnberg near Hallein, chariot-grave; for associated finds see WPZ 21 1934, 83 (Klose and Pittioni); Forschungen und Fortschritte 10 1934, 413 (Pittioni); Illustrated London News April 25th, 1936, 718; Die bildende Kunst in Oesterreich (ed. Ginhart) figs. 99, 100. *Pls. 184–6; PP 114, 152, 315, 316, 339, 394.* 46·5 cm. high (to tip of beak); largest diameter 17·3 cm., diameter of base 11·2 cm. Bronze with a high percentage of copper (for analysis see Klose l.c. 89). Fracture round base of neck; shoulder squashed; on the lower part of the body some rents in the bronze. The jug consists of the following parts:

(1) The footstand, probably folded over the everted rim of the body: the symmetrical shape suggests the presence of a wire band concealed. *Pl. 184* shows the embossed concentric rings; in the centre the trace of the chuck is visible; round it, several engraved circles.

(2) Body, neck, and spout; no joint visible. (3) The rim, soldered on, not riveted. (4) Cast in one piece: the handle, the openwork attachment, and the terminals on the rim. There is a nail under the terminal mask of the handle, its head decorated with engraved circles, and two others close behind the tails of the two animals on top.

Some noteworthy details: the cheeks and chin of the terminal mask are tricked out with engraved lines (like the fore and hind legs of the two larger beasts). On the upper lip, under the nose, the nostrils of which are not indicated, two engraved circles. The iris of the larger animal is marked by two small concentric circles, that of the little beasts by a dot.

In point of fact, these beasts are not elephants, as one scholar maintains: even in the plates it is clear that the tail of an animal which they have swallowed hangs out of the mouth.

383. JENA.[1] From Borscher Aue near Geisa (Rhön). Reinecke pl. 6, repeated Archaeologia 79 pl. 4 no. 13; Eichhorn in Thüringen 2 1926, 85 ff.; JL no. 131 pls. 19,

20, 37; Neumann, Der Thüringer Erzieher 1935, Heft 5. *Pl. 187.*

The associated finds are figured by Eichhorn l.c.: they are a Hallstatt urn, an iron cleaver, a fragment of the typical tube of a bronze girdle-hook, a fragment of an embossed bronze plaque with a picture of a long-legged, stork-like bird. The remaining parts of the flagon are small fragments of the body. The animal-shaped handle, 17 cm. long, cast in one piece with the terminals on the rim. The 'heater' below the attachment, which is decorated with the head of an animal, 6 cm. high, was wrought separately and once riveted on the flagon. The length of the handle suggests that the jug was taller than the Lorraine flagons no. 381, and shorter than the Austrian, no. 382.

384. BM. No provenience. *Pl. 173.* Still 14 cm. long. Coarse and heavy casting. Hind legs and tail coarsely retouched by filing. The animal was a handle; the chamfered forepaws rested on the rim of the vessel; there are no traces of fastening; the hind legs rested on the shoulder; owing to their incompleteness the angle cannot be established. Probably the vase was a beak- or spout-flagon. The animal is a wolf or a dog. Round the open mouth are irregular, coarse indentations, representing teeth. The jaw, up to the maxillary angle, is contoured by a thick rebate with slanting notches. The treatment of the under surface of the jaws is similar to that of the deer no. 372. The nostrils are coarse notches. The pupil of the left eye—this side is in a better state of preservation—is marked. The forehead has a plastically modelled median groove. Round the neck is a band with engraved vertical lines, an orientalizing feature and not meant to represent a real collar. The fore legs are square in cross-section; the toes are indicated by coarse strokes. The lower edge of the hams is tricked out with fine lines, placed radially. The over-elongated body is mitred below; like the exaggerated hind legs it lacks indication of natural or stylized detail. The long tail rests on the hams, the tip pointing upwards.

385. STUTTGART. From the Klein Aspergle. JL no. 130 pl. 20; Gössler in Christ, Ausgewählte Werke aus den Württembergischen Landeskunstsammlungen (1929); Kühn 381. For the other finds in the grave see JL 30. *Pl. 188; P 375.* The jug, in its present shape, is a modern restoration. Ancient are about a third of the hammered body, the cast parts, the handle (save a restored part), the mouthpiece with the beak. In its present state the flagon is 37 cm. high. It is worth noticing that the pattern on the vertical surface of the lip-plaque is the Celtic version of a classical tongue-pattern.

386. (a) TRIER. (b) MAINZ. (a): *Pl. 245, e; P 83;* (b): *PP 177–8.* (a) from Weisskirchen. JL no. 3 pls. 15, 18,

[1] I have been deprived of the opportunity of studying the original, and have to rely on the photographs which I owe to the kindness of the late Dr. Eichhorn. It must be noticed that

the drawings, published by him and Professor Neumann, are at variance with each other and both, as the photographs show, differ from the original in essential details.

37. 43·5 cm. high. (*b*) from Armsheim. JL no. 20 pl. 15; G. Behrens, Festschrift des RG Zentralmuseums 1927, 150, and Germania 14 1930, 114. 37 cm. high. The flagons are Etruscan imports, adorned by the Celts with the patterns engraved in tremolo lines.

387. BONN. From Waldalgesheim. AuhV 3, 1 pl. 2, 1–5, 8; RA 1883 pl. 22, p. 201; Déchelette fig. 654; BM EIA fig. 11; Ebert 14 pl. 56, a; Die Antike 10 1934, 43 fig. 16 (lid-animal only). *Pls. 189–92; PP 56, 159, 328, 335.* 32·7 cm. high (to tip of spout). The flagon, which was severely damaged, is shown in its present state after restoration by Hans Piehler of Munich. Patina moss-green to blue, similar to that of the Campanian bronze bucket from the same tomb, no. 156 *h*. The parts of the flagon are: (1) The hammered body, consisting of two sheets; before restoration numerous nail-holes were visible, set without regard to the engraved ornamentation. Top and bottom dressed to a straight edge and riveted at lip and foot. (2) The cast foot-plaque, hollow inside, turned on the lathe, in the centre a spike. (3) Spout, hammered, longitudinal joint faintly visible on the upper side; mouthpiece cast. (4) Lip-plaque, cast. (5) Handle, cast, riveted to the under surface of the lip-plaque and to the body, through the disk under the beard-tip of the terminal mask; a trace of another rivet appears near by, in the openwork ornament to the right of the beard. The cross-section of the handle resembles a falling rain-drop, the point of the drop being uppermost; here the median line of the handle is emphasized by a plastic rib. At the upper end the head of a ram, looking downwards, the horns in higher relief than the rest, rubbed by use; the eyes were engraved. At the lower end of the handle, a head with a pod-shaped beard; the ears stylized and placed horizontally; on top, the ritual leaf-crown. The mask is cast in one piece with the openwork ornament, the contours of which are repeated in dotted lines on the surface. (6) The lid is not itself preserved: it once hung on a chain which passed through a loop, part of which is still visible on the upper surface of the mouth-plaque: compare the Lorraine flagons, no. 381, and the flagon from Le Catillon, no. 389. That the animal now fixed on a modern lid occupies its original position is likely but not certain. The animal, a sheep or a horse, is 4·9 cm. long, solid casting. The original plaques under the feet are hidden by the modern mounting.

The ornaments on body and foot of the flagon have been very neatly engraved in dotted lines; guide-lines must have existed, but they are not traceable. Older reproductions of the ornament are quite unreliable; the drawing confines itself to what is certainly visible.

388. NUREMBERG. Germanisches Museum. Provenience 'Rheinpfalz'. *Pl. 189.* 35 cm. high, to lip, 40 cm. to tip of spout. Some restorations in painted plaster. The parts are: (1) The foot, said to have been found in the same excavation, certainly does not belong and formed part of a larger vase; its lower edge is folded over an iron ring. (2) The lower conical half of the body: near its bottom end, a nail-hole, close above it, an engraved horizontal line, marking the point where the original foot once joined. (3) The upper part of the body with neck; the joint of (2) and (3) concealed by a slightly convex strip, wrought separately. (4) Mouthpiece, embossed, probably soldered on (3) and (5). (5) Handle, also embossed, not cast; probably with an iron core. (6) Cast spout. There are no traces of engraved or other decoration.

389. SAINT-GERMAIN. Found at Le Catillon (commune de Saint-Jean-sur-Tourbe, Marne) in a grave the other contents of which, sword, spear, pottery, &c., are in the same museum. Reinecke note 26; Déchelette fig. 654, 2. *Pl. 193; P 268.* 29·5 cm. high (to lip), diameter of mouth-plaque 8 cm., of footstand 11 cm. The numerous fragments are mounted on a modern core, but the shape is certain. Bronze rather thin. The flagon consists of the following parts: (1) The body formed by three sheets, neck, shoulder, lower body, foot; the lower edge of the latter is folded over the base-plaque. Horizontal joints and nails visible. (2) The slightly concave decorated base-plaque. (3) The mouth-plaque, attached in the usual manner. (4) The spout with a visible longitudinal joint on the upper surface, fixed with three nails on the neck, inside reinforced by an iron tube. (5) The handle, ending downwards with the typical Celtic trio of circles, of which only two circles appear: the lower, connected with them by a sort of bridge, is hardly visible on the photograph; they bear a decoration of engraved concentric circles and dots between them. (6) The lid. The remaining embossed fragments, now fastened on a piece of cork, were once, as some nails still show, fixed on wood; the lid was held by a chain which passes through a hole in the upper part of the handle. The concentric circles forming the three bands round neck, shoulder, and foot are all of equal size and were made with a die-stamp; in the neck-row the artist has made some of these overlap, owing to miscalculation.

390. BRUSSELS.[1] From Eygenbilsen; the other objects from the grave are mentioned by Reinecke 61; JL 33. *Pl. 194; PP 144–6.* Two fragments correctly ascribed to a spout-flagon by Reinecke: (1) The lower conical part of the body, 13·6 cm. high, diameter at top 22·5 cm., at bottom 7·5 cm.; at a distance of about 3 cm. from the well-preserved upper edge a row of copper rivets. (2) Fragment of foot, maximum width 4 cm.; about a third of a circle, the original diameter of which was about 13 cm., is preserved. The patterns on body and foot are inscribed with compasses. Analogies of other spout-flagons suggest a height of roughly 30 cm.

391. WIESBADEN. From Langenhain (Taunus). Other pieces, belonging to the same find, are nos. 181–3. Ritter-

[1] I am indebted to Mr. J. Breuer for photographs, drawings, and information.

ling in Nassauische Annalen 37 1907 pl. 1, 1; 2, 13 a and b; p. 248. *Pl. 194; P 274.* Diameter 19 cm. In the middle a 'sugar-loaf' boss with crater-like depression, in the centre of which is an egg-shaped hole. The edge of the disk is held by a cramp of bent bronze; on the cramp engraved rings in tremolo lines, of which only the innermost is discernible in the photograph. The decoration of the disk is embossed. Ritterling l.c. pl. 1, 2, p. 248 figures a second, identical piece. The interpretation of these disks as footstands of vases is possible, but not at all certain.

392. AARAU. Found at Lenzburg in 1870; isolated find. Lenzburger Neujahrsblätter 1935, 41; Germania 19 1935 pl. 10, p. 130. *Pl. 195.* The flagons are the work of one artist and differ only in trifles. 16·5 cm. high. Extremely heavy casting, thickness of wall 0·4 cm. The spout of (*a*) consists of two flanges not joining, that of (*b*) is a closed tube. (*a*) has a ridge between neck and belly, (*b*) a groove. The animals are cast independently. Round their feet, a patch on the body of the jug: this need not be ancient; the hind legs of the animal on (*b*) rest on a kind of block. The beasts have no tails; they have two rows of teeth; their fur is spotted.

393. ZURICH.[1] From the Ticino. *Pls. 196–7.* (*a*) JL no. 123 pls. 21, 23, 24. From Cerinasca d'Arbedo, tomb 115. 34 cm. high. (*b*) JL no. 124 pls. 21, 24. From the same site, tomb 150. 31·3 cm. high. (*c*) JL no. 125 pls. 21, 23, 24. From the same site, tomb 111. 32·7 cm. high. (*d*) JL no. 126 pls. 22, 23. From Giubiasco. 32·2 cm. high.

The flagons are more primitive in technique than the foregoing vessels. They are tinkered in the Hallstatt fashion. The mouthpiece, the handle with attachments, and the terminals on the rim are cast. Body and neck are three sheets of bronze; the vertical joints are brazed and not visible; the horizontal joints appear, partially burst and here and there repaired in ancient times with big nails. The base is a separate sheet and turned over the lower rim of the body. The rams on top of (*d*) possibly had coral eyes.

394. BRUNSWICK. From Castanetta (canton Graubünden). JL no. 129 pl. 18, p. 72. *Pl. 197.* Height from top to lower end of attachment *c.* 26·5 cm. Restored from fragments; shape of vessel arbitrary and wrong.

395. ZURICH. From Molinazzo d'Arbedo. Ulrich pl. 35, 4, p. 260; Déchelette fig. 654, 4; Ebert 8 pl. 98 b, f. *Pls. 198–9; PP 143, 271.* 19·6 cm. high, largest diameter 18 cm., diameter of base 10·5 cm. Only small fragments of the ancient wooden vessel remain; the jug is a modern reconstruction. The arrangement of the bronze bands is arbitrary in some parts, but cannot be improved without detaching them. In the 'metopes' a checker-pattern, with an alternation of wooden and bronze pieces, which are

hammered into the body. How spout and body were connected must remain uncertain. The back-plate of the handle forms one piece with the swallow-tail-shaped attachment. The embossed decorated base is fixed to the body by a ring; the same technique was applied to the upper rim of the jug.

396. NEUCHÂTEL. From the tumulus des Favargettes (Lake of Neuchâtel). Déchelette fig. 302, 3; Ebert 11 pl. 132, 10; *Pl. 200.* 7·5 cm. high; diameter 9·9 cm. Pieced together out of many fragments, half of the vase is missing. In the middle of the base an omphalos of 3·5 cm. diameter. The high loop-handle ends with a trilobate attachment closely related to that of the spout-flagon from Le Catillon, no. 389; it is decorated with wildly confused patterns in tremolo lines. The handle here is fastened with three rivets; inside by a bilobate attachment with serrated contours, fixed by rivets, which appear outside on both sides of the handle just below the lip. The upper part of the exterior is ornamented with groups of horizontal lines, the intervals of which are partly filled with oblique strokes and hatched triangles pointing downwards. The cup is actually Hallstatt; I figure it for reasons stated on p. 68.

397. SPEIER. From Dürkheim. AuhV 2, 2 pl. 2, 8, whence Ebert 2 pl. 215; Déchelette fig. 437; Sprater, Urgeschichte der Pfalz fig. 123; JL 22 (list of the contents of the grave). *Pl. 200; P 19.* About two-thirds of the original preserved. Lindenschmit restored the fragments as a lid of conical shape and placed it on the Etruscan stamnos from the tomb, and it appears thus in the publications cited. Actually we are ignorant of its original shape, purpose, and position. The diameter of the reconstructed lid is 21·6 cm., the original diameter was smaller. The decoration is engraved by the compasses; thinner lines of bungled circles are occasionally to be seen.

398. MILAN, Museo Sforzesco. From an inhumation tomb near Castiglione delle Stiviere, on the road to Lonato, a short distance SSE. of Sirmio, so in the territory of the Cenomani. Not. Sc. 1915, 302; 1918, 257; AA 36 1921, 37; PZ 25 1934, 104, note 57 (to be corrected). For the other objects from the grave see p. 145. *Pl. 201; P 154.*

(1) Body of a bird. Maximum length 18 cm., height 12·5 cm., depth at the breast—in the present state of mounting—about 6 cm. It consists of two sheets of embossed bronze, somewhat squashed; they were assembled by overlapping their longitudinal, unornamented edges which have a breadth varying from 0·6 to 1·3 cm.; on the under surface there is a gap between the two sheets, probably due to modern mounting. The cross-section of the bird tapers from the breast towards neck and tail, first to a broader, then to a narrower ellipse. The ends are prepared for attaching separate pieces (see below). The ornament of the reverse, not figured here, is almost identical, but weaker in form and workmanship.

[1] The photographs were kindly provided by the Keeper, Dr. E. Vogt.

(2) Round disk. Diameter 6·8 cm. The edge everted downwards. Beside an 'omphalos', a bird's feet, three toes and a spur, round an original, roughly cut hole into which the legs joined.

(3) One fragment is possibly the mouthpiece, which fits into the bird's neck; its exterior diameter is 4·5 cm.; the plaque rises in the middle to a tube of ellipsoid section: its longitudinal axis is 4·5 cm., that of the neck-end of the bird in its present state about 3 cm.; it might fit into it, but the disfigurement excludes certainty.

(4) Fragments of similar bird-askoi. To how many pieces they belong cannot be established without experiment.[1] A glance at the fragments suffices to refute Patroni's suggestion of 'wings' and 'insignia' (Not. Sc. l.c.).

399. INNSBRUCK.[2] From Moritzing (Tirol). F. Orgler, Archaeologische Notizen aus Südtirol (Programm des K.K. Gymnasiums zu Bozen, 1871); Mon. dell' Inst. 10 pl. 6 and Annali 1874, 164 (Conze); Zannoni pl. 35, 64; Mon. Ant. 2, 184 and 37 pl. 4, p. 339. *Pl. 200; PP 31, 317.*

400. BM. ML 2167. 'Marne.' *Pl. 202; P 283.* Diameter 10·4 cm. Somewhat out of shape, but original concavity of centre, an essential feature of a sieve, still noticeable. On the rim traces of frame-band (braid?).

401. BERLIN, Museum für Vor- und Frühgeschichte. Purchased in Rome; probably from the region of Comacchio, i.e. the territory of the Lingones. *Pls. 202–5; (b): P 459, (h): P 133, (i): P 134, (k): P 214, (m): P 256, (o): P 215* (see also *PP. 124, 460–3*). The find, published in its entirety in PZ 25 1934, 62 ff., comprises more than thirty bronzes, the greater part of which are richly decorated in the style represented here by nos. (a)–(k) and (m), the smaller part of simpler make and decoration as here nos. (n), (o). I have inserted the bronzes here though only a part of them belong to vessels. The thickness of the bronze varies from 0·04 to 0·13 cm. They were nailed on wood; the reverse is dull, the obverse has mostly preserved its brightness. On nos. (a)–(d) the patterns stand out against a background roughened with the punch. The contouring rows of circles are stamped with a die. Measurements: (a): 12 cm. breadth, (b): 12·5 cm. breadth, (c): 11·8 cm. high, (d): 9·3 cm. high, (e): 8·8 cm. breadth, (f): 16 cm. original diameter, (g): 8·3 cm. high, (h), (i), (k): 32, 35, 40 cm. (with templet), (l): 7·3 cm. diameter, (m): 2 cm. high, 6·2 cm. broad, (n): 4·4 cm. diameter, (o): 5·2, 9·2, 5·3 cm. long.

Some of the bronzes have complicated curves: that of no. (b) appears in *pl. 204*. It is not possible to conjecture the nature and purpose of the wooden objects on which they were fixed. No. (l) is the mounting of the bottom part of a wooden globular cup; no. (k) apparently the veneering of a handle: its cross-section is a half-circle; the upper end is boat-shaped, the lower flattened out and straightedged.

Nos. 402–19

POTTERY[3]

402. BERLIN, Museum für Vor- und Frühgeschichte. From Matzhausen; for the grave-group see Ebert 8, 70. AuhV 5, pl. 50 no. 895; p. 282 fig. 2; Déchelette figs. 671, 672; Ebert 7 pl. 193 d; RM 35 1920, 12 fig. 13; Kühn 373; Kersten in PZ 24 1933, 153 fig. 9 a (the drawing no great improvement on his predecessors); WPZ 21 1934, 102 (Pittioni). *Pls. 206–7; P 91.* 24·5 cm. high. Pieced together out of many fragments; portion of neck restored in plaster. Unusually heavy make. No traces of wheel; clay micaceous, light grey in fracture, greyish-black on surface, but even here rather rough. In middle of base regular circular depression of 4·2 cm. diameter. The engraved decoration appears white, having been chalked over for reproduction. The outlines of the animals were drawn in the clay when at least half dry, hence the lines are uneven and feathery. The lines of the ornament are not continuous, but formed of separate dots and strokes.

403. CHÂLONS-SUR-MARNE. No detailed provenience, but certainly from the region of the Marne. *Pl. 206.* 11 cm. high, 25·5 cm. long, from point of beak to tip of tail. Intact, only some flaking on bottom and lower part of reverse. Fine greyish-brown clay, surface blackish and burnished.

404. NUREMBERG, Germanisches Museum. From Thalmässing. AuhV 5 pl. 50 no. 891; p. 282 fig. 1 a; PZ 24 1933, 140 note 87 (Kersten). *Pl. 206; P 281.* Figured and described here from facsimile in Oxford. One-half of the cup is preserved. Radius about 8·5–9 cm.; height about 5 cm.; about 0·5 cm. thick. Clay reddish-brown. Rim set off, also on the outer side. The centre is an omphalos, but there is no hollow corresponding to it on the bottom. The lines forming the ornament consist of dots.

405. SALZBURG. From Dürrnberg near Hallein, tomb 6. WPZ 1932, 52 ff. *Pl. 208; P 17.* 27·4 cm. high to tip of beak. Maximum diameter 27 cm., diameter of base 10·5 cm. Clay reddish-brown, slip mat, chocolate-coloured. Pieced together from numerous fragments. Beak repaired in ancient times with iron wire. Base flat; handle circular in section with two broad, flat grooves, in each of them a row of tangential circles.

406. VIENNA, Naturhistorisches Museum. From Hallstatt. Mahr, Das vorgeschichtliche Hallstatt fig. 11, 5; Germania 9 1925, 174 (Reinecke); JL pl. 27, p. 61; Willvonseder, Oberoesterreich in der Urzeit 89 fig. 98. *Pl. 209.*

[1] At the time of my visit to Milan they were not on view. I am greatly indebted to Dr. Nicodemi for the photographs of the pieces published here and of the other objects found in the tomb.

[2] I owe the photograph to the courtesy of the Keeper, Professor von Merhart.

[3] See also no. 153 b.

407. SAINT-GERMAIN. From Poix, tomb 41. Bull. de la Société Champenoise 8 1914. *Pl. 209.* 21·3 cm. high. Clay well washed, black, burnished; hand-made. The bottom of the foot is concave; the cross-section of the spout becomes square towards the end. The fragmentary spout of a similar vase from Champagne, without detailed provenience, is preserved in Châlons-sur-Marne.

408. BM. Inv. ML 2784. From Prunay (Marne). *Pl. 210.* 31 cm. high. Clay slightly impure, dirty brownish yellow, with a claret-red slip. The ornament, which is not visible in the reproduction, is painted with brown 'glaze'.

409. BM. From Mesnil-les-Hurlus (Marne). Morel pl. 41, 8; Reginald Smith, Archaeologia 79 1929 pl. 4 fig. 12; BM EIA pl. 5, 12. *Pl. 210.* 25·7 cm. high. Blackish clay, fairly well burnished. Some restorations in plaster.

410. Photograph and description taken from facsimile in Saint-Germain, inv. no. 21621. The original, formerly in the Nicaise collection, presumably came from La Cheppe (Suippes, Marne). *Pl. 208.* Present height 33·5 cm., height of neck arbitrary, general shape, however, certain. Preserved are three complete animals, and a half, all uniform.

411. From chariot-burial at La Cheppe (Suippes, Marne). Déchelette 1464. *Pl. 210.* Photograph and description from facsimile in Saint-Germain, inv. no. 31622. 34·5 cm. high. Only fraction preserved. Bodies of 'dragons' painted red in facsimile.

412. SAINT-GERMAIN. Inv. no. 27729. Ex Fourdrignier collection. No detailed provenience, but certainly from the Marne. *Pl. 211.* 4·9 cm. high, 9·5 cm. diameter. On the rim some restorations in plaster. Greyish-black clay, strongly burnished on the outside. Heavy and with thick walls. Inside a flat impressed pattern: pairs of radii at irregular intervals.

413. BM. Inv. ML 2628. From Marson (Marne). BM EIA pl. 5, 1. *Pl. 211; PP 252, 254.* 17·1 cm. high. Internal diameter at rim about 18 cm. Hand-made. Slightly impure, dirty brownish-yellow clay. Surface outside deep pinkish red, the result of a red ochre slip; traces of vertical burnishing. Ornament painted with lustrous paint, resembling the brownish-red glaze of Ionian pottery.

414. BUDAPEST. From Alsópél. Márton pls. 18, 19; p. 48 fig. 9; p. 63; Ebert 14 pl. 12 A. *Pls. 212, 213; PP 261, 443.* 40 cm. high. Diameter of mouth 19·5 cm. Wheelmade. Clay light brown to grey; well burnished.

415. BUDAPEST, Kund. From Kosd, tomb 42. *Pl. 214.* 14·5 cm. high, maximum diameter 19·8 cm. Surface mat black, well burnished. Traces of raised arms beside the head on the rim.

416. BUDAPEST. From Rozvágy, Kom. Abauj. Márton p. 77 fig. 19; p. 111. *Pl. 214.* Flat handle of an amphora with a human figure, arms raised, in low relief. Nipples circles.

417. SZÉKESFEHÉRVAR. From Nagyhörcsök. Márton pls. 21, 22. *Pls. 212, 215.* 26 cm. high. Clay yellowish-brown, carefully burnished. The ornament under the flat handles in very shallow lines.

418. SZÉKESFEHÉRVAR. From Nagyhörcsök. Magyar Müveszet 6 1930, 474; Márton pl. 22 figs. 3, 4. *Pl. 215.* 29·5 cm. high. Grey, well-burnished clay.

419. SOPRON. From Sopron, Wiener Hügel. Márton p. 58; Dolgozatok pl. 34, 11; p. 142. *Pl. 214; P 186.* Handleless flask. 31 cm. high. Surface grey to black. Base with omphalos. Wheel-made. The ornament shows clearer in *P 186*, borrowed from Dolgozatok l.c., but the drawing must be compared with the photographs.

ADDENDA AND CORRIGENDA

I arrange the additions and corrections in the order of the pages, but should like to begin with a major problem.

I have purposely refrained from becoming entangled in the net of the traditional, much discussed subdivisions and dates of La Tène A, B, C, D and La Tène I, II, III, on which de Navarro, Cambridge Ancient History 7, 42, and A Survey of Research on an Early Phase of Celtic Culture (Proc. British Academy XXII) gives the best information.

I borrow de Navarro's tableau, and I add Viollier's system and his

Reinecke (Bayrischer Vorge- schichtsfreund 1/11 1921/2, 21 ff.)	Schumacher (Ebert 8, 266)	Déchelette (pp. 928 ff.)	Viollier (p. 15)	de Navarro
A Second half of sixth century into second half of fifth century B.C.	I End of sixth century B.C. to 400 B.C.	I 500–300 B.C.	I a 450–400 B.C. b 400–325 B.C. c 325–250 B.C.	I 450–250± B.C.
B Beginning from the end of the fifth century B.C.	2 400–300 B.C.			
C Before and after 200 B.C.	3 300–100 B.C.	II 300–100 B.C.	II 250–50 B.C.	II 250± B.C.–120 B.C.
D c. 121–15 B.C.	4 c. 100 B.C.–A.D. I	III c. 100 B.C.–A.D. I		III 120 B.C.–A.D. I±

The danger of these pigeon-holes with rounded-off or, worse, precise figures is obvious: they have gained credence and currency, and nobody asks on what they are based.

121 B.C. (Reinecke), 120 B.C. (de Navarro) apparently refer to the foundation year of the Provincia Narbonensis; 50 B.C. (Viollier) is the approximate date of the Roman conquest of Switzerland and Gaul. Political changes, even drastic ones, do not necessarily mark a phase in customs and crafts, either here or later in Britain (where the 'Pre-conquest' ideology has led to distortion of facts and dates); and if these chronological systems are applied, as they are intended to be, to Celtic regions fairly distant from those immediately affected, the futility of the dates becomes manifest.

Viollier's system has the advantage of being based on the richest, best-excavated material in Western Europe, and on a careful study of the types of fibulae, rings, weapons, &c., and their inter-association in Swiss graves. His relative chronology is sound; his absolute dates, which have been accepted by Sir Cyril Fox (Arch. Camb. 1927, 67 ff.), de Navarro, and other writers, need revision. 450 B.C. for the beginning of Celtic art comes nearer the truth (p. 143) than the earlier dates advanced by Reinecke, Schumacher, and Déchelette. 400 B.C. for the end of his

phase 1 a is too early: I have established that the jugs from Lorraine no. 381, *pls. 178–83*, which undoubtedly are early works, seem to reflect classical ornament not in general use before the beginning of the fourth century B.C., and I have pointed out that at Ensérune an Attic red-figured cup painted about 400 B.C.—hardly much earlier —was found in the same grave as the girdle-hook no. 362 (p. 144): this fact indirectly provides a date hardly anterior to 400 B.C. for another important work of Early Style, the girdle-hook from Hoelzelsau, no. 361. Viollier suggested 400 B.C. as the end of 1 a and the start of 1 b, because it is the approximate date of the Celtic invasion of Italy: the invaders, Viollier (p. 13) says, are shown by the furniture of the Celtic tombs in Italy to have already quitted 1 a and entered 1b. He disregards the following fact: the Celtic cemeteries in Picenum and at Bologna, of which he is obviously thinking, can be dated with accuracy to the late fourth century and the early part of the third: they reflect the civilization of the Gauls in Italy after they had settled down, and had even been etruscanized and hellenized: if we had the graves of the companions of 'Brennus' they would tell another tale and no doubt be of 1 a character. Viollier's two subsequent periods 1 b and 1 c cover the years 400– 250 B.C.; 325 B.C. as the border year of 1 b and 1 c is just a half-way stage, based on no special evidence. 250 B.C. as

the year separating La Tène I and II is arrived at by a chain of combinations worth citing as an example of pseudo-historical method, and because this completely imaginary date has already become a fixed point in papers dealing with British archaeology of the third century B.C.

Viollier (p. 15) writes: 'Dans une courte note relative à la coutume de ployer les épées avant de les déposer dans la tombe, nous avons montré que toutes les épées ainsi courbées appartiennent au type La Tène II. Cette coutume est mentionnée pour la première fois par Polybe qui écrivait vers 150 avant J.-C. (S. Reinach, L'épée de Brennus, L'anthropologie 1906, 343–58 [reprinted in S. Reinach, Cultes, mythes et religions 3, pp. 141 ff.]); il en résulte que les tombes gauloises, à la violation desquelles cet auteur a dû assister, devaient dater au moins d'une centaine d'années. Le début de la période La Tène II ne saurait donc être postérieur à 250 avant notre ère' (Viollier, À propos de l'épée de Brennus, Revue archéologique 1911, I, 134). Polybius (2, 33, 3) does not mention the rite of bent swords, nor does he say he had seen early Gaulish graves opened: all this is Salomon Reinach and not Polybius; and Viollier's observation that bent swords do not occur in graves before La Tène II holds good for Switzerland: in the other Celtic lands of Europe the custom goes back to La Tène I and even to Hallstatt (Déchelette 1131).

This method will never lead to a sound absolute chronology. What I offer is less, but my dates are based on the chronological evidence of the Southern imports in Celtic graves and on study of datable classical features in the Celtic works themselves.

The Early Style began somewhere in the later fifth century B.C. and lasted into the fourth until it was supplanted by the Waldalgesheim Style. The graves at Filottrano and the tomb of Waldalgesheim, dated by their classical contents to the late fourth century, contain works of Waldalgesheim Style fully developed: this new style must have taken rise some time before: '350' B.C. might be a fair guess. Chronological evidence for the two subsequent phases, the Sword Style and the Plastic Style, is poor: there is only the Celtic burial at Mezek in Thrace, containing works of the Plastic Style: the burial, on historical grounds, can be dated after 275 B.C., possibly to the second quarter of the third century B.C. There was some overlapping of the Waldalgesheim phase and the two following ones. As pointed out on p. 96, the tendrils on the staple-medallions of no. 113, *pl. 67*, which is definitely a work of the Sword Style, are undistinguishable from Waldalgesheim ornament. The patterns engraved on the Hungarian sword no. 118 (clearer in Dolgozatok pl. 54 than on my *pl. 69*) are also of Waldalgesheim Style and have perhaps their closest analogy on the Münsingen fibula no. 336, *pl. 164*; of similar style, though less close to the Waldalgesheim Style proper, is the decoration of the handle of the anthropoid dagger from Szendrö (p. 94): the sword no. 118 is typologically not earlier than any

other work of the Sword Style in Hungary and Switzerland, and, on other grounds, the anthropoid dagger must belong to the same period. Fibulae also illustrate the duration of the Waldalgesheim Style, for instance no. 339, *pl. 165*—one of those Certosa laggards, not infrequent in Switzerland; the fibula is rightly dated by Viollier (on pl. 1, 5) to his period 1 *c*, i.e. about the second quarter of the third century B.C.

There is another case where typology of fibulae may shed light on the date of their decoration. *P 286* is from a brooch found at Conflans, arr. Épernay, dép. Marne (Troyes pl. 22 no. 233; BSPF 1916, 468): the same brooch bears zoomorphic tendrils, mentioned on p. 210 (on p. 57), and wave tendrils which are exactly like those on the pendant brooch from Conflans (Troyes pl. 22 no. 232; BSPF l.c.; *P 110*). The two fibulae, exceptionally elaborate and large (the first 12 cm., the second 17 cm.), works of the same master, are of a well-developed La Tène II type, and belong to the second half of the third century, a fact which study of their decoration alone would not tell.

The association of rings of Plastic Style with fibulae in the Münsingen tombs is instructive. I confine myself to mentioning rings illustrated here; I quote Viollier and not Wiedmer–Stern whose book is less accessible. I follow, with some slight modifications, Viollier's classification, which, as said before, is sound and acceptable.

No. 273: tomb 149: fibulae I *c* (pls. 2, 79; 4, 130, 142, 166; 5, 193, 194; 6, 233, 260, 262–4) and one II (pl. 7, 269).

Another specimen of the ring no. 273: tomb 75: fibulae I *c* (pls. 5, 193, 194; 6, 231, 266) and one I *b* (my no. 328).

No. 280: tomb 158: fibulae I *c* (pls. 4, 159; 6, 250); pl. 2, 71 seems to be I *b–c*.

No. 281: tomb 61: armlet no. 256; fibulae *b–c* (pl. 3, 87, 99, 102, 104, 108, 112); I *c* (pls. 4, 162; 5, 179).

The association of other specimens of no. 281 is as follows. Tomb 68: armlet no. 256; fibulae *b–c* (pl. 3, 93, 99, 102, 104, 108); I *c* (pl. 5, 176). Tomb 121: armlet no. 256; armlet pl. 28, 35; sword with two dragons (Wiedmer–Stern pls. 29, 30; p. 79 on tomb 183; omitted by Viollier pp. 115–16; see my p. 45); fibulae *b–c* (pls. 2, 49; 3, 104, 108); I *c* (pls. 4, 151, 156; 5, 185, 208). Tomb 130: ring pl. 17, 40 (occurring in tomb 81 together with brooches of the same type); armlet pl. 28, 35; fibulae I *b–c* (pl. 2, 64); I *c* (pls. 4, 155, 166; 5, 194; 6, 241, 261). Tomb 135: armlet no. 264; ring pl. 28, 35; fibula I *c* (pl. 5, 180). Tomb 140: rings pl. 23, 135 and 28, 35; fibulae I *c* (pls. 4, 128, 144, 147; 5, 195). Notice that four specimens of the ring pl. 28, 35 were found at Berne in the tomb which yielded the I *b* fibula no. 331.

No. 257: tomb 161: fibulae I *c* (pls. 4, 156; 6, 239); II (pl. 7, 270, 278, 285, 286).

Similar observations can be made in other graves at Münsingen. Interesting is the association of nos. 80 and 86 in tomb 181 with a glass berry ring (pl. 35, 27) and La Tène II brooches (pl. 7, 271, 280); or the fact that in tomb 49 fibulae I *b* (my nos. 328, 332, 338, 340) are accompanied

by the girdle-hook pl. 29, 6, related to my nos. 361, 362. The piece has analogies on the Ticino (Ulrich, pls. 7, 1, 8; 13, 14), where, however, the other contents of the graves give no clear date.

In the grave Andelfingen 1 the torc no. 234 and the bracelet no. 255 are associated with the rings Viollier pl. 27, 27, 32 and I *c* fibulae (pl. 3, 111, 113, 114).

The rings of Plastic Style at Münsingen are, as a rule, associated with I *c* fibulae: I *b* and II are exceptional. Münsingen was the burial-place of a respectable community: the standard of the furniture is pretty high, and, unlike the cemeteries in the Ticino backwater, the furniture is fairly homogeneous. If a tomb contains a Plastic ring and a I *b* brooch, the brooch is an heirloom, and if a ring is found together with a La Tène II fibula, the ring was a family piece—or, less likely, the production of these rings lasted into La Tène II.

This combined with the evidence of the Mezek burial pointing to a date about or after 275 B.C. for the Plastic Style would suggest a date about the second quarter of the third century B.C. for the Münsingen tombs with Plastic rings.

The association of objects in tomb 49 points to the fourth century: there is no reason to separate the girdle-hook by too long an interval from the related pieces, of which that from Ensérune (no. 362) is dated about 400 B.C.

In Hungary the chronology of the clay flask no. 419, *pl. 214*, can be checked by the fibulae from the grave. The ornament of the vase, to judge from the photograph of the damaged original and from the published drawing, on which *P 186* is based, seems to be between Waldalgesheim and Sword Style. One of the fibulae, Dolgozatok pl. 34, 3, is between I *b* and *c*: Viollier pl. 3 gives the Swiss analogies. The other, Dolgozatok pl. 34, 2, is a I *c* type: compare Viollier pl. 4, 144.

pp. 2 ff. Val Camonica, see also Duhn 2, 16 note 21.

p. 3 n. 7. Brendel, AJA 1943, 208 n. 42, still believes that the horse *pl. 217, d*, and even the other Camonica horse JRS 28 1938 pl. 10, 1 derive from Corinthian models.

p. 6 n. 6. There is an Iberian girdle-clasp, bronze gold-plated, in the Hermitage, from Bolsena, published by M. Rosenberg, Geschichte der Goldschmiedekunst, Einführung fig. 115 (wrongly described as *Helmschmuck*). It belongs to Bosch-Gimpera's class B (Ebert 10 pl. 143, B, b), which del Castillo (Ebert 4, 579) dates to the fourth and third centuries. If the provenience Bolsena is right, it may have formed part of the armour of an Iberian mercenary fighting in Italy.

p. 7 n. 2 (see also pp. 28; 67 n. 2). The brooch from Uffing is also in Åberg 2 fig. 177.

p. 10 n. 3. Beltz, Ebert 12, 272, takes the Holzgerlingen statue, no. 13, for Slav.

Add to the *testimonia* **p. 11** Propertius 4, 10, 43 illi (sc. Viridomaro) virgatis iaculantis ab agmine braccis.

An illustration of such patterned trousers is the statuette BMC Bronzes 818, pl. 21; AuhV 5 p. 83.

p. 11 n. 1. Impression of textile on sword, Morel pl. 32, 9.

p. 20 § 1. Add to JHS 1924, 187 fig. 11 a fragment of a very similar Rhodian eye-bowl from Egypt (Naucratis?) in Reading, University Museum.

p. 20 n. 3. The mask from Tharros also Vives y Escudero, Estudio di arqueología cartaginesa, la necrópoli de Ibiza pl. 92, 3; p. 165 no. 1007.

p. 21 n. 7. Add Dall'Osso p. 347.

p. 23 § 4. Add the late eighth-century steatite scaraboid in New York, G. Richter, Ancient Gems no. 6: the man's head is in the mouth of the lion.

p. 25 § 1. I ought to have quoted Etruscan examples of horses on lids, such as the sixth-century bucchero vase, Montelius pl. 243, 1, where the lid-horse is just the size of the Freisen one.

p. 27. A frieze of birds (swimming?) in relief on a La Tène vase from Lochenstein, Württemberg, Bittel pl. 21, 11; pp. 91–2; see also Leeds, Archaeologia 76, 231.

p. 28 § 3. The birds Vouga fig. 7 j are badly drawn: a good photograph is in Gross, La Tène pl. 1, 7.

p. 28 § 4. The brooch from Hallstatt also in Åberg 2 fig. 144. Add the brooches AuhV 2, 1 pl. 4.

pp. 28–9. 'Acroterion' birds on the sub-Mycenaean wheeled stand from Larnaka, in Berlin, Furtwängler, Kleine Schriften 2, 298 ff.; Lamb, Greek and Roman Bronzes pl. 12, a; KiB 108, 5; BSA 35, 124. The bronze chariot with the two ravens at Krannon (Furtwängler, Masterpieces 468 ff.; id., Kleine Schriften 2, 311; Cook, Zeus 2, 831–3) and the two eagles beside the omphalos at Delphi (Cook, ib. 180 ff.) probably go back to the same period. Caucasian 'acroterion' birds: Déchelette fig. 566, 2.

p. 29 § 6. The addorsed horse-protomai are of Greek origin, see Filow, Trebenischte pl. 9; figs. 55, 56, 58. These are sixth-century B.C. P. Wolters, Εἰς μνήμην Λάμπρου 488, 2, quotes unpublished geometric bronzes from Pherae in Athens 'neun Hähne, anscheinend Schmuckteile von Geräten, zwei aus gegenständig zusammengesetzten Vorderkörpern gebildet'.

Etruscan sixth-century handles with such horse-protomai from Foligno, in Berlin (Neugebauer, Führer Bronzen p. 68; Oe J 7 1904, 162–3 figs. 74 a, b; Mühlestein 153) and in Bologna (unpublished, photograph Archaeologisches Seminar Marburg no. 412). They are the horizontal handles of kraters, the vertical handles of which are a group of a warrior between two horses: these groups are preserved with the Berlin and Bologna pieces quoted (see p. 45 n. 4); a third from Belmonte Piceno is in the Pesaro Museum (Dall' Osso pp. 59; 95).

With the compound animals decorating Ticino vases compare the contemporary bronze pendant in Oxford, Report Ashmolean Museum 1939 pl. 6, 2: the piece is Carniolan, see p. 127 n. 2.

p. 31. Beazley adds another helmet of this class in Brussels, Bull. des Musées Royaux 1904, 69, 70. It is by the same hand as Lipperheide 504: it shows sphinxes and lions, such as occur on the other helmets, and besides, an ibex, a horseman, two wrestlers, and two warriors seated, facing each other, 'Achilles and Ajax'.

pp. 32, 35, and *pl. 222, e.* Talbot Rice, in Pope 1, 380 note 1, interprets the finials of the Karlsruhe ring as follows: 'The motif is that of a lion swallowing an ibex or similar animal. This animal symbolizes a constellation, the stars of which were in the ascendant during the winter solstice; it is swallowed by the lion, which represents the sun, overcoming in this case an unwelcome winter.'

p. 35 § 4. The motive of an animal head cabossed, with the paws on either side, migrated eastwards to China: see the T'aot'ieh *pl. 229, e.*

p. 37 n. 7. The bronze ibex in Berlin is also in Andrae and Schaefer, Die Kunst des alten Orients (1925) pl. 183.

p. 42 n. 7. The Luristan bridle-bit, Pope pl. 33, A, shows two crouching animals, back to back, their hind quarters clamped by a palmette.

p. 43 § 2. The earliest example of an axil between body and wings of an animal filled with a palmette is in the Luristan bronze, Pope pl. 33, A.

p. 44 § 2, and *pl. 230, h.* Compare the fourth-century horse-muzzle, Pernice, 56. BWP 6, which is possibly South Russian; on p. 122 I have quoted a phalera from the same burial.

p. 44 bottom. A 'dragon' with two heads forms the handle of a bronze mirror from Minusinsk, Borovka pl. 44, A.

p. 45 n. 4 (D). To the Greek seventh-century examples add the ram of the bronze chariot-pole from Olympia, JHS 59 1939, 196 fig. 3, and the Protocorinthian fragment from Syracuse, Not. Sc. 1925, 316 fig. 69, quoted by Dohan, Italian Tomb-groups 74. The stag no. (6) is more probably Anatolian than Greek: the window-shaped shoulder ornament recurs identically on the 'Halys' lion, H. R. W. Smith, CVA San Francisco I pl. 3, 2; p. 19.

ib. (E). Buccheri. Dohan, p. 76 gives more examples of Faliscan animals with a spiral or a rosette on haunches or shoulders.

p. 48, IV (1). On the Attic stele, Kerameikos 2 pl. 3 (inaccessible to me), Karo, An Attic Cemetery pl. 29, two antithetic single sphinxes are represented, each carrying a lekythos on head and wings, and putting her forelegs on the base of the loutrophoros in the middle: this awkward design is an unsuccessful variation of the stelai with a double sphinx supporting the vase.

p. 48, IV (2). Also in From the Collections of the Ny Carlsberg Glyptotek 1938, 244 fig. 9.

p. 48, IV (9). Louvre G 529: on restorations see Beazley, JHS 48 1928, 271.

p. 53 § 1. An early example of a double tail is given by the Luristan bridle-bit, Pope pl. 33, A.

pp. 53 ff. An example of a bird-lyre is the chape of a scabbard from Suippes, Saint-Germain no. 20249 (unpublished).

p. 55 § 4. Twisted snakes: Beazley showed me a photograph of an unpublished black-figured plate from Selinus in Palermo with a gorgoneion surrounded by snakes twisted kerykeion-wise; he compares the gorgoneion with the Little-master cup from Naucratis, JHS 49 1929 pl. 16, 18. An Etruscan cista, BMC Bronzes no. 554, p. 78 figs. 13, 14, bears a frieze of running Gorgons, the snakes of each intertwining with those of the next kerykeion-wise; the frieze is sixth century B.C., the feet of the cista and the figure on the lid are later and do not belong. Intertwisted serpents first occur in Sumerian art, on early cylinders (E. Douglas Van Buren, Archiv für Orientforschung 10, 56–7), then on the Gudea steatite vase in the Louvre (Heuzey, Découvertes en Chaldée pl. 44; Contenau, Antiquités orientales I pl. 22; id., Manuel 2 fig. 525; Ebert 8 pl. 63 A, a). The motif was copied in late pre-dynastic Egypt: see the gold-mounted flint knife in Cairo (de Morgan, Préh. or. 2, 144 fig. 186, and id. Recherches 1, 115 fig. 136; Marc Rosenberg, Geschichte der Goldschmiedekunst, Einführung 116 figs. 125–7), and ivory handles in London and Berlin (Scharff, Zeitschrift für aegyptische Sprache und Altertumskunde 71 1935, 98 note 4). I am not competent to discuss the mythological interpretations given to the snakes: 'Ningizzida' (Frankfort, Iraq I 1934, 10); ἱερὸς γάμος (Van Buren l. c. 65); see also Zimmer, Die vorarisch-altindische Himmelsfrau (Corolla L. Curtius 183, pls. 62–4).

On p. 42 n. 7 where I mentioned cylinders showing animals with twisted tails I ought to have discussed confronted lions with entwined giraffe-like necks. They appear on cylinders from Warka IV (Scharff, Zeitschr. f. aeg. Sprache &c., l. c. 98 fig. 2) and on the contemporary cylinder in the Louvre Weber fig. 559. These creatures, confronted but the necks not intertwined, are seen in Syro-Hittite bronze terrets (Syria 12 pls. 20, 21; Archiv für Orientforschung 9 pl. 2 nos. 3, 4), and survive into the first half of the first millennium B.C.: Luristan bronzes (Pope pl. 44, A, B, D; Godard pl. 53). A variety, lions with intertwined necks but wearing snake heads are seen on another Warka IV cylinder, Scharff, l. c. 98 fig. 4. An Egyptian reflection of the former type is on the slate palette of Narmer (Quibell and Green, Hierakonpolis I pl. 29; Zeitschr. f. aeg. Sprache &c. 36, pls. 12, 13; Andrae and Schaefer, Kunst des alten Orients (1925) pl. 183; Handbuch der Altertumswissenschaft, Erster Tafelband pl. 57, 1).

p. 57 § 1. The same bridle-bits occur at Wiesenacker (North Bavaria), Åberg 2 figs. 83, 89, 90.

p. 57. An animal tendril appears on the fibula from Conflans, cant. Anglure, arr. Épernay, Marne, which bears *P 286*, Cat. Bronzes Troyes pl. 22 no. 233, and BSPF 1916, 468; see above p. 207.

p. 58 § 1 and *pl. 237, b.* P. Wolters, Zur Geschichte des Haushahns, Εἰς μνήμην Λάμπρου 489, takes the creature depicted on the late Cretan larnax from Episkopi, Crete, ib. 490, and Arch. Deltion 6 1920–1, 158, 5, hesitatingly for a cock: it is one of those zoomorphic ornaments discussed, but the animal features are hardly those of a cock.

In this context the gold ornament BMC Jewellery no. 816, pl. 8, should be mentioned: a cup spiral with protomai of lions growing out of the lateral involutions. Marshall classes the piece, together with nos. 815 and 817, as 'Mycenaean'. The three pieces were purchased together, and their alleged provenience is Crete: for 817 Marshall himself rightly suggests Egyptian origin; 815 has a 'Proto-Scythian' look and is seventh century; 816 seems to be of the same date and possibly reflects Phoenician influence: cup-spirals and swinging axil-leaves, here given a zoomorphic interpretation, are frequent in Phoenician art; for the blend of abstract ornament and animal form compare the gold ring cited on p. 55 n. 5.

p. 58 § 2. For another hanging bowl with dragonized Running Dog, from Neulingen, Altmark, see Sprockhoff, Zur Handelsgeschichte der germanischen Bronzezeit pl. 32; p. 106.

p. 59 § 2. E. S. G. Robinson adds the silver tetradrachm of uncertain attribution (Thrace? Macedonia?), Regling, Zeitschr. f. Num. 37 1927, 86–7, nos. 146, 147; id., Die antike Münze als Kunstwerk pl. 2 no 53, with a whirligig of three winged lion protomai.

p. 59 § 3. Whirligigs of wings. Beazley adds the Corinthian plate BSA 39 pl. 12, p. 25; fragment of a cup by the Amasis painter, BM B 601. 27, WV 1890–1 pl. 6, 4 d: see Beazley CVA Oxford 2 p. 97.

p. 61, on *P 29.* The piece Montelius pl. 224, 3 is also in Åberg 1 fig. 404.

p. 61, on *PP 61–6.* Another example of the motif is given by the Lemnian terracotta in Athens, JHS 50 1930, 246 fig. 4; AA 43 1930, 141–2 fig. 18, where the zigzag leaves form the bottom edge of a patterned garment (clearer in the original than in the photographs published). A variant of the motif is on a Naxian amphora, JdI 52 1937, 171 fig. 5; 173 fig. 9.

pp. 62, on *PP 83–9,* and **69** (see also p. 104, § 1). The sentry-boxes appear on a bronze Luristan situla, Pope pl. 70, A: I wonder if 'middle of tenth century B.C.' is not too early a date. The pattern is possibly connected with the stiff leaves on the bowl Pope pl. 68, A.

p. 62, on *P 90.* See Duhn 2 (Messerschmidt) p. 59.

p. 62, *P 110* also Troyes, Cat. of Bronzes, pl. 22 no. 332.

pp. 62–3, *PP 125–34,* and **p. 71.** See post-Hittite pottery from Boğazköi, AA 48 1933, 176 fig. 7: probably seventh century B.C.

p. 62, *P 127.* See Dohan, Italic Tomb-groups 108.

p. 63, *P 161.* Also Déchelette fig. 489, 1. See Reinecke, AuhV 5, 291 n. 5.

p. 64, on *PP 186–212,* (C). Add to the Etruscan fibulae Åberg 1 figs. 170, 177. Add Pannonain pottery, Ebert 10 pl. 8, 2. The ornamentation of other vessels in this group (ib. figs. 1 and 3) also suggest a date not earlier than the seventh century B.C.: the date advanced by Wilke (ib. p. 28) is too early.

p. 64, on *PP 186–212* (after F). See the bronze ornament from Münsingen, tomb 12, Wiedmer–Stern pl. 3, 4. The pattern is latent in the ornament of the Gallo-Roman painted bowl from Lezoux, Déchelette fig. 682, 5.

p. 64, *P 207.* See also Åberg 2 fig. 156.

p. 64, *PP 221* ff. See Dohan, Italic Tomb-groups p. 72, no. 3.

p. 65, *P 318* (and *pl. 216, b*). Brendel, AJA 1943, 203, incorrectly interprets the pattern as a 'playful alteration of a Greek palmette', and compares it with the attachment-head of the silver-mounted bucket from Praeneste, Tomba Castellani, in the Capitoline museum (Stuart Jones pl. 77) and with two heads on a bronze disk in St. Louis, AJA 1943, 196 fig. 3. The pattern is not and never was a 'palmette', nor has it anything to do with those compared by Brendel. In the bucket the two spirals are the bottom scrolls of a Hathor coiffure, and the palmette below is a typical feature of handle-ornament. On the disk the start is not a 'palmette' but the human head: it also wears Hathor locks; the odd double-hook-shaped 'stand' is a simplifying stylization of a design like the seventh-century Phoenicizing gold plaques from Cervetri, BMC Jewellery nos. 1265–6, pl. 16, which have an interesting Oriental ancestry. Double hooks as mere ornament are used as pendants in a seventh-century gold necklace from Vulci in Munich, Mühlestein 81, and are set in a row on the contemporary gold plaque from the Tomba del Guerriero at Tarquinia, Montelius pl. 288, 13; Mühlestein 54.

p. 66. To *P 422* add BMC Jewellery pl. 35, nos. 1951, 1952, Greek gold necklaces of the fourth century B.C.

p. 67 n. 2. Add the brooches AuhV 2, 1 pl. 4, 1, 2.

p. 68. Zigzag leaves: see Schaeffer fig. 50, p and fig. 191, D.

p. 68 n. 4 (and p. 61, *PP 34–42*). J. Werner, Marburger Studien (1938) pp. 260, 266, gives more detailed and more correct information; he refers to Steiner, Altschlesien 5 1934, 261 (not accessible to me).

p. 73 n. 2. Boeotian fibula, Blinkenberg fig. 192.

Professor Beazley adds a fragment from the sixth-century temple of Apollo at Cyrene, Pernier, Il tempio e l'altare di Apollo a Cirene pl. 7, 1.

An exact analogy of the pattern *pl. 242, a* is on a Phrygian vase of about the same date, Bittel, Boğazköi, pl. 18, 2, p. 59.

p. 76 § 4. Balusters: there is a coarse copy of a Swiss brooch of the type no. 340 from Deal, Kent, Ant. Journ. 20 1940, 276 fig. 1; see Hawkes ib. p. 277 n. 4.

p. 77 n. 3. The Venetian lid quoted is also illustrated by Duhn (Messerschmidt) 2 pl. 15. A good example of a three-part whirligig in the North, of the type *P 285*, is on a *Gürteldose* like that illustrated in *pl. 238, b*, from Fjellerup, Fünen, Åberg 2 fig. 130, 1a.

p. 81 n. 1. Add to the mosaics quoted one from Ephesus (Forschungen in Ephesos 4 (1932) pl. 3), and one from Nîmes (Inventaire des mosaïques de la Gaule et de l'Afrique I, no. 290).

p. 95, top and *P 385.* An Etruscan analogy to this treatment of flowers is on the terracotta revetment from Rome (Velia), Ryberg, An archaeological record of Rome pl. 45 fig. 177.

p. 95 § 2. To the urn from the Basle Gasfabrik and *P 471* add the filled leaf-ribbons on the Gallo-Roman painted bowl in Roanne, Déchelette fig. 682, 1. I am now inclined to think that the hanging bowl from Cerrig-y-Drudion, *P 471*, was made in Britain by an immigrant Gaulish artisan.

pp. 98–9 (and p. 135). The gold ring no. 70 has an analogy in two bronze arm-rings from Steinhausen, cant. Zug, Switzerland (ASA 6 1888–91, pl. 21, 6, 7; Viollier p. 134, no. 133, tomb 2). The first shows little globes in groups, which also appear on two silver fibulae from Dühren, Baden, AuhV 5 pl. 15 nos. 248, 249 (second century B.C.). The second ring bears plastic lyres, similar to those on the Belgian gold torc, and between them human heads (not clear in the drawing cited). Of the other objects in the tomb a potin coin, l.c. pl. 21, 10, is of no avail for the chronology of the find: three of the fibulae (pl. 21, 1, 2, 3) are LT I *c*, and two (pl. 21, 4, 5) LT II: this indicates a date in the later third century B.C. and possibly for the gold torc as well.

p. 98 n. 1. See p. 126 n. 3; add Čurčić, Jahrb. f. Altertumskunde 2 1908, 1 ff. The problem needs retractation.

p. 99 §2. Berry-style in glass: see Wiedmer–Stern pl. 24, 5 (Déchelette fig. 580, 6; Viollier pl. 35, 27) and Viollier pl. 35, 28.

p. 100 n. 1 needs correction. Of the rings quoted only that from Marzabotto comes from a context definitely Celtic. The ring from Este (Fondo Baratela), even if it should be late enough to admit of Celts, is at any rate earlier than the Plastic Style. The ring from Oulx is not

associated with other finds: it should be compared with Hallstatt rings such as Déchelette fig. 338. The association of the ring from Saliceto di San Giuliano is not clear: the glass ring, Montelius pl. 113, 2, and the bronze rings, ib. nos. 3, 4, are Celtic; the silver fibula, ib. no. 6, which has an exact analogy at Luceria, prov. Reggio Emilia, Montelius pl. XII, 160, is difficult to date. The ring, on the one hand, is similar to the Hallstatt ring from Hallstatt, tomb 839, Åberg 2 fig. 9 (text pp. 17–18), on the other hand it strongly recalls Celtic rings of the Plastic Style, such as that from Münsingen, Wiedmer–Stern pl. 10, 2, where, however, the modelling has lost precision and is slurring. Montelius's drawing, pl. 113, 5, does not allow definite judgement but gives the impression of a pre-Celtic date. In point of fact, these rings are the forerunners of Celtic rings of the Plastic Style: see p. 103, § 1, and add to Déchelette fig. 337, Åberg 2 figs. 76, 78 (Hungary), Åberg 1 fig. 561 (Este, Tomba Benvenuti), and BM EIA fig. 33, 1, 3.

p. 101 § 5 (9) (see also pp. 129 and 132). These brooches have a pendant found on the Marne, Dict. arch. de la Gaule pl. 35, 13.

p. 101, last paragraph. Seventh-century snail-shells: brooches Montelius pl. 75, 9 (Benacci I) and pl. 90, 10 (= série A pl. VII, 62) (Villanova).

p. 102 n. 3. Compare the yoke of the bronze plough from Talamone, Studi etruschi 2 pl. 45, p. 409; Montelius pl. 204, 10.

p. 107 n. 4. There is a Hallstatt urn with triple spectacle-handle, from Rantau, Kreis Fischhausen, Eastern Prussia, Ebert 9 pl. 224, h.

p. 109, lines 3–4. The face at the handle-base of the flagon no. 393 *d* has an analogy in the brooch from Münsingen, Wiedmer–Stern pl. 13, 11; Viollier pl. 4, 130, which is among the coarser pieces at Münsingen and possibly comes from the Ticino.

p. 111 n. 2. For vessels on wheels see also Brommer, Hermes 77 1942, 368.

p. 112 n. 3. The models of Chinese rhyta were possibly Persian: see the Achaemenid electrum and gold horse-rhyton Archiv für Orientforschung 10, 301, and the Seleucid glazed clay rhyton Pope pl. 184, D and vol. 1, 659.

p. 118 n. 1 and **p. 145.** The krater Berlin 3987 also in Mon. Piot 18 1920, 59 fig. 12.

p. 127 § 2. The Spartan brooch BSA 13, 114, fig. 4, a (Orthia pls. 87, a; 88, k) gives a clearer idea of a good Syrian figure brooch than the poor piece from Ras Shamra, *pl. 252, f*. The masterly Ephesian gold fibula, Hogarth pls. 3, 2; 4, 35; p. 97 also belongs here. Schaeffer, Syria 16 1935, 151: 'Nous établirons ailleurs leurs rapports avec l'art La Tène en Europe.'

p. 127 n. 1. Another brooch of the type from Santa Lucia, Duhn (Messerschmidt) 2 pl. 19, c.

p. 127 n. 5 (and *pl. 252, c*). The fibula is also in Åberg 1 fig. 398.

p. 129 § 3. Add the following brooches. (1) From Grand Serenne, arr. Barcelonnette, dép. Basses Alpes, Congr. int. 1874, 421 fig. 29. (2) From Uzès, dép. Gard, Bull. arch. 1897, 488. (3) From Queen's Barrow, Arras, E. R. Yorkshire, Archaeologia 60, 296 fig. 43. (4) From Harborough Cave, Derbyshire, Proc. Soc. Ant. 22, 138 fig. 19; Leeds, Celtic Ornament 43 fig. 17.

p. 130 n. 7. See the list Viollier 60–1.

p. 131 n. 2. The brooch from the Thames at Hammersmith, Arch. Cambr. 1927, 82 fig. 13; p. 79, has a wooden peg across the coil. A similar use of wood occurs already in Hallstatt times: the rim of bronze cauldrons made in the British Isles and copying Southern models of the first half of the seventh century B.C. is beaten round a wooden rod (Leeds, Archaeologia 80, 4).

p. 132, lines 4–5. The Saint-Germain piece quoted comes from La-Croix-en-Champagne.

pp. 132–3 (and to p. 129). There are two hartshorn imitations of coral plaques with the kind of astragaloi that decorate the brooch no. 343, *pl. 165*, from Münsingen, tomb 6, which yielded no. 365, and from tomb 12, Wiedmer–Stern pl. 2, 5; Viollier pl. 30, 8: both writers wrongly took the pieces for the head-plaque of a pin.

p. 132 n. 6. The fibula from the Danes Graves, E. R. Yorkshire, Archaeologia 60, 267 fig. 13, is decorated with coral-carved 'snail-shells' and leaves, to be compared with no. 202 (c).

p. 135. For the evidence of coins in Swiss graves of the LT II period, i.e. the late third and second centuries B.C., see Viollier p. 62. The coins tell less about the date of the tombs than other objects found together with them.

p. 136. At Ollon, district of Aigle, canton Vaud, a black skyphos was found, illustrated by Viollier plate facing p. 74, fig. 12: Beazley does not know skyphoi of this particular shape later than the fourth century B.C., but the photograph and description do not allow definite judgement; the Celtic objects in the tomb, enumerated by Viollier p. 127 no. 122, a glass ring of berry style (pl. 35, 25), a chain with pendants (pl. 29, 1), and others date the burial to the later third century B.C. Non liquet.

At Ribič, near Bihač, Bosnia, an Italiote kantharos, probably of the third century B.C., was found in a LT II context; Beazley compares it with an Attic kantharos, Breccia, La necropoli di Sciatbi pl. 54 no. 108, which is of about the same date.

p. 138 § 3. On a pair of stamnos handles in New York Hesperia 12 1943, 103 fig. 4, the tendrils above the head can be dated to the fourth century B.C., probably to its second quarter; the heads also show the character of these years.

p. 138 n. 5. Another such basin in Trier, Hettner, Illustrierter Führer (1903) p. 125, bottom fig. 6; p. 126.

pp. 139–40. The Filottrano basin also Dall'Osso pp. 243–5.

p. 139 n. 5. From Brøndsted, Danmarks Oldtid 87 fig. 69 it becomes clear that the piece is the handle of a Greek cauldron of the third quarter of the fifth century B.C.

p. 140 § 5. The flask (b) is also in Åberg 1 fig. 219.

p. 142 (and **p. 159**). For the route by which the Greek vases reached the North the following facts are of importance: such Attic scale kantharoi as were found at Rodenbach and La Motte-Saint-Valentin, occur at Bologna, Adria, and Este (Déchelette, La collection Millon pp. 126 ff.), and the Amymone painter who painted the cup from the Klein Aspergle grave (no. 32, *pl. 26*) had a market at Adria and Bologna: BARV 551, 10–12; 552, 29.

p. 142 n. 3. The resinous substance in a bronze pilgrim-flask from Volterra is hardly the residue of fragrant oil (Dohan, Italic Tomb-groups 9) but of retsinato.

p. 145 n. 6. I deliberately ignore here the names of Celtic mercenaries written in Greek characters on Alexandrine tomb-stelae and on a Hadra hydria, Mon. Piot 18, 37 ff.

pp. 147–8. Cook, Zeus 2 figs. 338, 339 illustrates girdle-hooks in the collection of Professor A. B. Cook, Cambridge, purchased in Capri. Fig. 339 is of the type *pl. 260, c*; fig. 338 shows a pair of winged youths, naked, wearing greaves, one holding a dagger, the other a knife (thus Cook) in the right hand. Beazley refers to an Eros with sword on a sea-horse, Gerhard, Etrusk. Spiegel 2 pl. 119; or should one think of Thanatos as he appears on the Ephesian drum? Cook, l.c. 432 n. 3, refers to another piece of this class, BMC Bronzes no. 2858 'two rude male figures . . . they wear helmets . . . their hands are placed on their hips': I have not seen the object.

The Campanian warriors in the Capuan wall-paintings, JdI 24 1909, pls. 8; 10, 1 wear this type of girdles.

p. 156 § 2. The gold plaques nos. 20, 21 possibly copy Scythian ones such as the bronze from Brezovo, Ebert 2 pl. 70, e; PZ 18 1927 pl. 8, 5 (H. Schmidt); Bull. Bulgare 6, 8 fig. 4. Rostovtzeff's (SB 542) and Schmidt's zoomorphic interpretation of the Scythian pattern is without foundation: see Malkina, PZ 19 1928, 152 ff.

p. 157. Scythian influence on Celtic crafts in Hungary: see my remarks, p. 115, on the sword no. 127, and see the chape from Felsömérc, Kom. Abauj-Torna, Dolgozatok pl. 50, 14; pp. 156–7, which imitates a Scythian model such as Borovka pl. 44, A (pp. 38 n. 1; 45 n. 1).

Possibly the surgical instruments, found at Kis-Köszeg in a LT context, which experts take for Greek, belonged to a Greek surgeon who emigrated to Hungary (Ebert 14, 29, § 6).

p. 158 n. 2. On the find from Uffing see Sprockhoff,

Zur Handelsgeschichte der germanischen Bronzezeit 135.

p. 178 no. 129. Also illustrated Mannus 5, 85 fig. 34; M. Jahn, Die Bewaffnung der Germanen 34 fig. 33.

p. 178 no. 133. See Åberg 2 fig. 200.

p. 179 no. 141. Déchelette 1606 no. 56 takes the helmet for classical.

p. 188 no. 214. Also in Dict. arch. de la Gaule pl. 35, 8.

p. 191 no. 251. That the piece comes from the Marne is suggested by its likeness to the armlet from Lépine, arr. Châlons, dép. Marne, Dict. arch. de la Gaule pl. 35, 12.

p. 192 no. 277. Illustrated in Dict. arch. de la Gaule pl. 35.

p. 193 no. 294. The fibula from near Mainz, in Mainz,

AuhV 2, 4 pl. 2, 10 (now less complete than in the illustration cited), seems to come from the same workshop.

p. 194 no. 314. See Åberg 2 fig. 225, 3.

p. 194 no. 316. See ib. fig. 225, 4.

p. 195 no. 320. See p. 127 n. 3. The piece has no exact provenience and it is uncertain whether it reached the North in antiquity. Even if so, it was exported in Hallstatt, not in La Tène times, and it should not appear here.

p. 200 no. 381. Also in BM Quarterly 4 1929 pl. 42.

p. 205 no. 408. The ornament correctly drawn Déchelette fig. 660, 2 and EIA pl. 6, 5 (where, however, the profile of the vase is disfigured).

p. 205 no. 413. Also Morel pl. 41, fig. 12, and Proc. Soc. Ant. 26, 131 fig. 3.

SUPPLEMENTARY CORRIGENDA

pp. 28–9. Add Déchelette 1304, fig. 566.2 to list of antithetic birds: Jacobsthal, *Greek Pins*, 118, n. 1.

p. 35. Add the drachmai of Kaidos, Babelon, *Traité des monnaies grecques et romaines*, pl. 18.

pp. 57–8. Running-dog patterns: addenda in *Greek Pins*, 74, n. 2.

pp. 67, 122; Pl. 267, fig. 157. On the openwork mounting plaque from Castello sopra Ticino the strokes are sigma-shaped and not continuous: *Greek Pins*, 210, n. 2.

p. 72. The ivory handle from Buchheim (Baden), Déchelette fig. 367.1, is more likely an import than a foreign copy: *Greek Pins*, 157, n. 1; fig. 458.

p. 75. Ignoring Eastern examples led to wrong conclusions: *Greek Pins*, 75, n. 2; *J.H.S.* 71 (1951), 89–90, 93 ff.

pp. 92–3. The term 'tendril' is used unbotanically to mean 'main stem', and 'gesprengte' palmette is perhaps better translated 'split' rather than 'sprung.'

pp. 96, 177. No. 113; the context of this sword is further discussed by A. Birchall in *Proc. Prehist. Soc.* 31 (1965), 272 f., 314.

pp. 106–7. W. L. Brown, *The Etruscan Lion* (1960), 109, n. 2, considers the Lenzburg flagons, No. 392, later than *c.* 420–400 B.C., and sees nothing very Greek about them.

p. 148. Zahn conflates a group of Canosa glasses which reached the B.M. in 1871 with those found in Cozzi's 1895 tombs; D. B. Harden, in *J. Glass Stud.* 10 (1968),

21 ff. esp. 30; see also A. Oliver in *Antike Kunst.* (Beiheft 5; Berne 1968), with a reassessment of Cozzi's two 1895 tombs. Harden argues that the 1871 glass came from a late third century tomb.

p. 148, n. 4, bottom line, read 'See also Kisa, *Das Glas*, p. 522, note 2.'.

pp. 158–9. 'I underrated the role of Hallstatt in the genesis of Celtic art, and I ought to have said that certain forms can be traced back to the Bronze Age.' Jacobsthal, *Greek Pins*, 157, n. 2, contains much relevant to E.C.A.

p. 173. No. 70; for the Frasnes-lez-Buissenal gold see now R. R. Clarke in *Proc. Prehist. Soc.* 20 (1954), 42–4, with excellent photos; it is now on loan to the Metropolitan Museum in New York.

p. 177. Nos. 107 and 109 are the front and back of the same sword-scabbard which came not from La Tène but from Port (Kanton Bern); it is now not in Neuchatel but in the Bernischen Historichen Museum, Inv. no. 2 13594; J. M. de Navarro, in *Ber. R. G. Komm* 40 (1959), 94, n. 37; O. Tschumi, *Die Ur- und frühgeschichtliche Fundstelle von Port in Amt Nidau* (1940), 10, fig. 7a second from left. V. Gross, *La Tène un oppidum Helvète* (1887), pl. III.3, shows the chape of this scabbard.

p. 212, note for p. 132, n. 6. The carved settings on this Yorkshire brooch are not in fact coral but fine-grained sandstone, probably from the Jurassic of North Yorkshire (I. M. Stead, *The La Tène Cultures of Eastern Yorkshire* (1963), 64).

INDEX 1

REFERENCES TO THE PAGES AND PLATES WHERE THE OBJECTS CONTAINED IN THE CATALOGUE AND THE PATTERNS (*PP*) DECORATING THEM ARE ILLUSTRATED OR DISCUSSED

INDEX 2

KEY TO *Pls. 216–60*

INDEX 3

REFERENCE TO THE PAGES WHERE PATTERNS (PP) (pls. 261–79) DECORATING OBJECTS OTHER THAN THOSE ILLUSTRATED IN pls. 1–260 ARE EXPLICITLY OR IMPLICITLY MENTIONED OR DISCUSSED

INDEX 4

PROVENIENCES

Uncertain and notoriously erroneous proveniences in brackets.

The countries have the frontiers drawn in *The Times* Atlas (1922): in certain cases, however (e.g. Germany, Rhineland), I deliberately ignore actual political borders. *Greece* is not a modern geographical unit: it includes places found on a map of ancient Greece. *Near East* is a makeshift and incorporates sites in Africa, Syria, Persia, &c. For verification of place-names I am indebted to Professor Minns, Dr. Claude Schaeffer, Professor Tschumi, Dr. Weinstock, the Royal Geographical Society, the Czechoslovak, Netherlands, and Swiss Embassies in London.

[1] For lack of precise indication in the books where the find is published the place could not be verified.

INDEX 5

ANCIENT WRITERS AND INSCRIPTIONS

INDEX 6

ARTS AND STYLES (OTHER THAN EARLY CELTIC)

INDEX 7

SOME MATTERS OF INTEREST

INDEX 8

CONCORDANCE TO SOME BOOKS ESPECIALLY FAMILIAR TO STUDENTS OF THE SUBJECT

[1] There might be incorrectness in the references: since 1939 the book has been inaccessible to me.